HOGARTH

AND HIS PLACE IN
EUROPEAN ART

By the same Author

✱

FLORENTINE PAINTING AND ITS SOCIAL BACKGROUND

FUSELI STUDIES

Frederick Antal

HOGARTH

AND HIS PLACE IN
EUROPEAN ART

LONDON

ROUTLEDGE & KEGAN PAUL

First published 1962
by Routledge & Kegan Paul Ltd
Broadway House, 68–74 Carter Lane
London, E.C.4

Text printed in Great Britain
by William Clowes and Sons, Ltd
London and Beccles

Plates printed in Great Britain
by Headley Brothers Ltd
London, and Ashford, Kent

Preface

✳✳

EVERY scholar knows the pitfalls that occur in tackling another's unfinished work. However cautious one may be there is grave risk of errors; I can only hope that, in the present case, they are minimal and that the publication of my late husband's manuscript on Hogarth will prove to have been justified. His intentions in working upon this subject, which largely occupied the last ten years of his life, are adequately set out in the Introduction. Had he lived to see the book through the press himself, he would have made various rearrangements of, and additions to, the material, notably in Chapter II and (substantially) in Chapter XI. But such alterations would not have interfered essentially with the thesis as it now stands.

I cannot write too warmly of the generous help and collaboration I have received and without which I could not have completed my task. Once again Sir Herbert Read has been my mainstay. To Professor Sir Anthony Blunt, Mr. Robin Chancellor, Mrs. Enriqueta Frankfort, Mr. Benedict Nicolson, Dr. Andrew Révai and Mr. Arthur Wheen, I am especially indebted and to them I offer most sincere thanks. The staffs of the Warburg Institute and the Witt Library of the Courtauld Institute have readily assisted me and I wish to thank them too.

Grateful acknowledgment is due to H.M. The Queen for gracious permission to reproduce drawings by Hogarth in the Royal Collection and to the private owners no less than to the galleries and institutions who have kindly allowed me to reproduce their drawings and pictures.

EVELYN ANTAL

London,
July, 1961

Contents

Errata

Pages 11 and 164. Plate number of *Beer Street* should read 120a.

Pages 11, 30 and 165. Plate number of *Gin Lane* should read 121a.

Page 164. Plate number of Breughel's *La Grasse Cuisine* should read 121a.

Page 165. Plate number of Breughel's *La Maigre Cuisine* should read 121b.

In the list of plates, number 127a, the work quoted should read '*Afbeldinden der Merkwaadigste*' instead of *Afbeeldingen der Mekwaadigste*, and on number 149a the owner's name should read The Hon. J. V. B. Saumarez.

Plates

When not otherwise stated, the medium is oil.

Plates

81b PIETRO LONGHI: The Dancing Master. [Academy, Venice.]

82a HOGARTH: Mr. James, S.D. 1744. [Art Museum, Worcester, Mass.]

82b LATOUR: Duc de Villars, 1743. Pastel. [Le Musée d'Aixen-Provence.]

83a TOCQUÉ: M. Pouan, 1743. Conte Doria, Paris.

83b GOYA: Don Antonio Noriega, 1802. [National Gallery of Art, Washington.]

84a GOYA: Los Caprichos, No. 14, Que Sacrificio, 1799. Engraving.

84b HIGHMORE: Mr. B. coming upon Pamela Writing a Letter, c. 1744. [Tate Gallery, London.]

85a AERT DE GELDER: Marriage Contract. [Brighton Museum and Art Gallery.]

85b CHARDIN: La Gouvernante, 1738. [National Gallery of Canada, Ottawa.]

86a TRAVERSI: Marriage Contract, c. 1750. [Gallery Corsini, Rome.]

86b GREUZE: Village Bride, 1761. [Louvre, Paris.]

87a HOGARTH: Marriage à la Mode, 1745. I. The Contract. [National Gallery, London.]

87b FEDOTOV: Betrothal, 1848. [Tretyakov Gallery, Moscow.]

88a GRAVELOT, engraved by J. Major, 1745: Seated Cavalier.

88b GILLRAY: Morning after Marriage, 1788. Engraving.

89a HOGARTH: Marriage à la Mode, II. Early in the Morning. [National Gallery, London.]

89b COCHIN THE YOUNGER: La Soirée, Drawing. [Engraved in 1739.] [Ashmolean Museum, Oxford.]

90a BOUCHER, engraved by Cars, 1734: Illustration to Molière's Les Précieuses Ridicules.

90b MERCIER: Lady Preparing for a Masquerade. [Private Collection, England.]

90c HOGARTH: Marriage à la Mode, IV. The Toilette. [National Gallery, London.]

91a CH. A. COYPEL, engraved by Joullain, 1726: Illustration to Molière's Les Femmes Savantes.

91b J. F. DE TROY: Reading from Molière, 1740. [Marquess of Cholmondeley.]

92a HOGARTH: Marriage à la Mode, V. Death of the Earl. [National Gallery, London.]

92b HOGARTH: Marriage à la Mode, VI. Death of the Countess. [National Gallery, London.]

93a HOGARTH: Wedding Banquet, after 1745. [Cornwall County Museum, Truro.]

93b MAGNASCO: Visit in the Garden. [Palazzo Bianco, Genoa.]

94a HOGARTH: Wedding Dance, after 1745. [South London Art Gallery, Camberwell.]

94b CH. A. COYPEL: Don Quixote and Sancho Panza Dancing. Cartoon for tapestry, 1732. [Château, Compiègne.]

95a S. FOKKE: Maria Theresa and Frederick II dancing, 1742. Engraving.

95b HOGARTH: Operation Scene in a Hospital, c. 1745. Drawing. [Pierpont Morgan Library, New York.]

96a HOGARTH: Self-portrait, c. 1728. [Lord Kinnaird.]

96b HOGARTH: Self-portrait, S.D. 1745. [National Gallery, London.]

97a HOGARTH: Self-portrait, before 1758. [National Portrait Gallery, London.]

97b SOLDI: William Hogarth. [Newburgh Priory.]

98a WILLIAM HAMILTON, engraved by Bartolozzi, 1780/4. Kemble as Richard III.

98b CRUICKSHANK: Tom Thumb, 1830. Woodcut. Detail.

98c HOGARTH: Garrick as Richard III, c. 1746. [Walker Art Gallery, Liverpool.]

99a HOGARTH: March to Finchley, 1746. [Foundling Hospital, London.]

99b WATTEAU, engraved by Ravenet, 1738: Départ de Garnison.

100a HOGARTH: Moses brought to Pharaoh's Daughter, 1746. [Foundling Hospital, London.]

100b VIEN: La Marchande d'Amour, 1763. [Château, Fontainebleau.]

101a HIGHMORE: Hagar and Ishmael, 1746. [Foundling Hospital, London.]

101b HAYMAN: Finding of Moses, 1746. [Foundling Hospital, London.]

102a HOGARTH: Charmers of the Age, 1742. Etching.

102b HOGARTH: Battle of the Pictures, 1745. Engraving.

103a HOGARTH: Industry and Idleness, 1747. Sketch for plate I. The Fellow 'Prentices at their Looms. [British Museum.]

125b PAUL SANDBY: Magic Lantern, 1753. Engraving.

126 HOGARTH: St. Mary Redcliffe altarpiece: The Ascension, 1756. [City Art Gallery, Bristol.]

127a LUYKEN: 'Resurrection of Lazarus' from *Afbeeldingen der Mekwaardigste Geschiedenissen van het oude en nieuwe Testament*, 1729. Engraving.

127b HOGARTH: St. Mary Redcliffe altarpiece: The Sealing of the Sepulchre. [City Art Gallery, Bristol.]

127c HOGARTH: St. Mary Redcliffe altarpiece: The Three Marys at the Tomb. [City Art Gallery, Bristol.]

128a HOGARTH: Garrick and His Wife, 1757. [The Royal Collection, Windsor Castle.]

128b DESMARÉES: The Artist with His Daughter, 1760. [Pinakothek, Munich.]

129a DAVID: Lavoisier and His Wife, 1788. [Rockefeller Institution for Medical Research, New York.]

129b LOO, J. B. VAN: Colley Cibber and His Daughter, c. 1738. Engraving.

130a HOGARTH: The Bench, 1758. Engraving.

130b DAUMIER: Les Gens de Justice, 1845. Engraving.

131a FURINI: Sigismunda. [Formerly Earl of Lincoln.]

131b COYPEL, engraved by Drevet, 1730. Adrienne Lecouvreur as Cornelia.

131c HOGARTH: Sigismunda, 1758/9. [Tate Gallery, London.]

132 HOGARTH: His Servants. [National Gallery, London.]

133a HOGARTH: Portrait of Pine, c. 1756. [R. B. Beckett.]

133b HIGHMORE: Samuel Richardson, 1750. [National Portrait Gallery, London.]

134 HOGARTH: The Lady's Last Stake, 1758/9. [Albright Art Gallery, Buffalo.]

135a SUBLEYRAS: Le Faucon. [Louvre, Paris.]

135b STUART NEWTON: Yorrick and The Grisette in the Glove Shop, c. 1830. [Tate Gallery, London.]

136a HOGARTH: The Cockpit, 1759. Engraving.

136b ROWLANDSON: Royal Cockpit, 1816. Aquatint.

137a HOGARTH: Enthusiasm Delineated, 1762. Engraving.

137b Dutch print: Cromwell Preaching, 1651.

138a HOGARTH: The Shrimp Girl. [National Gallery, London.]

138b FRANS HALS: Fisher Girl. [Hallwylska Museet, Stockholm].

139a After HOGARTH: The Farmer's Return, 1762. Engraving.

139b METSU: Smoker by the Chimney. [Gemäldegalerie, Dresden.]

140a HOGARTH: Wilkes, 1763. Etching.

140b HOGARTH: Time Smoking a Picture, 1761. Engraving.

141a HOGARTH: Five Orders of Periwigs, 1761. Engraving.

141b CHODOWIECKI: Teaching the Fine Arts, 1780. Engraving.

142a HOGARTH: Times I, 1762. Engraving.

142b CALLOT: Smaraolo Cornuto. Ratsa di Boio, c. 1622. Engraving.

143a HOGARTH: Times II, 1762. Engraving.

143b HOGARTH: Bathos, 1764. Drawing. [Royal Library, Windsor Castle.]

144a ZOFFANY: Concert of Wandering Minstrels, 1773. [Pinacoteca, Parma.]

144b CHODOWIECKI: Progress of Virtue and Vice, 1778. Engraving.

145a FUSELI: Satan, Sin and Death, 1776. Drawing. [Ashmolean Museum, Oxford.]

145b MORLAND, engraved by Blake, 1788: Idle Laundress.

146a GAINSBOROUGH: Mrs. John Kirby, c. 1752. [Fitzwilliam Museum, Cambridge.]

146b ALLAN RAMSAY: Abigail Ward, 1747. [Dr. Thomas Loveday.]

147a REYNOLDS: His Sister, Elizabeth, 1746. [Radcliffe.]

147b RICHARD WILSON: Flora Macdonald, S.D. 1747. [National Portrait Gallery, Edinburgh.]

148a TROOST: Nelri No. 4. Rumor erat in casa, 1740. [Mauritshuis, Hague.]

148b COPLEY: Death of the Earl of Chatham, 1778. [Tate Gallery, London.]

149a GAINSBOROUGH: Farm Landscape, c. 1750–5. [J. V. B. Sauwarez.]

149b DE LOUTHERBOURG: Summer Afternoon with a Methodist Preacher, c. 1774. [National Gallery of Canada, Ottawa.]

150a JOHN COLLET: The Press Gang, 1767. [Foundling Hospital, London.]

150b WILKIE: Chelsea Pensioners Reading the Waterloo Despatch, 1817. [Wellington Museum, London.]

151a CRUIKSHANK: The Drunkard's Children, 1848. Engraving.

151b GILLRAY: Dilettanti Theatricals, 1803. Engraving.

152 MILLAIS: Race Meeting, 1853. Drawing. [Ashmolean Museum, Oxford.]

Photographs have been supplied by the following: Alinari 93b, 144a; Archives Photographiques 14b, 94b, 135a; Bulloz 65b, 70b, 82b, 83a, 86b, 100b; A. C. Cooper 16a, 18, 23b, 94a, 112a, 113b, 131a; Courtauld Institute of Art 84a; Durand-Ruel 41a; R. B. Fleming 51b, 68b; Giraudon 21b, 49b, 76b; Photo Studios 42b, 71b; Warburg Institute 2a, 3a, 5a, 6a, 8a, 15a, b, 17a, 20b, 34a, b, 35b, 40b, 41c, 43a, 53a, 55b, 61b, 63b, 64b, 78a, 79a, b, 88b, 95a, 98a, b, 103c, 104b, 108a, 112b, 119a, 121a, b, 122b, 127a, 129b, 130a, 137a, b, 140b, 141b, 142a, b, 144b, 145b, 151a, b.

Introduction

WHEN, in the 1920's, I first saw Hogarth's pictures in English galleries, they struck me as an inexplicable miracle. Here was a painter who, although generally considered at best a kind of prelude to Reynolds and Gainsborough, was (Blake apart) perhaps the greatest of all English artists. Yet there was apparently nothing in either English or continental art with which to connect him.

In 1942 I gave a lecture at the Courtauld Institute at London University on the occasion of an exhibition at the Warburg Institute illustrating the links between English and continental, especially Mediterranean, art. From this lecture the present book grew. The central problem, based on the first deep impression I received, has always remained the same. How, almost out of the void, did Hogarth create an art that was completely new, both in theme and form? What was his stylistic development? Where did his tendencies and affinities lie? Finally, what was the impact of his art on future generations?

Hogarth fascinated me, not only because he was a truly great and original artist, but also because his art reveals, to a far greater extent than is usual with artists, the views and tastes of a broad cross-section of society. Whereas everyone recognises that it expresses the outlook of the rising English middle class of the period, too few people realise that this forms only one facet of it.

Few artists of recent times open up such wide perspectives—both into the past and into the future—so that the trends of whole centuries are suddenly illumined. Viewed within the confines of English art, which hardly existed in the generations preceding him, Hogarth's originality becomes really elusive. Thus Horace Walpole's observation on his didactic works could be applied to his whole *œuvre*: 'Hogarth had no model to follow and improve upon.' For it is probably true to say that no other artist built up an art of such originality and such high quality upon so slender a native tradition—an art, moreover, that was far more progressive than any that had existed before him in any country. Hogarth's art reflects not only those works which he knew and which directly influenced him, but also the whole pattern of painting and engraving throughout Europe from which his art had to grow.[1] In shaping a rich new English art, he had to summarise

[1] Precursors and parallels are just as important as influences. There is no borderline between genuine, conscious, and potential, unconscious, influences. Both kinds support and emphasise but do not necessarily determine the development of an artist. He who accepts influences or, which is equally important, appears to have accepted influences, does so only from those directions in which his own tendencies lie. In using the terms 'theoretically' and 'historically speaking', I mean these unconscious influences or parallels.

in himself, as it were, almost to compress within his early development, the whole of this continental tradition, especially in the field of graphic art. The bewildering originality of his later works is only explicable if one eye is constantly kept on contemporary continental art, whose different trends he developed, varied and adapted, consciously or unconsciously, in his own personal way and against his own English background.

Throughout this book I propose to discuss Hogarth's relationship both with English and foreign art, past and contemporary, his premises and parallels, his similarities and even his borrowings, difficult though the latter are to detect. And this without, I hope, letting my imagination run wild. In addition to his impact in his own time, his influence on the development of English and of continental art of later generations was far-reaching. So in order fully to establish Hogarth's place amid the cross-currents of European art, I shall briefly indicate what his art signified for succeeding generations in England and abroad.

The way in which a book with such a complex theme should be constructed was no easy matter to decide. Clearly, Hogarth's art must be approached from different angles. Clearly, too, the first chapter should deal with Hogarth's world of ideas and his attitude to society, the motive power behind his most important works. The better to illustrate his view and new themes, I have also glanced in this chapter at the social and political structure of England in his time. Thereafter my difficulties arose, for from Hogarth's outlook and themes I had to deduce his stylistic development. Yet how could a conventional approach be made to an artist whose evolution sprang from such different starting-points and who did such astonishingly varied types of work—satirical–didactic compositions, portraits, historical paintings, popular caricatures, theatre pictures, book illustrations—which developed on parallel but distinct lines according to the publics for which they were destined? To discuss his entire *œuvre* chronologically would have involved clumsy repetition; on the other hand, to divide his works into different sections according to their nature would have obscured the line of his stylistic development. I have endeavoured to balance both these approaches and thus to provide a flexible yet coherent picture of Hogarth's evolution. True, I have had perforce to return to certain works several times over, but this seems to me a lesser evil. In Chapter II, I have given a general outline of the artist's development, indicating the main thematic and formal features of his major works. Placing his art in a certain, if simplified, perspective in this way gave me a freer hand for detailed analysis in the following chapters.

My chief concern has been to show how, in fact, Hogarth worked for many different social strata with widely differing tastes, corresponding with his manifold interests and aspirations. In Chapter III I have accordingly discussed the taste of the court, the aristocracy, the well-to-do middle class and the general public, and Hogarth's relations with each of them. By taking first the obvious differences between his portraits of members of the court, the aristocracy and the middle class, and then by drawing parallels between Hogarth, Richardson and Fielding, I have tried to elucidate to what degree and in what particular way Hogarth can be considered a genuine artist of the middle class. From this same standpoint, I have also here analysed his popular engravings.

In Chapter IV I have sought to epitomise Hogarth's stylistic development through the medium of one of his favourite themes, his representations of the theatre and public entertainments: how the style varied not only according to the artist's particular phase but also according to the subject of the work and the type of public for which it was intended. And since most of his theatrical portrayals date from his early period, I felt it not unfitting to delay the 'straightforward' account of his early period, the 'twenties and early 'thirties, to Chapter V. Here too I have analysed in

detail Hogarth's relation with Callot, whose direct influence was most marked at this time.

Chapter VI covers the main works of the 1730's and 1740's—the cycles. It also deals with Hogarth's visit to Paris in 1743, when he was most closely in touch with French art. Having here drawn attention to Hogarth's deep interest, even in such realistic works as his cycles, in expressive values and irrational features, I have devoted Chapter VII to tracing the tendencies towards the fantastic and the grotesque throughout his *œuvre*, especially in his caricatures. The historical compositions, which at first glance seem to exist in a world apart, are studied in Chapter VIII, where Hogarth's relation with great continental art is closely examined. Chapter IX covers the final phase of his development, the 'fifties and early 'sixties, during which he published *The Analysis of Beauty*.

Since throughout the first nine chapters I have referred to the main precursors and parallels to Hogarth's art, the final part of this book is concerned with its consequences, which involved out-lining the trends of middle class art following his pervasive impact. Chapter X traces Hogarth's influence during his lifetime and on succeeding generations in England. Chapter XI follows the same course for Europe as a whole.[2]

Those acquainted with the sociological method I employed in *Florentine Painting and its Social Background* may perhaps wonder why I have not here also devoted the first chapters to social and political history and ideas, and the history of religious sentiment. The answer is that, whereas readers of the earlier book are not necessarily well-informed on events and thought in 14th-century Florence, most English-speaking people have a fairly good idea of 18th-century England. Nevertheless I have associated Hogarth's art throughout with its social background as intimately as I did Florentine art, and here too I have used the themes to link the outlook on life with the style of the works.

Although 18th-century England, its history, literature and philosophy, have been thoroughly explored in many books, when I first embarked on this study, knowledge of Hogarth was mainly confined to a mass of facts concerning his life and works, often of an anecdotal and unreliable character. The chief sources were the writings of three antiquarians at the end of the 18th century: John Nichols' *Biographical Anecdotes of William Hogarth* (increasingly enlarged editions, 1781, 1783 and 1785) and his *Genuine Works of William Hogarth* (3 vols., 1808–17)[3]; John Ireland's *Hogarth Illustrated* (1791–8) and Samuel Ireland's *Graphic Illustrations of Hogarth* (1794–9). It may be said here that the catalogues of Hogarth's engravings in the various publications of Nichols and his son are still the only ones available, although they have never been critically revised. Finally, Samuel Ireland's own publication contains many works clearly not by Hogarth at all.

As regards 19th-century literature, F. G. Stephens' *Catalogue of Prints and Drawings in the British Museum, Political and Personal Satires* (London, 1873–83) gives thematic details of Hogarth's engravings. Austin Dobson's important monograph *William Hogarth* (last edition, 1907), summarises the material from the above-mentioned sources with the author's additional findings. Certain details of Dobson's researches were complemented by W. T. Whitley in *Hogarth's London* (London, 1909) and *Artists and their Friends in England* (1928). A few good

[2] These chapters contain some passages which, although growing out of the theme of Hogarth's significance, doubtless go beyond it. But Hogarth's art forms an obvious guide to an understanding and clarification of the various currents of middle-class art and art criticism. I hope that the interest of such passages, even when it has led me into perhaps unexpected bypaths, is sufficient apology for their inclusion.

[3] John Steevens was a collaborator on the *Biographical Anecdotes*. An offspring of the *Genuine Works* is *Anecdotes of William Hogarth* (1833) by J. N. Nichols, J. Nichols' son.

observations on Hogarth's works are scattered through Baldwin Brown's *William Hogarth* (1905).

Apart from these works, there was almost no other English literature on Hogarth. Nowhere was there any precise analysis of his style or its evolution, nor even any up-to-date critical catalogue of his works. Although my concern was primarily with Hogarth's art as a whole, such material, or at least a few reliable articles on questions of detail, would have greatly facilitated my task. The dates of Hogarth's chief works were well known, but many minor yet important works left one groping in the dark. Even what little pre-war research had been done proved full of errors. In this rather unpromising situation, I was obliged to do a lot of spade-work of a merely philological nature. And despite my own efforts, and the recent publication of two valuable books by Beckett[4] and Oppé,[5] a great deal of research, even of identification and cataloguing, still remains to be done on and around Hogarth. There is particular call for further study of his engravings and verification of a number of doubtful attributions to him; and more research is needed on references to him and his art in the newspapers and periodicals of his time. Knowledge regarding other English artists in his orbit is also insufficient and this further impedes both correct attributions and a true appreciation of the artistic atmosphere in which he moved.

I have recounted only the main events of Hogarth's life, together with a few details in so far as they shed light on his art. Individual works have been treated according to their importance for my theme, and many (not only engravings and drawings but also paintings) are scarcely mentioned, in order to avoid undue repetition. Those who seek further dates and facts should turn to the books mentioned above, particularly to Dobson's charmingly written one or those of the industrious Nichols. The numerous allusions in Hogarth's engravings and the identities of the figures in them are to be found interpreted in Nichols' books and Stephens' catalogue. I have naturally tried to be as accurate as possible regarding details of Hogarth's life and works and that of other English artists but, as I have explained, certain faults of an antiquarian brand are unavoidable today. Whether a picture was made the year of the engraving after it or the year before, I do not find of such vital importance nor do I think it of extreme gravity, in these days of quickly changing property, always to know the current owner of a picture; or whether a certain year before the change in the Gregorian Calendar in 1752 is that of the old or the new date; or whether, as some say Mr. X or as others Mr. Y. was Master of the Robes or Groom of the Bedchamber to the Prince of Wales.

I have quoted a fair number of Hogarth's own recorded sayings, even the familiar ones, and I hope that some of these, in this new context, may perhaps acquire a profounder meaning. Unless otherwise specified, such quotations come from Hogarth's autobiographical notes. Quotations from Nichols usually refer to his *Genuine Works*, which is more complete than the earlier *Biographical Anecdotes*. Unless otherwise stated, quotations from Horace Walpole come from his *Anecdotes of Painting*. I am also indebted for some interesting contemporary comments to Austin Dobson's zeal in ferreting out information about Hogarth's milieu. Generally speaking in order to reduce the number of bibliographical references, I have confined myself to quoting those works to which I was really indebted for ideas or facts or which are remote and unfamiliar.

When this book was almost completed, A. P. Oppé's catalogue of Hogarth's drawings and R. B. Beckett's of the pictures appeared. Both these had involved much useful research regarding

[4] *Hogarth* (London, 1949).
[5] *The Drawings of William Hogarth* (London, 1948).

the authenticity, dates and whereabouts of Hogarth's drawings and pictures.[6] I only wish I had had these books at my disposal from the start. Both authors, however, most generously gave me all the information they could before their books were published.

It may perhaps surprise the reader to find, at the end of this work, a somewhat vehement passage deploring the general neglect of Hogarth. This was written in 1941–2, and today such a defence of the artist is no longer necessary. My forecast that a time would come when Hogarth would once again rise on a tide of appreciation is, I think, at least partly fulfilled. I have retained the passage however, since it reflects the then prevailing attitude towards Hogarth which was one of the motives that induced me to embark on this study.

[6] Beckett's work can only be considered a first sifting of the enormous number of likenesses attributed to Hogarth. Fortunately these, despite their great number, form relatively the least important facet of Hogarth's art.

I

Hogarth's World of Ideas

❧❧

I N the 17th century, the great economic power of Holland had been regarded as something
of a miracle. Yet in the early 18th century, after the Peace of Utrecht (1713), an even greater
one emerged. As Dutch wealth declined, middle-class England slowly usurped and ultimately
far outstripped it, until her trade dominated the world. Later in the century, her industry too
was stimulated by the great technical innovations of the Industrial Revolution. The period
covered by Hogarth's life—from 1697 to 1764—saw the slow, systematic and organic growth
of the English middle class, as opposed to the meteoric rise and fall which had marked the brief
Cromwellian interlude. Already far distant from the Restoration, only towards its close did it
feel the first breezes of the coming reactionary trend, political, though not economic, under
George III. It was, in fact, the essentially bourgeois, one might almost say 'liberal', period of
18th-century England.

The son of a schoolmaster, Hogarth was named William in honour of William III, whose
seizure of power in 1688 had put an end to the absolutist rule of the Stuarts, and whose reign
marked the definite turn towards economic stability of the middle class.[1]

The prominence of the English middle class in the early 18th century would have been impos-
sible but for the two previous revolutions of Cromwell and of 1688. From these had sprung up
a situation unique in a Europe where the old absolutist and aristocratic tradition still prevailed:
the royal prerogatives were reduced, the power of Parliament enhanced, the responsibility of the
executive towards the legislative power secured and civil liberties jealously guarded. Only in
England, with its freedom of the press, could such a biting, political caricature have appeared as
Hogarth's engraving of 1724, *Royalty, Episcopacy and Law* (Pl. 8a), with its expression of en-
lightened democratic ideas. Political caricature, the weapon of the middle class against absolutism,
had originally come to England, significantly enough, from Holland. Here, in this striking work,
Hogarth not only exposed the well-known indifference of the clergy but also jeered at the vapid-
ness and singular dullness of court life under George I, who is represented as a kind of empty
dummy. Small wonder that a country where feeling against unpopular rule could be publicly

good

expressed in lampoons and ballads of this kind should have been the model and envy of all the middle classes of Europe.

It must not, however, be forgotten that in early 18th-century England the middle class and the aristocracy were not strictly opposed but tended to make alliance with each other. The former had already become linked with the landed gentry during the Commonwealth, and with the Whig aristocracy after the 1688 revolution. Equally, the ruling Whig aristocracy, which now almost completely monopolised Parliament, was often associated with commercial interests and increasingly promoted the far-reaching economic plans of the City. If this was evident under Sir Robert Walpole (Prime Minister from 1721 to 1742),[2] when trading and particularly banking interests were very strong, it was even more so under the succeeding Whig cabinets, formed by former opponents of Walpole: Carteret (1742–4), the Pelhams (1746–56), the elder Pitt[3] (1757–61). Pitt, a descendant of East India merchants and therefore not representative of the Whig aristocracy, although he was to lead it, identified his politics more closely with the City than had Walpole, the offspring of Norfolk country gentlemen.[4] Despite the restriction of voting rights to a very small section of the population and the control of seats by the aristocracy, many great merchants were enabled to enter the House of Commons; for instance, in 1761 alone, fifty or fifty-one London merchants were elected to Parliament, thirty-seven of whom had extensive business dealings with the government.[5] The City and the middle class, therefore, generally supported the Whig governments[6] and, despite its unpopularity, the Hanoverian dynasty, whose succession the Whig aristocracy had originally sponsored in 1714. The alternative would have been disastrous to their interests, involving the re-establishment of the Stuarts by the Jacobite Tories and the consequent dependence of England upon France—a situation which twice came dangerously near to realisation. As a good pro-Hanoverian, Hogarth shared this conviction. In a picture of 1746 which he originally intended to dedicate to George II, he represented *The March to Finchley* (Pl. 99a) of the Guards on their way to fight against the Young Pretender in 1745, Finchley being their mustering point. In this picture Hogarth savagely portrayed the Jacobite agents at their destructive work against the army. The receipt for the engraving of this work (1750) shows the weapons—arms, bagpipes, etc., mostly out-of-date—of the defeated Scots and those of the victorious English. Hogarth attacked the Jacobites in many other works, such as *The Gate of Calais* (1749, National Gallery) (Pl. 111), where they are ridiculed as miserable refugees in France. His portrait of 1745 of Thomas Herring, Archbishop of York (Pl. 76a), was engraved in the same year as a headpiece to the latter's speech proscribing the invasion in no measured terms. In 1747, Hogarth also did a frontispiece for *The Jacobite's Journal* (Pl. 114), an anti-Jacobite Whig periodical founded in support of the Pelham cabinet on the wave of reaction following the rising. This was edited by Henry Fielding, a friend of Hogarth's and one of the principal political journalists of the previously anti-Walpole group of Whig aristocrats now in power—men such as Lord Lyttelton, Lord Chesterfield and Pitt. It was Fielding who gave Hogarth the theme for this frontispiece, which was directed against the Scottish partisans of the Young Pretender: a bibulous Scotsman and Scotswoman, shouting 'Huzza', are riding upon an ass (symbolising Jacobitism), led by a Jesuit dressed as a friar. Other allusions also abound: the woman holds a copy, adorned with *fleurs de lys*, of Harrington's *Oceana*, a republican, pro-Commonwealth book written in 1656; thus Fielding was pointing to an alliance of the republicans, Jacobites and French against the Hanoverian dynasty and implying that anyone who opposed the Pelham Cabinet was a Jacobite. The friar is feeding the ass with *The London Evening Post*, an anti-government paper.

In accordance with the patriotic sentiments of his class and somewhat in contrast to the more internationally-minded aristocracy, Hogarth was strongly prejudiced against all foreigners, particularly the French. This found expression in many of his works, as, for instance, in *The Gate of Calais* the starving French sentinels and the gross, well-fed friars gaze enviously at the English roast beef as it is brought in for the travellers' hostel.[7]

The English middle class prided itself on having wrested world supremacy from France, the country of absolutism. The elder Pitt's grandiose policy of empire-building, well suited to the expansionist trading interests of the City,[8] was chiefly directed against the French and eventually led to the Seven Years' War. When, early in the war, in 1756, the possibility of a French invasion was in the air, Hogarth made two pungent engravings on the subject. Following the tradition of the anti-French and anti-Catholic 17th-century Dutch caricaturists, one of these ridicules the French invasion plans, showing poor, ill-fed soldiers boarding the ships as a friar loads instruments of torture to be used against the English Protestants.[9] In the other, English soldiers and sailors are seen thriving on an abundance of good native food and laughing at a caricature of the despot, Louis XV: a peasant, eager to enlist, stands on tip-toe to reach the regulation height, while in the background recruits are drilled by a sergeant. During another invasion scare in 1759, Pitt's government, for propaganda purposes, republished these engravings embellished with patriotic verses by Garrick, extolling English liberty.

Horace Walpole expressed the taste of only a small circle of pro-French aristocrats when he remarked of these two prints and of *The Gate of Calais* that 'Hogarth to please his vulgar customers stooped to low images and national satire'. A smaller version of the print after *The Gate of Calais* was accompanied by anti-French verses by Theodosius Forrest, a well-known song writer, and a cantata written to these was performed in the theatre; a woodcut of a hungry French sentinel in the same composition, juxtaposed with a well-fed British soldier, was used to stimulate recruiting. So popular with the middle class was the war against the French that in 1760 its principal events were depicted by Hogarth's friend Hayman, in four pictures exhibited in Vauxhall Gardens, an establishment to which Hogarth was a sort of artistic adviser-in-chief.

Apart from his anti-Jacobite attitude, Hogarth was not particularly interested in home politics which, under Whig rule, consisted to a great extent of personal quarrels and scrambles for office.[10] In fact, he distrusted all politicians. In the four scenes of his *Election* cycle of 1755 (Soane Museum, London. Pls. 122a, 123a, b, 124a), he showed up the corruption of the particularly notorious election of 1754, organised by the Duke of Newcastle, who had brought Walpole's election machinery to a fine point of perfection. Many of his motives were taken from Oxfordshire, where election bribery that particular year had reached its peak.[11] The candidate stages a lavish entertainment for his constituents; voters are openly bought, among them imbeciles, cripples and the dying, who are conveyed to the polls to record their votes. Though, in this last scene of the polling, Hogarth represented Britannia's coach on the point of over-turning while the coachmen play cards, he certainly did not imply any fundamental criticism of Parliamentary government. In no section of society was objection really raised to election bribery and it was common knowledge that large sums were needed to purchase every seat. As far as can be judged from this cycle and from his own notes on the subject, Hogarth probably held the view, with even more conviction than Fielding (who was, at least intermittently, more entangled in party politics than the artist), that all parties were corrupt, thought only of their own interests and had no clear programme.

Fielding's attitude to such abuses may partly reflect that of Hogarth. At first Fielding held up

to scorn the corruption of elections under Walpole, sparing neither side, as in his comedies *Don Quixote in England*, 1733, dedicated to the anti-Walpole Lord Chesterfield, and *Pasquin*, 1736, which Hogarth illustrated (Pl. 61b); and in *Jonathan Wild* he compared the political parties to rival gangs of pickpockets. When his political friends, the anti-Walpole Whig dissidents, came to power, he defended bribery as to some extent unavoidable, in an election pamphlet, *A Dialogue between a Gentleman of London, Agent for two Court Candidates and an Honest Alderman of the Country Party*, 1747, written to justify Pelham's administration and repeating the views already expressed in the anti-Jacobite frontispiece commissioned from Hogarth. Later still, in *Amelia*, three years before Hogarth's Election Cycle, Fielding, though indulging plentifully in moral exhortation, appears somewhat resigned to corruption as an ever-present feature in the government of the state. Hogarth himself did not side with either party. In fact, it is not even clear which party is represented in *An Election Entertainment*. The elector who, in the *Canvassing* scene, is taking bribes from both sides at once probably reveals most clearly his opinion of the prevailing state of affairs. At the time of his Election cycle, he must still have had Fielding's *Don Quixote in England* very much in mind, since there is clearly an association between 'Guzzletown' on the inn sign in the *Canvassing* scene and the innkeeper Guzzle, who is much in favour of bribery in Fielding's play.

Towards the end of Hogarth's life, though corruption persisted, the political situation as a whole changed considerably. While the middle class continued to develop economically, the political influence exerted by its wealthy members to some extent declined. In 1760, George III's accession brought to power a small, personally ambitious aristocratic circle, the so-called King's Friends, headed by Lord Bute, who had been the king's mentor as a young man. Antagonistic to previous Whig politics, they feigned belief in the Patriot King, a king above parties, who should rule with the best elements in the country—a conception of Lord Bolingbroke's,[12] and a role originally designed for Frederick, Prince of Wales, and later adapted for George III. They aimed, in practice, at extending the prerogatives of the crown, at the control of elections to Parliament, not as hitherto by the Whig aristocracy but by the king himself.

The new government was extremely unpopular with the wealthy upper middle class, for in a peace treaty with France hurriedly signed in 1763, scant attention was paid to the interests of the City when certain colonies were relinquished to the French. It seems perhaps surprising, and inconsistent with his former views, that Hogarth should have done political caricatures in support of this unpopular government. But his ambition to keep in with the ruling circles and receive recognition and commissions from them dated from much earlier days, probably from his first contacts with the highly successful Sir James Thornhill, Serjeant-Painter to the King, whose daughter he had married in 1729. Since Hogarth was unsuccessful in his attempts to approach the court of George II, he endeavoured to ingratiate himself with the circle of Frederick, Prince of Wales, who was opposed to the persons and politics of his parents and sought, particularly in the City, to gain popularity at his father's expense. For publicity's sake, Hogarth represented him with his wife in *Industry and Idleness* (1747) watching the Lord Mayor's Show (Pl. 108a).[13] After the prince's death in 1751, Hogarth kept in touch with his widow and son, the future George III,[14] and did his utmost to retain social connections with the aristocrats who surrounded this royal clique and to whom the future appeared to belong.

Most of Hogarth's friends were to be found on the intellectual and middle-class periphery of this circle which, during the prince's lifetime, intermingled closely with the anti-Walpole coterie.[15] Indeed the writers among Hogarth's friends were obliged for the sake of patronage to join these

two circles, since Walpole's reluctance to employ intellectuals offered them no other choice.[16]
Finally, in 1757, in the train of his father-in-law and brother-in-law, Hogarth was nominated
Serjeant-Painter to the King. This was not a very high post and carried the purely nominal
salary of £10 a year; Hogarth probably procured it with the help of the Duke of Devonshire,
rather as a member of the Thornhill family than for his own artistic merits. When, on Lord
Bute's advent to power, several intellectuals, including Dr. Johnson and Smollett, editor of the
government journal, received pensions from the new government, Hogarth considered himself,
and was considered by others, as also eligible. Hence his relative lack of sympathy for politics
made it easy for him to shift his ground in later life and come to support the views of court
circles.

Personal quarrels and opposition to Walpole, even before George III's accession, tended to
carry over those who originally had strong Whig leanings not only to the Whig dissidents but
even to the high-Tory Bolingbroke, spiritual father of the Bute clique. The year 1760 aroused
high political hopes in a number of intellectuals, for the new king was said to favour direct
approach to the people; this is evident in letters of Sterne, who was even less politically-minded
than Hogarth, and who had now come to London, having just dedicated *Tristram Shandy* to
Pitt, the greatest adversary of the Bute Circle. Moreover the king was a reputed protector of the
arts; even the 'republican' Horace Walpole was greatly flattered by Bute's proposal that eventually
he should publish the Royal art treasures. Among artists, the most significant parallel case to
Hogarth was that of Allan Ramsay, also a friend of Lord Holland; though a convinced Whig,
greatly interested in politics and even an author of political pamphlets, he made his real career
as court painter through the good offices of his fellow-Scotsman, Lord Bute.

Whilst in his early caricatures Hogarth had tended to avoid partisanship in home politics and
had only generally expressed anti-French or anti-Jacobite sentiments, in later years he gave his
work a more decidedly political flavour in the service of one faction. He also changed his opinion
and became a supporter of peace with the French. He did a caricature, *The Times* (1762) (Pl. 142a),
directed against Pitt and the City, in which Pitt, backed up by aldermen and a mob, is fanning the
fire of war, which Bute attempts to extinguish. In this he condemned the policy of acquiring
colonies and imputed to its partisans sympathy for the 'immorality' of the West Indian natives.[17]
Most other cartoonists during these years opposed Bute's government, and many skits were
published against Hogarth, Smollett and Dr. Johnson. Indeed through his engraving, *The Times*,
Hogarth made himself so unpopular that he had to abandon a projected sequel to it, *The
Times II* (Pl. 143a). This was not published until 1795, long after his death; at its centre stands
the statue of the young George III as a kind of Apotheosis; the building of churches and other
public edifices, and the encouragement of art,[18] symbolise the peaceful character of his reign;
Lord Bute and Henry Fox appear as diligent gardeners of the realm[19]; on the tribune to the left,
Parliament, with Pitt, is shooting at the dove of peace as it flies over the king.[20]

In both *The Times I* and *II*, Hogarth also attacked his former friend, John Wilkes, a member
of Parliament and future Lord Mayor of London, the only outstanding militant spokesman of
the radicalised middle class in this period. When Wilkes retaliated in an article in his anti-Bute
paper, *The North Briton*, Hogarth did a skit on him. Wilkes, meanwhile, had been imprisoned
for libelling the king but released on the grounds of breach of privilege; at his trial, Hogarth
had drawn a caricature of him holding aloft on a pole the cap of liberty, the fool's cap. The
etching of it (1763) (Pl. 140a), proved a huge success, even partisans of Wilkes buying it up in
large quantities. Four thousand copies were sold in the space of a few weeks. Hogarth's drawing

became the standard representation of Wilkes so that, even at a masquerade in 1770 a man who appeared as Wilkes was dressed in identical fashion. On the other hand, so great was Wilkes' popularity that an unusually large number of representations of him appeared in the form of porcelain statuettes and on plates, punch bowls, teapots, snuff-boxes, etc.[21] Wilkes' political companion, the poet Charles Churchill, resumed the attack on the artist in an *Epistle to William Hogarth*. Replying in another caricature called *The Bruiser* (1763), Hogarth derided the poverty of *The North Briton*[22] and depicted Churchill as a bear given to drink. It is evident from their polemics against Hogarth, who had originally begun the attack, that Wilkes and Churchill were bitterly disappointed that he should, as they put it, have deserted the cause of liberty.[23]

Hogarth's siding with the court, even with former Jacobites, combined with his vulnerability as the only caricaturist working in support of Bute and against Wilkes, brought upon him an unprecedented shower of satirical cartoons. There is no doubt that this accelerated his death, which took place in 1764. Politicians apart, he, the new royal pensioner, was undoubtedly the most caricatured man in England. Hogarth, who in his time had derided the Scots as Jacobites, was now represented in a kilt himself and even accused of associating with French and Catholics. In a woodcut which shows him drawing Wilkes in court he assumes the same stance as in his portrayal of himself sketching in *The Gate of Calais*, as a result of which he had been arrested— the implication being that Hogarth had assailed Wilkes and should be arrested again. Many of these attacks were of a personal nature and often most unfair. His past actions, whether justified or not, were distorted and used against him. He was lampooned as a money-grubber and for having accepted the office of Serjeant-Painter. Although very happily married, he was even portrayed as a cuckold. Yet his tendency, particularly in his later years, to approach closer to court and aristocracy, heralded at the same time the general change from the more 'bourgeois' Whig first half to the increasingly 'courtly-aristocratic' Tory second half of the century.[24]

It must not be supposed, however, that Hogarth ever really forfeited his solid, middle-class principles; he had no call to do so. Even if the aristocracy was still looked on as socially superior, the distinction between the two classes, both socially and culturally, had greatly lessened since the 17th century.[25] Unlike its counterparts on the continent, the English aristocracy did not stand aloof; while its members entered commercial and industrial enterprises, those of the middle class could rise socially by purchasing estates and acquiring seats in the House of Commons and titles. Moreover, the middle class had by now begun to create an impressive new culture of its own, based on its radically new and complex outlook—rational, utilitarian, realistic, property-worshipping, eager for knowledge, critical, tolerant, sentimental and humanitarian— and with this culture Hogarth was inseparably linked. Certain members of the Whig aristocracy (Shaftesbury, Steele, Fielding) contributed to the formation of these new ideas, which slowly and in a modified form penetrated the higher strata of society.

The new bourgeois culture embraced every field of thought, particularly moral philosophy and literature. In these the middle class justified the revolution of 1688 by its theories, proclaiming the sovereignty of the people, political liberty and religious tolerance and stressing the rights of the individual, particularly the right to own property.[26] Formulated by Locke, who was close to the Whig aristocrats who had overthrown James II, these ideas were popularised by many bourgeois writers and journalists. His theories on the utility of moral rules and their outcome, happiness, formed the basic principle of the middle class and their literature. For a formidable new literature had also sprung up, permeated with the moral maxims and reflecting the attitude of the new class which from now on made up the principal reading public.[27]

English literature, criticism and journalism, and even English empirical philosophy, all of which appealed to a broad public, became the model for the whole of middle-class Europe, just as had English political institutions. The poetry of Pope,[28] which expressed the new ideas of philosophical enlightenment, and the sober, common-sense, satirical writings of Swift, one of Hogarth's favourite authors and, in his turn, an admirer of the artist,[29] presuppose, at least as a background, the existence of a strong middle class. Nevertheless the real channel to this new public was by way of a new power, journalism.[30] Apart from Defoe's writings, the crucially important essays of Addison and Steele, in *The Tatler*, *The Spectator* and *The Guardian* were destined for a wide bourgeois public and entirely dedicated to the task of instructing and re-forming their readers.[31] By means of these essays the middle class was systematically and efficiently educated and humanised, and acquired culture and rules of conduct, the need for which it felt deeply. In spite of their new morality, these standards of conduct were a kind of compromise between the previous rigid, glum Puritanism of the Commonwealth on the one hand, and the extravagances of the Restoration aristocracy on the other, a compromise which allowed for graciousness, cheerfulness and good breeding. At the same time they pursued something of a 'golden mean' between reason and sentiment, with the emphasis on reason. Written shortly before Hogarth embarked on his career, these essays formed the storehouse of all his principal ideas. In literature, apart from the sensitive poetry of Edward Young and James Thomson[32] and the domestic tragedies of Lillo, the astonishing development of that essentially middle-class genre, the realistic novel,[33] with its capacity for creating the most complex individual characters from contemporary society, was unique in its intensity in 18th-century Europe. Chronologically the earliest, which coincided in date with Hogarth's most youthful works, were Defoe's stories, simply told as by a reporter. Somewhat later came the minutely descriptive, sentimental novels of Richardson and the psychological, analytical ones of Hogarth's close friend, Fielding.[34] A little later again, towards the end of Hogarth's life, appeared the highly subjective novels of Sterne, another of the artist's admirers, those of Smollett with their original, quaint characters, and those of Goldsmith with their trivial, intimate events, humanly experienced and lucidly recounted.[35] The decisive impact made by these writers on the continent provides a foretaste of the influence which was equally to be exerted by English art of this period—and that means chiefly the art of Hogarth.

Hogarth's views on social questions, which were those of the newly-evolved English middle class, were largely instrumental in shaping his art, just as they underlay the new English literature. Hard work and efficiency, honesty and benevolence, resistance to temptation and vice would be rewarded by wealth, contentment and respectability. This utilitarian, common-sense, and at the same time slightly sentimental, appeal to virtue and industry he expressed and propagated in large engraved cycles. Such basic conceptions of the English bourgeoisie on the conduct of life formed the most advanced outlook then held in Europe and derived fundamentally from Puri-tanism.[36] They expressed the moral revolution effected by the middle class during the 17th century, hand in hand with its social and political revolution. They were not directed against the aristocracy as a class, with which the bourgeoisie was in economic and political alliance, but against the extravagances, the immoral, brutal and parasitic way of life of the nobility inherited from the Restoration period, any imitation of which would have spelt doom for the bourgeoisie. The practical expression of virtue and hard work was essential if the bourgeoisie was to survive, and their attainability was reinforced by the new optimistic theory of man's moral perfectability. In Hogarth's series, the polemical and critical aspects of these theories were emphasised by

stressing the downfall of those who practised vice. Debauchery, idleness, drunkenness and gambling are scourged; and also cruelty in all forms—a feature of the new bourgeois humanitarianism.

Hogarth explained the spirit in which these cycles had been conceived. 'Ocular demonstrations will carry more conviction to the mind of a sensible man, than all he will find in a thousand volumes; and this has been attempted in the prints I have composed.' And Fielding enthusiastically commended Hogarth's themes and methods; in his periodical *The Champion* (1740) he wrote:

> We are much better and easier taught of what we are to shun, than by those which would instruct us what to pursue. . . . We are more inclined to detest and loathe what is odious in others than to admire what is laudable. . . . On which account, I esteem the ingenious Mr. Hogarth as one of the most useful satirists any age hath produced. . . . I almost dare affirm that those two works of his, which he calls the Rake's and the Harlot's Progress, are calculated more to serve the cause of Virtue, and, the Preservation of Mankind, than all the Folios of Morality which have ever been written.

In *Tom Jones* Fielding expressed his own similar intentions, namely 'to laugh mankind out of their favourite follies and vices'.[37] Fielding and Hogarth were convinced that art must express the new moral views, that it had to fulfil a useful function and appeal to sentiment. Of his cycles, which he called 'modern moral subjects', and with which he intended to 'strike the passions', Hogarth wrote: 'In these compositions, those subjects that will both entertain and improve the mind bid fair to be of the greatest public utility and must, therefore, be entitled to rank in the highest class.' 'Moral subjects', 'public utility', 'strike the passions'—such concepts, associated with middle-class ideals, were everywhere in the air ready for Hogarth to adopt.

Such artistic theory as had prevailed both in England and on the continent during the 17th century had been equally didactic and even moralist, but in a more general and vaguer sense. Now, in the early 18th century, the emphasis was on the utilitarian, secular aspects of art, reflecting a specifically and genuinely bourgeois outlook.[38] The philosophical foundations of this new attitude were laid by Locke, for whom morality was a positive science, based on experience and capable of precise demonstration, so that a careful and thorough education in virtue was possible. The transition towards it was taking shape in Locke's pupil, Shaftesbury; though less utilitarian and materialistic than his master, he recognised that art was a cultural force and, shortly before Hogarth's time, gave it a more constructive, moral, pedagogic aim. According to Shaftesbury our moral ideas are innate, moral sense and a sense of beauty are identical, and the moral beauty of art is apprehended by man's moral sense and assists his improvement.[39] He held that such a purposeful art was well suited to England where, as a result of political liberty, people were accustomed to use their judgment freely in all matters.

The essays of Addison and Steele in *The Tatler* and *The Spectator*[40] rapidly disseminated and popularised Locke's, and to some extent Shaftesbury's,[41] various theories (though these were not always in agreement with each other) on the utility of virtue and its necessity for happiness, on moral education,[42] on the perfectability of man, on benevolence as the outstanding moral virtue,[43] on the moral tasks of art and literature and their emotional appeal. By this means, the Puritan middle class was made more receptive towards the arts and 'good taste', the more so since Addison taught that all works of inspiration must be based on 'precepts of morality', these precepts being based in turn on truth, experience and common sense. Steele wrote in *The Spectator* (1711): 'I have very often lamented, and hinted my sorrow in several speculations that the art of painting is made so little use of to the improvement of our manners.' Appreciated by

a very wide public, these essays taught 'the practice of morality in all the affairs of life', criticised abuses in manners and laid down the necessary moral reforms.

Journalism, literature and art, interacting upon each other, had a great part to play in moulding and directing people's way of life. For instance, it was not only in *Robinson Crusoe* (1719) that Defoe, one of Hogarth's most important 'precursors' and one of the first writers to reach a large public, demonstrated the well-merited success of the industrious, inventive, virtuous tradesman. Whether in the role of political pamphleteer, economic investigator for the government, writer of social and ethical treatises or journalist in widely-read weekly newspapers, Defoe, originally a merchant himself, served as propagandist for those middle-class ideas to which Hogarth responded so readily. At the same time, the essays in *The Spectator* set out to interpret bourgeois public opinion, to mirror critically upper- and middle-class society and to 'scourge vice and folly as they appear in a multitude'. They help us to understand Hogarth's moralising and didactic cycles, in which the profligate habits of the aristocracy are held up to ridicule as a warning to the bourgeoisie. Thus attention is riveted on the vices of the Rake—gambling, drinking, duelling, affectation in dress and manners, prodigality, a loveless marriage. Moreover, a mere list of the subjects of these cycles reveals what an immensely topical bearing they had on current social problems, all the more since Hogarth was not only the painter and generally the engraver of each series but also himself evolved the stories they illustrate. Indeed, in the advertisement of *A Harlot's Progress* Hogarth called himself the 'author' and not the artist.

A Harlot's Progress (1732) (Pls. 36c, 37a, b) was intended to focus light on the mortal dangers to which a woman was exposed if she led an immoral life. Apart from its unhappy ending, it was virtually the history of Defoe's *Moll Flanders*, the first great English realistic novel, written ten years before. In *The Spectator* of 1712 Steele was already defending prostitutes as victims of the immorality of large towns and high society. His description, in the same article, of a procuress instructing a country girl newly arrived in London, may well have inspired the first plate of *A Harlot's Progress*.[44]

The eight episodes of Hogarth's next cycle, *A Rake's Progress* (1735, Soane Museum, London. Pls. 50a, b, 52 a, 53b, 54a, 55a, 56a), recount the gradual ruin of a foolish young man who recklessly dissipates the fortune he has inherited, after deserting the girl he has seduced and promised to marry. It is an elaborate satire on the new, bourgeois rake, who has stupidly adopted the vices of his predecessor, the aristocratic rake, whom Steele had cautioned his readers never to imitate. Fielding, too, in 1730 produced his sentimental comedy, *The Temple Beau*, directed against the libertine behaviour of the rake.

The following cycle, *Marriage à la Mode* (1745, National Gallery, London. Pls. 87a, 89a, 90c, 92a, b), made up of six scenes, gave warning against the marriage of convenience, which leads to immoral conduct. Contrary to the cynical views on marriage of the aristocracy, Steele had continually insisted in *The Tatler* and *The Spectator* that marriage should be based on love; in a fictitious letter in *The Spectator* in 1712, Addison had also derided the rich 'Sir John Envil', who had made a disastrous marriage with a woman of quality to elevate his social position[45]— the future theme of *Marriage à la Mode*. Many sentimental comedies had appeared on the stage, particularly in the 'thirties, directed against conventional marriage and against duelling—again the features of *Marriage à la Mode*. Later, in *Amelia*, Fielding also condemned the custom of duelling. In 1753, the Chancellor, Lord Hardwicke, carried through a reform of the Marriage Law, bringing marriage under the jurisdiction of the State and barring the clandestine, so-called Fleet marriages derided in *A Harlot's Progress*; these marriages were administered in or near the

Fleet Prison by dissolute clergymen. Dr. John Shebbeare, a well-known pamphleteer in the service of the Tory Party, attacked the reform in a political novel, *The Marriage Act* (1754), based on *Marriage à la Mode*. He argued that the new law would give too much power to parents, would make love matches impossible and thus would increase immorality. Both Fox and Horace Walpole objected to marriage reform as being 'against liberty' and the movement to oppose it for a time had popular support. In his *Election Entertainment*, Hogarth shows a popular demonstration against the new law with the slogan: 'Marry and multiply in spite of the Devil.'

Hogarth also planned a cycle on a happy marriage as a sequel to *Marriage à la Mode*. His aim, in this, would have been to represent in visual terms the new middle-class ideas on marriage, as expressed at length by Steele in *The Tatler*. Both Steele and Addison frequently used the theme of marriage based on love, family feeling and the charitable obligations of the happily married couple.

Hogarth's last large, indeed largest, cycle, *Industry and Idleness* (1747) (Pls. 103a, 104a, 105a, b, 106a, b, 107a, b, 108a), made up of twelve episodes, provides the quintessence of the middle-class outlook: industry leads to success, idleness to disaster. In Hogarth's own words:

> Industry and Idleness exemplified, in the conduct of two Fellow-prentices: where the one, by taking good courses, and pursuing those points for which he was put apprentice, becomes a valuable man, and an ornament to his country: whilst the other, giving way to idleness, naturally falls into poverty and most commonly ends fatally, as is expressed in the last Print.

Hogarth's later, short cycle, *The Four Stages of Cruelty* (1751) (Pls. 117a, b, 118a, b), was directed against various types of brutality. Here is unfolded the disastrous development of a boy who maltreats animals. 'The prints were engraved', wrote Hogarth, 'with the hope of in some degree correcting that barbarous treatment of animals, the very sight of which renders the streets of our Metropolis so distressing to every feeling mind.' Earlier, in *The Champion*, Fielding had pleaded for the humane treatment of animals, in particular, like Hogarth, of horses in the streets of London. In its later stages, the cycle shows the same boy, grown up to become the savage murderer of his mistress, a servant girl, whom he had incited to robbery. This series, with its urgent warning that vicious behaviour inevitably leads to murder, a theme that Hogarth had already treated in *Industry and Idleness*, is closely connected with Fielding's pioneering activity in social and penal reform as Chief Magistrate of Bow Street Police Court (1749–53). For it is significant that this novelist, who had shown such insight into English social life, had not only been a political journalist but had later felt the urge to give practical expression to his humanitarian ideas, as set forth in his novel *Amelia* (1751) and his pamphlets, by becoming an honest, disinterested and most conscientious magistrate. As such, he gained a deeper knowledge of social problems and, through administrative and penal reforms, attempted to get to the roots of criminality, which, as far as he could see, lay in drink and gambling.[46] Fielding's achievements in this sphere and his writings on social questions, on crime, punishment and poverty, are strongly reflected in Hogarth's own ideas and work; for Hogarth was intimately associated with the circle of Henry Fielding, his brother and successor, John, and their collaborator, Justice Welch,[47] all three of whom, as magistrates, raised the level and radically changed the course of English justice.

The Four Stages of Cruelty supported Fielding's campaign against the tremendous amount of murder and robbery in London and appeared in the same year as Fielding's *Enquiry into the Causes of the late Increase of Robbers*. This elaborate pamphlet initiated a revision of the criminal laws in Parliament. With its systematic proposals and its middle-class outlook, it was an im-

portant and remarkably progressive contribution to the literature of crime. Fielding made the suggestion that public executions should be prohibited, since they served as popular entertainments. Hogarth himself had but recently demonstrated, in *Industry and Idleness*, the behaviour of the crowds when the idle apprentice was hanged at Tyburn. And two other famous engravings of his, *Gin Lane* (Pl. 120a) and *Beer Street* (Pl. 120b), also published in 1751, only a few weeks after Fielding's *Enquiry*, were intended to reinforce Fielding's argument that drunkenness, particularly excessive gin-drinking by the poor, was one of the chief causes of crime, immorality and the undermining of health. In *Gin Lane*, some of the poor are shown intoxicated, famished and dying, while others, aided by the pawnbroker, are well on the way to similar conditions; even the houses are falling to pieces from neglect. *Beer Street*, by contrast, conjures up a picture of general prosperity with artisans flourishing on beer. Defoe had already advocated beer as opposed to gin in *Augusta Triumphans*. Combined with extensive press propaganda, pamphlets and petitions throughout the country, these efforts of Fielding and Hogarth—one of the first attempts to achieve social reform by bringing pressure to bear on Parliament—resulted in a bill, the so-called Tippling Act, against the sale of cheap gin.[48] Thus journalism, literature and art worked together with jurisdiction and legislation to express and put into practice the new social and moral convictions, about which the middle class was in deadly earnest.

Defoe, in whose novels virtue always earned its reward and vice its punishment, declared idleness to be a sin against the Holy Ghost (*The Complete English Tradesman*, 1725–7). Hogarth also believed that fate deals inexorably with those who do not work hard and resist temptation, and the everyday tragedies he saw around him touched him deeply. When he was working on his earliest cycle, *A Harlot's Progress*, the new domestic drama of Lillo and Moore, expressive of middle-class feelings and intent upon honesty and industriousness in contrast to depravity, was much in people's thoughts. The way for this had been well paved by Addison's fight in 1712 in *The Spectator* for morality on the stage, as also by the sentimental comedies of Steele and Cibber and the dramas of Rowe, writers who belonged to an older generation. In fact, Hogarth himself helped to develop this bourgeois, moralising theatre. He not only based his cycles on everyday life, but also treated them like a play, each scene featuring the same characters as events are pursued to the final, inevitable disaster. It is no surprise, therefore, to find him writing, in his introductory remarks to *A Harlot's Progress*:

> I thought both writers and painters had, in the historical style, totally over-looked that intermediate species of the subject, which may be placed between the sublime and grotesque. I therefore wished to compose pictures on canvas, similar to representations on the stage, and further hope that they will be tried by the same test and criticised by the same criterion. . . . I have endeavoured to treat my subjects as a dramatic writer: my picture is my stage and men and women my players.

Significantly, the publication—though not the preparation—of *A Harlot's Progress*[49] was preceded by the successful presentation in 1731 of Lillo's *Merchant of London* or *George Barnwell*, the first consistent drama of the moralising type, an unconventional play, written in prose and having as its protagonists, not persons of high rank, but a merchant and his clerks.[50] *Industry and Idleness* was directly based, at least in its principal motif, on Lillo's play; indeed, on a drawing for the first scene (British Museum), Hogarth gave the merchant the name Barnwell. The tragedy deals with an originally honest apprentice, who takes to stealing and later to murder under the influence of an immoral woman and, like Hogarth's cycle, it was destined for apprentices.[51]

Defoe had already pleaded for a close, personal, patriarchal relationship between employer and employed and he believed that it was the growing immorality of the lower classes which had tended to loosen this relationship (*The Great Law of Subordination*, 1724). Presumably Hogarth's standpoint was much the same. To lend topicality and instructiveness to his story, his apprentices are shown to be silk-weavers of Spitalfields, a group with a particular inclination to riot. The advertisement for his cycle reads: 'This little Book ought to be read by every 'Prentice in England, to imprint in their hearts these two different examples . . . and is a more proper Present to be given by the Chamber of London, at the binding and enrolling an Apprentice than any other Book whatever.'

Like Moore, his equally well-known follower in domestic drama, Lillo himself had been a merchant; his play is dedicated to a merchant, Alderman and Member of Parliament for the City and it eulogises trade in a new positive way, just as Defoe and *The Spectator* had done.[52] It is, in fact, set in Elizabethan times, but only because it was generally supposed that English trade had been formed and thoroughly developed at that period. Another middle-class drama with a very similar theme, *Eastward Ho* by Chapman, Marston and Ben Jonson, was early Jacobean. One of the first expressions of bourgeois ideas in drama, this play also revolves round two apprentices and certain details in it influenced Hogarth's cycle even more. For instance, it was from *Eastward Ho* that he borrowed the motif of the industrious apprentice sitting in judgment on his former fellow-worker.[53]

Lillo's play had a great influence not only in England, where Fielding considered its author the best tragic poet of his age,[54] but on the entire bourgeois vanguard of Europe—such men as Voltaire, Rousseau, Diderot and Lessing. This immediate literary and journalistic background —Shaftesbury and *The Spectator*, Defoe, Fielding and Lillo—pregnant with new ideas which affected the whole of Europe, gives us the clue to Hogarth. His cycles, deeply rooted in English middle-class thought and closely connected with its theatre, were immensely popular; they were continuously plagiarised, put into verse (authorised and unauthorised) and commented on; they inspired books and pamphlets and were, in their turn, adapted for the stage. One of the pamphlets on *A Harlot's Progress* ran through four editions in eighteen days.

One scene in *Industry and Idleness* marks the decisive moment in a middle-class career and contains the positive moral of the whole story: the industrious apprentice is promoted from the looms to the counting-house and entrusted with the books, purse and keys (Pl. 105b). Hanging from the desk is *The London Almanack*, on the cover of which Industry is depicted taking Time by the forelock. Thus the well-worn device of Virtue seizing Chance or Fortune serves as an explanatory emblem for the whole scene.[55] This scene is close to Hogarth's own experience in life. The son of an impoverished intellectual, teacher, proof-reader and writer of dictionaries, he began as an apprentice in a silversmith's workshop. Before long, however, as a result of unremitting labour, he made himself independent, first as an engraver and later as a painter, eventually becoming quite prosperous, with a house in Leicester Fields, a country-house in Chiswick, and six servants.

He always represented himself either at work or in close contact with his art. In his own shop-bill (published in S. Ireland, *op. cit.*, Vol. II), he stands beside his sign-board; in *The Gate of Calais*, he is the man drawing the gate; in his small self-portrait of 1758 (London, National Portrait Gallery) (Pl. 97a), he is painting the Comic Muse; even in his large self-portrait of 1745 (London, National Gallery) (Pl. 96b), the symbol of his artistic creed, the serpentine line of beauty, appears on the palette, and the same line was painted as a crest upon his coach. His is a real success

story: first silversmith, then engraver, then painter, then son-in-law of the King's titled Serjeant-Painter,[56] later still history painter and finally Serjeant-Painter himself. His life was a full one, even if not exactly adventurous; it was an example of prosaic, bourgeois advancement, similar to the life of the English nation itself at that time. Hogarth never tired of pointing the contrast between his strenuous early life and subsequent achievements, by which his outlook was moulded. His success as a self-made man was clearly recognised by his contemporaries. The engraver Vertue, the artistic chronicler of the time, registered in his note-books, almost year by year, increasing amazement and respect for him; in 1745, he wrote: 'A true English Genius in the Art of Painting has sprung and by natural strength of himself chiefly, began with little and low-shrubb instructions, rose, to a surprising height in the publick esteem and opinion.'

After freeing himself from his silversmith master, Ellis Gamble, Hogarth worked only briefly as a poor employee of booksellers, a calling which most English engravers before him had pursued all their lives.[57] From 1724, that is from the time of his *Masquerades and Operas* (Pl. 5a), he began to publish some of his engravings on his own account and from the early 'thirties did so exclusively. He advertised these widely in newspapers and contrived to support himself largely from their sale. As his position improved, he came to employ other engravers to copy his designs.[58] Despite his xenophobia, most of these were French since their technical knowledge was greater; he even commissioned Jean Rouquet, a French-Swiss engraver, to write a pamphlet in French (*Lettres de M. xxx à vu de ses amis pour lui expliquer les estampes de Hogarth*, London, 1746) to accompany the sets sent abroad. He was the most business-like of artists in a milieu pervaded by a business spirit. It is typical of his solid, bourgeois, commercial principles, typical of the new atmosphere prevalent in England,[59] that he was one of the first European artists to take action against the customary pirating of engravings. Pirating began in 1742 with Hogarth's *Masquerades and Operas*, and assumed such enormous dimensions that the artist indeed had every reason to complain. Even the pirated copies were themselves re-pirated. Eight fraudulent imitations of *A Harlot's Progress* alone were in circulation.[60]

In 1735 a law of copyright, the so-called Hogarth's Act, was passed through Parliament. This ruled that no one was allowed to make copies without the consent of the designer. Thus the profits from his engravings were secured exclusively for himself.[61] He even held back the prints of *A Rake's Progress* and *Southwark Fair* (Pl. 44a), until this law was passed and offered thanks to King and Parliament with a special engraving, *Crowns, Mitres, Maces, etc.*, in which the rays of royal favour, emanating from the crown, are shown falling upon mitres, coronets and the Speaker's hat.[62]

Hogarth was proud of having acquired a degree of prosperity and respectability through early privation and hard work and he sincerely believed this to be the right way of life for all those not born to riches. In 1721, one of the first engravings (Pl. 2b), he made after achieving independence was an allegorical composition censuring the lotteries because of the principle of chance on which they were founded and which encouraged an effortless pursuit of wealth.[63] He even carried his strong approval of the spirit of competition into the realm of art[64]; this chiefly accounts for his objection to such institutions as the projected Royal Academy and the Society for the Encouragement of Arts. In a memorandum he explained that a cheap artistic education, such as a Royal Academy would offer, could only serve to create a large proletariat of bad painters, causing the price of pictures to drop still further, whilst a handful of artists, teachers at the Academy, would glory in their titles.[65] In 1735, in St. Martin's Lane, he established his own academy, a school for drawing nudes, run on democratic lines. After his father-in-law's death, he endowed it with

furniture and casts from Thornhill's private academy. Hogarth's academy was managed by an elected committee of sixteen artists, whilst a small sub-committee met each autumn to examine the credentials of students who desired to join the winter classes. 'I proposed', explained Hogarth, 'that every member should contribute an equal sum to the establishment, and have an equal right to vote in every question relative to the society. . . . As to electing presidents, directors, professors etc., I considered it as a ridiculous imitation of the foolish parade of the French Academy.'[66]

For competitive, business reasons Hogarth was always thinking out new ideas for his profession. This was well recognised by his contemporaries. Vertue at first much admired Hogarth's business instinct but later it became a bit too much for him. He then wrote of Hogarth: 'Cunning and skill joynd together', and of his 'cunning artfull contrivances' and that 'Mr Hogart . . . is often projecting schemes to promote his business in some extraordinary manner.' Nevertheless Vertue was ever ready to recognise Hogarth's great artistic qualities and to justify his ambition. He spoke, for example, of 'the greatness of his spirit . . . to outvie all other painters'.

There was nothing unusual in Hogarth's issuing a trade-card when he started as an engraver; but that he should make one when he set up as a painter, announcing the efficient functioning of his studio, was something of a novelty. He also designed and produced with unusual care the engraved subscription tickets which served also as receipts; through these virtually free gifts, he advertised his own cycles and other important works. He often introduced small alterations into the various states of his plates in order to induce print collectors to buy successive issues. He even appears to have commissioned a poet, Joseph Mitchell, to write an epistle in his honour in which he is placed above his rivals. He was the first English artist to practise both painting and engraving with such facility that he could switch from one to the other according to the need of the moment, turning to whichever seemed the more profitable under given circumstances. Consequently his development can be viewed as a long journey on the up and down road of commercial success, with a decidedly upward trend, apart from his later years which brought many disappointments. Yet these preoccupations in no way ran counter to the sincerity of his ideas, nor did they impede the fertility of his inventive genius. On the contrary, it was the interdependence of all these factors which produced his art. Whereas he was fully conscious of his role as a bold innovator, he never failed to record the fact, when he obtained a higher price for some type of picture than another artist, just as he never hesitated to speak of his works in mere commercial terms. Of his conversation pieces—a genre for whose introduction to this country he was largely responsible—he wrote in the most matter-of-fact way: 'This having novelty, succeeded for a few years', but later 'it was not sufficiently profitable to pay the expenses that my family required'. And he went on to speak with great pride of his cycles: 'I therefore turned my thoughts to a still more novel mode viz, to painting and engraving modern, moral subjects.' Again, of his engraving *The Times*, he wrote quite dispassionately: 'The Stagnation rendered it necessary that I should do some timed thing to . . . stop a gap in my fortune.'

No wonder Hogarth, the successful business-like, middle-class artist, identified himself through natural self-assurance with the prosperous and, as he liked to put it, 'beef-steak eating and beer-drinking' Englishman. In conformity with the property-worshipping, individualist mentality of the whole period, he could not sympathise with poverty at a time when idleness, drunkenness and love of luxury were still largely held to be responsible, even by social reformers, for the condition of the poor; even Fielding adopted something of this attitude in his pamphlet of 1752, a memorandum to Pelham, Chancellor of the Exchequer, bearing the significant title,

A proposal for making an effectual Provision for the Poor, for amending their morals and for rendering them useful members of the Society.[67]

Nevertheless, Hogarth's humanitarian impulses carried him into hitherto little explored realms of human suffering, such as prisons and hospitals.

In a composition of 1729 he represented the first systematic enquiry into the state of prisons, (Pl. 24b): the session of a Parliamentary Committee set up, at the instigation of General James Oglethorpe, the famous philanthropist, to examine the dreadful conditions in the prisons, particularly the Debtors' Prison of the Fleet, whose Warden, Bambridge, was responsible for the torture and murder of many prisoners.[68] Hogarth's painting (National Portrait Gallery, London; also engraved) shows Bambridge trying in vain to defend himself as the emaciated prisoner and his fetters are produced. Although, in Hogarth's world of ideas, prisons and houses of correction were considered indispensable for punishing the immoral and the idle, he was the first artist, anticipated somewhat in literature by Defoe's *Essay upon Projects* (1698) and *Moll Flanders*, to depict the bleak, cruel conditions of prison life. He illustrated the Place of Correction at Bridewell in *A Harlot's Progress*; the Fleet Prison and the Madhouse at Bedlam[69] in *A Rake's Progress* (Pl. 56a). At the same time it should be remembered that Fielding never ceased to criticise the state of such institutions in his novels, particularly *Amelia* and in pamphlets written while he was a magistrate.[70] Not long after, Smollett and Goldsmith followed the same line.

Hogarth took a very active interest in the work of hospitals and other charitable institutions—an interest typical of all expanding urban communities throughout Europe from the Middle Ages onwards. During these same decades covering the span of Hogarth's life, when a pronounced middle-class outlook predominated, such an interest found widespread expression in England through the medium of personal initiative. Many London hospitals—St. Bartholomew's and the London Hospital, for instance—were built or rebuilt at this time. Hogarth became a governor of St. Bartholomew's and decorated its staircase with paintings for which he took no fee (Pls. 57a, 60). He also designed the admission ticket for the Infirmary of the London Hospital; and in a drawing for an engraving portrayed an operation scene in a hospital (two versions, Marquess of Exeter Collection and Pierpont Morgan Library, New York. Pl. 95b).

Foundlings also aroused Hogarth's humanitarian instincts. Middle-class communities throughout history seem usually to have become aware of this problem at a somewhat later phase in their development than they did of the need for hospitals, namely when they had achieved power and grown conscious of their spiritual requirements. Since they were industrious, rational, utilitarian and at least in principle humanitarian, they then endeavoured to collect the foundlings, bring them up and put them out to work through charitable institutions. As in the earliest consistently middle-class community ever formed—that of Florence in the early 15th century[71]—so now in England, in the first half of the 18th century, the middle class proceeded to tackle this problem. The original idea came from Addison (in *The Guardian* of 1713) and Defoe (*Augusta Triumphans*, 1728). The Foundling Hospital, established in London by the philanthropic merchant sailor, Captain Thomas Coram, granted a Royal Charter in 1739 and opened in 1741,[72] was a parallel institution to the Spedale degli Innocenti in Florence. In London, as in Florence, the most progressive artists were associated with it and Hogarth, a governor and a guardian, was perhaps its most industrious member.[73] He kept an eye on the welfare of children who were boarded out and even housed two of them for four years at his Chiswick home.[74] In 1739 he designed a head-piece for the institution's power of attorney to collect subscriptions. The foundlings are first shown arriving at the hospital, while the founder consoles a mother who had intended, but for

this timely assistance, to kill her child; and later leaving it with the various tools of their future trades of wool-comber, spinner, farm labourer, etc.

In 1747 Hogarth also designed the arms of the hospital (Marquess of Exeter), to be engraved.[75] He did portraits of two architects of the hospital, Theodore Jacobsen (1742, Oberlin College, U.S.A.), who made the plan for the building,[76] and Daniel Lock (Capt. E. G. Spencer-Churchill); also of its vice-president, Martin Folkes (1741, Royal Society) and above all of the founder himself, Captain Coram, which he presented to the institution in 1740 (still *in situ*) (Pl. 66a), this last being perhaps the first 'modern' English middle-class portrait which was to exert a considerable influence on future portrait-painting in this country. In 1746 he laid the foundations of the first public gallery, or exhibition of pictures in England,[77] by presenting the hospital with his *Moses Brought to Pharaoh's Daughter* and *The March to Finchley* (Pls. 100a, 99a). He did not present the latter outright to the Hospital. A lottery was arranged, the artist gave all unsold tickets to the hospital and one of these was drawn. Other artists soon followed suit (Pls. 101a, b), and twenty of them were made governors of the hospital. It is most characteristic that this humanitarian middle-class institution should have become an extremely important centre for English art, attracting crowds of people. And the fact that Hogarth and his fellow artist-governors held an annual dinner on the day of William III's landing and drank to 'Liberty as the parent and friend of the Fine Arts', bears witness to their loyalty and Whig sympathies. The organisation of public exhibitions on a more systematic scale was initiated in 1759 on a proposal by Hayman at one of these dinners, the resolution being signed by Wilkes, then treasurer of the hospital. The first exhibition was held in 1760 at the Society of Artists[78] and Hogarth illustrated the catalogue for that of 1761 (at Spring Gardens). Thus the hospital formed a link between middle-class politics and humanitarianism on the one hand, and artists' organisations and the buying public on the other.

If the moral purpose of Hogarth's work, to which he attached such importance, had its origin in the new bourgeois outlook, so also did his insatiable interest in every aspect of humanity. This enabled him to express his ideas through a wealth of previously almost unexplored material. Analysis of human nature was considered just as vital as the discovery of moral maxims, and Pope's 'the proper study of mankind is man' could be taken as the motto of Hogarth's work, indeed of the whole period. This was the time when, through Locke, empiricism and psychology gained the field in English philosophy; when, in the new psychological, realistic, domestic literature dealing with ordinary English life, the possibilities of exact observation appeared to be limitless, whether it was concerned with the diversity of everyday characters or the seemingly most trivial objects. In choosing to render subjects half-way between the sublime and the grotesque which had hitherto been 'totally overlooked', Hogarth emphasised the commonplace nature of his themes. He was conscious of exploring in his cycles an entirely new field, 'not broken up in any country, nor any age'. Such sentiments typified many outstanding figures of the period, with its intense pursuit of new ideas: in *Joseph Andrews* (1742) Fielding declared he had found 'a new province of writing' and, in *Clarissa*, Richardson was resolved 'to attempt something that never yet had been done'.

Keenly aware of the world around him, Hogarth wrote: 'The perpetual fluctuations in the manners of the times enabled me to introduce new characters, which, being drawn from the passing day had a chance of more originality and less insipidity than those which are repeated again, and again and again from old stories.' Like Fielding, he depicted every section of society. He was interested alike in the bourgeois and the nobleman, the rich and the poor, judges and

physicians, politicians and clergymen, shopkeepers and pedlars, craftsmen and labourers, musicians and singers; in the theatre and masquerades, in inns and fairs, drinking bouts and mad-houses, cockpits and boxing matches, prisons and executions, criminals and prostitutes. He painted sessions in Parliament and elections, the Lord Mayor's Show and the banquet of a city company. He even introduced into his works a great variety of well-known Londoners, both reputable and disreputable; this certainly amused him, whilst the enhanced topicality of the prints stimulated public curiosity and increased their sales. Hogarth drew on the crime reports in the newspapers for facts and names. He responded to public appeals. In *The Gentleman's Magazine* of 1747 a poem appeared inviting him to apply his skill at depicting human passions[79] to the representation of a cockpit; later, in 1759, he published an engraving of this theme. He was fascinated by every kind of human situation, by the diversity of men's character and expression, masked and particularly unmasked, by the varied settings in which his figures moved. Born and bred in London, he had an intimate knowledge of this immense city, the largest in Europe, the centre of trade, the seat of court and parliament and the focus of English cultural life. He was himself one of its best-known citizens. When he was portrayed in a crowd before the Guildhall in an engraving, *A Stir in the City* (1754), everyone recognised him. He used many London sites[80] as the topographical background for his engravings.[81] He was acquainted with its social, literary and theatrical events, its fashions, its vices, its *chronique scandaleuse*, its police reports and rough amusements. For vices and rough amusements there were in plenty, especially since the return of laxer moral standards under the Restoration.

Some of Hogarth's works, particularly his early ones, undeniably reflect the outlook of the popular journalist Ned Ward, who belonged to an earlier generation but who was still active during the first ten years of Hogarth's career. Ward, under a moral pretext, was quick to supply Londoners with that spicy portrayal of themselves which they relished.[82] It need scarcely be said that, even in his early phase, there was far more to Hogarth's work than this. Yet there might be some truth in Vertue's account of the genesis of *A Harlot's Progress*, which was not, to all appearances, greatly to Hogarth's credit. Vertue records that the artist painted a certain prostitute getting out of bed *en déshabillé* and, when this picture proved a success, followed it up with a companion piece; later on the idea of a moralising cycle based on these occurred to him. This does not imply any contradiction if regarded in the light of the transitional spirit of the 1730s. Hogarth was no prude; his own small collection of engravings included the mezzotints of John Smith after the cartoons of *The Loves of the Gods*, attributed to Titian and belonging to the Duke of Marlborough, a series with very obvious erotic appeal. Hogarth could easily reconcile his worldly experiences, including those of his gay youth, with the didactic demands of his deeply-felt middle-class convictions.[83] From the teeming wealth of life around him, he depicted what he fundamentally considered to be vicious in the minutest detail, even in his moralising cycles.[84] This aptitude, so natural and undisguised, cannot by any serious historical standard be held to denote 'immorality', although such may perhaps have been the purpose of a very few early works done to special order to earn his living, and these he was later inclined to repudiate.

Hogarth's case was very similar to that of Defoe, the most authentic mouthpiece of the middle class of his day. Whereas Defoe's sincerity cannot be doubted, in *Moll Flanders* (1722) he revealed an equal fascination for the sordid facts of pick-pocketing and harlotry, which he described in the greatest detail, while remaining convinced of the moral and didactic purpose in so doing.[85] Nor should any stigma be placed on Hogarth's boisterous and infectious gaiety. What he really enjoyed throughout his life was harmless, rumbustious amusement combined with good

food and drink, such as could be found at the Sublime Society of Beef-Steaks, of which he was a founder, and later at the Nonsense Club. This was characteristic of both the man and the artist. As in Fielding's case, both in his life and his work nothing was so alien to Hogarth as hypocrisy[86]; in contrast to Richardson, who was given to a one-sided sentimentality and over-abstract moralising, Hogarth and Fielding usually took a frankly matter-of-fact, humanitarian view based on a breadth of psychological insight. Perhaps a shred of latent sentimentality can be detected even in the very sober Hogarth, and certainly Fielding was never entirely without it, but in both cases, particularly in Hogarth, it was tempered by intellectual considerations. Moreover, compared with Richardson, the character of their moralising was more secular, more concerned with social problems, healthier and more full-blooded, and it sprang from a greater knowledge of society as a whole.

Hogarth's assiduous observation of life and his close contact with his fellow-men tended to increase his aptitude for detecting human weaknesses and follies, for he had a keen sense not only of the tragic but even more of the comic. Following in the steps of Shaftesbury and *The Spectator*, it was in fact Fielding who emphasised the moral and instructive tasks of the comic. Hogarth made ample use of tragedy and comedy to further his didactic aims. Fielding wrote of him in *The Champion*: 'In his excellent work you see the delusive scene exposed with all the force of humour, and on casting your eyes on another picture, you behold the dreadful and fatal consequence.' This capacity for combining both tragedy and comedy in an outlook embracing every side of life is by no means the least aspect of Hogarth's greatness.

Closely linked with this penetrating type of observation, the equally new and controversial spirit of satire also revealed itself in English literature at this time, in the writings of Swift and Pope (*Essay on Criticism*) and in *The Spectator*. This critical yet by no means uncreative spirit carried the always satirically-inclined Hogarth, and others besides him, very far. For often interest and still more dislike inspires not only criticism but also parody.[87] One's first impression on glancing through Hogarth's work, just as on reading Swift or Pope's *Dunciad*, is of a negative approach to people, which often merely consists of personal attacks.[88] Hogarth, particularly the young Hogarth of the period of Gay and the early, burlesque plays of Fielding, seems to have favoured and opposed so many things at the same time; he could never resist a gibe and even parodied his own compositions. Moreover, apart from Hogarth's individual sense of the comic, the general taste for criticism was in part a heritage from the Restoration period, with its derisive spirit and love of travesty. In this sense it was shared by many of Hogarth's contemporaries; typical, for instance, was Butler's *Hudibras*, 1663–78, which Hogarth particularly liked and which he illustrated in 1726 (Pls. 10b, 11a, b, 12, 13c). A quality of dissoluteness, frequently met with in aristocratic culture, imbued the whole Restoration period, with its sparkling, often cynical wit. The 'Restoration spirit' undoubtedly left its mark not only on Hogarth but on most intellectuals of the early 18th-century middle class.[89] This can be seen, for instance, in Gay's *Beggar's Opera*, 1728, which Hogarth illustrated and also burlesqued (Pls. 20a, b, 22a); and in Fielding's early satirical farces of the 'thirties, some of which Hogarth also illustrated. In view of the earlier attitude of the Puritan middle class to art and literature, which it had been inclined summarily to dismiss as irreligious and immoral, it would have been impossible for Hogarth and his contemporaries simply to ignore the cultural heritage of the Restoration. Without it there would have been nothing but a vacuum. So however strong the bourgeois character of the outstanding cultural achievements in Hogarth's time (or, for that matter, of Hogarth himself), it is usually possible to detect ironical and witty elements surviving from the previous aristocratic culture or, what at times amounts to nearly the same thing, 'vulgar' and popular features. This spirit of

burlesque could assume different shades: under the Restoration it tended to be cynical; in Hogarth's time, it was more matter-of-fact and critical.

In Hogarth a blend of all these elements—criticism, polemics, observation, burlesque, parody —were united with a genuinely moralising, humanitarian aim, thus providing, as in Fielding, a combination which is only comprehensible when related to the historical situation in England in the first half of the 18th century. Behind Hogarth's social satire lies the solid optimism of an efficient, successful middle class and in this it differs from the very personal pessimism and biting misanthropy of Swift, his favourite writer of satires. Had not even Addison, that arch-moralist, considered it a duty of *The Spectator* 'to enliven morality with wit, and to temper wit with morality'? Pursuing much the same ends, Hogarth's satire certainly helped to bring his works closer to the public. Yet it must at the same time be conceded that his great talent for caricature, for touching the vulnerable spot, made him rather a sarcastic jester and a sharp all-round critic. Furthermore, he frequently used burlesque to express the opinion of the man-in-the-street on every-day matters: doctors are quacks (e.g. *The Death of the Harlot*, the *Quack* scene of *Marriage à la Mode* and the engraving *The Company of Undertakers*)[90]; lawyers are thieves (e.g. the attorney in the first scene of *A Rake's Progress* and the pompous lawyer in *Hudibras*); scientists are stupid (e.g. in the engraving of *Scholars at a Lecture*)[91]: clergymen are bores; Catholics are dangerous; Wesleyans are mad, and so on. Once one has a clear picture of Hogarth's main tendencies, one learns how to recognise his changes of tone according to the stage of his development and the circumstances surrounding individual works. In this way one learns to distinguish the intentionally burlesque from the genuinely critical.[92] Sometimes one must turn to Fielding, the most cultured and logical thinker in Hogarth's circle, for a wider view of and a more definite guide to the artist's ideas and the potentialities behind his work. This applies not only to Fielding's very positive social theories but also to his literary and even his artistic ones.

Self-taught as he was, Hogarth affected to despise book-learning and tended throughout his life to be unsystematic in his thinking and clumsy in his writing, shortcomings not altogether unexpected in an artist. This is apt to obscure, or encourage us to under-rate, many of his opinions, even the very modern ones expounded in his *Analysis of Beauty*. Yet his art was greatly appreciated by the most prominent intellectuals such as Swift, Fielding, the poet Allan Ramsay, Garrick, Horace Walpole, Sterne and Smollett. Nor should it be forgotten that Hogarth's father was something of a serious classical scholar.[93] Not only as an artist but also intellectually, Hogarth grew in stature from decade to decade. In his late years one can almost watch him— often sitting amongst the intellectuals in their coffee-houses—meditating, learning from others and recording his artistic ideas, which often betray an amazing breadth of intellectual and scientific knowledge. Apart from his intimate association with Fielding and Garrick, he was befriended by an exceptionally wide circle of writers and scholars, among them outstanding members of that centre of contemporary scholarship, the Royal Society.[94] Dr. Parsons, Assistant Secretary of the Society, was a close friend; so was Dr. Freke, the famous surgeon and author of philosophical writings on the natural sciences. It is not surprising, therefore, that he should have in time acquired a fair grasp of many problems of the day in literature, and the theatre, apart from those current in the art world.[95] Undoubtedly many of his general artistic theories were traditional, probably adopted as a matter of course; at times, whether he realised they were out-of-date or not, he gave them a bold twist or added an entirely new shade of meaning. However, what is of most interest is that, in his late phase, far from deprecating books, he was capable of writing a very important one himself, *The Analysis of Beauty*, in which he discusses

the fundamental principles underlying beauty, upon which he must have pondered for many years. In its sphere, this striking work yields nothing in daring originality to any other of its time. Apart from this, fruitful ideas are scattered throughout his notes and even if these do not add up to a coherent and systematic whole, they give, as it were, a close-up impression of the ceaseless workings of his brain. Despite his many prejudices, which anyway are easy enough to understand, Hogarth was exactly the opposite of the insular, uncultured, barbarian he has often been taken for.

Hogarth's religious views should not be left out of the picture. He was, with an ever-increasing persuasion, a staunch member of the Established Church. Yet he was full of common-sense; he would certainly never have gone so far as the indifferent and sceptical aristocracy. One can take it, then, that his dispassionate belief, based on reasonable, practical morality rather than on dogmatic religion, was similar to that of the higher clergy and of course of the genuine middle class itself, as expressed in *The Spectator*.[96] (Even the Nonconformists had by this time lost their earlier zeal.) In the 1720s, at the time of the Deist controversy, when the clergy were subjected to considerable hostility, the young Hogarth seems also to have been very off-hand towards them. In his *Royalty, Episcopacy and Law* (Pl. 8a), the role of the Church with the help of the Bible is to work a pump from which money is pouring. In his painting of *The Sleeping Congregation* (1728, Minneapolis Institute of Art; engraved 1736) (Pl. 18), the scant respect shown for the Anglican clergy and the power of their sermons nevertheless only reflects general opinion.[97] He was on the best of terms with the leader of the Whig Low Church party, the liberal, broad-minded Bishop Hoadly of Winchester, whose portrait he painted in 1743 (Tate Gallery) (Pl. 77a). For Hoadly was the protagonist in the fight for the rationalisation of religion as foreshadowed by Locke. Noted for his tolerance and Latitudinarianism, and for his defence of liberty of conscience, he was not uninfluenced even by Deism. He supported the attempt to legalise the position of the Nonconformists, partisans of the 1688 Revolution and supporters of consecutive Whig governments; he even exceeded Locke's principles when he took a prominent part in efforts to diminish the power of the clergy by divesting them of all supernatural privileges.[98] He was disliked by the orthodox clergy[99] but praised by Fielding for his true, simple Christianity, in *Joseph Andrews*, through the mouth of Parson Adams. Apart from his friendship with Bishop Hoadly, who found Biblical justification for constitutional monarchy, Hogarth frequented various members of the Whig high clergy, the staunchest of all being Archbishop Herring of York, later Archbishop of Canterbury, whose portrait he painted (Pl. 76a).

Hogarth's prejudices, which reflected the general feeling, were assembled together in the *Emblematical Print on the South Sea Scheme* (Pl. 3b), in which a Roman Catholic priest, a Jewish rabbi and a Presbyterian minister are playing a game of hustle cap, the Catholics, also suspect as Jacobites being the special target; even more so if they also happened to be French, as were the friars in *The Gate of Calais* and *The Invasion*. In an early painted sketch not used in the cycle, for the first scene of *A Rake's Progress* (*Marriage Contract*, Ashmolean Museum, Oxford) (Pl. 54b) a picture on the wall caricatures Transubstantiation. Hogarth's antipathy for hypocrisy in Puritanism was voiced in one of his favourite poems, Butler's *Hudibras*. Moreover, like Fielding, Smollett, Goldsmith and the middle class generally, Hogarth thoroughly disliked the Wesleyans, whose enthusiasms conflicted with his own sober brand of religion. Yet he did justice to the Wesleyan preachers who habitually accompanied criminals to their execution to pray with them. In *Industry and Idleness*, the idle apprentice rides in a cart to his place of execution in company with such a figure, said to represent the Wesleyan John Todd, an ex-sailor who worked arduously among criminals. Converted by his companion, the apprentice is singing hymns while the

Anglican clergyman, the chaplain of Newgate Prison, sits unconcernedly in a separate coach. Hogarth here had only given expression to what was common knowledge.

In his later, more 'fashionable' years he showed an even greater aversion for the Wesleyans, who belonged to a lower social stratum, than for the Catholics, who were often of distinguished rank.[100] This is revealed, for instance, in the alteration he made to a projected engraving in 1762: the first version named *Enthusiasm Delineated* (Pl. 137a), which was to be dedicated to the Archbishop of Canterbury, was mainly directed against the idolatry of the Catholics. The second version however was directed almost exclusively against the Wesleyans and re-named *Credulity, Superstition, and Fanaticism*.[101] It is possible that Hogarth made this revision under the influence of an anti-Wesleyan book published the same year, *The Doctrine of Grace . . . vindicated from the Abuses of Fanaticism*, by the learned Bishop Warburton, with whom he was on good terms. Be this as it may, the struggle against fanaticism and superstition, which persisted throughout Hogarth's lifetime and which had already been voiced in *The Spectator*, was part of the campaign by the higher clergy for the rationalisation of Christianity and the stressing of its purely moral aspects. Apart from all this, it seems that the nature of Hogarth's engraving, both in its general spirit and in many details, was determined in particular by Swift's *Discourse concerning the Mechanical Operation of the Spirit* (1710). In this the satirist analysed, in great detail, the methods employed throughout the ages to stir up religious fervour and the relation between religious fanaticism and sexuality in the rites of the various sects: of course he only got as far as the Quakers. In this print representing a Wesleyan service, the atmosphere is permeated by belief in witchcraft and ghosts: the audience is worked upon by a crude sermon threatening hell-fire, and the couple sobbing and kissing each other can, in particular, be taken for a literal illustration of Swift; an apparatus placed on top of Wesley's *Sermons* is measuring the effect of excitement on the human brain; King James' *Demonology* and Whitfield's *Journal* are displayed side by side. It is clear that Hogarth himself, unlike Wesley and Dr. Johnson, did not believe in witches.[102] But these various opinions are really only facets of a very average religious outlook. When it suited his didactic purposes, as in the case of *Industry and Idleness*, destined for the widest possible public, he had passages selected from the Bible, with the assistance of his friend, the Rev. Dr. Arnold King, attached to the plates.

The Bathos of 1764 (Pl. 143b), one of Hogarth's last works, done as a deliberate 'tailpiece' to his engravings, is obviously not the work of a deeply religious man. Conscious of approaching death, Hogarth shows the end of all things such as time, nature and the sun. The expiring figure of Time fills the centre of the composition, the word *Finis* issuing from his mouth, whilst around him everything is disintegrating and a tottering sign reads: 'The World's End'. A paper in the left-hand corner bears the inscription: 'Nature Bankrupt'. This pessimistic symbol expresses the despondency of the artist's last days, when he was ill and broken in spirit by the vehement polemics stirred up against him by his print *The Times*, which he reproduced in *The Bathos*, and by the Wilkes case. In such a mood, he wished to imply that, through his own death, the whole world was ending for him. It is significant that, in his last period, Hogarth, the empiricist, should have dared to conceive and represent such a theme. He must by then have been living in a world of ideas which anticipated Hume's scepticism and Harley's materialism.

To round off this picture of Hogarth's outlook and put his character in a nutshell, one could describe him as honest, level-headed, industrious, ambitious, intent on making money, business-like, self-confident, careful of appearances, a lover of comfort, food and drink, inventive, shrewd, fundamentally kind, vain,[103] witty and pugnacious.

II

Hogarth's Stylistic Development

꘎꘎꘎

DRAWING a parallel between the outlook of Fielding and that of Hogarth brings more clearly into relief the central position Hogarth occupied in the rich intellectual life of the times.[1] At first, satirical and even farcical tendencies appear to have predominated in both: Hogarth's early parodies of the 'twenties and Fielding's burlesque comedies of the 'thirties are still pervaded with the cynical spirit of the Restoration, despite, and partly even because of, their frequently popular features. In his plays, the young Fielding juggled with Restoration motifs no less than with the new sentimental ones. Not until his novels of the 'forties was he to find his settled mode of expression, just as Hogarth did in his cycles of the 'thirties and early 'forties. Hogarth's great cycles correspond to Fielding's realistic, psychological novels, particularly *Tom Jones*.[2] The material for *A Harlot's Progress*, *A Rake's Progress* and *Marriage à la Mode*, with their constructive yet satirical comments on society and the masterly balance of their formal components, was equally drawn from the heights and depths of middle-class life. Finally, in their late phases—Hogarth's *Industry and Idleness* and *The Four Stages of Cruelty*; Fielding's *Amelia*—the moralistic attitude of these two men was more pronounced; Fielding, if increasingly sentimental, now took a more active line than Hogarth and even became a magistrate (1748–54). During the first and second stages of their development, in so far as any such divisions can be made, it was Hogarth, Fielding's senior by ten years, who took the initiative. In the last stage it was perhaps Fielding who influenced Hogarth.[3]

This rough sketch may shed light on the principal phases of Hogarth's development. It could with equal justice be applied to the general trend of thought among English middle-class intellectuals, leading from the brisk, early years, through the later heroic decades, to the more conservative second half of the century.[4]

Even if the content and tendency of some of Hogarth's most important works seem to form natural links in this chain, his evolution, taking his choice of subjects alone, was nevertheless a far more complex affair. At every stage past tendencies invaded the present and various reasons must be adduced to account for the amazing novelty and originality of his art. His inventive

nature was not alone responsible: nor was the fact that his career exactly spanned the great period of middle-class culture in England. The position for an artist was at that time unique. Since the Reformation, religious scruples had denied the English middle class (it would hardly be an exaggeration to say the whole nation) any appreciable output of painting, or even engraving. The consequent almost total lack of artistic tradition necessitated the evolution of completely new forms and contents, and to an artist of Hogarth's intensity and creative capacity this proved more of an asset than an impediment.

When he embarked on his career, two types of artistic tradition were vegetating in England, neither of them represented by any great output, and neither of them associated with the middle class proper. Baroque art was favoured by the court and aristocracy for decorative frescoes and portraits; the other inheritance was the popular engraving. Each appealed to a different public, one very high and the other very low, and each displayed clear-cut stylistic features. Hogarth made use of both, so that, although at first glance one might define his art as essentially bourgeois, it is never quite consistently so.[5] At one end of the scale he worked for the aristocracy and even for the court; at the other, through the dissemination of his cheap engravings, he reached a broader public, stretching beyond the confines of the well-to-do bourgeoisie to the lower middle class. These two extreme traditions, so remote from each other and apparently so irreconcilable, mark the stylistic limits of his art. But between them there was ample room for a great variety of genuine middle-class themes, and of forms to suit them. Moreover the close ties between the bourgeoisie and the aristocracy, coupled with the artist's ambition to improve his social standing, made an accommodation of these different requirements quite feasible.

Quitting his first humble calling as an heraldic designer for silverware, Hogarth took to engraving of a type popular with a wide public, and was to maintain this for the rest of his life. Soon, however, he turned to painting as well and thereby reached a select, more or less aristocratic circle, first through portraits and later through the most elevated genre possible, namely historical painting. Henceforth, though independent and master of his means, he was obliged to work simultaneously for all his different publics.

Hogarth can almost be said to mark the very beginning of a purely English art. His line of development naturally tended towards an ever-increasing concentration and clarification of structure and this, depending on the theme and public in question, assumed in varying degrees mannerist, baroque, rococo and even classicising features as the case might be. Here it may be noted once and for all that, from a merely formal point of view, no radical contrast exists between baroque and rococo; there is only one of degree, rococo being the lighter and more diffused of the two. Yet although rococo grew out of baroque and was, like baroque, an art of the aristocracy —but of the late phase of the aristocracy—it was at the same time a move towards the intimate and the small-scale. This made it more easily available to a middle-class public than its grander and more heroic predecessor. With the development of a more forceful and numerous bourgeoisie in the 18th century, it is easier to imagine a middle-class rococo than a middle-class baroque. Yet even this is not the whole truth; a crude baroque, that is an art attracting a large public socially beneath the aristocracy, is slightly more widespread than a crude rococo, a generally more refined and more playful style.

For simplicity's sake, one may call Hogarth's general style baroque, that is, the traditional style of that meagre English painting to which he was heir and which he had to emulate, however much he was to change its schematic character. Under the impact of new themes and new realistic observation, baroque painting faded out, 'died' several times over in 17th- and 18th-century

Europe. On each occasion it was resuscitated on a less schematic, less decorative level in repeated attempts to incorporate the new themes and the new realistic vision. Hogarth's efforts to bring about a baroque 'revival' (not in any artificial sense), to effect a unification of composition under the banner of baroque, was perhaps the greatest achievement of them all, for no other artist embraced so many new themes or such a vast new world of descriptive realism.

I have noted a certain differentiation, according to the theme and the clients concerned, which cut across Hogarth's stylistic development throughout his whole career. The factor determining the style of a particular work was not only the period at which it was produced but also its subject and its public. Following the two established artistic traditions, Hogarth, even in his early period, produced quite close-knit compositions on a 'higher' plane in a concentrated baroque style, such as book illustrations with rather exalted themes. Simultaneously, and at the other end of the scale, he was turning out engravings in a relatively popular style, at best in a very crude baroque, in which he had not yet found the formal solution for his exuberant, realistic motifs. His further evolution can be described as either a struggle or a compromise between these two poles. His most significant works, the cycles, lie roughly midway between them. As time went on, the two extremes tended to draw closer together, although some thematic as well as compositional discrepancies remained to the end. In works of a 'higher' character, in history painting and pictures he considered akin to it, particularly in those with few figures, the concentration is more apparent and may even approach classicism, though the inherent realism of his art ultimately prevented a final solution to the problem of unifying compositions of this type. In works of a 'lower' character, often depicting dense crowds, he achieved, especially in his late phase, the difficult but more congenial task of absorbing his ever-expanding knowledge of the world and even many of his 'popular' motifs into the agitated baroque pattern of the whole.

In view of the artistic situation in England, it is not surprising that Hogarth's art was composed of seemingly heterogeneous elements, derived from a variety of sources, most of which were necessarily continental. At times, if it suited his public, he was attracted by the retrograde, but more frequently by the most advanced manifestations in European art. It is not possible to draw a line between his creativeness and what one might term his by no means passive sensitivity towards other works of art. No doubt he himself was frequently unaware of the stylistic ancestry or parallels which we are at pains to discover to-day. However this may be, he transposed them so radically for his own requirements that they are often very hard to recognise.[6]

Hogarth's stylistic development in the various decades may be summarised as follows. He achieved independence as an engraver, probably between 1718 and 1720. He had little experience in painting, he was poor and had no social connections to speak of. Consequently, during the 'twenties, when he was living rather from hand-to-mouth, he confined his activities to shop-cards (Pls. 4b, 8b), and sign-boards of a more or less popular character. Until about 1728 his works were almost exclusively engravings, frequently satirical and bearing closely on topical events. This genre, partly through the artist's own efforts, was acquiring widespread popularity among a broad middle-class public grown wealthy from trading and now eager to acquire products of the visual arts. He therefore portrayed events of a social, political and economic character from the viewpoint of the man in the street—topics such as the South Sea Bubble (1721), the evil effects of lotteries (Pls. 2b, 3b), and the restoration of National Credit (1724). Furthermore— and it was chiefly on this plane that he broke new thematic ground—he was particularly addicted to caricaturing events in the theatre and the world of entertainment (Pl. 22a).

For his satirical work, Hogarth had to rely on the tradition of earlier popular prints, especially

caricatures, and this meant very largely products of Dutch middle-class art—political caricatures and engravings of a didactic, moralistic character (Pl. 22b), rather than genre painting. Formally, he linked up not only with the baroque, the current prevailing style, but also with mannerism, which preceded baroque as the prevalent international style: for the combined features of these two styles played a significant part in popular engravings. This can also be seen in Callot (Pls. 2a, 3a, 7a, b, 104b, 142b), whom Hogarth much esteemed and who was the greatest artist-reporter before him, and in various *petits maîtres* who followed in Callot's footsteps. Hence Hogarth's earliest satirical engravings are of a somewhat primitive, wooden baroque with remnants of mannerism, embodying cumulative elements of realism imbued with popular symbolism. Within this genre, however, even as early as his *Masquerades and Operas* (1724) directed against the state of the theatre, he no longer adhered to the traditional form of presentation, in which the text played a predominant part, but devised a new type of satire; in this the illustration was allowed to speak more for itself, although to the end of his life he never entirely discarded the use of inscriptions. His irrational elements of fantasy, in seeming contradiction with his inherent and increasing realism, derived from popular art and from mannerism. These were usually blended together, as in his astonishing caricature, *Royalty, Episcopacy and Law* (1724) (Pl. 8a).

During this period, from 1723 onwards, Hogarth's chief source of livelihood appears to have been book illustrations, a genre now gaining ground with the new middle-class demand for secular literature. Here Hogarth's style gradually evolved towards a more consistent and refined baroque. This can be traced through the first and second series of his extensive illustrations to Butler's *Hudibras* (1727) (Pls. 10b, 11a, b, 12, 13c), which show a development towards a moderate but highly realistic baroque. These illustrations were his principal work of these first ten years and more or less portray contemporary English life. In the second series a new English artistic language can be seen emerging, stylistically bridging the gulf between the artist's early popular engravings and his contemporary works on a 'higher' level, book illustrations which drew on contemporary Dutch and French works of a similar kind and which display a rather conventional, academic baroque tinged with mannerism. This thread of continental baroque in Hogarth's work was to culminate in his illustrations to *Paradise Lost* (Pl. 6b). But already this early, most popular phase betrays a marked inclination for grand continental art, such as that of Raphael and Rubens. Indeed Hogarth was to retain this *penchant* for monumental, even solemn, baroque throughout his life.

Although transitional in character, the few years between 1728, the date of his first recorded pictures (Pls. 18, 19b, 20b), and 1732, when his first cycle, *A Harlot's Progress*, was published, were extremely important in his development. After his marriage to Thornhill's daughter in 1729, he strove to gain a larger and steadier income and to acquire clients of higher social standing. The change in his circumstances affected his art in various ways; he gave up illustrating books and went over to painting, in which field he rapidly showed an astonishing versatility. The originality of his narrative pictures becomes clear if we compare them with his other main field of painting in these years, the conversation pieces. He was chiefly instrumental in introducing these to England and produced a great number of them over a period of years around 1730. Almost overnight he became the most fashionable and successful portrait painter of the upper classes, to some extent of the aristocracy and even, for a brief moment, of the Royal Family. In some of these conversation pieces, when not too cramped by the patrons' orders to fit a large number of figures into a small canvas, Hogarth achieved extremely free, loose, graceful baroque-rococo compositions. It is not difficult to detect the influence of contemporary French and Venetian painters, some of

whom were then working in England for an elegant clientèle. This is evident in individual motifs, in the fluid brushwork and delicate landscape backgrounds, though it must be admitted that a certain fresh impetuosity which characterised his earliest pictures of 1728, such as *The Sleeping Congregation*, vanished with his increasing formal discipline, brought about through the oft-repeated patterns of his conversation pieces.

Apart from narrative pictures, portraits and portrait groups, Hogarth now occupied himself with paintings resembling journalistic reportage on topics of general interest, such as *The Bambridge Committee* (1729), the sketch (Pl. 24b) for which is in a particularly lively baroque style. Here too, just as in his narrative works, it was chiefly in sketches and pictures of a sketchy nature that he attained the compositional skill of, say, the *Hudibras* engravings. From now on he alternated between pictures and engravings (in particular caricatures), sometimes painting a picture solely to have it engraved. In his favourite sphere of the theatre, he continued to do caricatures—engravings in a rather popular style—whilst at the same time executing orders for pictures of actual events upon the stage.

With his gift for reportage, Hogarth's rendering of the most notable theatrical event of the time—*The Beggar's Opera* (1728–31) (Pl. 20a, b)—has little in common with the dream-world approach of Watteau. It is even very remote from Gillot's realistic portrayal of scenes from the *Commedia dell'Arte* (Pl. 21b). Although the early stiffness of his painted compositions persists, this work represents a radical reorientation of the theatre picture towards middle-class solidity and matter-of-factness. Yet, without shedding this matter-of-factness, when he had to paint a performance of Dryden's elegant play *The Indian Emperor* (1731) (Pl. 33a), as it was given before an audience of high social standing, he laid even greater stress on the formal values of the composition than in his average portrait groups and the general effect is of a refined, fashionable near-rococo. His most important venture of this period, pointing into the future, lay in pictures and engravings which tell a story. *The Sleeping Congregation* (1728), *A Woman Swearing a Child to a Grave Citizen* (1729) (Pl. 26a), *A Baptism* (1729) (Pl. 25a) and *A Midnight Modern Conversation* (1733) (Pl. 43a), combine features of a documentary, satirical and popular middle-class character.

The originality of Hogarth's innovations, both thematically and formally, is striking. These pictures reveal surprisingly little contact with Dutch art. Even the influence of contemporary French art appears in a very disguised form. The incipient and promising formulation of the baroque pattern in Hogarth's renderings of such unusual contemporary scenes and stories of his own contriving makes one aware of the great formal consequences of his new themes. Yet, if the narrative paintings, in which he was forced to rely on his own powers of invention, offered him a clear field for original composition, one is particularly conscious of the initial difficulties he faced in the rigid patterns of *A Woman Swearing a Child* and *The Baptism*. In the conversation pieces the road was apparently easy from the very first, even if at best he could not reach beyond a certain schema, however charming. Hogarth's development, when unhampered by commissions for conventional works, may be seen in the change that took place between the still very rigid conversation piece of *A Club of Gentlemen* (c. 1730) (Pl. 28b), and the sparkling *Midnight Modern Conversation*. The faint suggestions of baroque in *A Baptism* assume a grander character in *Henry VIII and Anne Boleyn* (1729) (Pl. 17a), an 'historical' picture, even if only destined for a place of amusement, Vauxhall.

During the 'thirties Hogarth's art in many ways acquired more solidly bourgeois characteristics. Realising that his conversation pieces, with their small size and large number of figures, though

destined for a fashionable public, were unprofitable, he now thought of something more lucrative and more suited to his character and outlook. There now appeared his first moralising, didactic cycles: *A Harlot's Progress* (1735) (Pls. 36c, 37a, b), and *A Rake's Progress* (1735) (Pls. 50a, b, 52a, 53b, 54a, 55a, 56a). With these he created a genre unique in Europe. Their novelty lies not only in their critical conception and their publication as a series of cheap engravings, but also in their enormous wealth of detail and truthfulness of representation. In fact, they are so original that only occasionally can one find stepping-stones to them in Dutch genre painting, even in individual motifs. Of the two cycles, *A Rake's Progress* contains a greater amount of realist observation and an easier and more successful approach to spatial problems than the earlier *A Harlot's Progress*, and its build-up is of a more evolved baroque. The acute perception with which Hogarth noted material details extends far beyond the confines of the few narrative pictures of previous years. The structure of the composition seems at first to be somewhat loose and schematic, overburdened as it is by the mass of these details in each changing episode. Yet, considering Hogarth's revolutionary vision, it is astonishing that, in this field too, a fresh baroque composition is slowly but ever more unmistakably taking shape.

Hogarth's most important paintings and engravings during this decade exhibit similar formal features and the same growing capacity for an enriched baroque pattern[7]: for instance, *Southwark Fair* (1733) (Pls. 44a, b), the small series *Four Times of the Day* (1738) (Pls. 58a, b, 59a, b), and *Strolling Actresses Dressing in a Barn* (1738) (Pl. 61a). The last of these in particular, the first prosaic representation of the life of actors, divested of flattery, is evidence of the skill Hogarth had acquired by the end of the 'thirties at combining a whirling, flowing, extremely rich baroque with everyday realism.

Side by side with this realistic baroque, another most progressive aspect marked this decade—his caricature-like popular engravings. These often bear witness to his growing interest in physiognomy (*Laughing Audience*, 1733 (Pl. 41b), *Scholars at a Lecture*, 1737) and they reflect a type of European caricature, that of Ghezzi, which succeeded and differed from the popular Dutch print. But Hogarth's grotesque-expressionist vein sprang from a much deeper understanding of human nature than Ghezzi's. On the conservative side of his art there now appeared a stream of rather grand compositions, both in engravings and paintings. From the end of the 'thirties a greater clarification of the over-loaded composition is generally noticeable throughout his *œuvre*, naturally more in pictures of distinction than in popular engravings.

Possibly due to the financial success of the two Progresses, Hogarth could now afford to do his first historical paintings on a really grandiose scale. He depicted *The Good Samaritan* (Pl. 60), and *The Pool of Bethesda* (1736) (Pl. 57a), both destined for St. Bartholomew's Hospital. Their stylistic tendencies are mixed. Considering the subjects, unusually realistic elements appear. For their general pattern they lean on Raphael, on previous Biblical illustrations and on Rembrandt; for their handling, on the rococo of Ricci and Amigoni. In spite of the necessary presence of grotesquerie, the *Don Quixote* illustrations (1738) (Pl. 63b), commissioned by an aristocratic connoisseur, have stylistic affinities with fashionable, sophisticated Dutch-Italianising painting. In portraiture, whilst he never entirely discarded courtly-baroque likenesses with their requisite generalisation, Hogarth could now paint the impressively simple and original portrait of his mother (1735) (Pl. 49a). So far as dividing lines can be said to exist at all within an artist's development, the years immediately before and after 1740 form the important period of transition towards his new style.

During the 'forties, when the taste for rococo was growing, particularly in smart society

(reaching its climax around 1750), Hogarth's art to a great extent assumed a more elegant character than before. *Marriage à la Mode* (1745) (Pls. 87a, 89a, 90c, 92a, b), whilst continuing the moralising tendencies of the two Progresses, clearly surpasses them in elegance since it treats of life in the upper strata of society. Whilst so far Hogarth's main contacts had been with Dutch art, he now inclined towards France[8] and even went to Paris in 1743 to see for himself. His receptivity towards French art had already been noticeable in certain works of a fashionable character in the early 'thirties but never before had he come so close to that style or, to be more precise, to its more solid, realistic, 'English' potentialities. To speak of a 'second' phase of French influence would be an over-simplification. One should rather say that the formal influence from France was now more diffused and deeper. And closely associated with this growing refinement is a general tendency towards greater concentration in the composition, a reduction of cumbersome details, more spaciousness, an increased harmony of colours and a general restraint of tone. Hogarth was ready to learn from the structure of French rococo engravings: for instance, from a Cochin print (Pl. 81a), when painting *The Stay-maker* (Pl. 80). Moreover, precisely such a sketch-like picture as this reveals not only a keener sense of structure and harmony but also that his brush-work is becoming looser and broader. Yet contact with French art, particularly that of Gravelot, then living in London, served ultimately to carry Hogarth's own achievements beyond those of his model. During this period he did most of his amazing sketches and rather sketchy pictures, many of which undoubtedly surpass contemporary French art in their broad, bold painterliness: *The Wedding Dance* (Pl. 94a), *Ill Effects of Masquerades* (Pl. 73a), *The Shrimp Girl* (Pl. 138a). The sketch-like etching of *The Charmers of the Age* (1742) (Pl. 102a) is roughly of the same quality as the impressionist etchings of Gravelot. *The Wedding Dance*, an example of Hogarth's rococo style, probably belonged to the cycle of *The Happy Marriage*, begun after *Marriage à la Mode* but never finished. Other paintings in this cycle are in a simple, restrained style, in keeping with their unobtrusive subjects. In his history painting a tendency towards a more temperate baroque than was usual on the continent appears. Although in this much explored sphere Hogarth was obliged to keep close to the continental tradition, he paved the way for future works of this type in those done for middle-class institutions. In *Moses brought to Pharaoh's Daughter* (1746) (Pl. 100a), though not forgetting his painterly qualities, he was really introducing classicist elements, and in *Paul before Felix* (1748) (Pl. 112a), he modified Thornhill's baroque more in the spirit of Raphael. For even in a preponderantly baroque-rococo period, it was possible for an artist with Hogarth's unique degree of realism and with the formal clarification of *Marriage à la Mode* behind him to approach classicism, the most consistently middle-class art on the continent, at least in historical pictures with few figures. For then the gap between a strong, generally realistic tendency and a realistic classicism was not so wide. One can understand, therefore, how Hogarth, in precisely the same year of 1746, could paint one of his most densely crowded and realistic pictures, *The March to Finchley*, at the same time as the one which most closely approaches classicism, *Moses brought to Pharaoh's Daughter*. In another picture taken from contemporary life and dated a few years later, *The Gate of Calais* (1749) (Pl. 111), painted for an aristocratic connoisseur, he shows himself quite capable of concision if he so wished. Although baroque, his 'dignified' paintings of the stage at this period, such as *Richard III* (1746) (Pl. 98c), come near in conception and compactness to his historical painting. In the large number of individual portraits done rather at the expense of conversation pieces, he kept where necessary to the manner of grand, moderately baroque state portraiture, as for example in that of *Bishop Hoadly* (1743) (Pl. 77a), though he was never so conventional as the average English and French portraitists of his time. When it was a

question of the likeness of a middle-class sitter in an official capacity, such as *Captain Coram* (1740) (Pl. 66a), he took for his model the solemn baroque scheme of a Rigaud portrait, though with modifications. But many of his portraits of people in quite unofficial positions had no parallels abroad in their directness of expression; this is true of the portraits of *Mrs. Salter*, with its peculiarly delicate pictorial harmony, of *Mr. Arnold*, and of the Jacobite conspirator, *Lord Lovat* (1746), with its psychological discernment (Pls. 71a, 65a, 78b); whilst the engraving of *Characters and Caricaturas* (1743) (Pl. 78a) may be said to summarise his systematic study of physiognomy.

Hogarth's last large cycle of this decade, the robustly sentimental *Industry and Idleness* (1748), is the most didactic and moralising of them all. It probably most clearly and, so far as he was capable of it, most positively expresses middle-class mentality. Formally, it provides an interesting indication as to which elements of his new achievements Hogarth liked to retain when working for a less elevated public than that for which he catered in the elegant *Marriage à la Mode*. The cycle is entirely different in its appeal and in its means. Yet it contains some of Hogarth's most original and most important compositions, such as *The Industrious Apprentice in Church*, *The Execution of the Idle Apprentice at Tyburn* and *The Lord Mayor's Show* (Pls. 104a, 107b, 108a).

In his popular engravings (*Battle of the Pictures*, 1745) (Pl. 102b), the flavour of Dutch caricature still lingers; yet in such a rococo picture as *Taste in High Life* (1742) (Pl. 74a) done for a modish patron, with its strongly satirical note, the usual influence of Ghezzi is modified by a pervasive elegance, absent from his caricatures of the 'thirties and linking up with the ballet caricature, *The Charmers of the Age*. In *Taste in High Life*, the mannerist-irrational features which had previously appeared in a somewhat popular guise take on the required note of chic refinement.

When sketching the main line of Hogarth's art in the 'fifties and early 'sixties, it should be borne in mind that in 1753, after much preliminary work, he published *The Analysis of Beauty* and that henceforth, up to the end of his life, he was engaged on writing supplements to it. Well-informed, ingenious and original, Hogarth's brain was teeming with ideas at this late stage. All types of painting and engraving he now touched appear more concentrated and monumental, whilst features which had hitherto contributed to the exciting complexity of his art became immersed within the new monumentality. In this connection it is tempting to speak of a certain mellowness, a certain quiet naturalism, in his late art. Yet since everything in Hogarth is relative, it is only safe to refer to a kind of Louis XVI style in a very generalised way, for here, too, there are gradations and differences according to the different types of work.

The apparent failure of his historical paintings of the 'forties and his lack of success in disposing of the original pictures of *Marriage à la Mode* left Hogarth so depressed that in 1751 he took down the Golden Head of van Dyck from over his doorway in Leicester Fields. Though once again working mainly on engravings, he nevertheless eagerly seized the few opportunities that offered in the second half of the 'fifties to tackle grandiose painting, though he was never again to paint so restrained and classicising a picture as *Moses brought to Pharaoh's Daughter*. The reason for this may well be that he received no further commission for an historical picture from a middle-class institution. His large Bristol altarpiece, with the Resurrection at its centre (1756) (Pl. 126) is in a rather agitated baroque. Whilst his appointment as Serjeant-Painter to the King in 1757 does not appear to have brought him any notable orders, he now made greater efforts than ever to procure commissions in aristocratic circles. The results met with varying success; a 'moral' picture such as *The Lady's Last Stake* (1759) (Pl. 134), was well received, whereas a genuinely historical one, *Sigismunda* (1760) (Pl. 131c), was generally considered a failure. Dignified

and elegant, this latter composition is stylistically close to moderate baroque continental proto-
types. In a theatrical scene from *The Farmer's Return* (1762) (Pl. 139a), the figures are composed
rather grotesquely in a a swinging, baroque rhythm, though the general pattern, resembling
that of *The Lady's Last Stake*, is tauter than usual. In portraiture, which he resumed, particularly
towards the end of his life, one finds works of great discernment, an experimentation with varying
shades of naturalism, much less inclined to rococo: for example, the consistently documentary yet
freely-handled portrayal of his servants; the portrait of John Pine, the engraver (1759) (Pl. 133a)
forcefully painted in imitation of Rembrandt; that of Lord Charlemont (1764), of a solidity and
sobriety pointing far into the future; and the extremely delicate group of Garrick and his wife
(1757). A comparison of Mrs. Salter's portrait with that of Mrs. Garrick enables one to see
Hogarth's development from a broad rococo picturesqueness to an, as it were, Louis XVI
painterly realism; both are in their way highlights of his portraiture and the yellow-white colour
combination used in both, just as in *The Lady's Last Stake*, lends itself particularly well for
comparison.

Hogarth was increasingly fascinated by facial expression. This was not confined to portraiture,
such as his defamatory engraving of Wilkes. To a greater extent than in the previous decade,
he now delighted in doing systematic studies of faces (*The Bench*, 1758) (Pl. 130a), quite apart
from a continued preoccupation with caricature. After the failure of *Sigismunda*, he once again
became absorbed almost exclusively in engravings, which he generally found more profitable.
Yet even these, crowded and often agitated as they are, show a certain monumentality, a greater
concentration. This even applies to works of a very popular character such as the pedagogic and
low-brow *Four Stages of Cruelty* (1751) (Pls. 117a, b, 118a, b), *The Invasion* (1756), *Credulity*,
Superstition and Fanaticism (1762) (Pl. 137a), in which Bosch-like motifs deriving from Dutch
caricature still abound, and the political lampoons *The Times I* and *II* (1762, 1764) (Pls. 142a,
143a). These various examples carry us to the end of the artist's life. Perhaps the most
characteristic of this late period are the works of a semi-popular character: the didactic *Beer
Street* and *Gin Lane* (1751) (Pls. 120a, b), the half-didactic *Election cycle* (1754) (Pls. 122a, 123a, b,
124a), *The Cockpit* (1759) (Pl. 136a). Suggestions from Breughel and other semi-popular sources
helped him to build up such a condensed composition as *Beer Street*.

The Election is Hogarth's most monumental cycle, both in composition and in the size of its
individual scenes, for the dimensions of the various cycles increase from *A Harlot's Progress*
onwards. In painting, it is probably the climax of Hogarth's achievement in rendering teeming
everyday life in a monumental form with accomplished pictorial means. Characteristically, the
most over-flowing and to all appearances least consolidated of the scenes, *The Election Entertain-
ment*, is infinitely more balanced than the Rake's *Orgy* of over twenty years earlier—the most
daring attempt, among his Progresses, to create an unschematic, fluctuating many-figured
pattern. Painterly details in *A Rake's Progress* were treated in a more petty isolated manner than
those in *The Election*, where the large bold patches of colour all fall into place. Again, if one
compares *The Cockpit* with earlier works of a similar crowded, *mouvementé* character, such as
Strolling Actresses from the 'thirties or *The Wedding Dance* from the 'forties, it is at once apparent
how Hogarth increasingly clarified the agitated baroque pattern, despite the demoniacal ferocity
of the scene. Even if in some scenes of *The Election* and in *The Cockpit*, his exuberance, far from
having diminished, seems even to have increased, a balanced synthesis quite without precedent
has now been achieved between his various tendencies—baroque, realism and expressionism.
It is on this dynamic and at the same time mature note that Hogarth's art comes to an end.

Yet the emphasis in all these tendencies is on realism, an amazing, relentless, insatiable realism. Though both the sublime and the grotesque play a large part in his art, Hogarth was above all interested, as he himself said, in what lay half-way between the two, that is everyday life, with its implicit realism, however inseparable from his art baroque and expressionism were. It was this artistic creed that he wished to convey when he issued his subscription ticket to *A Harlot's Progress*, *Boys peeping at Nature*, or when he wrote: 'Nature is plain, simple and true', or when, in *The Analysis of Beauty*, he quoted with evident approval a passage from *Anthony and Cleopatra* and added: 'Shakespeare, who had the deepest penetration into nature, had summed up all the charms of Beauty in the words infinite variety.' His realism covers so wide a range that in every phase, in every type of work, a different word is needed to meet its full significance. Taken all-in-all, Hogarth's art, so new and yet so deeply rooted in the tradition of English intellectual life, may be most simply summed up by recalling his three favourite writers and the qualities he esteemed in them: the baroque descriptions of Milton, the mocking satire of Swift, and above all the characters of Shakespeare, so vivid and three-dimensional that one can almost visualise them. These preferences define fairly closely the ways and means by which he himself tried to express the new ideas of his age.

III

Hogarth's Art and
Contemporary Society

𝓈𝓈𝓈𝓈𝓈𝓈𝓈𝓈𝓈𝓈𝓈𝓈𝓈𝓈𝓈𝓈𝓈𝓈𝓈𝓈𝓈𝓈𝓈𝓈𝓈𝓈𝓈𝓈𝓈𝓈𝓈𝓈𝓈𝓈𝓈𝓈

I N 18th-century England the aristocracy, accustomed to a luxurious mode of life, was the only class with any artistic tradition. Its taste, like that of the court, tended towards the baroque, but in order to suit a Protestant and increasingly bourgeois country, this was a rather restrained, sober baroque, devoid of the extremes of irrationality and fantasy which marked its expression in more fervently religious Catholic countries with a less developed middle class. Nevertheless it was above all Italian baroque painters, apart from Rubens, whom the aristocrats favoured for their large collections, principally Reni, Albani, Guercino, Salvator Rosa, Maratta and Giordano.[1] Moreover the nobility, particularly the highest and most cosmopolitan among them, called in a large number of Italian, especially Venetian, and French baroque and rococo painters to decorate their houses. The most famous of these—Delafosse (in England, 1689–92), Marco and Sebastiano Ricci (the former c. 1708–11 and 1712–17, the latter c. 1712–17), Bellucci (1716), Pellegrini (1708–13, 1715), Amigoni (1729–36, 1737–9)—had also worked in the palaces of the continental aristocracy.

Delafosse came to England with a whole colony of French artists[2] and with them executed one of his principal works, the decorations in Montague House. Under the auspices of Rubens and the 16th-century Venetians, he had already, at an unusually early date, carried through a pictorial revolution in French baroque with certain characteristics which could eventually lead to rococo. Soon after him the Venetians Sebastiano Ricci,[3] Pellegrini and Amigoni, the last two of whom were under the influence of French art, initiated in England the gradual evolution of a rococo painting such as was springing up almost simultaneously in Venice and Paris.[4] A penchant for a pleasant, tempered rococo appears to have existed in England quite early. Whilst Bellucci with his heavy baroque stayed here but a short while, Ricci, Pellegrini and Amigoni became the favourite painters of the aristocracy. Even Lord Burlington, whose name would not come naturally to mind in this connection, became a leading patron of Ricci, whose superb ceilings and panels for Burlington House were one of the starting-points for rococo painting in England.[5]

During the first half of the 18th century the English aristocracy came to prefer its baroque decorations to be tinged with Venetian and French rococo, to make them lighter, more graceful and brighter in colouring. This is also true of the pictures they bought. In no country in the 18th century were so many contemporary Venetian pictures bought as in England. In fact it would scarcely be an exaggeration to say that, in order to understand the development of Venetian painting in the early 18th century, the taste of the English aristocracy has to be taken into account.

Soon contemporary French pictures were to take their place side by side with the Venetians. As on the continent, this propensity for French and Venetian rococo[6] reached its climax around 1750, although even then the English by and large preferred it on a more moderate note. Their portraiture, too, was now pitched in a temperate key of baroque where formerly a combination of Titian and Rubens derived from the van Dyck tradition had served. Early in the century and to some extent before Hogarth, imitators of Kneller, Dahl, Jervas and Vanderbank received the commissions of fashionable society. As the century wore on, the favourite portrait painters were Hudson from the early 'forties, Ramsay slightly later,[7] and Hudson's pupil, Reynolds, from the 'fifties onwards; the first two also received commissions from the court. But even in portrait painting, now increasingly the special domain of English artists, foreigners affecting a similar style were welcomed by a clientèle of high rank.[8]

Amigoni, who came closest among Italians to the elegant French style, was a typical international court painter. His visit to England was sandwiched between his early activity as Bavarian court painter and his later work at the Spanish court. Only in England did Amigoni turn to portraiture, among others Queen Caroline and the Princess Royal. In terms of French art, one might define the ruling taste in high circles in England as lying between Regency and rococo. Slightly less brilliant than his famous brother, Charles van Loo, Jean Baptiste van Loo, who had been one of the French Regent's protégés, spent several years in England (1738–42) and became a fashionable painter of the court and aristocracy, including amongst his sitters the Prince and Princess of Wales and Sir Robert Walpole. The Franco-Swiss Liotard, who was twice in England (1754–6, 1762–74) painted portraits of the Princess of Wales and members of the nobility—a mixture of rococo sweetness and exotically dressed-up realism.

When painting for the aristocracy, it was only natural that Hogarth should do so in the current baroque-rococo style of French and Italian derivation. He was by no means averse to the patronage of individual artists by this class. Far from it, for his social ambitions, which he had probably nursed since his early connection with Thornhill, demanded an *entrée* to this circle. Since there were no exhibitions, the only way for an artist to make himself known was through distinguished and influential patrons. In his writings, when referring to patronage, he followed the common practice in naming only members of the court and aristocracy. His father-in-law was the only outstanding English baroque painter; he came of a good county family and was the first English-born painter to receive a knighthood. Still more unusual, Thornhill was a member of the House of Commons and, as such, a supporter of the Whig aristocracy. In its degree of emphasis, his art represented the peak of baroque in England. Competing eagerly with the Italians working here, he was nevertheless greatly influenced by them[9] and the frescoes with which he decorated several palaces and great houses combined, stylistically, Venetian (Veronese), Central Italian (Pietro da Cortona) and French (Lebrun) features. In his youth, Hogarth had probably collaborated on one or two of these baroque ceilings with Thornhill,[10] for whom he never tired of expressing his predilection, naming him the greatest English artist of the previous generation[11] and hanging his sketches on his own walls.

From 1728–9 onwards, particularly during the early 'thirties and probably with the help of Thornhill's social connections, Hogarth received a large number of orders for portraits from the Whig nobility. So successful was he at this relatively early stage in taking the aristocratic citadel by assault,[12] that he even attempted to procure clients among members of the Royal Family. During these years he painted few of the customary single portraits but introduced the novel form of the conversation piece. These small-scale pictures became for a time the craze of elegant society. Those painted between *c*. 1728–33 express the quintessence of what was considered elegant and fashionable, both by Hogarth and his patrons. They show traits of French and Venetian rococo superimposed on the native van Dyck tradition. It is a slightly conventional and generalising style, yet graceful and most piquant in its colouring—a style, in short, well suited for Hogarth to make full use of his outstanding pictorial capacities.

Although these rococo conversation pieces undoubtedly reflect the taste of the aristocracy, yet they also reveal some middle-class facets. In fact Hogarth's clientèle for these conversation pieces stretched beyond the confines of the high aristocracy[13] to lesser titled people, to the gentry and the rich upper bourgeoisie. Accordingly, in this predominantly aristocratic type of picture, the elegant or, rather, pompous features are often, by continental standards, less marked in keeping with the general levelling-down within English society itself. Middle-class features also appear, such as the relatively informal and easy attitudes adopted by some of the sitters and, in particular, the uninhibited playfulness of the children. The final result, in spite of the external formal influences just mentioned, is frequently very English.

This type of small portrait group was originally a sign of democratisation, of a demand by the middle class for cheaper pictures for their smaller and more intimate rooms, and its roots go back to Dutch genre painting. Metsu was probably one of the first to produce a small-size family picture, that of the merchant Geelvinck (Berlin) (Pl. 32a). By the second half of the 17th century, however, having absorbed a quality of elegance from the large portrait groups of van Dyck, this genre attained a highly fashionable character in Flanders, as typified by Gonzales Coques, the 'little van Dyck' working in Antwerp. Before Hogarth's time it was already familiar, though on a somewhat larger scale, even at the French court, as in *Le Cabinet du Grand Dauphin à Meudon* (1699, Versailles) by an as yet unidentified painter. It is probable that, at the end of the 'twenties, Hogarth himself took over this elegant type from French and Flemish painters working here, in particular from Philippe Mercier (1689–1760), a French Protestant immigrant, slightly older than Hogarth, who was already doing a few works of this kind around 1725.[14] It was Hogarth, nevertheless, who made this type of picture really popular in the best society. The secret of their success was their moderate price combined with their elegance. That the aristocracy, like the middle class, should prefer small pictures was perhaps due to changing circumstances: their London houses, like those of the French aristocracy in Paris, were becoming smaller and more homely, if more elegant. The rapidity of his success is apparent from a remark of Vertue's in 1730:

> The daily success of Mr Hogarth in painting small family pieces and Conversations with so much Air and agreeableness Causes him to be much followed, and esteemed, whereby he has much imployment and like to be a master of great reputation in that way. . . . Mr Hogarths paintings gain every day so many admirers that happy are they that can get a picture of his painting. . . .[15]

Born in Berlin, where he had been a pupil of the French court painter Pesne, Mercier came to England after 1710, possibly in 1716 in the train of Prince Frederick, the future Prince of Wales, and

settled here for life.[16] In 1728, when the prince himself came over, he was appointed his Principal Painter, a position he held till 1737, and Hogarth certainly knew him and his works well. Mercier formed an important link between Watteau and Hogarth. In the 'twenties, long before the appearance of the bulk of the famous *Recueil Jullienne*, he made numerous etchings after Watteau, two dating from as early as 1723 and 1724, and all from before 1731, mostly of *scènes galantes*, idealisations of the outdoor amusements of the aristocracy, and these etchings could obviously have served Hogarth as compositional schemes for his conversation pieces. Mercier was a very early direct imitator and even forger of Watteau (and later of Hogarth) and even used original drawings by Watteau for his paintings of musical and *Commedia dell' Arte* scenes.[17] This was easy enough for him to do, since Watteau lived in Mercier's house when he was in England in 1720. Watteau came over in the hopes of selling his pictures better than he could in France and painted several for English connoisseurs. Prints after him became increasingly fashionable and a surprisingly large number of French engravers crossed the Channel[18]—Jean Simon, Dubosc, Baron, Ravenet and Scotin—and not only engraved after their compatriot, but also worked in close intimacy with Hogarth, who frequently employed them.

Whereas the Watteauesque conversation pieces of the often drab Mercier are usually hard and over-smooth, Hogarth's portrait groups of the aristocracy are often, from a formal point of view, more elegant and more 'French'. Mercier's picture of *The Prince of Wales and his sisters performing at a musical party on the lawn of Kew Gardens* (1733, National Portrait Gallery) (Pl. 42a), is a case in point.[19] Hogarth was in fact the first real English imitator of Watteau. So greatly did he appreciate the French artist that the few engravings he possessed included some after Watteau.[20] He had the opportunity to see not only paintings by Watteau but also many engravings after him, including the volumes of the *Recueil Jullienne* in the house of Dr. Mead. Physician to George II and Sir Robert Walpole, Mead was a patron of Watteau and bought pictures from him when he was over here to add to his collection, one of the first in England to which students of painting were admitted. The first half of the *Recueil* alone, *Figures de différents Caractères* (from as early as 1726–8; the second part 1735–6), a large publication of engravings after Watteau's drawings, must have served Hogarth as a treasure-house of motifs with its galaxy of figures, half-figures and heads drawn from elegant society.

Possibly Hogarth knew the early etchings by Watteau himself, the *Figures de Modes*. Although Watteau and his French imitators scarcely ever painted portrait-groups as such, Hogarth's conversation pieces not only made use of these individual motifs (such as a certain type of sprightly small girl wearing a long skirt) and resemble the *scènes galantes* in their general arrangement, but also reflect a marked influence by the French pictures in a colouristic, painterly sense, especially in the delicacy of the landscapes, for instance particularly noticeable in the backgrounds with their silvery trees in Hogarth's two conversation pieces where Lord Pomfret's children are playing in the open air—*A Children's Party* (American private collection) (Pl. 47a), and *The House of Cards* (formerly National Gallery of British Sports)—or in *The Angling Party* (Dulwich College Picture Gallery) (Pl. 31b). True, the treatment of these second-hand French trees betrays a certain superficiality; however, the latter group, with its delicate figure of the lady angling in a tender, enveloping atmosphere perhaps comes closest of all in spirit to, for instance, Lancret's carefree representations.

Of all English painters, Hogarth, in these portrait groups and in many other works, was perhaps the most instrumental in paving the way for the injection into English painting of *Régence* and rococo gracefulness as typified by Watteau and his school. The *English* potentiality

for such an elegant painterly style had received some slight impetus from the aristocratic portraits by Kneller and his follower, Vanderbank, in which certain qualities of the van Dyck and Lely tradition were preserved, and from the free handling of which Hogarth must have learned in his early years.[21] Yet this general trend towards a pictorial style in small pictures, in which Hogarth forms the outstanding native example, was complemented and cemented by the numerous Venetian painters visiting England—the harbingers, with the few French artists who came too, of a new, more graceful art. Hogarth's brushwork particularly shows the influence of Ricci and Amigoni, especially of those small-scale, very painterly pictures and sketches in which they themselves came closest to the gay and fragile tints of French rococo painting[22]; the picturesqueness of many of Hogarth's trees is at least as reminiscent of Ricci as of Watteau. Yet, however delicate, the English painter's colours are always more solid, less pale, 'milky' and abstract than Amigoni's.

One of Hogarth's earliest portrait groups, painted between 1729 and 1731, is of Lord Castle-maine, his family and friends in the grandiose hall of his newly-built Wanstead Manor (Pl. 28a), *Assembly at Wanstead House* (Philadelphia)[23]; the ennobled son of Sir Joshua Child, the famous banker and chairman of the East India Company, Lord Castlemaine was soon to become the first Earl of Tylney.[24] This portrait group of a titled city magnate's family, together probably with the equally early one, no longer extant, of the Duke of Montague's family, was largely responsible for opening up a relationship for Hogarth with the aristocracy. So far as the figures are concerned, the picture is slightly monotonous, for the crowd of children and guests had to be squeezed into the small canvas. Yet the artist obviously enjoyed rendering the picturesque, heavy baroque interior decoration, and particularly the carpet, blending its patterns and colours into a painterly whole and fitting it into the rest of the picture—a procedure which heralds the painting of the 19th century.[25]

Even by the early 'thirties, Hogarth had succeeded in loosening the composition of these portrait groups, making them lighter, better formulated, more balanced and elegant, more delicate and brighter in colouring, so that they conformed more closely to French painting, increasingly even to French rococo, e.g. *The Family of William Wollaston M.P.* (1730, Wollaston Collection). He now painted *Sir Andrew Fountaine and His Family* (Philadelphia) (Pl. 30c), Vice-Chamberlain to Queen Caroline and Warden of the Mint, one of the best-known art collectors of his time; he had lived for several years in Italy and many of his pictures (e.g. by Titian and Rubens) were acquired either there or in Paris; his own house was decorated with rococo frescoes by Pellegrini. For this connoisseur, an elegant man of the world, a close friend of Swift, who, as a collector, according to Jonathan Richardson the Younger, 'out-Italianised the Italians themselves', Hogarth did a graceful family portrait group which united the fashionable French conception of an open-air picnic (which in France, however, was never combined with portraits) with an appropriate motif of Fountaine inspecting a mythological picture held up by his son-in-law and a well-known auctioneer.[26] It would not be stretching the imagination too far to suppose that this composition was suggested by Watteau's *Collation*, engraved by Mercier in London during the 'twenties (original picture, Kaiser Friedrich Museum, Berlin) (Pl. 31a). The landscape, though unusually solid, is perhaps the most Watteauesque of all among Hogarth's conversation pieces.

Hogarth's portrait groups of these years show a marked differentiation in their degree of elegance and solemnity of style, according to the social rank of the sitters, most noticeably between the aristocracy and the court.[27] In England under Charles I, van Dyck had created the

standard portrait in the baroque style for sitters of high social rank, not only in the case of individuals but also in portrait groups, such as *Charles I and his Family*, *The Duke of Buckingham's Family* and *The Earl of Pembroke with his Family*, where interest in social rank submerges that in individual features. Lely, Charles II's court painter, maintained the van Dyck tradition,[28] which was carried over to France, mainly in individual portraits by Rigaud and in some large portrait groups by Largillière. Rigaud was above all the portraitist of the court, Largillière also of the city dignitaries of Paris in a type of portrait group established after the Fronde, when the City and Court were reconciled. Rigaud, in spite of imitating van Dyck, created something like a super-van Dyck style in a ceremonial Louis XIV manner. Largillière had even studied in England (1674–80) under Lely and returned to paint James II at his Coronation (1685); he was, however, less pompous and more varied than Rigaud and, in contrast to Lely's rather superficial elegance, he showed great skill in rendering the actual texture of material, in this adhering to van Dyck and even more to Rubens. Portrait groups of small size, though somewhat larger than Hogarth's, were also to be found in France. These, like Hogarth's, were also descended from van Dyck and the small Dutch and Flemish portrait groups. Traditional esteem for van Dyck, which persisted beyond the revolution of 1688, and the belief that he was the world's greatest portrait painter came so naturally even to Hogarth that he erected a bust of the artist in gilded cork as a sign (the Golden Head) over his doorway in Leicester Fields.[29] Later, perhaps soon after 1740, in answer to a challenge to paint a picture as good as a van Dyck, he even did an imaginary conversation piece in the manner of van Dyck (only known through an engraving made after his death)[30]; its distinguished-looking figures wear van Dyck costumes and the whole composition reminds one of van Dyck's famous painting of the Pembroke family.[31]

Apart from van Dyck, it is rewarding to compare the style of Hogarth's portraits of members of high society with that of their most striking parallels, the French portrait groups, which lend themselves to such comparison all the more readily since Hogarth's realistic and painterly sense of texture was as strong as theirs.

Touching a high social level, Hogarth's portrait group of the Earl of Cholmondeley (then Lord Malpas) and his family (1732, Marquess of Cholmondeley) (Pl. 40a),[32] is close to those of Tournières, one of the favourite painters of the French Regent (for example his two stately family pictures in Nantes (1721) (Pl. 40b), and of François de Troy. Both these French artists are less majestic, more approachable, more realist than Rigaud or Largillière. The arrangement and pose of the figures in Hogarth's picture resembles that of slightly earlier aristocratic French portrait groups, even of such a relatively solemn picture as that of Louis XIV with his son, grandson and great-grandson by François de Troy (1708, Wallace Collection, wrongly attributed to Largillière).[33] Hogarth's arrangement here is grander and more baroque than usual. The earl himself, the focal point of the composition, sits in costly attire in the attitude customary for high personages in baroque pictures, yet with a certain rigidity which is probably intended to convey distinction, as in various French courtly engravings.[34] This is even truer of his lady, who was no longer alive when the group was painted. Yet clearly the pompousness of van Dyck's *Charles I and his Family*, the ultimate source of Hogarth's composition, has been tempered to conform with the social rank of an earl. What, however, particularly distinguishes this picture from French ones of corresponding social rank is the extreme naturalness of the romping children, a feature deriving from Dutch-bourgeois sources but in Hogarth carried to greater extremes. Immense vistas of magnificent rooms open up in the background, showing off the famous mansion with Dutch minuteness; as in some van Dyck and Lely portraits, genuinely

baroque angels hover over the principal group or play with the tassels of the (van Dyck) curtains.[35]

One is again reminded of *Louis XIV and His Family* when Hogarth, touching the summit of the social ladder, made two attractive sketches of *George II and His Family* (indoor version, National Gallery of Ireland, Dublin; outdoor version, Windsor Castle) (Pls. 29a, b); but here, in accentuating the grand manner of the Cholmondeley group, Hogarth adopted, within certain limits, the prevailing international court style, a decorative van Dyck-Largillière style adhering closer than before to *Charles I and his Family*. Watteau in *Louis XIV decorating the Duc de Bourgogne with the Cordon Bleu* (c. 1710) (extant only in the engraving by Larmessin), a work so impersonal and rigid that one would hardly believe it to be by him, also conformed to the same official court style. Background details in Hogarth's composition may be taken to symbolise his social ambitions. Though less voluminous and undulating than in Rigaud and Largillière, the curtains in the indoor version, no less than the colonnades and steps, are displayed in ample profusion in imitation of van Dyck. A similar combination of draperies and large arches interspersed with pilasters dominates the background on an even more sumptuous scale in Thornhill's portrait groups and frescoes; indeed, enormous arches were amongst the most banal stock-in-trade of fashionable international art of the time, whether French engravings illustrating plays or Italian historical pictures popular with the English aristocracy, such as those of Amigoni or Pannini, who was, with Watteau, one of the most fashionable artists of his time. Pannini's *Meeting between Pope Benedict XIV and King Charles III of Naples* (1744, Naples) (Pl. 108b), for example, although of later date than Hogarth's Royal Family, has a similar stagelike architectural background.[36] In the outdoor version of the same composition, Hogarth aimed at producing a kind of elegant Watteauesque effect. Yet, stiff as are the attitudes, the picture has an intimate touch, most characteristic of Hogarth even in this courtly atmosphere, as in the way the Prince of Wales and the three princesses point with apparent eagerness to their favourite dish, and in the liveliness of the children playing in the foreground. The indoor sketch is partly a grisaille with a few subtly calculated, sparingly laid-on colours, among which quivering white highlights predominate. The general colour effect of the sketch is silvery with touches of pink, pale yellow and pale blue, as if a French court painter had seen a Velasquez. It is intentionally a very different effect from that of Hogarth's other conversation pieces: the unusually light-coloured, elegant court dresses are airier and more delicate than those of more ordinary folk. There is slightly more colour in the Windsor sketch and consequently it is somewhat closer to Hogarth's other conversation pieces, even if the general impression is lighter.

The circumstances surrounding the origin of this portrait group—which never developed beyond the two sketches—are somewhat obscure. Hogarth almost certainly never had occasion to paint the Royal Family in the flesh. In the early 'thirties he was commissioned to do so but, before the actual sitting took place, a quarrel with Kent in 1734 terminated the arrangement, for the circle of Lord Burlington and his protégé Kent was supreme at court and opposed to Thornhill and Hogarth. Both sketches were undoubtedly done before this incident with Kent,[37] as also was the portrait of the little Duke of Cumberland (Lord Glenconner) (1732) (Pl. 14a)— apparently the only member of the Royal Family Hogarth was allowed to paint from life. This picture shows the Duke, magnificently garbed, his tricorne hat in his hand, saluting—a pose typical of international portraits of royal children. Even so the attitude here is more natural, less affected, less emphatically rococo than in other similar examples, contemporary and later, such as Tocqué's *Duc de Chartres* (later *Duc d'Orléans*) (1755) (Pl. 14b). Decorative motifs,

reminiscent of the stage and of Pannini—curving arcades, balustrade and tall schematic trees—serve to round off the prospect in which the figure is set.

This is perhaps a suitable context in which to discuss Hogarth's litigation with Kent and Lord Burlington, since it sheds light on the artistic divisions and cliques at court and in high circles. Hogarth's dispute with Kent in 1734 concerned the right to make sketches—with a view to future engravings—of the wedding of the Princess Royal in the French Chapel, whose decorations had been designed by Kent. Kent won the day. Earlier on Hogarth, with Thornhill's blessing, had frequently and systematically attacked the Burlington circle; in the engraving *Masquerades and Operas*, otherwise designated *Burlington Gate* (1724) (Pl. 5a), Lord Burlington is shown conversing with his architect Colin Campbell, as he points to a statue of Kent set on the summit of Burlington Gate, high above the recumbent figures of Raphael and Michelangelo. In another print of 1725 Hogarth caricatured Kent's altarpiece in St. Clement Danes and demonstrated its faulty design. In an engraving entitled *The Man of Taste* (1731) (Pl. 15a), his answer to Pope's *Epistle of Taste* (dedicated to Lord Burlington), Hogarth again placed Kent's statue above Burlington Gate, which Pope and Burlington are whitewashing, bespattering the Duke of Chandos, Thornhill's patron, as they do so. Much later still, in the *Canvassing* scene of his *Election* cycle (1755) (Pl. 123a), Kent's low arch at the Horse Guards is made fun of on an inn sign.

The possibility that something more than personal antagonism lay behind these satirical attacks must not be overlooked. Genuine stylistic considerations may have come into play. With their consistent predilection for baroque, Hogarth and Thornhill were quite likely averse to the classicising tendencies of the Burlington circle. Pope spoke disdainfully of the 'sprawling' figures of Verrio and Laguerre, a French immigrant and pupil of Lebrun, by which of course he implied baroque. The Duke of Chandos, whom Hogarth shielded against Pope's imputation of bad taste, had engaged Gibbs to build his stately baroque palace at Cannons in Middlesex, which was decorated with frescoes by Thornhill, Laguerre and Bellucci. In all fairness to Hogarth and Thornhill, it must be conceded that Kent was a far inferior painter. It appears that although Lord Burlington at first employed Thornhill to decorate some of the ceilings in Burlington House, he dropped him later when Kent arrived on the scene and proved more accommodating to Burlington's classicising taste.[38]

Hogarth's portrait groups of the aristocracy, though on the whole more conventional than his individual portraits, are nevertheless endowed with unusual informality, ease and movement. Whether in conversation pieces or individual likenesses, Hogarth was rarely so empty, generalising and flattering as the professional portrait painters. Although his initial fame rested upon his facility for catching a good likeness, this in itself may have been one of the chief reasons why, in the long run and despite all his efforts, he could never achieve the coveted position of a favourite portraitist of the upper ranks of society. He himself complained: 'I found by mortifying experience, that whoever would succeed in this branch, must make divinities of all who sit to him.' Moreover, since his repeated attempts to paint the Royal Family had ended in failure[39] and portrait groups proved less lucrative than anticipated, it seems probable that this genre began to bore him; after these years around 1730, there is an abrupt and considerable drop in their number, and the artist never again had such close contact with the aristocracy. True, in 1738 he painted one of the most influential men in the country, Lord Hervey, Vice-Chamberlain to the Queen, together with his friends, including Henry Fox and the Duke of Marlborough (the Marquess of Bristol) (Pl. 73b),[40] and in later life he received numerous individual commissions,

great and small, particularly for individual portraits of the aristocracy, but never again does one find anything like the determined, concentrated attempt of these early years to capture the class as a whole. Apart perhaps from the last decade of his life, Hogarth never entirely abandoned portrait groups, although they became increasingly larger in size; and people with lesser titles were more frequently represented than the aristocracy. As his pictorial knowledge grew, these later conversation pieces became at once more pliable and firm, poised between the elegant and the homespun (e.g. *The Strode Family*, National Gallery, *c.* 1738) (Pl. 62a).

Compared with Hudson, Ramsay and Reynolds, who commanded the whole field of fashionable portraiture, Hogarth did few individual likenesses of the highest stratum of society and when he did, in his later phase, he generally avoided the elaborate and conventional formal arrangement, intended as a perquisite of distinction, which he favoured in his youth. Yet the very large state portrait of *Bishop Hoadly* (1743, Tate Gallery) (Pl. 77a), in his official robes, appears in its elegant and economic composition to hark back, the van Dyck tradition apart, to the celebrated portrait of *Pope Clement IX* (1669) by Maratta (Pl. 77b). This dominant figure in Italian painting in the generation before Hogarth was well known to English connoisseurs; few Italian artists, certainly none of his own generation, were better represented in the great English collections, with Luca Giordano far behind him in second place. Two versions of Maratta's likeness of the Pope were to be found in England in Hogarth's day; one belonged to Lord Burlington and the other to Sir Robert Walpole, forming the centre-piece of the Maratta room in his famous collection at Houghton. Hogarth's complex characterisation far surpasses Maratta's, just as his delicate transitions between the black and white of the garments and his almost Rembrandtesque painting of certain details, such as the chain of office, the insignia embroidered on the shoulder and the tassel hanging below the sitter's arm, exceed not only Maratta's by no means inconsiderable breadth, but also the painterly qualities of official French portraitists.[41] Yet the bishop's placing within the picture, his pose in the arm-chair and the angle of his head and arms, are almost identical with those of Maratta's Pope and in both cases the eyes are fixed upon the spectator. Maratta's formal style apparently struck Hogarth as a suitable model for his likeness of a famous and high-ranking ecclesiastic. It is distinguished yet does not over-solemnise; as a mixture of baroque and classicism it is far more simple and direct than the French baroque portraits and in this particular case almost simpler than Hogarth's. The 'international' character of Hogarth's grand schema stands out even more clearly when compared with another derivation from the Maratta portrait, *Pope Benedict XIV* (Chantilly) (Pl. 76b), painted by the French classicist Subleyras in about 1745.

Another baroque-decorative portrait by Hogarth of a member of the High Clergy, *Archbishop Herring of York* (1745, versions in Lambeth Palace and the Palace of the Archbishop of York) (Pl. 76a), also reverts with even greater fidelity to the van Dyck tradition, in particular to his *Archbishop Laud* and to Kneller's *Archbishop Tillotson*. It also furnishes positive proof that Hogarth was well aware of his obligation to adhere to the van Dyck tradition: at one of the sittings, he is reported to have said to the Archbishop: 'Your Grace, perhaps, does not know that some of our chief Dignitaries in the Church have had the best luck in their portraits. The most excellent heads painted by van Dyck and Kneller were those of Laud and Tillotson. The crown of my works will be the representation of your Grace.'[42] Even so the Archbishop apparently did not care for Hogarth's portrait, which he found exaggerated, caricature-like and insufficiently benevolent. Both this portrait and that of Bishop Hoadly were engraved by Watteau's skilful French engraver Baron, whom Hogarth kept in reserve for such great occasions. Baron had

worked in Paris for the Cabinet Crozat, in Paris and London for the *Receuil Jullienne*, and for Dr. Mead.

At various periods of his life, Hogarth also attempted to obtain commissions from members of the nobility for figural compositions. Aristocrats, however, never thought of buying the original paintings of Hogarth's moralistic cycles, preferring to order subjects which they considered more amusing or interesting. It is no cause for astonishment, therefore, that these commissions, particularly in the early 'thirties when much of the Restoration spirit was still alive, included subjects of an indecent or dissolute character. A 'vicious nobleman',[43] probably the Duke of Montague, required Hogarth in about 1730–1 to paint the companion pictures of *Before* (Pl. 38a), and *After*, in which the lovers are represented in two distinct and compromising situations[44]; both are rather salacious rococo works, certainly destined for a very exclusive public. Nor did Hogarth at this period have any compunction in painting two pictures for Lord Boyne, one of a night brawl in which Lord Boyne himself or his friends were involved (original picture, in a poor condition, formerly in the Lord Boyne collection, Burwarton), the other of a drinking bout (perhaps 1738) representing aristocratic members of one of the early Hell Fire Clubs, not the famous later one at Medmenham Abbey. In keeping with their pledge, they are draining the cellar of its wine while the composition of the group travesties a statue of Charity suckling her babies in the background, hence its title *Charity in the Cellar*.[45]

Far more important, however, than these by-products of the young artist's relationship with the aristocracy were the historical compositions which, in his middle and late phase, he was so anxious to paint and the success of which depended on the only class whose members were at all interested in such an elevated genre. Works of this kind, at least works which Hogarth considered as such, included his *Don Quixote* illustrations (Pl. 63b), made for, though not accepted by, Lord Cartaret; *The Lady's Last Stake* (Pl. 134), painted for Lord Charlemont; and *Sigismunda* (Pl. 131c), painted for Lord Grosvenor, who likewise rejected it. All these commissions naturally approximated to a moderate baroque, sometimes more French, sometimes more Italian.[46] Even competition with Furini was implicit in the case of *Sigismunda*.

A very different artistic situation obtained among the bourgeoisie. Not only were the various Nonconformist denominations (which were exclusively drawn from the middle class) hostile to the visual arts but so was generally speaking, the Established Church. Attachment to these various forms of Protestantism, particularly Nonconformism, was ingrained, since it represented one aspect of the struggle against the aristocracy (associated with the High Church) in the 17th century. By the 18th century this struggle had been resolved and a religiously more tolerant middle class was acquiring a much broader outlook, becoming slowly reconciled to the lighter sides of life, to its amenities, even to its luxuries; for despite the radical novelty of its view of life, it was now inclined to compromise with the aristocracy. Thus by Hogarth's time religious sentiment no longer interfered so insistently with the cultivation and appreciation of the visual arts.[47]

It was quite a big step for members of the bourgeoisie at least to desire to have their portraits painted. In general, Hogarth did not produce a great number of portraits of an outspokenly bourgeois character. Most were of members of the upper middle class and it is frequently noticeable that his attitude towards these was inclined to waver, varying on different occasions and probably following a similar lack of decision in the social behaviour of his sitters. Yet when he had to deal with genuine, solid representatives of the middle class, a very fresh approach distinguishes these from his comparatively conventional aristocratic portraits, not to speak of the general run of contemporary portraits on the continent.

Although the majority of Hogarth's conversation pieces around 1730 portray members of the aristocracy or the landed gentry, a few are obviously bourgeois. The general tone of these paintings is candidly middle-class; the sitters are less elegantly clad and their surroundings more natural and intimate. One such is *A Club of Gentlemen*, otherwise called *The Cock Family* (Private Collection) (Pl. 28b) which Hogarth painted for his friend, the auctioneer Cock, and which probably includes the theatrical producer, Rich, in the group. There is no trace here of the easy rococo arrangement of his aristocratic subjects. The eight men are seated in orderly fashion round a table, drinking, but clearly with moderation. A similar prosaic atmosphere pervades the picture *Mr. Dudley Woodbridge celebrates his Call to the Bar in his Chambers at Brick Court, Middle Temple* (Field Collection, New York) (Pl. 32b); with his friend Captain Holland, Woodbridge sits stiffly and unpretentiously at a table, drinking wine. It is instructive to compare this work with its pretentious, aristocratic predecessor: Kneller's picture of two members of the Kit-Kat Club, the Duke of Newcastle and the Earl of Leicester, drinking wine, with a profusion of curtains in the background (National Portrait Gallery) (Pl. 33b).

During these years, when occasion warranted, Hogarth also tackled the theme of the patron and the artist in this more severe middle-class vein. The seascape painter, Monamy, whose pictures were more realist and documentary than those of his Dutch predecessors, is represented with his patron Mr. Walker, apparently a rich bourgeois (Lord Derby) (Pl. 68a); they are standing before an easel upon which is one of the artist's pictures; this seascape in Hogarth's picture was painted by Monamy himself, Walker leaning upon a stick, Monamy holding his palette. Two more seascapes by Monamy hang on the wall, to give a clear indication of the nature of his art. Nothing could be less glamorous than this placing of the artist's patron solidly and stiffly in a commonplace studio. How different from the elegant, enchanting composition of fifteen years before, when Watteau portrayed himself painting in a pastoral milieu with his friend and patron, the art dealer Jullienne, seated beside him playing the 'cello (engraved by Tardieu) (Pl. 68b). But one only has to compare this picture with another by Hogarth from exactly the same years, representing an aristocratic patron: when Sir Andrew Fontaine contemplates a picture he is posed gracefully and at ease in the open air among decorative trees.

Another of Hogarth's probable innovations was the depiction of a middle-class wedding scene with figures of actual people, namely that of Mr. Stephen Beckingham of Lincoln's Inn and Miss Mary Cox at St. Martin's-in-the-Fields (1729; Metropolitan Museum, New York), (Pl. 27a).[48] This bourgeois Protestant wedding, in point of fact a portrait group, was painted at the end of Hogarth's youth, just when he was beginning his series of aristocratic conversation pieces. Setting aside the ceremonial and solemnity which would have marked his rendering of an aristocratic wedding, Hogarth grouped the figures around the clergyman in a most matter-of-fact, almost cumulative realism. The one or two baroque touches—the draped carpet, the angels with the cornucopia—do not substantially detract from the documentary, prosaic, almost secular character of the ceremony. The closest continental premises for this representation are the sober, serious engravings in J. F. Bernard's *Cérémonies et Coutumes religieuses de tous les Peuples du Monde*: this widely-read, scientific compilation directed against superstition and published in seven volumes in Amsterdam between 1723 and 1737, dealt in an enlightened spirit with the various religions of the world. Most of the engravings were done by a French artist, Bernard Picart, who chiefly worked in Holland as a refugee. Between 1733 and 1737 an English edition was published in six volumes, and it also appeared in German and Dutch translations. One illustration of a Catholic wedding set in a church with rather large figures by Picart (Pl. 27b) is

similar to Hogarth's composition, particularly in its central group. But Picart's figures although portraying middle-class people, are not real-life portraits and are in a more traditional, ceremonious vein. Even Hogarth's hovering angels and two spectators in the gallery introduce a slight element of decorative baroque. The freshness of Hogarth's presentation comes out well if compared with the comparatively realistic painting by Jouvenet, Hogarth's senior by half a century, depicting the celebration of a Mass by the old Canon de la Porte in Notre Dame (Louvre, probably 1720–30). Although similarities with Hogarth's composition occur in the architectural segment and its relation to the figures, yet the tradition of a solemn monumental baroque classicism is unmistakably present in the French picture, deriving from religious paintings like Lesueur's *Mass of St. Bruno* (Louvre).

Even more original than the Beckingham Wedding are Hogarth's plain bourgeois likenesses, keenly individualistic in expression, to an extent uncommon even for him. Foremost among these is the portrait of his mother, *Mrs. Anne Hogarth* (1735, formerly David Rothschild Collection) (Pl. 49a). In this portrait in the year of her death of the being closest to him (it is inscribed 'his best friend'), he produced an essentially middle-class portrait, almost brutal in its robustness and bare simplicity. This quality of plainness applies to the entire composition of the erect seated figure, to the unglamorous effect of the materials, to the forceful colour scheme and above all to the nakedness of her expression. Slight vestiges of the 'grand' portrait were inevitable in an almost full-length likeness[49]; the position of the hands and shoulders might have been inspired by those of the Mona Lisa and a small *supra-porte* breaks the monotony of the otherwise impressively bare walls. Its novelty and significance lie in the emphasis laid on everything individual, on the head and the expression of the features, which dominate the whole portrait. Although throughout contemporary Europe portraits of an artist's family were the first to acquire a bourgeois character, none can really hold its own beside this one of Hogarth's.[50] In comparison, Rigaud's portrait of his mother (Louvre) (Pl. 49b), also an elderly middle-class woman, although the most realistic he ever painted, strikes one as 'artistic' and contrived.

Just as original is Hogarth's portrait of *Mr. George Arnold* (c. end of the 'thirties, Fitzwilliam Museum, Cambridge) (Pl. 65a). The title of 'Dr.' applied to him is dubious, although the sitter conveys the impression of a bourgeois professional man.[51] Apparently Arnold was a businessman who lived in the parish of St. Martin-in-the-Fields and later retired to the country; he was certainly neither a member of the aristocracy nor even titled. The portrait differs entirely from those of this latter class. The pose lacks elegance, the look shows no consciousness of superiority; instead, an easy self-assurance, a high degree of individualism and an undisguised vitality animate the whole, whilst a directness of appeal in the rugged face and a solid naturalness in the arms, planted heavily on his lap, have no parallel in the fashionable French portraiture of the time.[52] The nearest, though even then superficial, approach to it in France was made by painters, all younger than Hogarth, who were interested in the psychological expression of their intellectual sitters, in particular La Tour, a Radical, a friend and follower of the Encyclopedists and the most analytical French portrait painter before the Revolution (e.g. portrait of the painter L. de Silvestre, 1753). To a lesser extent one could cite Perronneau and Aved (e.g. portraits of the Abbé Caperonnier and of M. de Theil, both 1740), both of whom, like La Tour, went to middle-class Holland to study portrait painting. But all are devoid of Hogarth's lively, thorough characterisation. Not even the late self-portrait by such a typically bourgeois artist as Chardin (1776, Louvre), done twelve years after Hogarth's death, can be held as a real parallel.

Hogarth, who was in Paris in 1743, some years after he had painted the Arnold portrait,

certainly knew and appreciated La Tour; an acquaintance, on Hogarth's advice, recommended an art lover staying in Paris in 1749 to look at La Tour's pastel portraits and to keep an eye open for Chardin's 'little pieces of common life'.[53] It is, therefore, quite possible that Hogarth, during his visit to Paris, was stimulated by La Tour's portraits with their emphasised expressions and rather monotonously similar play of features round the mouth. There is, for instance, a genuine likeness between Hogarth's portrait of Mr. James (1744, Worcester, U.S.A.) (Pl. 82a), and La Tour's portrait of the Duc de Villiers (Aix en Provence) (Pl. 82b), which Hogarth might have seen in the salon of 1743. The mobile expression of the face (rather more disdainful in La Tour, more good-natured in Hogarth), the intense gaze, the attitude, the position of the hand, are all similar. Yet it cannot be denied that beside the Arnold portrait those of La Tour and Chardin, look 'polished', the former even schematic, a woman's portrait by the latter might have been seen by Hogarth in the same salon. The massive self-assurance of the Arnold portrait, both in its expression and its informal attitude, goes far beyond Aved and already points to the middle-class portraits of much later generations.[54]

Another portrait of this type from Hogarth's later years is that of his friend, Pine (Pl. 133a). This half-length portrait of the engraver (*c.* 1756, Beckett Collection, Worthing)[55] shows a curious variant of a middle-class representation; as the inscription under McArdell's mezzotint records, it is 'in imitation of Rembrandt'. Since the Dutch artist was much in favour among connoisseurs of prints at that time, it is probable that Pine admired him just as much as Hogarth, who lamented: 'My portraitures met with a fate somewhat similar to those of Rembrandt. By some they were said to be nature itself, by others declared most execrable.' Thus Pine is portrayed somewhat in the manner, attitude and attire of the late Rembrandt's self-portraits; broadly, almost brutally painted in a kind of monumental *chiaroscuro*, with a voluminous artist's beret on his head, he has a smiling, self-confident expression.[56] A few small Rembrandtesque dashes of blue and red on the top of the beret and in the ear-ring enliven the generally sombre tone. If one chose to romanticise and to search for a specific model, then Rembrandt's style, with its emphasis on individual expression, was obviously far more suited to a member of the bourgeoisie,[57] particularly an artist,[58] than that of van Dyck, with its aristocratic bias.

Van Dyck came naturally to mind in Hogarth's last years too, when he was engaged on portraits of the aristocracy. While painting Henry Fox in 1761, he remarked to the sitter, and also to Horace Walpole, that the likeness would be as good as one by Rubens or van Dyck. Just as revealing of his taste at this time is his own portrait, as an old man, by Andrea Soldi (Newburgh Priory) (Pl. 97b), a Florentine artist settled in England and living amongst fashionable society on a very lavish scale. Hogarth's antipathy to foreign competitors who came here, as he declared, to exploit 'the snobbishness of the amateur' could yield on occasion, if keen artistic or business interests came into play. The only other representation of him by another artist was also by a foreigner, namely the striking bust by Roubilliac, (Pl. 46), who in turn was also painted by Soldi. At this late stage, when his renewed efforts to capture high society were meeting with scant success whilst the young, eclectic Reynolds, an adept at flattery, was inundated with commissions, Hogarth may well have coveted a distinguished portrait of himself in the best continental manner, and who was there better than Soldi to deliver it? The artist is shown almost full-length in an ostentatious, stately baroque pose, his hand clasping his gown in a rather precious manner. There is a dog, but no longer the self-contained, almost human-looking animal that graced Hogarth's famous self-portrait of 1745 (National Gallery) (Pl. 96b); it has now become the customary subordinate attribute and faithfully follows the general decorative curvature of the composition.

I have shown how Hogarth must have had certain clear notions as to the conformity of style with social standards and consequently portrayed members of the various social strata in different ways. Yet it would be carrying this thesis too far to deny a certain adjustment within his portraits. In his middle and late phases in particular, he relied a good deal on individual taste, including his own, and never became the fashionable portraitist of the aristocracy in general as did Hudson, nor of the rich middle class as did Highmore. His inherent complexity is sufficient to explain his most famous portrait, which he himself considered his best and which dates from the middle of his career, 1740. It is the largest he ever painted (94 in.× 58 in.), the imposing full-length of *Captain Coram* (Foundling Hospital, London) (Pl. 66a). It is of course significant that this likeness, which forms the climax of Hogarth's career as a portraitist, should represent the founder of that typically middle-class charitable institution, and that it was destined for the hospital itself. Yet it is equally significant that Hogarth should have here adopted many attributes of grand, generalising, baroque-aristocratic portraits in order to give Coram, and through him the hospital itself, an aura of impressiveness. For England lacked the unbaroque tradition of the collective portrait group with which middle-class Holland venerated the governors of her humanitarian institutions. Hence Captain Coram is seated in an imposing loggia to which steps lead up, with a draped curtain and a column at his back, while in the distance is a glimpse of the sea with ships—a motif common to portraits of Admirals of the Fleet. In spite of the excellent characterisation, Captain Coram has not the rugged directness of Mr. Arnold's gaze; a vague, benevolent smile plays about his lips and slightly generalises the features. Beside him on a table lies the elaborate hospital charter, whose enormous seal he is holding in his hand; a large globe stands below on the steps, whilst books and papers are scattered around to increase the effectiveness of the setting.

When engaged on this huge, semi-official picture, Hogarth naturally had in mind the eternal prototype of grand English portrait painting, van Dyck's likeness of Charles I with his family. Yet in general structure he rather closely followed a foreign model, itself a derivation from Rubens and van Dyck, namely Drevet's engraving of 1729 after Rigaud's portrait of the famous French financier Samuel Bernard, painted in about 1725 (Pl. 66b).[59] Hogarth's nationalism and dislike of foreigners frequently stopped short of foreign art, just as the equally nationalist Fielding was the best connoisseur of French literature in England.

As the richest French bourgeois of his time, Bernard had received a title and naturally wished to have himself portrayed in the grand manner, for which purpose Rigaud was the obvious choice. Two columns and a wealth of drapery form the background, the sailing ships being an allusion to the source of the sitter's wealth. Compared with its model, Hogarth's portrayal is in a minor key. The sumptuous baroque composition and individual details have been greatly simplified: the voluminous flowing robe has become a simple coat, albeit with stately folds; the number of columns, steps and objects on the table has been reduced; the fluttering draperies, particularly the curtain, reduced and subdued; even the distant ships appear less showy, as the quiet waterline dominates the horizon. It is typical of the picture's complexity that on the globe, that requisite of grand, schematic, baroque ensembles, Hogarth should have painted the reflection of the sun through the window evidently as he observed it in his studio, where Coram certainly sat to him.

Seen beside the Rigaud-Drevet composition, Hogarth's process of transformation leads the way from an aristocratic to a middle-class rendering.[60] It would be incorrect to regard this as a complete simplification from baroque to classicism, but it is at least a development from a very decorative, ostentatious baroque to a moderate one, with the road to classicism almost in sight.[61] In Hogarth's time a parallel evolution was taking place in France in the post-Rigaud generation,

though in consistency it necessarily lagged behind the English development. The portrait which lends itself best for comparison with *Captain Coram* is, curiously enough, that of Samuel Bernard's son, Bernard des Rieux, Président de la Chambre des Enquêtes du Parlement de Paris, painted by La Tour almost in the same year (1741, Wildenstein Gallery, Paris. Pl. 67b). The figure has the same 'speaking' expression, a somewhat similar pose, and is also full-length. La Tour similarly used motifs from Rigaud, but again with simplifications. Yet the *noblesse de la robe* remains noble and the whole character of the portrait, though the setting is in this case the more homely interior of a room, is more grandiose and official than is usual in La Tour and is far more impressively baroque and less intimate than Hogarth; for in *Captain Coram* Hogarth not only attempted a portrait of great respectability but also one of bourgeois plainness. In spite of the Rigaud model, used for compositional purposes, he characteristically kept it simpler and more human than the rather theatrical portrait of Bishop Hoadly (painted three years later), with its Maratta prototype (Pl. 77a). It was probably one of the very first English full-length and life-size portraits of a middle-class sitter—a type for which no previous schema existed. It is not surprising that this realistic work, having such a direct appeal and being kept always on view to the public in the Foundling Hospital, should have exerted so great an influence in England.[62]

It is equally true and important, however, that an aristocratic model, modified in a middle-class sense, was used for the Coram portrait. Notwithstanding his bourgeois outlook, Hogarth was obliged to draw some support for his representation from the well-worn, solemn schema of the aristocratic baroque portrait. The complex situation of the very powerful, highly-developed English middle-class nevertheless basically contained the potentiality to create a new and wide-ranging art of its own. Where ideological obstacles were far fewer, in the sphere of literature, it had already produced a radically new genre.

Another example of Hogarth's transposition is his picture from approximately the same time as *Captain Coram*, 1742, of the Graham children (Tate Gallery) (Pl. 72a), whose father was apothecary to the Chelsea Hospital. Apparently the model Hogarth had vaguely in mind was van Dyck's portrait of the Stuart children (Windsor); this, however, he radically transposed, giving it more bourgeois, homely features. True, the pose, expression and clothing of the baby faintly resemble van Dyck's and the curtain falls in sumptuous folds to the floor, even invading the foreground in the van Dyck tradition. But the poses of the two Graham girls are freer, the boy happily plays a musical box and the royal family's enormous, solemn-faced dog has given place to a mischievous cat eyeing a bird in a cage. This easy-going atmosphere is totally different from contemporary portraits of royal children, even from non-commissioned ones—such as Richard Wilson's well-behaved Prince of Wales and Duke of York (1749, National Portrait Gallery) (Pl. 72b). The small portrait of his friend, the writer and physician, Benjamin Hoadly, sitting writing at his desk (Fitzwilliam Museum, Cambridge) (Pl. 39b), was painted in the 1730s; though it is not far from *Captain Coram*, Hogarth has reduced the old schema more markedly to one of bourgeois simplicity and intimacy, while retaining traces of baroque. On the other hand, in his portrait from those same years of Frederick Frankland (Huntington Art Gallery, S. Marino, U.S.A.), who was not a writer but the son of Sir Thomas Frankland, director of the Bank of England, a member of the highest, near-aristocratic layer of the upper middle class, solemn baroque properties (curtains with tassels) immediately make their appearance, despite a close kinship with the schema of the Benjamin Hoadly portrait. The bourgeois naturalness of the latter is also well brought out by comparison with a somewhat earlier portrait of a writer, namely Jervas's more grandiose, baroque likeness of Pope (National Portrait Gallery).

I have frequently stressed that, owing to its rational outlook, the art of a developed, progressive, middle, particularly upper middle, class everywhere on the continent and at least till the end of the 18th century was a realistic classicism.[63] However, since this style can so easily lose its precarious balance, it can only thrive under the most favourable conditions and always results from a long development, based on a solid tradition; moreover it is at first accessible only to a select, cultured section of society. A genuine realistic classicism applied to scenes taken from real life, such as that practised by the school of Delft in Holland or by Chardin in France, could not be created in England for lack of a long artistic ancestry.

It often happened that the new artistic aims of the middle class only found their expression by subtly changing the emphasis of the existing aristocratic tradition of taste. This change leant sometimes towards realism, sometimes towards classicism. A classicist emphasis was apparent in architecture; a realist emphasis was even more apparent in the concept of the picturesque English garden, which derived up to a point from the ideas of Shaftesbury and Addison. Shaftesbury, when inveighing against French formalism, characteristically complained of 'the mockery of princely gardens'. It is precisely this kind of compromise, this failure to break completely with the old aristocratic tradition, which is typical of the artistic taste of the Whig aristocracy of the early 18th century. The same tendency is apparent in the ruling literary fashion where a certain rational classicism found expression, but only in a formal, elegant, and often frigid manner or context, as for instance, in some of Pope's poetry and Addison's rhetorical tragedy *Cato*.

So far as the English bourgeoisie had any independent artistic taste at all at the time,[64] this was for a moderately good type of Dutch genre painting which was being produced in large quantities in Holland and could be bought very cheaply.[65] English figure compositions scarcely existed, nor was their production encouraged when Hogarth was embarking on his career. Even a taste for English landscape painting—the typical theme of middle-class art—was only slowly emerging among the bourgeoisie and was at first confined to architectural subjects touching their own professional interests.[66] No one was more fully aware than Hogarth of the difference in artistic taste between the aristocracy and the middle class, as expressed in terms of continental art, and he was probably the first painter to express this contrast in visual terms: in *Marriage à la Mode* he showed the aristocrat's interior with Italian baroque pictures on the wall (*Signing the Marriage Contract*) (Pl. 87a), and the merchant's with most inelegant Dutch and Flemish ones (*Death of the Countess*) (Pl. 92b).

At this stage of English painting perhaps only one contemporary of Hogarth, namely Joseph Highmore (1692–1781), had some slight tendencies towards a realistic classicism. More exclusively than Hogarth, he was an artist of the wealthy upper middle class, and portrayed many rich city merchants. His own background was typically middle class; the son of a coal merchant, educated at the Merchant Taylors' School he at first studied law. His scientific interests, particularly in perspective and anatomy, governed his mentality and his art. Unlike the fashionable portraitists, these par excellence middle-class artists such as Hogarth and Highmore never engaged drapery painters to finish their portraits but completed their pictures themselves in a more individualising manner. In some of his portraits, as for example that of his friend Samuel Richardson[67] (1750, National Portrait Gallery) (Pl. 133b), Highmore came close to a realistic, painterly, harmoniously-toned, almost monumental French classicism.[68] His often interesting portraits are an organic mixture of grace, painterly knowledge, simplicity and even stiffness. His middle-class portraits in particular show a greater elegance and charm than Jonathan Richardson's shortly before him; whilst there is none of Hudson's pompousness. A pupil of Kneller, he

also worked a good deal for the aristocracy and even, for publicity's sake, represented the king and queen, though they never sat to him. But he did not, like Hogarth, paint actual events, self-experienced genre scenes or self-constructed stories from life. About 1744, he did, however, paint a cycle of twelve pictures (dispersed in the Tate Gallery, Cambridge and Melbourne) illustrating Richardson's novel, *Pamela*.

Following the tradition of *The Spectator*, Puritan family literature and books on social conduct, *Pamela* is the complete literary expression of the moral outlook of the middle class, with its new esteem for the wife and mother. In contrast with earlier works of fiction, which generally embraced only the marriage of convenience as experienced by the aristocracy, it exalts family life as a spiritual, virtuous unit. With its humanising of the family, its sentimental ripple of events, its trivial incidents of domestic life, described in great detail, and its happy ending, this novel was in many ways, and particularly in its less emotional scenes, well adapted for pictorial representation in Highmore's placid, restrained, balanced style and some pictures in the series stand out as exceptional in English painting, while others are less concentrated. The use of such a style was all the more possible since the sordid side of life is ignored in *Pamela*; indeed, Richardson reproached Fielding precisely because he did not gloss over the seamier side of life. This has involved a degree of idealisation which lends itself to expression in a classicist style, somewhat insipid perhaps yet realistic and painterly, and one can understand why the classicist Haydon was later to call Richardson 'the Raphael of Domestic life'. Such trifling incidents as a quiet breakfast scene or the writing of a letter usually call forth a firm, spatial composition, carefully calculated in plain horizontals, verticals and rather straight diagonals, in short a realistic classicism.

Highmore had studied in Holland and probably also in Paris; whether he knew Chardin or not —and it seems likely that he did—he clearly has affinities with Chardin. It is enough to compare the picture of *Mr. B. coming upon Pamela writing a letter in her room* (Tate Gallery) (Pl. 84b), with any Chardin painting of a tranquil scene in some contented middle-class family, for instance, that of a woman ministering to a small boy (National Gallery of Canada, Ottawa) (Pl. 85b), to recognise the source of this rare example of realistic classicism in England, however inferior, in every sense, it is in quality. Both Highmore's and Chardin's painting ultimately derived from Holland, the most progressive, bourgeois country of the 17th century—where the ruling middle class, although Protestant, was very susceptible to art—and here again from its most progressive school, that of Delft. The history of 17th-century Dutch painting can be regarded as at first a retreat from and later a return to the baroque. Dutch 'realist' painting stands midway between these two phases and covers a relatively short period. The casting-off of baroque concurred with middle-class ascendancy. About mid-century, when Dutch trade and upper middle-class republicanism was at its height, the realist-classicist trend—above all in the school of Delft—reached its peak. Afterwards, when the political and cultural links of the upper classes with France and the French court grew closer, a reaction set in towards the baroque, whilst much of the realism was lost.

A most important feature in Chardin's pictures, and one closely corresponding to contemporary English literature, is its emphasis, stronger than in any Dutch genre painting, on the positive happiness of family life in a middle-class sense, on the manifold cares of the mother for her children and on her various household duties. Even in Dutch genre painting there was an increasing tendency to stress the quiet, unobtrusive role of the wife and mother in the home, so that in Delft, during the 1650s and 1660s the scheme of a realistic classicism, since become traditional, was already created out of family and domestic life in its wider sense, as exemplified by Vermeer and de Hooch.[69]

Neither *Pamela* nor a realistic classicism, however, was much to Hogarth's taste. It appears that Richardson asked him to illustrate *Pamela* but, although he was on good terms with its author,[70] he refused. To him, as to Fielding, who wrote two travesties of *Pamela* (*Shamela* and *Joseph Andrews*), Richardson's novel no doubt appeared exaggeratedly sentimental, even of an affected hypocrisy, and insufficiently true to nature. Although Hogarth and Fielding certainly agreed with the principle of 'Virtue rewarded' (as the ostentatious sub-title of *Pamela* proclaimed), the heroine's prolonged, extremely calculated, cautious virtuousness, for which she was recompensed by an enviable marriage, was decidedly too much for them. Richardson represented one, Fielding and Hogarth another facet of middle-class mentality. Fielding and Hogarth's outlook, in a wider, dynamic sense, was that of social reformers, of democracy on the move; Richardson's, in a narrower, conservative sense, was that of a moralist preaching on the virtues of family life.[71] Fielding and Hogarth reveal a sober humanity, a fundamentally good-natured tolerance. The aristocrat Fielding was inclined to be more 'up-to-date': in spite of his bourgeois morality, he was more secular, intellectual, psychological, realistic, more imbued with the ironical Restoration spirit, than the exceedingly sentimental, religious, humourless and more old-fashioned Richardson. Richardson does not stand so much for the middle class itself as for its moral principles. Apart from Pamela and a few minor characters in his various books, his heroes and heroines were drawn from the aristocracy or, to be more exact, the gentry. A petty bourgeois by origin, he always remained one at heart, with his snobbishness and social ambitions, and was really unfamiliar with fashionable society from the inside. He recognised the social superiority of the aristocracy over the bourgeoisie,[72] but aspired to see it permeated with bourgeois moral principles, this being the usual middle-class compromise between the two ways of life, for his abhorrence of the immorality of the aristocracy was uncompromising. Fielding and Hogarth, on the other hand, thoroughly conversant from long experience with both the upper and lower social strata, picture society in its whole unbounded wealth and even make heroes out of figures from the lower classes. It would be almost true to say that Fielding and Hogarth came near to creating recognisable individuals from all classes, whereas Richardson created types of a middle-class morality.[73]

Rarely does Hogarth point the moral direct by showing the straight path followed by the virtuous, but deviously conjures up the dire misfortunes, sometimes even death, which befall those who do not follow that path. For, despite his fundamental optimism, Hogarth was critical and ironical, much addicted to picking out the negative or ridiculous side of things—a common practice in the literature of the day—and he revelled in unhappy endings. In *The Analysis of Beauty*, he attempted to explain what impeded the rendering of pleasing contents and good characters in art:

> It is strange that nature hath afforded us so many lines and shades to indicate the deficiencies and blemishes of the mind, whilst there are none at all that point out the perfections of it beyond the appearance of common sense and placidity. Deportment, words, and actions must speak the good, the wise, the witty, the humane, the generous, the merciful, and the brave. Nor are gravity and solemn looks always signs of wisdom.

If it is hard to imagine one of Hogarth's mentality and temperament illustrating the prudish *Pamela*,[74] it is equally hard to visualise him as the author of *The Happy Marriage*—a pendant to *Marriage à la Mode*. In pursuance of bourgeois-moral principles, he did in fact attempt to portray a marriage based on mutual affection but, after painting a few scenes, realized his incapacity to

render contented family life and relinquished the idea as a failure. In the two extant pictures of this cycle, *The Wedding Banquet* (Truro) (Pl. 93a), and *The Dance* (South London Gallery) (Pl. 94a), he characteristically devoted a great part to grotesquerie. But it is easy to appreciate, even from the weak engravings of the three other sketches,[75] done after his death, that he must have found it too boring and uninspiring, almost *too* bourgeois as it were, to represent the uneventful life of the good couple. Two of these sketches portray monotonous though well-behaved garden parties, and the third acts of charity. This latter scene may be interpreted as a reduced version of the medieval representation of 'The Seven Acts of Charity' fitted into a story of everyday middle-class life. It is perhaps significant that even in *Industry and Idleness*, whose sequence of dramatic events suited him far better than *The Happy Marriage*, he did not indulge in a consistent representation of happy family life, though the career of the industrious apprentice would have offered him occasion for it. Indeed he most characteristically discarded from the cycle the two drawings he had done, one of the industrious apprentice as a merchant presenting money to his parents (British Museum), and the other of him married and furnishing his house (Marquess of Exeter) (Pl. 109a).

Hogarth's mental attitude, combined with the general historical circumstances which did not favour a realistic classicism, held important consequences for the formal build-up of his compositions. From it no restful, restrained, dignified classicist style could consistently emerge— least of all in his pictures of contemporary life, where observation is piled upon observation. It was not by chance that the three rather weak compositions of *The Happy Marriage* already mentioned were kept in an almost classicising style. It is hardly extravagant to say that, whereas a happy marriage, the adequate rendering of which was out of Hogarth's reach, could be most genuinely expressed in a realistic classicism, an unhappy one, for the depiction of which no one was better suited, would find its most suitable medium in baroque or at least rococo. *The Analysis of Beauty* was directed against an over-stressing of regularity, simplicity and symmetry, which Hogarth held to be justified only in so far as they evoked unity, but not to the detriment of variety. 'It is a constant rule', he wrote, 'in composition, in painting, to avoid regularity.'[76]

The more one analyses Hogarth's style, the more one realises that in practice, too, his manner of composition is generally closely related to baroque and rococo, that the main elements are serpentine lines and characteristic, often grotesque, curves. All Hogarth's 'unpleasant' pictures with blemished characters which, as his best-known works, first spring to mind when one thinks of him, are in a very realistic baroque style which he slowly evolved from the more than slender baroque-narrative tradition—slender particularly as regards realism—that existed in England before him.

Some qualification, however, is necessary when speaking of Hogarth's relation with the classicist style. Great differences within this style obtained in each country and in each generation, both in conception and form. For instance, the almost doll-like figures in Highmore's *Pamela* compositions, which correspond to the often abstract, generalised types in Richardson's novels, are more schematic and empty than Chardin's or Vermeer's, despite a general similarity of pattern.[77] Indeed Hogarth's individualised figures, with their thorough realistic penetration, are essentially closer than Highmore's to those of Chardin, whose typification is only slight. For Hogarth learned a great deal in matters of detail from the realism of Dutch middle-class genre painting of the Pieter de Hooch type, even if he did not participate in the highly selective, quiet, classicist tradition of the school of Delft or the monumental classicism of Chardin. Scarcely any figural composition of Hogarth's recalls one by Chardin as a whole. A parallel between the man-

servant preparing tea in Hogarth's relatively simple and domesticated *Strode Family* (*c.* 1738, National Gallery) (Pl. 62a), and the mother placing food before her children in Chardin's *Bénédicité* (1740, Louvre) (Pl. 62b)—is just possible. In each case a figure leaning gently and quietly over the table at the centre of the picture connects the verticals of the composition.

Although most of Hogarth's paintings which depict subjects from contemporary life and are thus bound up with his observations have little relation with classicism, other types of his work undoubtedly do. I refer to pictures with heroic, 'historical', especially Biblical subjects, done for middle-class institutions, where an inclination to idealise and summarise has led even more towards classicism than did the three 'moral' scenes of *The Happy Marriage*. These exceptions among his historical paintings, however few, had interesting and far-reaching results: for in Hogarth it was here that the relationship between middle-class mentality and classicism tended to come into its own.

A quite consistent middle-class viewpoint, which could only be voiced later by someone many years younger than the artist, led Wilkes to reproach Hogarth for having failed to paint themes of a more ideal or positive character. And any fulfilment of this would in turn have involved a move towards classicism. Wilkes, as a radical, was more 'left wing' than Hogarth, his senior by thirty years, and quarrelled with his former friend on political grounds in 1762. Belatedly by almost twenty years, he censured Hogarth for disregarding the public's demand for a series on a happy marriage to follow *Marriage à la Mode*, and also reproved him for the ambiguity of his *March to Finchley*. Evoking the examples of Greece and Rome, he demanded from him patriotic history painting[78] and in so doing joined contemporary French art critics in heralding the next stage of middle-class art, the patriotic and classicist history pictures of the French Revolution.[79] Thus the relation of Hogarth's art to the middle class is not quite clear-cut.

Sharp and biting as were Hogarth's moralising cycles in their bourgeois tendency, it was a member of the middle class rather than of the aristocracy who bought the original pictures of the two *Progresses* in 1745: Alderman Beckford, a descendant of rich Jamaican merchants, most famous of the 'nabobs', later M.P. for the city and Lord Mayor of London, a political friend of Pitt and Wilkes.[80] And it was the same Beckford whom Hogarth caricatured in 1762 in *The Times*, because he clamoured for overseas colonies in the interests of the City. Ironical as this seems, it was a result of the artist's political gravitation towards the right at the end of his life and of his attachment to Bute's policy.

If Hogarth's art, taken as a whole, was not strictly that of the well-to-do middle class, some reason must be advanced other than the complete lack of a middle-class tradition in art, Hogarth's very pronounced ironical-critical disposition, or his obvious desire to gratify the taste of the aristocracy. The works by which he earned the greater part of his living, which brought him the greatest success and made him famous, were his engravings. For long periods of his life he did not wish to live merely by portrait painting, hitherto the sole stock-in-trade of English artists. He found this humiliating and uninteresting and favoured the more 'democratic' method of selling engravings, done by himself or by others, after his own drawings and paintings. He painted some of his pictures, notably the first three large cycles, solely with a view to engraving them. Moreover his most frequent practice was to discard preparatory paintings and do the engravings direct from very finished drawings. This was the case with most of his satirical engravings and with the large cycle *Industry and Idleness* and the shorter *Four Stages of Cruelty*. His engravings, roughly comparable with topical illustrated magazines, were destined for a public wider than the narrow upper middle class, wider even than that reached by the great

journalistic inventions of the age, the literary periodicals, indeed, for a more broadly-based public than that of any English artist before him—for the type of people among whom Hogarth had spent his early life; for anyone who could save a shilling for a print.[81]

Painters had hitherto mostly restricted themselves to engraving their portraits of distinguished personages for publicity's sake. Hogarth's novel idea was to have his moral-didactic scenes engraved. Whilst he was only able to sell the original paintings of his cycles with the greatest difficulty, the cheap engravings after them passed from hand to hand, twelve hundred people subscribing for *A Harlot's Progress* alone. They were to be found everywhere: not only, as the French art critic Leblanc says, 'in almost every well-furnished house in the kingdom, where they were often mounted to be stood on furniture', but also in the humblest surroundings where they were often just pasted on the walls.[82] As general favourites they were constantly copied and imitated; some, in particular *A Harlot's Progress*, were reproduced on objects of everyday use, such as cups and saucers, fans and box-lids; the much admired *Midnight Modern Conversation*, of which two versions, painted on the walls of taverns, are even extant to this day,[83] appeared on mugs and punch bowls, that is on objects of an entirely popular character. Hogarth clearly indicated the wide public of limited means he had in mind for *Industry and Idleness*: 'As these prints were intended more for use than ornament, they were done in a way that might bring them within the purchase of those whom they might most concern.' And of *The Four Stages of Cruelty* he wrote: 'As the subject of these Prints are calculated to reform some reigning vices peculiar to the Lower Class of People, in hopes to render them of more extensive use, the Author has published them in the Cheapest Manner Possible.'

Hogarth was fundamentally interested in engraving for its usefulness in disseminating his compositions, not for its own sake as an art requiring great technical knowledge and devotion. He himself was an average engraver, by no means an outstanding one in the sense in which he was a great painter and an excellent draughtsman. He produced his compositions, apart perhaps from the faces, in a rather dry, superficial manner, and his prints never attained the high artistic level of good 17th-century Dutch engravings and etchings. He was well aware of his limitations and excused himself with the plea of impatience: 'Fine strokes and soft engraving . . . require more care and practice than can often be attained except by a man of a very quiet turn of mind.' He was also able to distinguish clearly between the artistic needs of his various publics, even so far as engravings were concerned. Generally speaking, his own level of engraving quite adequately served his purpose of telling a story distinctly to an average public. Indeed, until at least 1738 he engraved practically all his compositions himself. But later, when counting on a more refined public for *Marriage à la Mode* or when it was a question of his grander portraits, he employed the best French engravers available in the country. At the other extreme, when he was concerned with a public even lower than that of the two *Progresses*, as for the *Four Stages of Cruelty*, he published two scenes as woodcuts in addition to the four scenes he himself engraved. He was fully conscious of the need to give different kinds of engravings to his various publics. Repeatedly he remarked that in engravings such as *Industry and Idleness*, destined for the broadest public, he aimed not at technical quality but above all at action and expression:

> Notwithstanding the inaccuracy of the engraving, what was thought conductive and necessary for the purpose for which they were intended, such as action, and expression etc. are as carefully attended to, as the most delicate strokes of the graver would have given, sometimes more: for often, expression, the first quality in pictures, suffers in this point for fear the beauty of the stroke should be spoiled.

And of *The Four Stages of Cruelty* he explicitly stated:

> The leading points in these, as well as in *Beer Street* and *Gin Lane*, were made as obvious as possible, in the hope that their tendency might be seen by men of the lowest rank and the fact is that the passions may be more forcibly expresst by a strong bold stroke, than by the most delicate engraving. To expressing them as I felt them, I have paid the utmost attention, and as they were addrest to hard hearts, have rather preferred leaving them hard.[84]

Hogarth's definition of the purpose of his popular style clearly reveals its relationship to the illustrations of the popular, indigenous chap-books, with their exaggerated gestures and attitudes and their emphasis on facial expression.

The new, broad public for which Hogarth catered had previously been fed by the crude woodcuts of these chap-books and by a small trickle of rough popular engravings, broadsides and political caricatures. Many of these, in their didactic and moralising tendency, were full of emblematic allusions, puns and explanatory inscriptions. Formally, their style, if style there was at all, was an extremely primitive baroque with numerous remnants of mannerism or, at worst, an accumulation of motifs, often of a documentary nature, placed side by side so that they could be 'read off' by an uncultured public. In particular there is evidence of remains of mannerism, the general European 16th-century pre-baroque style which, though it aimed at creating a general effect of unreality, was yet open to a wealth of realistic detail. Because of their backwardness, these popular engravings of the early 18th century retained certain features from the mannerist tradition, these in turn emanating from late Gothic, although they had often been almost unrecognisably transposed and divested of their former refined, formal qualities. The first appearance of these engravings in England can be traced back to the Sacheverell scandal of 1710 and to the South Sea Bubble of 1720, which released a stream of previously somewhat sporadic popular caricatures. Hogarth himself contributed to the general excitement over the latter event with an engraving of his own.

The early English popular engravings, particularly the caricatures of the 17th and early 18th centuries, which formed one of the points of departure for Hogarth's own works, were determined almost entirely by Dutch influence—indeed they were often only slightly altered copies of Dutch originals. Dutch popular engravings far surpassed any others in Europe before Hogarth's time and were of vital significance for Hogarth himself. That Holland, with her highly differentiated middle and lower classes and their correspondingly varied tastes, should have been the ultimate source of Hogarth's popular engravings indicates the character of these just as clearly as the Flemish, French and Italian origins on which he drew indicate the character of his aristocratic portraits. Dutch popular engravings have marked artistic-social gradations. Even Jan Luyken and Romeyn de Hooghe, the two most celebrated Dutch engravers shortly before Hogarth, produced many works which could be termed at least semi-popular in character.

These prints, together with their English derivatives, which to begin with were much more primitive, left their mark on Hogarth's whole artistic career. The formal language of the lowest level in Holland, consisting chiefly of caricatures, was popular mannerist and semi-baroque.[85] In them there survived something of the Bosch-Breughel tradition, of its grotesque rather than its fantastic elements. In Dutch popular art of the 17th and even the early 18th century, Bosch and Breughel were quite frequently imitated and individual motifs were taken over from them. On a higher artistic level a similar though not so antiquated idiom occurs in 17th century engravings illustrating the Dutch moralising, edifying literature—allegorical-didactic poems and proverbs. These illustrations, with their overwhelmingly intricate symbolism, display an astonishing

degree of realism in genre scenes and formed an immense treasure-house of motifs. Close to them were the illustrations to the countless emblem books published in the 16th and 17th centuries on the continent, including some by Luyken; many of these, among them even some in translation from the Dutch, appeared in England as late as Hogarth's time. Their purpose was instructive and moral-religious, and the character of their illustrations became increasingly popular.[86] Even the presentation of Hogarth's late popular cycle, *Industry and Idleness*, still derives from these emblem books;[87] each scene is accompanied by a statement of its pedagogic intention and a scriptural verse. Thus the bourgeois-instructive character of the cycle was enhanced through use of the traditional technique of the emblem-books.

But this is only one characteristic example. For the popular and half-popular, satirical and moralising Dutch and English engravings constituted the historical premises of a great part of Hogarth's art, and their pronounced symbolism, grotesque Bosch-Breughel fantasy, generally antiquated and disjointed formal idiom, inscriptions and puns comprise ever present conservative features, as it were, in Hogarth's engravings. Seen against this background, the allegorical and symbolical figures and motifs which often make up his caricatures, from the very early *Emblematic Print of a South Sea Scheme* down to *The Bathos*, are easily comprehensible. Most original and witty symbolical allusions frequently occur in Hogarth's narrative and point a situation or a character; for instance, in *Evening* (Pl. 59a), from *Four Times of the Day*, when a London couple return from an excursion, the husband's head is framed by the horns of a cow, clearly indicating that he is a cuckold. Nevertheless the emblematic imagery of Hogarth's prints—animals and inanimate objects which seem to be alive and as if taking part in the general action—is fundamentally that of the Middle Ages, come down to him through popular engravings. Such origins clearly show in his engravings, most forcefully in his more popular ones. For example, in *The Industrious Apprentice in the Counting-House* (1747) (Pl. 105b), two clasped gloves lie on the table, to show that the apprentice was being taken into partnership by his master. In another engraving, *Credulity, Superstition and Fanaticism* (1762) (Pl. 137a), which ridicules the zeal of the Wesleyans, the globe chandelier has a grotesque human face resembling a Bosch monster. This 'Globe of Hell' is covered with explanatory inscriptions to supplement the Wesleyan preacher's sermon with its threats of hell. One eye is labelled 'The bottomless pit', an expression probably taken from *Gulliver's Travels*, the other 'Moulton lead lake'; one cheek 'Brimestone ocean', the other 'Parts unknown'; and the mouth 'Eternal damnation gulf'. For, still following popular tradition —fundamentally a survival of the medieval Tituli—Hogarth in his engravings made constant use, apart from puns, of all kinds of inscriptions: notices on walls, book titles, letters and, in his early, particularly popular period, even scrolls bearing the spoken word to explain his subject. It appears to have given him pleasure to embody in a print some motif kept faithfully in the most conservative style of popular engravings. A good example is one plate of *The Invasion* (1756): an English soldier paints a caricature of Louis XV on the wall in the formal idiom of popular prints, and a long scroll in pidgin English issues from the king's mouth: 'You take a my fine ships: you be de pirate: you be de teef: me send my grand armies and hang you all, morblu.' Hogarth's frank differentiation between the various grades of his work is clearly apparent in that he saw no need to paint preparatory pictures for popular engravings of this kind; similarly, in cases where he engraved his pictures, he repeatedly introduced into the print popular features absent from the original, or augmented those already present.

Some light is thrown on Hogarth's predilection for popular art, not to mention his own background, by recalling that his father's brother, 'Ald Hogart', was a popular poet. A farmer in

Westmorland, from which county Hogarth's father also came, he wrote coarse, moralising satires, topical poems and play-jigs in the local dialect. His artist nephew in the same way adapted himself to the artistic needs of his broad public. But this apart, the realist motifs and possibilities of the popular and semi-popular engravings, Dutch even more than English, must have greatly appealed to Hogarth. His flair for reportage and facial expression inclined him to present interesting episodes and figures in a detailed and vivid manner and the informality of the medium was an encouragement to this aspect of his genius.[88] The works of the immigrant Dutch artist, Egbert van Heemskerk, show how easy it was to combine traditional features with more modern developments in semi-popular art. The use of animal imagery, which he introduced from Holland, was much strengthened by his lively, grotesque compositions, in which human figures were given animal heads; these were engraved and spread through this country by small English engravers and Hogarth himself retained something from this type in his popular print, *The Beggar's Opera Burlesqued* (1728) (Pl. 22a). The numerous engravings after Heemskerk, with their very popular whimsical style, were a great attraction for Hogarth, since they purveyed the most vivid picture of contemporary life in recruiting scenes, concerts, picture auctions, orgies in brothels, dissecting rooms and so on.

If Hogarth made quite conscious use, for his own purposes, of elements from popular engravings, his modifications of them became increasingly radical. As time went on, he enlivened and 'psychologised' them, stripping them of their rigidity (much of which had persisted in his own early works) and raising them to a high artistic level of his own. The large scrolls of writing streaming from the figures' mouths in course of time became small labels and, probably largely under Hogarth's influence, a gradual process can in fact be detected towards a simplification and diminution of inscriptions in the general run of popular engravings.[89] He altered another feature of popular engravings in a more unexpected manner by making use of greater fantasy, though in a more refined sense, as I shall show when dealing with his expressionism. Yet it is a measure of his closeness to popular art that his works could so readily be transposed back into it. A group of engravings exists, all made for some passing occasion and almost all bearing the inscription *Hogarth fecit*. But although Hogarth's invention and artistic power seem to lie behind them and some of them are not without a certain charm, they are cruder and more carelessly executed than his own prints, even those purposely kept in a particularly popular style such as his figure of Louis XV. A trade-card for the boxer Figg, or the two tickets for Fielding's comedy *Pasquin*, (Pl. 61b), are examples from this group. It is possible that these casual works were executed by a little-known small engraver, Joseph Sympson junior (died 1736), whose name appears on one of them[90]—a benefit ticket for Walker the actor, in *The Beggar's Opera*.[91] They may have been carried out on Hogarth's orders and based upon some quick sketches he had done. If so, Hogarth evidently approved of the transposition of some of his compositions into popular art.

Even coarser were the cheap pirated engravings after Hogarth's own prints. Throughout the 18th century Hogarth's engravings were frequently converted into very primitive paintings, entirely within the realm of popular art. Greatly simplified from the originals and often with brutal and caricature-like details added, they aimed at exaggerated grotesque expressions. Typical examples are the copies of *The Laughing Audience* (Oakley Collection, Andover) and *Morning* (McCrea Collection, New York).[92]

Hogarth's engravings were nearly always close to popular prints when he treated subjects traditionally of public interest and topicality although he often gave them a new slant of his own. An example of the way in which he satisfied the urgent demand for the documentary portrayal of

famous criminals, whose trial and execution commanded widespread interest, while at the same time combining this with an analytical study, is his portrait of the murderess, *Sarah Malcolm in Prison* (1735).[93] Equally noteworthy are the many guises in which this composition was presented by him and others to his various publics. Perhaps the first English artist to do a painting, as distinct from an engraving, of a criminal, he produced a skilful, psychological sketch of Sarah Malcolm (National Gallery of Scotland, Edinburgh) (Pl. 39a), for such a precious, aristocratic connoisseur as Horace Walpole. At the same time, after wide advertisement,[94] he published a simplified version of this as an engraving, knee-length against a dark background. *The Gentleman's Magazine* published a woodcut after this composition, but a summarised version, showing the head and shoulders only. So greatly sought after was the engraving that it was pirated and even used as a frontispiece for a popular pamphlet describing Sarah's appearance as a ghost in a gin shop. In one version Hogarth came quite close, in pose and lay-out, to an earlier, similar work by Thornhill of the highwayman *John Sheppard in Prison* (1724, mezzotint by J. White). It is possible that both of them followed the traditional pattern of popular engravings of this type, though on a much higher artistic level. For even Thornhill did not scorn to do an occasional portrait of such a topical figure as a criminal though apparently more rarely than his son-in-law[95]; indeed, he accompanied Hogarth to Newgate Prison to draw Sarah Malcolm. When Lord Lovat was brought to London for trial and execution after his part in the 1745 rebellion, Hogarth, as a good journalist-artist, travelled to St. Albans to meet him and be the first to portray him.[96] The impressive engraving (Pl. 78b), with its arresting expression, which he did after this sketch, was perhaps the most widely bought and the most financially rewarding of all his works; it is said that, sold at a shilling apiece, it brought him an income of £12 a day over a period of some weeks. In his *œuvre* these portrait engravings of criminals on a more or less popular level form an important corollary to his portraits of the aristocracy and the professional middle class.

So very accomplished was Hogarth's late *Election* cycle (1755) that individual engravings were dedicated to members of the aristocracy[97]: the Secretary of State, Henry Fox (later Lord Holland); Sir Edward Walpole; the diplomat, Sir Charles Hanbury Williams; the Lord Commissioner of the Admiralty, Sir George Hay, who owned Hogarth's picture, *The Bench*, which took off the judges of the Court of Common Pleas and even the Lord Chief Justice himself. In spite of the cycle's artistic level,[98] the origin of its various motifs must be traced to the tradition of the numerous popular prints designed to show up bribery at the elections organised by Robert Walpole, the first of which appeared in 1722. Hogarth's famous motif, in the second scene of the cycle, in which an elector is bribed by both sides at the same time, had already appeared in an engraving—*An Election won by Bribery* (Pl. 122b)—particularly popular in character, at the time of the 1727 election; elongated almost Gothic-mannerist figures are linked together in a cumulative manner and curving scrolls appear; the elector exclaims 'No bribery' and adds 'but pockets are free'.[99] Former popular engravings, *The Humours of a Country Election* (1734, 1741), also served Hogarth thematically for his scene in which the candidate provides a meal for the electors whilst flattering their wives, and for *The Chairing of the Electors' Candidate*, with its musical accompaniment.

Apart from Sympson's engravings after his drawings, the most crudely popular of Hogarth's works were his woodcuts. The two copies of Plates 3 and 4 of *Four Stages of Cruelty* were cut to his order by J. Bell, who must have been trained in the brutal but effective chap-book manner: in expression they are more striking than the corresponding engravings and more suited to their gruesome themes. For Fielding's anti-Jacobite periodical, Hogarth had a woodcut headpiece

executed (it is unlikely that he did it himself) in the emphatic style of the chap-books. Crude though it is, it is far more skilful than the latter and the simplification of the woodcut has served to intensify the shrewd characterisation of the types. Here again, characteristic of the flexible artistic mentality behind this, a red chalk sketch of the same composition (Windsor), probably a first thought for Hogarth's private use, is one of his most delicate and spirited drawings (Pl. 114).

Thus it can be seen from the above-mentioned examples of pictures and engravings that Hogarth had not one but various manners, not one but various publics. He lived at a time when patronage by royalty and the aristocracy, hitherto the exclusive rule, had begun to recede but was not yet entirely displaced, whilst completely new classes of consumers for the artist's output were presenting themselves—a public extending in scope far beyond the middle classes, and of which Hogarth, the great innovator, was the discoverer. It is difficult to imagine a greater contrast than that between, say, his sketch of the Royal Family and his popular engravings such as *Credulity, Superstition and Fanaticism*; or than that between the employment of the most refined French engravers for some of his compositions and of anonymous or little-known artisans for his brutal woodcuts.

It may be rewarding at this point to compare Hogarth's complex public with the more homogeneous ones of Defoe, Richardson and Fielding. The wide public who read *Robinson Crusoe* and *Moll Flanders*, *Mist's Weekly Journal* and *Applebee's Weekly Journal* was rather lower middle class; it was far below the social standard of those who read *The Spectator* and was despised by writers like Pope. Defoe created this new large public for himself and it was the same one into which Hogarth's engravings penetrated. Richardson's readers were almost entirely good, respectable middle class people, the bulk of them clergymen and women; not only the aristocracy, but also the upper layer of the middle class who imitated the aristocracy were beyond his reach. However large a part of the public for Hogarth's engravings belonged to the middle class, this was not the same Puritan, middle section as Richardson's, but situated either higher or lower. Fielding's public was smaller than Richardson's and far more cultured: some aristocrats, many professional people and intellectuals.[100] All or most of these would be Hogarth's public too: Horace Walpole, Lord Charlemont and Garrick were all assiduous purchasers of his works, even of his engravings, of which Walpole made the first catalogue; while for some of his portraits it would be necessary to go still higher up the social scale.[101]

To sum up, although the propagandist in art *par excellence* of bourgeois ideas, Hogarth often worked for higher and lower publics than the middle class proper. The higher public demanded a refined, restrained baroque; the lower contented itself with a very primitive 'baroque' in which the formal construction was scarcely stressed at all; while realistic classicism, the genuine style of the European middle class for centuries, was less apparent in Hogarth's art than might be expected. His outstanding feature, his love of realistic observation, is reflected in different degrees in his various works according to the public for which they were destined. It is not possible in his works to make a clear distinction between his various manners, which inevitably intermingle, but on the whole his style was a realistic baroque. The seemingly contradictory stylistic trends within his art have to be considered in relation to the complexity of the social and artistic background, as I have attempted to do in this chapter.

IV

Hogarth's Representations
of the Theatre

B Y the 1730s, the moral considerations which, during the 17th century, had led the bourgeoisie to oppose or boycott theatrical performances were beginning to lose their force and the theatre was now able to give expression to this more humanised and mellow outlook.[1] The rise of the sentimental domestic drama typified by Lillo's *Merchant of London* heralded the appearance on the stage of the new middle-class ideas and a purification of the old Restoration spirit. At the same time, the great Elizabethan dramatic tradition persisted and was even given fresh strength by a new, more realistic kind of acting (Garrick), whilst Restoration court drama and even Restoration comedy remained potent forces.[2] Moreover, farces, panto-mimes and ballad operas, which catered for audiences on a lower social level than the respectable middle class, also grew enormously in popularity.

Since he was at home wherever lively and amusing events of topical interest were taking place, Hogarth became *the* artist of the theatre early on in his career. An intimate friend of the leading theatre managers, Rich, Fielding and Garrick, he was on good terms with most of the famous actors as well, and his pictures connected with the stage display an astonishing variety.

Hogarth excelled at portraying actors, who were now receiving increasing social recognition.[3] In the years around 1740 he did a number of such portraits. Conceived as psychological studies, they were an important innovation, both in quantity and in quality, for hitherto only a few rather schematic likenesses of actors had been done in this country.[4] When Hogarth painted James Quin (National Gallery),[5] the most famous English actor before Garrick, the hollowness of this representative of the old declamatory school is unmistakably displayed on his conceited face.[6] He also painted Lavinia Fenton (Tate Gallery) (Pl. 69a), the original Polly Peachum of *The Beggar's Opera*, who was first the mistress and later became the wife of the Duke of Bolton, an unprece-dented event for any English actress. Hogarth's lively portrayal of this buxom lady apparently does not represent her as Polly, as was once assumed, but was painted when she had already

become a duchess. Another interesting characterisation, comparable even with La Tour's famous portraits of actresses and dancers such as that of Mlle. Camargo in St. Quentin, (Pl. 70b), is one which may possibly represent Peg Woffington (Lord Glenconner) (Pl. 70a). This celebrated actress mostly appeared in Farquhar's and Cibber's comedies, but she sometimes took men's roles and sometimes acted in Shakespeare. Whilst most portraits of her tend to generalise and idealise her features, Hogarth's, done when she was very young, perhaps at the time when she was Garrick's mistress, gives an excellent idea of her actual appearance.[7] Although probably painted in the early 'forties, when Hogarth's rococo elegance was at its height, it is devoid of false glamour, its charm lying in her gracefully perched head and the way in which the artist has caught and expressed her cleverness, tenderness, vivacity and humour.[8]

Hogarth was one of the first painters, most probably the very first in England, to represent actual scenes from plays, not only in engravings, as had been customary since the 16th century, but also in paintings. Apart from very sporadic Dutch examples in the 17th century by Quast and Jan Steen[9] the only artists before him to have done really true-to-life pictures of the stage, as distinct from having merely drawn suggestions from it, were Gillot, the first painter to devote a large part of his art to the world of the theatre, and to a much lesser extent his pupil Watteau. Most theatre pictures done by these two artists, to whatever degree faithful or fanciful, were confined to scenes from the *Commedia dell'Arte*, for which Gillot even wrote plays. Originally Italian, this folk comedy had developed in France by the second half of the 17th century into a rather refined entertainment, recognised socially and even accepted at court.

In contrast to the constant repetition of this kind of theme in French pictures of the stage, Hogarth depicted plays of manifold types. His first theatre picture of 1728, one of the first pictures he ever painted, drew its thematic inspiration from a source very different from the French: a scene from Gay's *Beggar's Opera*, first performed the same year in the theatre at Lincoln's Inn Fields. Typical of that half-Restoration, half-bourgeois mentality of the 'twenties and 'thirties, *The Beggar's Opera* was notorious for its blunt satire, its cynical, matter-of-fact realism and its novel, accurate observation of the contemporary underworld; with its popular tunes it stood in conscious, ironical contrast to the artificiality of grand Italian opera and deliberately mocked at the obligatory happy ending. At the same time it abounded in political allusions directed against Walpole and his corrupt system and put Walpole and the highwayman on the same level. It was considered patriotic and British in contrast to the Italian operas at Drury Lane. Although it exposed sentimentalism, it was somewhat sentimental itself. It was favoured by the general public and the intellectuals alike, including Swift, Pope and Voltaire.[10]

As the play was popular, so was Hogarth's rendering of it. So greatly was it in demand that Hogarth, contrary to his usual practice, painted at least four versions.[11] Of the two principal ones, the earlier of 1728 was done for Rich, manager of the theatre (no longer extant but similar in composition to the one in the collection of Lady Anstruther-Gough-Calthorpe), the later, between 1729-31, for Sir Archibald Grant, a Member of Parliament (Tate Gallery) (Pl. 20b). I shall mainly concentrate on the later version which, in individual motifs and general style, shows slight differences from and improvements in quality on the earlier. Hogarth chose the rather sentimental scene which marks the climax of the play, when Polly (acted by Lavinia Fenton) and Lucy kneel before their respective fathers, pleading mercy for Macheath. In the picture, as was the case in reality, distinguished spectators are sitting or standing in boxes on each side of the stage—mainly titled people[12]; for instance, in Grant's version, the Duke of Bolton, Lavinia Fenton's future husband. But among the spectators there are also some members of the middle

class, such as Gay,[13] Rich[14] and a friend of theirs and Hogarth's, Cock, the picture auctioneer. The introduction of privileged spectators on the stage, although a traditional and, as it were, aristocratic feature of the theatre, is treated here in the most prosaic, unglamorous manner, unlike French paintings of scenes from the *Commedia dell'Arte*, with their air of champagne-like unreality.

This is a transformation of great importance in the history of art. Although Gay drew his material largely from the underworld, giving its figures the manners of lords and ladies, Hogarth's picture, compared with Gillot and Watteau, signifies a transformation in a more full-blooded bourgeois sense, though not yet to the extent of the moralising middle-class drama.[15] The contemporary costumes, the everyday milieu of Newgate Prison, the rather clumsy, bourgeois stolidity of the actors all lend an air of novelty. This was in accordance with Hogarth's new, realist, almost journalistic relation to the theatre, and thus totally different from that of Watteau, who was not particularly interested in the faithful rendering of plays but created for the types of the *Commedia dell'Arte* a subjective, poetical, dream-world setting suited to the peculiar quality of this genre. Hogarth rendered a matter-of-fact theatre, non-existent in France at that time, in a most matter-of-fact manner which nevertheless was by no means lacking in spirit.[16]

Hogarth's figural composition cannot be called monotonous, though it is slightly symmetrical, with the figures of the actors and the groups of spectators vaguely corresponding to each other. This light symmetry occurs occasionally in the young Hogarth and is perhaps a residue from the tradition of building up compositions in rigid planes in theatre engravings, English as well as French and Italian, whether these represent operas, court masques, tragedies or ballets. Even Gillot's and the young Watteau's scenes from the *Commedia dell'Arte* tend to lack space, imitation of the shallow stage used in this genre probably encouraging the artist to draw up his figures in more or less straight rows. Engravings of such compositions could have been available to Hogarth; e.g. Gillot's etching of *Le Tombeau du Maître André* (the original picture, *c.* 1716, Louvre) (Pl. 21b),[17] which has a somewhat similar arrangement. But the English artist has manifestly loosened the previous general pattern and greatly modified the tradition of construction in strict planes, in order to give a more lively, undulating and uniformly spatial effect. The attitudes of the actors and the diagonal rows of spectators on the stage help to give the picture depth[18] and the skilful distribution of colour, devoid of harsh, obstructive tones, also draws the spectator's eye towards the grey wall in the background which, with its many apertures, seems to fade away in all directions. Notwithstanding the documentary character of the picture, the general pattern, particularly with regard to the accessories, is in an obvious baroque; the curtains, designed to flatter and topped by loops of ribbons; the decorative sculpture on both sides and the steep winding staircase on the right; the carpet, intentionally drawn up into a large fold. Though probably taken from the actual stage décor, the sculpture of the faun on the right, painted in *grisaille* (introduced only in the later version) is reminiscent of the more grandiose *grisaille* fauns which were Ricci's stock-in-trade for his ceilings in Burlington House, but Hogarth brought the motif down to earth, whilst utilising the painterly Venetian effects.

In a certain sense one is also reminded of Watteau. However different the French artist's general type of stage representations may have been, the arrangements of his late phase had a slight similarity with Hogarth's: e.g. his *French Comedians* (Metropolitan Museum, New York),[19] and even more his very important *Italian Comedians* (National Gallery, Washington) (Pl. 21a). This latter picture was painted as late as 1720 for Dr. Mead during Watteau's visit to England, and was engraved by Baron, whom Hogarth so often employed. It represents the various types of the

Italian comedy, perhaps lined up before the curtain at the end of the performance. That year a French company was playing Italian Harlequinades in London and it was probably members of this company whom Watteau painted. A suggestion from this picture, which Hogarth must have known and which is more realistic than the usual well-known examples of Watteau's middle period, may have filtered through into *The Beggar's Opera*, particularly the earlier version, which is fundamentally more baroque. In both pictures the composition is systematically built up round a dominating, almost isolated central figure—in the one case Pierrot, in the other, Macheath—on both sides of which the groups and figures move inwards in not dissimilar diagonals, though they flow more easily in Watteau. It is not surprising that Hogarth, with his knowledge of French art, should have made use of a Gillot or a Watteau; as will be shown later, one scene from *A Rake's Progress* reveals another borrowing from Gillot, from his *Scène des deux Carrosses* (Pl. 52b), also of the *Commedia dell'Arte*, and again with the spaciousness increased. Yet if slight formal suggestions perhaps more markedly stem from the somewhat grotesque Gillot than from Watteau, the transformation is complete.

Hogarth's fidelity of observation towards actual events where the stage was concerned comes out in his drawing (Windsor) for the early version of *The Beggar's Opera* (Pl. 20a).[20] Originally a sheet in the so-called 'Hogarth's Sketch-book', this drawing on blue paper was clearly a swift jotting in black chalk of the general impression received of the grouping and movements at an actual performance. To have made a quick sketch at all, and to have closely adhered to it in the painting, was an exceptional procedure for Hogarth, who usually relied on his memory, omitting all preparatory studies. And it is no mere chance that apparently the only other occasion on which he acted similarly was for another theatre picture, also of 1728. For *Falstaff Examining his Recruits* (later bought by Garrick, now Lord Iveagh) he did a black and white chalk drawing (Windsor) (Pl. 19a), which was also originally in his 'Sketch-book'; it is an even hastier record of an actual stage effect and is, in fact, one of his most spirited drawings. Here again the composition and all the attitudes are faithfully set down as they were to reappear in the picture. These two characteristic cases reveal the exact impression made on Hogarth by the events on the stage. His choice of the well-known comic scene from Henry IV, Part II, indicates the qualities in Shakespeare which seized people's imagination during those years.[21] And this line is maintained by the burlesque treatment, similar to that of his *Hudibras* illustrations done a year or two earlier; moreover, the types in the Falstaff painting, like so much of Hogarth's early work, call to mind the bizarre and popular Egbert van Heemskerk.

Hogarth certainly saw no contradiction in having, at about the same time that he painted the various versions of *The Beggar's Opera*, taken off the play in an engraving, *The Beggar's Opera Burlesqued* (Pl. 22a) (1728), just as did another contemporary print. Rather by way of a joke, he joined in the lively polemics which followed the play's success[22]; moral indignation was loudly voiced (including pamphlets and even sermons)[23] against the play's reversal of the accepted social values, by which a highwayman's profession was made to look attractive.[24] Yet some part at least of this moral resentment was merely a pretext for certain Whig circles to attack Gay, a personal adversary of Walpole. Hogarth's engraving is spread over the paper in the casual, grotesque manner of rather popular, narrative engravings, in marked contrast with the carefully balanced composition of the commissioned picture. The actors are given animal heads, an old habit in Flemish satire, particularly in more popular Flemish art, which was imported to England by Egbert van Heemskerk.[25] One case in which Heemskerk used this animal imagery was a representation of a concert, poking fun at foreign musicians. Whilst adhering to popular tradition,

Hogarth's work, however, is of a far higher artistic quality, both in its details and in its arrangement and inter-relation of the numerous groups, than the primitive engravings by Toms after scenes by Heemskerk. In Hogarth's print aristocrats, to the right, and the common fry, to the left, are applauding the play. As in Heemskerk's engraving, the orchestra plays fantastic instruments; Apollo and the Muses have dropped off to sleep and Harmony turns her back on the performance and flies to a spot where a rehearsal of an Italian opera is in progress, also rendered with an air of mockery. The motif of the flying figure, unusual in Hogarth, is reminiscent of Rembrandt's flying angel in one of his Tobias series but actually derives from a Picart engraving of 1720 on the John Law scandal, which was accessible to Hogarth from a copy by Baron; its English title ran: 'A Monument dedicated to Posterity in commemoration of ye incredible Folly transacted in the Year 1720' (Pl. 22b). No doubt Hogarth's intention was to show the complete contrast that existed between English popular opera and Handel's grand Italian opera, which also suffered financially from the former's success. Folk ballads, to the tunes of which the songs in *The Beggar's Opera* were set, are also derided in his engraving.

Here one may mention two other representations by Hogarth from the sphere of music, neither of which is chronologically far from *The Beggar's Opera Burlesqued*. One, an early concert ticket in a slightly baroque arrangement, shows a temperamental conductor with the instrumentalists. The other, *A Chorus of Singers*, of 1732 (Pl. 35a), depicts a rehearsal of the oratorio *Judith*, written by Hogarth's friend William Huggins, with music by de Fesch. This unusual composition is steeply built up, partly with grotesque half-length figures, and surmounted by the conductor. Yet it seems probable that a very different type of work was at the back of it, namely Watteau's *Réunion des Musiciens* (Pl. 35b); and possibly even another, quite dissimilar work— Egbert van Heemskerk's *Concert*. Watteau's scene had been published with hundreds of others in the *Figures de différents Caractères* and had been copied in England, in particular by the engraver Dubosc, with the title, characteristic of its new milieu, of *The Comical Concert*.[26] Watteau's horizontally spreading composition, probably an early work, adhered closely to Flemish tradition, whereas Hogarth pressed the heads tightly together into a vertical composition and created a unified, biting, half-grotesque, half-realistic scene. It is something quite new and entirely English, and few French or Flemish traces survive in a Watteau or Teniers sense.

In the first half of the 'thirties, the burlesque and satirical manner of *The Beggar's Opera* was carried on by the young Fielding; indeed since Gay's play nothing had amused London so much as Fielding's farces. His importance to the stage was, in every sense, considerable. Yet since he voiced the views of the anti-Walpole Whig dissidents, his activities in this sphere were halted by Walpole's Licensing Act of 1737 which, for political reasons, introduced a strict censorship of the theatre. Fielding's farces, parodies and ballad operas, combining political, social and literary criticism, were naturally composed in a simple, grotesque vein. It was Hogarth's print of 1731 for Fielding's *Tom Thumb* which marked the beginning of their long friendship. Fielding intended the play as a parody of Dryden's heroic tragedies. Hogarth's frontispiece illustrated the scene in which Princess Huncamunca, to enlighten her fiancé, Tom Thumb, illumines the ugliness of the giantess, Queen Glumdalca, with a candle; it is a scene which burlesques the meeting between Octavia and Cleopatra in *All for Love*. Hogarth also did a benefit ticket for one of the actors in Fielding's most successful farce, *Pasquin* (1736); this is a striking representation of one of the play's motifs, the murder of Queen Common-Sense by the giant Firebrand and the accession to the throne of Queen Ignorance (Pl. 61b). I think it probably belongs to the group of engravings done by Sympson in a popular style after Hogarth's drawings. The same is true of

another, larger and equally amusing ticket for *Pasquin*, with more action—Queen Ignorance with singers, fiddlers and rope-dancers—and a part of the audience represented.[27]

One degree less popular perhaps than these burlesques were Fielding's adaptations from Molière, one of his favourite writers. For, usually under the guise of more or less free adaptations, Molière was often acted on the English stage during these decades. From the *Médecin Malgré Lui* Fielding made *The Mock Doctor*, a ballad opera in one act, strewn with topical allusions, which was staged at the Theatre Royal with Theophilus Cibber in the title role. In 1732, Hogarth produced a benefit ticket for Fielding as the author of this play; it is an animated and charming composition in which Cibber can be recognised. The print, however, has been partially spoiled by a weak, quick engraver, who may again have been Sympson.[28]

In that same year Hogarth produced two other illustrations to Molière of an even less popular character, for an edition of Molière's principal comedies in which the English and French texts were printed side by side. Like Fielding's adaptations, this publication in eight volumes held quite an important place in English cultural life. It was destined to spread knowledge of Molière's original text through the wider circles of those unable to read French. Its whole *cachet* was socially distinguished; each comedy is dedicated to a different notable figure, from the Queen and the Prince of Wales, through the most cultured members of the (mostly anti-Walpole) aristocracy such as Lord Chesterfield, Lord Carteret, the Duke of Montagu, whom Hogarth painted about that time, and Lady Mary Wortley-Montagu, down to the famous Dr. Mead and a few lesser-known, apparently also middle-class people. Fielding had his share in these accurate translations and in the dedications as well. This *cachet* was stressed by the inclusion of three illustrations by the French painter Charles Antoine Coypel; the rest were by English artists, named and unnamed. The two by Hogarth were for *L'Avare* (Pl. 41c), staged from Fielding's adaptation of 1733, and for *Le Cocu Imaginaire*. The former, the more interesting of the two, depicts the scene in which Harpagon, despite the distraction of a tempestuous family gathering, finds occasion to extinguish one of the lighted candles on the table to save expense. Hogarth portrayed it in a vivid and natural manner; the figures are everyday types and each is in an easy and characteristic attitude; the whole composition is less posed and forced, flows more lightly and is more spatial than *The Beggar's Opera*. It differs greatly from the other English illustrations in this volume, nearly all of which, including even those by Dandridge, are stiff and cramped. Here the English illustrators show themselves incapable of constructing volume and space; yet they strain to be elegant and French, outwardly more so than Hogarth. Their elongated, rigid female figures assume an appearance of gracefulness. Consequently, of all the English illustrations, Hogarth's come closest in spirit to Coypel's compositions, though they are even more natural and relaxed; for Coypel's graceful scenes are quite realistic and lack the affectation of most French rococo artists. In fact, though the latter are rather more charming, Hogarth's, with their humorous conception and their good artistic standard, fitly take their place in the same publication. At the same time, this bourgeois, realistic, psychological interpretation of *L'Avare* certainly gives a faithful impression of one aspect of the English stage during those years.

One of the recurrent themes in Fielding's burlesque plays, with their spirit of all-out attack, was that the serious English theatre was perishing because of the vogue for frivolous harlequinades and pantomimes, the two types of which, the Italian and its English derivation,[29] were usually fused into one. Here Fielding expressed a view previously voiced by Hogarth, who never missed an opportunity for criticism; it was a not uncommon view and had been shared by

intellectuals and probably by the more intelligent public since the introduction and spread of the genre in the early 18th century. But such criticism did not prevent full enjoyment of these plays, which were an outstanding financial success. Just as Fielding expressed his anti-farcical viewpoint in farces, so he ridiculed the pantomimes in travesties. In this he followed Hogarth, who had sneered at the childishness of pantomimes and their public in several popular-style engravings with scroll inscriptions. The first two of these, the very first English caricatures of the theatre,[30] were *Masquerades and Operas* (1724) (Pl. 5a), otherwise known as *The Taste of the Town* and *A Just View of the British Stage* (1725). In the first, Hogarth's scene set in Piccadilly shows how great was the success of the pantomime *Harlequin Doctor Faustus*, staged by Rich at Lincoln's Inn Fields in 1723; enthusiastic crowds are edging their way into the theatre whilst the works of Shakespeare, Ben Jonson, Dryden and also Addison are carted away. In the second, the resulting situation, the attempt of the managers of Drury Lane to out-do Rich, is depicted; an even more elaborate pantomime is staged with wild beasts and dragons and mechanical effects, whilst Jonson's ghost rises up through the floor. In both engravings, Hogarth has taken up literally Steele's report on Rich written fifteen years earlier in *The Tatler*: 'But he, having no understanding in his polite way, brought in upon us, to get in his money, ladder-dancers, rope-dancers, jugglers and mountebanks to strut in the place of Shakespeare's heroes and Jonson's humorists.'

Hogarth's third engraving took as its subject Rich's *Triumphal Entry into Covent Garden* (1732): Rich, the producer of *The Beggar's Opera* and himself the most famous harlequin in town, is shown leaving the theatre in Lincoln's Inn Fields amid the enthusiastic applause of the populace, to take over Covent Garden for the production of spectacular pantomimes. *Masquerades and Operas* and Rich's *Entry* are in a kind of popular mannerism. The masses, contrasted with large empty spaces, are clumped together in a primitive manner and equally primitively balanced. In the arrangement of the crowds in *Masquerades and Operas*, a popular transposition of Callot's street scenes, such as his famous *Petite Vue de Paris*, can be sensed, whilst the figure of the Devil leading the crowd to the masquerade was considered even by Hogarth's contemporaries to be a copy after Callot. A crude but effective rococo was used for *A Just View of the British Stage* with its few figures. Just as Addison had done (in *The Spectator*, 1711) and Fielding was later to do in his play *The Pleasures of the Town* (1730), Hogarth, in *Masquerades and Operas*, ridiculed the Italian opera which was only frequented and appreciated by court and aristocracy. On a show-cloth in the engraving, Italian singers of distorted proportions are shown performing an opera—perhaps Händel's *Flavio*, staged in 1723—whilst aristocrats, among them the Earl of Peterborough, kneel before the primadonna, Signora Cuzzoni, offering her large sums of money.[31] Despite some personal enthusiasm for Händel, Hogarth held grand opera and Italian singers in unequivocal contempt,[32] and continually harped on this theme. In *A Rake's Progress* and in *Marriage à la Mode*, it is significant that Italian singers contribute to the financial ruin of both the rake and the countess. In *The Rake's Levée* (Pl. 50a), Farinelli, one of the greatest singers of his time, is probably represented; in the Countess's *Levée* (Pl. 90c), probably Carestini. Hogarth never chose the subjects of his theatre pictures from operas as French artists so often did.[33]

During his youth, Hogarth was in the closest contact with the popular theatre and did a number of tickets for the benefit of actors, all of them socially inferior to those whose portraits he was later to paint, such as Lavinia Fenton, Quin and Peg Woffington, not to mention Garrick. For example Hogarth did a ticket in 1728 for Spiller, who was usually drunk and in debt. He is shown incapable of paying his tailor or his bills for liquor and about to succumb to his creditors

and the debtors' prison. More usually these benefit tickets represented a scene from a play in which the actor in question performed; Hogarth, or more probably the engraver after him, adapted himself so genuinely to a crude, popular style, that there is some hesitation, probably unfounded, over attributing them to him.[34]

Hogarth's matter-of-fact, realistic attitude towards the theatre is reflected in the unusual interest he took in the audience itself in his early years. In contrast to previous engravings of theatre scenes, in which a large anonymous audience merely formed part of the magnificent baroque performance, this attitude was new, very democratic, unglamorous and almost intimate. He did not confine himself to representing the cream of the spectators, as in *The Beggar's Opera*. Probably for the first time in the visual arts, the etching of *The Laughing Audience* (1733) (Pl. 41b), the subscription ticket for *A Rake's Progress*, depicts the audience of the cheaper seats in the pit: nondescript, plebeian spectators are enjoying a comedy and rolling with unrestrained laughter. Perhaps not until Daumier was the democratic theme of a bourgeois audience again so explicitly realised. Together with a few hard-working members of the orchestra, the tight rows of spectators' heads are built up into a compact pyramid. Above them, in the lower boxes, two elegantly dressed cavaliers are making love, one to an orange girl, the other to a lady in the box. The compositional treatment of these, placed in a socially distinct part of the theatre, differs entirely from that of the audience massed below; in curling, wavy lines, like a rococo ornament, they crown the whole in a final flourish. The rather unusual, spirited style of the etching gives it the lively character of a sketchy drawing.

A far more exalted audience than this, or the one in *The Beggar's Opera*, received a much more polished representation in another of Hogarth's theatre pictures from the same years, albeit larger in size: *The Indian Emperor* (1731, Lord Ilchester) (Pl. 33a), probably painted for the Duke of Richmond. For even the Hogarth of those early 'democratic' years soon learned to flatter if occasion arose. Just as he chose an elegant, restrained baroque-rococo style for aristocratic portrait groups, so he did when presenting this play performed, not by professionals, but by children of the aristocracy—Lady Fermor, Lord Lempster, Lady Lenox, Miss Conduitt—in the exclusive house of Mr. Conduitt, Master of the Mint, before an audience consisting of three of the King's children—the Duke of Cumberland with Princesses Mary and Louisa—and various members of the high nobility, including the Duke and Duchess of Richmond, the Duke of Montagu and the Earl of Pomfret. At about this time Hogarth was also painting the same royal children in his sketch of the Royal Family and most of the aristocrats and their children represented in *The Indian Emperor* were also portrayed by him in a number of conversation pieces. In this picture, Hogarth was probably the first artist to represent one of the intimate private theatres, often with amateur actors, which were then coming into fashion. Significantly, the play in question is Dryden's heroic tragedy: fashionable at the court of Charles II, it remained popular in aristocratic circles throughout the 18th century. Yet it was in this same year that Hogarth illustrated Fielding's farce, *Tom Thumb*, with a grotesque engraving caricaturing Dryden's tragedies. For *The Indian Emperor* he chose, or was ordered to choose, a scene fundamentally similar to that of his *Beggar's Opera*: Cortez, commander of the Spanish forces in Mexico, stands, like the highwayman Macheath, between the two women who love him—no longer just Polly and Lucy, but two Indian princesses. Accommodating himself to the different social and literary milieu, Hogarth has, however, radically changed his treatment. The violence and ruthless sincerity of *The Beggar's Opera* give way to an all-pervading mood of quiet discretion, unbroken by any strident note. The mannered, measured, moderately baroque gestures of the young actors

accord with the 17th-century Spanish costumes. The typical Hogarthian motif of a child in the audience, amusing itself oblivious of the play, forms part of a charming group comprising the governess and another child, under the evident influence of contemporary, fashionable French engravings. Most probably Hogarth made use of the large published volume of engravings after Watteau's drawings of elegant society figures, but his treatment here is far more consistent and faithful to Watteau, in a thematic sense as well, than in *The Beggar's Opera* or *The Oratorio*. For the young Hogarth, *The Indian Emperor* is an extremely well-balanced, well-constructed composition in soft, simple lines, not unduly broken or disturbed by the detailed background decoration, which includes Newton's bust by Roubilliac on the mantelpiece.[35] Compared with the rather symmetrical, unrefined pattern of *The Beggar's Opera*, it is elegant, restrained and concentrated, though by no means schematic. The pleasantly unceremonious curtain in the earlier picture is in marked contrast to the sumptuous one here. The ingenious diagonal, forming the base of a triangle, into which the audience is skilfully welded in the left-hand bottom corner enables both stage and auditorium to be shown, the vertical of a female statue forming the transition between the two. Large chairs in the extreme right- and left-hand corners lead other diagonals deep into the picture. Within the left-hand triangle, the distinguished figures of the audience with their gently modulated gestures rise step by step from the small children by way of sweeping lines to the adults standing at the back.

Valuable insight into Hogarth's method of work is provided by glancing back from this elegant picture of 1731 to the rather popular engraving, *The Beggar's Opera Burlesqued*, of 1728. Even when every allowance is made for their great difference in style, an undoubted formal similarity exists between the two schemes: in the engraving the crowds advance from several directions towards the two stages, placed respectively in the centre and on the right; the spectators on the left, the back wall and the far-off stage of the engraving have been picked out of the engraving to form the principal components of the composition in the picture. Apart, however, from this resemblance in their 'skeleton' schemes, the difference between the two could scarcely be greater. Thus if Hogarth used similar rudiments of composition for several of his works, he could entirely change the character of any one of them through complete differences in form and content to suit the social stratum concerned. He followed this procedure throughout his career. It makes no difference whether one holds that he caricatured his own compositions or, as in this case, for chronological reasons, one has to say that he elevated his caricatures. The popular-satirical engraving and the distinguished picture are both facets of his art.

In 1742 Hogarth produced one of his most spirited etchings, *The Charmers of the Age* (Pl. 102a), in which he gave vent to his feelings against the vogue for foreign dancers in England. It is a combination of caricature and stage record. Two famous dancers, Monsieur Desnoyer and Signora Barberini, are leaping high in the air whilst on both sides of the stage enthusiastic spectators are frantically applauding the foreign guests. In the arrangement of the stage and the spectators, one can easily detect features of *The Beggar's Opera*, *The Beggar's Opera Burlesqued* and *The Indian Emperor*. But this composition cannot simply be regarded as a mature summary of Hogarth's works around 1730. Qualities customarily called 'French', that is charm, vividness and painterliness, which had already appeared in these early works and in drawings for them, particularly one at Windsor for *The Beggar's Opera Burlesqued*, are here developed to an unexpected degree. These qualities were inherent in Hogarth but were strengthened by an increasingly direct contact with French art through the great engraver, Gravelot, who was working in London at the time. This etching, directed against a French dancer, reveals better than

anything else Hogarth did that even if, as a John Bullish patriot, he was anti-French, he did not carry this sentiment into his art.

During the 'forties, however, Hogarth embarked on more ambitious projects as an artist of the theatre. It was somewhat in continuation of the elevated style of *The Indian Emperor* that, almost fifteen years later, in 1745, he painted another scene from Shakespeare, namely Garrick as Richard III (Walker Art Gallery, Liverpool) (Pl. 98c). This large, imposing work with its single figure—entirely different in scale alone from the small yet many-figured *Beggar's Opera*—was painted for a distinguished art collector, Mr. Duncombe, owner of Duncombe Park and uncle of the Earl of Feversham, and for it Hogarth received the large sum of £200. As he was proud to record, this was the highest sum ever paid to an English artist for a single portrait. Since the censorship introduced in 1737 precluded the staging of satirical and topical plays and since the influential upper circles, including the bourgeoisie, were becoming genuinely interested in learning and literature, performances of Shakespeare, which had never entirely ceased, became much more general. *The Spectator* and even Fielding had prepared the ground for this enhanced cult of Shakespeare.[36] Through his art, in which elaborate, dramatic characters played an outstanding role, Hogarth too can justly be claimed to have played a considerable part in bringing about a serious Shakespeare revival. Garrick's Richard III, staged at Lincoln's Inn Fields in 1741, was the great success of the town. Unlike that achieved in its time by the farcical *Beggar's Opera*, which appealed to the widest circles, this was rather a success engendered by a cultured public. A great struggle, involving somewhat varied sections of society, was in progress between Rich, producer of *The Beggar's Opera*, pantomimes and other spectacular performances, and the more high-minded Garrick.[37] Yet it is noteworthy that Shakespeare should now in the 'forties prove the great theatrical event and that it should again be Hogarth, a genuine admirer of his 'infinite variety', who depicted a scene from his play. The significance for him of this particular subject becomes clear in a passage in which he qualifies his opinion that comedies, meaning his own cycles, should be placed above tragedies: 'I will admit that with the drama of Shakespeare, and action of Garrick, it may be a nobler species of entertainment than comedy.'

In the picture Garrick is shown at the climax, when Richard in his tent has awakened from a horrible dream on the night before the fatal battle. But this is far from the conventional rendering, with the vertical shape customary for the portrayal of an actor dressed up for a certain role and isolated, as if cut from the scene as a whole, such as is usually to be met in French and English painting. Hogarth has chosen a spacious background embracing the entire width of the stage and emphasised by the oblong shape of the picture. No longer is the stage depicted in a minutely detailed, documentary way as in *The Beggar's Opera*; nor is the theatrical decor recognisable as such. Consequently the work not only acquires the unity already achieved in the Falstaff picture but assumes the character of an historical painting,[38] in the background of which is a Salvator Rosa-like scene of warriors around a camp fire. It is unlike anything in art before it; for here Hogarth represents not so much the exterior likeness of an actor as his actual performance in the play. This is as much a result of the more elevated theatre and the type of actor portrayed[39] as of the artist's own development, of his desire to gratify a more fashionable public and to acquire greater respectability. Garrick's role and Hogarth's picture are parallel aspects of the same line of evolution.[40]

Richard III is in a rather pompous, rhetorical baroque-rococo, more violent than that of *The Indian Emperor*, in order to suit the particular subject and setting. The composition is built up out of long diagonals, initially of the two which intersect through Garrick himself and which are

produced by his agitated pose and the calculated inclination of his body to the right. It is more *mouvementé* than *The Indian Emperor*, yet it is an elegant composition adapted to the taste of high sections of society in the middle of the century, just as was *The Indian Emperor* at a slightly earlier date. For the taste of the French and German aristocracy at about this time for a less restrained rococo found its parallel even in the more moderate English climate. Apart from its manifestation in painting and many fields of decorative art, such as porcelain and furniture, the new style favoured by the upper classes found particularly eloquent expression in the sumptuous baroque tombs of the aristocracy. This especially applies to those produced by Roubilliac, for whom both Hogarth and Garrick had the greatest admiration; in fact Garrick's pose doubtless resembles some impetuous, baroque figure of Roubilliac.[41] The picture was painted two years after Hogarth's visit to Paris; the engraving after it was done jointly by Hogarth and a Frenchman, Grignion, a pupil of Gravelot.[42] The elegant colours of Garrick's garments and of the surrounding drapery are throughout highly reminiscent of French rococo, in so far as an identification of the repainted central part with the original colours can be risked. The blue bedspread in the foreground calls to mind the compulsory blue of French Royal portraits; the pink upper part of Garrick's sleeves and their yellow lining are not far distant from French painting. Yet the dominant colour of the figure, the bright green of the doublet and trunk hose, strikes a rather original note. As regards the general elegance of both Garrick's and Hogarth's performance and conception, it is perhaps worth recalling that, in Hogarth's time, Shakespeare was not performed in the rugged original text but in a greatly altered, polished and graceful version more in accordance with French rules of unity.[43] In the case of *Richard III* the version used was by Cibber; in other cases it was often by Dryden, that most baroque of Restoration poets.

It would, however, give a wholly false impression simply to designate this as a conventional baroque-rococo picture. Like Garrick's acting, it is only partly so. Yet Garrick's acting was as new as the great naturalistic English novels of the time. He broke with the old declamatory style, so monotonous, unnatural and formalised, which drew no distinction between the various roles; he spoke Shakespeare's lines in such a way as to give them back their meaning and was thus able to create unified, human characters in great variety.[44] Garrick's favourite role, his Richard III, no longer appeared the abstract, bloodthirsty monster of previous interpretation but assumed the grandeur of a tragic figure, of a rich, complete individuality. Only after his time was it possible to see Shakespeare's characters in all their amplitude.[45] A great creator of characters himself, Hogarth appreciated Garrick's similar capacity, his agile play of features, by means of which the character was largely built. Similarly, Garrick's appreciation of Hogarth was probably largely due to the artist's ability to render the mobility of features.[46] A contemporary description of Garrick's acting in this particular scene leads us to assume that Hogarth's picture justly catches the spirit of it and this is confirmed by the German, Sturz, who recorded his impressions of a performance.[47]

Just as Garrick's acting with its new features, the expressiveness of the face and hands, was far more realistic and varied than anything on the contemporary French stage,[48] so Hogarth rendered these new motifs in such a way as to reveal far more accurate observation of events on the stage than, say, the French rococo opera pictures do, with their vague theatrical effects.[49] Witness, for example, Garrick's open right hand stretched out towards the spectator, to form almost the centre of the composition; this expressive, dramatic use of Garrick's hands, as here depicted for the first time by Hogarth, remained a feature of later portraits of him by B. Wilson, Zoffany and Dance. For the rest, the tent itself, giving more the effect of drapery than of an actual

tent, is characteristic of the dignified style of the picture and owes something in its shape and ornaments to the most celebrated composition of the time which includes a tent, namely Lebrun's *Family of Darius before Alexander the Great* (Versailles), a scene of the Alexander cycle well-known to Hogarth.[50] But, generally speaking, Garrick's innovations as a producer and his multiplication of stage properties have also had their effect. Though Garrick was not yet in favour of genuine historical accuracy and local colour, which were still to come,[51] he ventured to convey atmosphere, particularly by means of costume, to indicate the character of the role as he saw it. He usually achieved this through some alteration in contemporary dress, but in *Richard III* his costume has a subtle, supposedly Elizabethan but in reality somewhat van Dyckian nuance.[52] He has dispensed with a wig and wears his own hair. There has even been a slight attempt to reconstruct the scene historically by means of such suitable objects as armour borrowed from the Tower,[53] a crown and a crucifix. Hogarth rendered all these selected objects brilliantly and precisely. The painting of the armour gives the impression of good Italian 17th century work and the rendering of the crucifix, the frame of which is painted in imitation of Rembrandt, is even more astonishingly effective. It is characteristic of Hogarth that when it really came to the point, he was not at all afraid of giving full weight to such Popish properties. Nevertheless a most important aspect of the picture is the deliberate subordination of detail, more than in *The Indian Emperor*, to the grand, unified composition in which Garrick's conception of Richard III dominates both theme and form.

In 1748 Hogarth did a ticket (Pl. 115a) for the masque of *Alfred* by Mallet and Thomson, a kind of English opera which was performed at Cliefden House before the Prince and Princess of Wales, with Quin playing the principal role of the hermit. So some reward came Hogarth's way for having strenuously nursed his connections with this circle, to which the two authors, both pensioners of the Prince, also belonged. Pitt, the empire-builder, and his political associates also had contact, on and off, with the Prince's clique: indeed the play followed the Prince of Wales' policy, being an apotheosis of the British World Empire, and *Rule, Britannia* was specially written for this performance. Hogarth's ticket was in the baroque, Italianising style with two conventional academic figures of Hymen and Cupid. It was in fact conventional-international to such an extent that it may have had many prototypes; it contains possible suggestions from Amigoni, whose types of children in his small mythological pictures are similar, or from Watteau's *Venus and Cupid* (*L'Amour désarmé*, Chantilly, engraving of 1727 by B. Audran), or more probably from a composition with the same theme by the equally fashionable, smooth Van der Werff. At any rate, the black chalk drawing for the figure of Hymen (Marquess of Exeter) is perhaps the most academically constructed of all Hogarth's drawings.

Garrick played an important part in Hogarth's life as a close friend and ready buyer of his pictures. Hogarth designed an extremely rich baroque chair for him as president of the Shake-speare Club, whilst it was Garrick who, when Hogarth died, collected subscriptions for his tomb-stone and, with Dr. Johnson's aid, composed the epitaph for it. In 1757 Hogarth painted a portrait of Garrick and his wife (Windsor) (Pl. 128a). Since his days with Peg Woffington, Garrick had grown increasingly 'grand', fashionable, almost official. So, too, had Hogarth and so, consequently, had the scheme of the actor-portrait, particularly when a double portrait of a reputable married couple was in question.[54] No longer was Garrick treated, as actors generally were, as a rather despised Bohemian; he was on good terms socially with (if also subservient to) the aristocracy, just as he was with the Reynolds-Johnson circle and even with intellectuals of the Paris salons and philosophical circles, whom his acting impressed. As a theatre director he had

raised the stage, for the first time in England, on to a plane of perfect respectability; at the same time he was a good, indeed a harsh, business man. Even his marriage in 1749 raised his social standing. Though originally a dancer, his wife had been a *protégée* of Lady Burlington and destined to marry a member of the aristocracy; even the King had unsuccessfully fallen in love with her. Hogarth seized upon a rather playful moment for the portrait: Garrick, seated at a table, is writing a prologue to Foote's comedy, *Taste*, the theme of which followed Hogarth's well-known theory that collectors were wont to buy expensive, 'dark' Italian masters whilst neglecting contemporary English art. His wife, approaching silently from behind, attempts to snatch the pen from his hand. Yet despite this intimate, as it were middle-class motif, Garrick was Garrick and consequently the composition is surprisingly elegant and well thought out. It is in fact one of the high-lights of Hogarth's portraiture; on few likenesses did he expend such care, with such success. Though clearly and neatly built up into a pyramid, crossed by parallel diagonals, with its dominant waving lines, the impression given is entirely unschematic. The seated Garrick, dressed in blue, forms the solid base and the composition is crowned by the glittering, brilliantly-painted yellow-white of his wife's dress and her rippling lace, whilst the neutral brown of the Chippendale chair, on which the golden rays of the sun are beginning to gleam, marks the transition. Yet in the brown of the chair just as in the green of the writing desk there is something of a new post-rococo realism typical of Hogarth in these years. Hogarth's psychological approach does not appear to have diminished, though perhaps some generalisation of expression has taken place[55] in Garrick himself with his gesture of 'inspiration'. The motif of a man writing at his desk interrupted by a woman who touches his pen is taken from a picture, extant to-day only in an engraving, representing the poet laureate, Colley Cibber, also a playwright and actor, with his daughter as his Muse (Pl. 129b)[56]; it was painted while staying in England by J. B. Vanloo, the fashionable French portraitist.[57] Retaining the idea of inspiration but giving it a jocular slant—the 'muse' is not guiding the poet's hand as in the French picture but rather hindering his writing—Hogarth renders the motif more intimate and travesties the foreigner Vanloo.[58] Yet, despite this satirical allusion, he has used a baroque composition of somewhat similar organisation. The group as a whole has been made even more compact but has been given looser, freer, more individual poses, while the large curtain and imposing architectural background have been omitted. The pattern is elegant and intimate at the same time.

The intimacy and realism of this portrait is all the more striking when it is confronted with another double portrait of similar formal arrangement by Hogarth's contemporary, the Bavarian court painter George Desmarées, an imitator of the French court painters and of Piazzetta. At about the same time he did a portrait of himself seated at his easel, assisted by his daughter as the Genius of Painting (1760, Munich) (Pl. 128b). Desmarées may also have been acquainted with Vanloo's Cibber portrait from an engraving. Although in this self-portrait he naturally discarded the grandeur appropriate to his court likenesses, his picture, compared with Hogarth's, is of a more generalising, almost of an ethereal, character.

As late as 1762, Garrick acted at Drury Lane in a comic interlude, *The Farmer's Return*, which he had written himself. He dedicated the play to Hogarth, who did an engraving of the scene in which Garrick, as the farmer, returning to his cottage from the Coronation of George III, astounds his wife and daughter by accounts of the marvellous events in the capital (Pl. 139a). This was far from the elevated genre of Richard III, but Garrick, even in a comic role, moved with grace, maintaining the air of a man of the world. The days of Hogarth's grotesque, popular illustrations to Fielding's burlesque plays were now far distant and the stage representations of

his last twenty years seem to be dominated by Garrick's imposing and distinguished position in English theatrical life. These, like the whole output of his late phase, tended more to conform with the taste of the upper social strata; his baroque style assumed an increasingly clarified, less over-crowded character. In fact, in his last years, from which this engraving dates, his style was concentrated as never before. In *The Farmer's Return* he presents a most skilfully compact composition, equivalent to his own and Garrick's position of social repute, for he felt himself honoured by the play's dedication. Yet to catch the atmosphere of the scene, he has fully retained the realistic and jocular spirit of which he was so great a master and discarded the ceremonial essential to 'historical' compositions of the type of *Richard III*. The result is a balance of three or four figures in an astonishingly concentrated yet very realistic baroque; the swirling movement, for instance, of the farmer's wife spilling beer is very monumental, typically baroque and at the same time based on accurate observation. The two main figures—the farmer sitting smoking and his wife about to give him beer—resemble some of Metsu's in their external features. If it is true, as seems quite possible, that motifs of Metsu made an impression on Hogarth, then they have been greatly unified and monumentalised. Metsu's own compositions, of the type of *The Artist and his Wife* (New York), or *The Smoker by the Chimney* (Dresden) (Pl. 139b), are, by Dutch standards, unusually concentrated, sometimes even near to Vermeer. Yet, in Hogarth's picture, the lines have become more simplified, even slightly straightened; a few selected objects, each in its place, are set widely apart. The whole composition is so carefully reduced to its essentials that, if such a definition is sought, it might be termed baroque-classicism, or even rococo-classicism. In the neatness of this concentrated style an influence may be traced in French book illustrations, less perhaps in those after Charles Antoine Coypel, than in those after Gravelot. French elegance has been superimposed on English solidity and grotesqueness, just as it was in Garrick's acting.

This more or less chronological analysis of scenes from plays which Hogarth portrayed forms a kind of stylistic parallel to the development of the English stage itself, and also aims at shedding light on Hogarth's ideas on the theatre and his social-artistic aspirations in terms of style. It may be of interest to add two compositions from the 'thirties, that is, from the years between *The Beggar's Opera* and the Garrick period, which do not strictly speaking render scenes from plays but which most vividly illustrate the everyday life of actors in a completely novel manner; the original picture of one has survived, of the other only the engraving.[59] Hogarth was probably the first artist in Europe to interest himself in the humdrum, very primitive life of actors and actresses.[60] He had no illusions about that kind of livelihood; even in his youth he had done the benefit ticket for Spiller, an actor in reduced circumstances. But after Garrick had raised the profession, at least for the lucky few, to an unexpectedly high social level, Hogarth, by then very respectable himself, devoted most of his attention to the new type of actor, particularly to his renowned personal friend.

Southwark Fair (original picture, 1733, Bowdoin College, Brunswick, U.S.A., engraving from the same year but published 1735) (Pl. 44a), represents companies of actors within the framework of a famous popular fair and surrounded by the usual acrobats, conjurors, mountebanks, quack doctors and large crowds out for amusement. This early composition, whose ultimate source was of course Callot's *Fair of Impruneta*,[61] links up with pictures of fairs painted in England by Dutch and Flemish immigrants of the older generation such as Jan Wyck, E. van Heemskerk, P. d' Angelis and F. de Paula Ferg. In these pictures actors and their large show-cloths already play a certain part, though not so great as here. Hogarth may also have been acquainted with previous English representations of Southwark Fair of a more popular,

topographical nature; the general disposition and individual motifs of his composition bear some resemblance with a drawing of 1640 in the Batsford collection. In spite of Hogarth's over-crowded composition, typical of his early work, the various companies of actors stand out clearly, poised above the crowd on improvised platforms fixed to the façades of the houses. Each company is distinctly characterised; in the engraving the one on the left, 'Cibber and Bullock', is performing *The Fall of Bajazet* (Pl. 44b), whilst, as a pun on the title, the scaffolding is collapsing, carrying with it the actors in their heroic costumes. Hogarth particularly appreciated the dramatic effect of topp-ling figures and objects, whether upon the stage itself or in works by other artists. In this particular instance he was perhaps inspired by Coypel's representation of Don Quixote demolishing a puppet show (Pl. 45b), a scene which he liked so much that he reproduced the figure of Sancho Panza from it in *The Analysis of Beauty*; an engraving after Coypel's scene was even published in the 1725 English edition of *Don Quixote*. In it the dolls are falling in a similar manner to the actors in *Southwark Fair* and all the scenery is tumbling down after them. Even the motif of the violin falling from the accompanist's hand is repeated. On the show-cloth Hogarth reproduced, in a slightly grotesque vein, an etching, *The Stage Mutiny*, by Laguerre the younger, a popular painter-actor and a friend of his; it alludes to the quarrel then in progress between actors of Drury Lane, led by Theophilus Cibber dressed up as Pistol, and the managers of the theatre. In the centre background of Hogarth's composition the actors of another company appear in their stage costumes on a gallery, beckoning the public to view the rehearsal—a motif already present in E. van Heemskerk, in Picart's engraving, *Le Théâtre de la Foire*, of 1730—and forecasting Daumier's celebrated *Saltimbanques* (Pl. 45a). They are about to act Elkanan Settle's *Siege of Troy* and a huge show-cloth bears the wooden Trojan horse as an advertisement; for the old Restora-tion playwright and poet laureate, Settle, had been obliged at the end of his life to earn his living by writing popular plays and drolleries for fairs. Upon another gallery Punch on horseback and Harlequin are acting the traditional comic scene in which Harlequin's handkerchief is stolen by the horse; in progress near by is a Punch and Judy show. Actors, a drummeress amongst them, mingle with the crowds advertising the performances, and one of them, in full stage costume, is about to be arrested for theft.

Never before had the young Hogarth set himself such a bold pictorial task of representing so large a crowd, of inventing and accumulating so infinite a variety of agitated motifs on the ground and in the air. The eye is constantly drawn to new focal points of interest and yet the baroque balance of the whole composition is at least partly achieved. Equally daring for a novice is the way in which the paint is rapidly splashed on, for instance in the group of the falling actors' company, though the object is not quite achieved.

The second, somewhat later composition, *Strolling Actresses Dressing in a Barn* (original picture destroyed; engraving 1738) (Pl. 61a), represents a kind of rehearsal. The print had political implications and was intended to evoke sympathy for strolling, non-licensed companies, whose activities were impeded by Walpole's Licensing Act of 1737—directed against Fielding's plays because of their anti-Walpole bias: in the picture a copy of the Act is lying on the bed. The last rehearsal has been enlarged in Hogarth's composition into a representation of the life of a com-pany of players. It is very far from the gallant, glittering, romantic milieu of actors as conceived by Gillot and Watteau. In a dilapidated country barn, a strolling company is rehearsing a play. This cannot, however, be Coffrey's frequently staged ballad-opera, *The Devil is to pay in Heaven*, as is generally supposed, since the gods and goddesses here presented and recorded on the programme lying on the bed do not appear in Coffrey's piece. The tragi-comic life of such a

company, the incongruity between the miserable surroundings in which these poverty-stricken actors have to live and their roles as celestial figures, forms the main theme of the engraving. There is no call here for the respect later shown in *Richard III*; the grand, heroic gestures of these antique deities are mocked, however jovially.

This spirit of daring, middle-class flippancy, fearless in ridiculing the established idols of a bygone culture, was rather exceptional in the art of the time; it was more lively and topical than the average versified travesties of antique literature which now and then appeared, and was a prelude to Daumier and Offenbach. In this 'heaven reversed', some trace probably remains of the old pattern of the popular engravings of 'the world reversed'. In the centre of the engraving a scantily clad actress, almost a travesty of the antique goddess, rehearses her role of Diana with broad, ribald gestures. In the right-hand corner, in highly unsuitable surroundings, Juno is declaiming whilst the Goddess of the Night mends her stockings. Juno's gesture resembles the one used later with more serious purpose for Garrick's *Richard III* and again, with comical intent, in *The Farmer's Return*; this clearly indicates how close travesty and its opposite were in Hogarth's mind and how easily he succeeded in giving old motifs new meaning by placing them in different settings. Flora uses a tallow candle to pomade her hair; Jupiter's eagle pushes her mask aside to feed her baby; Amor, on a ladder, fetches stockings down from a shelf; the pannikin lies on the property crown; two child-actors, partially dressed as small devils, drink beer from the 'antique' altar. This last motif seems to be an evident parody of the two children assisting at a pagan sacrifice beside the altar in Raphael's cartoon of *The Sacrifice at Lystra* (then at Hampton Court). It is impossible to take in at first glance the whole galaxy of figures or the fantastic quantity of objects displayed; *The Indian Emperor*, *Richard III*, and *The Farmer's Return*, although dating from different periods, were all destined for the upper circles of society and are presented to the eye as an immediately comprehensible whole. But *Strolling Actresses*, like *Southwark Fair*, must be studied detail by detail and, as it were, read off; this was a popular milieu, in which Hogarth could let himself go in riotous minutiae. Far distant is his early, rather isolated and tentative attempt at concentration in *The Indian Emperor*; far distant also his later efforts in the same direction during the Garrick period. But although something of the popular engraving's method of story-telling is preserved, it has been made more vivid and raised to a higher artistic level. Even if the seemingly unbridled baroque composition bulges and billows in its swirling course, so that its several sequences cannot at once be taken in, by comparison with the far more clumsily constructed and more consistently popular theatrical engravings of the Gay and Fielding period, or even with the less unified and more teeming *Southwark Fair*, Hogarth has attempted, not entirely without success, to subordinate the mass of popular motifs to the pivotal centre of the half-nude actress.

Perhaps the nearest precursors in European art for rendering such a milieu are Ostade's crowded, dilapidated interiors of barns, although the Dutchman's repetitive themes have an air of greater indifference and his compositional patterns are less baroque and less rich. Individual motifs in Hogarth's scene, such as the broken roof, the pile of lumber and the washing on the line, reflect Ostade; the old woman in the background recalls Steen. Nor is it surprising also to find features from Dutch engravings. To enhance the sense of turmoil, following the Bosch tradition, the inanimate objects in the background take on an air of life; the washing and the property dragons assume the shape and expression of human faces.

Given his intense interest in the theatre and popular amusements of all kinds, one would perhaps expect Hogarth to have been the first well-known European artist to assist in the decoration of a

place of entertainment, namely Vauxhall Gardens, opened in 1732. He made suggestions for paintings to his friend, Jonathan Tyers, the proprietor of the establishment, of which Frederick, Prince of Wales was to become patron. He did a design from which silver entrance tickets were struck and for his labours was rewarded with a permanent golden entrance ticket. His picture, *Henry VIII and Anne Boleyn* (1729), was hung in the Rotunda. Later he allowed his friend, Hayman, to paint copies on the spot of his cycle *Four Times of the Day*. One of the pictures is dated 1736, the engravings, 1738; the original *Noon* and *Evening* now belong to the Earl of Ancaster; *Morning* and *Night* are in the Collection of Viscount Bearsted, (Pls. 58a–59b). Whether or not the artist had designed them with Vauxhall in mind, the choice is certainly typical: four lively scenes from everyday life in London. The singularity of this cockney-bourgeois cycle stands out clearly if it is compared with Lancret's series of *Four Times of the Day* (National Gallery), painted and engraved at about the same time and representing conventional scenes from the gallant life of the aristocracy. Hogarth's scenes take place on a Sunday, at different times of the day, in locations familiar to Londoners, and they are rendered with Hogarth's customary verve, brimming over with striking motifs. In *Morning*, a cheerful group emerges from King's coffee-house in Covent Garden; in *Noon*, a motley congregation leaves the French Chapel in Hog Lane; in *Evening*, a Londoner and his wife return home from an excursion to Ealington, in drenching rain; in *Night*, near Charing Cross, the Salisbury Coach has been over-turned by a bonfire.[62]

Vauxhall soon became a great centre for masquerades, an entertainment recently introduced and much in vogue. At an earlier date, in 1724, in a popular informal style, Hogarth had mocked the taste for this amusement in preference to the serious theatre in his engraving, *Masquerades and Operas*. Folly, said to represent the future George II, is shown hastening to a masquerade. Here, as in the so-called *Masquerade Ticket* (1727; Pl. 5b), Hogarth takes to task the foreign organiser of the masquerades, the Swiss Heidegger, a royal favourite.[63] Following the simple, documentary, rather frigid manner of his *Beggar's Opera*, he renders a dance of masqueraders and by means of symbolical allusions—for instance, thermometers gauging the motion of the dancers—he strikes at the new-fangled fashion.[64] The playful Lion and Unicorn placed over the clock are a further reminder of the future king's predilection for masquerades. Above the door hangs a baroque mythological picture showing the arche-type of the dancing crowd, the wild dance of a faun.

Echoes of Callot and Gillot are quickly discernible in this engraving and tend to slacken the general rigidity. The motif of the dancing faun, for instance, derives from figures of Callot's grotesque Balli cycle, as do many members of the crowd in their *Commedia dell'Arte* costumes. A similar influence from Callot can also be recognised in the figure of the devil and in various types of harlequins and masqueraders. This is not surprising. Callot's artistic education in Florence had been largely determined by theatrical performances and all kinds of public shows; as their chronicler he had, in his engravings, contributed a great deal of new artistic material for such representations and indeed was the first to establish in the plastic arts consistently and meticulously, the types of the *Commedia dell'Arte*. Hence a direct or indirect reflection from him can be sensed everywhere in popular engravings and in many artists with similar interests in the stage. This applies to those who arranged or depicted court festivals or Italian comedies in the 17th century, among them Inigo Jones,[65] and even to the more popular portrayals of harle-quinades or use of harlequin motifs in the early 18th century by such artists as Gillot and Hogarth.[66]

The apparent contradictions in Hogarth's attitude to the masquerades are less than might be supposed if the spirit of the times is borne in mind.[67] He loved any kind of entertainment and doubtless made full use of his permanent ticket for Vauxhall. Yet an outcry against the immorality of masquerades was already stirring in the 'twenties, particularly in ecclesiastical and middle-class circles, and the Bishop of London had preached against them. If Hogarth sometimes assumed a moralising attitude towards them, as he had done in the case of pantomimes and *The Beggar's Opera*, this was in part at least a necessary corollary to his wish to fall in with general opinion. But only in part, for, in the 18th century, people with a middle-class mentality like Hogarth and Fielding were always capable of adopting a negative attitude, serious and sincere, towards 'immoral' amusements like masquerades.[68] Though probably not averse to the amusements of the town in his early days as a playwright, Fielding had attacked the licentiousness of these entertainments in his first published poem, *The Masquerade* (1728), just as Hogarth had done in his *Masquerade Ticket* of the previous year. In his late phase as a responsible magistrate, Fielding took measures against them and wrote of their ill-effects in *Tom Jones* and *Amelia* no less than in his *Enquiry*. In Hogarth's *Marriage à la Mode*, the moral downfall of the Countess follows on her visit to a masquerade at the instigation of her seducer; significantly, the painted screen in the Countess's 'Levée' takes up, in a general manner, motifs from the *Large Masquerade Ticket*. In the second scene of *A Harlot's Progress* obvious disapproval is registered in the placing of a mask on the dressing table. At that time Hogarth had also planned a picture representing the *Ill Effects of Masquerades* (Pl. 73a): on his return home by night, a husband kills his wife and sister, mistaking them, in their masquerade costumes, for lovers. So it is that Hogarth's enthusiasm for the theatre must be set alongside his intense middle-class morality, without which even his representations of the theatre and of amusements cannot be understood.

V

The Early Phase

꩜꩜꩜꩜꩜꩜꩜꩜꩜꩜꩜꩜꩜꩜꩜꩜꩜꩜꩜꩜꩜꩜꩜꩜꩜꩜꩜꩜꩜꩜꩜꩜꩜꩜꩜꩜

OF his apprenticeship in the workshop of the silversmith, Ellis Gamble, Hogarth wrote: 'The paintings of St. Paul's Cathedral and Greenwich Hospital, which were at that time going on, ran in my head and I determined that silverplate engraving should be followed no longer than necessity obliged me to it. Engraving on copper was, at twenty years of age, my utmost ambition.' Thus at this early date, Thornhill's grand, baroque painting commingled with the craft of engraving in Hogarth's conception of art.

After a long apprenticeship, he fulfilled his ambition, probably between 1718 and 1720, of becoming an independent professional engraver on copper,[1] and during the 'twenties made his livelihood almost exclusively from this occupation. His desire to take up painting set a more difficult problem, there being no pictorial tradition in England other than that of Thornhill and portraiture. At any rate, in order to learn this *métier* as well, he entered Cheron and Vanderbank's Academy in 1720.[2] During the next seven or eight years, monumental art, reaching him through Thornhill and engravings of famous works, was blended in his own engravings with keen observation of everyday life and its comedy. Since he did not go abroad in his youth to study, he was obliged to acquire his knowledge of art in the widest sense almost exclusively from engravings. A certain number of foreign pictures which he saw later in England were no real substitute, and he was already forty-six when he visited Paris. He was of course acquainted with some famous engravings of the past, mainly after Leonardo, Raphael and Annibale Carracci, and probably with a few original creations such as Dürer's. But, unlike the dignified fresco and portrait painters in England, his interest in popular taste and topical events also led him to procure a good knowledge of Anglo-Dutch popular, political, satirical engravings. Callot's journalistic prints formed a kind of connecting link between these two very different traditions. Thus from the outset he was receiving stylistic suggestions from the most varied sources and one gets the impression that, depending on the theme and purpose of any particular composition, he started off from apparently quite disconnected points simultaneously; indeed, here is already displayed, in embryo, the stylistic complexity of his whole career.

The Early Phase

The unorthodox character of Hogarth's artistic education is further reflected in his early method of work, particularly in his unusual manner of drawing. When referring to his early training, he himself described the intensity with which he concentrated on details of everyday life: 'Be where I would, while my eyes were open, I was at my studies, and acquiring something useful to my profession.' And his famous remark: 'I have ever found studying from nature the shortest and safest way of attaining knowledge in my art' implied drawing from nature only to a relatively small extent, referring far more to keeping his eyes open. Indeed, as a rule he did not make careful studies on the spot and few such drawings by him have survived. Nor was he in the habit of carrying a sketch-book about with him, although in *The Gate of Calais* he represented himself drawing the gate in his sketch-book. From time to time he made tiny thumbnail sketches which he may have transferred to paper and later introduced into his works. He drew in the life-school occasionally, especially in his youth, but did not favour regular attendance.[3] He seems to have been too impatient to spend a great deal of time learning 'scientific' drawing, systematically studying the interrelations of the various parts of the body. In fact his drawings were intended to capture action and movement rather than form and structure.[4]

This habit of not drawing methodically or assiduously after nature remained with him through-out his life, and sheds a most important light on his art. Judging from his works and *The Analysis of Beauty*, his powers of observation were greater than those of any other 18th-century artist; so penetrating and intense were they that his patience would have been overtaxed had he con-stantly made preparatory studies. As it was, he could afford to rely largely on his extraordinary memory to conserve his impressions until the moment came to pour them into his compositions. The few drawings he did were mainly for whole compositions, particularly those destined for engravings and therefore involving no preparatory paintings. For, incredible as it sounds, with few exceptions he painted straight on to the canvas, omitting any preliminary drawings altogether.[5]

It was again his excellent memory and acute powers of observation which led him to rely, particularly in his early period, on an almost anti-realist, mnemonic aid or, as he himself put it, 'a sort of technical memory', that is, on certain linear schemes or 'perfect ideas of the subject in my memory'. These schemes to which he reduced individual figures were perhaps originally connected in his mind with the heraldic designs he did as a silversmith's apprentice and were at the same time their successors. Of his attempt to learn copperplate engraving he wrote: 'To attain this it was necessary that I should learn to draw objects something like nature, instead of the monsters of heraldry.' In fact these newer schemes were a help to him precisely because he needed to direct his vast store of things observed into practical channels. Thus he could report of his 'technical memory': 'A redundancy of matter being by this means acquired, it is natural to suppose I introduced it into my work on every occasion that I could.' It can be assumed that these early linear schemes and even the still earlier 'monsters of heraldry' stimulated his increasing interest in formal problems. They are reflected in the baroque floridity of his lines and in his retention, throughout his life, of interweaving baroque-rococo forms. This was the path which finally led, in *The Analysis of Beauty*, whose characteristic sub-title was originally *Forms linearly considered*, to the formulation of the serpentine line of beauty, the ornamental character of which he never tired of praising.

Hogarth was always complementing the standardised attitudes resulting from his figure diagrams [6] with a tremendous realism based on experience, which was in its turn sustained by his keen memory. In fact, his manner of reconciling his pronounced sense of form with his over-whelming realism defines the sphere in which his art moved. This process of adjustment differed

greatly in different types of work and at different periods; for instance, his free, spontaneous drawings generally contain more baroque curves than his pictures. Taken all in all, his formal patterns, if inclined in his very early days to be schematic and on rare occasions almost submerged by his realism, usually grew into markedly individual and spirited baroque-rococo compositions. A motto for his development, which tended to embrace nature in all its variety without impairing the unity of the composition, might be taken from *The Analysis of Beauty*: 'I mean here and everywhere indeed, a composed variety: for variety uncomposed, and without design, is confusion and deformity.' The Hogarth of the mnemonic aid and the serpentine line, which he perceived everywhere in nature, felt no contradiction in writing elsewhere: 'Nature is simple, plain, and true in all her works; and those who strictly adhere to her laws, and closely attend to her appearances in their infinite varieties are guarded against any prejudiced bias from truth.' This is very different in its emphasis from the traditional, vague demand for an 'imitation of nature'.

Nothing could have been more significant of this middle-class artist than that he should have started as a designer and engraver of shop-cards. In fact, he was probably the first great artist to do so. Lacking means and social connections, the young Hogarth, unlike any other artist of his time, lived in an atmosphere of trade. He did shop-cards for his master, for another goldsmith, for himself as an independent engraver, for an undertaker, for a tobacconist—the majority shortly before or after 1720.[7] Most of these, including his own, represented allegorical figures akin to those of the 17th century. Soon, however, his work acquired more realistic features. Transitional examples are the Callot-like woman in a hat with a broad up-turned brim on the card for the goldsmith, Hardy, and the card, typical of the early Hogarth's mentality and of this kind of commission in general, advertising Miss Holt's Italian Warehouse in the Strand, where oil, wines and silks were sold (Pl. 4b).[8] This, as its elaborateness would lead one to expect, follows the lines of contemporary Dutch cards, particularly those by Picart,[9] and gives a clear insight into the middle-class conception of the relation of art to trade. Its motifs include large allegorical figures of Mercury and the City of Florence, and an English ship lading Italian wares, while the god of Trade forms the centre of the composition, which exalts and advertises commerce. To Mercury, who is carrying out her behests, Florence indicates a jar of oil and a number of her principal articles of export; porters are busily taking goods on board—motifs by means of which Hogarth demonstrates his knowledge of international commerce. The two allegorical figures are in the conventional international-baroque style, though Mercury appears slightly more mannerist than baroque. Apart from his right arm and a few other trifling details, his pose and attire are taken from the Mercury in Vaga's cycle of *The Loves of the Gods*, engraved by Caraglio (Pl. 4c). It is a standardised pose that the young Hogarth learned from these engravings which, with their erotic motifs, had been well known throughout Europe since Elizabethan times.[10] The composition is in the moderate baroque style customary for such purposes and even the figures of the porters are partially subjected to it; these 'real' figures and the ship itself are strongly reminiscent of Callot, for example his *Petit Port*. They equally remind one of Callot's follower, Stefano della Bella, who frequently used motifs with ships and men loading cargoes, and of engravings by his Dutch imitators.

While this shop-card of Hogarth's was more prosaic and realistic than contemporary Dutch cards of similar conception such as Picart's for a cloth manufacturer featuring Pallas Athene, in most other tickets, which did not concern commerce on a large scale or an artistic enterprise, Hogarth even dispensed with the baroque allegory. The undertaker's ticket representing a funeral

bears traces of Callot and Hollar. The ticket for Richard Lee, a tobacconist, the authenticity of which has sometimes been doubted, shows a merry party of smokers and drinkers seated round a table—the germ of the famous *Midnight Modern Conversation*. The ticket for Hogarth's friend, the boxer James Figg, apparently done as late as 1721, and executed, I think, by Sympson, shows a boxing-match about to begin.

The most bourgeois of Hogarth's shop-cards was perhaps the one he did for his two sisters in about 1725, when their draper's shop moved from Long Walk to Little Britain Gate (Pl. 8b).[11] Nothing could have more clearly shown up the young Hogarth's family circumstances. A staunch bourgeois couple lead two sturdy children into the shop where they are welcomed by the sisters, one of whom is already unbuttoning the little boy's overcoat. The incident and its representation are equally realistic and solid and in complete contrast to the rich, almost dramatic French-baroque ornamentation in the style of Marot which fills in the scene and is in its way just as significant.[12] The traditional, though infrequent, habit of representing the interior of the shop in question with its customers again comes from Holland and the theme cropped up sporadically in England between 1710–20. Hogarth had a big share in effecting the change towards a realistic representation of trade and wares, and the high artistic level to which he quite suddenly raised the genre can be seen by comparing his sisters' trade-card with similar ones by other English artists dating from this decade, such as one for a linen draper, Benjamin Cole, which is infinitely weaker. This little-known Anglo-Dutch line of development in trade-cards culminated in Hogarth.

It is tempting to confront Hogarth's shop-card with a contemporary parallel of another kind, Watteau's famous signboard of 1720 for the art dealer, Gersaint, especially since at that time this was far and away the most factual picture Watteau had painted since his very early work. A certain similarity in the disposition of objects may even be noted between Hogarth's card and the right half of the signboard, such as the position of the counter, the angle of the background and even the side-view of the saleswoman. This only springs, however, from the similarity of theme, since Watteau's picture was not engraved until 1732 and was thus unknown to Hogarth at the time. Even so Hogarth's card is certainly much closer in spirit and formal idiom to later French bourgeois art than to Watteau; the motif of the sister removing the child's coat foreshadows Chardin. This unpretentious card is one of the most uniformly realistic, documentary and matter-of-fact of Hogarth's works.

Hogarth also painted signboards in his early years—not, like Watteau, in isolated cases but as a matter of course, to augment his income. Chardin, the other great middle-class artist of his generation, began at about the same time by painting signs for a surgeon and a chemist. Hogarth did a double-sided sign for a paver: one side now belongs to Colonel M. H. Grant; the other is known only through an engraving done after the artist's death.[13] Whether one calls this work a picture or not, it is important in European art for its novel theme of men breaking up and repairing a pavement. The extant representation of the demolition of the paving is of great interest since it is probably Hogarth's earliest picture (Pl. 16a). It is typical of a beginner who has not yet really learned how to paint and who, to put it mildly, does not live in a very refined milieu. Yet it is the work of someone who has it in him to become a great artist. It is full of weaknesses but has a few excellent passages. It is boldly and brutally painted. The crudity and superficiality of the centre part, the caricature-like coarseness of the faces, is obvious; but great strength can be felt behind these shortcomings. New chords are struck by some of the colouristic details in the two figures on the right and left at the back, and the grey-brown vista of houses stretching far

into the distance is surprisingly broad yet delicately painted. With all its realism, baroque-rococo features are not entirely absent from the composition. Again, the forerunner of this unusually popular work, thematically and to some extent formally, may be sought in Holland. The engravings of Jan (1649–1712) and Caspar Luyken (1672–1708), illustrating numerous crafts, were published in book form as *Afbelding der Menschelyke Beezigheeden* in Amsterdam as late as 1694; a famous series, they were undoubtedly accessible to Hogarth, though his own paver is conceived quite differently from Luyken's.

Some hard study must have lain behind the nonchalant ease with which, at such an early stage, figures are grouped in, for example, the shop-card for his sisters. His two earliest large engravings, *The South Sea Scheme* and *The Lottery*, both of 1721, are clear pointers to the nature of this study.

The South Sea Bubble provoked a shoal of caricatures. But the greatest number appeared in Holland, following the failure not only of the South Sea Company but also, simultaneously, of its continental counterpart, John Law's Mississippi Company in France. Round 1720, in the universal atmosphere of wild, unbridled speculation, a particular type of caricature sprang up in Holland, the home of political caricature, and soon assumed international proportions.[14] The Dutch supplied not only their own market but also the French and English; moreover the English copied many of the Dutch prints, affixing English inscriptions to them. Yet, from the point of view of the development of English art, the importance of this upheaval which shook society to its foundations lies in the facilities it offered for the rise of political caricature after the Dutch pattern.

English political caricatures in the 17th century, issued in the interests of the middle class, were mostly engraved in Holland. For the intellectual and artistic weapon of caricature, originally wielded against the Papacy, in England as well as on the Continent, was chiefly employed after the Reformation by the more vital, progressive and intellectually superior elements of society against the older and more decadent ones. It became secularised in Holland in particular when the Dutch bourgeoisie, attacked by the French, used it against Louis XIV and his absolutist régime. The importance of this in the realm of political caricature cannot be overrated. The outstanding Dutch caricaturist, Romeyn de Hooghe (1645–1708), constitutes another link prior to the South Sea Bubble between the Dutch lampoon and English political caricature; de Hooghe was the propagandist in the strife between William III and both Louis XIV and James II, and he continued to work for William when King of England.[15]

Hogarth's *An Emblematical Print on the South Sea Scheme* (Pl. 3b)—to give it its exact title (pencil drawing for the complete composition in Windsor)—carried on the Dutch line as did all his early social and political caricatures. His treatment was close to the emblematic, popular Dutch caricatures with printed keys to individual motifs, whilst the traditional symbolism took on a more bourgeois form—Self-interest, Trade, Speculation, with traces of the mentality of the popular prints in which everyone tries to cheat everyone else. The focus of interest is a merry-go-round on which speculators are riding, operated by directors of the South Sea Company in a street close to Wren's Monument. Surrounding this central motif many groups and figures are identified by captions on the print and described in verses below. Although the rather loose pattern is reminiscent of the careless, informal grouping of Dutch popular engravings, a greater effort has clearly been made to link up the figures. Their liveliness and flexibility, in marked contrast to contemporary, rather primitive English popular engravings, is probably due to the artist's study of Callot and later continental engravers of topical events, particularly Picart, who was far and away the most important contemporary engraver in Holland and who himself gave

a French flavour to Dutch art. The various motifs of the composition are of a very eclectic nature in the sense of searching and learning. Some of them derive from religious painting (*Scourging of Christ*, *Playing at Dice for Christ's Mantle*) and are here applied to events of an allegorical yet realistic character. The motif of the three clergymen on their knees, playing a game of chance, though reminiscent of the casting of lots for Christ's mantle, might have been inspired by a group of three speculators executing a commercial transaction in Picart's engraving on the Law scandal (Pl. 22b).[16] Other motifs have come *via* Callot from the Bosch-Breughel stock of Dutch popular engravings (monsters with birds' legs, devil).[17] Perhaps of most interest are direct borrowings from Callot, a strong undertone of whom lingers in many late 17th- and early 18th-century Dutch engravings of topical events. The allegory of Honesty, attended by a clergyman, being broken on the wheel by Self-interest, is taken from *La Roue* in Callot's *Misères de la Guerre* (Pl. 2a). Even the attitude of the executioner with raised club is identical. The comic group of South Sea Company speculators poised in mid-air on wooden horses is reminiscent of a similar motif in an anonymous Dutch engraving on the Law scandal, dated a year earlier and well known in this country; this, too, shows a horse-drawn merry-go-round with speculators riding in boats; hence its title (in the original Dutch): *The Actions and Designs of the World go round as if in a Mill.* Yet in Hogarth this same feature, whether borrowed or not, is a transposition into the English popular style of Callot's dreadful motif of the gallows in *La Pendaison* of the same series (Pl. 3a); in both Hogarth and Callot a ladder is placed at precisely the same spot, which confirms this suggestion. In Callot the ladder leans against the gallows as a priest consoles the dying man, whilst in Hogarth a figure is climbing it to join the equestrian speculators. The untold richness and, for England, even as late as this, the novelty of Callot's cycle must have attracted Hogarth, while from individual scenes he could learn how to loosen and disperse his masses.

The same year, 1721, Hogarth did an equally allegorical companion engraving, *The Lottery*, (Pl. 2b), directed against the hazards of lotteries as a means of acquiring wealth and commending steady work in contrast; here he followed Addison's attitude in *The Spectator* (1711), in which he drew attention to the superstitious manner in which omens were taken to indicate a winning number. This engraving formed part of the propaganda drive against state lotteries, instituted in 1711 by the Tory Harley in defiance of the Whig-controlled Bank of England. Indeed in 1721, after the *débâcle* of the South Sea Bubble, the Whigs temporarily prohibited these lotteries on moral grounds.[18] Hogarth's composition shows the interior of a building arranged as a state lottery with wheels on the platform whilst an explanation of the various allegorical figures is inscribed beneath, as in *The South Sea Scheme*, in the traditional manner of topical and popular engravings. The usual mythological gods and goddesses and the traditional medieval allegories were still used at this time not only in the popular emblem books but also in such works as Thornhill's ceiling paintings. However, in Hogarth's print the significance of these figures has been transmuted in a novel spirit and allegories of a new bourgeois character now appear, seemingly inventions peculiar to the English situation.[19] The pedestal on the platform is crowned by the figure of National Credit, for whose glorification the whole composition was designed,[20] and beneath which Britannia is placed surrounded by emblems of her wealth; other allegorical figures, similar to those in Addison's article on the same theme in the *Spectator* (1711), are represented: Industry, Fraud, Wantonness, Sloth, Fortune, Misfortune. The figure of the Arts, seated on the ground, leaning on a pile of books as she draws geometrical figures with a compass, harks back to Heraclitus leaning on a block of stone in Raphael's *School of Athens*, whilst the diagonal posture of Pleasure is slightly reminiscent of Diogenes in the same fresco.

These borrowings provide a clue to the general structure. The young artist who has here built up an exceptionally monumental pattern, has taught himself from Raphael's superbly balanced composition no less than from Thornhill's baroque frescoes. A more pompous and theatrical effect is achieved by surrounding his figures on three sides by whirling draperies. Yet some relationship also exists with Dutch engravings, whether political or book illustrations, and more particularly with Callot. Although at least one is borrowed from Raphael, the allegorical figures have a rather grotesque, even popular character; the figural idiom combines mannerism with some baroque and has gleanings from Jan Luyken, the best-known Dutch illustrator of the Bible and of religious-moral books in general at the end of the 17th century. The Callot streak in Luyken is so strong that many of his engravings can be looked on as baroque monumentalisations of the earlier artist. Shades of Callot are perhaps even more evident in the pointed, mannerist, *chiaroscuro* contrasts in Hogarth's preparatory pen, ink and wash drawing for the complete composition of *The Lottery* (Windsor). Yet, despite these heterogeneous features, so unlike Raphael in style, it is not surprising that for motifs and effects the young Hogarth should have drawn not only on the patriotic-mythological frescoes of Thornhill but also on one of the most internationally famous of compositions, in order to give artistic expression to the new economic creed.

Thus in the same year, 1721, a decisive year in his formation, the young Hogarth published two engravings of different character, and a certain dualism, though never clear-cut, was to remain a permanent feature of his art. *The South Sea Scheme* was a topical satire in the vein of Dutch caricatures; *The Lottery*, embodying lofty principles, was in a rather grand baroque. In the first, he learned and borrowed from Callot; in the second, despite the Callot contacts, preponderantly from Raphael. These two may appear curious company, yet it is precisely this combination that illumines Hogarth's situation in an artistically as yet unmoulded England. Raphael's fame was unrivalled, whether in classicist or baroque schools throughout Europe, and his work was naturally familiar to Hogarth after he entered Cheron and Vanderbank's Academy and especially after he came into close contact with Thornhill. Raphael's was the given monumental art and if, in Hogarth's day, any great continental art was easily accessible through engravings, it was this. Callot, on the other hand, with his journalist's interest in contemporary life and ordinary people, was bound to make a great impression on Hogarth; and as an engraver he could be studied more easily and directly than any continental painter. He stood at the junction between the mannerism of the 16th and the baroque of the 17th centuries, and his art was open to interpretation either way. Only in his early phase did Hogarth retain Callot's elongated, mannerist proportions, but Callot's favourite, undulating *repoussoirs*, often many-figured and darkly silhouetted, which could be used in mannerist or in baroque compositions, he employed to the end. In Callot, too, a duality of content indicated that, while he worked for the courts of Florence and Nancy, depicting their ceremonies and entertainments, he also recorded the amusements of the lower classes. Although Hogarth was greatly attracted to Callot's popular features, he was not unsusceptible to the elegant traits of his mannerism, and the borderline between these two is often impossible to draw.

In fact, Callot's mark on Hogarth was so clear in certain instances, such as his representations of the theatre and his shop-cards, that it was the main influence of which his contemporaries were aware.[21] Even more important than outright borrowings are stylistic recollections in motifs as well as forms of a more general nature. For behind these resemblances lay far more than a mutual interest in theatres and entertainments; indeed, a certain historically conditioned affinity

existed between these two, since each lived at rather similar turning points in history. As a result Callot often comes to mind when one faces Hogarth's most original works.

When Callot was a court artist, the high-born spectator was beginning to take an interest in the lower orders and in their representation, even if only as quaint, burlesque figures on the stage. In his other role as a popular artist he more than satisfied this interest by the more democratic medium of the etcher's needle. Beggars, if somewhat picturesque ones, were among his novel, more documentary themes and had acquired sufficient importance to be treated in a full series. In consecutive scenes he systematically represented the dreadful events of everyday life, the miseries of the Thirty Years' War (*Misères de la Guerre*),[22] where soldiers no longer appear in the traditional heroic light, the same as in the *March to Finchley*. Huge crowds at fairs are depicted with their dress, manners and attitudes given in the minutest detail, and unusual aspects of gipsy life. When a play or some other spectacle is portrayed, Callot like Hogarth is at once attracted by the public taking part; his audiences, at first very courtly, become increasingly infused with ordinary types. Though much of the grotesque, late medieval spirit still lingers on (*Temptation of St. Anthony*, Pls. 7a, b, *Gobbi*) linking him with Brueghel and even Bosch and thus, on the popular side, again with Hogarth, the vast wealth of Callot's new observations was not only revolutionary in his own time but, as raw material, still had its effect in Hogarth's period. His *Fair of Impruneta* alone, with its mass of narrative detail, inspired both by the actual event and by a contemporary play representing it,[23] was the starting-point for most European, particularly Dutch and Flemish, pictures of fairs in the 17th century and, however altered, transposed or compressed, was still the ancestor of Hogarth's *Southwark Fair*.

Hogarth lived at another turning-point in history as radical as Callot's epoch, when the middle class began to represent itself and the surrounding world with a hitherto unknown breadth, viewing itself critically from the standpoint of its new outlook and drawing on this vast new wealth of material. Probably no other artist of his time embraced such a wide field of ordinary life as did these two innovators. Taken individually, even the Dutch artists of the 17th century usually specialised in a limited thematic sphere, and often took up only one of Callot's many motifs. A searching and pervasive spirit of discovery, which appealed to both Callot and Hogarth, was combined with a common outlook which, even if one refrains from calling it democratic, was of a levelling character. It is possible that Callot, a one-time follower of the gypsies and free as yet from the prejudices of the respectable citizen, sympathised more, despite his outward detachment, with the poor and the *déclassés* than did Hogarth who, with his genuine bourgeois outlook, was humanitarian in principle but in practice tended to poke fun at the needy. Precisely because of the similarity of their historical positions, both artists had to face a comparable task, namely to raise themes which had mostly been confined to crude popular engravings on to a high artistic plane.[24] This applies more to Callot than to Hogarth. Callot's compositional schemes, created for his new themes in a late mannerist, early baroque style, became the basis for future representations of such themes in the 17th and to some extent even the early 18th century.

Since it was Hogarth who epitomised so many of Callot's tendencies, the numerous transitional artists between them acquire an added interest: engravers working chiefly in France and Holland and specialising in everyday themes—artists traditionally called *petit-maîtres*, with an undertone of contempt. Even if in them Callot's formal influence, quite general in Europe around and after 1630, gradually lost its force, the thematic influence is nearly always clear, however varied in degree. Apart from Luyken and Raymond de Hooghe, others who helped to pave the way from Callot to Hogarth include Callot's more baroque imitator, Stefano della Bella (1610–64), whose

sphere of influence extended to France and Holland; Abraham Bosse (1605–78), the French Calvinist artist who faithfully represented middle class life in all its details; Vencel Hollar (1607–77) from Bohemia, who in his engravings of topical events and the costumes of the different classes brought so much of the spirit of continental art to England, where he lived almost uninterruptedly from 1637 and whose works I regard as one of the most marked precursors in England of Hogarth's art; and the engravers of topical events, the Frenchmen Sebastien Leclerc (1637–1714) and his pupil Bernard Picart (1637–1733), a Protestant refugee working in Holland, who had a special influence on English engraving and the young Hogarth.

To such important historical premises as Callot and Dutch and French followers, must be added Dutch art in general, the most realistic of continental schools. Since I am here concerned solely with engraving, contact with Dutch art could have meant etchings of genre scenes from low life of the type of van Vliet, Ostade, Quast, Bega, Dusart and the like, which specialised in the representation of peasants. These engravings are far more realistic than Dutch pictures, such as the usual genre paintings of the Ostade variety. Their vulgar, grotesque, slightly literary tendency, which frequently stress the facial features in a caricature-like manner, would have caught Hogarth's fancy. Moreover it was this particular Dutch current, especially in its Dusart variant, which was brought to England at the end of the 17th century and carried on by Egbert van Heemskerk, who forms an important link between Dutch art and Hogarth. And from Hogarth's point of view something of Callot is reflected in the beggars and harlequins of these Dutch engravings, whilst occasional direct borrowings from Callot, for example from his *Gobbi* and *Beggars* occurred in quite popular Dutch prints.

This combination of Dutch art and Callot as one of the continental roads which led to young Hogarth the engraver is also recognisable in the book illustrations he did from 1723, mostly during the 'twenties. Here he linked up with another continental current, that of grand monumental art, through his early admiration for Raphael and Thornhill. These numerous book illustrations played an important part in his career for, together with his trade-cards and a few engravings, they provided him with a bare existence. What were his immediate models? English book illustrations at the time were scarce and the few produced were chiefly due to the enterprise of the famous publisher, Jacob Tonson, secretary and leading spirit of the Kit Kat Club, whose members ranged between Congreve and Vanbrugh at one end of the scale and Addison and Steele at the other. The artistic level of these illustrations was rather low; they were partly by very second-rate French and Flemish illustrators living in this country, partly by their even weaker English imitators. Rowe's two illustrated Shakespeare editions of 1709 and 1714, with which Hogarth was certainly acquainted, are outstanding examples of English book production of the time, as initiated by Tonson. Illustrations by different hands in the first edition are primitive, stiff, rather angular, on the whole of an almost pseudo-popular level; sometimes, as in the case of those by the English engraver, Elisha Kirkall (*c.* 1682–1742) (Pl. 17b), they are slightly mannerist in character. The second edition contains a number of plates designed in a more modern, generalising baroque style, with abundant reminiscences of Lebrun and Raphael, by a French immigrant, Louis du Guernier (1677–1716, in England probably from 1711 till his death) (Pl. 9b). They constitute a rather feeble echo of contemporary French work of this nature. Stylistic links with these types of English book illustrations are easy to find in Hogarth's early engravings.

By now, however, he already had some knowledge of similar but more advanced continental work. He was particularly well acquainted with Picart's *Cérémonies et Coutumes Religieuses*, which became one of the best-known books of its kind, with its many engravings of a docu-

mentary character and its lively stylistic fusion of Dutch and French art. Of Dutch book illustrators of a pronouncedly baroque character he may have known R. de Hooghe and Luyken; very different from each other, both were Italianising, with echoes of Callot.[25]

Of a necessity, very eclectic at first, and not of a very high standard, the young Hogarth's book illustrations quickly developed in quality until they achieved a level far above previous work of the kind in England. Their style varied greatly according to the thematic content of the book concerned. If of a contemporary or humorous character, they inclined towards the Callot-Dutch manner; if of a grand character, to the Raphael-Thornhill idiom, but with frequent points of contact between the two trends. Taken as a whole, a clear-cut evolution can be traced from the pronounced mannerism of some of Hogarth's earliest illustrations, such as those to de la Mottraye's *Travels* of 1723, through a combination of mannerism and baroque in the more mannerist *Golden Ass* of Apuleius of 1724 and the more baroque *Cassandra* of La Calprenède of 1725, to the realistic baroque of Butler's *Hudibras* of 1726.

Apart from some adventures of Charles XII of Sweden,[26] Aubry de la Mottraye's *Travels* (1723) chiefly record scenes from Turkish and Greek life which he had observed. Hogarth was one of several artists who collaborated on the engravings for the two large volumes, and his illustrations reveal the variable and complex features of his early art. In *Audience before the Sultan* and *Turkish Procession with Music* he attempted baroque groupings. *The Encampment of the King of Sweden in Turkey* (Pl. 4a),[27] complete with topographical plan, adhered to the arrangement, though not quite to the formal idiom, of R. de Hooghe's numerous representations of battles: riders in a wide landscape are depicted in a light, almost rococo vein and are undeniably mannerist in their proportions and attitudes, like most of Hogarth's other engravings in this book. *Dance in the Harem* also shows a curious combination of mannerist and rococo contours in the pattern of its Oriental architecture and rich figural ensemble, a stylistic anticipation, if one may so put it, of the Brighton Pavilion.

For the formal language dominating most of these illustrations is ultimately an offshoot from the late-mannerist, early baroque idiom which lingered on in European, particularly Dutch, book illustrations long after 1600. Hogarth's exotic figures have the over-long proportions, the often abstract curves and small heads of this style; similarly the draperies combine massive material with fluttering scroll-like folds. These figures stem from a long-drawn-out development in European engraving and book illustration, during which an originally courtly elegance was often preserved in a rather primitive, popular form.[28] Hogarth's skilful, rhythmic, fluttering *Dance of Greek Women* perhaps harks back to Callot, whilst in his rather heavy representation of *Lapland Life* with its more 'cubist' plasticity and strong *chiaroscuro*, the stylistic ancestry of the Florentine mannerist, Tempesta, can in the last resort still be felt. Somewhat older than Callot, Tempesta (1555–1630) through his engravings had a widespread, long-lasting influence throughout Europe. The impressive *Dance of the Dervishes* (Pl. 1a), equally recalls the 'cubist' three-dimensionality of mannerism. Picart's engravings in *Cérémonies et Coutumes Religieuses*, the first two volumes of which, dealing with Catholic and Jewish ceremonies, were published in Amsterdam shortly before de la Mottraye's *Travels*, offer some formal no less than thematic similarity with Hogarth's illustrations of Turkish life. Both publications represented religious ceremonies as curiosities, albeit in a documentary, detailed manner. Moreover their illustrations reciprocally influenced each other. One example of Hogarth's influence on Picart occurs in the volume of Mohammedan ceremonies published as late as 1737; two of his illustrations, *Dance of the Dervishes* (Pl. 1b), and *Turkish Bride conducted to the Bridegroom*, were almost

literally taken over by Picart or perhaps by a weaker engraver working under Picart's direction. Although in the transposition Hogarth's figures became less stiffly linear, fuller and more corporeal, their mannerist features did not entirely disappear in the Picart workshop.[29]

In Hogarth's illustrations depicting loftier themes, such as ancient divinities and mythological figures, he aimed at a rather grand, solemn baroque. This was the style of both French and Dutch book illustrations under fashionable French influence, the latter sometimes the work of French refugees.[30] The French-Dutch book illustrations frequently betray a mannerist undertone, which becomes stronger still in their provincial imitations, the primitive English book illustrations preceding Hogarth. This recurs in Hogarth's illustrations, particularly in the earliest, and doubtless he was often obliged by the booksellers to retain the general composition of the corresponding illustrations in some former English edition, however much he may have altered their details.[31] In his earliest illustrations in the grand manner, those to Apuleius' *Golden Ass* (*New Metamorphosis*, 1724) (Pl. 6a), his style is quite close to, though less crude than, the mannerism of the two Shakespeare editions of 1709 and 1714. In those for La Calprenède's *Cassandra* (1725) he followed du Guernier's book illustrations in the 1714 edition—probably the most advanced of their kind to be found in this country at the time. *Cassandra* was a favourite novel at Versailles and was translated in 1652 by Charles Cotterell, Master of Ceremonies to Charles I and Charles II. Du Guernier had a distinct mannerist flavour and this was intensified when translated by Hogarth, particularly in his super-violent *contraposto*; even so, Hogarth's illustrations are more pronouncedly baroque in character than those for Apuleius the year before. His baroque style is more realist and his observation sharper than du Guernier's. Thus it is instructive to compare Hogarth's illustration in *Cassandra* of a woman standing by a bed (Pl. 9a), with its presumable model of Cymbeline beside Imogen's bed in du Guernier (Pl. 9b). The baroque line, however, is still rather halting and does not flow easily.

Hogarth's mannerist accent never quite vanishes at this time and is easily detected in all his other grand Thornhillian illustrations of these and the following years. This is true of the illustrations to Leveridge's *Songs* (1727), to Dr. William King's *Pantheon* ('Historical Account of the Heathen Gods and Heroes', a compilation much used in schools, originally published in 1710) and to Milton's *Paradise Lost* (Pl. 6b). The mannerist element manifests itself, for instance, in a pointed, elongated figural idiom or in the abstract, intentionally vast expanses of the background. Yet significant of Hogarth's complexity is the presence of Callot's art behind these features, just as it lay behind his early realism. Even among the illustrations of *The Golden Ass*, the figure of a hunchbacked old woman derives from Callot but is even more caricature-like in her ugliness. In fact, in estimating Hogarth's closeness to Dutch-French baroque book illustrations one must always keep one eye on Callot. Hogarth's small, oval-shaped illustrations to King's *Pantheon*, each containing one or two antique gods or goddesses, recall most insistently not only Thornhill but also Callot's compositions of a similar shape. This applies to the formal language of the figures and their relation to the space around them no less than to the sparkling, sharp *chiaroscuro*, the unreal effect of which emphasises the abstractness of the space relations. These Callot-like contrasts can be seen in all their freshness in the preparatory pen, ink and wash drawings at Windsor (the engravings, if ever done, are no longer preserved), which at the same time reveal the influence of Thornhill's lively baroque technique. In Hogarth's works, a century later than Callot's, the general accent has shifted from mannerism towards baroque, and even rococo. Yet it is possible to feel something of the boldness of mannerism in such a spirited composition as his *Minerva*: the goddess's elongated figure links compartments of space which seem to rotate

abruptly in opposite directions—on her left a concave wall with brightly lit book-shelves vanishes into the background while the structure and the attributes on the right, placed in the shade, advance towards the spectator.

Hogarth's 'realistic' book illustrations culminated in his most extensive series for two different editions of Butler's *Hudibras* (both 1726). Hogarth much admired this popular yet subtle metrical satire on Puritan bigotry, hypocrisy, pedantry, fanaticism and superstition.[32] In the second edition, Hogarth added to the title of his illustrations: 'Exposing the Villany and Hypocrisy of those Times'.[33] In his first series he was obliged to adhere, in all sixteen scenes, to the themes and largely the composition of an earlier edition of 1710 published by J. Baker, the engravings of which, attributed to an otherwise unknown Walloon refugee engraver, Le Pipre, in their primitive stiffness, could almost be called popular and contain only the vaguest echo of Dutch art. Hogarth's transposition of these scenes of quasi-popular art, his manner of enlivening and so to speak of infusing breath into them, is fascinating, although in at least seven he retained the principal motifs and figures to a surprising extent. Here one can actually see English art taking shape before one's eyes. The figures assume real proportions and spring to life; instead of mere gestures to indicate feeling, a direct relationship is established between them and their faces acquire expression. Air is created round the figures, the masses are loosened and subordinated to the composition, light and shade are distributed to further this articulation and the bareness of the background is eliminated. The most Hogarthian and original are perhaps such mass-scenes as *Hudibras encountering the Skimmington* (Pl. 11a),[34] a grotesque pageant whose object was to hold a married vixen and her husband up to scorn, and *The Burning of the Rump* (Pl. 11b). As far as one can speak of foreign models, they were, at least in principle, chiefly Dutch. There is some similarity with rather primitive but realistic engravings by Luyken, and in *Hudibras encountering the Skimmington* one can also sense the grotesque narrative vein of Dusart. As for 'English' models for this first series, a few of du Guernier's illustrations in the 1714 Shakespeare may have served; these represent more or less contemporary scenes, illustrations to Shakespeare apocrypha such as *The Puritan* or *The Widow of Watling Street* (Pl. 13b), and are more realist than the rest, though also rather French in style.

In these illustrations Hogarth must have felt too closely bound by previous models and the same year he did, on his own account, a second, larger series of only twelve scenes, without a text. Here in turn he transformed his first series. Whilst initially he reconstructed what one could theoretically imagine to have been the Dutch originals of the earlier edition, in the more monumental amplifications of the second series the prevalent Dutch influence has acquired a somewhat Italianising flavour. A Dutch-Italianising style of course implies baroque and a link exists, though on a more humdrum plane, with the monumental, Italianising, tempestuous baroque of R. de Hooghe's satirical engravings with large figures. By means of this baroque element in his second series, Hogarth brought the scenes to life and held the composition together. The effect of his independence from the bookseller can be seen by comparing the scene of *Hudibras and the Lawyer* in the three sets (Pls. 12, 13a, 13c). In his first series Hogarth followed the 1710 edition so closely that the position and the attitudes of the two figures in the modest, barely indicated surroundings are almost identical, if less stiff; Hudibras's assumed pose of humility is spiced with a more comic cut as, hat in hand, he is placed in a setting enlivened by the addition of a carved desk, a bookcase and a window. But the same scene in Hogarth's second edition shows a real vision of a composition. In an imposing chamber the lawyer, extravagantly bewigged, is seated on a stately, intricately ornamental, throne-like chair; below him two clerks lean in

opposite directions in grotesquely duplicated attitudes. This elaborate, almost regal setting, including the flamboyant silhouette of a sculpted figure of Justice facing the lawyer, forms a seemingly endless diagonal stretching into the background and beyond through an open door where two women stand. Furthermore, the bookcase has now assumed enormous proportions, filling the entire background so that the tightly packed right-hand side of the room contrasts sharply with the emptiness of the left, where the floor recedes in rapid perspective, an overwhelming void (but for the presence of two dogs relegated to a corner) in which the isolated figure of Hudibras appears humbler than ever. So unexpected is the angle of the composition that the eye can never rest; patches of shade and light, silhouettes, curves and angles break through and sparkle wittily all over the place. It is a most spirited baroque, the excitement and grotesquerie of which is enhanced by features of a space arrangement deriving from mannerism. For only here, in the second series, could Hogarth afford to be playful to his heart's desire. Similarly, in contrast to the timid suggestions in the first version of *Hudibras in the Studio of the Astrologer Sidrophel*, Hogarth now presents a wildly fantastic interior with stuffed crocodiles, fish, reptiles and skeletons appearing as if alive. Here it was that he originally created from motifs of popular and half-popular art that characterisation of the milieu of quack doctors or pseudo-scientists which he was henceforth to portray; the scene may be compared with Egbert van Heemskerk's *Quack Physicians' Hall*, engraved by Toms, (Pl. 119b), where animals behave as human beings.

In the second *Hudibras* series, the baroque influence derives from the appropriate source, Italian art. The scene of *Hudibras encountering the Skimmington*, in its details relatively independent from Butler's text, is quite surprisingly monumental, commanding a dynamic rhythm in large billowing waves. The stout man, blowing a horn in front of Hudibras, offers an easy clue as to whence comes the direct artistic inspiration: his attitude derives from the naked faun playing a similar instrument in Annibale Carracci's celebrated *Procession of Bacchus and Ariadne* (Galleria Farnese), which was certainly familiar to Hogarth through engravings.[35] Various other features in the two compositions correspond but the outstanding similarity lies in the over-all swinging rhythm. Hogarth undoubtedly learned much from the Italian fresco, though he chose to caricature several of its motifs and indeed this entire Hudibras scene constitutes a parody of it. Yet another Italian work is also reflected and in this case the artist must have been even more intent on parody: Mantegna's *Triumph of Julius Caesar* at Hampton Court. The chief motifs in this scene were already extant in the 1710 edition, but Hogarth strengthened the parody. Country yokels, solemnly playing fanciful musical instruments or holding their shirts and hats aloft are surely taking off Mantegna's Roman trumpeters and military emblems. Such a representation, revealing Hogarth's knowledge of Italian art at this early date, is exactly suited to the parodying spirit of *Hudibras*.

For the frontispiece of the second *Hudibras* set, dedicated to Butler's genius, Hogarth designed an entirely independent composition quite unlike the rest, (Pl. 10b), in which large allegorical-mythological figures are represented in the Rubens-Lebrun style of Dutch-French book illustrations: Britannia, with a faun teaching a *putto*, who is chiselling a relief of the allegorical theme of *Hudibras*. On the other hand, on the bas-relief occupying the main part of the frontispiece, small figures of Hudibras, Ralpho, etc., are in the grotesque style of Dutch caricatures. The faun and the kneeling *putto*, one leg extended behind him towards the spectator, are motifs taken over literally from Rubens' picture of *Nature adorned by the Graces*, in which a faun helps to hang garlands of fruit round the statue of Nature. This picture (now in Glasgow) belonged to Thornhill and was thus well known to Hogarth.[36]

The name of Callot again arises, for there is a dash of him in both the *Hudibras* series, more apparent in the first than in the second, for the extreme mobility of the figures and the jaggedness of their formal language is still related to Callot's mannerism. For instance, in *Hudibras meets the Skimmington* of the first series a picturesque old woman appears in a large pointed hat tending a fire, a typically Callotesque motif absent from the second set. No precise model for it can be found in Callot, but only a vague counterpart in his *Halte des Bohèmiens*.[37] In the *Masquerade Adventure of Hudibras*, particularly in the far richer composition of the second series, Hudibras' pursuers in the carnival disguise of animals may equally well have been suggested by the *Commedia dell'Arte* figures of Callot's *Balli* as by the pursuing devils in his (second) *Temptation of St. Anthony* (Pl. 7b). Hogarth's composition calls to mind pictures of the Dirk Hals circle of genre painters where the influence of Callot's soldiers and grotesque *Commedia dell'Arte* figures is very frequent. *Carnival Jesters* by Duyster (Berlin), a painter of musical scenes and military amusements who belonged to this circle, gives some idea of this common Callot derivation. Other illustrations to *Hudibras* remind one of Duck or Codde, all members of the same circle, who echoed Callot by painting rather rough scenes of soldiers' amusements.[38]

Yet when all allowance is made for these 'influences', the larger, second *Hudibras* series marks a great personal achievement in Hogarth's career, a culmination of and at the same time a breaking away from his numerous book illustrations of the past, in which he had not yet found his own narrative style and where, besides de Hooghe, Picart and particularly Callot, the traditional French models still break through. Though remnants of the 1710 model survive, these illustrations open the way for a new English style, for a realistic baroque very much Hogarth's own and in which mannerist elements slowly decrease. The narrative style he created here reveals an astonishingly acute sense of form; in the various scenes he had already invented formal patterns peculiar to himself and largely based on the waving lines and grotesque curves which were to form the basis of many of his famous compositions. His amazing originality can be seen in many individual scenes, not only in *Hudibras and the Lawyer* and *Hudibras in the Alchemist's Study*, but in *The Committee*, with its comic motif of an endless row of hats, an entirely new composition absent from the two earlier *Hudibras* editions, and in *The Burning of the Rump* with, for such an early date, surprisingly skilful handling of a large moving crowd. No wonder Hogarth retained a fondness for these early illustrations all his life. Even the six finished drawings for the second series (Windsor) already reveal an accomplished draughtsmanship and a technique which was to remain fundamentally unaltered throughout his career. Most of them, in pen, ink and wash, are carried out in the usual broad manner of Dutch genre drawings, such as those of Ostade and Dusart. Yet Hogarth's outlines, quick and expressive as they are, flow more easily than Ostade's, and the distribution of light and shade, though just as flickering, is neater; consequently in some ways the Hudibras drawings are not far from the style of Italianising Dutch drawings. The drawing for *Hudibras meets the Skimmington*, the most important of the series, has nervous contours whose power is enhanced by the wide surfaces of broad wash surrounding them or enclosed by them, and its general liveliness comes close to the sparkling character of Gillot's work.

Even in some of the young Hogarth's popular engravings the same trend towards an articulated baroque can be seen, that is to say, they contain a greater degree of artistry within the popular style so that the compositions, by means of these baroque features, acquire a certain, if rather loose, structure. This is largely true of the early, popular engravings of theatrical events or entertainments already discussed. It particularly applies to a fanciful illustration to *Gulliver's Travels*, an engraving called *Punishment inflicted on Gulliver by the Lilliputians* (Pl. 10a) (published in 1726,

immediately after the highly successful appearance of Swift's book),[39] whose chief motif of the clyster as Gulliver's method of punishment was taken from Breughel's engraving, *Idleness*.[40] All the same, Hogarth's many Lilliputians derive from Callot's famous cycle of grotesque dwarfs, the *Gobbi*. Their general appearance, their formal idiom, allowing for a certain polishing up, their types, costumes and headgear are similar, even if their actions necessarily differ. In Callot's cycle it is easy to pick out the prototypes of the protruding noses, quaint bearded profiles and queer broad-brimmed hats with high painted crowns displayed by many of Hogarth's Lilliputians. Although the borrowings are not so literal as in *The South Sea Scheme*, perhaps in no other single engraving did Hogarth use so many motifs from Callot; it is significant that he chose precisely those figures in which traces of the Bosch spirit still linger and used them as decorative foliage for a Breughel motif which, in the original, is also surrounded by grotesque, Bosch-like figures. There is as much here from Bosch and Breughel as was possible for an 18th-century artist. The result is a style close to the second *Hudibras* set but more popular in appearance.

If ever there was an artist who in his beginnings depended greatly on a direct knowledge of foreign art, it was Hogarth. Influences came from so many different and at times apparently contrary directions, almost exclusively through the medium of engravings, from Holland, France and Italy, from popular and from grand art. Precisely because of his interest in such a diversity of themes and the absence of a dominant artistic native tradition, Hogarth had to attach himself to such heterogeneous traditions. Yet the development of his originality was in no way impeded by these contacts. In portrait groups and still more in theatre pictures he could be as unconventional as he was in *The Beckingham Wedding* and *The Beggar's Opera*. This even holds good for his earlier works as a mere engraver: he did trade-cards as original as the one for his sisters, political caricatures as striking as *Royalty, Episcopacy and Law*, book illustrations as novel as those for the second edition of *Hudibras*. And the more Hogarth drew on the life around him, for which he had to create a style of his own, the more he grew in artistic independence. In fact, of his artistic upbringing he wrote: 'The most striking objects that presented themselves, either comic or tragic, made the strongest impression on my mind.' It was for him a time of discovery, of plucking new motifs wherever he found them—an activity which came quite naturally to him. Not all his motifs, nor yet his forms, were new. In this early period his innovations often consisted in raising some already existing subject from its established level—an engraving to the plane, recognised as socially higher, of painting, or a popular engraving to an artistic one. Nevertheless, these were weighty processes in the development of modern art.

When did Hogarth begin to paint? It is impossible to give an accurate answer, but he had probably done so intermittently and on a small scale since he attended Cheron's and Vanderbank's Academy. One of these very early, very weak though promising works was the *Sign for a Paver* already mentioned. Another, probably painted when he was mainly engaged on book illustrations, was *The Theft of a Watch* (Ashmolean Museum, Oxford) (Pl. 16b).[41] Three prostitutes skilfully combine to steal a watch from a drunkard; whilst a fourth raises the alarm on the watchman's entry. If the theme has some similarity with that of the two *Progresses*, it is even closer to the actual life of the times, the spirit of which was caught so well in *Moll Flanders*, published shortly before. The theft of a watch was not a new theme in painting, but the spirit in which it is represented here was new. For instance, Steen, a story-teller with a literary tendency, had treated it in his picture *Bad Company* (Louvre); but in comparison with Hogarth's ruthless matter-of-factness, he portrayed a harmless pleasant milieu, where the motif of women robbing a sleeping young man assumed much of the character of a joke. Hogarth's arrangement in this picture still

has something of the primitiveness of his paver's sign and of some of the book illustrations, although the brushwork is becoming less brutal. The most striking figure is the woman giving the alarm: her violent gestures achieve a degree of spontaneity, even if in actual fact they are artificially constructed. She is slightly reminiscent of the *Dancing Dervishes* in de la Mottraye's *Travels* and it is interesting to observe Hogarth's method of translating the undifferentiated mannerist 'cubism' of the engraving into more flexible, differentiated and true-to-life movements. What is true of the elongated proportions of the figures in the illustrations is also true of those in the picture. Originally coming from such an elegant style as mannerism they later became quite common features, though a potentiality towards elegance always remained.

It is known for certain that Hogarth began to do paintings on a grander scale from 1727–8 onwards. Since he had grown up in the atmosphere of trade-cards and signboards, on setting up as a painter he decided to portray himself in an oil sketch,[42] as a sort of advertisement. In this assistants, who in reality never materialised, stand around whilst he himself shows visitors to his studio the signboard with St. Luke and a large inscription *W. Hogarth Painter* which he is about to put up.[43] If one looks at Hogarth's self-portrait (Lord Kinnaird) (Pl. 96a), painted during these years or slightly later, when he was about thirty, one is struck anew by his keenness of expression. Indeed, in this early phase he was entirely engrossed by the events of London life, in the theatre, literature, art and politics. From these sources he drew new motifs whilst subjecting them to his critical sense. Thus he became the artist of topical satires and trade-cards, the por-traitist of the fashionable world and of famous criminals, the illustrator of widely-read books, above all the delineator of his favourite sphere of the theatre and entertainments, where he was the first to paint scenes from plays and to do satirical engravings on the theatre.

To round off the picture of the thematic variety in Hogarth's early period, I will select a few other subjects which engaged his pen or his brush, and which were quite new of their kind in England and often on the continent as well. Apart from engravings, these include his earliest paintings from between 1728 and 1732, the prodigiously productive years between the *Hudibras* illustrations and his cycles, when he suddenly emerged as a painter of the first rank.

Among Hogarth's representations of the world of politics and public affairs was *The Committee of the House of Commons*, which dealt with the case of Bambridge and examined conditions in the Fleet Prison (1729, National Portrait Gallery).[44] It was commissioned by Sir Archibald Grant who, together with Thornhill, sat on this Committee. The picture served to portray Grant and his activities and was at the the same time, since it also depicted the accused and the witnesses, a journalistic document of humanitarian and topical significance. But to what extent Hogarth was bound by the nature of his commission is shown by the difference—despite a superficial outward resemblance—between the *Bambridge Committee* with its rather rigid, over-documentary setting on the one hand, and on the other the *Committee* scene in *Hudibras* of only slightly earlier date, or even better the picture of *Falstaff examining his Recruits*, with its more baroque, lively com-position. However, a first monochrome sketch for the *Bambridge Committee* (Fitzwilliam Museum, Cambridge) (Pl. 24b), in which Hogarth has as yet paid scant attention to facial resemblances, is also more baroque, dramatic and varied than the finished picture; therefore it is much closer to the *Hudibras* illustration, whose vivid, grotesque figures might also entitle it to be considered as an anticipated caricature of this sketch. In 1730 Hogarth collaborated with Thornhill on a picture of a sitting in the House of Commons (Earl of Onslow) probably ordered by the Speaker, Arthur Onslow. Here the Prime Minister, Robert Walpole, delivering a speech, and the Speaker are the main figures while among the Members Thornhill himself is represented. This is the only

visual record of the Great Commoner in action in the House when Prime Minister. Hogarth's share in the picture's execution was confined to the three portraits, including that of his father-in-law in the lowest row.

The atmosphere of the coffee-houses was naturally familiar to Hogarth. The custom of congregating in these establishments had rooted itself in England from the time of Cromwell and become really fashionable from Queen Anne's time; it came to play a great part in the formation of political, literary and artistic opinion and was much practised, in Hogarth's early years, by the writers of the didactic periodicals. Hogarth did drawings of some of his contemporaries as they sat alone or together in their favourite coffee-house: these include possibly Addison, Dr. Arbuthnot, Pope (drawings in the British Museum) and the literary critic, Dennis.[45] The conventional wash technique of these apparently very early works recalls Thornhill's rather similar, though less lively, portrait drawings.

Hogarth's very natural interest in the world of art and in discussions on art led him to do documentary representations as well as caricatures. He conducted a campaign against the Burlington-Pope-Kent coterie which barred his way. Thus a caricature (engraving of *The Man of Taste*, 1731) (Pl. 15a), baroque and rather popular in character, reviles Pope for laying down the law of taste[46] and Lord Burlington for taking Pope and Kent under his wing. Some years earlier he had skilfully parodied the anatomical inaccuracies of Kent's altarpiece in St. Clement Danes, representing St. Cecilia and angels, in an engraving (1725) which, so far as I am aware, is the first caricature of an actual work of art in England. It is, however, significant that the primary arguments against the picture in the eyes of the public were of a religious and political nature: it caused a scandal and had to be taken down on the grounds that it was Papist in spirit and Jacobite in its implications. Apart from a caricature with animal imagery by E. van Heemskerk, Hogarth was also the first artist to paint a picture auction (unfinished oil sketch, H. M. C. Jones-Mortimer) (Pl. 23b). This he depicted with the same baroque ease with which he portrayed the *Bambridge Committee* in the Cambridge sketch, but the composition, with numerous groups of people skilfully dispersed about the large auction-room, is even livelier.

The affair of Mary Tofts, a woman from Godalming, who claimed to be able to give birth to rabbits, caused a widespread sensation. At the instance of leading London physicians, Hogarth did a caricature of her—a rather crude engraving even if superior to others on the same subject, named *Cunicularii* or *The Wise Men of Godliman in Consultation* (*c.* 1726, still bearing inscribed labels) (Pl. 34a). Hogarth showed Mary Tofts on her bed, with rabbits running about the floor and credulous doctors standing around. As a true Cockney, he took a great interest in sport, particularly the national sport of boxing. He designed a ticket for the Master of the Sword, Figg, who died as early as 1734, and also painted his portrait.[47] His full-length likeness (present whereabouts unknown) of the pugilist Broughton, Champion of England from 1732 to 1750, sturdy, vulgar and full of vitality, probably painted in the early 1730s, is one of the most curious documents of English popular life of the time.[48]

Typical of Hogarth's bourgeois, man-in-the-street mentality and milieu are the pen, ink and wash drawings commemorating his *Tour* or *Five Days Peregrination* (British Museum), which he undertook in 1732 with some of his cronies from the Bedford Arms—the landscape painter, Scott, his own brother-in-law, the younger Thornhill, a notary and a woollen draper. The tour took them from London to small places in Kent and its trivial, commonplace events almost entitle it to be considered a caricature of the grand tours of the aristocracy. Indeed, the grotesque emblematical frontispiece declaring the journey to be avowedly 'without head or tail' and the

antique column lying on the ground may suggest something of the kind. The drawings were done on the spot, the most interesting being the spontaneous 'Breakfast at the Nag's Head Inn at Stokes' (Pl. 34b), which shows the entire company engaged on its prosaic matutinal occupations and gives the impression of a documentary drawing by Ostade, if such were possible. The Gothic tomb of Lord Shoreland in Minster Church was also drawn by Hogarth on this occasion; however he was probably more interested in the story connected with the grave, as described in the account of their journey, than in its style.

Among Hogarth's earliest pictures are some which go beyond mere genre painting, being more or less of a story-telling character. With their striking new themes, generally rather grotesque and probably largely of the artist's own invention, they met with the public's approval and were avidly bought up. Yet it was in this narrative and realist field that the paucity of Hogarth's precursors was most marked. The Dutch immigrant, Egbert van Heemskerk, can alone be held of any note in this respect; he brought here something of the colouristic, though less of the compositional, achievements of the Dutch 17th-century school, whilst he himself, a *protégé* of Lord Rochester, developed slightly in a satirical and moralist vein. Conforming, like Hogarth, to the intricacies of the English social system, his style varied between his relatively best pictures representing such scenes as a trial or a Quaker meeting, and his grotesque compositions designed for popular engravings. Both types had some relevance for the young Hogarth, emerging from the barren soil of English art, but his early paintings of middle-class life were more beholden to contemporary French art, then the decisive influence throughout Europe. The flexibility and occasional grace of Hogarth's figures owes a great deal to French sources, whose influence, especially that of Watteau, came to him through engravings. He was now obviously beyond the style of *The Theft of a Watch*, yet this impact from France can be perceived only indirectly and greatly transposed, being blatant in a few individual motifs alone. In some of these early pictures the composition remains at an experimental stage, offspring of the tradition of an almost cumulative realism; yet Hogarth's discerning hand can be followed as he attempts to divide the masses and create associated groups. Astonishing for a novice is the broad, evocative and yet unified manner in which, among these early works, sketches and sketchy pictures are painted, similar to the version of the *Bambridge Committee* in the Fitzwilliam Museum. In these kinds of works Hogarth may possibly have been influenced by van Dyck sketches, some of which he could have seen and which have more of an improvised, 'jotted-down' character than those of Rubens.

One example is *The Sleeping Congregation* (1728, Minneapolis Institute of Art) (Pl. 18), in which he satirises the monotonous oratory of Anglican divines. Brilliantly if still rather lumpishly painted, with the road from the very early, coarse but potentially gifted paver's sign still clearly in sight, this picture was his first dated one[49] and it shows how right he was to have regarded himself as an accomplished painter as early as 1727–8, on the occasion of his lawsuit against the upholsterer, Morris. The compositional problem of rendering a rather complicated section of a church interior with crowded pews, gallery and pulpit was a struggle for space. Hence the pattern, though extremely original, not unnaturally remained in many respects strongly mannerist. The composition is dominated by the large foreground figures to the left of the preacher, the churchwarden and the pretty woman asleep, grouped round the towering bulk of the pulpit as it looks out towards the spectator; the crowded congregation of smaller figures to the right occupies the far-away, darker background. Between these two principal constituents rise the high windows through which light is streaming; the massive heads in the body of the church below are thus

lit up in an almost Daumier-like manner, so clearly are their expressions revealed.[50] Rather later Hogarth produced a vivid, dramatically built-up sketch, equally brilliantly dashed off but colouristically more unified, of *A Consultation of Physicians* (Agnews, London) (Pl. 24a). The subject of this is not quite clear. Hogarth's object may have been to attack the staff of a hospital who are debating suitable methods of obtaining a fee. The scene has also been called *A Debate on Palmistry*.

Probably slightly later, about 1729-30, Hogarth painted *A Baptism* (Sir Felix Cassell) (Pl. 25a),[51] which combines the documentary rendering of a ceremony with story-telling and satirical features. The baptism is taking place in the room of a wealthy family, attended by a group of guests. There is a late van Dyck portrait of a military commander over the chimneypiece. In some particulars it is not unrelated to scenes in *Cérémonies et Coutumes Religieuses*: two or three figures in the central group, for instance, recall participants around the central table in Picart's *Catholic Baptism administered by a Priest* (1723) (Pl. 25c), whilst the woman tending a pot on the fire derives from his companion engraving, *Catholic Baptism administered by a Midwife* (Pl. 25b).[52] This very Dutch motif of a picturesque fire was to become one of Hogarth's favourites and here the woman is an almost Pieter de Hooch type. The central part of Picart's first-mentioned engraving may or may not have been done under the influence of Giuseppe Maria Crespi's *Baptism* (1712, Dresden), a scene from his famous series of *The Seven Sacraments*; however that may be, the connection aptly illustrates the historical place of Hogarth's composition. Although his knowledge extended only to Picart's engraving and not to Crespi's work, the resemblance in the very genuinely attempted baroque build-up is closer to the latter.[53] Maybe the stout clergyman performing the baptism as he gazes at his attractive neighbour is the notorious Orator Henley; if so Hogarth thus stigmatised this undignified priest, who broke away from the church, inducing large audiences to pay entrance fees to his Oratory Chapel in order to witness his acts of buffoonery and hear his sensational, much-advertised sermons. Another typical Hogarthian motif is the indifferent husband who, ignoring the ceremony, beautifies himself before a mirror whilst a young man pays assiduous court to the mother. The arrangement of the composition is a little freer than that of the previous picture. Hogarth again attempted to work from the centre—this time a circle consisting of linked figures—towards the outer periphery. But colouristically it goes beyond the dark monotony of the last-mentioned picture and points the way to his future development: the white, bright blue and pink of the modish dresses is beginning to appear and the richly decorated background of the room is dotted with picturesque suggestions.

In *A Woman Swearing a Child to a grave Citizen* (c. 1729, National Gallery of Ireland, Dublin) (Pl. 26a) Hogarth gave a complete satirical story in a finished picture.[54] The magistrate lays the guilt on an elderly worthy, who vainly protests as his jealous wife abuses him; the real culprit, a young man, amiably philanders with the pretty pregnant woman. There is possibly some connection, as Nichols avers, with an earlier, popular composition by Egbert van Heemskerk, *The Midnight Magistrate*, engraved by Kirkall (Pl. 26b), although Nichols exaggerates when he says that the entire design was stolen from Heemskerk. In this, in imitation of Teniers' well-known monkey pictures, the figures have heads of monkeys and cats; an amorous pair of cats, the tom in the engraving's caption designated as 'the young rake', are caught by the night watch and brought before a magistrate. The resemblances, in content and form, between Heemskerk and Hogarth are few and slight, since in Hogarth the animal imagery has disappeared and the rigid composition has assumed a more articulated baroque. Yet the comparison is interesting, for it shows on the one hand how primitive Hogarth's artistic ancestry was and, on the other, how greatly, even in his early works, he was changing the character of English art.[55] However, this picture too is

in many ways homespun and inarticulate and colour still plays only a minor part. The grave citizen's posture, and for that matter his wife's, still give the impression of having been constructed from the outside as it were. This figure of the citizen forms the stiff centre of the composition and it was only slowly that Hogarth succeeded in developing the pattern towards its extremities.

Hogarth was soon to develop a more concentrated baroque pattern—admittedly in a composition with only two figures—in the companion scenes of seduction, *Before* (Pl. 38a), and *After* (1730–31; two versions: one set indoors, Laurin, Stockholm; the other outdoors, J. Hugh Smith, London). These move in a similar, if even franker and more brutal, milieu than that of *A Woman Swearing a Child* and are known to have been painted to order. Both in theme and composition some resemblance can be traced between these works and similar contemporary French rococo types of erotic picture, in particular, those by Jean François de Troy (*La Surprise*, Pl. 38b, *La Proposition*, *La Jarretière*) painted in the twenties.[56] Hogarth had indeed seen works by this artist in Dr. Mead's house. The comparison at the same time emphasises the wide gulf separating the French and English pictures. In the gay 'thirties of Fielding's farces, the young Hogarth displays an uncouth bluntness, an unabashed brutality without any precedent whatsoever in painting particularly not in French rococo, where, however erotic the subject, a veneer of gracefulness was always requisite. In Hogarth's first scene, how violent is the woman's gesture, as she pushes away the head of the man attempting to tear off her dress; in the second, with what indifference does the man pull up his trousers; and in both, how animal is his expression! From the formal viewpoint, judged by French standards though by them alone, the possibility of an elegant rococo pattern of lines, particularly in the second scene, was ruled out by the realistic, unmitigated vehemence of the conception. Yet there are some points of contact; that any comparison at all can be made between the young Hogarth and the very refined de Troy is in itself instructive, just as at the opposite extreme it was possible to compare his works with popular engravings after Heemskerk.[57]

Finally among Hogarth's early subjects can be numbered one of his most popular works, *A Midnight Modern Conversation* (Pl. 43a). Although generally known from the famous engraving of 1733,[58] it was certainly painted somewhat earlier.[59] Eleven men, drinking and smoking, are grouped round a table, sitting, standing or falling in various stages of intoxication.[60] Hogarth's ability at this stage to present a contemporary scene of such a naturalist character as a drinking orgy in a near-baroque construction, certainly outstrips the average Dutch 17th-century genre painting in formal qualities. The term 'average', however, does not include a painter of Steen's calibre. It seems to me most likely that when engaged on *A Midnight Modern Conversation* Hogarth had in mind one of Steen's compositions of the type of *As Old Folks Sing, Young Folks Pipe* (Hague) (Pl. 43b). Despite the greater simplicity of Steen's grouping, the general idea is similar, as are such motifs as the tipsy backward-leaning figure on the left (in Hogarth a man, in Steen a woman), a seated figure holding a pipe, and the crowning one of the composition, the uplifted arm of the man seen against the wall, in Hogarth holding a glass, in Steen a jug. This same motif also appears, though less prominently, in one of the most famous pictures showing a group of drinkers, Jordaens' oft-repeated *Le Roi boit*, which has other points of contact with Hogarth's composition. The latter's important motif of the drunkard in the foreground breaking a cup as he falls, already figured in Jordaens' picture in the same position. Hogarth owned engravings after Jordaens, which proves his fondness for the exuberant Flemish artist. However, the spontaneous, arrested gesture in Hogarth is far more realistic and elaborate than in Jordaens, where it

assumes a more or less general baroque character.[61] Such movements, whose progressive character points towards 19th-century art, held an increasing fascination for Hogarth. Yet quite apart from the altered character of such individual motifs, there was a fundamental difference between *A Midnight Modern Conversation* and the general conception of Dutch and Flemish genre painting. The latter adhered on the whole to pleasant generalities, even when the themes tended to be low: drinking was shown largely as an amusing habit of the lower classes; comic drunken peasants were designed to be laughed at by upper-class spectators.[62] Steen's portrayal, similar to Hogarth's, of hilariously tipsy middle-class folk deviates from the norm; but even Steen depicted a slightly lower social stratum than Hogarth. Moreover Hogarth's thoroughly differentiated, unflattering characterisation of each participant in the carousal is far from Jordaens' or even Steen's general harmless gaiety.

Hogarth's early engravings and paintings became increasingly his own, thematically and formally. It was with bricks of this kind that he was to build up his cycles, works whose character was so new, yet for which he had so assiduously prepared through his past development.

VI

The Cycles of the 'Thirties and 'Forties

HOGARTH'S great moralising cycles of the 'thirties and 'forties were *A Harlot's Progress* (engravings 1732, original paintings destroyed)[1]; *A Rake's Progress* (engravings 1735, original paintings in the Soane Museum)[2]; *Marriage à la Mode* (engravings 1745, original paintings in the National Gallery); and *Industry and Idleness* (engravings 1747). Their purpose was to express and foster the new bourgeois outlook in its purest form. They are perhaps the most characteristic and original of his creations since they were so much part of himself and at the same time stemmed from the milieu peculiar to a highly developed middle class in the process of forging for itself a new code of behaviour. Their immediate thematic antecedents were essays in *The Tatler* and *Spectator* and to some extent *Moll Flanders*, and they formed a parallel in art to English middle-class literature of the 'thirties and 'forties, itself unique in Europe. Their spiritual atmosphere is evoked by such works as Lillo's domestic tragedies, Richardson's novels, in which the predominant ideas are close to Hogarth's however significant the individual differences, and, above all, Fielding's psychological novels, which instruct and amuse as they trace the consequences of their heroes' behaviour and destiny. Indeed in his prefaces to *Tom Jones* and *Joseph Andrews*, Fielding explicitly set forth the theoretical justification and guiding principles for both Hogarth's cycles and his own novels. An author, he claims, must have penetrated all sections of society; he must have the ability to depict every aspect of life without burlesquing it, a knowledge of his craft and, last but not least, the humanity to make his fellow-men laugh or weep because he has already done so himself.

The theme of *A Harlot's Progress* and partly that of *A Rake's Progress* had appeared in 17th-century Italian cycles of popular engravings (Venice, Bologna, Rome), such as *Life and End of the Harlot* and *Miserable End of Those who Follow Harlots*. But, in content, these cycles were fundamentally medieval moralities illustrating Luxury, one of the Deadly Sins, and did little more than supplement the didactic-religious art of the high Middle Ages, which was still being popularised even in the 17th century.[3] For instance, in one of these cycles, exceptional in that it

was not anonymous but by the well-known Bolognese popular engraver Mitelli (*La Vita infelice della Meretrice*, 1692), the harlot is seduced and lives in gay splendour; being later cast into prison and reduced to penury, she ends up dying in hospital with a large crucifix before her, mourned over by a nun. All this is depicted in a series divided as of old into twelve scenes corresponding to the months of the year, after the pattern of medieval cycles representing the various monthly occupations.[4] In composition these Italian popular engravings generally consist of many small scenes on one plate, each scene being restricted to two or three rather crudely drawn figures in a row; juxtaposed in profile or full-face, their treatment is rather summary and they often lack descriptive surroundings.[5] Thus it is only in a very qualified sense that they can be considered as forerunners of Hogarth's secularised cycles, which moralise from a bourgeois standpoint, are humanitarian, adhere closely to contemporary everyday life and even as engravings, are raised high above the level of popular art. Equally distant forerunners, though on a much higher artistic level, were the various 17th-century cycles of the Prodigal Son, the rake of the times. Callot also showed a predilection for this Bible story, which he illustrated in a cycle of fifteen engravings. But in some ways spiritually closest to *A Rake's Progress* is the moralising cycle by the Calvinist middle-class artist Bosse.

Since the birth of an artistic idiom came so suddenly in England and Hogarth in his cycles represented authentic scenes from daily life, the first school of painting to which one is tempted to look for origin and comparison is the Dutch. For it was in Dutch 17th-century genre painting that an extensive, systematic attempt was first made to represent faithfully scenes from everyday life. But Hogarth's mentality was very different from that underlying Dutch 17th-century genre painting which, lacking any critical, combative, humanitarian impulse, was designed to amuse a contented bourgeois spectator. This was in striking contrast to 16th-century Dutch and Flemish painting with its frequently instructional, satirical intent, when the fight was on for religious beliefs and national independence against the Spanish invader. In the more tranquil, self-satisfied Holland of the 17th century under middle-class rule, didactic and satirical intentions were no longer conveyed in pictures and engravings of a high artistic level but only, if at all, in popular prints. Such a moralising tendency did exist in half-popular engravings illustrating Protestant edifying literature, particularly proverbs, but—typical of a Protestant middle-class country at a relatively early stage of development—this did not take the specifically utilitarian form of exalting hard work, as Hogarth's cycles were later to do.

Hogarth, whose object was to express ideas through themes of his own invention covering all the vicissitudes of contemporary life, did not restrict himself to any particular field of human activity or stratum of society, as the Dutch genre painters did. Comparison with his cycles and their inexhaustible wealth of thematic material makes it at once apparent to how few basic themes Dutch genre painting of contemporary life can be reduced—principally to scenes of breakfast, drinking, card-playing, music, reading or writing a letter, a visit, a mother and child, a scuffle between peasants. Hogarth regarded human life as a whole, and his knowledge of it was deep; and he gave a full, critical account of his discoveries according to his own conception of it.

The cycles are more widely separated from Dutch painting than the early narrative pictures. Although many elements of Hogarth's anecdotal art even as late as this were necessarily present in Dutch painting, he had leaped amazingly far beyond them both in themes and individual motifs. One of the few compositions which bears some resemblance with Dutch art is *The Rake amidst an Orgy in a Tavern* (Pl. 50b). Though the scene's actual location is the Rose Tavern in Drury Lane, it certainly harks back to a type of Dutch genre painting representing the Prodigal

Son or, discarding the Biblical pretext, an orgy pure and simple (the Hals school in Haarlem; Dirk Hals, A. Palamedes, etc.). But even if the arrangement of young people round a table is by its nature similar, individual motifs in the Dutch scenes cannot be compared with the amazing variety of Hogarth's figures and episodes, based on long observation and cunning invention. The girl undressing in the foreground was possibly inspired by Steen who often painted a woman dressing in a similar attitude, with one knee crossed over the other (e.g. *La Toilette*, formerly Kann Collection, Paris; de Bruyn, Hague).[6] In the same work the pose of Hogarth's Rake with one leg on the table is equally reminiscent of similar young tipplers in Steen drinking with a girl, as in *The World Reversed* (Vienna) (Pl. 51b)[7]; here even the numerous objects on the floor in the foreground, some of them overturned, come close to Hogarth's arrangements. Steen used these motifs in most of his pictures to add to the liveliness of his story and facilitate the creation of space. Steen was one of the keenest observers and his scenes teem with ever-new ideas; inclined to humour and interested in psychology, he was absorbed in movement and in facial, almost caricature-like expression. Indeed, as the sole Dutch genre painter who could tell a story which lingers in the mind, Steen was perhaps the only one from whom Hogarth actually borrowed specific motifs. It is quite possible that the motif in the last scene of *Marriage à la Mode*, of the alderman removing the ring from his dying daughter's finger, was inspired by one of Steen's frequent representations of a physician taking the pulse of a female patient. *A Midnight Modern Conversation*, closely related in style to the *Rake's Orgy* and to *A Rake's Progress* in general, is another case in point.

But whilst laughter and merry-making were a predominant feature of Dutch genre painting, Hogarth conjures up a variety of expressions, passions, complex states of mind, fleeting shades of mood and situations of which the Dutch would never have dreamt.[8] No need for him ostentatiously to display the distinctive characteristics of 'vices', for his slightest sign sufficed. Whilst in Dutch genre painting, with perhaps the notable exception of Steen, all the figures are very much alike, Hogarth portrayed each of his as a distinct individual, having observed with intensity his way of walking and holding his head, the play of his features and his gestures. Shrewd passages in *The Analysis of Beauty* testify to the conscientiousness with which he dedicated himself to problems of expression and character. Gestures, too, are astonishingly individualised and never repeat themselves as they do in Dutch painting. He took great pains with external details: each dress, coiffure and adornment is correctly delineated. Or take again their surroundings. Systematic attempts to show an actual upper middle-class room with all its minutiae were first made by the Delft school, notably by Vermeer and Pieter de Hooch[9]; yet, compared with Hogarth's varied settings, how monotonous are those recurrent interiors with a single, select picture on the wall; always an Italianising, mythological one, since this alone was considered typical and worthy of a wealthy milieu. Each of Hogarth's has its own special furniture and pictures—Italian in the case of an aristocrat, Dutch and Flemish in the case of a merchant. In the *Marriage Contract* and *Breakfast* scenes of *Marriage à la Mode* (Pls. 87a, 89a), interiors in Kent's style are faithfully portrayed; the second is even said to be an exact copy of Horace Walpole's drawing-room in Arlington Street. The interior in the scene of the *Quack Doctor* is copied from that in St. Martin's Lane of Dr. Misaubin, a physician of French origin whom Hogarth also lampooned in the *Harlot's Death*, (Pl. 37a), and Fielding in *The Mock Doctor*. Engravings, too, even simple notices on the wall, and countless other accessories characterise a particular milieu; never did Hogarth portray general glamour or vague shabbiness as was customary with the Dutch painters. For the latter, poverty held no terrors; for instance, Ostade's

pitiful surroundings are made to appear amusing, picturesque, almost romantic. Hogarth's poverty, naked and complete, suggests a warning, as for instance the miserable room in *The Idle Apprentice returned from Sea* (Pl. 106a).

The Dutch and Flemish tendency to generalise—less marked in Steen or even in Terborch, Metsu and Maes—showed a certain swing near the end of the 17th century towards more concrete situations and motifs, more in line with the coming art of Hogarth (e.g. Brakenburgh). From the early 18th century representations were no longer confined to peasants on the one hand and aristocratising fashions, so characteristic of the late 17th century, on the other. The genuine middle class itself began to be included (e.g. Lambrechts, Horemans the elder, van der Berge and Troost). Among Picart's numerous engravings for the *Cérémonies et Coutumes religieuses*, which in Dutch art form a transition between R. de Hooghe and Troost, those representing Protestant, Catholic and Jewish ceremonies are not only documentary, while at the same time slightly anecdotal and even grotesque, but also most up-to-date in character. Hogarth's natural interest in them was stimulated by the appearance in London between 1733 and 1737 of an English edition on which Gravelot collaborated. Often in his cycles, particularly the early ones, somewhat similar motifs to Picart's can be detected. The pattern of the three main figures—bride, bridegroom and clergyman—in the *Marriage of the Rake* (Pl. 53b), their arrangement within the setting and even the stooping attitude of the little boy beside the bride, seem to derive from Picart's *Catholic Wedding in Church* (Pl. 27b); in fact Hogarth's composition looks almost like an intentional caricature of it. But the resulting compositions are entirely new creations, more animated and more markedly satirical.[10]

In England itself, before Hogarth or during his early years, the shift of accent in genre painting, however moderate compared with Hogarth, is noticeable in the works of such Dutch and Flemish immigrants[11] as the Brouwer follower, Egbert van Heemskerk (1634–1704), whose grotesque stories offer many points of contact with Hogarth; Peter d' Angelis (1685–1734)[12]; van Aken (died 1749); and the interesting Marcellus Laroon the younger (1679–1772), an Englishman of Flemish descent. A combination of adventurer and gentleman of fashion, captain under Marlborough, harlequin under Rich, Laroon could sing and make music; as a painter, he was almost a dilettante yet not without charm, and his music-parties, levées etc., in so far as they came earlier, may count as forerunners of some of Hogarth's compositions. A similar attempt is made in them to give truthful renderings of the milieu, with numerous paintings on the walls and types very like Hogarth's. Laroon certainly had ample occasion to come much closer than the average *petit maître* to everyday reality in its higher and lower spheres and, chronologically, he is an obvious link between Dutch-Flemish genre painting and the Hogarth of the early cycles. *The Rake's Orgy* (Pl. 50b), may be compared with his *Tavern Scene* (Tate Gallery) (Pl. 51a), of a small company of men and women drinking and smoking round a table. In him, as in Hogarth, a sharper, more bitter accent is discernible than in former Dutch genre painting; still imbued with something of the Restoration spirit, there is a certain natural and unadulterated vulgarity, and gaiety is just a façade. In *The Rake's Orgy* Hogarth shows the hostility behind this façade as each sex endeavours to get as much as possible out of the other. The resemblance between the two artists is not confined to their spirit alone; a formal likeness—it would be hard to say who was more the giver and who more the receiver—links Laroon with the early Hogarth's *Theft of a Watch* (Pl. 16b). They have the same elongated, somewhat rigid, stilted figures, the same plebeian gestures, abruptly outstretched arms and vulgar expressiveness of the hands.

Comparison between Hogarth's representations in his cycles of the underworld and prostitutes

and the numerous Dutch brothel scenes which, in their pretty-pretty conventionality, can scarcely be distinguished from genre representations of respectable society, produces the same result. For the first time, and of course far more than Laroon, Hogarth gave a true picture of this world in great variety. The relatively gay aspect of the almost documentary *Rake's Orgy* is only one facet of it. Another gay one, of a prostitute's life in a more refined atmosphere, is the second scene of *A Harlot's Progress*, when she is the pampered mistress of a rich Jew (Pl. 36c). Quite a different milieu is portrayed, however, in the seventh scene of *Industry and Idleness*, where the idle apprentice lies in bed with the prostitute in the most pitiable garret ever portrayed (Pl. 106a). And in the ninth scene (Pl. 107a), in a night-cellar, he is betrayed by a prostitute to the police amidst a most gruesome company of harlots and receivers of stolen goods. This could not be further removed from Laroon's fashionable gatherings of cavaliers and ladies.

So the tragedies Hogarth built up in his cycles were new both in theme and spirit. He set out to convince and win over the spectator by continually holding his interest, desiring his cycles to be judged as plays.[13] He used a tense, dramatic technique throughout; misery and suffering mount as the central figure sinks lower and lower and each scene makes a specific contribution towards this development. Yet in *Industry and Idleness*, with its parallel didactic theme, the unfolding of the story is not at all schematic and consequently the spectator's feelings are constantly swung between sympathy and antipathy. Most skilful is the transition between individual scenes, in which the spectator often learns of previous events and is prepared for those to come. Sometimes there are pauses in the action, gaps purposely introduced to create greater tension. Though the general trend of the cycles is undoubtedly tragic, they are interspersed with comic motifs. But the hero is never allowed to become a completely ludicrous figure. Hogarth knew well enough the narrow borderline between the serious and the absurd in everyday life; and he knew how to achieve a didactic purpose by an alternation between the tragic and comic elements just as Fielding did. By such means Hogarth could convincingly render all aspects of life as he knew it and at the same time provide a brief respite from sorrow and misery.

The last scene of *A Harlot's Progress*, the *Harlot's Funeral* (Pl. 37b), gives some idea of the extreme novelty of Hogarth's themes. Although the most macabre aspects of everyday life are observed in a manner perhaps no artist had hitherto dared to employ, this completely unsentimental scene of prostitutes bidding farewell to their dead colleague offers at the same time a kind of serio-comic relaxation after the climax of the harlot's tragic death in the previous picture. The coffin, placed in the centre of the room, serves the hideous waiting-woman as a table on which to set a bottle of spirits for the mourners.[14] One of these, a pretty young woman with bare breasts, is raising the coffin lid to peer at the dead woman's face. Other guests in the background weep, gossip, drink or titivate before a mirror. In the right foreground kneels the deceased's employer, a well-known London character, an old procuress named Mother Bentley, howling with grief; she is tipsy, a bottle of gin lying beside her on the floor. Also on the right, the grim-faced undertaker flirts with a prostitute who responds by stealing a lawn handkerchief from his pocket. On the left the clergyman is about to perform the funeral rites; he is one of the notorious 'chaplains of the Fleet' who, for a few shillings, would marry couples, often intoxicated inmates of the Fleet Prison, without a licence. Closer scrutiny reveals that his stiff attitude is due to complete inebriation coupled with his amorous occupation. From his glass liquor pours over his trousers as with his hat he screens the lap of a buxom woman, one Elizabeth Adams, later hanged for robbery, who has linked arms with him. On the floor beneath the coffin the harlot's young son, dressed as chief mourner, plays happily with a toy.[15]

Among Hogarth's unprecedented variety of scenes was that of a mad-house, probably the first representation of such a subject.[16] Attracted by the psychological interest of the theme, he introduced it into *A Rake's Progress*, the last scene of which (Pl. 56a) gives a fairly faithful portrayal of the lunatic asylum at Moorfields, which Londoners knew well. Led to Bedlam from the Debtor's Prison, naked and stark mad, the rake is put into chains by an attendant to prevent his committing suicide. Frenzied, he is unable to recognize the weeping woman at his side who is the only person, throughout the cycle, who has been faithful to him. Round these central figures Hogarth placed various types of lunatic: crazy musicians, astronomers, a would-be king, one who believes himself to be Pope and—significant of the artist's hatred of religious fanaticism—a religious maniac. To strengthen the allusion to Bedlam, two of the figures are free versions of Caius Cibber's sculptures at that time placed over the gate of the building (*c.* 1680, now Guildhall Museum); the rake himself is based on *Melancholy Madness*; the religious fanatic, even down to his expression, on *Raving Madness*.[17] Hogarth's incorporation of these two famous Restoration sculptures, derived from those of Michaelangelo's Medici tombs and so admired by Roubilliac, points again to his partiality for baroque art. The lunatic types in his picture, laughing, shouting, masquerading and grimacing, are physiognomic studies of an unheard-of novelty in European art. The scene is made even more realistic by the presence of onlookers: as Londoners were wont to amuse themselves in Bedlam on payment of a small fee, so here two finely dressed ladies are walking through this house of horrors, tittering behind their fans.[18] Not until Goya's famous madhouse (Academia di S. Fernando, Madrid; Pl. 56b), did any artist dare to present these dreadful motifs so nakedly, for even in Fuseli's fantastic madhouse visions the realistic and comic features of Hogarth's subject are omitted.

In the cycles, the spectator is constantly reminded of Hogarth's preoccupation with psychology. His wealth of characters seems inexhaustible, each apart from his heroes usually appearing in one scene only. They are palpable, living beings rich in individuality. Only the heroes of his most didactic cycle, *Industry and Idleness*, approach mere types. Hogarth did not start from the abstract type and progress to reality, but typified on the basis of empirical knowledge. So behind and in his types there is always the individual. Each fresh character is completely expressed through his features, his bearing, his gestures, as for instance the gallery of strange, skilfully characterised professions—a dancing master, a fencer, a prizefighter, a gardener, a bravo, a jockey—in the *Levée of the Rake* (Pl. 50a).

Hogarth rendered tragic and comic figures with equal understanding: the expression of the idle apprentice, condemned to death by the magistrate, is as unforgettable as that of the modish connoisseur of music, his hair in curling papers, sipping his chocolate in the *Levée* of *Marriage à la Mode* (Pl. 90c). Each picture in *A Rake's Progress* displays a different feature of the rake. These characters often surpass in vividness even those of contemporary English literature. Fielding, who equally disliked depicting people in black and white, as Richardson so often did, never ceased to admire Hogarth for his gift of characterisation and of portraying states of mind; he refers to him in the same breath as Shakespeare and it was no empty compliment when he declared himself envious of it. It is a sign of their parallel development, that while the young Hogarth illustrated some of Fielding's early satirical plays,[19] Fielding, the writer of superb analytical novels, relied greatly on Hogarth's cycles. It was Fielding who, in *Tom Jones*, picked out a number of figures from Hogarth's cycles to give his own deeply and truly seen characters greater relief and a visual basis familiar to every reader.[20] The flogging pedagogue, Parson Thwackum, orthodox and intolerant, speaking of the 'divine power of grace' in order to circumvent use of the

word 'goodness', reminded Fielding of the brutal gaoler in Bridewell, threatening the harlot with upraised cane. Mrs. Partridge, the schoolmaster's formidable, jealous wife, resembled for Fielding the disagreeable stout attendant pouring tea for the harlot. In *Morning* (Pl. 58a), from *Four Times of the Day*, an elderly spinster with frosty nose and thin lips to which she presses her fan is making her way to Covent Garden Church, followed by a shivering little boy and glaring at some blatant scenes of love-making. It is to this creature that Fielding refers for the visual likeness of his gossiping, silly, priggish Miss Bridget Allworthy, passing herself off as an experienced woman of the world.

Fielding (particularly in his plays) often held up to ridicule the same familiar London figures as Hogarth such as the ugly Swiss Heidegger, the director of the masquerades; the French quack doctor, Misaubin; the eccentric, money-making clergyman, Orator Henley, who was also Fielding's political adversary. Familiar to all intellectuals, the figures of Hogarth's cycles became current terms of reference; when, in a letter to Gray (1766), Horace Walpole describes a whimsical French poet of his acquaintance, he likens him to the self-applauding versifier reciting in the *Levée of the Rake*. Finally, however original Hogarth's characters were, they could yet be linked quite closely with modern international art. This is true even of his renderings of well-known London figures. In the *Death of the Harlot* (Pl. 37a), Dr. Misaubin, the French quack doctor practising in London and famous for his pills which could cure everything, was a personal variation on Watteau's caricature of his fellow-countryman, drawn in Old Slaughter's Coffee-house in St. Martin's Lane (Pl. 36b).[21] Both artists fastened on Misaubin's extreme thinness and height, long coat and tight stockings, which invited caricature. But while Watteau represented the quack in a static pose, holding bottles and a syringe and, surrounded by graves, skulls and bones, i.e. the symbols of his profession, Hogarth shows him in full action, wriggling like a worm as he excitedly points to his pills and quarrels with another doctor whilst the harlot is dying beside him.

The formal problems of the cycles, even including the two *Progresses* from the 'thirties, cannot be summarily defined, since these works were spread out over a long period. In spite of Hogarth's baroque and to some extent mannerist inheritance, the outstanding feature of the cycles was an extraordinarily high degree of descriptive realism, resulting from their new themes, the artist's insatiable urge to tell detailed stories and his uncanny powers of observation. In the early cycles, this realism expressed itself in the unrestrained natural movements of the figures and in countless accessories, thus almost ruling out the formation of a new, solid baroque composition. These unconventional, infinitely varied attitudes and gestures dominate one's first impression of individual scenes.

When Hogarth tried to construct a consistent pattern, it was usually the traditional pyramidal grouping of figures, as in *The Death of the Harlot, The Rake's Marriage, The Rake in Fleet Prison, The Rake in Bedlam*, or *Morning* from *Four Times of the Day* (Pls. 37a, 53b, 55a, 56a, 58a). He did not consider this too schematic and made the best use of it in his own way ('There is no object composed of straight lines, that has so much variety with so few parts as the pyramid': *Analysis of Beauty*). Take, for instance, *Morning*, a work rather later than *A Rake's Progress*: on the one hand the old spinster, the centre of the composition, glaring in the middle of Covent Garden at the objects of her indignation on the other. These latter occupy the whole left side of the composition, the love scenes and other incidents being depicted with baroque impetuousness, though formally pressed into a pyramid. Of individual scenes in the early cycles perhaps only the *Rake's Orgy* represents a genuine attempt at a richer, freer build-up. Yet important fragments of a baroque framework, mainly serpentine lines and waving curves, exist in most of the compositions.

As far as one can judge from *A Rake's Progress* (the paintings of *A Harlot's Progress* not having survived), it would appear that the composition is usually more closely knit in the engravings than in the paintings.[22] These, with their relatively uneven handling at this early stage, could be said to serve rather as models for the engravings than as works of art in their own right. Yet sometimes, even while working on the engraving, his vision would so teem with new motifs that he was compelled to enlarge the composition. This occurred, for instance, in the scene of the *Rake's Arrest* where he added, in the second state of the print (in contrast to the clarified composition of the picture, Pl. 52a), a crowd of boys gambling; and later still in *Industry and Idleness*, in the transposition from the drawing to the engraving of the scene of the idle apprentice betrayed by a prostitute. Hogarth had no fixed rule as to which was the right moment to clarify the composition and reduce it to its essential details. Sometimes the interval between painting and engraving was quite long, although the space of eight years in the case of *The Sleeping Congregation* was exceptional.

The thematic relationship between Hogarth's cycles and Dutch genre painting, particularly as regards Steen, has its counterpart in their formal characteristics. For Dutch genre painting, with its new content, had already broken up the schematic grandiosity of baroque composition before Hogarth's time and lent a note of reality and greater material solidity to its rather decorative colours. But even in the early cycles Hogarth was striving just as much to build up a new composition as to break down the old one. That is why, compared with Steen's large, many-figured compositions, the patterns of even his early cycles are rather more closely knit. His manner of distributing varied and vivid colours throughout his pictures came no less from baroque art than from Dutch genre pictures. It is easy to identify some of Hogarth's individual colours such as his deep reds with those in Steen, Metsu and Teniers. Steen's pictorial leanings towards rococo (the soft yellows, light blues, mauves and pinks of his late phase) may also have appealed to Hogarth. However, in their imaginativeness, variety and harmony, the colour schemes of *A Rake's Progress* go far beyond Steen and Dutch genre painting in general, although E. van Heemskerk's almost pearly painterly technique could have had some bearing on it. On the whole Steen's colours are harsher and colder than Hogarth's. Some of the delicate, typically 18th-century colour effects in *A Rake's Progress*, not to speak of the later *Marriage à la Mode*, clearly exceed the rococo 'potentialities' of Steen: for example, the rake's figure in the *Arrest* scene, with his flowing purple-black tie, or the whole of the Rake's *Orgy* with its free, painterly handling, particularly the sketchy yellow dress of the girl in the background. These are what is commonly called 'French', though to a large extent they are new even from a French point of view. Taken altogether, the early cycles, despite their Dutch and particularly French affinities, are totally different from Dutch and French art. With their new, uninhibited themes, their wild motifs and slowly unfolding painterly qualities, they reflect a style very much Hogarth's own. They are, indeed, incipient English rococo.

A most significant aspect of the compositions of Hogarth's early cycles is their relationship with the stage. It is typical of his mentality and procedure that, in their general arrangement and in the movements of his figures, he learned more from the stage than from the ever-recurrent motifs of Dutch genre painting. He appreciated every kind of stage effect—the *tableaux vivants* of the pantomimes as well as ordinary drama, its characters and techniques.[23] For, although the general ideas of his cycles are close to sentimental bourgeois drama, Hogarth shared the public's love of pantomime, the popular English derivation of the *Commedia dell'Arte*. He himself expressly compared the scenes of his cycles with dumb shows: 'My picture is my stage and men and women

my players, who by means of certain actions and gestures are to exhibit a dumb show.'[24] On the other hand, so great was the success of his series that they in turn gave suggestions to the theatre. With the same title, *A Harlot's Progress* was at once dramatised at Drury Lane by Theophilus Cibber (1733): as a kind of gay pantomime-ballad opera, in which Hogarth's figures mixed with the traditional ones of the harlequinades, it equally proved a great success. Though staged without dialogue, in a series of *tableaux vivants*, all the characters with the exception of Harlequin sang.[25]

Hogarth undoubtedly memorised stage-effects and used them in his works. Indeed, many events in the cycles, particularly the effective, concentrated death scenes, closely resemble the climaxes of acts or finales. It was often through study of the theatre that he attained his dramatic effects, achieved by the pointed and expressive gestures of his figures. That is also why, in *The Analysis of Beauty*, Hogarth insisted that gestures on the stage should be expressive, whether elegant or inelegant, so that even a foreign spectator, ignorant of the language, would be able to understand the different characters. Yet the stage did no more than reinforce Hogarth's natural inclination for emphatic characterisation, as witness his growing knowledge of physiognomy, his preoccupation with the parallel between the play of features and the movements of the body (the husband yawning after a night's amusement in the *Breakfast* scene (Pl. 89a) of *Marriage à la Mode*) and his aptitude for suiting his huge treasure-house of gestures to a character or a situation. It was probably his scrutiny of the 'actions and gestures' of the stage that heightened his facility for depicting quick, fleeting movements, sometimes giving the impression of a stage climax: the earl in the *Death* scene (Pl. 92a) of *Marriage à la Mode*, represented as he falls dying to the ground, is a typical case in point. *A Midnight Modern Conversation* (Pl. 43a) also shows Hogarth's predilection for these seized movements, the systematic rendering of which points far into the future, to realistic painting in the 19th century. He even anticipated the effects of high-speed photography. In *The Analysis of Beauty*, when describing the movements in his *Wedding Dance*, which are caught almost as in a snapshot, he asserts that if he came closer still to rendering suspended action, the effect would appear unnatural. Another favourite motif, which had already been prominent in his conversation pieces, was that of objects such as chairs or tables overturned or at the moment of overturning. This was also a motif in Dutch painting, used by Steen, Ostade and others. Dim stage lighting, particularly effects of candle-light, deriving from Dutch painting, mainly from Schalcken, seems also to have appealed to him.

For instance the second scene of *A Harlot's Progress*, with its arrested movements, provides a typical stage effect (Pl. 36c); to cover the secret exit of her lover the harlot knocks over the table so violently that the dishes fly into the air, to the consternation of her Jewish protector, her negro servant boy and even her monkey. Such a dramatic impression had already been recorded by the anonymous illustrator of Rowe's Shakespeare edition of 1709. This work must have been familiar to Hogarth, for his inspiration came from the scene in it from *The Taming of the Shrew* (Pl. 36a), in which Petruchio overturns the table, scattering the dishes, to the agitation of Catherine, the servant and the dog. The lay-out and individual motifs are surprisingly similar, though Hogarth vitalised the old, artistically weak model almost beyond recognition.[26]

In *A Rake's Progress* it is most revealing to see how Hogarth transformed a motif from the French harlequinades, although in France the *Commedia dell' Arte* had to some extent lost its popular character. The Rake, as a debtor waylaid by bailiffs while riding in a sedan chair (Pl. 52a), is derived from a composition by Gillot which Hogarth could have known through Huquier's engraving. Gillot's picture (*c.* 1707, Louvre) shows an incident from an interlude, *La Scène des*

Carrosses (based on a real event) (Pl. 52b), enacted in Paris in 1707 together with the 'Italian' comedy, *La Foire St. Germain*: dressed as women, Arlequin and Scaramouche are carried along in sedan chairs, quarrelling with each other, and like their lackeys refusing to give way. Hogarth took over main compositional features of the French scene—the sedan chair, the rake, the chair-carrier, the bailiff. But Gillot's typified stage effect has been transformed into a realistic, many-faceted story. In Gillot the composition is more unified; there are only four characters and (in the engraving) a simplified background,[27] while the figures—the customary types of the *Commedia dell' Arte*—all behave in the same way and repeat the same conventional gestures. Hogarth reduced this composition to one main group and at the same time enriched it. In the manner of contemporary English middle-class drama, he enlivened the scene psychologically, increased the number of figures, all of which he individualised, and introduced a receding background, with an actual view of St. James's Palace and a quantity of lively accessories.[28] Gillot's kinship with Hogarth is even more evident in his preparatory drawing (Princesse Murat) with its highly mobile contrast of light and shade.

Hogarth's stylistic development within the cycles, as within his general evolution, shows a definite trend, particularly from around 1740, towards a clearer and more compact composition, increased spaciousness and—so far as the original pictures of the cycles, which now gain in importance, are concerned—towards more even handling of individual colours. Even during the 'thirties *A Rake's Progress* of 1735 is more spatial than *A Harlot's Progress* of 1732 and some of its scenes have a colouristic finesse which strikes an astonishingly 'French' note. But taken altogether, *A Harlot's* and *A Rake's Progress* from the 'thirties represent the earlier, while *Marriage à la Mode* from the early 'forties the later phase. This raising of quality follows Hogarth's natural line of evolution. However, in certain features, his development towards *Marriage à la Mode* coincided with his search for a more elevated public. If the 'dignified' representation in 1745 of Garrick as *Richard III* marks the climax of his stage portrayals, *Marriage à la Mode* forms its counterpart amongst the cycles (even the title is derived from Dryden's flashy comedy in the grand manner).[29] It is built around the life of the elegant upper strata ('a variety of modern occurrences in high life' Hogarth calls it) and, although it took them and the aristocracy severely to task,[30] it was to them that it was largely designed to appeal. 'Particular care is taken that the whole work shall not be liable to exception on account of any indecency or inelegancy.' Much greater care, too, was taken in relating the story. The structure is more concise; the figures are reduced in number, more agile, more monumental. The size of the engravings and even more of the original pictures was also increased, while the popular cumulative realism and predominance of local colour characteristic of the previous series was reduced. *Industry and Idleness*, three years later than *Marriage à la Mode*, was again destined—perhaps owing to the relative financial failure of the latter—for a more popular public and therefore kept on the whole in a more popular, less refined style, even if greatly clarified in comparison with the two *Progresses*. It is self-evident that the artist of *Industry and Idleness* had already passed through *Marriage à la Mode*.

A general definition for the composition of Hogarth's cycles must be some shade of realistic baroque, a shade very much Hogarth's own, different in the main from Dutch 17th-century painting. But *Marriage à la Mode*, with its greater elegance, grace and fluidity, can more adequately be characterised as the rococo sequel to baroque. In fact, it stands comparison better than the previous series with contemporary continental rococo pictures, particularly French ones. While the two *Progresses* could eventually be called 'anticipated' rococo, *Marriage à la*

Mode was full rococo, so far as such a style was possible in English painting. Hogarth's new trend certainly coincided with the upper strata's taste for continental rococo, which was at its strongest in these selfsame years. For instance, the fashion for Watteau, whom Hogarth had already appreciated fifteen years earlier, was now at its height in England,[31] just as was the fashion for rococo interior decoration, applied arts and furniture.[32] Since Hogarth wished to make this cycle technically more skilful, more French and closer to international taste than his earlier works, he had it engraved by well-known French engravers who had come to work in London.[33] The advertisement for the series which appeared in April, 1743, when apparently the paintings themselves were more or less ready, announced that they would be 'Engraved by the best masters in Paris'. These included Baron, Ravenet[34] and Scotin, the same three who worked on the famous *Reçueil Jullienne*. They had already excelled in France, not only on work after Watteau but also after Gillot, Lancret, Boucher and Cochin. From now on, Hogarth was to maintain the habit of entrusting his more important works (but never those in popular style) to French engravers. The six prints of *Marriage à la Mode* cost almost £2,[35] those of *A Harlot's Progress* £1 and the later but popular *Industry and Idleness*, with its twelve prints, only 12/-.

Very soon after advertising the 'best masters in Paris', Hogarth himself went to the French capital. On the last day of May, 1743, Vertue reports: 'Mr Hogarth is set out for Paris to cultivate knowledge or improve his Stock of Ass[urance].'[36] Even before this, when he was still painting *Marriage à la Mode*, he had ample occasion to study French painting and engraving in London, particularly in Dr. Mead's collection. Moreover, through his engravers, as through Gravelot's extended sojourn in London at that time, his knowledge of French art was still further increased. Indeed, probably no other English artist of his time had the occasion and capacity to be so knowledgeable about contemporary French art. In 1748, five years after his first journey, he attempted to visit the French capital a second time, doubtless with the same object of acquiring artistic information and perhaps also for business reasons. But his adventure in Calais while sketching the town gate prevented his further progress; on suspicion of being a spy he was arrested and turned back to England.[37]

Hogarth's visit to Paris and his great knowledge of French paintings and engravings were only outward landmarks on the road of his own stylistic development which, in the 'forties, showed strong leanings towards contemporary French art and rococo. Yet his evolution towards French rococo must be treated with caution. Even in *Marriage à la Mode* his range is infinitely wider than that of the gallant and usually sugary French rococo painters. Nor does this cycle signify an evolution towards the subtle dream-world of Watteau and his school. In its complete novelty, its theme is almost as far from French 18th-century as from Dutch 17th-century painting, despite contacts with both. The expression of the figures in *Marriage à la Mode* (though far less exaggerated than in the two *Progresses*) is more varied than the usually rather schematic ones, in most of Hogarth's French contemporaries. Formally, too, *Marriage à la Mode* would not fit easily into the aristocratic world of French rococo painting. For all its elegance and subtlety, it is yet too real and solid: it is the middle-class features of rococo which stand out in it rather than those of the aristocracy. In other words, this is English rococo with a far stronger middle-class tinge than the French. In spite of more obvious general similarities with French rococo than before, *Marriage à la Mode*, like the two *Progresses*, also continues the line of Dutch middle-class realism and solidity.

Only occasionally can an actual contact be found with more realist, anecdotal artists of the French rococo period such as Ch. A. Coypel, who was also particularly interested in facial

expression, or J. F. de Troy. In the *Levée of the Countess* (Pl. 90c), one of the most fashionable rococo ensembles Hogarth ever depicted[38] although fundamentally a satire upon the aristocratic habit of the levée,[39] a group composed of a comical, dandified singer, his flautist and their audience occupies the greater part of the picture. The chief place in this admiring company is taken by a distinguished lady at the centre of the composition, who spreads her hands and half rises from her chair in excitement. The whole foolish scene is of course immediately reminiscent of similar ones in Molière's *Les Femmes Savantes* or *Les Précieuses Ridicules*, which Hogarth might easily have seen even in London. Representations of these plays, in pictures or engravings, were given sources, were he on the look-out for something of the kind. Thus it is no surprise to find him taking inspiration from one of Coypel's illustrations to *Les Femmes Savantes*, (Pl. 91a), engraved by Joullain in 1726 and re-engraved in this country by van der Gucht. It should be recalled that other illustrations by Coypel were published in the 1732 English-French edition of Molière, for which Hogarth also supplied illustrations, and that, throughout his career, Hogarth had the highest regard for this French artist who, like himself, was much preoccupied with the theatre.[40] It is equally significant that no longer was it Gillot's relatively modest theatre scenes that inspired Hogarth in *Marriage à la Mode*, but Coypel's much more elegant ones. Hogarth's singer in the *Levée* bears some resemblance to Coypel's Tissotin reading his silly sonnet, while the woman leaning forward in ecstasy is almost identical with Philaminte. Even Hogarth's compositional motif of this lady sitting back to back with the countess may come from Coypel's similar arrangement, in which Armide declines to listen to the reading.

Despite these borrowings, Hogarth's composition is far richer in detail, more complex and more realistic than that of Coypel, whose scene, with fewer figures, apparently simulated the rather bare stage effects of the Comédie Française. It is quite likely that Hogarth also knew another, even more famous illustration to Molière. In Boucher's illustration to *Les Précieuses Ridicules* (1734, engraved by Cars) (Pl. 90a), two swashbuckling lackeys talk with two ladies in very similar attitudes to those in Hogarth's group. But here again the French composition is more closely constructed and more rococo than Hogarth's. Yet the point to stress is that for one of his most famous compositions he should have started from French illustrations to Molière.

Finally, the parallel should be remarked between Hogarth's work and another French painting by J. F. de Troy (1679–1752) from as late as 1740. This was closer in time and, in its turn, seems also to be derived from Coypel. Again the subject is similar to Hogarth's: a group of people intent on a reading from Molière (Marquess of Cholmondeley Collection, Houghton) (Pl. 91b). It is the unaccustomed reality of de Troy's scenes and the unusual solidity of his figures within and in spite of his baroque-rococo style, which permit a comparison, even in a general sense, between the two artists. Indeed the parallel here is more striking since de Troy's scene has more figures than Coypel's and is decidedly richer. Yet even here it is quickly apparent that, like Coypel, de Troy could easily reconcile the degree of *his* realism, that is, the position of his figures made as true to nature as *he* wanted them, with the necessarily artificial flow of aristocratic rococo lines. Compared with this painting, as with Coypel's engraving and naturally even more with Boucher's, Hogarth's composition appears rather inelegant; yet how vital, how natural and unaffected are his attitudes and gestures.[41]

This naturalness, Hogarth's favourite 'intricacy and variety', does not however prevent the patterns of *Marriage à la Mode* from being far more concentrated than those of the two *Progresses*, nor the poise from being astonishingly well calculated. This is even true of the rather crowded *Contract* scene, with its two distinctly balanced, sinuous groups (Pl. 87a). Note with what incredible

ease the lawyer sharpening his pen—a realistic motif to accommodate into a formal pattern if ever there was one—fits into the rococo curve. But this is truer still of the compositions with few figures which now play a major part in the cycle and in which not the faintest constraint is perceptible. Thus in the *Breakfast* scene (Pl. 89a), the steward's gentle but long-drawn-out curve is counterbalanced by the two massive groups of the aristocrat and his wife, both seated, while the overturned chair skilfully yet unobtrusively placed in the foreground is the pivot of the composition. Similarly in the scene at the quack doctor's, every shade of movement by the three central figures carefully corresponds and all finally dissolve in the almost straight and fragile line of the sick girl. And in the *Duel* scene, the compact central group of the couple creates a big void around itself, determining every other component of the composition (Pl. 92a).

Never before had Hogarth attained such unity and concentration, such colour harmony— what in *The Analysis of Beauty* he termed 'composed variety'—as in *Marriage à la Mode*. But it is not quite the harmony of French rococo; it is a harmony based on his view that 'colours cannot be too brilliant if properly disposed'. Although he attempted to unify them, they are richer and yet more real than those of French rococo. In the earlier cycles a certain connection was noted in their colour schemes with the attempt at balance in baroque painting and with the variety and reality in Dutch genre pictures. Now, in *Marriage à la Mode*, where rich, brilliant colours are widely dispersed in a scintillating pattern, skilfully woven in and out of the composition, they become more varied, and yet more balanced. In the *Contract*, *Breakfast* and *Levée* scenes, the wavy pattern, with a striking centre surrounded by more neutral colours and the revival of this lively key at both edges of the composition, is built up in a consistent, spirited manner. For instance, in the *Contract* scene, the alderman's brick-red forms the centre of the composition, the predominantly blue-white combination of the young couple the left side and the elderly peer's brownish-pink (with gold and white) the right. Their vividness is enhanced by the neutral patches of the lawyer's black on the left, the attorney's grey on the right, and by toning down the numerous pictures and their gold frames on the walls in the background. Hogarth's colours are richer, more original, more brilliant and more real than those of French rococo and come very near to the natural colours of the objects in question, bringing out their plasticity and substance. These qualities in them and their close interaction constitute their chief difference from French rococo.

Neither Watteau's fleeting, delicate colour effects reminiscent of the old masters and his stippling technique, nor Boucher's monotonous, conventional rococo hues, so limited in number, were really suited to Hogarth. Even Boucher's relatively broadly painted genre pictures seem cold, pale and rather abstract when compared with *Marriage à la Mode*. Only seldom does Hogarth come anywhere near to a Boucher colour; the pink of the bed curtains in the *Levée* scene approximates to that in Boucher's *Modiste* (Wallace Collection), exceptionally real as it is for the French artist. Elsewhere his pinks and yellows, such as the light pink of the Countess's underskirt or the light yellow of her skirt in the *Levée* scene, are of a less cold and abstract shade than Boucher's and devoid of over-sweetness. Again, for the harmonising of blue and white, compare the almost Gobelins-like abstractness of this combination in Boucher's picture with the breathing, rustling wealth of it in the young couple of the *Contract* scene. Beside *Marriage à la Mode*, even the colours in Lancret's most genre-like scenes have a faintly decorative, *recherché* quality. By means of colour, Hogarth now expressed structure and texture far more vividly than he had done in *A Rake's Progress*. His folds and creases even excel the rendering of silks and satins in Dutch and French pictures. Witness the nightdress of the kneeling countess in the

Duel scene, or her white overdress (the green-white combination being rather Dutch in origin) in her *Death* scene (Pl. 92b). In *Marriage à la Mode* the painterly broadness in rendering the solidity of material at times reminds one of Hals (the lawyer's black gown in the *Levée* scene), while only occasionally, even in the late Watteau, for instance his domino dresses, could Hogarth have met such broadness serving a similar purpose. Quite improbable in contemporary French art is such a bold, realistic effect of light as the broad vertical brush-stroke indicating the firelight gleaming on the chair, an indispensable feature of the *chiaroscuro* composition of the *Duel* scene. Hogarth here gave the customary chair repoussoir of Steen or the school of Delft a Rembrandt-esque twist and in the same motif also brought decorative features from baroque painting down to earth by merely indicating a curtain with a bright, vertical, painterly stroke.

Nevertheless one is always conscious of contemporary French rococo in the background. It is true, of course, that some of the French flavour derives from the elegant nature of the dresses of the English upper class, the particular style of which came chiefly from France (e.g. the young couple in the *Contract* scene or the enraptured lady in the *Breakfast* scene). True, also, that one is quick to call 'French' any genuine feeling for colour composition in an 18th-century artist and, equally vaguely, to call 'rococo' the undeniably graceful character of a whole cycle painted in the 1740s. But the fact remains that Hogarth's gift for harmonising or toning down a variety of colours was certainly enhanced by his knowledge of French painting and that his skill in certain delicate juxtapositions had been acquired in that field. In this respect he perhaps learned even more from French portraits, where the colour pattern is more concentrated and the individual colours more real. Yet individual combinations in *Marriage à la Mode* also reveal the experience gained from Watteau and his school and quite possibly from J. F. de Troy, no less than from Boucher. Watteau's brownish-pink, Pater's yellow and pink, de Troy's white and dark yellow seem to recur quite often in *Marriage à la Mode*. A concrete example occurs in the striking black-red combination of the large, ugly woman who forms the centre of the *Quack Doctor* scene—the application of a familiar colour scheme of the Watteau school, though less delicate. On the other hand, it is a scheme which, used as a solid block, also occurs quite frequently in Dutch painting (e.g. de Hooch), but there it only seldom dissolves into the composition of the whole with such ease as in Hogarth.

To summarise the colour scheme of *Marriage à la Mode*, and the same applies to its whole unique style, one can say that, for all its increased concentration and even gracefulness, it is more realistic and more varied than decorative contemporary French rococo painting, lying somewhere between this and the sparing, careful, painterly classicism of Chardin which in turn owed so much, even more than Hogarth, to Dutch painting.

But even if *Marriage à la Mode*, in its realistic rococo, is peculiar to Hogarth, an elegance that had not been evident in him for quite a time cannot be denied it. Indeed, a strong rococo streak characterised not only Hogarth but English painting in general in these years, and this was strengthened by outward influences tending in the same direction.[42] Hogarth was the first English painter to respond, in works done for the aristocracy, to the elegance and charm of Watteau and his followers; and a taste for Watteau in artistic circles set in earlier and more intensely here than in France, largely because no strong academic tradition obstructed it. Some, at least, of Watteau's great influence was due to the fact that England was the only country he ever visited; nor should it be overlooked that Mercier, the earliest Watteau imitator, spent his whole adult life in England, forming an important link in French-English artistic relations.

To this centre of receptivity and avidity for French rococo, following Watteau and Mercier,

there came one of the greatest French engravers and draughtsmen of the century, Gravelot (1699–1773). He arrived in London in the year of the Molière publication and remained for some thirteen years. Living amongst the small group of English artists, he must have created a deep impression and greatly helped to impart a feeling for French rococo. He was on particularly good terms with Hogarth and in addition to his own drawing school in James Street, Covent Garden, he taught in Hogarth's academy in St. Martin's Lane.[43] With him he frequented the same coffee-house in which Watteau had met artists of the older generation. Gravelot was the given French artist for England at that moment, graceful, tempered and realist. He taught to draw with precision and charm from the skilfully arranged draperies of his movable dolls and in his own drawings and engravings rendered figures and interiors with an exactitude rare for French draughtsmen of his generation.[44]

One could say, in a general way, that the development in England from a taste for Watteau to one for Gravelot implied a development from rococo elegance to rococo realism, from the rococo of the aristocracy to that of the middle class. Partiality for Gravelot and the influence he exerted were naturally only the outward signs of this general evolution. For during the 'thirties and 'forties, as exemplified in the stylistic evolution of Hogarth's cycles, the general artistic situation in England had rapidly changed. A certain development in Mercier from the Watteau-esque to the Gravelotesque, obvious in some of his drawings, is characteristic of this. And it is equally characteristic that he who at first imparted Watteau's elegance to Hogarth should be later influenced by Hogarth's realism. In a bizarre picture in which he represents a lady preparing before a mirror for a masquerade (English private collection; Pl. 90b), he has tightly compressed Hogarth's *Levée* scene of *Marriage à la Mode*, adding one or two *Commedia dell'Arte* figures of a rather heavy, realist type[45]; the head and expression now largely dominate the scene, in the manner of Hogarth's engravings of the type of *The Oratorio*.[46]

Gravelot was originally called to London to make engravings for the English edition of the *Cérémonies Religieuses* (1733–7). As was frequently the case in French 18th-century art, these early engravings of his combined Parmigianinesque Mannerism with rococo elegance. Sometimes he added entirely new compositions; sometimes he rendered Picart's more graceful.[47] Hogarth certainly knew these illustrations as well as those of the earlier edition. The development of his taste from Picart, still so marked at the time of the early cycles, to Gravelot, whose spirit hovers over *Marriage à la Mode*, denotes a radical change. Though not himself a painter, Gravelot's influence was great on most English painters of importance such as Hogarth, Highmore[48] and Hayman, who also taught in Hogarth's academy and whose drawings Gravelot in turn engraved. Particularly forceful was Gravelot's impact on the young Gainsborough, who was his pupil. Strange as it may seem, it was Gravelot and Hogarth together who influenced, in a 'French' sense, by far the most important of Gainsborough's works—his early portrait groups of the Suffolk period. These graceful pictures, painted from 1746 onwards, immediately after his visit to London and apprenticeship with the Frenchman, have a particular Gravelot flavour. In English painting, they derive not only from Hayman, who was probably another of Gainsborough's teachers,[49] but also from Hogarth's early, elegant 'French' conversation pieces in outdoor settings, that is, from the former French wave in Hogarth as typified by his Watteau-Lancret-like *Angling Party* in Dulwich (Pl. 31b).[50]

Even more than portrait painting, English engraving and particularly book illustration can scarcely be understood without an appreciation of the part Gravelot played. In the 'twenties, Hogarth had been responsible for raising the standard of book illustration to such an extent that

now, in the 'thirties and 'forties, it was capable of absorbing the influence of a continental artist of a high level. In place of Coypel the accomplished, refined Gravelot now became the ideal for English illustrators. In contrast to the former large-size books, he illustrated small-size, intimate ones. These included the most famous works of English literature, such as Dryden's plays (1735) and Gay's *Fables* (1738); Richardson's *Pamela* (1742) and Shakespeare's plays (1744) together with Hayman; and, on his own again, Fielding's *Tom Jones* (French trans. 1750). The style of his illustrations although markedly rococo was occasionally more moderate and quiet, a kind of transition from Régence to Louis XVI. The closeness between English and French art is particularly pronounced in the illustrations done jointly by Gravelot and Hayman. These again, especially those for the large Shakespeare edition of 1744 (published by the Oxford University Press) (Pls. 79a, b) marks a climax in the development of English book illustration towards French elegance which had begun with the Molière edition of 1732. Whilst many of Hayman's illustrations to Shakespeare's tragedies could almost be called French, their manner being in the grand baroque of French academic pictures of the Natoire type—they remind one of Fragonard's *morceau de reception* for the Academy, *Coresus Sacrificing himself for Callirhoe* (1765, Louvre), with its combination of Natoire and Pietro da Cortona—it must be admitted that Gravelot's excellent engraving technique adds greatly to this impression. His illustrations to the comedies are again in the rococo vein, closer to Boucher's Moliére illustrations and to Gravelot himself. On the other hand, as in the *Pamela* illustrations, Gravelot's graceful yet natural figures come almost closer to Hogarth's realism than Hayman's more affected ones, despite their stylistic similarity.

The intimate contact between English and French art can be further explored by juxtaposing Hogarth's *Breakfast* scene of *Marriage à la Mode* with a composition by Cochin the Younger (drawing, Ashmolean Museum, Oxford, Pl. 89b), engraved in 1739 by Claude Gallimard, *La Soirée*, and with an engraving by J. Major after Gravelot of a seated cavalier (Pl. 88a), a kind of fashion-print of 1745, the year of Hogarth's cycle.[51] A recollection of the two main figures in *La Soirée* must have lingered in Hogarth's mind as he constructed his debauched Countess, holding aloft her mask, and her weary husband. Gravelot's print shows an elegantly gesticulating dandy, the perfect model of correct pose and behaviour. In Hogarth, the modish young man has almost exactly the same costume and hat and is seated on a very similar chair, but there is a psychological penetration reflecting some change of attitude very much the artist's own. Here is a dejected figure with spreadeagled legs, the body lolling back against the chair, hands in pockets, yet not ungraceful. The stylistic relation between the two figures is so close that the borrowing could have been either way. Yet in this case it is more likely that Gravelot borrowed from Hogarth, whose picture was probably painted some time earlier. It was Hayman who sat as the model for Hogarth's aristocrat; quite probably, as Gravelot's close collaborator, he had to sit in the same attire for Gravelot too, attracted as the latter must have been by Hogarth's composition.[52]

Several other works of Hogarth's close in date to *Marriage à la Mode* and his visit to Paris, also have clearly French associations. For instance, a somewhat similar relationship to that between the *Breakfast* scene and the Beau of 1745 exists between an etching by Gravelot, *L'atelier du peintre*, and an oil sketch by Hogarth representing a painter's studio (known only through an engraving done after his death).[53] Gravelot shows a painter at his easel, chatting to friends, whilst two ladies sit in a corner; to one of these the artist's sitter, a gentleman with his hand on her chair, is paying close attention. Possibly Gravelot's most lively etching, it is an unusually sketchy work rendering a chance moment and, as such, was likely to attract Hogarth's attention.

In Hogarth's picture, where the grouping and relationship of the figures bears a noticeable resemblance to Gravelot's, a little dog has upset a table so that everything in the room is in the process of sliding—another table, an easel and the lady herself, who is in danger of falling off her chair, although the gentleman is springing to her rescue. The undulating tenor of the composition is similar to Gravelot's, though Hogarth has fused the two groups into one. The entire scene is now put as it were into motion, its 'seized' quality increased by the artist's favourite device of showing objects about to overturn and people in arrested motion.

In addition to Gravelot's work, Hogarth must have come to know through his French engravers a probably unexpectedly great number of prints which they or other French artists had done in their native country.[54] The style and motifs of these may well have had their impact on him after *Marriage à la Mode*. He certainly knew, for instance, the cycle *Diverses Charges de la rue de Paris* (1737) after Cochin the younger, engraved by his own employee Ravenet, by Cochin himself and others.[55] For he made ample use of the engraving *Le Tailleur pour Femmes* (Pl. 81a), from this cycle (engraved by Cochin) for his sketch-like picture *The Staymaker* (National Gallery) (Pl. 80), which I should date at approximately the time of *Marriage à la Mode*. Hogarth took over the compact group of the lady, the tailor and the maid almost *in toto*, the chief difference (though even this is not certain) being that it is now a staymaker, not a tailor, who is taking erotic advantage of his position and that his face is slightly caricatured. To this group Hogarth added the lady's family and members of her household: the nurse grotesquely dandling a baby, her unsuspecting, somewhat decrepit husband and two mischief-making children. So the picture has completely changed from the gallant French original. It has become not only a skit on the silly husband but a whole realistic-grotesque family ensemble. While such a theme as a tailor and his customer had been possible in France only in engravings, the realism of Hogarth's sketch was still further ahead of anything in French painting. It is again English rococo in content and form if ever anything was. Hogarth used Cochin's close-knit composition to create a compact group within a picture, which forms an even more clarified structure than most of the scenes of *Marriage à la Mode*.[56] Yet even though Hogarth seldom borrowed so literally as here, the general flow of the rococo line is a shade less stressed than in Cochin. Thus the contrast between the straight pose of the woman and the slightly comic curve of the tailor, a linear contrast the artist often adopted, is more pointed. The thin, delicate manner in which this sketch is painted has, at first glance, certainly much of French rococo. The group of the nurse, the baby and its father on the couch, with their pale yellow, blue, grey and white forming the colour centre of the composition, presents a typical, pleasing rococo harmony, yet the impression the colours convey is far more real than anything in French art. One does not get the feeling as in French painting that the colours exist only for the sake of an abstract, decorative composition. There are bold, broad brush-strokes, for instance, in the white and grey silk of the lady and in the red pouffe on the floor, which are scarcely to be found anywhere else at that time except, perhaps, here and there in Watteau. But if Watteau used this sketchiness, as in his unusually realistic *Toilette du Matin* (engraved in England at a very early date by Mercier), it was, unlike Hogarth, more to heighten the fragrancy and delicacy of a dream-world than to give reality to a genre scene.

In view of these numerous instances of the Francophobe Hogarth's extreme familiarity with French art,[57] particularly at the time of *Marriage à la Mode*, it is not surprising to find, at about the same time, a work which, for all its rococo qualities, amounts more or less to a caricature of rococo elegance. This is another sketch-like picture (South London Gallery) (Pl. 94a), erroneously called *The Wanstead Assembly* but in reality representing a wedding dance, which in my view

was intended to form part of the cycle *A Happy Marriage*, planned soon after 1745 following the success of *Marriage à la Mode*.[58] Thus, in a wider sense, it belongs to the cycles. Apart from the bride and groom, all the guests are shown dancing in a comic fashion, each couple offering a different variation. What is novel here is that the well-worn tradition of European, particularly Dutch, art of casting ridicule on dancing peasants has been transmitted to bourgeois people. Since Hogarth excluded the happy couple, he was able to give free rein in the rest of the composition to his love of satire and caricature. The other surviving picture from *A Happy Marriage* is the equally broadly painted *Preparation for the Wedding Banquet* (Truro Museum) (Pl. 93a), in the style of *Marriage à la Mode*. Returned from the church, the bridal pair is seated happily in the foreground in exactly the same place in the composition, in intentional contrast to the indifferent couple in the *Contract* scene of *Marriage à la Mode*, while the bride's father—the counterpart of the haggling father in *Marriage à la Mode*—is toasting them. Musicians in grotesque attitudes occupy the other side of the picture, whilst a clergyman gives directions to the fat cook in the kitchen.[59]

Some years later, in 1753, Hogarth was to publish the same composition, with a few appropriate alterations and re-named *The Country Dance*, (Pl. 116), as one of the two principal illustrations to *The Analysis of Beauty*. In the book he gives a graphic scheme for the dancers: the graceful bridal pair illustrate his serpentine line of Beauty, whilst the diverse grotesque attitudes of the other dancers are rendered by means of bizarre forms, curves, circles, letters and so on. After discussing the comic dances of the *Commedia dell'Arte* figures, he then deals with country dancing, and one realizes that Callot's grotesque cycle, the *Balli*, is in a general sense the ultimate origin of the comic dance motifs in his composition. In other words, the *Commedia dell'Arte* figures here become anglicised and bourgeois, as they did in the picture of *The Beggar's Opera*. (In *The Gate of Calais* (Pl. 111), painted at about the same time, Harlequin, in checked close-fitting pants and jacket, becomes a melancholy Scottish refugee.) Contemporary dress and English dancing of course entirely alter Callot's mannerist-baroque poses. The light rococo touch imparted to the good people solemnly dancing round makes them look a great deal funnier than those in Callot's engravings, with their genuine theatrical straightforwardness. The relatively monotonous dances of the equally Callot-influenced *Large Masquerade* ticket (Pl. 5b), have given place to individualised, lively, bizarre movements; something of the spirit of the wild, unrestrained dance of the faun in the mythological picture Hogarth introduced into that early engraving has here been given greater prominence in a bourgeois guise.

Callot, however, is only the ultimate, not the direct, source for *The Wedding Dance*. The direct suggestion comes once again from Coypel, this time from one of his *Don Quixote* illustrations, showing the knight, Sancho Panza and two ladies dancing in Don Antonio Moreno's ballroom (Pl. 94b).[60] The setting is similar in both works: a long gallery with chandeliers and, to the right, an aperture with a full moon beyond—an open doorway in Coypel, an open casement in Hogarth. Hogarth also took over Coypel's baroque device, the large billowing repoussoir silhouette. In the French composition this contains a curtain, while the recumbent figure of a guitar-player occupies part of the left side and forms a dark, floating framework. Hogarth extended the repoussoir, which also includes a recumbent figure, much further to the right by the addition of the silhouette of a realist-fanciful hat-stand, thus giving a sweeping, jagged effect to Coypel's outlines. The whole character of the dance has been even more altered, though here again individual suggestions undoubtedly came from Coypel. The graceful bridal pair recall Coypel's two ladies dancing, whilst the dominant theme of Hogarth's picture, the grotesque

dance, was apparently impressed on him by the figures of Don Quixote and Sancho Panza. The movements of his short, stout dancer in particular are almost identical with those of Sancho, though even here there is still an echo of Callot's *Gobbi*.[61] If Coypel's conventional aristocratic rococo society is transformed in a middle-class sense (as are Callot's *Commedia dell'Arte* figures), the real and comic attitudes of the dancers are carried a great deal further. Indeed, in the last resort, the many Coypel motifs seem, in Hogarth's picture, to be entirely submerged.

The solid yet grotesque theme of *The Wedding Dance* gave birth to an exuberant, swirling baroque-rococo composition. Yet, for all its wealth of original details, the composition is fundamentally a balanced one, the over-flowing baroque of the *Strolling Actresses* (Pl. 61a), has been clarified [62] and its rather popular, over-crowded realism of detail discarded. As regards the general outline of the formal scheme, the baroque repoussoir silhouette taken over from Coypel is often to be met in Flemish and Italianising Dutch painting of the 17th century and probably harks back, like the motifs themselves, in great part to Callot. The looseness and bold sketchiness of the brushwork is intrinsically suited to the turbulent composition, its subtle, dusky light effects and the diffusion of light and shade being mainly determined by the numerous candles studded about the large hall or concentrated in the huge chandelier suspended from the high ceiling. The handling, though rather more finished, is very close to *The Staymaker* and, within secular European painting of the early 18th century, can be compared with only a few other pictures and sketches. One is conscious of a certain resemblance with the dashing, sketch-like paintings and expressive figures of Magnasco, who was only sixteen years older than Hogarth, particularly with those of his works in which contemporary society people behave and dress in a relatively unromantic manner, such as his *Visit in the Garden* (Palazzo Bianco, Genoa) (Pl. 93b). Magnasco comes to mind because of his own connection with Callot [63] and with the Genoese period of van Dyck, and because he to some extent determined the technique of the two Riccis with which Hogarth must have been well acquainted.[64]

Because of its grotesque subject *The Wedding Dance* at first reminds one less of Watteau and French rococo than does *The Staymaker*. It is certainly not incompatible with the workings of Hogarth's mind, that the artist wished, even if only by the way, to travesty the graceful dances of Watteau and his imitators, so much in vogue in England in those years. Yet, though it appears a mere persiflage of elegance, it is at the same time an elegantly painted society picture and the borrowing from Coypel is by no means incidental. Hogarth may well have wished not only to burlesque Watteau but also to compete in his own broad and sweeping way with the magic, stippling technique of the French artist. At some distance from the place occupied by *The Wedding Dance* are sketches by J. F. de Troy, such as his freely-painted *Hunt Breakfast* (1737, Wallace Collection), combining Watteau-like grace with a more tangible solidity. But even de Troy's colours, brilliant and broadly handled as they are, seem schematic in comparison. Above all, his stereotyped movements and conventional, neo-baroque pattern are quite different from Hogarth's new, bold attitudes and types. This holds good also for *The Staymaker* in its relation to contemporary French art. Nevertheless the names of Watteau, Coypel, J. F. de Troy and Cochin crop up quite often and naturally when one studies Hogarth, particularly in his rococo decade. He is even quite close to the coming French generation, to Fragonard's 'unfinished', apparently improvised pictures. In England, with its lack of a burdensome tradition and therefore greater potential boldness, an artist could dare to go further in drawing pictorial consequences from contemporary French painting than was possible in France itself. Yet not even in England was

the general public accustomed to sketchiness in pictures. This probably explains the commercial failure of Wilson's often astonishing landscapes, painted towards the end of Hogarth's life.

Hogarth kept *The Wedding Dance*, *The Staymaker* and a surprising number of similar sketches in his studio until his death—sketches which he must have painted largely for his own pleasure. Two of these 'private' sketches, probably also from his middle period, throw apt light on the artist's method and various ways of painting.

One of these, usually considered to be for the *Death of the Countess* in *Marriage à la Mode* (and sometimes even for the Rake's love fainting in prison), in fact almost certainly represents *The Ill Effects of Masquerades* (Ashmolean Museum, Oxford) (Pl. 73a). A husband, returning at night, kills his wife and sister in their masquerade costumes since, through mistaken identity, he takes them for lovers.[65] The sketch is probably somewhat earlier than *Marriage à la Mode* and apparently Hogarth did not pursue the theme further. What is important, apart from the amazingly free way in which it is painted, is that its very 'unfinished', merely suggested, nature should have sufficed for the artist to indicate the unified pattern as well as the colour scheme of his composition. If, in Hogarth's time, a painter wished at an early stage in a work to clarify its build-up for himself, he did a quick drawing; had he gone as far as an oil sketch he would have carried the work to a far more finished state. But Hogarth's impetuous method of work was entirely different. He usually went straight to the canvas to outline his composition and if alterations were required he carried them out then and there. Without doubt he could express himself far better in paint than in drawing.[66] The sketch now in question is not one in the customary sense but is Hogarth's 'thinking aloud' on the distribution of colours (woman: pink, white, blue; red cushion; child's black cap; pink couch with blue cap on it) at a very early stage in his process of work. Scarcely any contemporary French sketch was painted as loosely as this. It is jotted down in a manner again genuinely anticipating Fragonard and even the nervous brushwork of the Delacroix-Bonington circle more than the tame, neo-baroque English history painting to come.

Indeed it is more difficult to find antecedents than successors for this work which, in its dramatic, apparently disorderly suggestiveness, combined with a clear indication of the colour scheme goes far beyond the usual Rubens or even van Dyck sketches. However the bold painterliness of the latter, one or other of which Hogarth could easily have seen, may have had an influence on him in a preparatory sense, as it probably did on English painting as a whole.[67] Even clearer ancestors are intentionally unfinished Italian baroque sketches for frescoes or religious paintings, the use of which apparently originated in Venice in Tintoretto's circle. These were quite a common requisite of continental art studios and Hogarth could equally well have seen them in the atelier of Thornhill or in the studios of sculptors who came to England from the continent. It is again significant that it was in unconventional England that an artist could risk going even further than these 'secret' atelier sketches without a qualm. Here is the same unusual boldness that characterised *The Staymaker* and *The Wedding Dance* and which will be met again in *The Shrimp Girl*. The path by which Hogarth had arrived at this lightness of touch and complete control of pictorial means can be traced from his earlier sketches, which still retain a harder texture, such as that for the Drummeress in *Southwark Fair* (1733, Fattorini Collection) and even to some extent the striking, very broad grisaille for *The Enraged Musician* (1741, Ashmolean Museum, Oxford) (Pl. 75a).

The other sketch is the famous *Shrimp Girl* (National Gallery) (Pl. 138a). It is not, as is customarily considered, a work on its own account, but in terms of the first half of the 18th century was

intended for a figure in one of Hogarth's finished compositions—either for the milkmaid in his engraving *The Enraged Musician* (1741) or the fisherwoman in the engraving *Beer Street* (1751) (Pl. 120a). It has no precise form or definite colours. Out of the turmoil of a few blurs and brush-strokes, out of the tangle of broken, swimming tones—reddish-brown, grey, pink, green—grows the vision of the figure. Despite the liquid surface-impressionism, it is not quite lacking in substantiality. It is this combination which gives the sketch its unique place in its time. Here again one is at a loss to find a contemporary French parallel. It is equally very far from van Dyck's boldest portrait-sketches. Perhaps Hals's free, sweeping brushwork can serve as the nearest historical precursor, for instance his whole series of extremely broadly painted half-lengths of laughing fisher boys and girls, sometimes even bearing baskets on their heads (Pl. 138b). Hogarth may well have even learned directly from pictures of this type, since Hals's unusually individual-ising genre figures would have particularly appealed to him.[68] But on the one hand, these colour-ful works never have *The Shrimp Girl*'s degree of impressionism; and on the other, even Hals, and still more Rubens, seem too plastic in comparison and to cling too closely to details. One must go back almost to the late Titian (whom Hogarth praised as a colourist) or look forward to sketches by Manet to find somewhat similar handling.

But the 'private' character of these two paintings, as auxiliary sketches, cannot be emphasised strongly enough. It is not sufficient to state that Hogarth's painterly knowledge here approaches that of Fragonard and Delacroix, or even to some extent that of the Impressionists. The way in which the painter himself wished to have his pictures considered is also of significance when judging his art. The further one advances into the 19th century, the more one finds painters regarding as finished works, pictures which artists of previous generations regarded as sketches. Hogarth himself never considered these two sketches as genuine pictures. Although he greatly appreciated Rubens, he disapproved of the relative sketchiness of those of Rubens' paintings which had to be scrutinised closely. 'Rubens boldly, and in a masterly manner, kept his bloom tints bright, separate, and distinct, but sometimes too much so for easel or cabinet pictures' (*Analysis of Beauty*). What he publicly disapproved of in Rubens' finished pictures, he himself privately practised in such sketches as *The Shrimp Girl*, painted for himself. But he never went further than that.

One gets a more balanced view by considering at the same time a finished picture, similar in subject to *The Shrimp Girl*, namely the portrait of *Mrs. Salter* (1744, National Gallery) (Pl. 71a). One could find no better example of Hogarth's extreme degree of painterliness than this portrait from the year after his visit to Paris, when he was still full of his new experiences. It is perhaps not quite an accident, and at least it shows their contemporaneity, that there should be a close physical resemblance between *The Shrimp Girl* and *Mrs. Salter*. Yet they are painted very differently. This elegant and natural middle-class portrait cannot be termed surface-impressionism. The colours are of the same refined quality as in *Marriage à la Mode* but even more calculated, being entirely concentrated on the few details of a single half-length figure. As in *Marriage à la Mode*, their delicacy is combined with the material solidity of the dress, face and body. The yellow dress, with reddish tints in the folds, dominates the picture. Above and below, sometimes entwined with it, are the white lace fichu and undersleeves. A light green scarf projecting at each side frames the figure, while a pale pink rose in the centre brings all the other colours together. The whole is crowned by the fresh face with its brown eyes and hair (again with reddish tints in it) and the whole is enveloped in a dark green background. Nothing could be more like material than those rustling yellow sleeves, painted with an astonishing broadness reminiscent of the best

Dutch paintings of the type of the school of Delft. They make one realise why Hogarth could never have employed a drapery painter, like the other English portraitists.

Only after long experience could Hogarth reach such high achievement, as can be seen by comparing *Mrs. Salter* with, for example, the somewhat earlier portrait of *Lavinia Fenton* (Pl. 69a). However vivid the colours here, they are far less harmonised: however bold the brushwork, it was a much cruder boldness. There is nothing of the Hals-like delicacy and softness of *Mrs. Salter*. Even the portrait of *Bishop Hoadly* (Tate Gallery) (Pl. 77a), engraved in 1743—which one can perhaps assume was painted the year before the artist's visit to Paris—is far less delicate, however masterly its broadness. Indeed, *Mrs. Salter* summarises all Hogarth's knowledge of painting and colouring: it shows him to be stimulated by French colouring but surpassing it, beating it at its own game. Though not superior to, it is even richer and more varied than, the calculated, sparing, subdued colouring of Chardin, the greatest colourist of the time, some of whose original works Hogarth had certainly had occasion to see.[69] Hogarth may also well have seen in Paris Aved's best portrait, in respect of colours, that of *Mme. La Traverse* (private collection, Paris) (Pl. 71b), which was exhibited in the Salon in August of that year. Schooled like Chardin in Dutch painting, Aved was the most bourgeois French portraitist of those years. The unconventional pose of the half-turned face in *Mrs. Salter* (and most of Hogarth's portraits), making the portrait no less elegant but more personal, is similar to that of *Mme. La Traverse* but unlike the general run of French portraits, in which the sitter is nearly always represented schematically full face. Apart from the lesser degree of characterisation and the greater flatness of Mme. La Traverse's face, her blue dress and white bonnet and lace, although well painted, are less bold and present a much poorer colour pattern than that of Mrs. Salter.[70]

The essentially 'English' character of *Mrs. Salter* is continued in the highly original self-portrait (National Gallery) (Pl. 96b), which Hogarth painted the following year, 1745, at the height of his powers. This is conceived in a manner unthinkable at that time anywhere else than in England. It is the self-portrait of an English painter, a middle-class painter, an intellectual painter—nonchalant, almost insolent, certainly very daring. Hogarth's pug-dog, Trump, sits in the foreground on the right and is exactly the same size as Hogarth's own bust, which rises just above the animal, an independent oval panel (shaped and arranged like the portrait of Mrs. Salter) within the composition. In the left foreground are placed the works of Hogarth's favourite writers and his palette, bearing the provocative Line of Beauty. The picture represents a kind of prelude and intellectual preparation for *The Analysis of Beauty*. But if its whole conception was possible only in England, so was its colouring which, although more sparing than that of Mrs. Salter, is extremely bold. It is based on the relation of the chocolate-brown dog to the dark harmony of the whole, a striking effect yet one which achieves perfect unification in its way.

An astonishing pictorial drawing in pencil and wash, probably also done around or soon after the middle of the 1740s, portrays an operation in a hospital (Pierpont Morgan Library, New York) (Pl. 95b). The delicate, economical contrast between the wash and the voids of empty paper is such as one would normally expect to meet only in French art. However, there is nothing like it: such a degree of painterliness combined with such realism simply does not exist in French art of the time. For the lesson taught by study of Hogarth's relations with France at this peak period is that, though he learned everything from contemporary French art that had to be learned for his own purposes, he went, in his own way, beyond it.

Even Hogarth's last large cycle, *Industry and Idleness*, though a much more popular and less elegant series than *Marriage à la Mode*, is still imbued with the painterly consequences of his

rococo period. Many of the preparatory drawings (there are no paintings) equally show this tendency to an astonishingly high degree. There are two almost complete sets of drawings in the British Museum[71]: the second contains the finished ones ready for the engraver, but the first, consisting of Hogarth's preliminary ideas, provides a real parallel to his sketch-like pictures. Though he kept to his old technique of pen, ink and wash, these drawings are less neat, far bolder, freer and more expressive than most of his earlier, more or less finished ones, which in many ways so closely resemble the usual Dutch genre drawings. French influence—Gillot for instance— has superseded Dutch. There are now more dynamic effects, even in comparison with such a sketchy pen drawing of his earlier period as *Breakfast at the Nag's Head* (Pl. 34b), illustrating an episode on his Tour. With their quivering lines and their wash skilfully splashed about, they now show an awareness of how to capture masses in movement. Two of them—one, not used, of the idle apprentice stealing from his mother (Pl. 110a); the other of his betrayal by a whore (Pl. 107a)— are amongst the most striking specimens of Hogarth's extremely loose, painterly draughtsmanship. In his drawings he always showed himself to be more interested in movement than in form; now the form almost dissolves and his rendering of transitional movements leads to hitherto unheard-of painterly surface-effects. In *The Sheriff's Banquet* (Pl. 106b), despite the pronounced, gargantuan inelegance of the subject, which anticipates Rowlandson, the outlines sparkle, flicker and dance even more than in his other drawings, thus conveying, together with the various tints of the wash, an extremely picturesque rococo atmosphere. Compared with this, not only Gillot's but even most of Fragonard's drawings appear smooth, while it already heralds Guardi's much later, somewhat Magnasco-like impressionist rococo.

In this *Sheriff's Banquet* from *Industry and Idleness* and even more in various others from the same cycle, particularly *The Execution of the Idle Apprentice at Tyburn* (Pl. 107b), and *The Lord Mayor's Show* (Pl. 108a). Hogarth gives examples of large crowds, in contrast to the few selected figures in *Marriage à la Mode*. For such a prolific story-teller the handling of masses was an important, ever-recurring problem throughout his career, to be freshly solved at each new stage. And not only a problem, but also a temptation. Whilst in scenes with few figures he increasingly mastered the concentration of the composition, in scenes with crowds it took him a very long time to learn to resist the temptation of over-charging them with new and interesting episodes.

In some of the engravings of the early twenties, Hogarth's masses are but loosely linked; the groups are distributed in rather inarticulate patches and the arrangement of the figures within the crowds is equally of a cumulative character. These engravings contain direct and indirect echoes of Callot through late-mannerist Dutch genre painting of the Vinckeboons type and the rather detached, silhouetted figures of Luykens' book illustrations. Even the best representation of a small crowd among Hogarth's book illustrations, *The Burning of the Rump* (Pl. 11b) in *Hudibras*, a composition for which he showed a partiality even in later life, is rather primitive. The large crowd in *Southwark Fair* (1733) (Pl. 44a) still retains something of the old style yet tends towards a richer and more organic composition; some influence is possible from Italianising Dutch or Flemish representations of fairs, all more or less derivations from Callot's *Fair of Impruneta*.

Still further indications of an organic composition appear in *The March of the Guards to Finchley* painted in 1746, only two years before *Industry and Idleness*. With its vast concourse of figures it looks at first sight rather disorderly, although more monumental than *Southwark Fair*. This is truer of the picture than of the engraving after it (engraved by Sullivan in 1750), in which the unity was of course easier to keep. Hogarth wished to relate so much in the immensely topical scene of *The March to Finchley* (Pl. 99a), that at first sight he appears to have been undecided

where to begin or end. Yet, though the crowds can only be disentangled slowly, light and shade mould the composition into an intricate rhythm. The three outstanding groups in the foreground —the drummer on the left, the guard with his two women in the centre, and the drunken, falling soldier on the right—are lighted up to attract immediate attention. Fleeting shadows behind them are equally rapidly interspersed by new patches of light. In *The Analysis of Beauty* Hogarth compares the inspection of a picture with a hunt and it was probably his intention that the spectator should discover many of the smaller figures as bit by bit he follows the pattern. This is well worth while, since some of the motifs probably have no parallels in 18th-century painting: for instance, the soldier to the right-centre kissing a girl with such vehemence that his eyes are popping out of his head, and the boxing-match in the left foreground. The formal build-up of this kissing scene is almost identical with a motif in Watteau of a couple—the man again a soldier —also enjoying a parting kiss; Hogarth must also have known Watteau's composition of a similar theme: *Le Départ de Garnison*, engraved by Ravenet in 1738 (Pl. 99b). The young Watteau was the only artist before Hogarth to paint the more prosaic aspects of a soldier's life. However, in Hogarth these unheroic aspects are much more frequent, and in using Watteau's motifs he makes them grotesque, as in this kissing scene. Other motifs which hark back to Watteau are, for instance, Hogarth's striding drummer and the long rows of marchers in the background, though the overcrowded character of the composition could not differ more from Watteau's clear, easily comprehensible one. Yet Watteau's undulating rhythm also offers clues for Hogarth's compositional intentions. Besides the system of light and shade, a few pre-eminent colours also help to weld the composition together, whilst the various large buildings and the wide expanse of sky fulfil a similar function. The right side in particular is dominated by the amazing, theatrical effect of a three-storeyed house with inquisitive women hanging from every one of its nine windows, each expressing a different attitude towards the soldiers. This again is a transposed and amplified motif from Watteau's composition, where the house (certainly not a brothel as in Hogarth) is also tilted at an angle but with only two windows from which women are gazing out.

Among the engravings of *Industry and Idleness*, *The Execution of the Idle Apprentice*, a much crowded scene with the procession itself, soldiers, onlookers and hawkers, a compact, ebbing and flowing ensemble, shows Hogarth's very decided development towards a more close-knit yet varied grouping. The other scene with large masses in this cycle, *The Lord Mayor's Show* (Pl. 108a) surprises by the new, more polished construction of the crowd round the Lord Mayor's carriage. Within the grouping of the cheering onlookers, the increasing stress of the diagonals towards the left is counterbalanced by the lackeys standing behind the carriage and bending to the right. For although the cycle is rather popular in character, even here Hogarth cannot conceal what had by now become his general tendency to satisfy fashionable taste by a formally satisfactory composition. Hogarth had by now reached a stage where individual episodes, however striking, no longer prevented a unification of the crowd. With an increasingly sympathetic understanding of contemporary French art, he now aimed more and more at incorporating the large masses of spectators organically into the composition. In this way he raised his engravings to a higher social and artistic level, away from popular art.

This process had its premises in a similar, much older and more consistent development on the continent which had been going on since Callot and Stefano della Bella who worked at the Courts of Nancy and Paris respectively. An interesting link in this chain were the crowded scenes of Entries and Processions at William III's court by R. de Hooghe, derived rather from della

Bella than from Callot. In these the crowds of spectators, grouped in baroque flourishes yet rendered individually with great precision, play an astonishing part. In France graphic art of the second half of the 17th century, mainly representing events at Louis XIV's court, also continued a tendency which originated in Italy. This culminated in the 'twenties, 'thirties and mid-'forties of the 18th century in the engravings of the older and the younger Cochin, depicting festivals at the court of Louis XV (ceremonies, marriages, funerals, fireworks), where the main objective of the many preceding artists of this line—skilfully to build up great multitudes and smaller groups—was achieved. If to the art of Charles Nicolas Cochin, father (1688–1754) and son (1715–90), is added that of the still earlier Nicolas Cochin (1610–86), a Callot imitator and official historiographer of the young Louis XIV, one can appreciate, through the *œuvre* of these three generations of French engravers, the extent of Hogarth's development: how in creating English art he was obliged to traverse more than a century and a half of continental evolution.[72] It has been shown that Hogarth imitated the art of the younger Cochin in the case of *The Stay-maker* and the *Breakfast* scene of *Marriage à la Mode*. It is not difficult to see also, in the measured *élan* and balanced interlocking of the crowds in his *Execution of the Idle Apprentice* and *The Lord Mayor's Show*, the impact of the style of Cochin or, at least, a parallel to it.[73] For the younger Cochin's style, forming, as it does, the climax of a long French and Italian development, had a real international character. So closely connected was he with the contemporary art of Pannini that he was called the 'Pannini of engraving'. Pannini himself went beyond the social limits of the strictly courtly engraving, being almost the only artist at that time to represent large, contemporary crowds in fashionable pictures. With all his 'French' elegance—in his early days he, too, was influenced by Watteau engravings—he also shared Hogarth's unusual predilection for reportage and still derived to some extent from Callot. He often took such themes as royal visits or festivals in the streets of Rome attended by large crowds and so became the model for this type of composition throughout Europe, particularly in France. In works of this type (for instance, *King Charles III of Naples before the Church of St. Peter*, 1744, Naples) (Pl. 108b) the masses are neatly built up from many smaller, slightly agitated, well-balanced baroque groups and these, whether termed a parallel or an influence, produce a somewhat similar effect to that of Hogarth's onlookers round the Lord Mayor's coach.[74]

This is perhaps the appropriate place to speak of the probable source of another scene in *Industry and Idleness*, a source very close to Pannini's and Cochin's royal festivals but of an even grander character. A pen drawing, not used in the engraved cycle, representing the industrious apprentice married and furnishing his house (Marquess of Exeter) (Pl. 109a), suggests in its pattern the influence of Lebrun's famous tapestry portraying Louis XIV visiting the Gobelins factory (Pl. 109b)—a composition which Hogarth might have seen in an engraving. The surprising realism of this scene, belonging to the sumptuous series of *l'Histoire du Roi*, is most unusual for Lebrun, but might be explained by the non-heroic subject-matter. The young man on the right, seen from behind and below as he arranges the wall decorations, is similar in both works and gives the clue to the general resemblance. In Lebrun it is Louis XIV who is entering with his retinue from the left corner; in Hogarth it is the industrious apprentice, now a house-owner, with his wife and surveyor. The bustling movements of the subordinates and the shapes of the objects they are carrying and by which they are surrounded—in both cases they are attempting to put the room in order—show surprising analogies. Hogarth saw the realistic possibilities of Lebrun's work, singled them out and, simplifying the composition, brought the royal incident down to a good middle-class level.[75]

The impact of the international Cochin-Pannini style on Hogarth during these years is shown by the calculated way in which he disposed his figures in relation to the surrounding architecture. Canaletto, not uninfluenced in his turn by Pannini, might have played a part in this as well. As the favourite painter of topographical views for the English connoisseurs, Canaletto stayed in this country, with one slight break, from 1746 to 1755. Out of Hogarth's wildly grotesque London he made a kind of well-ordered, monumental Venice. His views were always enlivened with neat but extremely painterly figures which, more stable than Pannini's baroque ones, emphasise the verticality of the whole composition.[76] Hogarth was certainly acquainted with Canaletto's works, probably even before he came to London; his friend, Samuel Scott, the 'English Canaletto', with his numerous views of London, was a second-rate imitator of the great Venetian master.[77] It was during Canaletto's stay in London, immediately after *Industry and Idleness*, that Hogarth produced the fruits of his second journey to France, his famous *Gate of Calais* (1749) (Pl. 111). Here, although larger than those in pictures by the Venetian painter, the delicately handled figures, compositionally supported and integrated by quiet architecture, undoubtedly bear the mark of Canaletto and even more perhaps that of Pannini.[78]

But these various sources and analogies reveal only one side of Hogarth's style during these years. The two compositions in *Industry and Idleness* with dense crowds are essentially quite dissimilar in style from Pannini. Even with his new organising ability, Hogarth was unable to prevent his masses, when these entirely filled the composition, from being more crudely, even indissolubly interlocked than those of Pannini, with his delicate, rhythmic, flickering intervals between groups, or, for that matter, those of Callot, whose groups, although loose, hang organically together. This is true both of the *Execution* scene and of *The Lord Mayor's Show*. Although rather similar in theme to those of Pannini, Hogarth's figures are more common and grotesque—in order to poke fun at the frumpish municipal troops (in this rather akin to Callot), even though Pannini did not neglect expression to the extent of Canaletto. Hogarth's figures in the first set of drawings for this cycle are even more grotesque than in the actual engravings. Putting his first thoughts to paper, he could not at times resist drawing bizarre, 'vulgar' figures which he modified in the second set and in the engravings. But even so, in their extreme realism they are quite different from those of contemporary French and Italian engravings. The crowds in *The Execution of the Idle Apprentice* in particular are not merely anonymous, identical spectators as in continental prints but abound in revealing observations on different professions and customs.[79]

The 'commonness' of the figures in *Industry and Idleness* stands out even more in one case where Hogarth had apparently found a model for his composition in Italian art, whether Pannini himself or his master, Salvator Rosa. I refer to the scene of the idle apprentice gambling in the churchyard during a service (Pl. 105a), the pattern for which Hogarth may have acquired from Rosa, perhaps the most fashionable of all Italian painters in England at the time. Rosa's *Gambling Soldiers* was a composition well-known through several painted versions (one now in Dulwich) (Pl. 104c), whereas individual figures in his large cycle of etchings with motifs of soldiers, which Hogarth owned, may also have had some influence. In Rosa two soldiers are tensely throwing dice, one sitting on a stone bench on which the money lies; the other kneeling beside it; a third bending over them holds the group firmly together and the pattern is completed by another onlooker, a tall soldier with a sword, standing on the other side. Hogarth seems to have taken over all the chief motifs, but from them evolved a real story. At the same time, he dispersed more widely the compact Italian composition. The player to the left—now the idle apprentice—

is no longer seated on a stone bench but half lies across a tombstone; the tall soldier has become a beadle, drawing his sword for attack. Incidentally, the idle apprentice is doing his best to cheat, as do so many soldiers in Caravaggesque genre scenes. Rosa's etchings of soldiers, while under the influence of Callot, portray more sombre and romantic figures. Hogarth, as if sensing the realistic Callot elements in Rosa, produced a tale of ragged future criminals, based on Rosa's pattern. However, even if he did not know the Rosa composition in question, he certainly knew works by Pannini (engravings after which he also owned). Perhaps the most frequent motif in these—equally used by Hogarth and absent from Rosa—is that of an antique figure or shepherd lying or half-lying (though never gambling) on stone slabs or ancient sarcophagi among ruins. These are usually conversing with others who surround them in attitudes reminiscent of Rosa's warriors, from whom Pannini's rococo compositions derive. In Hogarth, Pannini's elegant ruins are transformed into a very realistic cemetery. Indeed, Hogarth may well have combined motifs from the two artists, with the usual result that he is equally distant from both.

Another scene in *Industry and Idleness* has a most illuminating compositional ancestry—that of the industrious apprentice in church with his master's daughter (whom he was later to marry) (Pl. 104a). This is undoubtedly one of the most unusual compositions representing contemporary life in the 18th century. Even for Hogarth it is astonishing to find the interior of a church represented during a service from an angle of such unaccustomed height, looking down into the building below. Furthermore, a few extremely large-scale figures set in the foreground form an extraordinary contrast to the minute ones in the body of the church. Even the most original church interiors ever painted by Emmanuel de Witte, who was close to the progressive, realist-classicist school of Delft, do not touch Hogarth's theatrical, fundamentally mannerist lay-out. Yet there can be no doubt—it is even clearer in the original drawing (in the British Museum) than in the engraving—that the angle chosen is based on personal observation from the gallery of an actual church itself, probably St. Martin-in-the-Fields, an angle which Hogarth found artistically stimulating. It is precisely this combination of observant realism and an originally mannerist pattern that is so significant. For here, as so frequently happens, one must go back to mannerism, particularly to Callot's records of the theatre, if one wishes to gain a deeper understanding of Hogarth's work. He was probably not acquainted with Callot's early representations of the stage, various intermediaries existing chronologically between them and his engraving; moreover, in his own work the preliminary step to this build-up, the engraving of *The Sleeping Congregation* of 1736, shows little of this particular stage effect. However, in an historical sense I think Hogarth's ostensibly theatrical setting of a church interior harks back in its essentials to such a work as the early Callot's representation of *La Liberazione di Tirreno* (First Interlude) (Pl. 104b), the great theatrical event of the Florentine carnival of 1617, produced by Parigi: in each a raised foreground with very large figures, a vista over a wide space below with a multitude of small figures and a distant stage, in Hogarth repeated as a pulpit with a sermon in progress. In Callot and in many 17th- and 18th-century representations of the stage and the audience, the spectator regards what is happening in the foreground as well as in the background as part of the theatrical scene; there are stage effects within the stage effect.[80] And fundamentally this is how Hogarth treated his subject. As an 18th-century artist, he has compressed Callot's unreal depth and transformed the whole into a more baroque composition. Yet, compared with a contemporary baroque picture with a somewhat similar theatrical church setting, Pannini's *Christ Child among the Pharisees* (Madrid), which also has a tribune on the left with spectators, Hogarth's closeness to Callot is more explicit: the steep rise of the mannerist repoussoirs plays a

far bigger part and the difference in scale between the immediate foreground figures and those further back is much more startling. Another difference from the rather conventionally baroque Pannini[81] again shows up Hogarth's relations with Callot's theatrical arrangements: the large foreground figures, apart from the two main ones, which are treated sentimentally, appear grotesque, as is usual in styles particularly expressive or expressionistic in character. It is the silhouettes of these large farcical figures which emphasise the unusual, still rather mannerist character of Hogarth's composition. Incidentally the introduction of such burlesque figures as the hideous, Callot-like old woman singing hymns (or the churchgoers asleep in comic attitudes in *The Sleeping Congregation*) would probably not have been permissible before Hogarth's time in any representation of a Protestant service in a Protestant country, and even less of a Catholic service in a Catholic country. But exceptions occurred in the representations of 'exotic' religious ceremonies; for instance, in Picart's *Cérémonies Religieuses*, similarly grotesque women appear in the illustrations of Jewish festivals in the synagogue. Perhaps even more important for Hogarth were the various, apparently much sought-after engravings of Quaker meetings, done after paintings by Egbert van Heemskerk (Pl. 103c), who had settled in England during the Restoration period and with whose lively themes and often ugly grotesque figures those of Hogarth frequently bear a resemblance.[82] Although Picart and Heemskerk, both known to Hogarth, are to some extent 'sources' for his old woman singing hymns, those closest to her in spirit occur in works by Magnasco. Not long before, in the 1720s, Magnasco had portrayed a Quaker service in several pictures, in the satirical, caricature-like and fantastic vein one would expect; and he probably used as documentary models the same or similar English engravings after Heemskerk that Hogarth did, such as his identical motif of a woman preaching.[83]

Another Dutch model, not far from Egbert van Heemskerk and Picart, seems to have served for the *Industrious Apprentice at the Weaver's Loom* (Pl. 103a), the first scene of the cycle. This is a rather obvious model—the figure of the wool-weaver in Luyken's cycle of the human occupations (Pl. 103b). Although one cannot exclude the possibility that the similarity follows simply from the documentation of the actual weaving process itself, it is noteworthy that in both works the angle of the weaver's loom and the weaver's position at it are almost identical, with the oblique line of the shuttle cutting across the figure. Even the suggestion for a figure peering in—in Luyken a woman, in Hogarth the master—might have come to Hogarth from the Dutch source; moreover the general arrangement of all three figures in Hogarth's engraving is similar to that of the weaver and the two women in Luyken.

Thus one finds Callot's, Luyken's and Egbert van Heemskerk's realistic art as sources on the one hand, and again Callot's as well as Pannini's and Cochin's courtly art on the other; even Lebrun's art glorifying Louis XIV does not seem to have passed unnoticed by Hogarth. Moreover the importance of Rosa's compositions, particularly his cycle of etchings, in regard to the realism of late baroque and early rococo cannot be sufficiently stressed. Magnasco, the two Riccis and Pannini were all greatly influenced by him. The reader will by now have realised that the historical relation of Hogarth to these pre-rococo and rococo artists, and their forebears, Rosa and Callot, and particularly to the latter's elegant and at the same time popular mannerism which later became so important for rococo, are recurrent themes in this book as the elegant, like the popular, features of Hogarth's rococo are indissolubly linked with this continental ancestry. These parallels to the Callot-Rosa-Magnasco trend brings home the need to look at Hogarth's cycles, even the late ones, from a wider view-point than that of an increasing rococo elegance. It is essential, in order to understand the complex style of all his cycles, never to lose sight of their

ultimate destination as engravings, as distinct from original pictures as ends in themselves. This holds true however masterly their execution and however much greater their formal qualities compared with the engravings, even in the case of *Marriage à la Mode*, which was in the hands of good French engravers. From a commercial standpoint, matters were different. No pictures of *Industry and Idleness* were painted at all and the other (painted) series were not easy to dispose of.

The prints, on the other hand, were a great financial success, being bought by a wide public. In the case of *A Rake's Progress*, where the paintings have survived and Hogarth himself did the engraving, the prints sometimes differ (if only slightly) from the originals, greater stress being laid on their less formal, more popular features by exaggerating expression for example, and especially by increasing the various inscriptions (a similar difference probably also occurred in *A Harlot's Progress*). Consequently the engravings are less unified in composition than the paintings. Many expressive or unrealistic features of popular engravings in the cycles—even in *Marriage à la Mode*[84]—served for Hogarth the same purpose as that of his realism, namely to enliven his story-telling.

It is the combination of late medieval art, popular art and mannerism which recur in Hogarth's engravings of the cycles. Even when the initial purpose was the faithful rendering of factual objects, an intentionally fantastic effect could sometimes be achieved. For instance, in the scene of the earl's murder (Pl. 92a), in *Marriage à la Mode*, the very long, clear-cut shadow of a pair of tongs stretches across the floor—a most uncanny addition to the scene in the dimly lit room, since neither the tongs themselves nor the fire which casts their shadow is visible. In the picture itself, among the numerous objects thrown down by the Countess when undressing, heaped in a corner and lit up by the fire, the most fantastic effect is that of a black-and-white, rather Japanese-looking mask. Hogarth also liked the striking, somewhat grotesque silhouette formed by a pair of stays, as used here, as well as in the *Rake's Orgy* (Pl. 50b), and in the engraving *Before* (1736) (Pl. 38a). But one can find more extreme examples of unreal effects than these, which are merely Hogarth's own variations of the grotesque shadow effects he had experienced, say, in Dutch painting (Schalcken)[85] or in Coypel's *Don Quixote* illustrations (Pl. 48b).

Even in *Marriage à la Mode*, the least popular of all the cycles, Hogarth maintained the tradition of animal symbolism. The most obvious example is that, in the *Contract* scene (Pl. 87a), of two dogs chained together in front of the unhappily betrothed couple: indeed it explains not only the situation but the theme of the whole cycle. Hogarth equally retained the popular tradition of making inanimate objects appear alive. In the scene at *The Quack Doctor's*, the whole apartment is crammed with objects, inducing a creepy atmosphere. Many of these appear to be alive. The effect is similar to that in *Hudibras in the Astrologer's Studio* (the requisites of which are reminiscent of those in Egbert van Heemskerk's dissecting scene); in fact even the composition is similar, if more restrained. In the glass case there are a skeleton, a withered corpse and a wig, apparently in animated conversation (cf. the unending tradition of the motif of the skeleton alive, even after the Middle Ages: e.g. *Dances of Death*, skeletons on tombs, mannerist anatomical diagrams in medical books, popular engravings, Emblem books). On top of the cupboard reposes a human head with a wild expression, amidst a number of bones and arms, hung side by side on the wall to create an uncanny feeling, further emphasised by complicated machines resembling grotesque monsters; this 'expressionistic' rendering of machinery, an effect so familiar in 20th-century art, is slightly foreshadowed in mannerism, as in Stradanus' glass-blowing workshop and even more in Hogarth's just-mentioned *Hudibras* scene. Mummies with uncanny expressions and an alligator

hanging from the ceiling (the usual motif of curio collectors' cabinets, or alchemists' workshops in Dutch 17th-century painting) gaze wildly at an even more ferocious wolf's head.

In addition—a significant innovation—Hogarth applied this popular tradition of giving life to inanimate objects to artistic commodities in bourgeois households, namely paintings on the walls. These are precisely those objects he also used for a realistic and faithful characterisation of the milieu, and nowhere in Hogarth is the transition from realism to non-realism so evident as here. A first step in this direction is the use made of pictures to stress symbolically the content of the whole theme: for instance, in the first scene of *A Rake's Progress*, where the rake takes possession of his rich, miserly father's effects, the picture of a money-lender counting his gold hangs on the wall. This method was not new. It had appeared in Dutch painting, particularly in Steen and even in Breughel's engravings. What was new was the exaggerated, grotesque or changed expression or 'impossible' additional details which Hogarth gave the paintings.[86] In the *Contract* scene of *Marriage à la Mode*, for example, a portrait is shown of one of the peer's ancestors in the usual, grand, Rigaud style but which Hogarth could here afford to parody: the ancestor, clad in greatly exaggerated robes, holds a thunderbolt like Jupiter, while a gun explodes behind him, a comet flies over his head, two winds in a corner blow contrariwise and the lion's head on the frame breaks into a gentle smile. In the same scene, Caravaggio's picture of Medusa, whose terrifying features seem to be exaggerated, is placed at an angle to show its comic horror at the young couple's complete indifference to each other, thus taking part in the general action.

But if Hogarth caricatured pictures in the grand style, he also mocked the crude taste of those in low style: Flemish, Teniers-like peasant paintings in the alderman's house (*Death of the Countess*) (Pl. 92b). In one of these, for instance, a drunkard tries to light his pipe from another's red nose; in another, two hearts are pinned on a spit above piles of meat and vegetables. As a final example of these grotesque or 'alive' pictures, I return to the scene of the murdered husband in *Marriage à la Mode* (Pl. 92a), the slightly tragi-comic air of which is effected by means of various paintings. One of these shows St. Luke curiously taking stock of the spectacle as he depicts it; in another a woman, supposedly Moll Flanders, holds a clyster in one hand and a squirrel on the other; alongside hangs a tapestry portraying a grotesquely conceived *Judgment of Solomon* (probably an allusion to the just judgment which awaits the frivolous countess) and a soldier in this is covered by the woman's portrait in such a way that his legs appear to be a projection of her body.

But if, by exaggerated expression, the pictures and portraits on the walls are almost reduced to caricatures, the minor figures of the cycles themselves are often similarly treated. No real border-line can be drawn in *A Rake's Progress* between, for example, the uncanny physiognomic studies in the madhouse and the crazy ensemble in the prison (Pls. 56a, 55a). In the latter scene the rake is seated at a table in the wildest despair[87]; his hunchbacked wife howls like a fury into his ear; on his other side stand an awestruck boy asking payment for beer and an ominous-looking turnkey awaiting a tip. No less forbidding is the man beside the fainting girl on the other side of the composition. All this is well on the way to expressionism.

The style of the moralising cycles may be summarised as follows. Hogarth's utilitarian middle-class outlook, which furnished him with the basic ideas for his series, was essentially rationalistic. But such a manifestly rationalist style as the classicism of the school of Delft, quiet and restrained although used for motifs of everyday life and based on great realistic knowledge, was in no sense congenial to him or suited to his representations of the passions and their effects—not even to the relatively temperate *Marriage à la Mode*. Hogarth's inexhaustible, exuberant realism, embracing

the new situations, milieu and figures down to the smallest detail, must needs compromise with his English artistic inheritance, the baroque composition, which was not adapted to accommodate such a wealth of true-to-life story-telling. And the various phases of this gradually successful compromise formed the style of the various cycles. In the two *Progresses*, with their burgeoning of entirely new motifs, a genuine balance is only occasionally reached. In *Marriage à la Mode*, with its relatively few figures, all drawn from the world of fashion, a compromise is achieved in a pattern which it is perhaps more appropriate to call rococo than baroque. In *Industry and Idleness*, although Hogarth returned to the popular-realist motifs of his early cycles, he was now capable of largely absorbing this exuberance into his newly-acquired equilibrium of the baroque-rococo composition. Yet in all the cycles ample scope existed for his quite exceptional realism and —as always in baroque—for a streak of irrationality, for all kinds of expressionist manifestations, as was even truer, for instance, of the decidedly more baroque Magnasco. Many irrational features in the cycles are due largely to the character of the series as popular engravings and generally derive directly from popular tradition, another of Hogarth's artistic inheritances. While preserving this tradition, he often interpreted it in a personal, original way.

Thus the style of the cycles, unique in European art, sprang from the peculiar artistic situation in England, having to be built up from diverse elements which were neither simple in themselves nor easily fused together into a homogeneous whole.

VII

Expression and Caricature

LANCING through Hogarth's works, one is constantly struck by his pictorial imagination, which revelled in emblematical and literary allusions and so gives his documentary realism an unaccustomed flavour.[1] Even in his most realistic narrative works—the cycles—he employed means to bring out the unusual, fantastic or grotesque potentialities in human figures as well as in inanimate objects. This slightly irrational streak in Hogarth, his interest in expressive values, is a most unexpected tendency for an artist of the first half of the 18th century and on the face of it accords ill with his natural common-sense. I propose here to concentrate on one revealing aspect of this, namely his attitude towards expression and caricature —meaning by caricature not only intentional distortion of the human face but this whole type of art.[2] By so doing it will be possible to penetrate deeper into his style and to analyse some of its 'expressionist' features, which vary greatly in intensity.

There is no reason why the term 'expressionism' should be confined to the trend of art which set in on the continent between 1905 and 1910 (mainly in Germany) and became widespread in the early 1920s. By then the term had also come to be applied to the late style of van Gogh and the early style of Munch in the 1880s, as being the movement's immediate precursors. It is now almost as commonly extended to the early style of Cézanne in the 1860s and to countless other 19th-century artists. One also frequently reads of the 'expressionism' of Blake and Fuseli, and with them the 18th century is already reached. As for 17th-century baroque, more irrational than classicism, less irrational than mannerism, an expressionist undercurrent frequently occurs in it, verging on mannerism, as for instance in Magnasco. There can be no doubt that the mannerism of the 16th century—Pontormo, Rosso, the late Michelangelo, El Greco—is an expressionist style; for around and soon after 1500, such a mass of naturalistic technique had been accumulated that artists who broke through this and used it to express themselves intensely in a fundamentally unrealistic or even anti-realistic way can without hesitation be called expressionist. I do not think the chronological demarcation is of any real importance. 'Expressionism' is only a convenient term, like 'baroque' or 'realism', used in order to define a broad tendency and in no

{ 128 }

way impeding historical precision in detailed analyses. To speak of expressionism in Hogarth —even if it is only an undercurrent—just as Dvořák spoke of '*Ausdruckskunst*' in the late Michelangelo seems to be historically justified.

With his deep interest in his fellow-men and as the creator of so many tragic and comic situations, Hogarth naturally paid the keenest attention to physiognomy and every variety of facial expression. This propensity was already evident in his youth: it is said that the sketches he was in the habit of making on his finger nails were usually 'the leading features and prominent markings'[3] of faces. Various examples of this interest recur throughout his work, in his rendering of action on the stage—where the play of features in Garrick's acting is an apt parallel—and frequently in the cycles. Thus, as a critic and satirist, he often slid imperceptibly from a most decided realism to what is almost its direct opposite—caricature.

In fact, from the descriptive, analytical realism of his portraits, especially those of professional people and actors, in which he laid more emphasis on expression than even La Tour ever came near doing, it is only a step, albeit an important one, to his psychological studies of criminals (real and political), in which he was quite unconcerned with flattery and could even permit himself, consciously or unconsciously, an underlying tinge of caricature. Revealing in this respect are Swift's well-known lines addressed to him:

> How I want thee, humorous Hogarth
> Thou, I hear, a pleasant rogue art.
> Were but you and I acquainted,
> Every monster should be painted:
> You should try your graving tools
> On this odious group of fools;
> Draw the beasts as I describe them;
> Form their features, while I gibe them;
> Draw them like, for I assure ye,
> You will need no *car'catura*;
> Draw them so that we may trace
> All the soul in every face.[4]

Thus it is difficult to draw even a vague line between Hogarth's portraits and those 'caricatures' in which he tried to convey the essence of a personality—to use the expression of one of his few outstanding predecessors in this genre, Annibale Carracci. Take the portrait of the Jacobite conspirator, Lord Lovat (1746, engraving (Pl. 78b); picture in the National Portrait Gallery[5]) done shortly before his execution. Lovat was an adventurer and cheat on a grand scale, both in his private and public life. His flabby features are to all appearances faithfully rendered, but they lend themselves well to the dramatic treatment of Hogarth's brush and the general effect of the portrait is almost diabolical. In view of the apparently harmless presentation, the man's malicious, crafty, cynical expression appears all the more sinister. Yet *Lord Lovat* is certainly far less of a caricature than many figures in the cycles.

The same can be said of the uncanny, monumental 'caricature' of the radical middle-class leader, Wilkes, whom Hogarth drew during his trial (1763, etching; pen drawing, British Museum) (Pl. 140a). Is this a portrait or a caricature? Which carries greater weight, the likeness or the satirical *exposé*? Even at the time of its publication, opinions were divided. Good-naturedly, Wilkes admitted his own ugliness and said that he grew more like Hogarth's print every day.

Indeed, so close was the likeness that his own partisans bought it. Lichtenberg, the best connoisseur of Hogarth in the 18th century, who also knew Wilkes, in a letter written in 1775, took the work for a caricature; the squinting of the eyes, he maintained, was overdone and the print lacked the noble appearance of Wilkes' profile. Although even as astute a judge as D. Low is undecided,[6] Lichtenberg was probably right. Again, in *The Chairing of the Member* from the *Election* cycle (Pl. 124a), Hogarth chose to represent Bubb Dodington as the successful candidate; for, although he did not in fact belong to the Opposition Party, here shown as victorious, nor was he elected in Oxfordshire, the county from which Hogarth took the motifs of this cycle, Dodington's well-known, squat, undignified figure lent itself so admirably to comic effects.[7] At the same time Hogarth did a genuine caricature of Dodington (pen drawing, Earl of Exeter).[8]

Particularly in his early, more popular phase, Hogarth delighted in exaggerated, caricature-like expression, close to the spirit of popular engravings with their frequently irrational features. Quite a series of his early engravings use some event merely as a pretext to draw a variety of grotesque heads. In many of these he paid little heed to true-to-life realism but concentrated either on deformity or strongly delineated expression, usually on both. Such scenes include *The Oratorio* (1732) (Pl. 35a), *Delivery of a Lecture* (1737, the nearest to gross, popular caricature) and, in a kind of coat-of-arms, *The Undertakers' Arms* (1736), exposing the quack doctors of London.[9] In these engravings, Hogarth built up a steep composition entirely from a number of facial studies, with heads and shoulders or even heads alone. The ultimate historical origins of these were, of course, Leonardo's caricatures and the many mannerist derivations from them. Bosch's religious scenes of half-length figures with caricature-like faces may also have played a part in the development leading to Hogarth. In painting, though again in a very remote sense, the preliminary steps for these kinds of composition were the Caravaggesque half-lengths of characters drinking, playing cards or singing, produced as much by Flemish and Dutch as by Italian and French artists. In these, however, the emphasis was more on gaiety than on physiognomy proper.[10] But Hogarth completely transposed such Caravaggesque scenes by making facial expression their principal element and giving them, formally speaking, a new, extremely condensed composition. On the influence of Watteau's *Réunion de Musiciens* on Hogarth's *Oratorio* I have already written. Popular, grotesque engravings after Egbert van Heemskerk, in which the figures have animal heads, also have their share in this ancestry. But undoubtedly a strong, direct impact came to Hogarth from the caricatures of the Roman artist Pierleone Ghezzi (1679–1751) which, with their wittily distorted features, became familiar throughout Europe.

Sometimes Hogarth incorporated his facial studies into scenes of a more descriptive character, when the expressions are rather less caricature-like. In the etching, *The Laughing Audience* (1733) (Pl. 41b), a distinction is drawn between the tired, bored members of the orchestra in the front row, the cavaliers at the back and the smaller fry in the pit, the latter forming a series brilliantly depicting the different way in which each individual laughs or smiles at the entertainment. The intensity of these studies, concentrated on the expression of gaiety alone, paved the way not only for Rowlandson, who often used Hogarth as a starting-point for his own riotous, still more 'expressionistic' outpourings, but also, in this particular etching, for Daumier (Pl. 41a).

Apart from these works, based on the stressing, over-stressing or distortion of human expression, Hogarth in his early years did a number of straightforward caricatures with social, literary or theatrical themes and containing a multitude of small figures, such as *The South Sea Scheme*, *Gulliver's Punishment* and *The Beggars' Opera Burlesqued* (Pls. 3b, 10a, 22a). Usually in a popular

vein, these works retained much of the 'Bosch-Breughel' tradition of Dutch popular engravings, but combined with greater fantasy. Most of them have already been discussed, but there remains the outstanding *Royalty, Episcopacy and Law* (1724) (Pl. 8a), whose political implications have been mentioned and whose expressionistic tendency is most patent. The few figures in this caricature, whose alternative, Swiftian title is *Some of the Principal Inhabitants of the Moon*, are almost entirely unreal, the faces of the three main figures—King, Bishop and Judge—being replaced by pieces of money, keys and mallets. Going farther still, the bodies of the courtiers and chamber-lains are composed entirely of fire-screens and looking-glasses, together with candlesticks and keys to indicate their functions, whilst a lady-in-waiting whose head is a teapot, neck a drinking glass and breast a fan, represents a dinner-bell.[11]

The high degree of expressionism here—it is not even unhistorical to say that it foreshadows Surrealism—undoubtedly originated in the mannerist style. The archetype of these transforma-tions were engravings with mask-like faces done at the French court in the 1530s by Rosso, who also contributed greatly towards creating a new, anti-classical, sometimes almost caricature-like approach to physiognomy. In his wake an even more radical breaking up of faces and increasingly of whole figures into unreal particles (animals, plants, objects and even other figures and faces) became usual in courtly art, e.g. in the paintings of the Milanese Arcimboldo (1530?–93), who worked for the Viennese court. Parallel with this, the same trend appeared in popular caricatures, particularly when used as political or anti-clerical weapons, and the borderline between these two categories is often indistinguishable. For instance, in 1577 the well-known German-Swiss painter, Tobias Stimmer, did a woodcut caricature of this kind against the Pope built up out of clocks, candles and bells in a style approaching the popular.[12] A practitioner of the courtly type was Braccelli, a highly mannerist Florentine engraver of the early 17th century and most typical representative of this playful, bizarre method of disintegrating human figures, even into kitchen utensils[13]; he is not far from Hogarth's caricature and, perhaps no mere coincidence, an imitator of Callot. Similarly in Dutch popular caricatures and even in pre-Hogarth English illustrations the same tendency occurs, though on a lower artistic level, showing transitional stages between human bodies and inanimate or stereometric objects after the pattern of Breughel's engraving *Combat between the Large Strong Boxes and the Little Saving Boxes* (1563).

A further tradition in English popular engravings brings the graceful Rosso-Braccelli in-heritance more down to earth and consistently represents trades and occupations with figures composed of objects symbolising them, such as a kitchen-maid out of a mop, pail and broom. A woman transformed into a bell is a frequent motif in English popular art, for instance in Staf-fordshire pottery and in table bells themselves. Hogarth seems to have followed these traditions. Moreover his caricatures contain quite typical stylistic features of popular engravings: the simplifi-cation of various figures is intentionally kept close to the primitive, angular reduction to essentials of popular prints in general. At the same time, he used these popular features in a rather subtle elastic way. In *Royalty, Episcopacy and Law*, refined and popular features of a common European type of caricature combine to produce perhaps the most striking, most powerfully concentrated political caricature of the 18th century.

Later in life Hogarth, socially as well as intellectually more venturesome, gave a great deal of thought, both in his various engravings of the 'forties onwards and in *The Analysis of Beauty* (1753), to questions of physiognomy he had previously neglected or but lightly touched on (*Characters and Caricaturas*, 1743) (Pl. 78a). In particular he attempted to define the borderline between character and caricature and studied the problem as to whether or not expression really

betrays character. He also considered how lines and wrinkles help to compose the features of a face and the way in which their alteration effect these at different periods of life. He was fairly conversant with the stand taken by past and present practice and theory on these questions—questions now much in the air, largely as a result of his own art—and with the most important continental caricatures of the past—Leonardo's and Annibale Carracci's—but naturally was especially interested in those of his most famous near-contemporary Pierleone Ghezzi. He owned Pond's engravings after Ghezzi's caricatures, which were very popular in England, and even reproduced one of them in *The Analysis of Beauty*.[14]

In art theory itself, especially since the 17th century, since Poussin and Bellori, the question of expression in relation to emotion and passion was much in debate because of its importance for dramatic and dignified history painting.[15] As to expression of physiognomy, Hogarth much appreciated Lebrun's famous *Traité sur les Passions*, with Picart's engravings, published in 1698, translated into English in 1701 and well-known throughout the European art world of the time. The object of this publication was to particularise Descartes' general theory on expression, and in it the effects of various emotions were depicted on individual faces.[16] Lebrun's numerous classified heads of expression are fundamentally refined and polished versions of baroque heads illustrative of the passions in pictures and are intentionally kept in the Raphael-Poussin tradition. They are rational, depicting typical passions, and mainly confined to showing which type of face is best suited to express each passion. From his remarks on Lebrun in *The Analysis of Beauty* Hogarth, the empiricist, appears to have been further interested in the play of muscles and their part in the formation of expression. In his historical pictures, he probably followed the common practice of making certain use of Lebrun's types, which were reputed to be great aids in the teaching of painting. Apart from this, however, and in contrast to Lebrun's schematic types, Hogarth in practice developed the portrayal of physiognomy to an unprecedented extent by his renderings of an enormous variety of everyday expressions.

Hogarth could not have known Lebrun's other book, *Traité sur la Physionomie, La Physionomie de l'Homme comparée à celle des Animaux*, since it was not made public in his lifetime. But he almost certainly knew the older Italian treatise on which Lebrun's was based, though in a modified form, namely, the Neapolitan G.B. della Porta's *De Humana Physiognomonia* of 1586, since Addison and Gay knew it and Dr. Mead owned a copy of it. This work, rather theoretical and speculative in spirit but immensely rich in its variety of types, bears witness to the keen interest taken in physiognomic studies by 16th-century mannerism. One feature of this anti-classical style was that it replaced the tranquil, solemn type of beauty of the High Renaissance with strange, sometimes grotesque expressions. Indeed, employment of della Porta's method necessarily led to over-expressive faces and intense caricature. By extending della Porta's types in his own way Hogarth himself frequently offered examples of the similarity between human beings and animals, sometimes in such a way that he went beyond caricature and illuminated character. In the second scene of *A Harlot's Progress*, the heroine's Jewish protector looks like the frightened monkey in the same composition (Pl. 36c). In the fourth scene of *Industry and Idleness*, the hideous porter's features are repeated in the gruff, snarling dog beside him (Pl. 105b). In *The Gate of Calais* (Pl. 111), two old fishwives resemble the fish they are selling; whilst Charles Churchill (1763), Wilkes' friend, is portrayed as a bear—a variation on Hogarth's own portrait of 1745 with his dog beside him. The animal heads placed on actors in *The Beggar's Opera Burlesqued*, directly inspired by Egbert van Heemskerk's popular imagery, could also number della Porta's types among their ancestors.

Expression and Caricature

I have the impression that in *The Analysis of Beauty* and certainly as a painter, Hogarth profited to a far greater extent from the more empirical researches of his great friend, the physician, Dr. James Parsons (1705–70), than from the eclectic and academic Lebrun. Assistant secretary of the Royal Society, Parsons published his results, 'Human Physiognomy Explained', in the *Proceedings of the Royal Society*.[17] More radically than Lebrun and only slightly anticipated, theoretically, by Addison,[18] he here demonstrated that it is the changes in the facial muscles, the play of features, which determine expression. In the illustrations, which he drew himself (engraved by S. Mynde), he showed the various changes in one and the same face according to the ruling passion of the moment,[19] and herein lies the decisive difference from and advance on Lebrun. It is clear from his book that Hogarth agreed that the movements of the muscles caused by the passions of the mind create expression, although as an empiricist he cautioned 'the physiognomist' against too hasty a judgment of character based merely on expression, for different causes might well produce the same aspect. *The Analysis of Beauty* is full of careful observations of this kind.[20] One of its illustrations showing the same face twice, once smiling and once laughing, exactly follows Parson's method.

Even in his later years, Hogarth was concerned to raise his art, at least theoretically, above the level of caricature. He attempted this in a rather programmatic engraving, *Characters and Caricaturas* (1743) (Pl. 78a). He covered this print with some hundred heads, extraordinarily varied in expression, all of his own invention and taken, he asserts, mostly from *Marriage à la Mode*, for which the engraving served as a subscription ticket. His intention was thereby to illustrate a recent statement in the preface to *Joseph Andrews* (1742), to which he drew attention. Here Fielding, already the Fielding of the psychological novels, no longer of the burlesque plays, drew a definite distinction between comic writing of the *Joseph Andrews* type and comic history painting on the one hand, and burlesque and caricature on the other, declaring that he and Hogarth, who did not 'deviate from nature', represented the former. It was here that Fielding made the oft-quoted reference to Hogarth: 'He who should call the ingenious Hogarth a burlesque painter, would, in my opinion, do him very little honour; for sure it is much easier, much less the subject of admiration, to paint a man with a nose, or any other feature of a preposterous size, or to expose him in some absurd or monstrous attitude, than to express the affections of men on canvas. It hath been thought a vast commendation of a painter to say his figures seem to breathe; but surely, it is much greater and nobler applause, that they appear to think.' In accordance with this, Hogarth now wished to demonstrate the appreciable difference between characters and caricatures. Though in his early phase he never thought of drawing such a distinction, the Hogarth of the cycles, particularly of *Marriage à la Mode*, wished to be recognised as a painter of characters, a psychological painter, a 'comic history painter', and not as a mere caricaturist. Thus in the bottom row of his engraving, beside examples of caricatures by Leonardo da Vinci, Annibale Carracci[21] and Ghezzi,[22] he placed three heads from the Raphael tapestry cartoons, then at Hampton Court—the St. John from the *Sacrifice of Lystra*, the *St. Paul preaching at Athens* and one of the beggars from *St. Peter and St. John Healing the Lame*. He thereby inferred not only that three of these caricatures were distortions of Raphael, but even more that his own heads placed above them, which he called 'characters', derived from Raphael's and were not so exaggerated as those of the other three Italian artists.

This provides good insight into the sources of Hogarth's inspiration and of the great respect in which he held Raphael, a respect fostered by *The Spectator*. In an enthusiastic article on the Raphael cartoons, Steele considered that in them the full gamut of human emotions was expressed

and 'almost all the different tempers of mankind represented'. Even so, Hogarth could not refrain in his engraving from slightly emphasising the original expressions of Raphael's heads and even more those of the Italian caricatures, in order to show how they differed from his own heads. At the same time it cannot be denied that, although clearly based on observation, some of his own studies are so exaggerated as to verge on caricature. For, as an empiricist, Hogarth considerably individualised Raphael's types (and still more Lebrun's abstract constructions) and from such individualisation it is often but a small, involuntary step to caricature. In this programmatic engraving, however, he purposely came down generously on the side of character so that all his heads should fall within this favoured category.

Since he would use every means to acquire the dignity of a history painter, he could not afford the broad-mindedness of Annibale Carracci, whose reputation as a history painter was never in doubt. At the same time he was the probable inventor of the portrait caricature and, according to him, both the master of sublime pictures and the caricaturist reveal the very essence of a personality, each in his own way.[23]

So great was the interest in physiognomy in Hogarth's circle and so close the interdependence between Hogarth and Fielding, that when Fielding borrowed from Hogarth he drew chiefly on the latter's gift of characterisation and of portraying states of mind. The attitude of Smollett was quite different, though he was equally appreciative of Hogarth. In his even more frequent borrowings he relied mostly on ridiculous attitudes or comic expressions[24] and, fond of eccentricities and exaggerations, was inclined to transpose Hogarth's very realistic motifs into caricature.[25] In the year in which Hogarth did *Characters and Caricaturas*, Fielding published *An Essay on the Knowledge of the Characters of Men*, full of penetrating remarks on men's faces and behaviour, and close in conception to Hogarth's ideas.

Another engraving from the late phase, *The Bench* (Pl. 130a) (1758, picture Fitzwilliam Museum, Cambridge) is in a spirit and of a programmatic character similar to *Characters and Caricaturas*. Here Hogarth was jeering at one of the most serious state institutions, representing in a most disrespectful manner four well-known judges of the Court of Common Pleas, including the notoriously coarse and immoral Lord Chief Justice Willes: these are shown as indifferent towards the case in progress, two of them even sleeping through the proceedings. Probably no deep question of principle lay behind this, though it seems that the creator of *Royalty, Episcopacy and Law* had scant respect for the administration of the law and often tilted at judges and courts of justice. When he did a parody of his own *Paul before Felix* (Pl. 112b), a picture destined for Lincoln's Inn, he caricatured the informer Tertullus and, through him, the actual practice of justice in England. The statue of Justice is made to appear comic and drunk, while her dagger is part of the coat-of-arms of London. It is also known through Vertue that in about 1731 Hogarth painted a satirical representation of a court of justice. But, apart from Hogarth's usual satirical vein, he may well have been averse to certain judges and it is known that he had a special grudge against the Court of Chancery which, under Lord Hardwicke's presidency, failed to administer his copyright law in a helpful manner. Certain it is that in this case he could not resist the temptation to ridicule these terrifying, pompous figures in their enormous wigs and sleeves, just as he had already portrayed one of them in the first plate of his *Analysis of Beauty*, to demonstrate the burlesque effect of an oversize wig. The result undoubtedly suggests Daumier; for here again—if one takes Rowlandson ('*We Three Loggerheads*') as forming the transition—scarcely any other artist prior to this combative Frenchman ever treated this daring subject so caustically and by similar means of accentuated expression. For here expression was Hogarth's outstanding

problem. This is more evident in the varied studies of heads in the top row than in those of the judges themselves; they were an unfinished addition (1764) to the original engraving and indeed the last work on which Hogarth was engaged just before his death, showing the extent to which such motifs preoccupied him. These heads are obvious derivations, in varying degrees descending to mere caricature, from those in Leonardo's *Last Supper* and Raphael's *Sacrifice of Lystra*, some being close to those of the judges in the same composition.

Thus for his favourite physiognomic studies—here as in *Characters and Caricaturas*—Hogarth liked to draw on famous compositions of Italian art, particularly those of Leonardo and Raphael, deducing from them new and often quite surprising effects of expression, whilst attempting to classify the fluctuating transitions between the different types. The heads in the original composition of *The Bench*, the judges themselves, Hogarth called 'Characters'; it was of this type alone that he claimed to be the artist. The heads in the top row he put partly into the category of caricatures, partly into an intermediary stage which he called '*outré*'—an expression used by Fielding in his preface to *Joseph Andrews*—for he perhaps felt that many of his own caricature-like heads could not reasonably be placed under the heading of 'Characters'. At any rate, one of the ruling ideas of his later years was that he did not wish to be considered a caricaturist.

I think Hogarth was the first artist to attempt a definition of caricature. In an explanatory passage on the plate accompanying *The Bench* he is very explicit: 'There are hardly any two things more essentially different than Character and Caricature. . . . When a character is strongly marked in the living face, it may be considered as an index to the mind, to express which, with any degree of justness in painting requires the utmost effort of a great master. . . . Caricature . . . may be said to be a species of lines that are produced rather by the hand of chance than of skill.'[26] The engraving, complete with its additional studies, is a kind of protest through which Hogarth sought to prove—as he did in his late phase on many occasions and using different arguments— that his art was not of an inferior character but could be raised to the heights of historical painting or, at least, to something corresponding to it.[27]

Yet however much Hogarth may latterly have fulminated 'theoretically' against caricatures, in practice, of course, most of his works—and not only the cycles—are full of slightly caricature-like heads. Historically they may recall those in Dutch genre painting, above all Steen, but they are now even more monumental than in his early period; moreover, the number to be found in any one work is more impressive than in Dutch art, where they form mere accents in large crowds.[28] Other examples in Dutch and Flemish genre painting of caricature-like expression occur in the works of Ostade, Dusart, Brouwer, Craesbeck. The most *outré* expressions are those of Egbert van Heemskerk, but Hogarth did not follow him to the same extremes. Yet while Heemskerk's faces are more individualised than those of Craesbeck, for example, they are less so than Hogarth's.

In 1742 he painted a picture which it is rewarding to compare with the most important contemporary type of continental caricature, namely Ghezzi's, whose manner Hogarth himself followed in *Characters and Caricaturas*. Ghezzi set a fashion for caricatures in high society in Rome, particularly among the international colony of collectors living there—caricatures based mainly on external features which his patrons enjoyed in their leisurely way.[29] Ghezzi's manner spread all over Europe and especially to England, since the English aristocracy made up a great part of the international settlement living in and passing through Italy.[30] This certainly had an influence on Hogarth; but, given similar motifs, any comparison shows that Hogarth's figures, with their more careful treatment of expression, are more penetrating and pungent. In 1742

Miss Mary Edwards, the wealthy, eccentric patron he had already portrayed, ordered from him a skit on French fashions then in vogue in England. This is known as *Taste in High Life* (Earl of Iveagh) (Pl. 74a), but its original title was *Taste à la Mode*. The over-dressed gentleman with a large muff on his arm—reputedly Lord Portmore, who had long resided at the French court—and the foolish, grotesque old woman in her enormous, pyramidal hoop, affectedly holding up a small china cup, cannot have relished these caricatures as Ghezzi's clients did. Beside Hogarth's intense, aggressive work, a squib by Ghezzi, despite its outward crudity and stronger exaggeration, is just a harmless, good-natured joke, and even a 'portrait' by Hogarth, such as Lord Lovat's, looks far more demoniacal.

Yet *Taste in High Life* is a caricature destined for upper circles similar to those catered for by Ghezzi. Even here Hogarth used motifs, such as the summarising contour of the hoop, that originated in the simplifying outlines of popular engravings, popular caricatures of fashions, particularly hoops, being a most usual genre. The effect of such a motif, similar to that of the court lady shown as a dinner-bell in *Royalty, Episcopacy and Law*, is typical of Hogarth and results in a subtle stylistic blend lacking any distinct borderline between the 'aristocratic' and the 'popular'. As regards the whole composition, the hoop, together with the sweeping outlines of the other figures, creates a grotesque but more concise pattern than any to be found in *Marriage à la Mode*, painted during the same years. Indeed, in this picture grotesque, fashionable and popular features are all fused together.

To emphasise the bizarre content of *Taste in High Life* and further parody the super-elegant gentleman, a fashionably dressed monkey, inspecting the bill of fare through a magnifying glass, takes part in the general action—a motif sometimes occurring in Flemish and related French art (Teniers, Gillot, Watteau), whence it probably derived.

Just as the monkey's behaviour is made more grotesque by taking its participation in a human event for granted, so a similar role is adopted for the paintings on the wall, which occupy almost half the picture. As in other motifs in the work, Hogarth here carried on the tradition of emblematic allusion. While this originated in medieval and popular art, he transformed it, as one would expect at this stage, into a really fashionable idiom. The paintings on the wall are neither faithful reproductions nor, as in the cycles, at best mere hints of their full expressionist possibilities, but are new creations directed, in the satirical and caricatural vein of the whole work, against the figures in the picture. Like *Royalty, Episcopacy and Law*, they are more than expressionist; they are almost what to-day is termed surrealist. In the large central picture, the *Medici Venus* is shown from behind, posed on a pedestal, nude except for stays and high-heeled shoes, while her front is covered by an enormous half-hoop (Pl. 74b). Hogarth's object was to show how these accoutrements distort the natural shape of the human body. In some ways his Venus anticipates Fuseli who, for less innocent reasons, used similar motifs of semi-nudity.[31] In the same picture, to the left of Venus, a winged cupid is miraculously paring superfluous flesh off a woman, while another cupid is bracing the hoop and stays. In another picture to the left of this one, a dancing-master—the famous French ballet-master Dunoyer—is lampooned as Jupiter in a ballet[32]; rigidity, a popular feature, is again used in a refined way and the dancer is almost reduced to a geometrical pattern, as he teaches butterflies and insects—symbols of worthlessness—to dance. Fashions worn by such people again appear in the picture to the right which contains a kind of surrealist *trompe l'œil*[33] (labelled 'Exotic' by Hogarth), an accumulation in space of pigtails, wigs, muffs, solitaires, enormous petticoats, French-heeled shoes and so on. Beneath, another picture shows a lady dressed in an extravagantly wide, pyramidal hoop, stereo-metrically folded (also

reminiscent of Fuseli). Finally, the fire-screen bears a design of a sedan chair into which a lady appears to be compressed into a rigid pattern by means of her strange dress: the ensemble—sedan-chair, steps beneath—is built up from cubic volumes and is presented as an independent composition; even the single leg of a chair-carrier, the only visible motif connecting it with the outside world, seems abstract-cubist.

I have described these typical background motifs and pictures on the wall in detail since I think they represent, at this relatively late stage, the climax of Hogarth's tendency to stress expressive values and occasionally abolish realism. A certain parallel to this occurs in the methods of many 15th- and 16th-century Italian artists who dared to proceed more boldly and follow their own artistic inclinations in background motifs, in contrast to the often schematic, traditional composition of the foreground. This treatment also represents the climax of Hogarth's irrational tendencies, which had their origin in mannerism—derivations already encountered in his caricatures, book illustrations, representations of the theatre and cycles. For the ultimate stylistic origin of most of these background motifs, particularly the cubist ones like those in *Royalty, Episcopacy and Law*, was the irrational mannerism of the 16th century, in particular again Rosso, the features of whose style could have reached Hogarth—were it necessary to suppose this at all —through many intermediaries. It is the adaptation of this subtle style tending towards the abstract that makes Hogarth, himself a kind of intermediary, approach quite close to the equally refined style of the end of the 18th century,[34] as typified by Fuseli (and in turn directly indebted to mannerism) and point even further towards the 20th century.

Such an astonishing climax as *Taste in High Life* would not have been possible but for a constant, strong undercurrent of this kind in Hogarth, as has frequently been observed in his various physiognomic studies, often intensely expressive and caricature-like, and in the irrational features of the cycles. In his early, more 'popular' days, when still unconcerned as to whether he was considered a caricaturist or not, he dared to exploit the features of an exaggerating or 'abstract' style more than he did later on. It was then that he created such an intense caricature as *Royalty, Episcopacy and Law*. In his late, 'fashionable' period, a painting like *Taste in High Life* was an exception and even then only owed its existence to a well-paid commission. It is not surprising that Hogarth, fearing lest his talents as a caricaturist should be generally recognised, did not allow this picture to be engraved.[35] On the other hand, the unreal-expressive features which come to the surface in it reveal more aristocratically refined and 'fashionable' qualities than the early, not dissimilar though rather popular *Royalty, Episcopacy and Law*.

Nevertheless a development towards the fashionable, if the main one, cannot be called the only line of Hogarth's later evolution. He also did caricatures and caricature-like works, but only as engravings of a very unreal, even popular or semi-popular character: for instance, *The Battle of the Pictures* (1745; Pl. 102b), in which his own paintings are fighting foreign ones; *False Perspective* (1753), where wit assumes an entirely fantastic character; *Credulity, Superstition and Fanaticism* (1762), where irrational, popular Bosch motifs, incorporated into the portrayal of a Wesleyan service are perhaps more marked than anywhere else in his art; *The Weighing House* (1763) an illustration to a humorous pamphlet on physiognomy, where symbols of the different temperaments hover in mid-air at various angles; and finally *The Bathos* (1764) (Pl. 143b), with its crazy, symbolical presentation of the world's end.

This leaning towards the irrational and fantastic lay just below the surface of this great, rationally minded, realist artist and was always ready to spring out. It was in works like *Taste in High Life* and *Royalty, Episcopacy and Law*, both fundamentally caricatures, that he indulged

in a really high degree of abstract shapes and both works derive from mannerism—a style in itself considered, from a merely realistic viewpoint, almost caricatural. He would certainly not have used such irrational, abstract motives in his average works or for scenes of real events. But when it comes to details, however empirical or, better said, the more empirical their starting point, such as physiognomic studies, his inclination for the expressive and for biting effects may quite frequently have led him in an unempirical direction. For the expressionist and the irrational were deeply embedded in Hogarth's art, with its partly popular character, its baroque style and its receptivity towards even the fantastic features of mannerism.[36]

VIII

The Historical Compositions

$\scriptstyle\mathfrak{R}\mathfrak{R}\mathfrak{R}\mathfrak{R}\mathfrak{R}\mathfrak{R}\mathfrak{R}\mathfrak{R}\mathfrak{R}\mathfrak{R}\mathfrak{R}\mathfrak{R}\mathfrak{R}\mathfrak{R}\mathfrak{R}\mathfrak{R}\mathfrak{R}\mathfrak{R}$

HOGARTH grew up imbued with great admiration for Thornhill's art, which followed the tradition of the painting of 16th- and 17th-century Italy and France. He too had been strongly influenced from early youth by the art of these countries, which he had assiduously studied through engravings; and he held the great masters of the past in deep respect throughout his life. The pervading spirit of *The Analysis of Beauty* testifies to this; moreover, he explicitly affirmed as much in a supplement he prepared to the book. Frequent allusions reveal his particular veneration for Raphael, Leonardo, Titian and Michelangelo. Although he knew most of their works only through engravings, he was undoubtedly familiar with the originals of many famous Italian pictures in the royal palaces and private collections[1]; this is evident from the astonishingly large number of correctly rendered paintings on the walls in *Marriage à la Mode*.[2] He sincerely held the view expressed in his supplement to *The Analysis of Beauty*, that it is better to look at and understand a few pictures thoroughly than to undertake a hurried tour of Europe. Until the death of his father-in-law, he could always view Thornhill's large collection, which included pictures by Veronese, Caravaggio, Annibale Carracci, Reni, Domenichino, Albani, Mola, Rubens, Poussin, Castiglione, Giordano, Sebastiano Ricci, Luti and Pannini.[3] He owned a copy of Pond's and Knapton's *Imitations of Drawings by Old Masters* (*c.* 1732–6), with sixty-eight engravings after drawings mostly by Parmigianino, Annibale and Agostino Carracci, Guercino, Claude Lorraine and Pannini, largely chosen from the collections of Jonathan Richardson and Dr. Mead. It is characteristic that he should have bought this important book, which was apparently a commercial failure for want of subscribers.[4] He also owned engravings by Robert Strange, the only really outstanding English engraver of the time to have worked after Italian historical pictures; Strange had studied in Paris, spent many years in Italy and, from the late 'forties, engraved various famous works, particularly those of Reni.

Hogarth was much interested in the formal elements and subject-matter of compositions by the great masters. While he used these, he would also sometimes caricature them—as in *Strolling Actresses* (Raphael), *The Beggar's Opera Burlesqued* (Rembrandt) and *Hudibras* (Mantegna). He

forms the watershed between two different, though sometimes compatible, attitudes in England: on the one hand, the popular, burlesque, anti-heroic vein as exemplified by *Hudibras*; on the other, the upper strata's respect for grand art of the past, a respect which increased from decade to decade throughout the century.[5]

However conscious one may be of Hogarth's Protean mentality, one should not inquire too closely whether he intended to travesty a famous composition, borrow from it, or simply make use of it.[6] Traces of such instances often occur in the most surprising places, for instance J. Nichols mentions that in *Noon* the boy crying as he spills the pudding is a caricature of Poussin's weeping boy in the version of his *Rape of the Sabines* at that time in the Hoare Collection, Stourhead (now Metropolitan Museum of Art, New York). In the last scene of Hogarth's *Election* cycle, *The Chairing of the Member*, a goose flies over the triumphal scene: according to Nichols this is a parody of the eagle in Lebrun's *Victory of Alexander the Great over Darius at the Granicus* (Louvre).

The etching of Columbus solving the problem of how to make an egg stand on end by breaking its top (Pl. 113a) is a burlesque transposition into baroque of Leonardo's *Last Supper* with rather Salvator Rosaesque and Italianising Dutch types. Hogarth's public probably enjoyed this very obvious allusion, which almost faithfully retained the attitude of each figure in the central part of the fresco. Christ has become Columbus triumphant as the egg stands upright on the table before him, while the apostles have changed into startled, despondent scholars. But behind this joke lay a clear understanding of Leonardo's construction and Hogarth transformed its classicism into the undulating, fashionable style of his own day with remarkable ease.

It is not so easy to recognise the relevance of Leonardo's same composition to the first scene of the *Election* series (1755, Soane Museum), *An Election Entertainment* (Pl. 122a), although the complete table with all its surrounding figures is reflected in the wild, burlesque drinking bout of the electors, to which the unfortunate candidate has to submit.[7] Grotesque motifs from Steen (or Egbert van Heemskerk), popular engravings and especially inventions of the artist's own, have here been freely intermingled within a transposition of the most celebrated religious composition in the world. It is conceivable that, in this whirlpool of motifs, Hogarth deliberately sought steady support from Leonardo's meticulously balanced composition; for here, as in the cycles, he was inclined to cling to the traditional pyramid-pattern as a formal bulwark against his own realism, and in this *The Last Supper* could play a valuable part.

Less obvious still is the use of *The Last Supper* in the engraving *The Cockpit* (1759) (Pl. 136a). The blind nobleman gambling in the centre is derived from Leonardo's Christ: a tall lean figure towering over the crowd, he holds the money on the table in outstretched hands. The poses of the two figures to his right and left, one of them stealing his bank-notes, are taken from Judas and St. Peter. These three world-famous attitudes again served Hogarth as a solid focal point within a wildly agitated pattern, but in a manner more helpful to the composition than in *An Election Entertainment*. In fact, the most pronounced attitudes of the figures in *The Last Supper* sank so deeply into Hogarth's mind that they recur almost unconsciously in his work. For instance the famous gesture of St. Thomas in *The Last Supper* seems to be the source of the upraised hand with stiffly extended forefinger of the Methodist preacher accompanying the criminal to the gallows in *The Execution of the Idle Apprentice at Tyburn* (Pl. 107b).

It is common knowledge that Hogarth sometimes made a pretence of disliking the works of foreign artists of the past. It suffices to recall his famous remark to Mrs. Piozzi: 'The connoisseurs and I are at war, you know; and because I hate them, they think I hate Titian, and let them.'

The Historical Compositions

In an engraving *The Battle of the Pictures* (1745) (Pl. 102b), after Swift's *Battle of the Books* whose theme, originally emanating from France, was the struggle between Ancients and Moderns, he represented individual pictures from his own cycles defending themselves from attack by various foreign paintings of the past, which appear to include travesties of Titian and Rubens, and even the antique *Aldobrandini Wedding*. The motif of pictures leaving their easels to join battle was probably inspired by the books leaving their shelves to ride in mutual combat in the 1710 frontispiece to Swift's work. The ultimate pattern for both was perhaps Brueghel's engraving, *Combat between the large Strong Boxes and the little Saving Boxes*.

Hogarth's engraving was the ticket for the private sale of the original paintings of some of his series which he could dispose of in no other way, and it expresses his forebodings as to the financial outcome. Italian mythological paintings, endless, identical Rapes of Europa and Apollos skinning Marsyas fly unaided to the auctioneer's sale-room, whilst his own pictures remain unwanted in his studio. His fears were justified, for the 1745 sale proved a great failure; the six pictures of *A Harlot's Progress* sold for c. £88, the eight of *A Rake's Progress* for c. £185; thus, on an average, each painting of the first cycle fetched 14 guineas, each of the second 22 guineas. At the next sale in 1751, even *Marriage à la Mode* commanded only £126, or 20 guineas apiece. In 1750 Hogarth presented the Foundling Hospital with unsold tickets in a lottery for *The March to Finchley*. A worse failure attended the raffle for the *Election* cycle, with 200 tickets at two guineas a stake; so few subscribed that Garrick, who alone appeared at the studio, acquired the set for two guineas, but unwilling to take unfair advantage of this, he sent Hogarth 200 guineas in payment.

In the announcement of the sale of the pictures for *Marriage à la Mode*, Hogarth described his cycles as being 'of the historical or humorous kind'. He believed—and this was probably his deepest conviction—that his cycles, 'placed between the sublime and grotesque' and built up as everyday dramas, were 'in the historical style', and in consequence much above Dutch painting. Sometimes he even claimed that their 'public utility' entitled them to rank higher than 'sublime' religious or mythological paintings by foreign artists.[8] Although he sincerely admired certain formal features in the latter, often employing them in his own compositions, and furthermore made great efforts himself to create historical pictures in the traditional, narrow sense of the word, he was equally sincere in describing them as 'what the puffers in the books call the great style of history painting' and 'the eternal blazonry and tedious repetition of hackneyed, beaten subjects, either from the Scriptures or the old ridiculous stories of heathen gods'. Hand in hand with this went his oft-expressed idea—originally derived from Fielding and applied by both to painting and to plays—that it is more difficult to produce everyday comedies than tragedies, which are 'made up of more extraordinary events'. Yet, as the sales of his pictures proved, the aristocratic connoisseurs did not share this unconventional, bourgeois-utilitarian point of view. Any attempt on Hogarth's part to sell the originals of his various cycles met with scant response compared with the high prices given for any unimportant, old, so-called historical picture by a foreign artist.

On the rare occasions when the aristocracy ordered historical pictures from contemporary artists, they did so from foreigners. A typical case in point is the set of paintings, depicting the Apotheosis of famous people—all of them Whigs, including William III—commissioned, from 1726 onwards, for his house in Goodwood by the Duke of Richmond from Ricci. Hogarth, in his article in the *London Magazine* of 1737, gave a witty description of the dishonesty of the foreign dealer and the ignorance of the aristocratic patron. His accusation that aristocratic

connoisseurs understood little about old pictures was justified. It was common knowledge among art dealers all over Europe that rich English connoisseurs paid the highest prices for old pictures while comprehending them least. Hogarth's conviction that many of these were only copies was also undoubtedly true.[9] Moreover, as Rouquet asserts, dealers in England deliberately decried the work of living artists in order to sell their old masters more profitably. In France the situation was quite different. As Rouquet wrote to Hogarth from Paris (1753), artists there did not have to struggle for their very existence against the old masters. Among the French public there was a strong tradition of art appreciation, so that it came quite naturally to them to buy pictures from contemporary artists. Moreover, through the usual annual Exhibitions, the Salons, artists had closer contact with the public than they had in England.

The little satisfaction he derived in the long run from painting portraits, even of the aristocracy, led Hogarth increasingly to concentrate on historical pictures—not in his own wider interpretation, but in the usual sense of the word. Therein he had hopes of greater recognition in circles beyond those to which his engravings appealed, despite the deep satisfaction he felt at their success.

Behind his thirst for acknowledgment as a painter of conventional historical pictures lay a more or less genuine belief in the Italian-French art theory (Bellori-Félibien and even Shaftesbury) that history painting was the highest type of art. This view was not only held in conservative, official circles, but was quite widespread, being fostered in England by translations of Bellori and Dufresnoy (by Dryden 1695), Roger de Piles (1706, 1711) and Lairesse (1738) and through the essays of the portrait painter, Jonathan Richardson: *The Theory of Painting* (1715), *The Whole Art of Criticism in Relation to Painting* (1719) and *An Argument in Behalf of the Science of a Connoisseur* (1719).[10] Richardson expressed the hope that there would soon arise and flourish an English school of painting in the grand manner, similar to that of the old masters, and his views were generally accepted in the literary coffee-houses. These writings of a patriotic English author must have acted as a strong incentive for Hogarth to attempt history painting. It is significant of the artistic situation in England before Hogarth's time that it was a portraitist who had to give expression to this sentiment. It is equally characteristic of the beginning of the century that Richardson had never been in Italy himself but based his guide to works of art in Italy—*An Account of the Statues, Bas-reliefs, Drawings and Pictures in Italy, France*, published in 1722, which served as a guide to all English noblemen on the Grand Tour—on his son's experiences. According to Hogarth, who belonged to the next generation, the time of good English pictures had already arrived; but he had less faith in the new English connoisseurship, which Richardson had hoped to promote through his essays, since old foreign masters were still preferred to contemporary English ones.

Richardson's theories, no less than Hogarth's own ambition, were closely connected with the artist's general struggle for social recognition. Begun by Alberti during the 15th century in middle-class Florence, this struggle did not really break out in England until three centuries later.[11] Only now were serious efforts made here to raise the social standing of painting by comparing it with poetry. Richardson, insisting in the traditional manner on the dignity and culture necessary to the painter, put up the ancient claim that painting was a liberal art. But the newly fortified bourgeois self-confidence of the artist gave this struggle in England rather different features than it had, for instance, in contemporary France. There, as elsewhere in Europe, the academies served to raise the artist's social standing; moreover, the academician's chief ambition was to be classified as a history—not as a genre—painter. Such an elevation implied a high social position in every sense and above all a closeness to court and aristocracy. In England with its

highly-developed middle-class, the self-assurance of the artist was stronger than anywhere else at that time, stronger even than it had been in the case of Poussin. And whereas for religious reasons he was only tardily being accepted by the bourgeoisie, the artist was urgently seeking to become one of their number or, to use more precise contemporary terminology, a gentleman, as Jonathan Richardson put it. Thus during Hogarth's lifetime there was a far greater likelihood in England than on the continent of middle-class ideas being incorporated into history painting. With Hogarth this likelihood was farther increased since, for democratic reasons, he was opposed to academies. It was, indeed, this unusually strong bourgeois tinge which made his ideas on history painting less exclusive than was customary on the continent, so that he could count his cycles as history painting, ignoring the idealisation that traditionally went hand in hand with the grand style.

From the mid-'thirties onwards Hogarth produced historical pictures whenever occasion arose. For certain charitable institutions he even offered gratuitously to paint suitable Biblical themes—considered as within the range of history painting—such as *The Good Samaritan* and *The Pool of Bethesda*, for St. Bartholomew's (1736)[12] (Pls. 60, 57a), or *The Foundling Moses brought to Pharaoh's Daughter*, for the Foundling Hospital (1746) (Pl. 100a). Yet since, in practice, the middle class were not sufficiently educated in the arts to buy historical pictures, Hogarth was forced to appeal to the only class that did, namely the aristocracy, in order to satisfy an aspiration which, paradoxically, derived largely from his bourgeois self-assertiveness. He was further spurred on by the artistic and social achievements of his father-in-law. Following in Thornhill's footsteps, he wished to show that an English painter of his generation was as capable of producing this elevated genre as were his predecessors or foreigners. When he was still a silversmith's apprentice, Thornhill's frescoes in St. Paul's and at Greenwich 'ran in his head', and his artistic ambitions most likely emerged at the time when he was associated with Thornhill in the execution of frescoes. So his convictions as to the superiority of history painting were based on elements related both to the middle class and to the aristocracy. Thus it is easy to appreciate that the older he grew and the closer his ties with the aristocracy, the more he aspired to the glories of an historical painter. But one can equally understand how, even in his late phase, he often wearied of the efforts involved and grew contemptuous of them.

In his early days, when he was gaining his livelihood from book illustrations and the rendering of topical, mainly theatrical, events, Hogarth's mind was not much given to the painting of historical pictures, even if some of his works approached this genre[13]; some of his book illustrations, particularly of poetical and mythological subjects, were of a loftier character, reaching a peak in the two for Milton's *Paradise Lost*, possibly ordered by a bookseller who made no use of them. These give an insight into his early treatment of a noble literary subject which genuinely appealed to him. The advent to power of the Whigs brought with it a recognition of Milton; previously defamed as a Cromwellian and a Puritan, he was now recognised as a champion of political and religious liberties,[14] and in Hogarth's time his fame had already become almost as great as Shakespeare's. He was also one of Hogarth's favourite poets and his works appear with those of Shakespeare and Swift in the artist's self-portrait of 1746.[15] He was attracted by the formal as well as the sublime features of *Paradise Lost*: in *The Analysis of Beauty* a quotation from the poem is used as a motto, showing Milton as a champion of the baroque serpentine line of beauty[16]:

> So vary'd he, and of his tortuous train
> Curl's many a wanton wreath, in sight of Eve,
> To lure her eye.

One of the engravings for *Paradise Lost* illustrates Satan summoning the myriads of devils to his capital, Pandemonium (Pl. 6b); the other represents God the Father and Christ looking down on Earth, towards which Satan is flying. Both are among Hogarth's most explicitly baroque compositions and are perhaps the most continental in appearance of all his works.[17] In an historical sense, the models on which he drew are different in each case. The representation of God the Father and Christ sitting on a rainbow, accompanied by a host of music-making angels[18] in a *chiaroscuro* of whirling clouds, is typical international-baroque; it is super-Thornhillian, related to French and Italianising Dutch book illustrations (e.g. Luyken), and can easily be termed somewhat Venetian in appearance.[19] *Pandemonium* displays a spectacular baroque style in which elements that are mannerist in origin are clearly discernible. An enormous, dark and wildly ornamented repoussoir arcade completely fills the left side, pushing far into the background, across a vast, unreal space, the large figure of Satan seated beneath a swirling canopy surmounted by a slight variation of one of Michelangelo's Sistine slaves. The space between is occupied by teeming hosts of devils: as Milton says, they can reduce their shapes to the smallest of forms.

This obviously theatrical setting, so characteristic of Hogarth, again originated in Callot's courtly theatre representations. To prove this, one need only compare it with Callot's early, mannerist recording of the *First Interlude* of *La Liberazione di Tirreno* (Pl. 104b), a play produced by Parigi in 1616 at the Medici court. This is the same composition I compared earlier on with the Church scene in *Industry and Idleness*, to show how Hogarth was latterly to adopt and extend mannerist schemes of this type through his own naturalism and the wealth of his own observations.[20] In Callot, the vast silhouettes of extremely elongated, ruggedly ornamented cavaliers in the raised foreground form a shrill prelude to the fantastically remote stage, while between them the large hall is packed with an assembly of minute spectators; even Hogarth's column and curtain repoussoir to the right is already present. Yet the point to observe is that, in this same Milton illustration, Hogarth was attracted by the popular features in Callot's art, though on this occasion he was ready to 'purify' them.

The theme of Satan's capital was bound to be influenced by Callot's two versions of *The Temptation of St. Anthony* (Pls. 7a, b) with their hordes of devils, offspring of the Bosch-Breughel tradition—engravings which had certainly passed through Hogarth's hands. As I have mentioned, popular and courtly features were indissolubly mixed in Callot, and in these two compositions the influence of the Florentine court stage with its tall, narrow rock repoussoirs is particularly pronounced. Indeed, the extremely jagged repoussoir silhouette in the first version of *The Temptation* is even closer to Hogarth's arcade than that in the *First Interlude* (Pl. 104b). Although stylistically Hogarth's illustration is perhaps closer to the first, more mannerist version of *The Temptation*, in the representation of certain figures he was apparently more interested in the second, more baroque, version. His tiny silhouettes of devils probably derive from the latter, particularly the striking one at the foot of the column, similar to the one which Callot placed on a rock. The gun and monster beside it have also been suggested by Callot's grotesque monster gun. But only the more respectable upper part of Callot's motif has been retained, and even that is smoothed down to a kind of polished Cerberus; beside it Hogarth drew a genuine gun. Thus in this lofty composition, he deliberately polished up popular motifs, however sympathetically and more literally he adopted them in other works.

In 1729 Hogarth painted a picture, of which only the engraving exists,[21] of a subject from English history: Henry VIII leading Anne Boleyn to court, discontentedly watched by Cardinal Wolsey and Queen Catherine (Pl. 17a). This illustrated a poem by the Scottish poet, Allan Ramsay,

one of Hogarth's admirers. It was destined not for an individual but for Vauxhall Gardens.[22] The theme had naturally to be light and interesting, yet it is undeniably a kind of historical easel picture, that is, something that perhaps no other English painter of these decades had attempted. Painted in the year Hogarth married, started his elegant conversation pieces and really embarked on his social career, it not only marks a step on his road to fame but constitutes a minor landmark in English painting. In Vauxhall itself it initiated a series of pictures illustrating English history, mainly contemporary, painted by Hayman from the 'forties onwards.[23]

Works with such themes had occurred only sporadically in the past, mainly as book illustrations to Shakespeare's plays. There are, in fact, certain resemblances between Hogarth's composition and the illustrations to Shakespeare's historical plays in Rowe's editions of 1709 and 1714. This is particularly true of scenes in the later edition which, with their 'Elizabethan' costumes, are slightly historising, if less consistently so than in Hogarth; such a 'romantic' figure as Hogarth's Anne Boleyn did not yet occur here. In the illustration to *Henry VIII* the king stands in a Holbein-like pose and similarly attired as in Hogarth's picture. Kirkall's illustration to *King John* (Pl. 17b), in the same edition, seems to have had more importance for Hogarth: the enthroned king, with the Papal Legate, Cardinal Pandulph, beside him, is offered the crown on the Pope's authority. The cardinal's position close to the throne is similar to that of Wolsey in Hogarth's picture, whilst the shape and ornamentation of the throne, though it is set at rather a different angle, are much alike in both scenes. The window and curtains, too, are in almost identical positions. But the third-rate Kirkall's figures are lifeless puppets compared with Hogarth's. This historical and at the same time psychological subject, so far as the rivalry of the two women is concerned, was rather suited to Hogarth and within his competence. But the characterisation of the brooding Wolsey, on which he was debarred from dispensing his customary humour, was beyond his reach at this early stage. Formally, something of the baroque structure of *Pandemonium* is retained, though it is brought down to earth. The scheme of the throne, canopies and curtains is fundamentally similar. But Hogarth clarified the composition with a few large figures and the event does not take place in infinite space but is lucidly represented in a very concrete royal apartment. In retreating from the realm of Hell and from the mannerist stage, Hogarth came closer to the contemporary stage. Henry VIII's figure, the centre of the composition, recalls Macheath's pose in *The Beggar's Opera* of the same year; but the king forms a more genuine connecting link in the build-up of the pattern. On the other hand, copious details, such as the rich interior decoration and the more or less Tudor costumes, are employed as a means both of characterising the event and its setting and of lending dignity to the whole. The final result is a formal solution between the super-grand, mannerist baroque of the Milton illustration and the realist baroque of *A Harlot's Progress*.

Hogarth cherished high hopes of giving an impetus to historical painting in England by his two unusually large-scale Biblical paintings on canvas for the staircase of St. Bartholomew's Hospital—*The Good Samaritan* and *The Pool of Bethesda*; begun as early as 1734 when, as he himself says: 'I quitted small portraits and family conversations and, with a smile at my own temerity, commenced history painting.' They were presented as gifts in 1736. Such phenomena were quite general in northern Protestant Europe where, at least in the case of charitable institutions, donors gave some kind of painting as a substitute for the altarpieces presented to churches in Catholic countries. But Hogarth's pictures are of higher quality than the general run of such works, which were of a rather dilettante character. Stylistically, they are quite a striking combination, typical of his complex approach. He attempted here to produce historical pictures in

the grand manner and on a very large scale. At the same time they are almost touchingly human, rational and unusually realistic-grotesque interpretations of the Bible, in line with the general European tendency to humanise the Bible, to teach practical rather than dogmatic Christianity— a tendency in which, since the end of the 16th century, Protestant Bible illustrators, mainly engravers, had played such a large part, with Rembrandt, although not a Bible illustrator in the narrower sense, as the outstanding example.[24] Bible stories with a moral content were naturally favourite themes and Hogarth chose two of them for this hospital.

The markedly human and charitable character of the main scene in *The Good Samaritan* is calculated to evoke compassion and Hogarth shows an almost medical preoccupation with the pain of the wounded man, the suffering expressed on his pallid face. Yet, however traditional the main motifs of the composition may be, he appears to have had in mind that type of Bible illustration which started with the Swiss Stimmer and included works by Jan Breughel and the Rembrandt school.[25] The arrangement of the picture probably stems largely from one of these but is transposed into a somewhat up-to-date baroque. Since knowledge of these usually Protestant Bible illustrations spread widely through Catholic countries as well, it is not surprising to find that, a hundred years before this, a composition painted in Antwerp for a similar secular institution, the Surgeons' Hall, apparently derives from the same model: this is by van Cortbemde and dates from 1647 (Museum, Antwerp). Here the wounded man is rather different and Hogarth may have borrowed the attitude of his own figure from one of the versions of van Dyck's *St. Sebastian Cured by an Angel*, which seems all the more probable in that the position of the Samaritan resembles that of van Dyck's angel. The Samaritan is somewhat Venetian in type, although the painting as a whole, probably on account of its model, is of a slightly Flemish character.

The theme of *The Pool of Bethesda* naturally appealed to Hogarth as another suitable one for a hospital. He must have prided himself on representing this concourse of sick people on the basis of accurate studies, for each of his figures is suffering from a different, medically recognisable illness.[26] Continuing the Dutch-Protestant tradition of Bible illustrations, he evoked pity for the poor and oppressed and even introduced a note of liveliness in the motif, somewhat unusual for him, of the struggle between rich and poor at the pool. This, after all, could safely be shown in a democratic institution like a hospital. A rich woman, bathing in the pool, orders her servant to push aside a poor mother seeking to cure her child in the waters. Thematically, as well as in the individual attitudes of the main figures, it is not difficult to see Hogarth's source for this motif, namely Rembrandt's Hundred Guilder Print, *Christ healing the Sick*, in which St. Peter pushes back a young mother holding up her child to be healed by Christ. Hogarth gave the Biblical motif a twist, the suggestion for which might have come from the same source: a wealthy young man seated beside the woman finds it impossible to give his earthly belongings to the poor and follow Christ. The composition as a whole may well also have affinities with one of the Bible illustrations then current. In the event of Hogarth's having known Callot's small cycle of the New Testament, it must be assumed that his main group, depicting Christ with the sick man seated before him, came from the latter's representation of *The Raising of Lazarus*. The attitudes and gestures of the figures and their inter-relation are very close in the two works. Nevertheless one of the leading suggestions for the painting, perhaps even for the main group itself, must have come from the Raphael cartoon of *St. Peter and St. John healing the Lame*. The motifs of the naked child seen from behind, the cripple on crutches (the old man clutching a stick is similarly placed in Rembrandt's print as well) and the woman with the sick child, seem to derive from here.

Certain other features may also be connected with Rembrandt, in particular with his two etchings of *The Raising of Lazarus*: the figure of Christ, designed to appear noble and human, especially shows Rembrandtesque qualities, his attitude with his hand on his hip probably deriving from the Christ in the 'great' *Raising of Lazarus*.[27] Such Callot and Rembrandt influence as there is helped Hogarth to render the original Raphael arrangement more baroque, and the originally heroic contours more realistic.[28]

This is a rather groping, compromising, not wholly unconventional and in any case very eclectic style. Yet it seems to be extraordinarily personal and realist when compared with that of the very schematic religious pictures of such French rococo painters as Jean François de Troy or Charles Antoine Coypel, certain aspects of whose secular themes can, as has been shown, be well compared with Hogarth's. Seen from the viewpoint of previous painting in England, Thornhill and Amigoni could perhaps be considered the origins of its language. In principle one feels Hogarth's picture to be closer to Thornhill's heavy baroque, with its strong leanings towards realism, than to Amigoni's rococo, particularly superficial in his large sized paintings.

Yet some of Hogarth's individual motifs are reminiscent of Italian, particularly Venetian, rococo, that is of works by those Italian painters who had lived in England or were otherwise very fashionable here: Amigoni, who at this time was still in England and who, before Hogarth supplanted him, had been seriously considered for the paintings for St. Bartholomew's[29]; Ricci, whom Amigoni took as his model; and in particular Pannini. Both the latter two had represented *The Pool of Bethesda*[30]—Pannini frequently—for in Protestant countries this theme was generally considered suitable only for hospitals, whereas in Italy it was quite often represented in grand, fashionable works. Hogarth's composition betrays features from both these sources. As regards the north Italian representations of Bethesda, only one version by Pannini (Baroness Aretin, Agg), (Pl. 57b), could have had any importance for Hogarth. It is an early work; its flying angels and the disposition of its main group derive, as do Hogarth's fundamentally, from Raphael. Hogarth's realistic figures are naturally very different from Pannini's; but the grandiose, theatrical setting with curving arcades, which in Hogarth summarises the whole composition, could be a pointer towards the Italian artist. In Hogarth's composition one is even conscious as well of the historical implications of Italian rococo, in so far as they coincide with his own trend. Venetian rococo, in its formation, harks back strongly to Venetian 16th-century art, so does implicitly Hogarth's painting; that is why the architecture, though very probably an imitation of Pannini, is somewhat reminiscent of Veronese, while the naked woman, although an imitation of Amigoni[31]—and particularly recognisable as such in her whitish-blue drapery—also implies the mannerist pose of a Susannah by Tintoretto.[32] This latter similarity in particular—though more unconscious than conscious—also reveals the early mannerist penchant in Hogarth himself.

But in order to understand Hogarth's *Bethesda* the features coming from both historical sources must be balanced. Although it is an historical painting, it is undoubtedly also a 'democratisation' of Pannini's picture; in the latter the small classical figures merely serve to fill up the grand architectural setting, while Hogarth's main concern is to humanise and characterise his figures. Specifically his own are the two grotesque women in the left corner: the aged cripple and her young companion, burlesque, idiotic, almost a dwarf—a typical Hogarth invention in the best Callot spirit. These two figures are much bolder and more original in conception and characterisation than the rest, although few are really conventional; they were improvisations, since they do not appear in the sketch (Beckett Collection) for the picture. Such figures, reminiscent of the more 'popular' Hogarth, could certainly not be found in any fashionable Venetian rococo work,

but Hogarth probably felt that he could afford them in this painting for a hospital. And if their conception is bold, so too is the extremely broad, free manner in which they are handled; significantly, in this they again differ from the rest, but only in degree. This sweeping, loose manner of painting plays a larger part in the whole composition than one realises at first glance. It is also manifest in the intricate ornamentation of the painted, rococo framework (not executed by Hogarth himself) which surrounds the picture and curls into it, so that the shriller, less usual motifs within the composition stand out the more clearly. The whole work thereby acquires a flamboyant, flickering quality which, although certainly rococo, lends a very personal note to its elevated character.

The landscapes in both Hogarth's pictures are by Lambert who, in his combination of Dutch painting and Claude Lorraine, was probably the earliest English landscape painter of some significance. However, in these two pictures the backgrounds are merely a somewhat schematic, decorative accompaniment to the figures.

As these pictures bore no fruitful results, at a date shortly before 1738 Hogarth tried something different but now associated with an aristocratic connoisseur.[33] This consisted not precisely of historical pictures but of a kind of preliminary for them: six plates to illustrate the Spanish edition of *Don Quixote* published in 1738 at the expense of Lord Carteret. Already fashionable during the Restoration, *Don Quixote* had a great vogue in English educated circles in the 18th century.[34] For them the novel was more than a mere pattern for topical satire (though as such it was used too); for instance, Fielding's boisterous play, *Don Quixote in England* (1734), while extolling English democracy, mainly showed up the reigning political corruption. It now signified something which went psychologically far deeper than its popular imitation from the Restoration period, *Hudibras*, which Hogarth had illustrated twelve years before. Its humour and humanity provided one of the most profound outside influences on the formation of the English novel from Fielding, whose favourite writer was Cervantes, through Sterne, to Smollett, who in 1755 himself translated *Don Quixote*.

Fielding now used *Don Quixote* as a starting-point, not for burlesque as in his youth, but for a psychological novel, *Joseph Andrews*, 'written after the manner of Cervantes'; and in his preface he elaborated the point that he was not a writer of burlesques. So, too, in these illustrations, Hogarth wished to keep as far away as possible from caricature. Although they were not a success and the greatly inferior illustrations of Vanderbank, who was more at home in high circles, were finally accepted, the ambitious Hogarth certainly did his best. In these engravings one is continually reminded of continental art, and naturally of far grander continental art than with *Hudibras*. Close contact is evident with contemporary French illustrations to *Don Quixote*, as well as former Dutch Italianising art in its fashionable aspect, and there are even direct signs of Italian 17th-century art.

In Hogarth's time *Don Quixote* was most frequently represented in France, since it combined a literary theme with wide opportunities for comic effects.[35] But since it was not 'noble' and actually persiflaged chivalry, even in France it could not become the subject of an official commission until the very end of Louis XIV's reign. After some burlesque illustrations in the 17th century and a few grotesque pictures by Egbert van Heemskerk (possibly known to Hogarth), it was treated in pictures and drawings by Gillot in 1710.[36] But the outstanding French *Don Quixote* illustrations of the 18th century were by another artist even more closely connected with Hogarth —Charles Antoine Coypel, who did the cartoons for a famous series of twenty-eight tapestries. Knowledge of these cartoons was widespread through engravings and publications and they

became the prototypes for all *Don Quixote* illustrations throughout Europe. Coypel's work on these cartoons for the Manufacture des Gobelins began in 1716 and the execution of the tapestries lasted from 1723 till 1751,[37] but from 1724 onwards sets of engravings after them were published and also used to illustrate editions of *Don Quixote* (with a few by other artists, such as Boucher and Cochin). Some of these would have been familiar to Hogarth. In 1725 and 1731 two English editions of *Don Quixote* came out, each with re-engravings after Coypel,[38] and Ravenet, one of Coypel's original French engravers, later worked for Hogarth. Coypel's illustrations were products of their milieu—elegant and somewhat dandified. Yet the artist, a member of an originally Flemish family of painters, introduced into French rococo his delight in story-telling, his love of observation, his interest in the stage and physiognomy and perhaps also a dash of his native, grotesque realism.

Coypel, himself a playwright, showed himself in his art to be more closely connected with the world of the theatre than any other French artist apart from Gillot and Watteau. He painted portraits of actors, sometimes in their roles; he drew opera scenes for tapestries; and in his usual mythological pictures was even under the impact of stage-settings. It is an interesting corollary to Coypel's literary leanings and to his, in some ways realistic, in some ways academic, anecdotal compositions, that he had grandiose ideas about art and as Director of the Academy did much to raise the cultural and social status of the artist and the position of history painting in France. In so far as he can be compared with an English artist of Hogarth's type, there were numerous points of contact between them in their intellectual and artistic make-up. In fact Hogarth was greatly interested in Coypel and, as has been seen, was not infrequently influenced by the older painter. Coypel was one of the very few contemporary artists whom he actually mentions in *The Analysis of Beauty*, in which he even reproduced, as a didactic example of a comic figure, the astonished Sancho Panza 'following the direction of one plain curve' from the scene of *Don Quixote demolishing the Puppet Show*. It has been noted that in *Southwark Fair* he was influenced by the falling dolls in the same composition.

Although he never entirely lost sight of Coypel's *Don Quixote* illustrations, it was probably in this, his early 'grotesque', period that Hogarth was prone to learn the most from him. Apart from *Southwark Fair*, his closest link with them occurs not so much in his drawings for Lord Carteret as again in an earlier, separate engraving (of the same year as *Southwark Fair*) showing Sancho Panza as Governor of Barataria (1733) (Pl. 48a).[39] In this scene, in which Sancho Panza's physician forbids him to partake of any of the dishes brought to the table, Hogarth retained the grotesque spirit and lively features of Coypel's representation of the same subject (Pl. 48b), carrying it further in individual figures. But since this Coypel composition does not appear in the English editions of *Don Quixote*, Hogarth must have known the original French engraving by Beauvais, published in 1724. His rather compact baroque-rococo arrangement undoubtedly came from it, although, following his habit at this time, it is slightly more spread out. The motif which particularly caught his attention was the quick movement of the two serving pages; the one seen front-view, bringing in a dish, is juxtaposed diagonally to the other seen back-view, taking a dish away, whilst the capriciousness of these movements is further enhanced by the very long, narrow shadow thrown by one of them on to the steeply raked floor. Hogarth imitated but varied the shadow motif, giving it fantastic outlines and using it as a means of composition (a device he was later to accentuate in the cycles).

Lord Carteret's Spanish *Don Quixote* edition, the succeeding English one translated by Jarvis (1742), and their illustrations—both those projected by Hogarth and those by Vanderbank—

were doubtless intended to replace the two English editions of 1725 and 1731 (17th-century translations by Shalton) and to 'outdo' their Coypel illustrations.[40] Hogarth's illustrations for Lord Carteret are of quite a different character from the scene of Sancho Panza's meal, only five years earlier in date; he now compressed the stories, reduced the number of figures and rendered each composition more monumental and concentrated, to lend it greater dignity. He retained much of Coypel's elegance and certainly remained close to Coypel's narration in general spirit, psychological conception, and his quest for the interesting. Formally, however, the compositions possess a different, more unified character and there are no direct borrowings from Coypel.[41] Among them, *The Innkeeper's Wife and Daughter administering chirurgical assistance to Don Quixote* (Pl. 63b), and, to some extent, *The Curate and Barber disguising themselves* (drawing in Windsor) are the most original, Hogarthian compositions, very exact 18th-century reflections of Cervantes. The former in particular, in which grotesque and non-grotesque features imperceptibly merge in the various personages, is one of Hogarth's outstanding thematic and formal solutions: he could now concentrate his composition without sacrificing the fruits of his intense observation.

The other scenes come relatively closest to Italian and Italianising Dutch art. In the former case, the influence of Salvator Rosa is most marked in Hogarth's scenes of fighting and especially in his wooded and mountainous backgrounds. Rosa was perhaps the most fashionable Italian artist in England at that time and Hogarth even owned a copy of his famous cycle of etchings of soldiers. The Italianising-Dutch pictures with semi-Italian, or perhaps more correctly international, increasingly idealised, scenes of peasant life were considered of a more elevated character even outside Holland, being held in far higher esteem—and hence far more expensive—than those treating Dutch peasants in a realistic way. They formed a link between Italian life and Dutch art, subordinating Dutch realism to a pronouncedly baroque treatment, and were much preferred by English collectors too. Such a scene as Hogarth's *Don Quixote meeting the Knight of the Rock*, with its shepherd and goat as complementary motifs, remind one of Karel du Jardin, one of the most fashionable representatives of this school depicting 'noble' shepherds.[42] Hogarth also represented Cervantes' story of the shepherdess Marcella, offspring of Italian 16th-century pastoral poetry: Marcella vindicates herself from the charge of having caused Chrysostom's suicide. This he conceived in the baroque, literary style of Italianising-Dutch pictures with idyllic and pastoral themes,[43] and embellished it with Salvator Rosa motifs. But whereas, in Italianising-Dutch art, the original Callot motifs of Italian peasant life were softened and ennobled, Hogarth was not afraid of occasionally using grotesque features from Callot, even in these illustrations. This does not only apply to the very obvious figure of Sancho Panza; the old dwarfish woman and the servant in *Don Quixote lying wounded in the Inn* and the landlady in *The Curate and The Barber disguising themselves*, are even closer to real Callot types such as the Gobbi. Both these figures are variations of the girl dwarf in *The Pool of Bethesda* but, in keeping with the new compact composition, she has now become more monumental, more absolute in her monstrosity.

Vanderbank's illustrations which finally adorned Carteret's and Jarvis' *Don Quixote* editions (1738 and 1742 respectively), intended to be as dignified and monumental as possible, are still closer to Italian art (Salvator Rosa, Giordano, Amigoni, even Parmigianino) than Hogarth's, and too grand to have anything to do with Dutch art. His generalising, academic style is still further removed from Coypel than Hogarth's. Whereas due to his poverty of invention, Vanderbank closely followed some of Coypel's compositions, he dropped all Coypel's delicate and

realist details in the interests of the grand style and, unlike Hogarth, was incapable of inventing anything of the kind himself. In fact, here as elsewhere, Hogarth is more 'French' than Vanderbank. The main motifs of two scenes, *Marcella* and *Don Quixote lying in the Inn*, are very similar in Hogarth and Vanderbank (Pl. 63a), although, in Vanderbank, Hogarth's Callot note has vanished.[44]

In some of his late, more explicitly historical pictures, Hogarth sometimes sought to conform to the formal ideas of the acknowledged Italian masters of the past, above all Raphael, not only seeking guidance from them but aiming thereby to increase the standing of his own works. A deep veneration for Raphael was traditional, particularly since the 17th century, and was taken as a matter of course by all those whom Hogarth especially respected: the Carracci, Reni, Sacchi, even Pietro da Cortona and Lebrun. In particular, the very moderately baroque style of Maratta signified exclusive adherence to Raphael; he was the most favoured Italian artist of the second half of the 17th century among English connoisseurs and his name became a real household word.[45]

Steele, following the general enthusiasm for Raphael, including Shaftesbury's, wrote a rapturous article in *The Spectator* (1711) on the famous cartoons; in this he analysed the various characters and recommended the Frenchman Dorigny's engravings after the compositions. The cartoons were often copied and engraved at that time by both English and foreign artists, such as Le Blon, Jervas, Gribelin, Richardson and Goupy. Nicholas Dorigny came to England from Rome in 1711 to engrave them bringing Dubosc and du Guernier with him as assistants. With him began the succession of great European Raphael engravers. Dubosc, who settled here permanently, was responsible for bringing over many other French engravers, for instance, Jean Simon, Beauvais, Lepicié, Baron and Gravelot. It is characteristic of the ambivalence in English taste, Hogarth's included, that these French artists, whilst they never entirely dropped the engraving of grand art for which they were first engaged, became increasingly occupied on engravings after Watteau or in his style. Jonathan Richardson was also a passionate admirer of Raphael and the cartoons ('Hampton Court is the great school of Raphael and God be praised that we have such an invaluable blessing' (*Theory of Painting*)). Thornhill, who had closely studied Lebrun in France, showed a similar attachment and certainly fostered Hogarth's interest; during his last years, after 1729, he painted at least two copies of the whole set of cartoons and intended to publish engravings of many details; it is possible that an engraving by Hogarth after four heads in one of the cartoons, namely the blinded sorcerer Elymas surrounded by three heads expressing astonishment, was connected with this project. A drawing by Thornhill (Marquess of Exeter) shows him with his whole family, including Hogarth and his wife, reverently lined up before a large picture held by a servant on an easel: this is in fact a copy by Thornhill himself after Raphael's cartoon depicting *St. Paul's Sermon at Athens*. Had it been done in 19th-century France it would have been called *Hommage à Raphael*.

Although probably the best example of Hogarth's fidelity to Raphael's formulas is his *Paul before Felix* of 1748, one must first consider *The Child Moses brought to Pharaoh's Daughter*, painted slightly earlier (1746),[46] for the Foundling Hospital, where it still hangs (Pl. 100a). In its formal composition it is perhaps even more interesting, for in his own way Hogarth again humanised the Bible. The child's mother, whom the princess takes to be his nurse, receives payment from the treasurer for her services; the child himself shows anxiety to remain with her, while the two attendants suspect the princess herself of being his mother. The formal pattern goes beyond a moderate baroque; the rather straight diagonals of the seated princess, in light

colours picked up again in the luminous vista in the centre-background, connects two vertical groups, placed in shadow at either side of the picture—the mother, the infant Moses and the treasurer on one side, the two female attendants on the other. The group on the right is backed by a broad, massive-based monumental column (a far more powerful motif than the column in the Coram portrait). The slight baroque waviness of some details, most restrained if compared with the conventionalised baroque movements in contemporary French and Italian religious paintings, does not detract from the quietness and straightforwardness of the composition. On this occasion Poussin may have replaced Raphael and Hogarth used parts of the French artist's *Child Moses treading on Pharaoh's Crown*, known to him through a copy or an engraving. If the stiffly erect, seated pose of Pharaoh's daughter in Poussin is compared with Hogarth's diagonal attitude, one immediately realises that Hogarth is at best only classicising, not classicist. Even so, the degree of unification in this picture marks a very definite advance towards European classicism, and on this account its exact date is of great consequence. At the same time, it is, as is to be expected of Hogarth, a very realistic and extremely painterly classicism. The 'French' colours of the princess's dress (white and pink) are skilfully harmonised, while the monumental realism of the simple, robust figure of the old treasurer foreshadows Géricault, and brings to mind Hogarth's potentialities, not only towards a realistic baroque but even towards a realistic classicism as expressed theoretically in numerous observations in *The Analysis of Beauty*. The germs of the build-up of Hogarth's composition can be traced in the realist, somewhat Venetian rococo of *The Pool of Bethesda*. Yet in the intervening ten years Hogarth undoubtedly covered a great distance to arrive at the almost classicising style of *Moses before Pharaoh's Daughter* without appreciably sacrificing any of his vitality.

The unusual character of this picture is revealed even better if it is compared with the three other works, probably from the same year 1746, painted for the principal room of the Foundling Hospital by Highmore, Hayman and Wills. All of these depicted Biblical themes concerning abandoned children and were entries in a competition for history pictures, the first of its kind in England. Highmore was evidently embarrassed by the unfamiliar subject of *Hagar and Ishmael* (Pl. 101a); although he aimed at classicism, he only achieved an academic picture, stiff and petrified in its effects. Hayman's *Finding of Moses* (Pl. 101b) is in an agitated, blurred, very French rococo vein, like so many of his works. The weak painting of *Christ and the Children* by Wills, who had studied in Italy, is more Italian-baroque. All three follow the familiar lines of more or less contemporary international art.[47] On the other hand Hogarth, who was so preoccupied in his cycles with the manifold aspects of daily life that he could not simplify to the extent Highmore did in some of his *Pamela* illustrations, could deal sovereignly with a Biblical theme in a novel, concentrated, almost heroic way without the artificiality of the other three. Yet he by no means lacked a real basis in a style which, in French painting, had not yet emerged.

The commission to paint a picture for the Honourable Society of Lincoln's Inn (still *in situ*) was secured for Hogarth by his friend, Lord Mansfield, the future Lord Chief Justice, on Lord Wyndham's bequest of £200 for such a work. For this dignified setting—the chapel was first proposed but Hogarth found the hall more suitable—the artist's style differed entirely from that of twelve years before, when in the humbler, charitable milieu of St. Bartholomew's he could give free rein to his fancy. His 'fashionable' ambitions at this late phase were in full swing. He chose as his subject the appropriate episode from the Acts of the Apostles—*Paul pleading against his accuser Tertullus before Felix, Governor of Judea*[48] (Pl. 112a). Seldom, and certainly never when he painted for aristocratic connoisseurs, had Hogarth occasion to present history painting on

such a vast scale and thus convey a moral sentiment through the solemnity of historical events rather than through everyday life. Here he was particularly intent on achieving a monumental, well-balanced composition with skilfully connected figures which, Vertue claimed, showed 'the pretences and magnificences of Mr. Hogarth's genius'.

The composition largely follows Raphael's cartoon depicting a similar theme, *Paul and Elymas before Sergius Paulus*, from which Hogarth engraved four heads. Here he followed his model more closely than in the earlier *Pool of Bethesda*. The transposition is less pronouncedly baroque in general and less markedly realist in detail. Hogarth made only slight alterations to the strictly classicist character of the original, transposing it into a kind of moderate baroque: Raphael's symmetry is loosened, Paul's pose is less rigid and more diagonal, in a manner similar to the man raising his arm on the left side of Raphael's *Transfiguration*; he has been moved further into the picture, a great floating baroque curtain envelops the tribunal, and the angular steps leading to the throne are now curved.

But Hogarth's picture was equally influenced by Thornhill's frescoes in the cupola of St. Paul's depicting the Saint's life (1715–19). These in turn were closely based on Raphael's cartoons; two of them show Paul before Agrippa and before Sergius Paulus and derive from the same cartoon as Hogarth's picture. In these frescoes, which he particularly admired, Hogarth found a baroque transposition of Raphael of a kind at which he himself to a certain extent was aiming. Of the two mentioned, he adhered most closely to *Paul and Elymas before Sergius Paulus*: the concentration of the three main figures (Tertullus replacing Elymas), Paul's pleading gesture, the two lictors on each side of the Roman governor, the baroque curtain and steps, all stem directly from Thornhill and not from Raphael. Thornhill's other fresco, *Paul before Agrippa*, contains the motifs in Hogarth's picture of Paul's raised arms and the arcade. But the features of Thornhill's baroque are very different and a comparison shows how unusually moderate Hogarth's baroque is in this composition. Thornhill's illusionistic frescoes are more heroic; their composition is more dependent on tempestuous diagonals, more consistently baroque and, in this rather abstract-decorative sense, more unified.[49] They tend to transpose Raphael in the spirit of Veronese.

With Hogarth, on the other hand, the theme has been brought down to a more earthly, prosaic level, expanded and realistically reported. Consequently, from a formal viewpoint, Thornhill's excessively baroque transposition of Raphael has been arrested and, within a moderate baroque style, an unmistakable tendency towards a more realistic, less decorative pattern emerges. In Hogarth, the baroque semicircles do not quite achieve their object of flowing easily towards the background; the large, solid figures, particularly that of Paul himself, incline to arrest their movement. The picture contains many realistic details and even—unlike Thornhill's—bizarre ones, despite the solemn purpose of the composition. Two scribes introduced into the foreground take down minutes on an enormous scroll and show vestiges of the two comic clerks in *Hudibras and the Lawyer* (Pl. 12) (in *Paul before Agrippa*, Thornhill's seated recorder is a heroic figure with the appearance of an evangelist); on the tribune—reminiscent in style of *The Pool of Bethesda*—stands a grotesque Jewish priest, almost a caricature of a Rembrandt or Eeckhout figure. Nevertheless, Hogarth took pains to represent a dignified Paul and his pose and physiognomy, like those of his accuser, if not possibly a little too solid and earth-bound, would fit quite well into an Italian baroque picture. The colouring, though sober, is not dull: the three figures seated in a row on the tribune—Felix, his wife Drusilla, and the high priest Ananias—have something of the elegance and 'French' colouring of *Marriage à la Mode*.

The Historical Compositions

With its historical-moral content, its slightly classicising pattern, and destined for an organisation of professional people, the work is a landmark not only in Hogarth's career but, like *Moses before Pharaoh's Daughter*, in the general European development towards a new classicism, associated everywhere with imitation of the revered forms of Raphael.

In a subscription ticket (1751) to the engraving of *Paul before Felix* (Pl. 112b), Hogarth included a caricature of his own composition 'in the true Dutch taste', 'in the ridiculous manner of Rembrandt', to show that Rembrandt's 'vulgar manner does not suit the great style'. Here he followed the official-academic view, as expounded by Lairesse in his famous book, *Het Groot Schilderboek* (Amsterdam, 1727, Eng. trans. 1738), in which 'low', 'ignoble' Dutch art is denigrated,[50] Rembrandt in particular because he introduced 'vulgar' types and motifs even into history painting. Hogarth in this conformed to the elegant rococo society view, as expressed by Lord Chesterfield, that Rembrandt only painted caricatures. It must have been difficult for him to accept Lairesse's contention that contemporary life was unworthy of representation; indeed, some twelve years earlier he had imitated Rembrandt even in such a religious composition as *The Pool of Bethesda*. Nevertheless his adherence, however temporary and superficial, to official art-theory—a necessary corollary to his growing absorption in history painting—drove him to do this parody.[51] The caricature is genuinely funny in parts: the emaciated Paul, with a vulpine face and a halo hovering uneasily over his head, stands on a stool to plead the more impressively; his very stout guardian angel, in whose type traces of Rembrandt and his school can be detected, has carelessly fallen asleep with his legs ignominiously twined round his stool. The caricature, I think, quite decidedly recalls motifs in a narrative picture by Egbert van Heemskerk representing *A Prisoner in Court* (formerly Savile Collection) (Pl. 113b)[52]; the figure of Justice (although Hogarth here kept relatively closest to the original, he gave her a drunken air), the Prosecutor, the 'vulgar' spectators in the gallery and the figures on the bench. It is most illustrative of Hogarth's complex ideological situation that, after painting a picture in which he hoped to have caught something of Raphael's spirit, he should make use in this caricature of motifs from a Dutch picture—one, moreover, by an artist for whom he had such a predilection that occasionally he even borrowed from him in a very positive manner.[53] And he even exaggerated these motifs so as to be sure of scoring his point in defence of grand painting. Contradictions usually did not disturb Hogarth [54] and in his own picture he perhaps excused the caricature-like Jewish priest on the grounds that an enemy of the Saint could be so represented.[55]

Hogarth's next historical composition was the large triptych for St. Mary Redcliffe, Bristol: *The Sealing of the Sepulchre, The Ascension* and *The Three Marys* (1756, Bristol Museum and Art Gallery) (Pls. 126, 127b, c).[56] This work is more baroque than his last two religious ones, which had comparatively more secular themes and were destined for lay institutions. Its general style reminds one mostly of Luyken's Italianising, agitated monumental (if rather facile) Bible illustrations at their loftiest[57] (Pl. 127a), and partly also of Ricci. The centrepiece of *The Ascension* in particular is more consistently in Ricci's character, as regards the figural idiom and the relation of the figures to the space, than the *Bethesda* picture. In individual motifs, which required to be majestic and solemn, Hogarth clung more than ever to Raphael; but since he also wished to describe an exciting event, he kept closest to Raphael's *Transfiguration*. This is strongly reflected in the Christ and the two main figures of St. Peter and Mary on the left; indeed, never before, perhaps, was Mary represented in such an agitated manner in an *Ascension*. In their violent attitudes and gestures these latter figures summarise the three main ones on the left of Raphael's composition, namely the seated evangelist, the man with one arm upraised, whom Hogarth

had already used for his St. Paul in the Lincoln's Inn picture, and the kneeling woman. Transformed as they are, they offer stylistic parallels not only to Ricci but even to Magnasco, though admittedly weaker and more provincial. On the right of *The Ascension*, one senses the customary suggestions from the various Raphael cartoons.

Yet for all its direct borrowings from Italian art, *The Ascension* necessarily also reflects the sporadic religious pictures of Italianising Dutch genre painters of the 17th century, in which an agitated baroque and realistic genre features combine (e.g. Berchem's *Annunciation to the Shepherds*, 1649, Dresden). In the unusual representation of *The Sealing of the Sepulchre*, the two guards on the right, particularly the movement of the larger one with the naked back and the general pose of the other, whose foreshortened face is hidden by his helmet, apparently derive from the guards searching for the apostle in the Vatican fresco of *The Liberation of St. Peter*; the former also recalls the large, semi-nude warrior in the foreground of *The Battle of Ostia*.[58] The type of the angel in *The Three Marys* probably also derived from the angel freeing St. Peter in the first-mentioned Raphael composition. These borrowings now stand out in a more concentrated, monumental way; they are of a less 'vulgar' baroque than in the hospital painting of almost twenty years earlier. The wild, rocky backgrounds to all three scenes appear to go back beyond Ricci to Rosa's turbulent landscapes.[59]

Even stronger is the Rosa impact in another composition, somewhat different from his other late historical paintings, which Hogarth did for Garrick (Pl. 110b); the scene in *Paradise Lost* where Satan and Death meet in combat, with Sin intervening. This picture (formerly Fairfax Murray Collection)[60] was left unfinished, possibly because Garrick was dissatisfied with it or else because Hogarth's quarrel with him for other reasons interrupted the work. There is nothing here of the Callot-imitating conception of his early, small-size illustrations to *Paradise Lost*; instead, a wild fight between a few large, macabre, vaguely baroque figures, with emphasis on the grim-grotesque. Rosa was one of Hogarth's favourite artists; there was also a certain resemblance between their personalities. Each had an extremely high opinion of himself; each had social aspirations, literary ambitions, and hankered after recognition, not only as a painter of his own genre but, increasingly, as a painter of historical pictures.

The imitation of Rosa's 'savage' style paved the way for Romanticism in painting, gardens, and literature. Since in this picture Hogarth wished to be 'savage', he followed the line of some of Rosa's historical paintings of similar intention. His two protagonists recall the uncanny ghosts in Rosa's *Witch of Endor before Saul* (1668, Louvre); and the violent attitude of Satan is probably a direct borrowing from the figure of Jason killing the dragon in one of Rosa's best-known etchings. The female allegorical figure of Sin, with her motifs of a snake and a monster, goes beyond Rosa, retaining something of the medieval Bosch tradition, while at the same time there is a tendency to raise the gruesome-popular to the level of the gruesome-fashionable. For in this picture Hogarth participated to some extent in the smart, pre-Romantic, slightly expressionist atmosphere of the Gothic Revival—a sophisticated extreme, more so than the baroque, of the general taste for the picturesque which was to explode in the next generation in Fuseli's nightmares. It is not surprising that Fuseli himself was influenced by this picture of Hogarth's. Hogarth's appreciation of Gothic architecture is in fact apparent from remarks in *The Analysis of Beauty*; 'Have not many Gothic buildings a great deal of consistent beauty in them?' He further praised the spire of Strasburg Cathedral and claimed for Westminster Abbey 'a consistency of parts altogether in a good Gothic taste and . . . a propriety relative to the gloomy ideas, they were then calculated to convey'.[61] The way in which his picture reflects the spirit of Strawberry

Hill is shown by comparing it with Bentley's illustrations to Gray's poems, done for Walpole (1753), in particular the ferocious tailpiece to the *Ode on the Death of a favourite Cat* (Pl. 115b), showing Charon, with Cerberus beside him, transporting the cat to the Underworld. This composition recalls Tibaldi's mannerist frescoes in Bologna, engravings after which were perhaps to be found in Strawberry Hill (the big Venice publication of prints after Tibaldi was as late as 1756). But even if, with this picture, Hogarth participated in the general fashionable trend, he was unable entirely to conceal the popular origin of his literary and artistic fantasies.[62]

Another historical picture of 1759, this one explicitly undertaken for an aristocratic connoisseur, shows a new aspect of Hogarth's relation to Italian and French art. It represents Sigismunda mourning over the heart of her murdered husband, Guiscardo, sent to her by her father, Tancred, Prince of Salerno (Tate Gallery) (Pl. 131c). This theme originated with Boccaccio and was known to the English public through a poem by Dryden.[63] It is not by chance that the name of Dryden occurs so often in connection with Hogarth's grand manner; Dryden did much to raise the dignity of painting through his translations and writings on the theory of art, and it was through his translation of Dufresnoy and parts of Bellori that Hogarth came to know the prevailing Italian-French art theory. In *The Analysis of Beauty* he refers to Dryden's 'incomparable genius' and quotes his *Epistle to Kneller*, one of the few serious poems of the time in praise of English painting. The history of *Sigismunda*, which represents the climax of Hogarth's efforts to prove himself an historical painter, is too familiar for detailed repetition. Hogarth was very annoyed when an old, celebrated Italian picture, falsely ascribed to Correggio and of which he did not think too highly, fetched £400 at a sale. He persuaded Lord Grosvenor, one of the bidders, to let him paint the same subject for the same price as a challenge.

I have re-discovered the Italian picture (formerly Earl of Lincoln) (Pl. 131a),[64] which aroused Hogarth's competitive fury; it is, as Horace Walpole already suspected, not by Correggio but by Furini, a 17th-century Florentine painter who, in his numerous female half-figures, whether Magdalens or secular subjects, combined sentimentality with sensuousness in the common fashion of the baroque post-Reni paintings of this type.[65] For of course the prototypes of Furini's and Hogarth's compositions were Reni's famous female half-length figures with tragic themes, his Lucretias and Cleopatras, which were imitated everywhere, even in the 18th century (e.g. de Troy's *Cleopatra*). Hogarth's collection of engravings included several by Robert Strange, whose two best known were done after Reni's Cleopatra and Magdalen (1753). In fact, in an epistle on the subject of *Sigismunda*, written jointly by Hogarth and his friend Paul Whitehead, Hogarth himself is compared with Reni. This picture gives the impression that the artist was intent, as he imagined, on 'surpassing', 'improving upon', the old Italian (or, as he thought, French) master.[66] He tried to avoid the realistic and grotesque features of his other works, even of some of his previous historical pictures. This time he was in deadly earnest: 'My object was dramatic and my aim to draw tears from the spectator. Thus far I have been gratified: I have more than once seen the tear of sympathy trickle down the cheek of a female while she has been contemplating the picture.'

Adhering to the baroque-artistic tradition of the aristocracy, he wanted the whole composition to be as heroically passionate, elegant and distinguished as possible. From the 17th-century picture he apparently retained—and accentuated—only what he considered to be on these lines. Hoping to improve on the original, he instilled greater passion into the heroine and enveloped her whole figure in a more grandiose, decorative atmosphere. He sought to raise the passionateness which he himself deployed in so detached and merciless a way in the everyday occurrences of his

narrative cycles, on to what he took to be the more elevated, heroic plane.[67] On the one hand, in terms of baroque facial painting, he is somewhere between the more emotional Guercino and the more accurate Domenichino trend, and closest of all perhaps to the intensity of Caravaggesque French half-length figures of the early Vouet type, his degree of realism being certainly closer to contemporary French historical pictures. On the other hand he sought support from a grand French stage effect by Charles Antoine Coypel, in his famous portrait of *Adrienne Lecouvreur as Cornelia* in Corneille's *Death of Pompey*, weeping over the urn containing Pompey's ashes (engraved by Drevet, 1730) (Pl. 131b).[68] This portrait constitutes a great advance, within French 'role portraits', towards enlivening expression, as compared with Largilliere's *Mlle. Duclos as Ariadne* (1714, Louvre), for example. But it is still a typical transitional work; her features are not in the least distorted by anguish and her pose is statuesque in the old style. True, in accentuating Sigismunda's expression, Hogarth in no way repeated Adrienne Lecouvreur's sentimental, upward glance,[69] but in place of the rather contemplative pose Furini gave his Sigismunda, brooding over the salver bearing her husband's heart, Hogarth borrowed and exaggerated a movement from Coypel which struck him as more passionate.[70] Whereas Cornelia gently clasps the urn to her, Sigismunda emphasises this gesture, half lifting the salver from which her husband's heart protrudes, and pressing it to her bosom. While Cornelia's is the usual 18th-century theatrical gesture, Sigismunda's has a realism by which Hogarth *malgré lui* disturbed the dramatic effect he intended. Coypel's and Hogarth's motif of the hand with outstretched fingers pressed to the bosom is general to baroque half-length figures with heads of expression (for instance, those of Reni or Dolci) but the fingers have now become more elegantly curved. Hogarth also kept something of Furini's conventional contemplative attitude, with the hand pressed to the cheek, but here again he made the gesture more elegant, more 'French'. Like Coypel, he gave Furini's half-naked Sigismunda royal attire, besides floating drapery over her head, a large curtain and grand architecture as in Italian baroque pictures. It would seem that the oblong shape of the picture, by which Hogarth differentiated himself from both his models, was necessary to allow room for these commanding requisites.[71] Though Hogarth certainly restrained himself as regards details, he placed some elaborate objects on the table, such as a richly ornamented casket, which again tends to upset the effect of the whole. Nevertheless the general result is a baroque stage effect and the diagonal sweep of lines dominating the picture is similar to that of *Richard III*. By first choosing *Hymen and Cupid* before *Time smoking a Picture*, as the subscription ticket for an engraving of *Sigismunda*, Hogarth stressed the picture's grand, international-baroque character even more.

The general colouring is intentionally simple and unified, being based mainly on blue and white interspersed with yellow. But these rococo hues of *Marriage à la Mode* have here been used more smoothly, as if Hogarth intended, as in his story-telling, to raise them on to a higher plane. One is conscious of the artist's restraint in the use of both colours and brush. Though *Sigismunda* may be called an elegant or even a state portrait,[72] there is no question of the refined, subtle colour harmony of *Mrs. Salter*. Only a few objects on which Hogarth dared to use his pictorial skill are really broadly painted, such as the golden salver. Sigismunda's pink-tipped fingers are reminiscent of the elegant yet not quite unsolid handling of J. F. de Troy. Rather harsh intrusions, perhaps, on the simple, decorative colour unity are the large blue rectangle of the casket and the red heart, reminders of Hogarth's irrepressible realism.

If this picture, despite Hogarth's laborious, indeed too laborious, efforts, was not accepted by his aristocratic patron and received such a catastrophic reception from the critics, including

Horace Walpole, it was partly because a work of this kind, precisely on account of his realism, was not quite within the reach of his otherwise great gifts. On the other hand, there was the usual strong personal element in these attacks and it must be conceded that *Sigismunda* is by no means weaker than many Italian baroque pictures of a similar type, while its expression is certainly less vague than that of contemporary French portraits. There is a stylistic resemblance between *Sigismunda*, with her intentionally facile baroque-decorative linear rhythm, and Reynolds' equally Italianising picture of the same year, *Kitty Fisher as Cleopatra* (Iveagh Bequest, Kenwood). While Hogarth was competing with Furini, Reynolds' picture was an attempt to raise the social-artistic level of a portrait by a quotation from Italian painting; his likeness is almost a literal copy of a motif in *The Banquet of Anthony and Cleopatra* (Galleria Spada, Rome) by Trevisani, the Roman late baroque-rococo painter much favoured in England. In fact, *Sigismunda*, more than any other English picture of these years, was in line with the coming development of English neo-baroque history painting.

From these various examples, no doubt can remain as to Hogarth's knowledge and apprecia-tion of grand continental, particularly Italian, art. Yet despite his use of standard formulas [73] and certain obvious weaknesses, these compositions frequently have higher artistic qualities than many contemporary history paintings on the continent and the two most striking and original of them, *Garrick as Richard III* and *Moses brought to Pharaoh's Daughter*, contain only minor borrowings from continental art.

Hogarth's incentives to do historical compositions were complex. His ambition to succeed as a history painter was bound up with desire for social recognition. He wished to obtain orders from the aristocracy, which still inclined towards 'uplifting' historical pictures in the traditional sense. Furthermore, middle-class convictions, a fresh appreciation of the utilitarian in art, in-truded on history painting—mainly Biblical-moral history painting at this particular stage. And from these it is a short step to his moralising cycles. So, however astonishing it may at first sight seem for Hogarth to have painted such works, the transition in his mind from the cycles to his grandest historical paintings was not so great as might be imagined. He himself says, in his notes (in connection with his *Election Entertainment*): 'An old blacksmith in his tattered garb is a coarse and low Being; strip him naked, tie his leathern apron round his loins, chisel out his figure in free-stone or marble, precisely as it appears—he becomes elevated, and may pass for a philosopher, or a deity.'

His attitude to history painting was closely linked with the general European art theory of the time. The conservatives, with Félibien and Lairesse on the one hand, and the progressive from a middle-class point of view with Shaftesbury and even Diderot on the other, seemed to be in agreement as to the supreme importance of history painting. Yet their theories were funda-mentally different. Steele's oft-quoted article in *The Spectator* on the Raphael cartoons is a good example of this mixture of new and old: 'If the virtues and vices . . . were given us by the painter in the characters of real life, and the persons of men and women whose actions have rendered them laudable or infamous, we should not see a good history piece without receiving an instruc-tive lecture.' Such a combination of notions would embrace not only the Raphael cartoons but also Hogarth's coming cycles, as the artist frequently understood them. For Hogarth's views on history painting were sometimes narrow and sometimes wide, sometimes old and sometimes new; on account of their unusually strong middle-class streak, they were certainly not so clear-cut, rigid or positive as those held on the continent. There is therefore some truth in the grounds on which he was attacked in the 'fifties and 'sixties for his opposition to academies and thus to

elevated art. But even his aversion to academies was dictated by his middle-class outlook: he did not want painting, apparently not even history painting, to depend on the protection of the state, but to be based on free competition. Although it is difficult to differentiate at this early stage of English history painting, it is perhaps not erroneous to say that, in Hogarth's late phase, his works in this genre related to the bourgeoisie had rather more of a classicising tinge, whilst those related to the aristocracy were rather more baroque-rococo. This dualism in Hogarth and in the English art of his time, as yet not very marked, will reveal its true significance only when seen within the entire European development.[74]

Among Hogarth's historical compositions I have purposely included some of his more 'elevated' book illustrations. On the one hand there was his genuine sympathy for such eminent writers as Cervantes and Milton and his desire to conceive compositions with historical or literary subjects, for which he often adopted a different style from the rest of his production. On the other, his preoccupation with literature ranged widely: he was as interested in Butler's *Hudibras*, Fielding's burlesque vaudevilles, Gay's *Beggar's Opera* and Swift's *Gulliver's Travels* as in *Don Quixote* and *Paradise Lost*. His favourite authors were avowedly Shakespeare, Milton and Swift. Thus the 'elevated' genre in literature was, for him, on the same level as his history paintings.[75] His approach was just as catholic in terms of his artistic borrowings: just as his grotesque works contain many quotations from Leonardo's *Last Supper*, so Callot motifs appear not only in his satirical engravings or book illustrations of the *Hudibras* type but also in those of the Milton type and even in his Biblical paintings.

As in his other works, naturalism was the outstanding feature, even when he rendered Garrick's tragic acting or painted according to Fielding's theoretical requirements as expressed in *Joseph Andrews*. The same tendency towards naturalism dominated Garrick's acting and Fielding's novels, even if certain facets were considered by the artists themselves to be on a somewhat higher and more heroic, others on a somewhat lower, plane. The transitions in the art of all three were easy and smooth, often almost imperceptible. Moreover, in this same intense first half of the 18th century, novels and art, poetry and art, acting and art, were as little divided off from each other as were critical essays and art, or enquiries into social conditions and art. Hogarth was part and parcel of the creative intellectual life of his time, just as were his contemporaries, the great English writers. Once this intellectual and artistic interdependence is appreciated, the differences within Hogarth's *œuvre*—though very real—seem less artificial and not at all inconsistent, whether he did moralising cycles based on his own stories, or whether he illustrated Butler or Cervantes, Fielding or Sterne, the Bible or Milton.[76]

IX

The Late Phase

NO period in Hogarth's career was so complex as his late phase—the 'fifties and early 'sixties. For never during his lifetime were social and artistic conditions in England so involved as they were then. The position of the middle class had altered. As it continued to increase in strength, it lost the need to fight as an entity and carve out for itself a new world of ideas. Its ideological heyday, epitomised by *The Spectator*, Defoe, Lillo, Richardson and Fielding, was slowly passing away. The last great realist middle-class novels, Fielding's *Amelia* and Richardson's *Grandison*, appeared in 1751 and 1754 respectively. Smollett and Sterne, however interesting, no longer really belonged to the heroic, militant and unequivocally middle-class period of the first half of the century.[1] Indeed, so rich and influential had the upper middle class grown that the social as well as cultural barriers between it and the aristocracy had begun to break down. Culturally, this levelling process implied that the bourgeois world of ideas, whilst permeating that of the aristocracy, itself became diluted. What I term the 'aristocratic reaction' under George III might equally be termed an aristocratisation of the rich upper middle class, a phenomenon already incipient in the 'fifties.

A social situation such as this was bound to affect Hogarth's various types of work with their different publics. Only in the very early 'fifties do militant middle-class themes occur, as in the old days, in his rather popular engravings. Here and in other works treating topical and everyday themes, Hogarth developed a far higher degree of realism than ever before—higher, in fact, than that of any other European artist. Such realism was only possible at a time when the middle class was very strong and in the work of an artist who felt very close to it. How it reached or failed to reach an understanding with the traditional baroque forms, and how these latter forms had to adapt themselves to the changing social conditions, constitute the history of Hogarth's art during these last fifteen years.

In order to understand such an important aristocratic commission as *The Lady's Last Stake* of 1759 (not to mention *Sigismunda* from the same year), or Hogarth's portraits from the late 'fifties and early 'sixties, one must first study the rather complicated artistic predilections of the upper strata at this period. In fashionable circles in the 'fifties the ruling taste in painting and

interior decoration still favoured a lively rococo. At the same time new tendencies began to appear in other fields; these, although at first not directly opposed to rococo painting and interior decoration, nevertheless differed from it. A new slant was first given in architecture to the interpretation of the antique, emphasising it in a different manner. On the continent, the 'return to the antique' which set in around 1760 and led to the Louis XVI style and to classicism, was broadly speaking due to the pressure of the middle-class predilection for realism, nurtured on the antique, in reaction to the aristocratic aspects of rococo. But the line this struggle took was not entirely simple in its beginnings, especially in England, where it made itself felt earlier than on the continent.[2] Precisely because, from the 'fifties onwards, the genuine middle class counted ideologically and therefore artistically less as a unit than before, a return to the antique could not take place here under the aegis of a consistent middle-class realism and simplicity. Only since Hogarth's advent had the middle class had any artistic language at all and that at first not of a very independent character. Furthermore, rococo had a stronger bourgeois tinge in England than on the continent and consequently the reaction against it was not so deeply imbued with middle-class qualities; or in other words the reaction against it, the trend towards greater simplicity, was not so strong, general or consistent as in France. Finally, a classicism far in advance of that on the continent already existed in England, at least in architecture. The 'return to the antique' in English interior decoration in the mid-1760s only continued the change that had set in in architecture during the second half of the 'fifties.[3] And this, in turn, had merely carried on the various more or less classicist styles previously favoured by the Whig aristocracy in a more precious, elegant and also, in its initial stages, more massive form.

It is into this world, when everything was in the melting-pot, that Hogarth's later art has to be fitted.[4] This art, with its various publics, was already complex. And now, when the line of ideological development in England was far more equivocal than before, Hogarth's stylistic evolution became equally so and its various trends can only slowly be sorted out.

In 1753, in *The Analysis of Beauty*, Hogarth gave the theoretical grounds for his partiality for a gracefully undulating, moderately baroque or rococo line—a partiality that had been obvious in his works for a long time. Yet the importance of this book extends far beyond its implicit inclination for baroque art, however momentous this was in itself. The outcome of its author's thinking and reading about this theme for many years, it is just as intelligent and complex and, despite its borrowing from Lomazzo, fundamentally just as original as his art. It contains numerous references to other books, and Hogarth frankly acknowledges that he had some assistance from learned friends. It appears that in fields with which he was less familiar and in the literary style he was helped by such scholars as the classicist Thomas Morell, the physician Benjamin Hoadly, and the writer, Dr. J. Townley, headmaster of Merchant Taylors' School. The book's real significance lies in its revolutionary approach to art theory on the part of an experienced painter —an empirical and psychological approach, no longer based on the customary vague phrases[5]— its amazing wealth of new observations[6] and the way it stresses variety in art in contrast to a belief in cut-and-dried mathematical proportions. 'All the muscles shift their appearances in different movements, so that whatever may have been pretended by some authors, no exact mathematical measurements by lines, can be given for the true proportions of a human body.' Hogarth was thus the first to reject the axiom of classical art theory—the congruity between mathematics and beauty.[7] It lies further in its being addressed not only to painters and connoisseurs but also to the general public, on the assumption that they could appreciate art.[8] *The Analysis of Beauty* brought art theory down to earth, thus in its own field fulfilling the same

task as its author's art or the literature of his time. I do not propose to deal here with every detail of Hogarth's views or to determine their exact historical place in art theory before and after him.[9] But the book's main contentions are of considerable interest, since they tend to throw direct light on his paintings. Thus it is worth while summarising some of his ideas and opinions.

Although Hogarth is (unjustifiably) regarded as lending too much weight to 'literary' considerations in his art, it is most revealing that in those sections of the book based purely on his own observations, he shows himself to have given more thought than perhaps any other theorist before him to formal questions, particularly to linear composition and to light, shade and colouring. In fact the whole book deals exclusively with formal problems. Its underlying idea is the apotheosis of the two-dimensional serpentine line of beauty and, even more, of the three-dimensional serpentine line of grace (as coiled round a cone) which 'by its waving and winding at the same time different ways leads the eye in a pleasing manner along the continuity of its variety'. This is the serpentine line of mannerist-baroque Italian art theory, and Hogarth, as he admits in the preface, took it over from Lomazzo's *Trattato dell' Arte della Pittura* (1584; Eng. Trans. 1598).[10] But, as he also affirms in his preface, he deviates from Lomazzo in proceeding not from 'the order of teaching' but from 'the order of nature', which Lomazzo declared impossible. In fact Hogarth's attitude to the serpentine line is far more thorough and consistent than in former art theory, and most up-to-date. It is that of a baroque artist, but also of a keen observer of nature, even of an empirical scientist. He was convinced of the elegance (his favourite word) of this line, and of the need to learn graceful movements by means of it, in daily life or when dancing or on the stage.[11] At the same time a large part of the book is devoted to discovering traces of this favourite line everywhere in nature, particularly in the human body (bones, muscles, skin) and the face.[12]

Hogarth appears to have been widely influenced by the ideas and terminology associated with the English garden. The word 'serpentine', after 1715 the favourite term for the leading motif of the informal garden, grew in popularity after the creation of the artificial lake in Hyde Park by Queen Caroline and Bridgman in 1753. It is an epithet as typical for the English landscape garden, baroque-realistic-picturesque, as it was for Hogarth's art. Curves and spirals were also favoured motifs in this new type of garden. According to Horace Walpole, Kent's 'ruling principle' was that 'nature abhors a straight line'; the irregularity and naturalness of the landscape garden were further increased by Capability Brown. Apparently Hogarth, too, influenced the development of garden-construction. Even English poetry on landscape of the 'seventies (Graves, Mason) was obviously under the influence of Hogarth's line of beauty.

To the baroque stylistic principle Hogarth gives an empirical motivation, thus showing himself, in theory as well as in practice, the advocate of a realist baroque. Indeed, he came as close to realism as was possible for a baroque artist—the artist of a 'composed variety'. 'Though in nature's works the line of beauty is often neglected, or mixt with *plain* lines, yet so far are they from being defective on this account, that by this means there is exhibited that infinite variety of human form, which always distinguishes the hand of nature from the limited and insufficient one of art.'

Hogarth's references to artists or works of art in which the serpentine line could be studied illumine his attitude towards the various schools. The figure he selects as the best illustration of its use is the Woman of Samaria with her 'fine turn' in Annibale Carracci's well-known picture. It is to this dignified Italian figure that Coypel's Sancho Panza in *Don Quixote demolishing a puppet show* (Pl. 45b), is contrasted, as a 'comical posture of astonishment expressed by following

the direction of one plain curve'. In fact, this predilection for baroque, albeit of a somewhat moderate type, is reflected in all his examples,[13] and though at times one senses an echo of the preferences of the official Bellori-Félibien school, on the whole he voices his own predilections: the late Raphael, Correggio (also as a colourist), Reni, Sacchi, the sculptor Duquesnoy, even Pietro da Cortona.[14] Sacchi, whose baroque is so restrained that it often approaches classicism, is called 'one of the great Italian painters', his *St. Romuald's Dream*, having 'the reputation of being one of the best pictures in the world'. Hogarth also praises Rubens, who 'made use of a large flowing line as a principle which runs through all his works and gives a noble spirit to them'. On the other hand, he tends to reproach him for allowing these lines to 'bulge' too much and thus to deviate from the precise serpentine line. He is prone to condemn a too exaggerated baroque, finding it inelegant or, as he says, 'gross and clumsy'. But when he prefers Rubens as a colourist to Poussin, who 'scarce ever obtained a glimpse' of colouring, one feels that he found an unpainterly classicist far less tolerable than Rubens with all his boldness, for lines, as they straighten, become 'mean and poor'.

Most obvious is Hogarth's liking for the 'elegant' aspects of mannerism. He pays tribute to Parmigianino for elongating the appropriate parts of the human body, namely neck, legs and thighs: 'On this account his works are said, by all true connoisseurs, to have an inexpressible greatness of taste in them, though otherwise very incorrect.'[15] In line with this, he speaks highly of baroque spires with particularly pronounced mannerist elements, such as Wren's spire of St. Bride's and that of St. Mary-le-Bow, which he considers the 'most elegantly varied' steeple in Europe. He praises 'the finely and artfully varied' Gothic spires, quite rightly sensing some artistic relationship between the two styles, Gothic being the stylistic origin of mannerism.

The theme of the receipt for *The Analysis of Beauty*, depicting Columbus breaking an egg to make it stand on end (Pl. 113a), implies that Hogarth's art theory was so obvious that it had not yet occurred to anyone else. The whole composition was designed to demonstrate his favourite line of beauty: not only was it a baroque transposition of Leonardo's *Last Supper*, but the serpentine line was itself made manifest in the form of two eels twined round an egg on a dish. The emblem of the book is a serpent enclosed in a pyramidal crystal, the pedestal of which carries the word 'variety'. Further, in one of the book's two large plates he adduces the composition of *The Wedding Dance* (now called *The Country Dance*) (Pl. 116), as a practical example of his serpentine line, as well as of many plain, inelegant curves. To illustrate this more clearly, two diagrams of the composition are appended, one showing the linear reduction of the various, mainly comic dancers, the other showing the inter-weaving, imaginary serpentine lines produced by performers in a dance. That Hogarth should have taken over the spiral from the late mannerist Lomazzo is just as significant as the fact that the representation of grotesque dances should be based on motifs of the late mannerist Callot. Both Lomazzo and Callot stood at the turning-point between mannerism and baroque; Callot's art and Lomazzo's formal views on art may be interpreted in either sense and it is understandable that Hogarth, whose art was open to both mannerism and baroque (or, for that matter, rococo) took so well to these two predecessors.

The other plate in the book, *The Statuary's Yard*, is chiefly composed of antique sculptures, on which Hogarth lavishes admiration throughout. This at first glance resembles one of Pannini's pictures of ancient ruins and statues.[16] This plate was possibly suggested to Hogarth by the visit of Socrates to the sculptor Crito about which he read in Xenophon's *Memorabilia*, translated for him by his friend, Dr. Thomas Morell. It is one of Hogarth's main arguments that antique sculptures (the plate includes a very Roubilliac-like baroque tomb) also serve to

demonstrate the superiority of the serpentine over the straight line. So, as was usual at that time, the antique is seen through a baroque eye, albeit a moderate one. No wonder Hogarth selected the Laocoön ('as fine a group of figures in sculpture as ever was made, either by ancients or moderns'), the Farnese Hercules and the Vatican Torso, deliberately depicted at an oblique angle. Apart from the Apollo Belvedere, Hogarth's favourite antique statue was the curving Antinous, which he particularly praised for its gracefulness.[17]

A quick glance from this Antinous to the graceful, whimsical painter on the ladder in the engraving *Beer Street* (1751) (Pl. 120b), makes it at once apparent how Hogarth put his theory into practice when dealing with his usual popular and realistic everyday subjects. He not only applied the serpentine line of beauty to the dignified figures of his historical paintings but also to many of his everyday ones which he did not intend to be particularly grotesque. This painter on his ladder, repeating the bending posture of the antique statue, of course wears contemporary dress and, in order to justify his baroque, backward-leaning pose, he mixes his colours as he contemplates the bottle he is painting on the sign-board.[18] Hence this figure, which despite its baroque curves is a close anticipation of 19th-century art, symbolises the fusion of baroque with Hogarth's increasing realism. This well-balanced synthesis is evident in the whole composition; the style, which has not yet quite shed the earlier exuberance, is characteristic of many works of Hogarth's late period. The grotesque curves of such very realistic motifs as the beer drinkers, the corpulent blacksmith and the abnormally stout butcher, fit well into the general formal pattern.

But before dealing with the thematic origins and topicality of these motifs in *Beer Street*, I should like further to explore the engraving's formal features and refer, in passing, to another late work in which the baroque curves of the butcher and painter again appear. The first of Hogarth's two illustrations to *Tristram Shandy* (1759) (pen drawings in the New York Public Library) (Pl. 119a), the frontispiece to the first instalment, shows Corporal Trim reading a sermon to Tristram's father and Uncle Toby while Dr. Slope falls asleep. In his novel Sterne maintains that the author of *The Analysis of Beauty* could easily caricature Dr. Slope's appearance; later, through a friend, he requested Hogarth to depict this scene since 'it would mutually illustrate his system and mine'. Sterne, who could draw himself, imitated Hogarth and warmly commended *The Analysis of Beauty* to his readers. Indeed, he conceived this particular scene in *Tristram Shandy* with one eye on Hogarth, so that the latter, who returned the author's admiration, found motifs ready to hand when illustrating it. In little Dr. Slope asleep in an armchair he drew an even more grotesque and pot-bellied version of the butcher in *Beer Street*. His art was clearly more suited to Sterne's ironical, fanciful and withal extremely visual conception, than to the drabber descriptions of Richardson. It suited him that *Tristram Shandy* was full of topical allusions to well-known individuals, just as were his own compositions. Hogarth and Sterne were both equally interested in the relationship between the mental processes and the movements of the body. Dr. Slope, as drawn by Hogarth, is a perfect example of his grotesque curve; thus he resembles not only the butcher in *Beer Street* but also the gross dancing figure in *The Country Dance*. Corporal Trim, to whom Sterne especially alludes in the above-mentioned letter and whose tottering gait is so minutely described in the novel, is shown in an attitude close to the undulating baroque of the painter in *Beer Street*.

Returning to *Beer Street* itself, it is interesting to observe the general source for this ensemble of happy cockneys blissfully drinking from huge tankards—symbols of British well-being. This is Breughel's engraving *La Grasse Cuisine* (Pl. 121b), with its monstrously obese characters.[19] In the first state of Hogarth's engraving one figure was even directly taken over from Breughel:

the lean, intruding bagpiper becomes, in Hogarth, a scraggy French postilion. In the second state this figure was discarded, apparently as an element disturbing to the formal unity of the whole; yet here also the stout blacksmith and butcher clasping mugs of beer clearly betray their origin (Breughel's bulky woman even holds a glass too).[20] But Hogarth's Breughel-impressions of corpulent drinkers have been modified by motifs in Jordaens (after whom he owned prints), such as those in the famous *Le Roi boit*; and his own composition in turn, following the more or less baroque Breughel-Jordaen's line, leads straight to 19th-century genre painting.

However, it would be misleading to regard *Beer Street* purely as an anticipation of 19th-century realism and overlook its topical, didactic and moralising tendency. It drew attention to the healthy effects of drinking beer and, together with other engravings on the same lines, served to publicise the bill of 1751 designed to restrict the sale of gin through high taxation. The companion engraving, *Gin Lane* (Pl. 120a) (red chalk drawings for both engravings in the Pierpont Morgan Library, New York) in fact illustrates the devastating effects of this drink on the underfed poor. The principal foreground figures are a drunken woman whose baby is falling out of her arms and a drunken itinerant ballad-seller. Here there is even stronger evidence of its origins in Breughel's companion engraving, *La Maigre Cuisine* (Pl. 121a). Both these figures, as also the drunken woman with bare breasts and the skeletal man dying of starvation, are derived from it; Hogarth even took over the jug, using it as an inn-sign.

In their respective engravings, Breughel and Hogarth represent the contrast between wealth and poverty. But whilst Breughel shows up wealth in an antipathetic light,[21] Hogarth, who specifically juxtaposes healthy beer drinkers and starving gin drinkers, comes down decidedly on the side of affluence, as one would expect of him. Like a number of popular caricatures and ballads of the time, many of his works draw a similar contrast between healthy, wealthy Englishmen and starving, poverty-stricken Frenchmen: in the first state of *Beer Street* there is a thin, frightened Frenchman whom the corpulent English blacksmith is lifting by his belt.

In this small series Hogarth's critical faculties were assuredly not confined to demonstrating horrors alone. Like Fielding, he was far more positive in his late phase than hitherto. Seldom, in fact, even including the history of the industrious apprentice done shortly before, was he so positive as in *Beer Street*, in which he voiced his deep faith in a happy England of prosperous bourgeois and artisans. Even the inn-sign on which the painter is engaged depicts a group of merry harvesters dancing round a hay-stack surmounted by a sturdy yokel, beer mug in hand. No better example could be found of this truly English-bourgeois transformation of Lancret's parallel themes which, even at their most rustic, contain a strong tinge of aristocratic elegance (e.g. *Summer*, Louvre).[22] And in keeping with the bourgeois spirit of the whole composition, Hogarth included an advertisement for commerce: two fisherwomen reading a ballad on the herring fishery by John Lockman, secretary of the British White Herring Fishery Company and a friend of the artist. The whole spirit of *Beer Street* is middle-class democracy as Hogarth and Fielding wished it to be understood and experienced.

These, however, were far from being the only popular engravings Hogarth did in his late phase. Indeed, many in his most popular satirical manner originated from this period and a large number even from his last years, after the failure of *Sigismunda*. Apart from *Beer Street* and *Gin Lane*, in the same year of 1751 he produced the *Four Stages of Cruelty* which censured cruelty to animals[23]; in 1756 the two patriotic-popular plates of the (planned) French invasion[24]; and in 1762 both *The Times I* and *II* in defence of George III's and Bute's policy and *Credulity, Superstition and Fanaticism*, virulently attacking the Wesleyans.

The *Four Stages of Cruelty* (Pls. 117a, b, 118a, b), which probably came more directly from Hogarth's heart than any other cycle, was designed to appeal to the widest possible public. It follows the progress of a boy who, from maltreating animals,[25] finally develops into a murderer. Its moral undertone and pronounced sentimentalism, stronger than hitherto and emphasising the trend of *Industry and Idleness*, *Gin Lane* and *Beer Street*, keep pace with the spirit of the times, especially with the late Fielding whose ideas this cycle popularised. The last two *Stages of Cruelty* were also made into woodcuts and the one depicting the really terrifying scene of the murder and its perpetrator's arrest would have been a most suitable illustration to another of Fielding's popular pamphlets, written expressly for the poor and published in the next year—*Examples of the Interposition of Providence in the Detection and Punishment of Murder*. Hogarth's woodcut exactly reflects Fielding's thought and both works were intended to serve as deterrents. The final scene, *The Reward of Cruelty*, in which doctors brutally dissect the murderer, might well be considered a travesty of Rembrandt's famous *Anatomy Lesson of Professor Tulp*: the actual dissection, the position of the corpse and the scholars grouped around it all vaguely suggest this. Hogarth lacked the respect for medical scholarship felt by Rembrandt, whose picture was commissioned by the Guild of Surgeons and Amsterdam's educated middle class. For he shared the general belief in England that surgeons were on the whole disreputable and insensitive to human suffering.[26] He also gave expression to the popular conviction that, though they must be hanged, the corpses of criminals should not be dissected.[27] The motif of distended bowels suggests the possibility that, apart from Rembrandt's composition, he also intended to caricature Poussin's celebrated *Martyrdom of St. Erasmus*, which hung at the time in St. Peter's. In Hogarth this becomes a dissecting operation in Old Surgeons Hall: the bowels are now gobbled up by a dog, while the executioner is turned into a surgeon. The towering statue of a heathen god is replaced by two skeletons, seemingly alive like the corpse itself—motifs from popular art such as Hogarth so often introduced. But these same skeletons, together with the motif of the bowels, betray the real source of Hogarth's inspiration: the identical theme, though with animal imagery, occurs in Egbert van Heemskerk's crudely popular *Quack Physicians Hall* (engraved by Toms) (Pl. 119b), in which the bowels of a cat are extracted by monkeys, foxes, bears and asses, symbols of butchery committed by human ignorance. The cat lies in the same position as Hogarth's corpse and in the foreground the unappetising fruits of the operation, including the bowels, are similarly displayed. The connection between Heemskerk and Hogarth is so obvious that if one of them thought at all of Rembrandt here (Poussin now seems a far-fetched ancestor), it was the Dutch Heemskerk rather than Hogarth. However, in Hogarth Heemskerk's popular engraving received quite a new form in an uncouth but, particularly in the case of the woodcut, a most impressive baroque.

Still more popular in style are the other late engravings mentioned above. Admittedly Hogarth's general shift towards compactness, depth and monumentality has rendered these compositions rather more concentrated and spatial than the popular engravings of his early days and less use is made of merely abstract-allegorical figures than in the 'twenties. Nevertheless the general continuity is surprising. Fundamentally, in most of his late engravings of this type the former popular conception has survived, with its elaborate symbolical allusions, sometimes even with numerous explanatory inscriptions. In *Credulity, Superstition and Fanaticism*, whose pattern is based on *The Sleeping Congregation* of 1728, these features, compared with the latter, have even tended to increase. For here Hogarth does not represent the usual Anglican service but a Wesleyan one. He gives as free a rein to his sentiments as those artists of the previous

generation who, like Magnasco, Heemskerk or Picart, also represented 'exotic' religious services. This is seen in its popular features and the grotesqueness of the figures. For example, from his own early, equally 'anti-enthusiastic' engraving (1726) he took over the figure of Mary Tofts. Compared with *Credulity*, and its ecstatic, ugly old woman, Heemskerk's Quaker meetings appear harmlessly documentary and Hogarth's representation of a contented audience in a trance comes closer to Magnasco's wild, baroque renderings. Yet the 'resemblance' of *Credulity* with Magnasco is only a very general one and closer inspection reveals the Dutch-English popular features to be predominant. In its first state, called *Enthusiasm Delineated* (Pl. 137a), and directed against the Catholics, a Jesuit preaches a sermon and the whole of continental art, as being a focus for idolatry, is thrown to the lions of the populace. From the Jesuit's hand dangle puppets copied from the famous God the Father with Angels from the ceiling of the Stanza d'Eliodoro in the Vatican, then considered to be by Raphael [28]; and the pulpit is further decked with comic puppets of Biblical characters caricaturing Dürer (Adam and Eve), Rembrandt (St. Peter) etc., by means of which the preacher illustrates his sermon and works up his audience. [29]

Narrower than ever is the borderline between caricature and a straightforward use of foreign art when Hogarth is in popular mood. In this late phase his predilection for Breughel motifs is by no means confined to *Gin Lane* and *Beer Street*, nor is his fondness for grotesque Callot features diminished. In 1757 his 1727 Breughel-cum-Callot illustration to *Gulliver's Travels* was republished, though he was not responsible for its new title of *The Political Clyster* (Pl. 10a). All that part of *The Times I*, (Pl. 142a), depicting efforts to extinguish a fire appears to be influenced by parts of the allegorical Breughel theme of Hope; while the motif of Pitt on stilts surrounded by an admiring crowd from the City is taken from one of Callot's *Balli* scenes, *Smaraolo Cornuto* and *Ratsa di Boio*, in which a crowd in the background dances round a *Commedia dell' Arte* figure on stilts (Pl. 142b). [30] This association was even remarked on by Hogarth's political adversary, Wilkes, who is himself caricatured in the engraving.

One would scarcely have expected that Hogarth's art would still be in the service of boxers as late as this, but so it was. In 1750 he did a drawing for a ticket of admission to the famous boxing-match between Broughton and Slack—a picture of Slack fighting apparently in his own butcher's shop (formerly Marquess of Exeter) [31]: and, probably in 1759, two sets of drawings for the epitaph on the tombstone of the equally noted boxer, Taylor (Marquess of Exeter and A. P. Oppé)—one of Taylor defeating Death, the other in the manner of Holbein's *Dance of Death* of Death as Taylor's conqueror.

In 1761 Hogarth showed his works at one of the exhibitions then becoming fashionable and illustrated its catalogue. However, in 1762, perhaps recalling his own beginnings as a sign-painter and certainly parodying this same type of exhibition, forerunner of the Royal Academy whose foundation he so strongly opposed, he took part in and probably helped to promote an exhibition of sign paintings organised in the spirit of the Nonsense Club, of which he and Colman were members, by his friend Bonnel Thornton, proprietor of the *St. James' Chronicle*. In this journal, under the significant signature 'A Plebeian', he further explained the satirical purpose of the exhibition, opened as a counter move on the same day as one organised by the Society of Artists for the Encouragement of Art. [32] By literally taking over into *Beer Street* two street workers from his *Sign for a Paver*, done some thirty years earlier, Hogarth also demonstrated in a practical manner that, even when he had 'arrived', he was not ashamed of his early sign-board. In his last work, *The Bathos* or *Manner of Sinking in Sublime Paintings* (1764) he mocks at painting in the grand style, even if in his customary ambiguous way, and pokes fun at the trivial objects it

sometimes depicts. The title is a squib on Pope's 'Treatise on the Bathos; or the Art of Sinking in Poetry' (1727). The composition (pen drawing in Windsor) is reminiscent of Dürer's *Melancholy*, but the accumulation of so many scattered objects recalls, perhaps even more, a baroque derivation from this Dürer engraving, Rosa's print of the philosopher Democritus.

Many of Hogarth's late works are, however, neither so popular as these engravings nor so grand and elegant as such pictures as *The Lady's Last Stake* and *Sigismunda*. Now in his stylistic maturity, he brought the two currents closer together. For instance, the red chalk drawing of *Taylor defeating Death*, reminiscent of *Laocoön*, or *The Bathos*, designed as a tailpiece to his engravings, have both popular and monumental qualities. This is particularly true of the pen drawing for *The Bathos* with its large empty upper section (Windsor) (Pl. 143b). Other works which may be said to form a bridge between the two extreme publics and styles rank among his most outstanding productions, since in them he could deploy the characteristically new features of this period. Such are the *Election* cycle (1755, original paintings in the Soane Museum) (Pls. 122a, 123a, b, 124a), and the engraving of *The Cockpit* (1759) (Pl. 136a). Perhaps nowhere else can Hogarth's art of the 'fifties be better judged than in these works. Here he recounts his stories in quite a fresh manner and with a new sense of reality; little remains of the theatrical effects of the *Progresses* or of *Marriage à la Mode*. With this new depth of realism goes a greater degree of monumentality. The figures are more individualised and their features sometimes approach caricature, not unlike those in his popular engravings. Monumentality, a latent feature of *Marriage à la Mode*, where it was applied to groupings with few figures, is now extended to large crowds in the pursuit of organisation and clarity. At the same time the anonymity of the masses in *Industry and Idleness* is superseded by individual figures which now play a bigger, though never entirely dominant, part.

The potentialities of *The March to Finchley* reach fruition in the four, nearly all very crowded, scenes of the *Election* cycle. In this most monumental of Hogarth's cycles his new realism rises, apparently unrestrained, to unprecedented heights. Yet for all its crowds, a pronounced baroque equilibrium is achieved, not schematic or superficially superimposed but real, growing out of their variety and intricacy (qualities eulogised in *The Analysis of Beauty*). They deploy a wealth of characters unsurpassed elsewhere in his works and most of them are studies which linger in the memory. The original pictures are as important, perhaps even more so, than those for *Marriage à la Mode*. For the *Election* cycle also marks the climax of Hogarth's achievement in painting. Nowhere does he come so close to the 19th century as in this cycle where, at least in certain details, he seems to pass almost beyond himself and the possibilities of his time.

Just as the figures are realistically conceived, everyday types, so are the colours as it were realistically seen, everyday colours. No longer does one find the delicate pastel shades of *Marriage à la Mode*, but large, bold patches of broad colour, through which Hogarth gives a more robust feeling of solidity than before. It is largely on this new basis that he has toned the colours together: no longer on that of rococo harmony, but with the experience and knowledge of it behind him. The broad manner of painting and the brilliant, spirited distribution of colours among the crowds firmly support the variety and monumentality of the whole. At the same time the pictures have increased in size, becoming larger than those of *Marriage à la Mode*, not to speak of the two *Progresses*.

The most crowded is the first scene, the *Election Entertainment*, where votes are won by flattery, food, drink and amusements. At first sight its composition resembles *The March to Finchley*, an over-crowded popular engraving. Yet in fact the bulging waves of people round the

vast expanse of adjoining tables (placed at an inclined angle to heighten the impression of space) constitute the most exciting serpentine line Hogarth ever conceived, with the figures firmly, though in no way schematically, held in balance.[33] I have already discussed the part played by Leonardo's *Last Supper* in this. To the right, the elaborate still-life on the floor, though more realistic than similar motifs in the past, also helps to stabilise this pandemonium. The apparently overflowing composition is the conscious work of an artist skilled in holding a composition together and thus able to afford such freedom. In this loose arrangement every figure makes himself felt more insistently than in earlier works, when the artist still had to struggle to achieve any pattern at all. The balance and articulation of the *Election Entertainment* become obvious if it is compared with the *Rake's Orgy* of over twenty years earlier. Everyday colours, greys and browns, predominate, but big patches of red are dispersed in undulating waves across the surface (e.g. to the left, the man raising his glass; in the centre, the boy filling the punch bowl; to the right, the man fainting; in the right bottom corner, the lobster). The usual rococo shades (silver-grey, lemon yellow etc.) still appear in the clothes of the aristocrats but in rather subdued and neutralised tones, with more substance and vitality.

The second scene, *Canvassing*, representing the open and concealed bribery of the electors, is built up, like Hogarth's earlier works although on a looser, freer scale, by means of a large central and two lateral groups. Yet with its comparatively few figures, its graceful episode of the agent paying court to two ladies on the balcony and its delicate, mellow colouring, this picture bears the closest affinity to *Marriage à la Mode*. The colours are based on a subdued grey, while the scattered patches of red are smaller and more sporadic in this relatively quiet composition than in the *Election Entertainment*. The foreshortened inn with its balcony, all in pale brick red, forms a delicate stage effect. At the same time Hogarth makes use of strange, striking motifs close to popular art; in this respect, particularly impressive among the inn signs is one representing Punch as a candidate for Guzzle-Town distributing money to the electors. This inn sign with its dark blue background shows, as a pendant to Punch, a broadly painted (brown-white) old witch in the Callot-Magnasco vein, with a pointed hat reminiscent of the one in the first *Hudibras* series. Another motif of this type is the ship's figure-head placed outside the inn and representing the British lion devouring the French lily. Hogarth learned from Italian literature, probably from Lomazzo, that for one of the festivals at the French court Leonardo had constructed a lion whose breast opened to reveal lilies, symbolising the King of France.[34] He now used this motif in a grotesque popular sense as anti-French propaganda.

The third scene *Polling* or, rather, the illegal practices of polling, again contains a large crowd. But here the composition, though most original even for Hogarth with its unexpected angle and waving line rising from the left bottom to the top right corner, is tauter than the *Election Entertainment* although equally full of character studies. It is probably this picture in the cycle whose figures give the closest impression of the 19th century, being painted with exceptional realism and solidity. Take, for instance, the two sick men being carried to vote: the pallid, dying creature wrapped in a blanket, with a bandaged head, and the feeble-minded deaf man in a sedan-chair, paralysed by a stroke. Here the accuracy in observing symptoms of disease, already displayed in the *Pool of Bethesda*, is carried to a degree and monumentality that would only be rivalled much later on by Géricault. To the right, one of the lawyers, shown in profile as he contests the validity of the oath taken by an old soldier who has lost his right hand, is equally close in attitude and expression to Daumier. The landscape is designed to follow the unexpected bulges of the composition—Italianising, perhaps with some influence from Zuccarelli but on the basis of Callot.

The Late Phase

The undulating pattern of the final scene, *The Chairing of the Member*, although it includes a violent fight between a drunk sailor and a thresher, is perhaps more balanced and certainly more monumental than that of the preceding episode. The general scheme probably derives from one of Charles-Antoine Coypel's *Don Quixote* illustrations, *Sancho Panza's Entry as Governor of the Isle of Barataria* (engraved by Tardieu) (Pl. 124b). As in Coypel, a short fat man—the elected member—is carried shoulder high; architecture and groups converge from both sides towards the background, where another building encloses the scene. Hogarth also repeats the motifs of the woman seated on the balustrade and the boys playing above the crowd. However the initial borrowing, the whole triangle formed by the chairers and the chaired, becomes far more lively in Hogarth, with transitions towards the other parts of the picture. In fact this vibrant pyramid of figures, which should be compared with the more schematic groups in *A Rake's Progress*, is a good example of how sovereignly Hogarth could handle his composition on a new realistic plane. At the same time a few large, very freely conceived figures summarise the pattern by clearly indicating the direction of the main lines, in contrast to Coypel's only faint suggestions. In order to hold the composition together, striking use is made of the back-view of a wooden-legged sailor fighting in the centre foreground (in a dark blue coat, very impressive among the many greys). As in *Canvassing*, Hogarth also introduces a charming episode—the lady fainting on the terrace. To all appearances, this figure is very rococo in its delicately painted pink dress, yet the pink is not a pastel shade and the figure is more realistic than any in French rococo. On the other hand, some boys placing a pair of spectacles on a skull form a typical popular motif. In this composition Hogarth again used his favourite grotesque shadow motif. This time it appears on the wall of the building at the back, to indicate the approach of the second Member, also carried shoulder high.

Compared with the last two scenes of the *Election* cycle, only in the engraving of *The Cockpit* (Pl. 136a), is an equally successful or—since the colour problem is lacking—perhaps even greater synthesis achieved between the artist's efforts to unify the composition and the inexhaustible profusion of agitated figures. An impression of great space—a recurring phenomenon at this stage—is created in a really breath-taking way by the enormous oval cockpit itself with the fighting birds, which forms the centre and defines the billowing waves of spectators to either side. In the foreground, on the near side, only the upper half of the wildly gesticulating spectators is visible, forming an undulating base to the general whirlpool. On the far side, a large crowd jostles and shoves; in its midst, almost immobile, sits the chief gambler, a blind nobleman (Lord Albermarle Bertie, a well-known London figure) towards whom all the violent movement is converging like waves on a breakwater. Again Leonardo's *Last Supper* plays a part here, being put to even better use than in the *Election Entertainment*. Across the arena projects the grotesque shadow of a man who, according to the rules of the game, has been suspended (out of sight) in a basket from the ceiling for failing to settle his gambling debts; the shadow further reveals that he is dangling his watch as the stake for a new bet. It is instructive to compare this engraving with *A Midnight Modern Conversation* of 1734, which treats a rather similar theme, namely drunken, agitated figures round an oval table: in *The Cockpit* all the clumsiness and angularity has disappeared, though the subject is far richer and more lively. Indeed, here baroque, realism and expressionism strike an even balance; Hogarth's various tendencies and achievements seem to amalgamate. The search which began in *The March to Finchley* for means to build a compact composition out of a large crowd of individual characters now reached its goal. This engraving, whose rough and tumble subject was ideally suited to Hogarth's talents, reveals a unity and harmony that were only possible at the end of his career.

A picture from these years that comes the closest to his late history paintings is *The Lady's Last Stake* (1759; Albright Art Gallery, Buffalo) (Pl. 134). It was ordered by Lord Charlemont, a patron whose taste was very characteristic of this period; a great friend and admirer of Hogarth, he was closely connected with the new artistic trends. A famous dilettante, he was one of the most cultured peers in the realm and a future president of the Royal Irish Academy. His taste, which ranged over antique French and Italian art, was on the whole more fastidious and inter-national than that prevailing during the earlier part of the century. Through his early travels in Greece and later as a prominent member of the Society of Dilettanti, he pioneered the study and publication of Greek and Roman monuments from which, at least in part, the new styles in architecture and interior decoration evolved. When living in Rome (1750–54) he supported a group of interesting artists staying there, including Chambers and Patch [35] and nearly became the patron of Robert Adam's (and Chamber's) close friend and companion in art, the engraver Piranesi. Such was the aristocrat who chose Hogarth to paint his portrait, who bought *The Gate of Calais*, drawings for the *Four Stages of Cruelty* and—the theme of *The Lady's Last Stake* was apparently Hogarth's own choice—a picture with a 'moral' scene of seduction.

At this time Hogarth's 'elegant' pictures are touched by something new that was in the air. Thematically as well as formally, they are more restrained and refined. *The Lady's Last Stake* depicts a lady threatened with the loss of her honour in payment of her huge losses at cards, and it probably illustrates an identical situation in Cibber's sentimental comedy of the same title (1707, but also frequently performed in the 1740s). Its purpose is moral: to illustrate the dire effects of gambling. I have already referred to the constant interaction in the conduct, moral and otherwise, of the two classes: the bourgeois learned better manners from the nobility and the nobility, compromising with the bourgeoisie, tended to improve its morals. Lord Charlemont was a rather different type from the cynical Lord Chesterfield of an earlier generation or the 'vicious nobleman' who had ordered *Before* and *After*. Yet although the aristocracy had adopted a certain preference for moral themes from the middle class (and Lord Charlemont became, in Shaftesbury's sense, a virtuous virtuoso), the point of view expressed is not so radically middle class as in *Marriage à la Mode* and no longer is so daring a satire implied. The positive, moral side of the theme, the hope of saving the lady's honour, is stressed by her hesitant, contemplative and dignified attitude. [36] While the didactic purpose has been taken rather more nonchalantly than in the cycles, the event is represented less grotesquely than before, more graciously even than in *Marriage à la Mode*.

To appreciate the elevated conception and elegant style of this late work and its particular relation to contemporary French art, one should think back to the brutality and gracelessness of *Before* and *After*, painted about 1730–31. *The Lady's Last Stake* is totally different in every respect. The moralising theme is woven into the presentation of a fashionable couple enacting a refined scene of seduction in a fashionable milieu, which is alleged to be a slightly enlarged version of a room in Hogarth's own house at Chiswick. That is why, in this picture far more than in *Marriage à la Mode*, there is real similarity, almost a kinship, with the *soigné*, moderate French rococo seduction scenes by Jean François de Troy, so crudely transformed in *Before* and *After*. The well-bred young man now pays court in the prescribed manner, with his hand on his heart [37] exactly like a de Troy gallant (as, for instance, in *The Proposition*, Thyssen Collection, Lugano) and less heartily than the lawyer who, in the Levée scene of *Marriage à la Mode*, presses his attentions on the countess. The finely-dressed lady, with all her hesitation, lends him a cautious ear. Altogether *The Lady's Last Stake*, devoid of abrupt movements and economic

in its flow of lines, is perhaps the most French and undoubtedly the most elegant of Hogarth's works, and it can easily bear comparison with any more or less contemporary French scene of this type.[38] Since in Hogarth's oblong composition the figures stand out less than in de Troy's upright ones, and more of the interior is shown, Hogarth's work can almost better be compared for its general pattern with one of Lancret's illustrations for La Fontaine's stories of a rather erotic character[39] (*Les Remois*, 1738, engraved by Larmessin). Hogarth may well have known this composition, since in *The Discovery* he copied another of Lancret's successful series of La Fontaine illustrations.

The story itself is told with greater simplicity and concentration than *Marriage à la Mode* and the details, too, have been greatly simplified. There is little evidence here of a 'return to the antique' and a taste for rococo decoration still predominates. Yet seldom did Hogarth so reduce details to the essential or create such a concentrated, almost monumental composition as in this spectacular commission. Characteristic in this connection, and different from that in the *Quack Doctor* scene of *Marriage à la Mode*, is the role of the window: the 'Venetian window' of the Burlingtonians, considered Palladian, is used here as a dominant, almost classicist motif to tranquillise the composition. Characteristic also is the summarising effect of the wide expanse of elegant ink-blue wallpaper in the background. The colours themselves are slightly more solid and real than in *Marriage à la Mode*.[40] This greater concentration and solidity, in spite of its elegance, relates the picture to Subleyras' French-Roman type of seduction scene, which inclines towards a monumental, realistic classicism. Subleyras, younger than de Troy and Lancret, was a close contemporary of Hogarth and Chardin and the picture which here lends itself for comparison is his slightly sentimental *Le Faucon* (Louvre) (Pl. 135a), illustrating another La Fontaine story (after Boccaccio). Within rococo painting, *The Lady's Last Stake* represents a thematically expurgated, formally monumentalised and simplified version of *Marriage à la Mode* and, from Hogarth's standpoint, it could certainly be regarded more truly as an historical picture even than the cycles. And in so far as the patron's satisfaction went, it was a genuine success.[41]

Finally, a few words on Hogarth's last portraits. Although he did not paint many at this time, towards the end of the 1750s he seems to have made an attempt to capture some of Reynolds' large, fashionable clientèle. In 1757, in a letter to Warton, John Hoadly wrote: 'Hogarth has got again into Portraits, and has his hands full of business and at a high price.' In fact, in the same year, in the advertisement for the *Election* series, Hogarth announced that for the time being he would not publish engravings but would paint portraits. A few of these half-length portraits —though to my mind only the latest of them, such as *Henry Fox* (1761, Earl of Ilchester) and *Lord Charlemont* (1764, Kane Collection, New York)[42]—strike an unusually quiet and monumental note. In contrast to the elegant rococo gentlemen of the 1740s, towering tall and slim, the bust now became shorter so that the sitters, in their simpler attire, appear broader and more massive. Solidity of composition, a direct quiet look and a new simplifying realism in the colouring characterise these pictures, beside which the fashionable rococo figures just mentioned look supercilious, trivial and artificial, though colouristically still delicate. No doubt this type among Hogarth's late portraits is simpler, less sweet and less flattering than in Reynolds. However, in some other late portraits of his painted a few years earlier, in the second half of the 'fifties, there appears a streak of emptiness, of chalky superficiality not hitherto met in him and possibly a concession to the spreading vogue for Reynolds.[43] It perhaps gives some indication of Hogarth's outlook during these rather 'aristocratic' years which saw the ascendancy of Reynolds, that he was fond of dressing some of his sitters in fantastic garb and especially his women in 17th-

century ruffs. When he painted Peg Woffington's sister, the Hon. Mrs. Mary Cholmondeley (1759, Lord Leconfield) she acquired, in addition to the ruff, a mob-cap and a cross. Here the archaising paraphernalia were justified as suitable attributes for a lady of the aristocracy. When in 1755 he portrayed Mary Lewis (Lizzie Hogarth Collection), his wife's cousin, who lived in their house and in whose arms he died, her ruff was less ostentatious and more Dutch, in the vein of bourgeois portraits by the early Rembrandt. Yet Hogarth certainly had beautifying effects in mind and in 18th-century England these usually implied van Dyck.

From the choice of costume as well as from the handling of the paint Hogarth, at this time, seems to have drawn equally on both van Dyck *and* Rembrandt, not unlike Hudson, who in 1748 had been in Flanders and Holland and who became one of the most passionate collectors of Rembrandt's etchings. In so far as is compatible with an artist of Hogarth's originality, one could say that he combined to some extent the style of both van Dyck and Rembrandt in his portraits, just as the young Reynolds had done, though Reynolds' preference lay with the Flemish artist. At the same time Hogarth's differentiation remains true: a van Dyck manner in portraits of the aristocracy and a Rembrandt manner in those of the middle class; Reynolds on the other hand reserved the Rembrandt style almost exclusively for self-portraits, members of his family and intellectuals—all works of a far more penetrating character than the general run of his portraits.

Furthermore, even if Hogarth now imitated certain features of van Dyck, his manner of doing so was more naturalistic and individualising than Reynolds, who laid the greatest possible emphasis on a strikingly elegant appearance. Compare, for instance, the more conventional Reynolds' portraits of Lord Robert and Lord Charles Spencer in van Dyck costume (1758 and 1759, Duke of Marlborough, Blenheim) with Hogarth's piquant *Mrs. Cholmondeley*. In 1757, by order of Lord Edward Littleton, he had to copy a van Dyck portrait of Inigo Jones (Maritime Museum, Greenwich) after the engraving of van Voerst: as the portrait of an artist, van Dyck's is by no means a conventional aristocratic one—yet the realism of the face in Hogarth surpasses the original.[44] His innate naturalism inevitably made itself more vigorously felt at times; then it was characteristically under the auspices of Rembrandt rather than of van Dyck. That is why in the avowedly Rembrandt-imitating portrait of his friend, the engraver Pine—although clearly dating from the same years as his elegant likenesses—the broad brushwork is more daring and the modelling of the structure more pronounced. Yet it remains true that in his renewed efforts at portraiture his archaising *à la* Rembrandt sometimes had not only naturalistic features but also elegant overtones *à la* van Dyck. For—and this is the essential —a levelling took place in the artistic as well as the social field between the aristocratic and middle-class points of view. For all this, Hogarth's renewed attempt to become a fashionable portrait painter proved a failure. The impression persists that, in principle, he would dearly have loved to paint portraits of the aristocracy but that the elegant portraits then becoming *de rigueur*—far more ostentatiously elegant and decorative than the average conversation pieces of his youth or the rococo portraits of his middle period—were not really in his line. He may have learned some attributes of elegance from Reynolds, but only in so far as his realism and his, from an anti-rococo point of view, increasing simplicity permitted. There were always strong artistic limits to Hogarth's social ambitions.

Most significant of what is really personal in Hogarth's outlook, even at the time of Reynolds' elegant portraits, is his pioneer painting of his six servants (National Gallery) (Pl. 132).[45] Hogarth is known to have been warm-hearted yet strict towards his servants, whom he retained for many

years in his service. The enthusiasm of one of the men-servants for his master's works is also on record. The characterisation of each individual in the picture is of surpassing penetration as compared with the portrait of Mrs. Salter, for of course he could afford to paint his servants (as he did criminals) more faithfully than his ordinary sitters and devoid of any 'vest of beauty'. He would never have dared depict one of his high-born patrons with the realism of his ugly red-nosed butler in the centre—indeed, scarcely any painter in any country at that time would have found it sufficiently rewarding to put such a face on canvas. The whole work is a bold experiment in painterly realism, for Hogarth regarded it as another kind of private sketch on which he could let himself go. The butler's tasselled collar is painted with the verve of the late Hals. The caps of the women servants present a masterly combination of white with a different colour in each case. The picture certainly expresses Hogarth's sense of his own respectability and his extreme self-esteem. The arrangement of the heads, so much closer together than they would have been in a commissioned picture, unconsciously expresses the sitters' inferior rank. Yet if the picture signifies subordination, it signifies democracy even more, and it is impossible to imagine any other country in which it could have been painted.

If this portrait of his servants, revealing his profound analytical knowledge of the individual, bears something of the character of a 'secret' study, the small portrait of 1758 (or shortly before) of himself painting in his studio epitomises his late style as we have come to know it (Pl. 97a): a sweeping, most agitated, yet monumental and summarising baroque, though the late meticulous realism is not missing. In fact, the baroque spiral as it appeared on the palette of the 1745 self-portrait and as it was eulogised in *The Analysis of Beauty*, could not have been more boldly applied. Hogarth is seated not directly in front but rather to the side of the easel, so that his posture, in bending towards it, constitutes a well-rounded curve, counter-balanced on the other side by the large scaffolding of the large easel itself, stretching diagonally and foreshortened into the depth of the picture.

In France and even in Germany there existed a few contemporary self-portraits of painters beside their easels, done in the spirit of realistic classicism. Either the easel is placed parallel to the picture surface, as in the self-portrait of Subleyras (1740, Academy, Vienna) who followed the tradition of a Roman-French classicism combined with a genre-like, somewhat bourgeois realism: or else it is completely foreshortened, forming almost a right angle with the picture surface, as in the self-portrait—stylistically somewhere between Chardin and Highmore—of the German painter Juncker (1752, Cassel), who lived at Frankfort, the great middle-class centre in Germany. In Hogarth's portrait the artist is seen in intense communion with his work. On the easel is sketched the baroque figure of the comic Muse beside an imposing column, in the way he liked to think of her, with the comic mask in one hand and a book in the other—dignified, yet intimate and very direct. It is the self-portrait of a great artist painting tragi-comic subjects in the baroque style.

X

Hogarth's Impact on English Art

꧁꧂꧁꧂꧁꧂꧁꧂꧁꧂꧁꧂꧁꧂꧁꧂꧁꧂꧁꧂꧁꧂꧁꧂꧁꧂꧁꧂꧁꧂꧁꧂꧁꧂

HOGARTH towers like a giant over the English art of the first half of the 18th century. Before him, English painting had little or no relevance in a European context; by his death, England was artistically the most progressive country in the world. In painting and engraving, Hogarth gave complete expression to the outlook of the age, perhaps the most heroic phase of the middle class in England, and Hogarth's was the most pronouncedly middle-class art that England ever produced. At the same time it was the most pronouncedly middle-class art that Europe produced before the French Revolution, not excluding the Dutch art of the 17th century. Only in England and only during those years could an art have developed with so intensely didactic, utilitarian and moral a purpose and so vigorously combative a spirit.

In so far as it lay within the power of one artist alone, Hogarth during his lifetime determined the trend of English art, including its formal features—a fact which cannot be sufficiently stressed. Apart from landscapes, all types of English painting and engraving in the course of his life showed the decisive influence or at least the stamp of his realism, dramatic power, humour and formal gifts.

The artistic manifestations most truly expressive of the period were Hogarth's new didactic-critical works, his cycles, with their prodigious underlying realism. Yet, despite the profound and immediate impression they made,[1] it is significant that numerous copies but no genuine imitations of any significance appeared. Their quality and novelty placed them beyond imitation.

Hogarth was also the true father of English book illustration and dictated the line and rapid pace of its development for a quarter of a century. While his *Hudibras* illustrations of the 'twenties were still close to Dutch art and Callot, his Molière scenes from the 'thirties inaugurated an approximation to French art which reached its climax in Hayman's Shakespeare illustrations in the 'forties. Crossing to an allied field in painting, the theatre pictures, one only has to glance at Hayman's *Play Scene* from *Hamlet*, possibly painted for Vauxhall, or Pieter van Bleeck's *Mrs. Cibber as Cordelia* (1755),[2] to realise the impact of Hogarth's grand baroque style in *Garrick as Richard III* on other painters of Shakespearean subjects during his lifetime.

{ 175 }

The impression made by Hogarth's portraits on other artists, especially during the latter half of his career, is not perhaps sufficiently appreciated. For the directness and solid painterliness of his portraits, in contrast to the schematic and superficial products of the Kneller school, also genuinely express the strong bourgeois features of the time. That is why at first, during the 'forties and 'fifties, the younger generation of portraitists was either directly or indirectly much under Hogarth's influence, or else reveals clear parallels with his tendencies.[3] Reynolds' portraits during these first two decades of his career were the most structural and individualising he ever painted. His outstanding, tender and very direct portrait of his sister (1746, Radcliffe Collection, Knebworth) (Pl. 147a), significantly combines the influence of Hogarth (e.g. *Captain Coram*, at that time already on public view, and likenesses of the *Mrs. Salter* type) with a considerable Rembrandtesque flavour.[4]

The 'French' element in the Hogarth of the 'forties was shared, amongst other contemporary English portraitists, by the young Gainsborough. In fact, when he was studying in London (1742–6) under Gravelot and possibly Hayman, Gainsborough almost certainly knew Hogarth and his works. But quite as important as the painterliness and grace of the young Gainsborough's portraits done in Suffolk (Sudbury, 1746–52; Ipswich, 1752–9) is their uncanny psychological insight and the natural, unconventional poses of the sitters. This capacity for psychological penetration, so striking in *Mr. and Mrs. Andrews* (soon after 1748, National Gallery, London) (Pl. 30b), was certainly sharpened through contact with Hogarth's works, and it does not seem at all impossible that Gainsborough and Hogarth mutually influenced each other in their portraits. If, to the likenesses of the young Reynolds, the young Gainsborough and of course Hogarth himself, one adds the acute characterisations of Allan Ramsay (Pl. 146b), Rousseau's and Hume's friend, who was trained in Italy and France, one obtains a good general notion of the unique group of portraitists of the 'forties and 'fifties,[5] the great period of English portrait painting.[6] The piercing character of this portraiture emerged best when a member of the middle class was depicted, such as Gainsborough's old *Mrs. John Kirby* (c. 1752, Fitzwilliam Museum, Cambridge) (Pl. 146a), which it is hard to imagine divorced from the group of Hogarth's servants. Although the sitters included aristocrats and, in the case of the young Gainsborough, landed gentry, this portraiture of the mid-century had by and large a far stronger bourgeois tinge than either any preceding or subsequent period.

Towards the end of Hogarth's life, as the courtly reaction set in, and even more after his death, as power passed almost exclusively to the Tories, the whole complexion of the English artistic situation altered. Although this was also the period of the advancing Industrial Revolution and the emergence of England as the leading industrial nation in Europe, the early, combative self-assurance and independent way of thinking of the middle class had diminished. The levelling between aristocracy and bourgeoisie was now more widespread, the latter tending increasingly to rise socially and to assume landownership and other aristocratic attributes, even if the former remained the ruling class.[7] True, the younger sons of the aristocracy now associated with commercial and industrial enterprises sat together with City men on the boards of the joint stock companies.[8] True, also, the middle class was now firmly established and its well-tried ideas had permeated the general outlook of good society. Nevertheless the moneyed middle class no longer took pride in itself as such and propagation of its ideas had lost its earlier impetus. In fact, the period was now beginning which would culminate in the violent, frightened reaction against the French Revolution shared by the court, the bulk of the aristocracy and the well-to-do middle class.[9]

English painting now became more prudish, elegant and consequently less original. Its style from the 'seventies onwards was on the whole less realistic, more traditional and conventional than hitherto and the more one advances into George III's reign the more this conventional style was favoured by the upper circles in smart society. The change had already set in before Hogarth's death and even some of his own late tendencies point in this direction, owing to his increasing proximity to court and aristocracy and accommodation to their taste.

Portraiture again dominated English painting, almost to the pre-Hogarthian degree of careless manufacture. Stylistically it now assumed a totally different character from Hogarth's, acquiring more traditionally courtly-baroque, decorative, woolly qualities and consistently imitating van Dyck's, or occasionally Venetian, elegance. It became more generalising, sometimes almost empty in expression. After 1760, Reynolds' portraits entirely changed in this direction. Only in the few isolated cases where Hogarth himself had, for social reasons, kept close to the courtly van Dyck style does Reynolds seem of necessity to continue in his line, just as the van Dyck costume which Hogarth had once used by way of amusement now became a general fashion in portraiture. Consider, for instance, the stylistic similarity of Hogarth's early sketch of the Royal family (Dublin) with Reynolds' sketch of the Duke of Marlborough's family (1777, National Gallery). Moreover, Reynolds often intentionally raised the dignity of his portraits through literal borrowings from Italian history painting.[10] As the perfect man of society, he not only portrayed practically the whole aristocracy but was also the special portraitist of the connoisseurs and the Society of Dilettanti—types whom Hogarth so disliked.

Needless to say, Gainsborough was less of a manufacturer; he was less academic, more sensitive and delicate than Reynolds, even if in his own individual way equally 'flattering'. Nor are the social strata portrayed by Reynolds and Gainsborough quite identical. Gainsborough painted the world of the theatre and the demi-monde more frequently than Reynolds. However, Gainsborough's portraits too assumed more conventional characteristics in expression, poses and the handling of the paint,[11] as he moved step by step from middle-class Ipswich through fashionable Bath (1759–74)[12] to London (1774–88), and the orbit of the court, to which near the end of his life he even became official painter.[13] Only when portraying intellectuals did Reynolds, and even more Gainsborough, relax generalisation. It is instructive to compare Hogarth's and Gainsborough's pictorial treatment of their mutual friends, the actors Quin and Garrick. Gainsborough's powerful unfinished portrait of Quin (*c.* 1763, Buckingham Palace) is in its psychological conception and the angle of the head obviously under the influence of Hogarth's. His somewhat later portrait of Garrick (Ashcroft Collection, London), though more natural and nonchalant than Reynolds' (1776, Lord Sackville, Knole), is more insipid and brings out less of the sitter's character than Hogarth in his amazing likeness of the Garrick couple. It is again instructive to compare this latter with Reynolds' more dignified, boring and conventional portrait of Garrick and his wife seated together on a bench (1773, Foster Collection, Apley Park). Generally speaking, Reynolds, Gainsborough and nearly all the fashionable portraitists drifted increasingly away from Hogarth, to develop features in common with the usual type of portrait of conservative upper circles on the continent, where social conditions were more backward.[14]

If, exceptionally, a neo-baroque portraitist for lack of other models kept close to Hogarth's pattern, as in some 'role portrait' of an actor, he would transform it entirely in the new manner— just as the whole manner of acting had itself become affected and declamatory. Thus when William Hamilton painted Kemble, a chief exponent of this declamatory style, in the grand role of Richard

III (engraved by Bartolozzi) (Pl. 98a), the *contraposto* of Hogarth's Garrick portrait in the same role and scene is wildly accentuated and Kemble stands with one foot placed on the couch; armour and couch are now set at an angle in a more baroque manner and even the curtain is bunched up more dramatically. Despite the general similarity, Hogarth's portrait appears almost classicist beside it.

A certain connection does however exist between Hogarth and Zoffany—especially the early Zoffany of the 'sixties and early 'seventies. He was the most realist and bourgeois-minded of all fashionable English artists, and since he was influenced by German (Frankfurt) middle-class painting, he understood Hogarth best among all English painters. Even the portrait group of Queen Charlotte in her dressing-room with her two children (*c.* 1766, Windsor), painted with a photographic neatness beloved of the prosaic king, contains motifs from Hogarth, albeit more trivial in character, such as the vista of rooms from *The Cholmondeley Family* and the reflecting mirror on the dressing table from the *Levée of the Countess*. A whimsical, often striking realism of detail and many individual characterisations in such paintings as *An Optician with his Attendant* (1772, Windsor) and *Concert of Wandering Minstrels* (1773, Parma) (Pl. 144a), all point towards Hogarth. Among Zoffany's early pictures of the stage, *The Farmer's Return* (1762, Earl of Durham) is astonishingly close to Hogarth's representation of the same play in the same year: the identical incident is chosen and identical too is the arrangement of the figures. But in Zoffany the psychological conception is less intense, the composition is more loosely knit, the figures have less *élan* and accessories abound. In a wider sense, all stage paintings and 'role portraits' by Zoffany and de Wilde (who, like Hogarth, mainly portrayed comedies rather than 'elevated' tragedies) derive from Hogarth, whose early *Beggar's Opera* was the foundation and *Farmer's Return* the immediate stepping-stone to the documentary trend of theatre pictures—an outstanding genre peculiar to English painting since Hogarth's time. But within this documentary guise, theatre pictures were increasingly apt to assume the character of anecdotal genre pictures. Moreover Zoffany was much weaker and more superficial than Hogarth and from a painterly point of view less interesting, his figures often resembling mere dolls. The crudeness and greater dryness of his colouring imply not only a turning away from Hogarth's rococo painterliness but also, for this was the time of the new, realistic but harsh, classicist paintings of the continental bourgeoisie, a move towards a sober, prosaic, middle-class realism. His whole art reveals both the possibilities and limitations of a bourgeois-tinged realism in a courtly, aristocratic milieu.[15]

Apart from portraits and theatre pictures, various historical compositions were also produced during these last decades of the 18th century, partly because of the interest shown by the middle class in at least the engravings after them, partly because a good deal of official lip-service was now paid by the upper strata to the doctrine of their pre-eminence. Alderman Boydell's enterprise in commissioning historical pictures from which to make engravings went back to Hogarth's similar enterprise, but now on the elevated plane of selling engravings after painted compositions.[16] With Reynolds, history painting regained its former conventional characteristics as a real 'higher' art of a courtly-aristocratic character in the 16th- and 17th-century sense. Through it he hoped to raise the social standing of artists, especially in elegant society and among intellectuals. Increasingly drawn towards fashionable society and wishing to conform to its taste, Hogarth laid the foundations of this development. In him, however, it was combined with a strong bourgeois sentiment of self-assurance. That is why the slightly 'enlightened bourgeois' trend of English historical painting in the second half of the century, that of the American-born Quaker, Benjamin West,[17] with his moderate baroque, sometimes even entirely classicist, style was ushered in by

some of Hogarth's late works[18] such as *Paul before Felix*, and in particular *Moses brought to Pharaoh's Daughter*—a picture more classicist than many works by West himself and yet infinitely truer to life.

From such pictorial reportage as Hogarth's sittings of the Bambridge Committee of the House of Commons, a direct path leads to history paintings in the narrower sense, such as those depicting contemporary events in contemporary costume by West or Copley (Pl. 148b)[19]: the subjects had only to become more dramatic, preferably tragic, and the pictures to acquire a larger scale.[20] Even Boydell's Shakespeare Gallery of 1786 seems almost to have been inaugurated by Hogarth's *Richard III*, or even for that matter his *Henry VIII and Anne Boleyn* of over half a century earlier. This was the foremost English middle-class attempt to create history painting by placing orders for themes from Shakespeare's plays with all outstanding contemporary English artists.[21] Northcote said of Boydell (who had ordered historical pictures from him) that he 'did more for the advancement of the arts in England than the whole mass of nobility put together' and Burke called Boydell 'the commercial Maecenas' and 'an English tradesman who patronises the art better than the Grand Monarque of France'.

In 1790, at Mrs. Hogarth's sale, Boydell himself had bought the ill-fated *Sigismunda*, and it was such late historical pictures by Hogarth as this that paved the way for the ordinary trend of fashionable, neo-baroque, 'tragic' historical paintings. These now were mainly produced by Reynolds, who occasionally took a short respite from his almost non-stop labour of portrait painting to do a work of this kind for the Russian Court or for Boydell, though, in keeping with his outlook, he preferred to paint historical pictures for the Empress of Russia than for Boydell, whose Shakespeare Gallery he considered too commercial.

But even *Sigismunda* is more original and realistic than Reynolds' eclectic, superficial works, imitating old masters and carrying on the baroque tradition in a conventional manner.[22] Reynolds' unspontaneous, historising art, so characteristic of the second half of the century, was by its very nature systematically based on countless borrowings from and imitations of the recognised masters of the past.[23] He demanded of the artist of his day that he should live himself into the style of the master he followed. Delighting in his skill, he did a great number of almost 'deceiving' copies after old masters, whereas Hogarth, as he records, did not care to copy other artists though he was well capable of doing so. He naturally scorned Hogarth's historical pictures, where even the occasional borrowings, quite unlike his own, were those of an extremely original and realistic artist. According to him, he who represented 'the ridicule of life' (and as such even Reynolds recognised that Hogarth 'probably will never be equalled') ought never to try his hand at the elevated genre. It is worth quoting Reynolds' *Fourteenth Discourse* delivered in 1788 to students at the Royal Academy because of its narrow-mindedness, hypocrisy and conservatism:

> He (Hogarth) very imprudently, or rather presumptuously, attempted the great historical style, for which his previous habits had by no means prepared him: he was, indeed, so entirely unacquainted with the principles of this style, that he was not even aware that any artificial preparation was at all necessary. It is to be regretted that any part of the life of such a genius should be fruitlessly employed. Let his failure teach us not to indulge ourselves in the vain imagination that by a momentary resolution we can give either dexterity to the hand, or a new habit to the mind.

In accordance with this general reaction, Reynolds reversed Hogarth's art theory, turned away almost completely from its revolutionary empiricism and again whole-heartedly adopted the

idealistic art theory of the 17th century (Bellori), now becoming increasingly conventional and conservative.

Fuseli's more refined current of history painting, with its irrational, neo-mannerist features,[24] was only slightly foreshadowed by certain expressionist tendencies in Hogarth's art, for instance his *Satan, Sin and Death*. Fuseli was in fact influenced by this picture, which he must have seen in Garrick's house. When treating the same Milton theme he recalled Hogarth's composition, (Pl. 110b): in a drawing done in Rome (1776), (Ashmolean Museum, Oxford, Pl. 145a), the arrangement of the three figures is almost identical and their conception in some ways similar. Fuseli's picture for the Milton Gallery, *Sin pursued by Death* (1790s, Kunsthaus, Zürich), also bears the stamp of Hogarth's composition. Similarly, Hogarth's *Rake in Bedlam* is reflected in a sketch by Fuseli for another picture in his Milton Gallery—the famous drawing of the *Vision of the Madhouse* (Kunsthaus, Zürich).[25] The mad woman in the left-hand corner with raised arm and outspread fingers is similar in expression to Hogarth's centrally placed lunatic tailor squatting with a tape-measure in his outstretched fingers. Fuseli further transformed Hogarth's rake lying in chains on the floor into a raving lunatic attempting to break free from the clutches of the woman who loves him and a warder. The connection—not at first sight evident—between these two works is most interesting, since it shows how a characteristically and consistently realist composition of the first half of the century could be transposed in the late 1790s in an expressionist mannerist vein.

When, in Rome, Fuseli drew *The Ghost appearing to Richard III* (1773–9, Kunsthaus, Zürich), he may have remembered Hogarth's rendering of Garrick in the same scene. Here the transposition is even more radical, almost beyond recognition. Yet it would be quite reasonable to suppose that Fuseli knew these two compositions, since they were the only serious portrayals existing in England of his own two subjects. Even in his pictures Fuseli at times followed the moral trend of Hogarth's works: his *Family Life in the Country* (Private Collection, Oberhofen) and *The Boudoir* (Private Collection, Basle) are companion-pieces representing morality and immorality; they are illustrations to Cowper, almost the only poet of this period who was a genuine imitator and admirer of Hogarth.[26]

It also seems to me that Hogarth's ambitious ticket of Hymen and Cupid (Pl. 115a) heralds the line of certain well-known foreign artists of an academic nature, working in England in the following generation, such as Angelica Kauffmann, Cipriani and Bartolozzi. Cipriani appears to continue Amigoni's style, so that engravings of Bartolozzi after both of them look very much alike. Mythological compositions of the middle of the century like Hogarth's ticket are chronologically the connecting link between these two waves of Italian artists visiting England.

Hogarth's true greatness, however, did not lie in his few historical compositions nor even his numerous portraits, but in his didactic-critical works, both painted and engraved. In the second half of the century these works, with their amazing realism, their deep-rooted, popular, almost plebeian features, lost their appeal amongst the smart upper strata of society and had little following among artists. This was not due to the middle-class ideas themselves—to which lip-service was now paid even by the aristocracy—but to the ruthless, blunt realism with which Hogarth expressed them.[27] Any period of reaction fears realism above all else. Towards the end of his life, Hogarth was already being lampooned as the painter of ugliness. The Reynolds–Dr. Johnson circle in particular got its knife into him. In his *Third Discourse* delivered in 1770, Reynolds spoke of Hogarth as one of 'the painters who have applied themselves more particularly to low and vulgar characters'.

In the same way, Fielding's novels with their 'low' themes were now less favoured than Richardson's.[28] Dr. Johnson called him vicious and corrupt, a blockhead and a barren rascal. The level and features of the literature of this time are a parallel to its art. Whilst the appearance of Hogarth's works coincided with the heroic age of the English analytical novel, towards the end of the century there only appeared over-sentimental or 'Gothic' novels, or combinations of the two. So the former lively contact between Hogarth's work and contemporary literature naturally ceased. There are, I believe, but few reminiscences or allusions to him in the literature of this period and then mainly in the works of sincere, slightly liberal, somewhat unconventional writers like Cowper (a fellow member with Hogarth of the Nonsense Club), in whose early moral satires (*Truth*, 1782) the old spinster in Hogarth's *Morning* is described, or Crabbe in his faithful, realistic descriptions of miserable village life.

Hogarth's works, though they did not sink into oblivion, now fell out of fashion not only with the upper ranks of society who bought the pictures—and with whom they were never in favour anyway—but also with those who normally bought his engravings. Individual connoisseurs of refined taste like 'Athenian' Stuart, whose parlour was adorned with Hogarth's prints and Soane, who bought *A Rake's Progress* and (after Garrick's death) the *Election* cycle, were, I think, rather exceptional.

Even Horace Walpole, who had the greatest contemporary collection of his engravings and published their first catalogue, fundamentally looked down on him, as he did on all low-born artists and writers. While in his *Anecdotes of Painting in England* (finished 1770, published 1780) he maintains that Hogarth's art was highly original and had a reforming and even benevolent quality, there can be no doubt that he regarded it as inferior, if not absurd. Living in the refined atmosphere of an aristocratic dilettante, Walpole naturally found much of it too plebeian for him, just as he dismissed the whole of Dutch and Flemish art as too vulgar, and he could apparently never reconcile himself to the way Hogarth chose to set his tragedies among people of low rank. Walpole defined Hogarth's position—not greatly at variance with the artist's own view of himself in certain moods—as lying between Italian and Flemish painters. Those of Hogarth's pictures which he genuinely liked and which he acquired either as gifts from the artist or by purchase were small, *haut gout* paintings such as *The Bambridge Committee*, with its macabre details or the murderess, *Sarah Malcolm*. So he appreciated the characters and passions in Hogarth's works but with a peculiar snobbish twist of his own. Characteristically, he dismissed *Gin Lane* as 'Horridly fine, but disgusting'. *Tom Jones* was also too low for him, and anyway he disliked Fielding; he also disparaged Garrick's acting, calling him 'the young wine merchant turned player'. He maintained that 'as a painter Hogarth had but slender merit' and added the usual accusation levelled by those with academic tastes, that Hogarth could not draw well—an accusation that was to be repeated for a long time to come.[29]

Soon after Hogarth's death, since the demand for his engravings had greatly diminished, his widow, to augment her income, accepted an offer from the Rev. Trusler to have the most important prints re-engraved and republished under the significant title of *Hogarth Moralised* (1768). Trusler's often unctuous commentary, designed to counterbalance the blunt realism of the scenes, was on combined moralistic, edifying and didactic lines.[30] This tendency was on the whole to remain dominant for a very long while, even up to modern times.

In the 'eighties and early 'nineties Hogarth's engravings certainly received deeper appreciation. This might possibly be regarded, at least in part, as a reflection of the democratic tendencies in those years of widespread sympathy with events in France, though I think that it

was confined largely to collectors and that it would by now have been unthinkable for a well-known painter, working also for the upper classes, to court the general public through prints of this kind. In addition to Horace Walpole's catalogue, in 1781 J. Nichols, a respectable bourgeois printer, bookseller, antiquarian and president of the Stationers' Company, published another, more complete one, full of interesting documented information (*Biographical Anecdotes of William Hogarth*). Within four years, this ran into two more, increasingly amplified, editions and it will always remain the fundamental source for students of Hogarth and his art.

Apart from Nichols, it was Boydell, very progressive middle-class in outlook, who probably did most to promote the understanding and popularisation of Hogarth. In 1790 he published most of the engravings, some hundred and ten of them (*Original Works*).[31] Although a champion of history painting, he was not quite so rigid in his interpretation of this elevated genre as Walpole, though more so than Hogarth himself. In connection with this publication he also commissioned from J. Ireland, a print-seller and collector, a book entitled *Hogarth Illustrated* (1791). Ireland's thorough commentary in two volumes, covering every detail of Hogarth's works, was much wider in scope than Trusler's narrow, moralising one. Of course he too took the general view that Hogarth's engravings were better than his pictures. He fulsomely praised the artist, in particular his representations of character (only in England is there a variety of characters, he says, so it was fortunate for Hogarth that he was born in this country), and blamed the profligacy of the age for the licence Hogarth took.[32] He had his reasons for this. For if everyday, even bourgeois, life was now portrayed in painting for the better-class public, it had to be idealised and strongly sentimentalised, as in Morland and Wheatley.[33] True, the time had come when middle-class ideals were represented positively, rather than negatively, as they had largely been in Hogarth's cycles. But since the middle-class way of life was no longer questioned, this positiveness acquired an elegant, over-sweet, affected flavour which neutralised the bourgeois tendency and made it appear almost a hypocritical survival. Even the contrast in character between Hogarth and Morland is significant of the sincerer spirit of the earlier period. Hogarth, who depicted dissoluteness in all its aspects, was a model husband, had a well-ordered household, earned a good living through skill and hard work and, where charity was concerned, was openhanded. Morland, who portrayed the most saccharine triumphs of virtue, spent his life in dissipation, was in constant flight from the debtor's prison, roistered with the dregs of society and drank himself to death.

It is not surprising, therefore, that in Morland's few pictures of an apparently didactic character nothing remains of Hogarth's blunt, ruthless sincerity and fighting spirit. In fact he was an imitator of Greuze rather than of Hogarth. He retained something perhaps of the early 18th-century purse-proud spirit, combined with the new shallowness, in his *Fruits of early Industry and Economy* and *Effects of youthful Clairvoyance* (1780s, both in Philadelphia), in which a successful merchant is shown surrounded by his sources of wealth (docks and warehouses) and his family, with a picture of his country-house on the wall. More consistently in the new vein are two companion-pieces of *Industry* and *Idleness* (Lord Glenconner, engraved in 1788), each of which represents a fashionably dressed lady seated beside a desk; only careful scrutiny reveals that one of them is doing a trifling piece of needlework and the other nothing at all. Occasionally, especially in his early phase, Morland also depicted an *Idle Laundress* (Pl. 145b), or an *Industrious Cottager*, *Domestic Happiness* or a *Virtuous Parent*. His equally early *Letitia* cycle of six pictures (engraved in 1789), where the innocent country lass, after leading a life of sin in town, returns ruefully to her parents' home, is just a sugary transposition of *A Harlot's Progress*, with a happy

ending. The compositions are unusually conventional and straightforward. Similarly, in his *Cries of London* (1795), Wheatley transformed into sentimental genre scenes the numerous popular series on this theme, the documentary tradition of which Hogarth still followed. In 1797, Northcote, a Reynolds' pupil and anything but a follower of Hogarth, had engraved his *Diligence and Dissipation*—a set of ten scenes treating the progresses of an industrious and an idle house-maid—thinking it would be a sound investment. However these contrasting themes had evidently lost their attraction, for the engravings did not sell well. While the career of the virtuous maid is merely an illustration of Richardson's *Pamela*, that of the immoral one has some insignificant details from Hogarth imposed upon it.

On a somewhat higher social level there actually appeared a follower of Hogarth: John Collet (1725–80), a rather weak imitator of his genre pictures, who specialised in 'low life', used many of his motifs and even retained his popular habit of using many inscriptions. But as a painter he was rather an exception and not much favoured in fashionable circles. He chose, for instance, such a plebeian theme as *The Press Gang* (Foundling Hospital) (Pl. 150a), which certainly did not interest high society. He is also said to have painted copies after all the scenes of *A Rake's Progress* and also *The March to Finchley*. The prints after his pictures, done by popular or half-popular engravers, seem to have been more in demand than the original paintings. Almost all of these were built up out of Hogarth's motifs, which were then applied to low life and became far more crude and caricature-like. *Taste in High Life* played a prominent part in them; also the *Levée* scene of *Marriage à la Mode* and *The Wedding Dance*.

It was, rather, in the broad lower layers of society that Hogarth's engravings penetrated deeply and survived with unimpaired popularity into the 19th century. For instance, John Adams, a teacher of mathematics who lived in Edmonton towards the end of the 18th century, hung framed engravings of *Industry and Idleness* on his class-room walls. Hogarth's engravings also survived on this social level as represented on popular pottery, sometimes painted, sometimes in low relief: e.g. *The Cockpit* reappears on Staffordshire jugs and mugs between 1780 and 1790. It is also significant that the caricaturist John Collier (1708–86), the 'Lancashire Hogarth', a student of folk dialect who worked under the pseudonym of Tim Bobbin and whose main published work was the engravings of *The Human Passions Delineated* (1773), was a small schoolmaster, a provincial, entirely popular artist and sign painter.

Furthermore, Hogarth's art lived on, though greatly transformed, on a lower level of good society art, as an inexhaustible source of material, almost one might say as the basis, for endless caricatures in the late 18th and early 19th centuries. For this time of intense reaction was also the great period of English caricature. These years saw attempts to intervene against the French Revolution give way to the nation's life-and-death struggle against Napoleon. From fear of the new ideas coming from France, civic liberties were suppressed throughout both phases. Political caricatures now gave forceful expression to the government's point of view. Others, escapist, sought to provoke excitement or humour in the permissible, more harmless spheres of women's fashions or sport, any deep social problems being taboo.[34] But to be satirical now simply implied to follow Hogarth, and that is how the situation was universally regarded by both artists and public alike. Hogarth had entirely changed the character of English caricature by elaborating the situation and facial expression, whilst freeing it from the dominant part hitherto played by explanatory inscriptions (though not from the inscriptions themselves). All caricatures and satirical engravings after Hogarth were based on these features. Moreover, quotations from his works, which were familiar to nearly everyone, were deliberately used to heighten the comic

effect, at any rate in the 'low' and *risqué* sphere of caricatures. Indeed, these allusions continually recur in the works of the great caricaturists, as well as in those by anonymous provincial artists.

At first the caricaturists appear to have been somewhat measured in their whole relation to Hogarth. The extremely witty Bunbury (1750–1811), who worked chiefly in the 'seventies, before the upheaval in France, and whom Horace Walpole named the 'second Hogarth', stood midway between genuine caricature and representation of concrete scene. So did Richard Newton (1777–98), a precocious genius who died very young, a radical and one of the outstanding caricaturists of his time. Even he, in his *Old Maid treating a favourite Cat* (1792), transformed Hogarth's elderly spinster and shivering page boy in *Morning* into exaggerated though skilful caricatures, almost in the Ghezzi manner. In large plates, he also reduced Hogarth's *Progresses* to the form of the 'strip-cartoon'.

The works of the two great caricaturists at the turn of the century—Rowlandson (1756–1827) and Gillray (1757–1815)—were so frequently based on Hogarth, that they cannot be imagined without him in so far as raw material is concerned. But by sharpening Hogarth and exaggerating the expressionistic possibilities of his baroque compositions, they brought his art—though this is truer of Gillray than of Rowlandson—entirely within the realm of what Hogarth rightly called caricatura. Gillray concentrated on politics, following the wishes of his patron, Pitt. It was even assumed that Gillray was blackmailed by Pitt to work for him, his true sentiments being decidedly in favour of the opposite side. Rowlandson, who was not particularly committed politically, dwelt on small human weaknesses, though by no means in a 'moral' spirit; he loved erotic jokes and as it were continued the spirit of rococo, albeit in a grotesque Dutch vein. Although, like all intensive caricaturists, both were obsessed and haunted, Gillray's and Rowlandson's art was no longer the expression of deep convictions, of a positive outlook on life. For them Hogarth was valuable source material but, particularly with Gillray, only for motifs and scattered details of incoherent purpose, so that in them the bulk of Hogarth's art lost its real, original meaning.

Gillray's fantastic caricatures, in which baroque almost seems to destroy itself, no longer appear to grow out of a close observation of life like Hogarth's. At least, they certainly go beyond that point. His faces—and many of his caricatures appear to consist mainly of faces—express character strikingly; but they certainly exceed that degree of caricature which Hogarth displayed as examples in his *Characters and Caricaturas* and *The Bench*. On the whole his borrowings from Hogarth are most frequently apparent when the caricature is not of an absolutely unreal nature. Even so, when he combines Hogarth's *Midnight Modern Conversation* and *Election Entertainment* in a caricature of his own, *The Union Club* (1801), showing a drinking scene celebrating the union of all political adversaries in Parliament, no 'real' persons or actual surroundings occur in the Hogarthian sense, but only excellently caricatured expressions and wildly pointed attitudes. Even when in his *Anacreontics* (1801), he renders one of the usual drinking clubs of his day, again taking over and varying some of the attitudes in *A Midnight Modern Conversation*, he is only a shade more real than in *The Union Club*. The same applies when he converts the bored married couple in Hogarth's Breakfast scene of *Marriage à la Mode* into the Prince Regent and Mrs. Fitzherbert in *Morning after Marriage* (1786) (Pl. 88b). In *The Middlesex Election* (1804), the general lay-out and individual motifs of Hogarth's *Lord Mayor's Show* are unmistakable; and *Visiting of the Sick* (1806)—remorselessly showing Fox's last illness and his fainting wife—is equally obviously based on *The Rake in Prison*. Similarly, in his *Dilettanti Theatricals* (Pl. 151b) (1803)—Gillray, like Hogarth, loved the theatre—which revives and

intensifies the grotesque spirit of *Strolling Actresses* but now with elegant amateurs, Gillray borrows one of Hogarth's most famous poses, the girl undressing in *The Rake's Orgy*. Such quotations could be prolonged almost indefinitely.

Rowlandson was often a documentary portrayer of contemporary life and manners, a story-teller and illustrator, not merely a caricaturist. No one recorded the social life of his day so faithfully and attentively; he ranged over many social levels and occasions, especially urban and rural amusements. As a result he was inevitably far closer to Hogarth in conception and style than Gillray, whose borrowings were of a more external character. Even his most exaggerated works are less caricature-like in an expressionist sense and less irrational than Gillray's wildly swirling ones, and they usually treat the subject as an actual event. His works therefore fall mid-way between Gillray's and Hogarth's. Lacking Hogarth's deep knowledge of character, his figures are burlesque types, not real individuals, and his facial contortions, like Ghezzi's, are of an external nature. He also copied della Porta's illustrations, comparisons of human and animal heads, and created some of his own (which he called Lebrun travestied), accentuating a tendency which Hogarth pursued only occasionally. With all their vitality, his compositions are increasingly apt to display only cheap contrasts between prettiness and ugliness, youth and age, and so on. No wonder his grotesque style appears much more suitable when illustrating Smollett than Fielding.

When of a documentary character therefore, Rowlandson's art is necessarily based on Hogarth and at the back of his works of this kind one always senses some Hogarth composition, even if only vaguely. In his more naturalistic early drawings, he kept perhaps somewhat closer to Hogarth's manner than he did later: for instance, the illustrations to his *Tour to Southampton* of 1782 (to see the wreck of the Royal George) imitate those done by Hogarth for his *Tour to Gravesend*, engraved and published with Rowlandson's own assistance a year before.[35] In 1810 Rowlandson re-engraved Hogarth's *Hudibras* series. Yet, in this late phase, when his style became increasingly exuberant, he appears to carry on Hogarth's late, broad, picturesque style of draughtsmanship, as exemplified in the first set of pen, ink and wash drawings for *Industry and Idleness*, particularly the one of the *Betrayal of the Idle Apprentice*. Drawings of this kind even appear to anticipate some of Rowlandson's types. The two last-mentioned drawings, for instance, contain Rowlandson's fat, overflowing woman with undulating contours, though less schematically.

Lord Lovat was surely the starting-point for many caricature heads by Rowlandson. Frequently in 'genre' motifs, he started off from Hogarth's engravings in quite a concrete manner. He would keep the pattern, for instance, of *A Midnight Modern Conversation*, *The Stage Coach*, *The Cockpit* or *The Bench*, while making something exaggerated, wild and riotous out of it, always within a composition of a concrete scene. Such was the origin of his *Hunt Supper*, *Stage Coach* (1816), *Quarrel in an Inn*, *Royal Cockpit* (1816) (Pl. 136b), and *We Three Loggerheads*. And here again, as in Gillray, there seems no end to Hogarth quotations.[36]

Towards the end of the Napoleonic War, as the democratic trend in England gained in strength, appreciation of Hogarth developed into genuine enthusiasm. This was quite general among the Liberal *avant-garde*, including Lamb, Hazlitt and Landor (Leigh Hunt was less concerned with artistic questions). All these writers had a strong political bias, stood together in the same camp, and did not, like the Lake poets, alter their opinions with the changing political scene. Even Lamb, the mildest of them, did attack the Prince Regent and supported Godwin and Hone. The far more intransigent Hazlitt, a fervent political pamphleteer, had whole-hearted sympathy for the poor, assailed Pitt's and Castlereagh's reactionary home politics and even became an ardent

admirer of Napoleon. He directed his attacks against the corruption of elections and the un-representative character of Parliament, thus continuing Hogarth's campaign in a more radical vein. Landor was also a radical and a partisan of every popular uprising in Europe from the French Revolution up to 1848. The middle class was now of course much further developed in every sense and, following the suppression of all liberal ideas during the preceding decades, its most advanced intellectuals were all the more radical. In the artistic sphere, Hogarth was their given rallying point. His sincere and consistent realism must now have conveyed an impression of extreme topicality and provided a most refreshing escape from the hypocritical pseudo-realist paintings of the previous generation.

Lamb's famous essay *On the Genius and Character of Hogarth*, published in 1811 in Hunt's paper, *The Reflector*, was only the first visible sign of this natural development.[37] The change of attitude towards Hogarth from the sentimentality of the late 18th century comes out in Lamb's verdict that he was not milk for babes but strong meat for men. In fact Lamb lived surrounded by Hogarth's engravings. At his evening parties such works of art were discussed as Hogarth's engravings, Claude's landscapes and the Hampton Court cartoons, and such writers as Shakespeare, Milton, Dryden, Pope, Steele, Addison, Swift, Gay, Richardson, Fielding, Smollett and Sterne—a perfect revival of the artistic and literary atmosphere around Hogarth. He accords Hogarth the highest possible praise: 'Perhaps next to Shakespeare, the most inventive genius which this island has produced.' He was well aware that the cycles were deeply felt tragedies in spite of, or better because of, certain comic features and that in Hogarth, as in Shakespeare and the 'drama of real life', comedy and tragedy are closely intermingled. He draws close parallels between *A Rake's Progress* and *Timon of Athens*, between *The Rake in Bedlam* and *King Lear*. A romantic who was not in the least afraid of realism, the scene he singles out for the highest praise is the *Harlot's Funeral*, where the comic motifs only enhance the tragic effect. He took up Fielding's argument, protesting against the old assumption that Hogarth was only a comic painter. He was amazed by the reality of Hogarth's situations, his figures and their expressions, and the human-ness of so many of his characters. He well understood—as did the artist's intelligent contemporaries—that Hogarth was fundamentally an optimist and in no sense a misanthrope. He saw that even many of his ridiculous characters were made endearing and that in every scene there was always a hint of man's better nature, which helped to counterbalance the sordidness of life.[38]

As a connoisseur and lover of the 18th century, Lamb realised that Hogarth's place was beside Fielding, Smollett and Sterne, and indeed the former's rehabilitation was also due to him and his circle. Keenly aware of the stature of Leonardo and Raphael, he certainly could not avoid a positive feeling for the formal values in Hogarth; in fact he especially refers to the ease with which *An Election Entertainment* is arranged. He clearly saw how superior Hogarth was to Reynolds, especially in rendering expression.[39] All these years later, he gave the most radical and stabbing answer to Reynolds' and Barry's attacks on Hogarth, demolishing Sir Joshua both as an 'historical' painter and as a pompous anti-Hogarthian theorist. He no longer shared the belief in history painting; in fact he did not believe in the 'rage for classification' at all. He ruthlessly tore to pieces the assertion that Hogarth was a 'vulgar' artist[40] and boldly raised *Gin Lane*, which he called 'sublime', above Poussin's *Plague at Athens*.

But when at the same time a Royal Academician like the conventional portraitist T. Phillips wrote about Hogarth (in Ree's *New Cyclopedia*), he kept strictly to Reynolds's views. So did Flaxman, who disapproved of Lamb's article on Hogarth, and claimed that Hogarth was not a

moral painter, being wicked, if most witty.[41] As a conservative who objected to a ribald attitude towards vice, Flaxman did not credit Hogarth's sincerity and compared his approach to that of Voltaire. Yet he admired Fuseli, who was certainly more 'wicked' than Hogarth but whose art was of an idealist nature and not based on realism. J. T. Smith, Keeper of Prints and Drawings at the British Museum in the early 19th century, also described Hogarth as a great yet immoral artist who was anything but a 'moral teacher of mankind' and whose works one cannot show to young people. It was he who invented the myth that Hogarth was a drunkard and a profligate on which the 'Victorian' interpretation of him was based.

Lamb's attitude, however individual in certain respects, only reflects the growing appreciation of Hogarth, an exhibition of whose pictures was arranged immediately after the war, in the British Institution in 1814, the year following one of works by Reynolds, the national idol. R. Payne-Knight, the famous connoisseur and collector, stressed, in his introduction to the catalogue, not only Hogarth's moral purpose but also his skill as a draughtsman and painter.

People could now breathe again and think more freely; hence Hogarth's rehabilitation was one of the first artistic demonstrations. Never before had the public been able to see his painted works in any number, and it was from now that his fame as a painter dated. Thus Hazlitt's review of the exhibition, published in another of Leigh Hunt's magazines, *The Examiner*, was written on the basis of the pictures and not the engravings, as was Lamb's article. As a painter at heart and a lover of Titian and Rembrandt, Hazlitt now had the opportunity to admire Hogarth's colouristic effects and discoursed upon them with an appreciation that the artist had little enjoyed in his lifetime.[42] Taking *Marriage à la Mode* scene by scene, he praised its conception and painterly qualities. Apart from this very important encomium, his estimate of Hogarth fundamentally tallied with Lamb's: realism and truthfulness of the complex characters. And in this regard it is significant that he too repeated Fielding's old arguments. It was the fleeting expression on Hogarth's faces that he especially admired.[43] In various letters Landor, like Hazlitt, praised Hogarth's pictorial qualities, considering him the greatest painter after Raphael. Quite consciously, this whole circle linked up with the problems of the intellectuals of the first half of the 18th century and, as it were, re-lived them. Hazlitt, keener on classification than Lamb and bent on doing Hogarth justice, now affirmed—almost out-doing Fielding—that Hogarth's paintings were 'in the strictest sense historical pictures', parallels to *Tom Jones*.

It was not only the expressed opinions of Lamb, Hazlitt and Landor that signalled the re-opening of the Reynolds-Hogarth battle and this time pronounced in favour of Hogarth. The latter's superiority seems to have been generally assumed among liberal intellectuals of the 1820s, as distinct from the more conservative upper-class public. For instance, Crabb Robinson, concurring with Lamb, put Hogarth far above Reynolds. And while the aged, conservative Northcote, in whom the Reynolds-Johnson tradition survived, loudly voiced the usual complaint of 'lowness' against him, still talking of the 'imbecility' of his historical pictures and claiming that one could tell from Reynolds' works that he was a gentleman, while Hogarth was not, Alan Cunningham, author of the widely read *Lives of the most eminent British Painters* (1829–32), devoted his longest and most sympathetic study to Hogarth,[44] reproaching Reynolds for *his* attitude and leaving little doubt as to which was for him the greater of the two: no wonder Northcote said he did not know where Cunningham had his ideas from! One has the feeling that behind the endless artistic controversies of those years, this old combat always revived with fresh vigour. Its increased intensity testifies to its topicality, for the battle for or against Hogarth was of course the battle for or against realism.

How was this new assessment reflected in art? Now, when middle-class feeling was gathering strength, England was again for a short while the most progressive European country in art and literature. This was the brief period of English realist landscape painting, the decades of Constable, Cotman and Turner.[45] These artists, though little appreciated by the general public in England, counted greatly in the evolution of European art. Nevertheless figural compositions from contemporary life which might reflect Hogarth's influence were rare, even if less so now than in the second half of the century.[46] By international standards, Wilkie's genre pictures, especially the early ones, doubtless represent a certain development towards realism. Particularly in his rendering and differentiation of individual expression, more than a dash of Hogarth is apparent for quite a while. No wonder that in 1821 Géricault still admired the varied expressions in *Chelsea Pensioners hearing the news of Waterloo* (Pl. 150b), then on exhibition. As he rightly felt, there was nothing similar to it at that time in French painting. But Wilkie made increasing concessions to the conservative taste of his rich clients; his painterly qualities diminished and his pictures became more or less smooth imitations of Ostade and Teniers. At the same time his expressions grew emptier, more blurred and sentimental, and there remained little possibility of a genuine relationship with Hogarth.

Of somewhat greater interest is another contemporary painter of anecdotes, Stuart Newton (1794–1835), a nephew and pupil of the well-known American painter, Gilbert Stuart. With him the choice of 15th-century themes had not reached the full banality of the later Victorian painters but, as with many romantics, still held a certain intensity, all the more since he also tried to learn from the painterly realism of French 18th-century painting itself. His not unexpressive illustration to Sterne: *Yorrick and the Grisette in the Glove Shop* (1830, Tate Gallery) (Pl. 135b), may be said to hark back, on a passable early 19th-century romantic level, to *Marriage à la Mode*. One of his compositions of *The Beggar's Opera* (a favourite subject of his) showing Macheath sitting in prison, drinking between his two adorers, is a sentimental undramatic version of Hogarth. At the same time however his art of course heralds Victorian anecdotal painting.

Wilkie's tragically unsuccessful friend Haydon, a less compromising painter, really linked up with Hogarth through the force of his development. He lived in more or less close contact with Lamb, Hazlitt and Leigh Hunt, all of whom valued his art. Far more than West had been, he was the exponent of a realistic classicism (with great stress on the realistic), the artist of a progressive upper middle-class outlook. As one would expect, he began by painting mythological and religious themes which, as one would also expect, remained unsold.[47] But he became increasingly involved in the turmoil of political and social questions caused by agitation for the Reform Bill. Furthermore, since in 1827 he was thrown into the Debtors' Prison, Haydon came into touch with low life in quite a different sense from his successful friend. It was from then onwards— and I think this chronology is very significant—that he turned to painting contemporary subjects. Just as important was the fact that this new road—stylistically a development from classicism to realism—a development parallel to that of the somewhat younger Géricault—passed through Hogarth. For an English painter to return to realism at this time still implied going back to Hogarth, who was now much in the air, numerous cheap, popular publications of re-engravings after him having appeared, especially in the 1820s and '30s, when the political struggle reached its height. Haydon's *Mock Election in the King's Bench* (1827, Buckingham Palace) was inspired by a mock election organised by his fellow prisoners, to choose two members to protect their rights in the House of Commons. In his autobiography (London, 1853) he wrote: 'I was resolved to paint it, for I thought it the finest subject for humour and pathos on earth' and 'I saw, in an

instant, the capacity there existed in this scene of being made morally instructive and interesting to the public'.

The following year he painted a sequel, *The Chairing of the Member* (1828, Tate Gallery) (Pl. 125a), in which soldiers obstruct the mock chairing. Hogarth's *Election* cycle is here revived in a more tragic, bitter vein. In both paintings, especially the second, Haydon sought to show what excellent human material was unjustly cast into prison. These monumental canvases revert quite consciously and to an astonishing degree to Hogarth, especially in the attempt to give very realistic and varied expressions. Haydon himself remarks of the head of the high sheriff in the *Mock Election*: 'the careless, Irish, witty look, the *abandon de gaieté* of his head and expression was never surpassed by Hogarth'. In Haydon's art there occurs a revival of the English 18th-century middle-class mentality during its most heroic period, the same as in the Lamb circle. In his own description of his *Mock Election*, Haydon quoted Fielding's favourite writers, Rabelais and Cervantes, and concluded: 'It should be a sort of Beggar's Opera—Polly and Macheath affair.' And Lamb, who thoroughly approved of Haydon's pictures of this type, assured the artist that 'your *Chairing of the Member* gave me great pleasure; 'tis true broad Hogarthian fun, the High Sheriff capital'. The general composition carries on Hogarth's formal intentions. The build-up of the *Mock Election*, reduced to a few large figures, continues in terms of a realistic classicism the clarifying process in Hogarth's development from the overcrowded *Southwark Fair*, with its small figures, to the more concentrated scenes of the *Election* cycle.

Within and beyond the classicising composition of his pictures, Haydon opened up the way for a more consistent realism, not unlike Géricault's achievement in France a few years before. This development, so important for English painting and accompanied by a corresponding loosening of the colours, took place under Hogarth's banner. Apart from the close general affinity Haydon obviously leaned on Hogarth in numerous individual motifs. The *Chairing of the Member*, however original, makes no attempt to disguise its debt to Hogarth's picture of the same theme. For his background construction Haydon also used Hogarth's large cube-like blocks of houses (with figures in the windows), divided by wide expanses of sky. He even adopted Hogarth's practice of including numerous inscriptions. His next picture, *The Punch and Judy Show* (1829, Tate Gallery) has *Southwark Fair* for its ancestor, even taking over some individual motifs; at the same time, it is a monumentalisation in paint of one of Cruikshank's favourite themes, as exemplified by his Hogarthian engraving published in *The English Spy* three years before.[48] After these Hogarthian pictures, Haydon painted scenes of various contemporary events, mostly in connection with the passing of the Reform Bill (e.g. *The Reform Banquet*). Whilst Hogarth had 'advanced' from painting contemporary events to history painting, Haydon's ambition to paint historical pictures for historical reasons, had in the meantime spent itself and he slowly reverted to topical subjects though like David he still worked sporadically on history painting. Realism, however, remained the common denominator of his various types of pictures as he himself clearly saw.

After the franchise had been extended to the middle class by the Reform Bill, only the intellectual *avant garde* felt a need to continue the struggle for social reform, though they did not identify themselves with Chartism. Among the writers, Dickens played an impressive role in influencing public opinion in this regard.[49] He was conversant as no other writer with the way of life and point of view of the man-in-the-street and the social conditions of the poor. Like Hogarth he was of humble origin and each in his own way started as a reporter; and, in a wider sense, both remained reporters of the social scene all their lives. In their scope and outlook,

Dickens' writings followed on those of Fielding, Smollett and Goldsmith; thus for him and his whole circle Hogarth necessarily became as topical and sympathetic as he had been for Lamb and Hazlitt. In Dickens' eyes Hogarth ranked alongside such great inventors as Watt, Jenner, Brunel and Stephenson as a benefactor of mankind, and in his opinion they should all have had seats in the House of Lords. He wrote with the greatest respect of Hogarth's works, dwelling in detail on *Gin Lane* in an article for *The Examiner* (Cruikshank's 'The Drunkard's Children', 1848). For someone so progressive, to appreciate Hogarth naturally meant to go beyond him. Under the entirely changed social and political conditions he felt genuine pity for the poor—a sentiment unknown a hundred years before—and necessarily searched much deeper into the reasons for poverty than Hogarth or even Fielding had done. Although his violent attacks on the Poor Law and the workhouse were fundamentally based on Fielding's old ideas, his concern over low wages, bad housing and education would naturally have been unthinkable to Hogarth or Fielding. Thus Dickens no longer believed that drunkenness was the cause of poverty but, on the contrary, that it was bad housing, education and working conditions among the poor, together with lack of leisure, that produced drunkenness; or, as he put it briefly in the *Sketches*: 'Gin-drinking is a great vice in England, but poverty is a greater'.

However, so deep was his respect for Hogarth that Dickens, professing to appreciate *Gin Lane* more than Lamb did, claimed—partly at least with exaggeration—that here Hogarth had seized on the conditions of the poor, the real cause of drunkenness, with the same understanding as his own. However Dickens rightly pointed out that Hogarth did not confine drunkenness to the poor: 'that he did not spare that kind of drunkenness which was of more respectable engenderment, as his midnight modern conversation, the election plates, and a crowd of stupid aldermen and other guzzlers, amply testify'. Of Hogarth's other works—*A Rake's Progress*, *Marriage à la Mode*, *Four Stages of Cruelty*—he argued that their great merit lay in their rendering not only of the effects but also of the causes of the events depicted. Undoubtedly the artist and the writer were kindred spirits, even if many of Hogarth's ideas had by Dickens' time become old-fashioned.[50] Both identified themselves passionately with advanced social reforms. Dickens also wished to share Fielding's experience and become a London Magistrate and to speak directly to the less well-to-do through cheap magazines, as Hogarth did through cheap engravings. The parallel between them suggested itself quite naturally and even in Dickens' own time was frequently referred to. R. H. Horne, for a while the leading journalist of Dickens' popular magazine, *Household Words*, based his essay on pictures—in his book, *A New Spirit of the Age*, 1844—on countless detailed comparisons (rich humour, tragic power, moral purpose, tragedies within the poorer classes, truthful characterisation and expression, animation of lifeless objects, manner of composition, etc.) with Hogarth, who stood closer to him than any other writer. Lamb's and Hazlitt's articles on Hogarth, still so topical for Horne—even his book took its title from Hazlitt's earlier *Spirit of the Age*—were constantly quoted and elaborated and considered most necessary for the understanding of Dickens himself ('Any one who would rightly . . . estimate the genius of Mr. Dickens, should first read his works fairly through, and then read the Essays by Charles Lamb and by Hazlitt, on the genius of Hogarth'). In his biography of his friend, John Forster also said that Dickens closely resembled Hogarth in genius, adding prophetically 'as another generation will be probably more apt than our own to discover'.[51] Even concrete thematic parallels between Dickens' writings and Hogarth's engravings are most frequent.[52]

Unlike the Lamb–Hazlitt circle, Dickens' connection with art was not very intimate and his

interest in it rather vague. Indeed it would be foolish to deny the very conservative taste of the intellectuals of the Dickens–Thackeray generation so far as contemporary art was concerned.

Nevertheless Dickens was gratified to have two of his early works illustrated by George Cruikshank (1792–1887), a lively and exuberant Cockney, the last descendant of the Hogarth tradition and foremost illustrator of his day. These were the *Sketches* (1836), 'illustrative of every day life and every day people' [53] and *Oliver Twist* (1839), which struck at the Poor Law. In 1838 Dickens edited the memoirs of the pantomime clown Grimaldi (1779–1837), who, for the amazing variety of his expressions was called the 'Hogarth of action'. This was also illustrated by Cruikshank. Cruikshank originally began in a very popular vein with chapbooks and illustrations to street ballads. As a young man, he was inclined to radical ideas. In his most famous broadsides he successfully attacked the custom of capital punishment for forgery of £1 notes (1819). His greatly sought-after caricatures directed against George IV, were done between 1819 and 1823 for Hone, the radical pamphleteer, who published Hazlitt's political essays and was still esteemed by Dickens a generation later, thus forming with Leigh Hunt a connecting link between the two intellectual circles. At that time his style was closely connected with the expressionistic baroque of Gillray. Later, however, his interest in serious social or political satire dwindled and the objects of his jokes became increasingly trivial, his humour less and less biting. Moreover he did not remain exclusively a caricaturist but developed into a considerable illustrator of books in a kind of grotesque Romantic, quasi-baroque, usually realist idiom. Often dramatic, sometimes of a fairy-tale quality, on the whole mildly though consistently caricaturing, it is tempting to call these illustrations 'average-European' in style, but it would perhaps be more correct to assume that it was with Cruikshank himself that this very widespread style began. Perhaps it is because one has Cruikshank's increasingly philistine followers in mind that one is so intensely conscious, behind the grotesqueness, of a relative complacency and lack of intensity in his later style. But even so this also implies a realism entirely absent from Gillray's nightmares. Cruikshank's work belongs, in a wider sense, to the great period of English realism of the first half of the century, even if it only lay on the periphery. Although in many respects these illustrations continue Rowlandson's baroque compositions of a documentary nature, they keep much closer to reality.

This approach also characterises Cruikshank's whole relation to Hogarth. His knowledge of the lower classes and the London underworld was probably as great as Hogarth's. Moreover he even helped to re-do Hogarth's engravings as woodcuts for one of the reissues of Trusler's *Hogarth Moralised* (1831). His numerous early cockney scenes, such as *The Punch and Judy Show* in *The English Spy* (1826), are revivals of Hogarth's London scenes rather in the manner of a chronicle, a kind of transition between Hogarth and the illustrated magazines. His *Knackers Yard* (1830–33) is an up-to-date version of Hogarth's second scene of *Four Stages of Cruelty*. His *Pit, Boxes and Gallery* (1836)—Cruikshank was equally fond of the theatre—is Hogarth's *Laughing Audience* elaborated into a real genre scene. True, his figures—he is increasingly apt to seize on their mere outward appearances—are usually far more schematically grotesque than Hogarth's. However, in his Dickens illustrations, which were not really late works, he sometimes created individual, very vivid characters in Hogarth's footsteps, and occasionally even approximated to Hogarth's whole composition. Compare, for instance, Oliver Twist kneeling before the magistrate with the industrious apprentice as an alderman, impeaching the idle apprentice. [54]

It is quite characteristic of Cruikshank's whole artistic tradition and atmosphere that he not only illustrated *Don Quixote* and *Tristram Shandy* like Hogarth, but specialised in illustrating all the famous 18th-century novelists: Defoe, Fielding, Richardson, Smollett and Goldsmith.

He also illustrated modern historical novels, set in Hogarth's London, and in many of his figures and settings for these it is particularly easy to recognise their derivation from Hogarth. For, apart from realist and generalising features, Cruikshank's imitation of Hogarth increasingly displays the qualities of a 19th-century Romantic artist. Much of it is already of a consciously historising nature, and it is in this respect that he overdoes the Hogarth figures in a caricatural sense. Yet the result is so innocent that it scarcely seems such: compare, for instance, the elderly beau in St. James's Park from Ainsworth's *The Miser's Daughter* (1842) with its original in *Taste in High Life*. When Cruikshank illustrated a farce, the imitation of Hogarth is all the more innocuous. In 1830, in his illustration of a modern version of Fielding's *Tom Thumb*, he transposed Hogarth's *Richard III*—a favourite figure of his—into a comic character to whom Gaffer Thumb's ghost appears (Pl. 98b).

Thus, although there was doubtless quite a lot of realism and the Hogarth tradition in Cruikshank, his art, especially in his late phase, was nevertheless of a rather harmless, philistine nature, judged by previous standards. His main obsession at this stage was the fight against alcoholism and smoking—a fight which now implied much less than in Hogarth's day and was worthy of a petty bourgeois who became a teetotaller and had no other ideas to preoccupy him. Cruikshank was also wildly anti-French and anti-Catholic, just as Hogarth had been; but at his time this attitude was more or less limited to the petty bourgeoisie and not shared to any extent by the cultured upper middle class. Direct imitation of Hogarth is most evident in his two famous series, which he himself invented, *The Bottle* (1847) and *The Drunkard's Children* (1848) (Pl. 151a). *The Bottle* was also performed on the stage, like Hogarth's cycles. It enjoyed a particular success, mainly with temperance societies, and tended to be compared with Hogarth, above all with *Gin Lane*.

The slow but inevitable decline of a genuine appreciation of Hogarth's greatness towards the mid-century is shown by an essay in which Thackeray treated Cruikshank and Hogarth with equal enthusiasm, just as Sala bracketed these two together. Dickens, however, fully realised the very simple Cruikshank's inferiority to Hogarth and the insipidity of his ideas. He frequently stated as much in articles and letters, above all in the article previously quoted on *The Drunkard's Children*, in which he elaborated his views regarding the two artists. 'The philosophy of the thing, as a great lesson, I think all wrong' he wrote of *The Bottle* in a letter to Forster in 1847, referring to his firm conviction that poverty, not drunkenness, was the prime evil and, realizing that Cruikshank would not understand this, he added 'too "radical" for good old George, I suppose'.

Indeed, lack of radicalism might be extended beyond Cruikshank to the outlook and work of most English 19th-century artists, particularly following 1848 and the defeat of the Chartist Movement. After 1832 the English middle class had no further need to fight for its economic and political influence as it had on the continent, especially in France. On the contrary, the levelling process between aristocracy and middle class in England was even more extensive in the 19th than in the 18th century. In France during this same period, the bourgeoisie repeatedly engaged in revolutions to promote its influence and expansion, created an unbroken, consistent line of middle-class art, such as could only develop out of a genuine struggle for existence: classicism, realism and impressionism. In England, on the other hand, after the early enthusiasm for the Reform Bill had died down, a consistent, uncompromising, really advanced middle-class mentality and art were scarcely able to evolve. After the 1830s, the English middle class in the main produced only sweetened or sentimentalised, stylistically backward genre paintings. These,

fundamentally derivations from Wilkie, carefully avoided realism whenever it might in any way remind the spectator of anything socially unpleasant or depressing.

At this time it was very difficult for a conventional painter bent on consolidating his success to find interesting yet pleasing themes. Frith offered large rewards, even £200, for suitable suggestions. In his dilemma he twice imitated the principle of Hogarth's cycles but in a characteristically Victorian way, choosing themes which had by then become innocuous and could no longer offend the susceptibilities of any member of wealthy society. In 1878, in a series of five pictures, he showed the evils of gambling, culminating in suicide, the final scenes being set in France, that wicked country. A year later, in another cycle of five pictures, he traced the career of a fraudulent speculator, ending in a prison sentence. Frith's *Autobiography* (London, 1887) is an invaluable source by which to gauge the conservative outlook of an anecdotal painter in the second half of the 19th century.

The most revolutionary art that could possibly originate from the English middle class in this period was Pre-Raphaelitism, a hybrid mixture of late Romanticism and—by advanced continental, especially French standards—insufficient realism. It is certainly correct, by European standards, to consider this painting provincial. Seen from the English viewpoint, however, this solves its problems and complexities as little as calling the Austrian or Russian genre painting of the early 19th century provincial.[55] On first reflection one would not expect such a movement to have any links with Hogarth. Yet during the 1850s, the heroic period of Pre-Raphaelitism, the movement was so complex that there was room in it even for a limited 'Hogarth revival'. These artists' early efforts and ideas show obvious links not only with Ruskin and Carlyle but also with the strictly scientific, as it were, 'Darwinian' mentality. Pre-Raphaelitism at that time produced the maximum degree of analytical realism possible in the prevailing social and ideological conditions. Yet it is equally characteristic of this school that its 'fellow-travellers' such as Madox Brown, Brett, Wallis and Deverell, were more progressive than its genuine members. It was mainly they who produced this relatively most advanced, most documentary and at the same time, most intense English middle-class art of the 1850s.[56] However, much of the genuine Pre-Raphaelites' mentality and a certain amount of their hard, painterly formal language can only be understood as a belated continuation of the rather retrograde German Nazarene painters of the early 19th century, who a long time before (and more consistently than their English followers) were inspired in their search for truth and purity by 'primitive' Italian painting. But while the Nazarenes were ardent Catholics, with the Protestant and very English middle-class Pre-Raphaelites the religious tendency was transformed, especially at first and in Holman Hunt even permanently, into a moralising purpose whose obvious parallels and part originators were once again Carlyle and Ruskin.

The Pre-Raphaelites' programme consisted throughout most of the 1850s, at least theoretically, in realism and morality. Among some of them and in some of their works, there was therefore a certain approximation to Hogarth, of which both the artists and their theorists were well aware. But what did it signify? Did it merely imply adopting Hogarth's own themes? In Victorian times these naturally seemed far more conservative than they had over a century before. Obviously, new social themes were now needed in order genuinely to carry forward the 'Hogarth spirit'; or, at the very least, the old themes had to be taken up with a ruthlessness and robustness similar to Hogarth's. In the relationship of the Pre-Raphaelites to Hogarth both these approaches are to be found. One tendency in the early 1850s was to exploit the old Hogarthian themes or at least implications in a sentimental way, that is, in a manner alien to Hogarth and derived

rather from Greuze and the art of the second half of the 18th century in general. Such a tendency prevailed especially in the moralising genre pictures of Holman Hunt, the most genuine of the Pre-Raphaelites (e.g. *Awakened Conscience*, 1853, Anderson Collection). These are Hogarthian in the conventional, Victorian sense,[57] while their pronouncedly Hogarthian symbolism by now seems almost archaic. Even Rossetti, the least apt medium for this kind of painting, was for a short while caught up by the tendency to treat a subject from modern life in a moralising spirit (*Found*, beg. 1853, Bancroft Foundation, Wilmington, U.S.A.). Millais, too, during a few years of exceptional intensity, did a great number of Hogarthian drawings from contemporary life such as *Retribution* (1854, Collection Gray). But not all these drawings were just sentimental; most of them were also genuinely sincere, searching and expressive and some, such as *The Race Meeting* (1854, Ashmolean Museum, Oxford; Pl. 152), were of a refreshing brutality. This latter composition, with the debauched bankrupt in the carriage surrounded by bourgeois vultures in top hats, is as much of a 'revival' of *A Rake's Progress* as was possible.

However, it was Madox Brown, the best painter among them and the realism of whose art probably debarred him from entry into the Pre-Raphaelite Brotherhood proper, who had a real enthusiasm for Hogarth and the closest understanding of him. In him alone are any real social convictions and new, radical ideas to be found, not merely aping Hogarth but in many ways going beyond him. Some of his pictures, didactic and satirical as they are, display characteristic Hogarthian features, both thematically and formally. In particular, his famous series *Work* (1852–58, Manchester), with its praise of manual labour in marked contrast to the idle rich and its display of beggars and unemployed, possesses something of Hogarth's spirit in a progressive, 19th-century form, closer to Carlyle than to Dickens (Carlyle himself and F. D. Maurice, leader of the Christian Socialist movement, are portrayed in the picture). Also reminiscent of Hogarth is the way in which the composition is conceived: a dominant idea expressed in heterogeneous scenes and individually, somewhat grotesquely, characterised figures, cramped together and not easily disentangled. This same picture, like Hogarth's *Election* cycle, contains a satire on an English electioneering campaign: men stroll about with red posters on their backs bearing the inscription 'Bobus for Middlesex, Vote for Bobus'. The exact, detailed lettering of the posters, newspapers, etc., is of course deliberately Hogarthian. William Rossetti, Dante Gabriel's brother, rightly held that 'this is a picture to interest the countrymen of Hogarth'. In another series to which he devoted much effort, *Stages of Cruelty* (1856–60, Manchester), Brown was inspired by Hogarth's cycle but sought to be more subtle and psychological; it also opens with dog-baiting, but ends in the cruel treatment of a lover in place of a murder. In fact even William Rossetti, in various articles in *Fine Art, Chiefly Contemporary* (London, 1857), repeatedly acknowledged Hogarth's outstanding importance. According to him 'Hogarth was the initiator both of British and of modern art.' Somewhat later, in a lecture given at the Société des Vingt in 1873, Madox Brown also maintained that modern art derived from Hogarth and, what is more, attached such importance to this view that he and William Rossetti corresponded about it. Politically the most radical of the Pre-Raphaelites, it was Brown (and perhaps Morris) who was in 1859 the chief initiator of the Hogarth Club, at which the group could exhibit in opposition to the Academy.

All these pro-Hogarthian tendencies were, however, but a thread within the Pre-Raphaelite Movement, particularly evident in its early days. It was the pseudo-romantic, pseudo-medieval, languid art of Rossetti, one of the least important painters among them, which in the 1860s gave the movement its now familiar stamp. This escapist art of Rossetti, Burne-Jones and their

followers [58] left little room for sympathy with Hogarth. Nor was any to be found even where it might more reasonably be sought, namely in the topical illustrations of the satirical magazines. Cruikshank's slow descent into tameness resulted from the general historical trend and was in line with the development of English caricature as a whole. Although *Punch* was founded as early as 1841 after the pattern of Philipon's *Le Charivari*, begun in 1832, the fighting spirit of the illustrations in the French press of those years—themselves symbols of the relentless social and political struggle [59]—very soon disappeared from the cartoons of this essentially English satirical middle-class magazine. In fact, nothing could be less apt than to compare Leech with Daumier, Philipon's chief artist. A middle-of-the-road policy was no stimulus for vigorous, intense caricature. The respectable, over-compromising caricatures of *Punch*, expressed in a banal formal idiom that in itself had little to do with caricature, drove any thought of Hogarth out of mind. Even if some of the *Punch* illustrators professed their respect for Hogarth, it was more of a theoretical respect for their great ancestor without practical consequence.

Rossettian Pre-Raphaelitism and *Punch* between them buried Hogarth's art, but only for a while. [60]

XI

Hogarth's Impact on European Art

ONE of the objects of this book has been to show that Hogarth's art and whole line of development, though utterly English, could never be entirely detached from the various artistic currents on the continent. But just as important as the international premises of his art were its international consequences. So deeply and uniquely middle class in character was his art that it was bound to exert a major influence all over the continent, once the social and ideological ground had been prepared and each country came to develop its own middle-class art. It was this very outlook underlying Hogarth's art, such as could have arisen in the first half of the 18th century only in England, which gave an impetus to the subsequent development of bourgeois art on the continent.

Although at the time of Hogarth's death, France had the strongest middle class on the continent, the situation there differed considerably from that in England. Hitherto court and aristocracy, taking full advantage of the absolutist régime, paid little heed to the economic needs of the bourgeoisie, who scarcely counted politically and were considered socially much inferior. Thus the French middle class now had to launch its own revolution for the economic, political and social influence already secured by its English counterpart a century before. The general cultural atmosphere in England in the first half of the 18th century, in which Hogarth played an outstanding part, helped to set in motion the process by which French culture and art became an increasingly strong weapon of the bourgeoisie, leading up to the Revolution. For instance, after the mid-century, when censorship was slightly relaxed in France, the production of popular caricatures made headway and, by the time of the Revolution, was catching up with the situation in England in Hogarth's time.[1] Whilst in England middle-class culture had no need to be directed aggressively against the aristocracy, this same English culture was often used on the continent in a vehemently anti-aristocratic sense.[2] For instance the Deist controversies (against revealed religion) reverberated much more strongly and widely in France than in their country of origin. For English intellectual circles, lacking any real discontent with the social order, did not carry these polemics to consistent, dangerous conclusions.

An art like Hogarth's heralding ideas of the middle class inevitably had almost as stimulating an influence on continental art as English Parliamentary institutions had on Montesquieu and Voltaire,[3] or Locke's empiricism, Shaftesbury's optimistic moral philosophy, Newton's theories on the Encyclopedists[4] and English middle-class magazines and literature, embodying such subjects as appeals to virtue, psychological realism, sentimentalism and a feeling for nature, had on French writers like the Abbé Prévost,[5] Rousseau and Diderot.[6]

Far from being a mere matter of direct influence based on personal knowledge in each case, Hogarth's impact on French art was of a highly complex nature. It is, in fact, impossible to draw a strict border-line between a concrete English influence and a belated French parallel. Moreover, besides Hogarth and English paintings and engravings in general, other spheres of English art of the first half of the 18th century such as architecture and gardening, whose formal features tended even more to coincide with the general French development, have also to be taken into account for their impact on French art.[7]

Nevertheless Hogarth's engravings were more widely dispersed in France than is generally realised. I have referred to Rouquet's special French commentary, published in 1746 as a companion to Hogarth's engravings in France: 'Lettres de Monsieur . . . à un de ses Amis à Paris pour lui expliquer les Estampes de Monsieur Hogarth'. These contained explanations of the two *Progresses*, *Marriage à la Mode* and some other prints. This pamphlet was sent everywhere where there was a wide demand for Hogarth's prints, in particular to Germany and Italy. Moreover another of Rouquet's pamphlets, *l'Etât des Arts en Angleterre* (1755), which also covered much of Hogarth's art, ran through two editions in France, the first of which was dedicated to Marigny. The famous German connoisseur Hagedorn's book in which he contrasted the morality of Hogarth's works with the corruption of the French, was published in France in 1775 as *Reflexions sur la Peinture* and had a very wide influence. The French critics proclaimed Hogarth a top-ranking artist, recommended imitation of his moralising cycles and regretted the lack of them in France.[8] How popular Hogarth's engravings were in France is revealed by the anonymous author of a pamphlet, *Lettre à Sir Ch. Lovers*, in 1779: 'On s'arracha les estampes des mains, il n'y eut aucun chef de famille qui ne so crût obligé d'en faire l'emplette et qui ne les regardât comme une instruction plus propre que toutes les exhortations à retenir les jeunes gens dans le devoir.'[9]

The attraction of these engravings must be seen within the context of the great change taking place in continental, especially French, art. In a general way, this was a switch from gallant and erotic to didactic and sentimental subjects commending bourgeois virtues. The tendency in post-Restoration England to stress the moral aim of art was repeated all over again in France in the second half of the 18th century. Gravelot who returned to France in 1745 successfully propagated in his works the new moral spirit. Diderot, the art theorist of this movement, was influenced more than any other of the Encyclopedists by English thought and literature. An enthusiastic admirer of Richardson, whom he linked with Homer and Moses as a benefactor of mankind, he was much governed in his dramatic theories by the plays of Lillo and Moore and he compared the former with Sophocles and Euripides. Above all his ideas were thoroughly imbued with those of Shaftesbury, whose philosophy he translated and adapted.[10] His views on the close connection between art and ethics and on the role of morality in art in promoting general welfare, were derived from Shaftesbury and *The Spectator*. And together with the neo-antique doctrines of Winckelmann[11] and David, it was Shaftesbury's and Diderot's ideas which were to make up the art theory of the French Revolution.[12]

Diderot himself read *The Analysis of Beauty* before its translation into French and was clearly influenced by its empirical character as well as by the emphasis it laid on beauty and grace in nature.[13] His whole approach to art, as expressed in his *Salons*, is in many ways similar to Hogarth's: his thoughts did not run exclusively on theoretical lines, as was customary, and as a friend of artists he understood atelier jargon and its implications. In his *Salon de 1765* his observations, especially on principles of composition, were obviously inspired in part by *The Analysis of Beauty*. Like Hogarth, he recognised the public as a judge of art. In all these essentials, he was perhaps the only European parallel to Hogarth; whilst it is well to recall that in his conservatism Reynolds, the English art theorist of the following generation, stood at the opposite pole. I think there can be no doubt that Diderot not only knew *The Analysis of Beauty* but also Hogarth's engravings. At all events, his attitude in many respects sprang from a similar mentality: witness his plea to Greuze to represent bourgeois domestic life and bolster morality through his works, his emphasis on naturalness and expression,[14] and his advice to Greuze to create *tableaux vivants* in his pictures out of which, in turn, he made *tableaux vivants* on the stage.

Thus in their main aspects Greuze's compositions, forerunners of the art of the French Revolution and already compared with Hogarth's by his contemporaries, introduced the new genre of moral paintings, virtually invented by Hogarth into French art. The English origin of Greuze's world of ideas is self-evident. His sentimental picture of *The Dying Father*[15] (1761, Leningrad) can be traced back to Steele's description in *The Tatler* of a family mourning round a dying mother. His *Village Bride* (1761, Louvre) (Pl. 86b), a real landmark in French painting, one of Diderot's favourite pictures and the one through which he originally discovered the artist, had Hogarth's *Marriage Contract* as its thematic premise, though with a different slant. The choice of this particular theme was in itself significant of the new outlook: the signing of the contract with its financial settlement, the firm basis of a bourgeois marriage, now acquired sufficient importance to be shown in a picture,[16] whereas in former representations it had nearly always been the church ceremony. Indeed when the signing of the contract had been portrayed before, it was by such French and Dutch artists with middle-class mentality as Bosse (in an engraving), Steen (Brunswick) and Aert de Gelder (Brighton Museum and Art Gallery) (Pl. 85a).[17]

Never before had the marriage contract been depicted in such a reasoned, argumentative way as in Hogarth where, precisely because the underlying tendency is solidly middle class, it becomes a satire of social snobbery: the bridegroom's father—his crutches no less than the stool supporting his gouty foot are decorated with coronets—points to his genealogical tree issuing, as Horace Walpole put it, 'from the bowels of William the Conqueror', whilst the rich merchant eyes it as he ruminates on the likely cost of a title. In Greuze, then, where the honest, kindly father of the bride pays out the dowry to the bridegroom (the original title of the picture was, *Un Père qui vient de payer le dot de sa fille*) and even the notary with the marriage contract is benign towards the children, everything ironical and critical of the middle class falls away and the aristocracy does not even enter the picture. Thus Greuze's less intense, less polemical painting becomes a pleasant eulogy of the simple, homely bourgeois and peasant.[18] Comparing the two works, there is evidence not only of a thematic modulation towards the positive but also of a certain simplification in the build-up from Hogarth to Greuze. As appreciation of bourgeois conduct grew, happy, virtuous family life as already portrayed by Chardin became one of the main themes of French painting; and so the composition necessarily grew quieter, simpler, less baroque-rococo, at a later phase even rigidly classicistic, but always on a realistic basis.[19] This simplifica-

tion, at once rational and realist, easily developed out of a formal tradition—so different from the English—which always had Poussin in the background. Yet the build-up of *The Village Bride* is by no means far from Hogarth's manner. Diderot must have felt this instinctively, since it reminded him of Hogarth's serpentine line of beauty. In his *Salon de 1761* he describes the figures of *The Village Bride* in terms of *The Analysis of Beauty*: 'Comme elles s'enchaînent toutes, commes elles vont en ondoyant et en pyramidant'. In fact, simplification of the composition as it appears here was to a considerable extent prepared by Hogarth.[20] In him the clarity and accentuation of the gestures, largely modelled on those of the theatre and pantomimes, followed on the clarity and accentuation of the story-telling. This same process is repeated and even emphasised in Greuze. When Diderot advised Greuze to imitate the pantomimes in his paintings, he was fundamentally reiterating Hogarth's views. That is why I think it most probable that, in his famous moralising pictures such as *The Father's Curse, The Son Punished*, which like *A Rake's Progress*, are, in a way, middle-class versions of the Prodigal Son theme, or *The Dying Grandfather*, Greuze both thematically and formally adapted dramatic, theatrical scenes from Hogarth's cycles such as *The Harlot's Death*, the fainting lover in *The Rake in Prison* or such a particularly simplified composition as *The Dying Countess*. As was his custom, Greuze sentimentalised these and stripped them of grotesque details.[21]

Characterisation and expression—Hogarth's forte, but neglected features in French rococo painting—received close consideration from Greuze in his narrative pictures.[22] Encouraged by Diderot, Greuze also took over the principle of the narrative sequence—*The Father's Curse* and *The Son Punished*—and towards the end of his life planned a small series, *Life of the Harlots* after the pattern of *A Harlot's Progress*, and a large one in twenty-six scenes, *Baʒile et Thibaut* or *Les Deux Educations*, after the pattern of *Industry and Idleness*. In this latter, two young men were again to be contrasted and, as in Hogarth, it was to fall to the former, by virtue of his office, to pronounce the death sentence on the latter as a murderer. In his unfinished cycle of *The Happy Marriage*, Hogarth had represented the old theme of Acts of Charity—perhaps for the first time in painting—on a new bourgeois level, performed by a virtuous, happy young couple. This theme was portrayed anew by Greuze in his *Benefactress* bringing her small daughter to the bedside of a sick old man (Lyon). Greuze's art would certainly have been impossible without Hogarth; nor would the severe, moral, patriotic bourgeois art of David have been possible without Greuze.[23] Differences between Hogarth's compositions on the one hand and those of Greuze and David on the other have hitherto obscured the relations between the outstanding representatives of English and French middle-class painting and realism.[24] But these differences, particularly between Greuze and Hogarth, are not so great and they fade away once the deeper similarities are realised.

Between Hogarth and David there also existed firm points of contact. The impact of some of Hogarth's middle-class portraits emerges most strongly in David, his entourage and school. The patently unrefined vitality of the portrait of Hogarth's mother already points towards *La Maraichère* (Lyon) which—whether by David or not—is an apt expression in a female portrait of the new natural and unrestrained outlook prevailing in France during the 1790s.[25] And the robustness and individualisation of *Mr. Arnold*, so far in advance of its time, was the preliminary step towards the extremely realistic, nonchalant middle-class portraits of David and his circle, such as the famous portrait group in Le Mans (catalogued, apparently erroneously, as Michel Gérard, a member of the Convention and his family). Apart from obvious general connections, in one case there even appears to have been a direct and concrete influence on David, for it

seems probable that the build-up of his portrait of *Lavoisier and his Wife* (1788, Rockefeller Institution for Medical Research, New York) (Pl. 129a), was suggested to him by Hogarth's *Garrick and his Wife*, known on the continent through engravings.[26] Both reveal the same middle-class intellectual pose, with the important and completely new role of the wife behind her husband at his desk. David gave the scene a more serious character and, of course, subdued Hogarth's triangular composition in a classicist sense. And even going beyond David, there is a surprising similarity between *Mr. Arnold* and Ingres' portrait of *M. Bertin* (1832, Louvre) (Pl. 65b), a rich newspaper proprietor and editor of the *Journal des Débats*, which is generally referred to as the most typical portrait of a self-assured member of the middle class. A glance at *Mr. Arnold* confirms that such a rendering of bourgeois self-confidence could only have originated in Hogarth's England. M. Bertin's expression as well as his informal pose derive from its English predecessor: although the function of the hands is different, the effect is identical.

Portrait painting thus formed an important link between Hogarth and his English contemporaries on the one hand, and the next generation in France on the other.[27] But this is not all. In David, twenty years after Hogarth's death, history painting was to become the French middle class's chief means of self-expression in art; indeed Chardin directed his own son to the practice of history painting and was one of the first to encourage the young David. But Hogarth had also favoured history painting[28] and was perhaps the first painter in whom this genre was associated with middle-class feeling—an association which would not last much beyond David's time. As I have said, Hogarth regarded his moralising cycles as history paintings; he also painted genuine historical pictures. And it was the combination of these two genres—Greuze's and David's together, so to speak—which led to the great change in France towards the end of the century. With the prevailing, intense tradition and practice of history painting, this fusion of types became the most suitable field for didactic and moral aims after Greuze's genre pictures tailed off. Moreover, Hogarth's 'genuine' historical pictures prepared the ground for David's works in this genre, just as his portraits did in theirs.

A very important point which is frequently overlooked is that the evolution towards classicist history painting in France was an evolution towards naturalism.[29] Caravaggio, Domenichino and Poussin, who had in their time so radically arrested baroque painting, were necessarily the main influences on Vien and even more on David, as each strove to formulate a realistic classicism.[30] Yet, strange as it may seem, the immediate forerunners of the new French style were Hogarth's historical pictures, to which nothing in contemporary France could be compared. Even *Sigismunda*, painted for a member of the aristocracy and therefore in the usual Italian-baroque tradition, paved the way through its unaccustomed realism and directness of expression for the young David's figures such as *Andromeda mourning Hector* (1783, École des Beaux Arts, Paris).[31] But, since they were not destined for the aristocracy, some of Hogarth's earlier historical pictures were less pronouncedly baroque than, for instance, those of such contemporary Roman painters as the Maratta followers.[32] And since history painting in France up to about 1760 was generally of a Rubens-imitating character, Hogarth's works distinctly foreshadow the new French classicism from a formal viewpoint. His *Paul before Felix* anticipated by almost twenty years Vien's famous religious composition heralding the new style, *St. Denis Preaching* (1767, St. Roch, Paris), equally based on the Raphael cartoons. And the composition of his somewhat Poussinesque *Moses before Pharaoh's Daughter* is echoed in Vien's *Marchande d'Amour* (1763, Fontainebleau) (Pl. 100b), done eleven years later. Although Vien's picture was inspired by an antique painting in Herculaneum, discovered at that time, it coincides in so many details with

Hogarth's that it seems likely he knew an engraving of it.[33] And even David was not far from these pictures of Hogarth's, especially *Moses before Pharaoh's Daughter*.

In this same context it should be noted that the young David, like Hogarth and Greuze, studied pantomimes in the theatre in order to achieve his clear, precise language of gestures on his road to classicism. It is highly significant of this stage of close French-English artistic relations that on the one hand David painted his *Socrates* (1787, Bianchi Collection, Paris) after Diderot's pantomime on the same subject, and that on the other he took the suggestion for his *Oath of the Horatii* (1785, Louvre)—the French classicist picture *par excellence* and an early fulfilment of the artistic postulates of the French Revolution—from a pantomime of English origin based on Corneille's *Horace*.[34]

However difficult it may be to draw a strict border-line between influences and parallels, numerous concrete instances exist of English influence on French history painting during the decisive years when French neo-classicism was being formed by Vien and David. Given the greater strength of the English middle class, English classicism, in spite of the main 18th-century baroque-rococo tradition, was necessarily an earlier phenomenon than French and its influence was therefore inevitable. Besides, the impact of Hogarth's historical paintings on the French may have been the earliest, but it was by no means an isolated case. West's pictures, with their historical, mythological or Biblical themes, are an even more striking anticipation of David. These and similar English ones, such as those done by Gavin Hamilton in Rome, were disseminated through engravings and assiduously bought on the continent, especially in Paris.[35] By this means they strongly influenced David and other French artists in their progress towards classicism. For instance, in his early picture of *Andromache Mourning over the Dead Hector* (1783, École des Beaux Arts, Paris), David literally copied the head and bust of the corpse from a composition of the same subject by Gavin Hamilton (engraving 1764), while David's child Astyanax is taken from a picture by Angelica Kauffmann, painted and engraved in England (1772). Even so, the French critics reproached their painters for not keeping close enough to West and Hamilton.[36] English history painting was also ahead of the French in representing contemporary or past events in a patriotic vein—another result of the English middle class's early development, and consequent sense of pride in its country's history. And Hogarth's *Henry VIII and Anne Boleyn*, also to some extent his *Garrick as Richard III*, belonged to this early patriotic vein of history painting which soon after reached a climax of international importance in West.[37]

In France in the second half of the century it was only the enlightened absolutism of the court which, ready to concede to the taste of the middle class, assisted the evolution of a history painting which was sometimes classicising, sometimes baroque, but thematically frequently patriotic-monarchistic (through orders given by the Directeurs des Bâtiments du Roi). In England, however, George III's personal sympathy for West's art was sufficient to provide not only a parallel to, but even an anticipation of, French classicist history painting. In both countries innocuous subjects or those lending themselves to Royalist or patriotic interpretation—often identical and usually of English inspiration—were selected from Greek or Roman history: e.g. the theme of *Antiochus and Stratonice* treated by David (Prix de Rome) and by West. David's picture (1774, École des Beaux Arts, Paris) was influenced by Hamilton's *Andromache* while its subject was taken up in turn the following year and further developed in a more classicist sense by West.

Apart from the constant interaction between the history paintings of the two countries before

the Revolution, it is noteworthy that the young David's picture was still at that time more baroque than either of the two English works. But as the political trend in England became increasingly reactionary and in France increasingly radical, English history painting and classicism were soon to be overtaken. The Revolution gave French history painting the chance fully to unfold itself. A consistently realist-classicist art was created, with intensely patriotic themes taken from ancient and contemporary history and displaying civic virtues, whilst its English counterpart, with the part Hogarth had played in its inception, was for historical reasons to remain only a latent possibility of great promise.

One could multiply indefinitely these English–French parallels in which Hogarth was always the precursor. I will mention only one more interesting case. Hogarth favoured history painting, but not a Royal Academy. Thus he had anticipated David's attack on the inherent inequalities of the French Academy, whose abolition he effected in 1792. In his own Academy as early as 1735, Hogarth abolished the prerogatives held by the leading members of institutions of this kind in order to avoid imitation of 'the foolish parade of the French Academy'. For, like a symbol of his whole art, his Academy constituted a democratic, bourgeois interlude between that of Kneller and Thornhill on the one hand, and Reynolds' Royal Academy on the other.

I have treated at some length the artistic development from Greuze to David, inaugurated by Chardin and leading to the realism of Géricault and Courbet; Hogarth's role in this evolution is not generally realised, since the formal features of his art, based on the intermittent English development before him, do not conform entirely with the realist classicism that developed gradually in France after him. It has been more usual to stress his immediate influence on the art of European countries other than France which followed the bold French development slowly and after a certain time lag. Even to-day such expressions as the 'Dutch Hogarth', the 'Italian Hogarth', the 'German Hogarth', the 'Hogarth of Sculpture', are frequently applied to these so-called Hogarth imitators.

By English standards Holland was increasingly a social and political backwater. Apart from some elegant, decorative, mythological-allegorical painting in French and Italianising baroque-rococo taste, realistic genre painting in the old tradition was vegetating, with a more or less precarious, epigone existence. Cornelius Troost (1697–1750), the Dutch Hogarth, a contemporary of his English namesake, was the outstanding artist of the middle class. He mirrored Amsterdam bourgeois life, though in an infinitely less complex, more superficial and amiable way than Hogarth reflected that of London. At first, like Hogarth, he concentrated on portrait groups in their natural surroundings; but the faces were more doll-like, the compositions more closed, primitive and rigid, the colouring louder and the handling less painterly. Later, like Hogarth, he practically discontinued this genre. Towards the end of the 'thirties, he represented many theatre scenes, mostly from gay Amsterdam vaudevilles together with a few from Molière. Some of his scenes from the Dutch comedy *The Disguised Servant* (The Hague) have a certain compositional resemblance with Hogarth's *Farmer's Return*. In the event of Hogarth's having seen engravings after these, one could add their influence on *The Farmer's Return* to those other Dutch influences already noted; but it is more probable that Troost's scenes are merely Dutch parallels to Hogarth's late rococo-classicism. In his scenes from Molière, Troost too seems to have been influenced by Coypel's and perhaps by Lancret's representations. Like Lancret, he depicted various scenes from these plays in consecutive pictures, but compared with the French and with Hogarth, fidelity to the actual performances is diminished by the introduction

of hackneyed elements from Dutch interior genre painting, as in his rendering of *Le Malade Imaginaire* (1740s, Berlin).

He was less attentive to psychological expression than Hogarth but more so than the French. In his preoccupation with merely humorous expression, he accentuated the Dutch tradition, especially that of Steen. But whereas, like Hogarth, he started from Steen, he only went as far as Hogarth did. In his delectable narrative series of five gouache paintings, *Nelri*[38] (1740, The Hague) (Pl. 148a), he comes fairly close to Hogarth's cycles, which were naturally well known to him and from which he would have taken the idea of such a series. But there is little here of those aspects of middle-class society which—by English but not by Dutch standards—had greatly changed since the 17th century; and none of Hogarth's combative, critical outlook and didactic aims. Troost's series shows the cumulative but tranquil effect of drink—from moroseness to tempered hilarity—on a harmless bourgeois circle of friends. For all his acute observation, he fundamentally upheld the 'pleasant' ways of Steen and Dutch genre painting, even when representing drunkenness. His works show little of Hogarth's striking individualisation and none of his ruthless characterisation, compared with *A Midnight Modern Conversation*, the likely source of his inspiration. Stylistically Troost's series combines Steen, the realistic classicism of the school of Delft and something of rococo.[39] Compared with Hogarth, it has much less French rococo painterliness, if indeed any painterly knowledge at all, while the remnants of Pieter de Hooch's classicism strike a harsh, monotonous note. Although Troost had behind him all the tradition of Dutch 17th-century painting his pictures, compared with Hogarth's, betray a more backward country and a far more insignificant painter.

In the various small principalities of Italy in the 18th century, court and aristocracy counted to an even greater extent than in France, and a middle class scarcely existed on an effective scale. Exceptions were the large mercantile cities such as Naples, Genoa, Milan and particularly Venice, but even so the aristocracy was far and away the most decisive factor. From such conditions it follows that baroque and rococo religious painting and courtly-aristocratic portraits were the main types of art. However, an Italian translation of *The Analysis of Beauty* was published in 1761,[40] and Hogarth's engravings had a certain vogue, especially among the middle-class intellectuals. Typical of such admirers was the political philosopher and reformer of criminal law, Beccaria, perhaps the most progressive Italian of the 18th century, who attempted an imitation of *The Spectator* in Milan. In his *Essay on Public Happiness*, he cited Hogarth's *Rake in Bedlam*.

It was certainly a sign of the new spirit in Venice—where in 1760 Gasparo Gozzi edited *l'Osservatore* in imitation of *The Spectator*—that Pietro Longhi (1702–86), the 'Italian Hogarth', who was only six years younger than Tiepolo, soon renounced painting baroque-mythological frescoes for genre pictures of contemporary life in an entirely new documentary vein. This changeover perhaps dates from as early as *c.* 1734, but most of these pictures were apparently painted during the last years of Hogarth's life and after his death. Longhi is said to have taken up this genre either as a result of studying under Crespi in Bologna or under the influence of Hogarth's engravings. However that may be—and it seems to me that individual figures in *Marriage à la Mode* could well have interested him—his pictures show more variety and greater penetration than Dutch 17th-century genre painting. He rendered the leisure pursuits and manners of the Venetian merchant aristocracy, which had certain urban, middle-class features and also occasionally of humbler people.[41] This he did more systematically than had ever been done before in a faithful, journalistic manner with a strong feeling for atmosphere. Thus Longhi,

but for whom we should know far less than we do about the life of the Venetian aristocracy,[42] has a certain affinity with Hogarth. But Hogarth's art is not mere genre painting but critical and argumentative; and the faint, almost imperceptible humour in some of Longhi's pictures—far from the irony it is nowadays fashionable to detect in it—is no substitute for this spirit.

Nor did Longhi have Hogarth's penetrating powers of observation. The few rather static figures to which his pictures are reduced reveal a greater naturalness than those of average French rococo genre compositions; less stocky than those of Troost, they are at the same time more rigid and elaborated than Chardin's or Hogarth's, while the compositions are less concentrated. His rigidity—the embarrassment, as it were, of the new naturalism—accords ill with his baroque apparatus, as can be seen in his strongly accentuated repoussoir figures; whereas Hogarth, who had started from a somewhat similar stylistic position, soon managed after his initial difficulties to create for himself a realist baroque idiom,[43] Longhi never succeeded in mastering this new idiom with any ease. From a painterly point of view, he never advanced beyond Hogarth's early stage, as typified by the charming, not very broadly painted pink and white girl holding a fan in the scene of *The Rake in Prison*—a Longhi figure at its very best or even perhaps too good for him. Despite a certain colouristic *finesse* on a minor scale, Longhi is harder, less 'French' than Hogarth. So that, even as to the manner of painting, one can at most only compare his genre scenes with the weaker examples of the two *Progresses* and not at all with Hogarth's later works. Perhaps only Longhi's most graceful work, *The Dancing Master* (Academy, Venice) (Pl. 81b), can be compared with the group on the left of Hogarth's *Staymaker*, derived from Cochin. But Longhi's conventionality and tameness, however charming, always tell against him *vis-à-vis* Hogarth; compare, for instance, his *Dancing Master* with Hogarth's formidable *Wedding Dance*, his *Toilet Scene* (Museo Civico, Venice) with the *Levée* scene of *Marriage à la Mode*, his *Fainting Scene* (Kress Collection, New York) with the *Death of the Harlot* or, for that matter, even such an interesting work as his *Rhinoceros in an Arena* (National Gallery) with Hogarth's far more baroque, expressive overflowing and exuberant *Cockpit*. Even Longhi's compositions of identical subjects cannot really stand the comparison: for example, his *Tailor* (Academy, Venice) as against Hogarth's far more flexible *Staymaker*. Longhi's portrait groups fare a little better, that is in relation to Hogarth's less important, relatively most conventional paintings: if, for example, one juxtaposes his portrait group of a family (Bergamo) or his *Cup of Tea* (Private Collection, Florence) with *The Strode Family*, despite more or less similar differences to those already noted, Longhi's characterisation of individual figures and his settings are almost on a level with Hogarth's.[44]

Longhi could not on his own new level of realism create a baroque style which his teacher Crespi was quite capable of achieving on his own lesser level of naturalism.[45] That is why Crespi is at times almost closer to Hogarth than Longhi: I refer, for instance, to the baroque build-up of his *Baptism* (1712, Dresden) as compared with Hogarth's *Orator Henley christening a Child*. A genuine line of realistic, narrative, forceful, baroque in north Italian painting led from Crespi and Piazzetta to Guardi's genre pictures of the *Ridotto* type[46] and to Pietro Longhi's son, Alessandro (1733–1813). Like Crespi (with whom he has resemblances) but now on a new level of realism, Alessandro Longhi was able to create in his few genre pictures an organic synthesis between baroque and realism. That is why his own version of the *Rhinoceros in an Arena* (Count Salom, Venice) is closer to Hogarth than the purely documentary one by his father: it is more dramatic and pointed in its conception, has a newly established, more clarified baroque pattern, is broader and more pictorial. Pietro Longhi's timidity stands midway between the

baroque *élan* of Crespi and that of his own son. But the importance of his new themes, his new realism, his elaborate details, is undoubtedly great, at least from an Italian point of view.

The younger Tiepolo, like the younger Longhi, is also frequently compared in Italian art-historical literature with Hogarth. There is, indeed, something slightly satirical (i.e. mildly critical of their own stratum) in Giandomenico Tiepolo (e.g. his fresco of the *Mondo Nuovo*, from the Villa Zianigo) even perhaps more than in Alessandro Longhi and this tendency, by the standard of previous, nonchalant Italian baroque aristocratic painting, connects them in a general way with the new social-critical trend of which Hogarth was the outstanding exponent. In Italy a realist-baroque narrative art naturally developed later and less intensely than in England and by comparison remained not far from mere decorative baroque, in spite of its occasional vigour. Within these limits, Giandomenico's evolution away from the art of his father corresponds to the relation between Hogarth and Thornhill.

Hogarth's interest in physiognomy and the stage are much more closely reflected in one of the most fascinating artists of the 18th century, the Neapolitan Gaspare Traversi (1732–69). A good deal younger than Hogarth, Traversi received his artistic education in the city where the tradition of della Porta's exploration of physiognomy was still very much alive. He was little known, even in his own life-time[47]; but for this, he too would probably have been designated an 'Italian Hogarth'. His interest in fleeting expression, seized gestures, the correct attitudes to stress the psychological undertones in his anecdotes and theatrical effects predominates in his genre pictures of day-to-day Neapolitan life. In one of his pictures (formerly attributed, characteristi-cally enough, to Ghezzi), he also represented the middle-class subject of *The Marriage Contract* (Galleria Nazionale, Rome) (Pl. 86a), almost certainly with the engraving of the same theme after Hogarth in mind, since some of his attitudes are very similar, though in different combinations. Traversi's scene is given a schematically decorative setting; with its large columns, sinuous draperies, obliquely placed windows and groups juxtaposed in diagonal waves, it comes closer to the pattern of a baroque equilibrium than the peer's dwelling in Hogarth's work with its descriptive, less generalised realism. The facial expressions of these members of the wealthy, aristocratising Neapolitan bourgeoisie are also slightly more conventionalised than Hogarth's, perhaps because the Neapolitan, otherwise so original, was attracted by the similarity of subject and used Hogarth's composition as a model.[48] Again, Traversi would seem to have recalled certain gestures and expressions in another scene of *Marriage à la Mode*, the *Levée of the Countess*, when painting *A Musical Entertainment* (present whereabouts unknown). Obsessed as he was with the problems of pungent story-telling and facial expression, he would have been well acquainted with Hogarth's engravings, at that time much in demand in Italy.[49] This throws an interesting light on the international aspects of Traversi's type of painting, though of course it in no way detracts from his originality.

There is also a curious similarity between Traversi's work and Zoffany's *Concert of Wandering Italian Minstrels*, based closely on Hogarth but painted in Italy *c.* 1773 for the Duke of Parma (to this day in the Gallery at Parma) (Pl. 144a). This shows an astonishing variety of expressions (including a blind man), faithfully and penetratingly observed without any sugary toning-down. It is difficult to imagine this picture by Zoffany, who had gone directly from England to Italy, without Hogarth; at the same time perhaps no other 18th-century painting is so close to Traversi, despite the over-crowded Hogarthian composition, the Italian actors with their musical instru-ments adding to the similarity of the conception. It is the general European interest in physiog-nomy in the second half of the 18th century and the connection of both artists with Hogarth that

explains this similarity. Yet another link exists between Zoffany and Traversi: Zoffany's first master, the German Speer, was, like Traversi, a pupil of Solimena in Naples and might well have contributed to Zoffany's education in physiognomy—a traditional Neapolitan interest. Generally speaking, Traversi's pictures (very often half-lengths with a discernible Caravaggesque starting-point as in Hogarth) can instructively be compared with some of Hogarth's caricature-like compositions such as *The Singing of an Oratorio, Taste in High Life* or best of all *The Laughing Audience,* in which a real genre subject is combined with an exercise in sharpness of individual physiognomy. [50]

Economically and socially, Germany stood somewhere between France and Italy; she was less advanced than France, more so than Italy. But the courts—where the prevailing art was baroque-rococo—did not have the monopoly of cultural and artistic life, which extended to the middle-class intellectual centres in both towns and universities. Although isolated in their usually tiny states, the urban middle classes took an interest in politics, at least until the French Revolution, when fear of revolutionary excesses ended the political topicality and realism of German literature. Intellectually very wide-awake, sentimental, moral and philanthropic, the middle classes were increasingly keen on the cult of the individual and a painting corresponding to this outlook thrived in Germany, mainly from the 1760s. Given this situation, the stimulus of England on the German bourgeoisie was enormous; not only was a keen interest taken in English middle-class literature, particularly Richardson, Fielding, Sterne and Goldsmith, but Hogarth himself was greatly appreciated.[51] Based as it was on a wide general knowledge of a vast number of his engravings, this reverence for him far exceeded that in any other country.[52] In fact, Hogarth was *the* 18th-century artist for the progressive German intellectuals of Enlightenment, not only through his engravings but even through his art theories.

In 1762, still in Hogarth's lifetime, the foremost German art connoisseur, Charles L. Hagedorn (1713–80), director of the galleries and art-academies of Saxony, praised the morality of Hogarth's works in his *Reflections on Painting.* Hogarth's popularity was further enhanced by the pungent, witty commentaries of his great admirer, the physicist and critic Lichtenberg (1743–99), on all the cycles and a few individual engravings, published in Göttingen in 1794–9 (*Ausführliche Erklärung der Hogarthischen Kupferstiche*).[53] One of them, *A Midnight Modern Conversation,* was probably the first English print to be re-engraved and re-published on the continent. It was so popular in Germany that it was copied on porcelain pipes, snuff-boxes and in life-size wax groups. Intellectually the spirited Lichtenberg was far superior not only to his relatively more solemn and dry contemporary English counterpart, J. Ireland, but also to any other systematic commentator on Hogarth in that period. The masterly essays in which he discourses on Hogarth's engravings far exceed mere commentaries yet cannot be termed fantasies; he himself names them 'poetic commentaries' and clearly indicates his wish to avoid moralising sermons in Trusler's manner. Meticulous by nature, he implements his own witticisms to explain details of Hogarth's engravings, but does so in the spirit of the artist himself. Indeed his humour, though more delicate and lighter than Hogarth's, has kindred qualities with its impishness and inclination even to punning. His often erratic, rambling observations are also reminiscent of Sterne, though they keep more to concrete facts.

Lichtenberg was particularly well equipped to appreciate the countless associations that the cultured (in this case almost too cultured) 18th-century spectator experienced when faced with Hogarth's prints and no German, indeed no continental writer, was better qualified to comment on them. Teaching at Göttingen University in Hanover, under the King of England's rule, he

was the outstanding exponent and greatest connoisseur of English thought in Germany. Politically, too, he favoured the English constitution, with a limited monarchy, and opposed the aristocracy's class prejudices. No foreigner knew England, which he visited twice (1770, 1775), more thoroughly, whether her court or her lower classes,[54] her literature, theatre, art, philosophy or science.[55] Nothing was more congenial to his rationalism and empiricism than the realism of English art and literature. His consuming interest in mankind—as consuming as Hogarth's—drew him irresistibly to a profound study of Shakespeare and, through Garrick's interpretation of him, to the study of Hogarth and Fielding.[56] He frequently compared these two, their representations of reality and their observations on human nature, often alluding to motifs in Fielding for the better explanation of Hogarth's scenes. As Lamb did later, he clearly saw the human element in Hogarth's figures from low life. And one of his main tenets was the betterment of morals through art and literature. Not only his humour but his whole outlook was akin to Hogarth's, and conversely Hogarth could almost have been the author of many acute observations in Lichtenberg's *London Diary*.

Interest in physiognomy naturally followed on Lichtenberg's studies of the individual. In the 1770s and 1780s the physiognomic studies Hogarth had largely helped to promote, became the most topical theme for theory and art alike, and under Hogarth's auspices it was to a large extent in Germany, with its sensitive intellectual climate, that the battle of physiognomy was fought out. In his *Physiognomische Fragmente* (1775–8), one of the books most widely read throughout Europe,[57] Lichtenberg's adversary, the far more irrational Lavater, assigned a high but very strange place to Hogarth's art. Lavater was not really interested in the composition of a work of art as a whole but only in the expression of the faces; he held an almost religious belief in the harmony between soul and body, in the outward reflection of inner and moral beauty in the human face: consequently Raphael was his ideal and Hogarth, even more than Rembrandt, his aversion. In fact, he regarded Hogarth as the 'false prophet of beauty', that is, as the greatest artist to render bad characters and thus to demonstrate that 'nothing makes man so ugly as vice'. To show this, Lavater assembled many figures by Hogarth on three plates in newly invented groupings, to illustrate his depravity. Besides the portraits of Lord Lovat and Wilkes these figures were mainly selected from the cycles as well as from *A Midnight Modern Conversation*, *Gin Lane* and, surprisingly, even *The Laughing Audience*. The most devilish figure, in Lavater's view, was that of the idle apprentice sent to sea in a boat scornfully jesting in the presence of his mother. To underline his point of view, Lavater, through his engravers, either greatly exaggerated the expression of Hogarth's figures or introduced an entirely new one—e.g. among the originally harmless figures of *The Laughing Audience*.[58]

This emotional and fanatical representation of Hogarth as a kind of Lucifer shows what a unique place his engravings occupied during these decades in the conscience of even those intellectuals who took a negative view of him. Lavater held that it was mainly the bone structure of the head which determined character, whereas the empirical Lichtenberg, under the influence perhaps of Parsons and certainly of *The Analysis of Beauty*, was chiefly occupied with the play of features and mobility of expression. He believed that Lavater's point of view would lead people with the 'wrong' physiognomy to despair, believing themselves to be born criminals. He himself, like Hogarth, took a deep interest in unusual traits and in actual criminals; and, like the English and the whole of German Enlightenment, he believed fervently in the perfectibility of man. His cautious scepticism on questions of physiognomy and his warning against forming hasty judgments based on outward appearances are close to *The Analysis of Beauty* as well as

to the French Encyclopaedia. As for Hogarth, Lichtenberg denied that he was a caricaturist or, in Lavater's sense, a painter of vices, and upheld him as an expert painter of the soul.

The best known German engraver of these times was Daniel Chodowiecki (1726–1801), an artist of the Berlin middle class who was already named the 'German Hogarth' during his life-time. He was perhaps even more business-like and industrious than Hogarth (he began as a grocer) and, in accordance with the more frugal Berlin atmosphere, less keen on good living. Like Hogarth, he tried to be a useful citizen and was much occupied with charitable and adminis-trative duties. Perhaps no other 18th-century artist of his not inconsiderable quality worked so exclusively for the middle class, inspired by subjects of interest only to them. However, even a generation after Hogarth's death, the small, provincial and philistine middle class of Berlin could only within very moderate limits produce something that might be called an independent, militant, critical art.[59] Chodowiecki had little of Hogarth's unique creativeness, still less since he was almost purely a book illustrator, even if a very likeable one. His art accorded with the pro-nouncedly philanthropic spirit and sentimentality of German Enlightenment and, as he himself says, he was averse to the bitterness and ugliness in Hogarth. Yet he took from Hogarth as much as, and perhaps occasionally even more than, was compatible with his own art. Though more versatile, he sometimes seems to have found Greuze's mentality congenial, as witness his popular and ambitious work, *Calas's Farewell to his Family in Prison* (picture and etching, 1767) (Pl. 55b); Calas, a French Protestant executed on false evidence, was rehabilitated by Voltaire after his death. Yet the case is not so simple as a first glance might suggest. Paradoxically, this com-position, which made Chodowiecki's name amongst a wide public and won him Lavater's admiration and consequently the series of commissions to illustrate his book, is based on *The Rake in Prison* (Pl. 55a), by Lavater's arch-enemy Hogarth. The build-up of the two main groups and their inter-relation are identical. The Rake in despair becomes Calas in despair, and the girl fainting is Calas' wife fainting, also surrounded by figures attempting to revive her. Calas' gesture is that of the Rake's wife, and the priest entering the cell corresponds to Hogarth's turnkey. Chodowiecki's only transposition was to turn Hogarth's tragi-comic prison scene into a tragi-sentimental one and to temper Hogarth's baroque in the direction of Greuze.

As the outstanding German book illustrator of his time, Chodowiecki is generally far less heroic, 'grand' and dependent on foreign sources than in the Calas composition. He illustrated popular books of the German middle class, mainly novels and works of a didactic character. Here he represented everyday events and stories of family life, not only from German literature (often under English influence) but also from France and England—works such as Goldsmith's *Vicar of Wakefield* (1784), Sterne's *Sentimental Journey* (1784) and Richardson's *Clarissa* (1784–5). Compared with previous German art, there now appeared quite a new, realistic characterisation of the figures, new, natural attitudes, and facial expressions based on genuine study. Harmless and tranquil, idyllic and sentimental, these countless illustrations inaugurated a new era of German realism.[60] Chodowiecki made some attempt to imitate contemporary French engravings and his style is an often charming, sometimes rather rigid Louis XVI, frequently even close to classicism.

Chodowiecki's etchings of didactic-moral cycles published in various Calendars are not properly speaking book illustrations. Almost inevitably all these cycles are fundamentally emanations from, or imitations of, Hogarth. This is most directly true of the first of them, *The Life of a Rake*, published in the Berlin Calendar in 1774, some forty years after the appearance of Hogarth's *Progress*. By the standard of his own best book illustrations and at the same time bearing his model in mind, Chodowiecki's cycle is rather artificial, stiff and in places almost

ridiculous. Like Hogarth, he invented his own story [61] but was incapable of plumbing the wealth and depth of life like his great predecessor; indeed, in all his cycles he only produced scenes of a generalised character. Moreover, as a lover of the happy, tranquil marriage and family life which he most often represented, he felt out of his element when called on to portray passions or scenes of dissoluteness. Unsure of himself in such episodes he kept even closer to Hogarth—yet not too close, for fear of his out-and-out realism. Thus, in the drinking scene of this cycle, he chose to imitate the more harmless *Election Entertainment* rather than the corresponding scene of *A Rake's Progress*, *The Rake's Orgy*; and his *Death of the Rake* obviously derives from Hogarth's *Rake in Prison*. Another cycle, *The Life of a Badly-educated Woman* (1780), also published in the *Berlin Calendar*, was again an extremely tame, lady-like combination, as it were, of themes from *A Harlot's Progress* and *Marriage à la Mode*. The scene *Teaching the Fine Arts* (Pl. 141b), goes back, even in its details, to Hogarth's *Levée* (Pl. 90c).

In contrast to Hogarth, Chodowiecki much preferred to portray positive, moral activities and did so increasingly; even Goethe praised his method of juxtaposing the hateful and the lovable, thereby implying a contrast to Hogarth, whom he found too satirical. Yet Chodowiecki's sincerity, arising from his more austere and socially more backward milieu, distinguishes his from such equally positive, moral and sentimental cycles as Morland's. Thus in the following year, in *Occupation des Dames*, he showed the domesticated, industrious housewife at work. However, most of his cycles were done for Lichtenberg, who invented their themes and whose empirical views suited him far better than Lavater's. Enhanced by his own lively comments, Lichtenberg brought out Chodowiecki's cycles in the various annuals of the Göttingen Calendar, of which he was editor and in which prior to his detailed Commentary he also published many engravings after Hogarth.

Chodowiecki's first cycle for Lichtenberg was *The Progress of Virtue and Vice* (1778) (Pl. 144b). Half-figures were juxtaposed, so that their physiognomy could be stressed and the influence of the two opposing modes of life revealed in their faces down the years. Lichtenberg explicitly required that the cycle follow Hogarth's manner—*Industry and Idleness* being the obvious prototype—and as models for the harlots' heads he proposed those in *The Rake's Orgy* and *The Rake in Prison*, even offering to lend Chodowiecki his own Hogarth engravings for this purpose.[62] The latter, however, having neither Hogarth's boldness nor his range of physiognomic knowledge, contented himself, especially in scenes of a negative character, with a conventionalised rendering of the chief features of the face. His cycle of *Natural and Affected Actions*, published in 1779 and 1780 (according to Lichtenberg, naturalness reflected an English education, affectedness a German one), was again studded with reminiscences of Hogarth. Notably in the scene of *Greeting*, his affected couple recalls the one in Hogarth's *Taste in High Life*, which probably inspired this particular series and which frequently recurred as a model in Chodowiecki's works, though with any offensiveness as usual toned down. In his two juxtaposed scenes of dancing, Chodowiecki took over from Hogarth's *Wedding Dance* the contrast between the graceful and clumsy couples, his affected dancer being perhaps an even closer imitation of Hogarth's dancing master in *A Rake's Progress*.

With Chodowiecki, however, it is unnecessary to record every individual borrowing from Hogarth, whether in a literal or a general sense. Frequent parallels follow from their positions as pioneering middle-class artists. This applies to the various other cycles Lichtenberg commissioned from him with themes designed to evoke works of psychological and physiognomic interest: *Marriage Proposals* (1781–2), *Centifolium Stultorum* (1783), *Reasons for Marriage*

(1789), *Sincerity and Hypocrisy* (1794). The natural temptation to compare them with Hogarth's is not to the benefit of these often charming cycles. As a result of such comparisons they often appear of an unnecessarily superficial, didactic and typifying character, although Chodowiecki certainly took pains to find the right attitude, gesture and facial nuance in each case and sometimes succeeded to a remarkable degree.[63] Despite his inferiority in comparison with Hogarth, this typical representative of German art in the second half of the 18th century was nevertheless in many of his ideas the German Hogarth imitator *par excellence*.[64]

This new exploration of physiognomy, inspired far more by Hogarth than by Ghezzi or even Lebrun, was pursued by many others in Germany besides Chodowiecki and culminated in the art of a man of far more unusual temperament—the Württemberg-born sculptor, Messerschmidt (1732–83), the 'Hogarth of Sculpture', although only partially so.[65] Messerschmidt first lived at Vienna, teaching at the Academy and painting various members of the Imperial household and a few intellectuals. Although his earlier portraits were in the grand baroque-rococo vein, they reveal a more than usual interest in characterisation. Even so, they became increasingly realist and classicist. In 1775, after signs of incipient madness, Messerschmidt left Vienna and in 1777 settled in Pozsony (Pressburg) in Hungary[66] to concentrate alone and haunted by ghosts on a long series of character studies. It was mainly there, in the last six years of his life, that he did some forty-nine extraordinarily varied and subtle heads. Forty-five of these are preserved in casts, while some of the original lead and stone busts are now in the Austrian Baroque Museum in Vienna. His own head always formed the starting-point for these studies, but only a few can be regarded as self-portraits depicting specific passions and definable as physiognomic studies proper; as such, they correspond more or less to the ideas of Parsons, who had demonstrated varying shifts of expression on one and the same face.[67] Most of these heads, however, rendered artificial grimaces, with only elements of true expression. A few are entirely fantastic and irrational. And even if these heads grew out of the general interest in physiognomy, most of them can only be understood as the creations of an insane, obsessed artist, as an expression of his psychosis. Thus the appellation 'Hogarth of Sculpture' was merely a posthumous attempt to rationalise works seemingly beyond explanation.

In the realm of art theory *The Analysis of Beauty* made an immediate and deep impression on German intellectuals. At this time of middle-class naturalism, bourgeois theorists inevitably felt the need to link up with Hogarth, who was capable as an artist of giving art theory a precise and empirical basis. It was into German in 1754, only a year after its English publication, that the book was first translated, and it was read far more appreciatively in Germany than anywhere else, not excluding England. In 1757, the Academy of Ausburg, as a tribute to the book, elected Hogarth a member—a distinction which greatly pleased him. It was above all welcomed by Lessing, the outstanding spokesman of Enlightenment, the playwright and theorist with the most obviously middle-class mentality and responsiveness to English literature. A Shakespeare propagandist and a follower of Shaftesbury, Richardson, Lillo and Moore, Lessing enthusiastically acclaimed *The Analysis of Beauty* and suggested a second, cheaper edition—which, in fact, appeared in the same year—for which he wrote an introduction. The theory of the serpentine line appealed to him as giving precision and clarity to the various current notions on beauty. He believed that, thanks to Hogarth, the time had arrived when quarrels over taste were no longer possible. As a middle-class theorist lacking any close relation with art, he attempted to outdistance Hogarth and work out the Englishman's waving line mathematically, an attitude, which at the time of the French Revolution, was understandably carried even further by dilettantes.

In his famous treatise *Laokoön* (1766), heralding Winckelmann's classicism, he shows himself greatly indebted to *The Analysis of Beauty*, especially to its qualifying remarks on a canon of proportions in antique sculpture,[68] and Mendelsohn, the true philosopher of German Enlightenment, was even more influenced than Lessing himself by the book's realist method.

More unexpected, at least on first reflection, is the influence exercised by *The Analysis of Beauty* on Mengs and especially on Winckelmann. Yet this was quite consistent. A middle-class intellectual like Lessing, who had laid the groundwork of his art theory, Winckelmann nevertheless stood much closer to art and allowed it a far greater importance in life. Both were convinced that imitation of the antique meant naturalness, in contrast to the unnatural courtly art from which it was their task to break away. Winckelmann, however, did not live in any ivory tower but played the role of a discoverer anxious to vitalise art for the general public by relating it to history. Obliged to spend his youth under the despotism of petty German rulers, he was athirst for liberty and his culture was based on the English and French middle-class thought of Shaftesbury, Addison, Pope, Montesquieu[69] and Voltaire to an extent scarcely realised to-day.[70] And *The Analysis of Beauty* was just as new and revolutionary as the most progressive English and French middle-class literature.

In Winckelmann traditional abstract art theories were closely linked up with the empirical elements in the new English bourgeois outlook. Fundamentally his ideas were derived from the neo-Platonism of Italian 16th-century theorists, not to mention Shaftesbury. And for him even more than for the neo-Platonists, the human figure became divine by becoming simple, and simplification implied linearity. Line was the kernel of his system, the key to antique sculpture. And since no one else treated this nearly so thoroughly, Hogarth's serpentine line—also derived from Italian theorists like Lomazzo—was of decisive importance for Winckelmann (*Gedanken über die Nachanmung der Griechischen Werke*, 1755). Like Mengs, who explained all changes in art by a change of line (*Gedanken über die Schönheit*, 1765), he exactly described Hogarth's serpentine line as the line of beauty. It is true that Winckelmann, like Mengs, never quoted Hogarth explicitly. But ideas and descriptions in both German writers (Winckelmann, for instance, speaks of 'sea-waves') leave no doubt of Hogarth's decisive influence and Justi accepts it as unquestionable, however astonishing. Of Hogarth's and Mengs' agreement on the serpentine line of grace he wrote: 'Can two artists be less similar to each other than Hogarth, the chronicler of London and of its fine and coarse mob, the remorseless realist, the Smollett of the brush, and Mengs, the blender of Raphael and Correggio, whose historical pictures scarcely indicate any definite time or place? And yet they are at one on this point.'[71]

Naturalness, the antique, sense of form—all combine in Hogarth's line as Winckelmann understood it, though his standpoint was certainly more abstract. The difference, however, between the 'baroque' Hogarth and the 'classicist' Winckelmann is not so great as it might at first appear. Hogarth's line is explicitly only a moderate baroque, and once a formal definition of his style had come through him into being, Winckelmann could build his classicism upon it. For in Winckelmann's theory (particularly so long as he was in Germany), just as in that of Mengs (an admirer of Correggio), a moderate baroque and classicism were not so widely divorced as they soon after became.[72] Most antique statues which Winckelmann praised and which served him as an argument against baroque were, in fact, very close to baroque and, what is more, usually the same ones that aroused Hogarth's enthusiasm: Winckelmann's passages describing the Vatican torso, the *Laocoön* and the *Antinous*, could almost be illustrated by the first plate of *The Analysis of Beauty*, *The Statuary's Yard*; while on the other hand Hogarth was equally

responsive to the qualities of the *Apollo Belvedere*.[73] Moreover Winckelmann did more than admire, he explained these antique statues and in his precise visual analyses of them Hogarth was the necessary prerequisite.[74]

All this shows the historical perspectives Hogarth opened up by bringing both art and art theory down to earth. It is astonishing that his art theory could have left its mark so strongly on Winckelmann's system, while his art in certain respects even inspired French classicist painting. Yet these are really only incidentals. His prime importance for Europe as an artist was that he gave middle-class art everywhere an impetus far beyond the powers of Dutch 17th-century art. His art, at once rational and emotional, touched and strengthened almost every continental current with genuinely middle-class elements during the second half of the 18th century.[75]

I have here discussed various continental artists of a more or less pronounced middle-class outlook who were generally, for the most heterogeneous reasons, called Hogarth imitators. Their works, whether representations of middle-class life or extolling industry and virtue, whether sentimental, documentary or concentrating on physiognomy, all reflect one feature or another of Hogarth's complex art. These artists were all inferior to Hogarth in quality and necessarily attached themselves to their own native artistic traditions. Thus they were to some extent formed when they began. None of them ever reached Hogarth's pitch of intensity and complexity. When it so happens that they give explicit expression to middle-class ideas of Hogarth's kind, as with Greuze and Chodowiecki, they are less original, less trenchant, as a result of their similar but later historical position in the second half of the century. The same is true of their realism, however great the impact of Hogarth's achievement in this sphere.

It shows the lasting importance of Hogarth's art that Géricault, the decisive artist of the early 19th century in Europe, who constituted the vital transition from classicism to realism, still had Hogarth's novel and intensive realism, in addition to David's, as an indispensable prerequisite to his art.

Hogarth's views on history painting were much less fanatical and exclusive than David's and it was his alternation of this genre with less elevated subjects which Géricault followed up. Most important as stepping stones towards Géricault were the merely realistic features of Hogarth's art. His numerous renderings of seized movements not only anticipate photography but also, implicitly, Géricault's horse races, which fall chronologically between the two. Géricault's studies of sick and mentally diseased people probably have no precursors so exactly and thoroughly conceived as Hogarth's figures in *The Pool of Bethesda* and the *Polling* scene, particularly the latter's pallid man with bandaged head being carried upstairs, painted in such an astonishingly 19th-century vein, or his renderings of murderers such as Sarah Malcolm or Gardelle. Moreover Géricault acquired his main inspiration for his late realist evolution in England not only from Morland, Ward and Wilkie, as he himself states, but also from sporting pictures and engravings and, in the case of his London lithographs, from the Hogarth imitators.

But even on Delacroix the English influence was not confined to Constable's landscape backgrounds or the representation of horses by Stubbs and his followers but also included sketches by English neo-baroque historical painters. Through Bonington there is in the early Delacroix perhaps more of this English pictorial tradition (Reynolds-Opie) than of the native tradition of French half-baroque, half-classicist historical painting of the late 18th century (Menageot, Vincent, Brenet). And there is possibly no sketch by an English history painter so reminiscent of the brushwork of Delacroix, for instance in *Samson and Delila* (formerly Schmitz Collection, Dresden), as Hogarth's sketch of *The Ill Effects of Masquerades*. This is no accident. Only in

Delacroix does French painting reach a synthesis of baroque and realism comparable to that which Hogarth had achieved by the middle of the 18th century.

But Hogarth's art, with its amazing stylistic intermingling of baroque, realism and to some extent expressionism, had quite a specific bearing on artists of a kindred, militant spirit who were working stylistically on similar lines. For Goya and Daumier, Hogarth's satirical engravings were inevitably of topical interest. Like Hogarth, David and Goya reveal the extent of the European middle-class's struggle between the English and French Revolutions; while Daumier does the same for 1848. Thus Hogarth, Goya and Daumier between them represent the whole *comédie humaine* of the periods they covered far more than the general run of artists, who did not look below the surface of events and people. Like Hogarth, Goya and Daumier had much to tell. Although chiefly painters, they too had to express themselves in graphic cycles, often even larger than Hogarth's, notably Daumier's 4,000-odd lithographs (much cheaper than engravings) with recurrent themes and a seemingly inexhaustible wealth of types. Like Hogarth, Goya and Daumier had a penchant for social criticism, mordant caricature and closely related physiognomy and expression. Caricature, in its varying degrees—primarily introduced by Hogarth into an art above the merely popular level—became in these men's hands an instrument not only of ruthless characterisation of individuals but also of uncompromising social and political satire. The similarities in individual motifs between Hogarth on the one hand, and Goya and Daumier on the other, are only outward signs of a wider analogy. Daumier's motifs are not mere accentuations of Hogarth, as in Gillray, but are based on kindred observations, shaped formally in a similar way.

The analogies between Hogarth and Goya are so obvious that Hogarth's satirical engravings form the only source of external suggestions on which Goya could possibly have drawn, had he felt any such need. Strange as it may seem, there is a certain similarity in the premises of Hogarth's and Goya's art, the artistic evolution of both England and Spain being at variance with the steady development in other countries, especially 18th-century France. Not only do Hogarth and Goya give expression to the new ideas of the middle class[76] but, as a consequence of the general artistic situation in their respective countries, both have strong links as well with popular art—Goya in the wider sense, in that a great deal of Spanish art before him tended to reflect the mentality of the common people. The thematic and formal kinship between Hogarth and Goya are related with all these circumstances. Goya partook of the ideas of Enlightenment and, in common with English thought in Hogarth's time, believed in the supremacy of reason.[77] In particular *Los Caprichos* (1799), above all the first half of it with its attacks on hypocrisy and superstition, its exposure of vices and corruption in Madrid society, has various points of contact with Hogarth's themes. Goya here censures the nobility and expressly represents the theme of *Marriage à la Mode*, the unhappy marriage of wealth with birth (Pl. 84a). The fact that both Hogarth and Goya generally preferred in their graphic work to attack what they considered evil rather than praise what they considered good, arose from their similar satirical dispositions. At the same time, this negative approach preserves something of the spirit of the medieval representations of Hell, whereas a positive attitude is a more characteristic reflection of the new secular tenets of a developed middle class. Popular-expressionistic elements play a large part in the art of both: in Hogarth popular, particularly Dutch, engravings in the Bosch-Breughel tradition; in Goya, not only the fierce, imaginative popular elements of Spanish art before him and (as in Hogarth) animal imagery, but also the direct impact of Bosch himself, whom he had ample occasion to study.[78]

Goya's ruthless realism, only possible in an art as extreme as that of Spain, finds no parallel among his international predecessors apart from Hogarth (and to a far smaller extent Callot).[79] Popular elements, both expressionist and realist, merge in Hogarth and Goya in a style which, surprisingly enough for artists of a middle-class mentality, is fundamentally baroque. Hogarth's art was baroque because the English middle class before his time had rejected art for religious reasons, thus he had to conform to the prevailing taste of the internationally cultured aristocracy. So far as one can use such yardsticks to judge an art as non-formal as that of Spain and an artis so non-formalistic, Goya's art was baroque because the extremely weak, undeveloped and un-cultured Spanish middle class also lacked an artistic heritage. In Hogarth the baroque tradition he had to develop was more superficial, scanty and moderate. In Goya this tradition, which superficially blends that of the upper level with that of monastic-popular art, is more deep-rooted and intense, owing to its religious origins. On the other hand, like everything formal in Spanish art, it could be more easily discarded by great individual artists. Underlying this whole baroque, popular-realist framework is a visionary note which gives Goya's art a very different character from Hogarth's. But this obvious difference should not mask the great similarities between the two.

It is self-evident that from Hogarth's late works such as *The Cockpit* a line of stylistic evolution leads, historically, to many of Goya's works of a somewhat documentary character.[80] But a more concrete example of Hogarth's 'influence' on Goya appears in the latter's painting of *A Madhouse* (Academia di S. Fernando, Madrid) (Pl. 56b), for which he did sketches in the asylum of Saragossa. Goya may possibly have known an engraving of *The Rake in Bedlam*, but con-sciously or unconsciously, his composition must surely have derived from Hogarth's. The entire conception and the arrangement within the architectural setting are strikingly similar; so too are the use of nudes in the foreground and the attitude of the madman posing as a king. Without wishing to overplay the tracing of direct influence, I think that this is one of the very few occasions on which an artist of Goya's originality might have been stimulated by a previous work.[81]

Goya was equally absorbed in physiognomy. Often through only small alterations he pro-duced entirely different heads of character; he also liked to show the resemblance between animal and human heads.[82] Both these great realists were at the same time portraitists of the aristocracy. Thus even their 'elegant' portraits, revealing so unexpectedly profound a knowledge of their sitters' characters, have striking parallels, the like of which cannot be found in any other of Goya's predecessors. Hogarth's *Mr. William James* (Pl. 82a), in his grand, excellently painted uniform, friendly and smiling though not over-intelligent, reminds one of the penetrating, fashionable portraits of Goya's middle period (Pl. 83b).[83] So does *Captain Sabin* (1740, Knoedler Gallery, London), equally glittering in his red and gold uniform. But above all, and again historically speaking, it is the devilish *Lord Lovat* who foreshadows Goya's misnamed 'malicious', that is to say most truthful, portraits.[84]

As Hogarth was the spiritual ancestor of Goya, so were Hogarth and Goya the ancestors of Daumier. Daumier, who criticised a middle class in a far more advanced and mature stage, was naturally more radical. And his extremely sincere criticism was a pronounced reflection of his viewpoint. His lithographs in *La Caricature* and *Le Charivari*, drawing their themes from day-to-day events, illustrated the struggle between the Republicans and Radicals from 1830 onwards, successful in 1848, temporarily suppressed under Napoleon III.[85] Furthermore, they show up the narrow-mindedness, meanness, philistinism and hypocrisy of the ruling *juste-milieu* bourgeoisie. The acuteness of the struggle made the artist sharp-sighted and free of illusions.[86]

Thus the range of Daumier's attack was wider and its social and political intensity deeper and more bitter than Hogarth's.[87] But, even taking all this into account, thematic and formal analogies between their works are obvious. They were often attracted by the same motifs, such as judges, lawyers, doctors, actors, street musicians or clowns, and seized on the typical and individual alike with similar intensity. Few artists have better understood the human face. The analogies are so great that the question scarcely arises as to whether or not Daumier knew Hogarth—though it seems most probable that he did.[88]

An attraction for both was the comic effect produced by the pseudo-majestic behaviour of judges, often wielding enormous power while failing to live up to it. In fact, for Daumier (himself imprisoned for an attack on Louis Philippe) the Law Court was the symbol of injustice, of the rule of the conservative bourgeoisie. Hogarth's *Bench* was the forerunner of Daumier's innumerable variations on this theme (also sometimes satirically showing judges asleep) (Pl. 130b). And whilst he exploited the grotesque expression of insincere and corrupt lawyers in full, this was clearly foreshadowed in the *Polling* scene of the Election cycle by Hogarth's wildly gesticulating lawyer in an attitude as baroque as it is solid.

Daumier chronicled Paris as faithfully and vividly as Hogarth did London a hundred years before him. Like Hogarth, he was deeply interested in the theatre, in the actors[89] no less than the spectators. Some of his water-colour versions of a bourgeois audience at a theatre (especially *Au Théâtre*, in a French private collection) (Pl. 41a) quite naturally bring *The Laughing Audience* to mind. In a kindred vein, they emphasise the expressions of the spectators; the angles of the compositions too are rather similar, so that Daumier may indeed have known Hogarth's engraving. Like Hogarth, he sympathised with the theatre's outcasts, the poor strolling actors and clowns: even his row of sad, grotesque comedians advertising their show (*La Parade des Saltimbanques*; pen and ink and chalk; Szépmüvészeti Müzeum, Budapest) (Pl. 45b), had already appeared in *Southwark Fair*.[90]

The spirited effect of a number of Hogarth's pen, ink and wash drawings, particularly from his late phase, bring Daumier to mind. It is not impertinent that both these sharp observers of nature generally preferred to draw from memory. Daumier, who often used a technique identical with Hogarth's, accentuated still further the main features of the Hogarth drawings I have referred to. Sometimes he was even more economical in his use of contours to express the whole *raison d'être* of a figure; sometimes he conveyed the flickering effect of constant motion through the same kind of broken, trembling outlines that Hogarth employed. He was unacquainted with Hogarth's drawings; but Rowlandson, whom he certainly knew and who conserved in his engravings the line duct of Hogarth's drawings, could have been the connecting link between the two. Hogarth's most sketch-like drawings, such as his first ideas for *Industry and Idleness*, remind one of Daumier as no other 18th-century drawings do. Surprisingly reminiscent in this respect is the vibrant atmosphere of one of Hogarth's most impressive drawings, *The Idle Apprentice stealing from his Mother* (not used in the cycle) (Pl. 110a). And, to mention a drawing in a more monumental, summarising and sparing manner, *An Operation in a Hospital* (Pl. 95b). Daumier-like too in effect is the drawing of the murderer Gardelle on his way to execution; although the lay-out for this was by Hogarth's godson, J. Richards, the whole expression of the face and through that, of character, was determined by Hogarth.

I have cited Daumier to show that even as late as the stormy times around 1848 in France, Hogarth's art had not yet lost all topicality. However, its immediate significance was naturally for the 18th century, and it is within that period that one must seek to understand its features

and its mission.[91] Yet, in spite of the outstanding importance and originality of his art, Hogarth fared ill with posterity. His art and the adverse criticism it had to suffer show how far even the greatest formal qualities could be ignored, merely because of the forceful nature of the content.

Until quite recently, this favourite artist of Swift, Fielding and Sterne, of Lamb and Dickens, and whom Garibaldi called 'Il pittore del popolo' was appreciated neither by the general public nor by art historians. True, other combative artists such as David and Géricault, whose art was similarly at the service of middle-class ideas, have met with some, though insufficient, esteem; but in their works these objectives tend to be submerged in grandeur and can therefore be over-looked if the spectator so wishes. The numerous topical themes and allusions in the works of David, Goya, Géricault, Daumier and even Delacroix and Courbet, which came so naturally to them and divorced from which their art cannot really be appreciated, tend to be glossed over or only mildly objected to. Although, as regards the importance of content, the difference between these artists and Hogarth is, at best, only one of degree, and in Daumier's case not even that, this difference was enough to make Hogarth the scapegoat for the lesser sinners. At first con-demned as unduly realistic or caricature-like,[92] he was later held to be too literary.[93]

After many upheavals, under Napoleon III, the French middle class finally sat in the saddle. Anxious to avoid further changes which might upset its rule, it fostered the conservative theory that art must refrain from interfering in the social and political struggle and remain neutral, indifferent, independent. The lively intellectual forces of the dynamic 'thirties and 'forties, opposed to the idea of a necessarily static society, had clung to the notion of the social usefulness and topicality of art—an approach typified by Victor Hugo and George Sand. This was super-seded by *l'art pour l'art*, propounded by Gautier and Leconte de Lisle, which became the official doctrine of most of the writers and the élite. It proclaimed that art and usefulness were mutually exclusive and stressed the 'eternal' and 'absolute' in art, that is, the merely formal values.[94] Gautier, champion of *l'art pour l'art*, in an article on Hogarth's pictures that he saw at the Inter-national Exhibition in Paris in 1868, expressed admiration for their pictorial qualities, especially in *Marriage à la Mode*. In fact, in spite of himself, the article reads like one long eulogy of Hogarth's art, even if he protests in principle against its didactic and moral character.[95] Generally speaking, during the almost exclusive reign of *l'art pour l'art*, Hogarth's art, usually judged moreover on the basis of the engravings alone, could not be understood. A very few connoisseurs during these years recognised Hogarth's painterly qualities. In 1872, Sidney Colvin (*Portfolio III*) placed him, as a painter, above Reynolds and Gainsborough. Whistler thought him the greatest, indeed the only, English artist and never lost an opportunity to expound this view. He admired Hogarth's engravings as a child; later he enjoyed him above all as a painter and compared his sketch of the Royal Family (Dublin) with Velasquez; also he rightly saw a connection between Canaletto and Hogarth.[96]

Even to-day Hogarth's art is still termed 'literary' from a mere *l'art pour l'art* point of view, although a like reproach could be directed against Bosch or Breughel, whose didactic tradition Hogarth in part continued. But the half medieval subject-matter of Bosch and Breughel is remote in time and has by now become 'interesting' and permissible. Moreover, these artists satisfy the modern inclination for religious-expressionistic art. Hogarth, on the contrary, is still close to us and is therefore considered by a taste which has meanwhile grown refined to be no longer too realistic but too uninteresting and bourgeois. For the same reason the modern spectator does not object to medieval moralities because they indulge in detailed representation of the deadly sins. Yet Hogarth was accused of hypocrisy for showing up vices of which he disapproved.

Following on this changed valuation, no exception is taken to Breughel's over-crowded compositions as it is to Hogarth's, though these types of composition actually occupy far less of Hogarth's *œuvre* than they do of Breughel's. Furthermore, if in our own time a combination of baroque, expressionism and realism is to appeal to the public, as it does in Goya and Daumier, then the expressionist element must be more obvious and immediately striking than it is in Hogarth.

In the early 20th century, Hogarth's one salvation seemed to lie in the impressionist technique of his *Shrimp Girl*, for it was easy enough to make this picture one of the innumerable fore-runners of Impressionism.[97] Its freshness, as a pleasing exception in Hogarth's otherwise 'boring', 'literary' *œuvre*, had been emphasised over and over again in every book on English painting. But, even as regards painterliness alone, Hogarth's historical position must be measured on a much broader basis. *The Shrimp Girl* is not the sole testimony that Hogarth could and did paint on the highest possible level of his time. It is only his best-known work because it has been so long in the National Gallery. Hogarth did many other sketches and sketch-like pictures, for instance, *The Ill Effects of Masquerades* or *The Wedding Dance* (not to mention the first set for *Industry and Idleness*) which were almost unique in their time. But these astonishing works were only possible because the colouring of his finished paintings was generally more refined and bolder than that of French rococo. No contemporary French painter had such an unconventional colour scheme or such subtle handling as are to be found in *Mrs. Salter*. Every line of *The Analysis of Beauty* testifies to Hogarth's unusual understanding of formal and painterly values, to an extent unknown among other writers on art of his day. Apart from this, his works speak unmistakably for themselves.

It has taken a long while for Hogarth, so much of his own time and yet in so many ways ahead of it, to receive the recognition he deserves. In his own day he was mainly judged by the moral-social aims of his engravings. In Lamb's and Hazlitt's, the truthfulness, the consistent inner and outward realism of his characters, was already understood. However, the painterly qualities of his pictures was only beginning to be realised at the time of Impressionism. None of these judgments taken alone can do him justice; he has to be seen as a whole. The time has come when both his art and his critics can be viewed in historical perspective. Now that increasing attention is being paid to social problems and the social aspects of art, when events are moving far more rapidly than in the majestic times of the second half of the 19th century and caricature once again has something real to express, interest in Hogarth rapidly deepens.[98]

Hogarth put his vast pictorial and formal resources at the service of his radically new themes. He fused the two as completely as few other artists have done. Yet perhaps no other artist extended the themes of art so widely as he. No artist before him, not even Callot, portrayed man's activities in such rich variety and exposed them in such utter bareness. It is not difficult to predict that a time will come when the principle of *l'art pour l'art* will no longer rank as absolute and eternal, applicable to all periods, when art will have concrete aims connected with everyday life, when content will once again come into its own. Many new themes might then be created and painted on the highest pictorial level possible at their time. Such a period will certainly hark back to Hogarth, one of the greatest artists England has ever produced, who reached the same goal in his own time.

Notes

❧❧

CHAPTER ONE

1. For Hogarth, as for all adherents of the Hanoverian dynasty, William III's image remained the symbol of loyalty. His portrait hangs on the wall in the City Banquet scene of *Industry and Idleness*, and in *An Election Entertainment* it has been disfigured by a Jacobite mob.

2. After the publication and success of *A Rake's Progress*, Hogarth turned down a proposal to design a series entitled *The Statesman's Progress*, to be directed against Walpole, who was widely accused of corruption. Hogarth was not explicitly anti-Walpole, like many of his journalistic friends, particularly since his father-in-law, Sir James Thornhill, was a member of Walpole's party and also his portraitist. Hogarth himself collaborated on a portrait of Walpole by Thornhill. It was probably largely through Thornhill's social connections that Hogarth received numerous commissions from political partisans of Walpole. He painted portraits of Walpole's children, i.e. Lady Cholmondeley in the conversation-piece of *The Cholmondeley Family* (Marquess of Cholmondeley, Houghton Hall, Norfolk; Pl. 40a), Sir Edward Walpole (Knoedler Gallery, New York) and possibly also Horace Walpole.

3. Though not actually Prime Minister, Pitt was the leading spirit in the Cabinet.

4. On Walpole's relations with the City, see A. J. Henderson, *London and the National Government, 1721–42* (Durham, U.S.A., 1945).

5. See L. B. Namier, *The Structure of Politics at the Accession of George III* (London, 1929).

6. Although up to 1760, the city Radicals called themselves Tories, Namier has shown what little real significance there was in the schematic denominations of Whig and Tory. I use the terms in this book to denote general political tendencies.

7. The alternative title of the print of *The Gate of Calais, O the Roast Beef of Old England*, was taken from a patriotic song in Fielding's *The Welsh Opera* (1731), a burlesque of George II's court. The Sublime Society of Beefsteaks, to which Hogarth belonged, had as its motto 'Beef and Liberty'.

8. In 1745 a number of City Merchants founded an Anti-Gallican Society, to oppose the import and consumption of French produce.

9. Ch. Hardy ('The History of a Hogarth Portrait at Geneva', *Burlington Magazine*, XVI, 1909–10) stresses that Hogarth, apparently impressed by the fact that French Protestants should prefer to leave their native country and settle in England, made several friends among them. Yet he was caricaturing the London Huguenots in *Noon*, (Pl. 58b), in the cycle *Four Times of the Day*.

10. See L. A. Namier, *England in the Age of the American Revolution* (London, 1930).

11. R. J. Robson, *The Oxfordshire Election of 1754* (Oxford, 1949).

12. The 19th-century assumption that Hogarth painted a portrait of Bolingbroke is almost certainly without foundation.

13. The prince had, in fact, made frequent appearances in the City and was the first Prince of Wales to receive its freedom. The prince was also fond of amusements and it is probably he that a Hogarth drawing (Windsor), not of course a caricature, represents seated at a gambling table.

14. In the first plate of Hogarth's cycle, *The Four Stages of Cruelty* (1751) (Pl. 117a), the kind-hearted boy who offers his tart to save an ill-treated dog was alleged to be the future George III, then thirteen years old. If this is true, as it may well be, Hogarth must have been connected, in its initial stages, with the general attempt to build up George III's reputation at the beginning of his reign. The future King and his mother, the Dowager Princess of Wales, headed the list of subscribers to Hogarth's Election cycle (1754).

15. Hogarth was on the best of terms with Bishop Hoadly and his family; one son, Benjamin, was physician and the other, John, Chaplain to Frederick, Prince of Wales. He painted several portraits of Benjamin (Fitzwilliam Museum, Cambridge (Pl. 39b), National Gallery of Ireland, Dublin), also Benjamin's wife (R. C. H. Thomas Collection, Aldbury, 1740); and Benjamin himself with his wife's

family; also one of John (Smith College, Northampton, Mass., U.S.A.), who owned a number of the artist's works. Both brothers composed verses for his engravings, John notably, for *A Rake's Progress*. Benjamin helped Hogarth with *The Analysis of Beauty*, and the artist painted a scene from his comedy, *The Suspicious Husband* (1747). Hogarth may also have painted another chaplain to the Prince of Wales and George III, Gregory Sharpe, and his family (Vose Gallery, Boston); he certainly did a frontispiece for Sharpe's pamphlet directed against Hutcheson's philosophy (1763, published in S. Ireland, *op. cit.*, Vol. 1). Joshua Kirby, drawing-master to the future George III, was another friend; Hogarth did a satirical design of *False Perspective* (1754) as a frontispiece to Kirby's book, *Perspective of Architecture*, published in 1760 by order of the prince, whose coronet is included in recognition of his encouragement of the arts.

16. See D. H. Stevenson, *Party Politics and English Journalism* (Menasha, U.S.A., 1916). Nicholas Amhurst, whose book, *Terrae Filius*, was illustrated by Hogarth (1725), became in 1726 the first editor of the principal anti-Walpole paper, *The Craftsman*. His successor was Thomas Cooke, for whose translation of Hesiod Hogarth did the frontispiece (1728). The Rev. John Miller, for whose comedy, *The Humours of Oxford*, Hogarth also did a frontispiece (1730), wrote anti-Walpole pamphlets.

17. Hogarth wrote of this engraving: 'When war abroad and contention at home engrossed everyone's mind. . . . This drew forth my print of *The Times*, a subject which tended to the restoration of peace and unanimity, and put the opposers of these humane objects in a light which gave great offence to those who were trying to foment destruction in the minds of the populace.' In fairness to Hogarth it must be admitted that a great war-weariness pervaded the country, while Pitt was exerting himself to prolong the war in the interests of the City and his ally, the King of Prussia, who appears in the engraving gaily fiddling.

18. In the frontispiece to the catalogue of the Society of Artists (1761) Hogarth placed a bust of George III as the source of artistic patronage. Hogarth shared this loyalty to the new sovereign with Dr. Johnson, who the previous year had composed for this same Society an 'Address of the Painters to George III on his accession to the Throne'.

19. It was during these same years that Hogarth did the portraits of Henry Fox and of Samuel Martin, Secretary of the Treasury, who strongly supported Bute's policy.

20. According to F. G. Stephens (*Catalogue of the Satirical Prints in the British Museum*), in some minor details Hogarth also criticised Bute's party.

21. See G. W. Rhead, 'Wilkes and Liberty' (*The Connoisseur*, XLVIII, 1917).

22. In one of the small medallions on this engraving, Pitt is reproached as in the engraving *The Times*, for drawing so large a pension. In Hogarth's drawing, *Four Loggerheads* or *B—e Triumphant* (known only through an etching by White), Lord Bute is knocking the heads of Wilkes and Churchill together.

23. A complete account of the quarrel can be studied in Nichols or Dobson.

24. By 'Tory' I mean a political state of mind and not a

rigid party line, which simply did not exist. Lord Bute, for instance, was by no means a Tory in a strictly party sense. How fluid the party lines were in the second half of the century is shown by K. G. Feiling, *The Second Tory Party, 1714–1832* (London, 1938).

25. Defoe most lucidly expresses this middle-class mentality: on the one hand recognition of the superiority of the old landowning families, on the other appreciation of the fact that, by the second generation, the humble origin of a gentleman had already been forgotten.

26. The rights of the individual, his 'liberty' of action, were so deeply felt that their expression was sometimes carried to extremes. Hogarth did a portrait of the eccentric Miss Mary Edwards (Frick Collection, New York; Pl. 67a), a patron of his and one of the richest women in England. In 1773, this lady, unaided by legal proceedings, divorced her husband, Lord Hamilton, for wasting her money—an event referred to in the portrait, where an ode to the liberty of the English lies beside her on the table.

27. See A. Beljame, *Le public et les hommes de lettres en Angleterre au dix-huitième siècle* (Paris, 1881), Leslie Stephens, *English Thought in the Eighteenth Century* (London, 1902), and *English Literature and Society in the Eighteenth Century* (London, 1903).

28. Hogarth often attacked Pope but probably only because they belonged to different factions.

29. Swift's famous lines on Hogarth occur in his poem *The Legion Club*.

30. The first English daily newspaper, *The Daily Courant*, was founded in 1702.

31. Hogarth must have been interested at a very early age in the coffee-house circles which these writers frequented and where these periodicals had their birth. A tradition maintains that, at the time Steele was producing *The Guardian*, Hogarth designed a lion's head (1713; published in S. Ireland, *op. cit.*, Vol. 1) for him, to be placed in Button's Coffee-house as a receptacle for letters to the periodical. Hogarth would then have been only sixteen, but since this lion's head has the same ornamentality as a heraldic lion and Hogarth was at that time employed in drawing coats-of-arms in a silversmith's workshop, one cannot entirely exclude this possibility.

32. Various portraits attributed to Hogarth are said to represent Thomson, but these 19th-century identifications are unreliable.

33. See R. Fox, *The Novel and the People* (London, 1937).

34. In 1762, some years after Fielding's death, Hogarth did a pen and ink sketch of him from memory, an engraving after which served as a frontispiece for that year's edition of his works. This is the only extant portrait of Fielding.

35. Goldsmith must have identified his own miserable condition so closely with Hogarth's composition, *The Distressed Poet*, (Pl. 47b), that in a letter of 1758 to Robert Bryanton he described himself as 'in a garret writing for bread and expecting to be dunned for a milk-score'. The portrait of an old woman in Philadelphia, probably rightly attributed to Hogarth, was traditionally entitled *Mrs. Butler* or *Goldsmith's Hostess*.

36. See M. Weber, *The Protestant Ethic and the Spirit*

of Capitalism (Eng. trans., 1930) and R. Tawney, *Religion and the Rise of Capitalism* (London, 1926).

37. See W. C. Cross, *The History of Henry Fielding* (New Haven, 1928).

38. A certain transition towards this new attitude is apparent in the writings of the painter, Jonathan Richardson, published between 1715 and 1719. Although principally based on continental art theory, his treatises lay a greater stress on the moral purpose of art.

39. In his *Dialogue Concerning Art* (1744), James Harris, a follower of Shaftesbury and a friend of Fielding, expressed the view that painting and poetry rank higher than music since they are more useful.

40. Addison wrote in *The Spectator*, 1711: 'I shall be ambitious to have it said of me that I brought philosophy out of closets and libraries, schools and colleges, to dwell in clubs and assemblies, at tea-tables and in coffee-houses.'

41. T. H. Fowler (*Shaftesbury and Hutcheson*, London, 1882), quite rightly contends that, in Shaftesbury's system, virtue had been made attractive to the man of taste and fashion.

42. The great importance attached to moral education in the 18th century was based on Locke's theory that all ideas originate in sensations and that the child's mind, since it is to begin with a *tabula rasa*, must be moulded through knowledge. Locke's pedagogic ideas were generally accepted as confirmed in the writings of Addison, Richardson, Fielding and Sterne. See K. Maclean, *John Locke and English Literature of the 18th Century* (New Haven, 1936).

43. Locke, Shaftesbury, Addison, Steele and Fielding were profoundly steeped in the Stoic thought of Antiquity, an active, vigorous, optimistic philosophy of life which has usually flourished in times of great middle-class ascendancy such as obtained in Greece in the 4th century B.C.; in Rome from the 1st century B.C. to the 3rd century A.D.; in early 15th-century Florence; also in Calvinism.

44. The engraving itself had a definite effect on those in authority. In 1755 Sir John Fielding, who succeeded his brother Henry as Chief Magistrate at Bow Street, published an advertisement in which he advised servants arriving in London without friends immediately to contact the Universal Register Office which the Fieldings had set up. See R. Leslie-Melville, *The Life and Work of Sir John Fielding* (London, 1934). It is generally held that Magdalen Hospital, the oldest home for prostitutes in England, was founded in 1758 as a direct result of the publication of *A Harlot's Progress*.

45. In Defoe, however, we can still find bourgeois satisfaction and pride in the possibility of a member of the middle class marrying into the aristocracy.

46. See D. George, *England in Transition* (London, 1931), B. M. Jones, *Henry Fielding, Novelist and Magistrate* (London, 1933) and Leslie-Melville, *op. cit.*

47. Welch, who gave Fielding and Parliament their first real insight into the poverty and misery in London, was a friend of Hogarth who painted his portrait (E. I. Rowat Collection, London). While Hogarth was on the best of terms with these magistrates, who were bent on reform, he castigated Fielding's predecessor at Bow Street, Sir Thomas de Veil, notorious for his immoral conduct, in

the engraving *Night* (Pl. 59b), one of the cycle *Four Times of the Day*.

48. John Fielding explicitly referred to these two engravings in a letter to *The Public Advertiser* (1757) in which he dealt with the ravages of gin among the poor. Even Pope had already denounced the plague of gin-drinking in his *Epilogue to Satires*.

49. Hogarth had certainly been working on *A Harlot's Progress* for some time before 1732, the year the engravings were issued, probably since 1729, soon after his marriage.

50. See W. H. Hudson, *George Lillo and 'The London Merchant'* (A Quiet Library Corner, Chicago, 1915), E. Bernbaum, *The Drama of Sensibility* (Cambridge, U.S.A., 1925) and F. O. Nolte, *The Early Middle-Class Drama* (New York, 1935).

51. Perhaps no career better illustrates the lesson of Hogarth's cycle than that of Benjamin Franklin, for in the American colonies, unfettered by any aristocracy or aristocratic prejudices, a man could make an even more incalculable economic, social and political advance than in England. Franklin's career became the model for subsequent American success stories in which apprentices achieved prosperity through hard work. This man, in whose mind virtue, respectability and success were closely linked, had reared himself on Defoe and *The Spectator*. He rated Hogarth highly and it so happened that the last letter the artist received, to his immense pleasure, was from Franklin.

52. In *The Spectator* (1711), Addison summarised the attitude of the middle class towards merchants and trade: 'There are not more useful members in a commonwealth than merchants.... Trade ... has multiplied the number of the rich.' And E. Budgell, Addison's cousin and imitator, echoed this opinion the following year, also in *The Spectator*: 'I regard trade not only as highly advantageous to the commonwealth in general, but as the most natural and likely method of making a man's fortune.' After Defoe's various honest, industrious merchants, particularly Robinson Crusoe (the incarnation of English individualism and enterprise), Thorowgood, in Lillo's play, not only embodies all the good qualities of a merchant, but is also kind-hearted, the same as Heartfree, in Fielding's *Jonathan Wild*.

53. This play was revived in 1751, apparently under the influence of Hogarth's cycle, with the title *The Prentices*. See W. Creizenach, *The English Drama in the Age of Shakespeare* (London, 1916) and L. M. Wright, *Middle-class Culture in Elizabethan England* (University of North Carolina, 1935).

54. Fielding did all he could to help Lillo and Moore. When a theatre-manager, he produced Lillo's *Fatal Curiosity*, and when a magistrate he tried to make Moore Deputy-Licensor of the Stage; both these moralising playwrights, who had once been merchants, were Nonconformists.

55. A. Warburg ('Francesco Sassetti's Letzwillige Verfügung', *Gesammelte Schriften*, Leipzig, 1932) explains how the device of Sailing Fortune was first used by a merchant in 15th-century Florence. In the previous scene, both apprentices sit at their looms; behind the industrious one is pinned up the ballad, 'Turn again Whittington', whilst the idle one has thrown away *The Apprentices' Guide*.

56. Hogarth married Jane Thornhill without her father's consent but a reconciliation soon took place and, up to the time of Thornhill's death in 1734, the two families lived on the best of terms.

57. Such, for instance, was the position of Hollar, the outstanding engraver of the Restoration.

58. In his portraits, however, he never availed himself of the help of a drapery painter, like most portraitists, but did the entire work himself.

59. It was this commercial attitude, dominating every aspect of life in England, that changed Watteau's outlook on finance after his visit to England in 1720. Gersaint wrote of him: 'C'est-là [en Angleterre] où il commença à prendre du goût pour l'argent dont il avait fait jusques alors aucun cas, le méprisant même jusqu'à le laisser avec indifférence.' The portraitist Smibert left England in 1728 and settled permanently in America because, as Vertue says, 'having a particular turn of mind towards honest, fair and righteous dealing, he could not well relish, the false selfish, gripping, over-reaching ways too commonly practiz'd here.' Abbé Leblanc, the noted French art critic who lived in England from 1737 to 1744, also wrote of the English painters: 'Aussi ont-ils toujours exercé cette profession si noble comme le métier le plus vil, pour de l'argent uniquement, et sans le moindre sentiment de gloire' (*Lettres d'un François*, 1745.) Rouquet, Hogarth's agent, wrote that the aim of English portrait painters was not to paint well but a great deal, and he describes their tricks for catching a large clientele (*L'état des Arts en Angleterre*, Paris, 1755). Yet continental artists, and Watteau himself, came to England for the purpose of making money.

60. See details in F. G. Stephens, *op. cit.*

61. Struggles to secure the copyright of engravings had, of course, been going on since the 16th century on the continent. Lancret obtained rights similar to Hogarth's, and at approximately the same time, in 1730; but his privileges were more limited than Hogarth's, referring only to engravings of twenty-five of his compositions and then only for six months' duration.

62. The act was administered by the judges in such a way that it did not greatly help Hogarth. Even *A Rake's Progress* was widely plagiarised. One pirated set came out even before the original, since the plagiariser, a subscriber to Hogarth's engravings, had seen the original paintings in Hogarth's studio and copied them from memory. Two sets after *A Rake's Progress*, one by Boitard, came into circulation and later still two more. Hogarth did his best to counteract this by himself publishing small, cheap engravings of his cycle, done by a certain Bakewell.

63. Fielding later wrote a play, *The Lottery* (1732), satirising this institution and its irregular practices.

64. Nichols, *op. cit.*, Vol. III, p. 44.

65. From the end of the 'forties, numerous attempts were made to found a Royal Academy, all of which Hogarth appears to have opposed. In a memorandum, later published by J. Ireland, he set out his reasons for this. Apart from those specified, he may perhaps have been afraid that, in such an institution, he would only rank as an engraver, i.e. a kind of inferior artist without full rights. In 1753 his opposition to such a plan incurred vehement

attacks in satirical engravings (see F. G. Stephens, 'Old London Picture Exhibitions', *Art Journal*, 1887). As usual, the chief onslaught apart from Reynolds came from Paul Sandby, the favourite landscape painter and fashionable drawing-master of the aristocracy (Pl. 125b). On this subject Hogarth apparently quarrelled with his old friend, Hayman, who sided with Sandby. Hogarth disliked the connoisseurs, particularly the Society of Dilettanti, who played a large part in the plan for establishing an academy; in 1748, their project won the approval of Frederick, Prince of Wales, and in 1755 they successfully negotiated this right with the committee of artists headed by Hayman.

66. The very sound of 'freedom' so greatly attracted Hogarth that in 1761 he proposed that the Society of Artists to which he belonged should be called *Free Professors of Painting, Sculpture and Architecture*. See W. Whitley, *Artists and their Friends in England*, 1700–99 (London, 1928).

67. Fielding's proposals for a new Poor Law and new orderly workhouses seem severe but they were certainly humane by contemporary standards and were, in fact, only accepted a century later. See D. Marshall, *The English Poor in the 18th Century* (London, 1926) and D. George, *op. cit.*

68. John Huggins, a warden of the Fleet Prison who sold his patent to Bambridge in 1728, was an intimate friend of Thornhill and even procured his knighthood for him. Thornhill painted frescoes in Huggins' house, Headley Park, built out of the money extorted from prisoners, and Hogarth is said to have assisted him. Later Hogarth even did a portrait of Huggins and one of his son, William. The Huggins family had apparently not greatly disturbed by the enquiry (although the committee resolved to send not only Bambridge but also Huggins to prison), since William Huggins acquired for himself the version of Hogarth's picture originally commissioned by Sir Archibald Grant, a member of the committee.

69. Ned Ward, the popular journalist, had already described Bridewell and Bedlam in his *London Spy* (1699) and the Debtors' Prison in his *Metamorphos'd Beau* (1700), but more as a reporter than as a reformer; in his account of Bridewell, he describes the scene in *A Harlot's Progress* in which women are beating hemp under the supervision of a jailor, whip in hand.

70. See also R. M. Baum, 'Hogarth and Fielding as Social Critics' (*Art Bulletin*, XVI, 1934).

71. In Florence, Bruni, the most sober and public-spirited of all humanists, suggested this idea and the whole trend of Florentine architecture was changed by Brunelleschi's design for the Spedale degli Innocenti, a rational, typically middle-class conception.

72. During the first four years, nearly 15,000 children, mostly illegitimate, were admitted.

73. Fielding was also keenly aware of the injustice done by society to foundlings. The hero of *Tom Jones* (1747) is a foundling. *The Foundling* is also the title of a domestic comedy by Fielding's protégé, Moore (1748).

74. See R. H. Nichols and F. A. Wray, *The History of the Foundling Hospital* (London, 1935).

75. A small drawing of the chapel of the Foundling

Hospital (Fitzwilliam Museum, Cambridge) is attributed to Hogarth.

76. Jacobsen's building, although it had not the same decisive influence on the architecture of his day as Brunelleschi's, was also the invention of a rational mind—monumental, imposing, simple and solid, really utilitarian and yet not lacking in grace.

77. Hitherto it had been almost impossible for the general public to see pictures. Excessively high tips had to be given to the servants before access could be gained to the paintings in the houses of the aristocracy. As Rouquet tells us, the lower classes were even excluded from the auction-rooms. Later, when the artists organised their own exhibitions in the Society of Arts, a regulation of 1762 declared that 'no servant in livery shall be admitted on any pretence whatever'. It may be recalled that from 1540 onwards exhibitions of pictures at Antwerp were associated with an even more typically middle-class institution than the Foundling Hospital, namely the Stock Exchange, in the courtyard of which exhibitions were organised by art dealers.

78. The Royal Society for the Encouragement of Arts, Manufactures and Commerce, founded in 1754 for the stimulation of all kinds of arts and inventions, was also a typically middle-class institution. Benjamin Franklin was a member of its committee which organised the exhibition of 1760.

79. Nichols, *op. cit.*

80. There were many parallels in contemporary literature. In his mock-heroic poem *Trivia* (1716), Gay gives a most accurate account of the sights and streets of London. Ned Ward and Tom Brown also described the minutiae of London streets, inns and characters in the burlesque vein of popular reporters.

81. Hogarth's views of London are collected together by F. G. Stephens, *op. cit.*, and H. Wheatley, *Hogarth's London* (London, 1909).

82. But even the unscrupulous Ward at times manifests genuine sympathy for the sufferers from obvious social injustice. See H. W. Troyer, *Ned Ward of Grub Street* (Cambridge, U.S.A., 1946).

83. It is not impossible that J. T. Smith's account (in *Nollekens and his Times*) of Hogarth's youthful experience in a tavern with Hayman has some substance: when he saw a prostitute spit wine over another, he was so enthralled by the wild spectacle that he made a sketch of it. He certainly used this motif later in the Rake's *Orgy*. Nor were there real contradictions in Fielding, even though he was taunted with having, as a magistrate, condemned behaviour of which he himself was guilty as a young playwright and man-of-letters. Broadly speaking, both Hogarth and Fielding's outlook on life remained much the same throughout their development. See W. Cross, *The History of Henry Fielding* (New Haven, 1918).

84. Many pamphlets which imitated the two 'Progresses' certainly made the most of their salacious aspects. But even the pamphleteers had to assume the appearance of moralists. See R. A. Moore, *Hogarth's Literary Relationships* (University of Minnesota, 1949). The virtuous Pamela, on the other hand, was painted and engraved by Mercier and Highmore in versions which chiefly suggested eroticism.

85. In *Moll Flanders*, Defoe was following the example of Bunyan who, in *The Life and Death of Mr. Badman* (1680), used the life of a rake for cautionary purposes; *Moll Flanders* was intended to be a 'puritan' story of crime in contrast to the current 'immoral' ones, and recorded the experiences Defoe had collected as a reporter at Newgate Prison for *Applebee's Journal*. The middle-class public of the 1720's was certainly not shocked by the details of Moll Flanders' life (see P. Dottin, *Daniel De Foe et ses Romans*, III, Paris, 1824).

86. Hogarth must not be accused of hypocrisy for accepting patronage from his aristocratic clients and protectors. But it is true that he was careful to keep up connections with the notoriously immoral but by no means uncultured aristocrats around the Prince of Wales, most of whom were members of the licentious and blasphemous Hell-Fire Club, which existed from 1753 to '62. There were rumours, apparently quite unfounded, that Hogarth also paid occasional visits to its meeting-place at Medmenham Abbey. The two best-known members of the club, Sir Francis Dashwood, later Chancellor of the Exchequer, and the Earl of Sandwich, later First Lord of the Admiralty under Lord Bute, were also leading members of the aristocratic Society of Dilettanti with Lord Charlemont. Hogarth painted a portrait of the Earl of Sandwich's son (*c.* 1749–50, Lord Hinchingbrooke) and perhaps also, though it seems unlikely, of his mistress, Martha Ray; portraits of the three Vansittart brothers wearing Medmenham turbans are also attributed to Hogarth. Members of the Hell-Fire Club, like their spiritual ancestor Bolingbroke, were well able to reconcile High Tory politics with irreligious sentiment, an accommodation which dated back to the Cavaliers under the Restoration. Morality, that powerful middle-class ideal, became, in the hands of the aristocrats who recognised its strength, a pawn in the political game. But Hogarth, with his non-political attitude, was not the type to concern himself about such matters.

87. See G. Kitchin, *A Survey of Burlesque and Parody in English* (London, 1931) and R. Bond, *English Burlesque Poetry, 1700–1750* (Cambridge, U.S.A., 1932).

88. Pope never once mentions Hogarth, the greatest English artist of his time. Personal reasons can alone explain this. Hogarth—also for personal reasons—several times satirised Pope in engravings.

89. The Parodies produced by members of the Scriblerus Club (1713), Congreve, Lord Oxford (Harley), Swift, Pope and Gay, provide an example of this fusion of old and new.

90. Hogarth's anger against quacks was really justified; and it was not until 1748 that the Apothecaries Act finally forbade unqualified persons to concoct medicines.

91. Hogarth shared this opinion with Swift and even with Fielding.

92. When Hogarth sent his *March to Finchley* (1746) to George II with a request that he might be allowed to dedicate it to him, he acted in complete good faith. His object was to stress the dangers to which the guards were exposed from Jacobite spies and agents; if at the same time he showed disorder among the soldiers, partly as a result of this infiltration, in his usual satirical way, he saw no

discrepancy in this and, in the background, depicted the guards marching away in best military fashion. His own loyal, anti-Jacobite feelings were beyond doubt. He was therefore taken aback when the military-minded king took his presentation to imply contempt for his soldiers and refused to grant his request; the indignant artist then dedicated the engraving (1750) to the King of Prussia, Great Britain's ally. Hogarth acted in equal good faith when he dedicated the individual engravings of his Election cycle (1755) to high officials, among them a secretary of state, Henry Fox.

93. He compiled a Latin dictionary and in 1712 published a Latin grammar.

94. Hogarth did likenesses of Martin Folkes, President of the Royal Society (1741, Royal Society), Dr. T. Pellett, President of the Royal College of Physicians (*c.* 1738–40, whereabouts unknown), of Sir Caesar Hawkins, Serjeant-Surgeon to George II and George III (*c.* 1740, Royal College of Surgeons), of Dr. E. Sandys, Sherardian Professor of Botany (Knoedler Gallery, New York) and a drawing of the classical scholar, Dr. T. Morell (1762; whereabouts unknown).

95. Hogarth was a frequent visitor to a club of artists and literary men, which held discussions twice a week in Slaughter's Coffee-house; his fellow-guests were the painters Richardson, Hudson, Lambert, Hayman, the engraver Gravelot, the sculptor Roubilliac, the musician Händel, the antiquarian Folkes.

96. Addison wrote in *The Spectator* (1712): 'Notwithstanding this general division of Christian duty into morality and faith, and that they have both their peculiar excellence, the first has the pre-eminence in several respects.' In Hogarth's portrait of the Edwards family (formerly Knoedler Gallery, New York), Mary Edwards holds a volume of *The Spectator* opened at one of Addison's articles on the conception of God (1714).

97. The introduction of private pews for the wealthy, in which they could slumber at ease, was a feature of these times (see N. Sykes, *Church and State in England in the 18th Century* (Cambridge, 1934)). Even Addison's famous character Sir Roger de Coverley, who was as a matter of course religious, sometimes slept in church. Pope and Goldsmith refer to the habit; Swift even wrote a sermon on *Sleeping in Church*, of which Hogarth's composition is said to be an illustration. Yet, when it suited his purpose, Hogarth would portray the custom as objectionable: beside the industrious apprentice, who closely follows the service, another member of the congregation, perhaps the idle apprentice, has dropped off to sleep (Pl. 104a.) Likewise

little respect is shown for the Anglican clergy in Hogarth's conversation piece, *Lord Hervey and his Friends* (1738, Marquess of Bristol, Ickworth; Pl. 73b), in which the Rev. Wilman stands on a chair gazing so excitedly through a telescope at his prospective living that he is in danger of falling off.

98. This was too much even for Sir Robert Walpole, who needed the support and political influence of the clergy. See F. C. Hearnshaw, *The Social and Political Ideas of some English Thinkers of the Augustan Age* (London, 1928).

99. At the time of the Sacheverell scandal, around 1710, when that High Churchman and Tory, suspended by a Whig cabinet and reinstated by a Tory one, received support from innumerable satirical engravings, Hoadly was the butt of every attack. To show his contempt for Sacheverell, Hogarth placed his portrait on the wall beside that of the highwayman Macheath in the scene of the harlot's arrest, which confirms that, in Hogarth's time, the mob was High Church and Tory and, for a while, even Jacobite. In the same scene Hogarth derided the notorious pastoral letters directed against the Deists by Gibson, Bishop of London, who, although a Whig, was an extreme High Churchman and an adversary of Hoadly: on the harlot's breakfast-table a scrap of butter is wrapped in a torn piece of one of these letters. Gibson, nicknamed 'Dr. Codex' after his codification of ecclesiastical law, was considered a slightly comic figure and his pastoral letters in particular were an object of journalistic wit (see N. Sykes, *Edmund Gibson*, Oxford, 1926).

100. On the other hand Hogarth respected the Quakers, who were known to be good businessmen. On the first sketch of the counting-house scene in *Industry and Idleness* (British Museum), Hogarth wrote 'a Quaker' beneath the figure of the prosperous proprietor and gave him the characteristic costume.

101. The quick-witted Horace Walpole entirely approved of the tendency of this second engraving, which he considered 'for useful and deep satire . . . on the Methodists . . . the most sublime'. The differences between Hogarth's two engravings are listed in F. G. Stephens, *op. cit.* Dr. John Hoadly thought the first engraving irreligious and this may have been one reason for its withdrawal.

102. The law against witchcraft had been repealed in 1746.

103. Hogarth's vanity and self-confidence were closely interlinked. Because he was aware of his greatness and yet received most inadequate recognition, he was inclined to boast and fell an easy prey to flatterers.

CHAPTER TWO

1. Leslie Stephen (*English Thought in the 18th Century*) quite rightly maintains that no one else expresses the middle-class spirit of the time better than these two.

2. In *Tom Jones*, Fielding criticised his own early plays with their Restoration flavour and cited Hogarth's art as an example of his new postulate, *il faut être de son temps*:

'Vanbrugh and Congreve copied nature; but they who copy them draw as unlike the present age as Hogarth would do if he was to paint a rout or a drum in the dresses of Titian and of Vandyke. In short, imitation here will not do the business. The picture must be after nature herself.'

3. R. E. Moore (*Hogarth's Literary Relationships*,

Minneapolis, 1949), whilst neglecting the parallels between Hogarth and Fielding throughout their careers, overrates the influence of Hogarth on Fielding in their middle phase.

4. A parallel can also be traced between the development of Hogarth and that of English acting, a craft so close to his heart and so important for his work. To begin with, both evolved realism only within the comic genre; but when, in the early 'forties, Garrick introduced it on the higher plane of tragedy, he was only attempting something similar to what Hogarth had already done, in some of his cycles and in his historical paintings.

5. It would have been tempting to assume that Hogarth was the most exclusively bourgeois-minded of all European artists and, in consequence, had created a perfectly consistent middle-class art; all the more tempting since this thesis, though on the whole true, has never been seriously formulated or proved. L. Halévy, for instance, in his excellent *History of the English People in 1815* (Eng. Trans., London, 1924) makes the following brief reference: 'Hogarth had been a popular artist, hostile to the aristo-

cracy.' But this is not the whole truth and I shall intentionally emphasise the qualifying factors in this book.

6. In fact, Hogarth's direct borrowings however carefully I have tried to detect them (see my article 'Hogarth and His Borrowings', *Art Bulletin*, XXIX, 1947), were surprisingly rare. Yet, they show Hogarth to have been extremely conversant, for an 18th-century artist, with past and contemporary art (Leonardo, Raphael, Callot, Brueghel, Rubens, Steen, Rigaud, Gillot, Coypel, Cochin, etc.) and that he could adapt it with sovereign skill. It is of little importance that it is frequently Hogarth's minor, or to put it otherwise 'less known', works which reveal the closest contact with continental art.

7. His trend towards a more agitated baroque can be seen most clearly in the difference between the pictures *Before* and *After* of 1730–1 and his engravings after them of 1736.

8. Though frivolous, when speaking of an artist of Hogarth's incredible originality, it is nevertheless tempting to call his art a synthesis of Steen and Watteau to illustrate its vast range.

CHAPTER THREE

1. Although classicist pictures (Poussin) and Dutch and Flemish genre pictures were to be found in such collections, these principally consisted of Italian baroque. Even Lord Shaftesbury whose aesthetic theories ultimately led to a new middle-class taste, still had high praise for such artists as Salvator Rosa and Maratta. See E. Wind, 'Shaftesbury as Patron' (*Journal of the Warburg and Courtauld Institutes*, Vol. II, 1938–9). Frederick, Prince of Wales, the only member of the Royal Family to show a genuine interest in art during Hogarth's lifetime, bought works by Reni, Albani, Poussin, Claude and Maratta, apart from Rubens and van Dyck.

2. Jacques Rousseau, J. B. Monnoyer, Parmentier and Cheron, most of whom settled in England for good. Cheron even founded an Academy here, of which Hogarth was a pupil. In 1712 the celebrated Desportes came with the French Ambassador for a short visit and his paintings of hunting trophies were acquired by the court and aristocracy.

3. Apart from Sebastiano Ricci, a lesser known Venetian artist, Niccolo Cassana (1659–1714), worked for Queen Anne. In some ways a stylistic precursor of Ricci, he had previously worked in Florence for the Medici court and did baroque mythological pictures.

4. It seems that Venetians such as Pellegrini and Amigoni and to some extent Ricci, who worked at South German courts and in Paris and who were thus doubly under the influence of French art, were rather more quick to assimilate the clear-cut French tendency towards rococo than their colleagues in their native city. Ricci and Pellegrini, in turn, had a certain influence on French painting. It was, by the way, this more international taste, in architecture as in painting, which made Genoa and Piedmont take to rococo or pre-rococo earlier than Venice. London profited from the early rococo tendency of these Venetians.

5. The work of most of the French and Venetian artists

in England still coincided with the taste of the English aristocracy for baroque architecture at the beginning of the century. Since the 'twenties, following Lord Burlington's lead, a Palladian classicism tinged with baroque had become fashionable for this class, at least for the façades of their houses. Yet their furniture, designed by Kent, was often heavily baroque, in imitation of Marot and Venetian models, whilst the ornate interior decorations, often done by Venetian plasterers, increasingly developed towards rococo; moreover, Kent's 'English' landscape garden followed up Vanbrugh's tendency towards a picturesque, somewhat realistic, partially baroque style. As a painter, Kent frequently showed surprisingly strong baroque features both in his pictures and in his frescoes, which have both Correggesque and Venetian features, on the staircase and ceiling at Kensington Palace. As for Lord Burlington himself, his taste was by no means consistently classicist, since his own houses were decorated by Sebastiano Ricci and Pellegrini.

6. The two most notable Italian artists who came to England at this time were landscape painters: Canaletto (c. 1746–50 and c. 1751–5); and Zuccarelli (1751–c. 62 and 1768–c. 71) who had introduced French rococo pastoral motifs into Venetian landscape painting. George III who had bought a number of Riccis in 1762, also acquired a large number of pictures painted by Canaletto and Zuccarelli in Venice. Pillement, the French landscape painter, lived in England c. 1750–61 before becoming court painter to Marie Antoinette: his international-rococo style was close to that of the Italianising Dutch artists and of Boucher and Zuccarelli.

7. Since Ramsay had studied at the French Academy in Rome and under Solimena in Naples, his portraits contained some French and Italian features.

8. The very fashionable Raoux was here from 1720–4, Denner from 1721–8.

9. Before going abroad in 1711, Thornhill was completely attached to Verrio's style. This was the only type of Italian baroque-heroic painting on a grand scale to be seen in England. Thornhill's journey mainly covered France and Flanders. Although he was more baroque and heavier than Amigoni, a certain stylistic affinity is apparent; this can be seen at Moor Park, where important works by both can be studied together.

10. Nichols states that Hogarth assisted his father-in-law on the ceiling in John Huggins' house at Headley Park, depicting the story of Zephyrus and Flora. Amongst others, Hogarth is said to have painted the figure of a satyr. Thornhill may also have been assisted by Hogarth on the frescoes at 8 Clifford St., London, where the putti closely resemble the type of children in Hogarth's engraving *Children peeping at Nature*—a fact to which R. B. Beckett has drawn my attention.

11. See Hogarth's article in the *St. James's Evening Post* (1737) and his conversation with Horace Walpole (described in Walpole's letter to J. Montague, 5th May, 1761).

12. Acquaintance with the numerous members of the jail enquiry committee of the House of Commons, whom Hogarth portrayed in 1729, proved a useful source of future patrons. From amongst them he was given commissions by the Earl of Inchquin, the Earl of Cholmondeley, Field-Marshal Wade, Sir Archibald Grant and Mr. Conduitt.

13. Members of the aristocracy whom Hogarth painted in this very early phase, either singly or in portrait groups were the Duke of Montague and his family, Lord Cholmondeley and his family, Viscount Castlemaine and his family, Lord Boyne, Lady Byron, Lord Ann Hamilton and his family, Lord Mornington, singly and with his family, Lady Fermor and other children performing Dryden's *Indian Emperor*, and the children of the Earl of Pomfret.

14. Mercier had already in 1725 painted a conversation piece representing an assembly on the terrace of Shotover House (formerly Lord Rothermere), larger in size than Hogarth's. A slightly later one of Viscount Tyrconnel and his family (Lord Brownlow) is the same size as Hogarth's. Some pre-Hogarthian small-scale portrait groups exist by Dutch and Flemish immigrants such as Egbert van Heemskerk and Peter d'Angelis.

15. The other painters of conversation pieces, Gavin Hamilton (*c.* 1617–1737) and Charles Philips, were imitators of Hogarth. Hamilton competed for commissions from the aristocracy by reducing his prices below Hogarth's.

16. Pesne also came to London in 1724 and painted the princesses and also Prince Frederick.

17. A. Vuaflart, *Jean de Jullienne et les Graveurs de Watteau* (Paris, 1929) and R. Rey, *Quelques Satellites de Watteau* (Paris, 1934).

18. At that time Anglo-French artistic relations were far closer than is usually supposed. Various causes contributed: the Peace of Utrecht (1713), the accession of George I (1714), the death of Louis XIV (1715) and above all the conclusion of a trade treaty between the two countries in 1719.

19. See R. Edwards, 'Mercier's Music Party' (*Burlington Magazine*, XC, 1948).

20. The catalogue of the sale of Hogarth's artistic possessions after his widow's death does not specifically state that they were engravings, but the summary reference of 'Various' excludes the possibility of their being pictures. See 'Hogarth's Collection' (*Burlington Magazine*, LXXXV, 1944).

21. Hogarth himself owned engravings after the portraits of the Kit-Kat Club painted by Kneller between 1702–17; the influence of Vanderbank can, I think, be traced in Hogarth's single portraits with decorative woodland backgrounds from the mid-1730s.

22. These small pictures usually have mythological or gallant-religious themes; but one also finds very jauntily painted sketches of portrait groups by Amigoni. These are in the habitual international court style and surprisingly similar to Hogarth's in their general features (decorative motifs, pose, manner of painting). A good example is Amigoni's sketch in the gallery of Schleissheim (painted in 1723) for a ceiling in the castle representing the Bavarian elector, Max Emmanuel, receiving a Turkish envoy in Belgrade; in its elegant broadness it even exceeds sketches of grand French portrait groups from Largillière (e.g. *Banquet to Louis XV by the City of Paris*, 1687, Louvre) down to Hogarth's time (e.g. J. B. van Loo, *Allegory of the Birth of the Dauphin*, 1729, Amiens). Hogarth probably learned much from French and Italian sketches of this type (and from their common source, van Dyck), but he tended to make the baroque generalities more realistic and sharply individualised the expressions.

23. A favourite theme of the aristocracy was the portrayal of their castles and country houses. In the views of Westcombe House done by Lambert after 1733 for the Earl of Pembroke (picture still *in situ*), Hogarth painted the small figures, thus greatly enlivening the rather dull compositions.

24. Defoe singled out Sir Joshua Child as an outstanding example of the social advance of a member of the middle class.

25. A small picture, very near to Hogarth (Earl of Jersey), is also connected with the Child family. According to S. Ireland, to whom it belonged and who held it to be by Hogarth, it represents the directors of Child's banking house rescued, through some happy intervention, from a financial catastrophe. This typically bourgeois-capitalist theme is elevated onto a higher plane by the enthroned figure of Britannia as the protectress of the banking house. Although the young Hogarth's authorship cannot be entirely discarded, the picture may be by the Flemish immigrant Nollekens the Elder (1702–48) who, from 1733, painted numerous portrait groups of the English aristocracy in the Franco-Flemish taste.

26. Apart from the presence of a man seated on the ground, this group corresponds to another picture which S. Ireland published as an engraving (*op. cit.* Vol. II) and described as a representation 'in the style of Watteau' of the theatrical director Rich (the seated figure) and his family. So two versions exist: Hogarth's original in Philadelphia and a somewhat altered copy or version now in a private collection. On the face of it Ireland's identification seems less probable than the one traditional in the Fountaine family which, as regards the Philadelphia version, is

accepted by W. Roberts ('Two Conversation pieces of Hogarth', *Art in America*, I, 1913). The unusual motif of holding up a picture to view is more suited to a composition representing a great art collector than a famous harlequin like Rich, who was little concerned with pictures. According to both Ireland and Roberts, a friend of Hogarth's the auctioneer Cock, in whose rooms *Marriage à la Mode* was later exhibited, appears in the composition. But whereas in Ireland's 'Rich Family' the picture is held by a servant and explained by Hogarth himself to Cock, who forms the centre of the composition (which is most unlikely), in the 'Fountaine Family' version, Cock is said to be holding the picture whilst Fountaine's son-in-law points out details to his father-in-law (which is more probable). However, since Cock and Rich were friends and owned nearby villas, they could well have been represented together. Nor can the possibility be ruled out that one version was painted for Cock, identical with the 'Cock Conversation' mentioned by Hogarth himself as having been ordered in 1728 and still in his studio in 1731, and that Fountaine is represented here not with his own family but as Cock's important client, with Cock's family. Whilst the Philadelphia picture was originally in the possession of the Fountaine family, Ireland's 'Rich Family' belonged to a certain Langford, also an auctioneer and Cock's successor: so the mix-up of the sitters could perhaps be associated with a desire to raise Cock's social standing in the picture.

27. The country gentlemen were generally satisfied with the less fashionable portrait groups of Arthur Devis (1711–87; Pl. 30a), and his followers—more provincial versions of those of the aristocracy by Hogarth and Gavin Hamilton.

28. This applies only to Lely's third, late phase under the Restoration. His earlier styles also accorded with the political circumstances: under Charles I, moderately baroque (between Dobson and van Dyck); and under the Commonwealth, Dutch-austere. See Collins-Baker, *Lely and the Stuart Painters* (London, 1912).

29. Jonathan Richardson wrote (in *The Theory of Painting*) that England had become the most important country for portrait painting since van Dyck brought the art here. The most fashionable club for artists and connoisseurs was the van Dyck Club, otherwise termed the St. Luke's or Virtuosi Club. Hogarth called van Dyck 'one of the best portrait painters in most respects ever known', but he also criticised him in *The Analysis of Beauty* for ignoring the serpentine line of beauty, that is, for his stiffness, citing as an example his portrait of the Duchess of Wharton.

30. As far as one can judge from the weak engraving published by S. Ireland (Vol. II), it is at least possible that the original was by Hogarth, though it could have been by Nollekens.

31. Van Dyck costumes were used to heighten the elegance of portraits; Robinson, a pupil of Vanderbank, tried to make them a general feature of his portraits. The fashionable Hudson as well, like Reynolds, seems to have taken to this habit.

32. In 1734 Hogarth also painted six 'faces' into a hunting-piece by Wootton, ordered by the Earl of Cholmondeley. Hogarth received less for the six faces than the framemaker for the frame. See R. W. Symonds, 'Hogarth, a Ghost for John Wootton' (*Burlington Magazine*, LIII, 1942).

33. A comparison of these two pictures has already been made by S. Sitwell (*Conversation Pieces*, London, 1936).

34. Other painters of portrait groups in England—Hamilton, Laroon—are even more rigid than Hogarth and retain this feature longer. Somewhat later, in Devis, rigidity inclines rather to naturalness than distinction. Finally in Zoffany it is almost entirely absorbed by naturalness.

35. The comparative sizes of family portrait groups are very revealing: Van Dyck's are enormous—*The Pembroke Family* 3·35× 5·80 metres, *Charles I and his Family* 2·90× 2·47 metres: in comparison, François de Troy's *Louis XIV and his Family* is very small (1·27× 1·60 metres). Portrait groups of the aristocracy by Tournières are smaller still, 0·97× 1·24 metres: Metsu's *Family of the Merchant Geelvinck* only 0·72× 0·79 metres (Pl. 32a); the conversation pieces by Coques and by Hogarth are of approximately similar size.

36. Of all contemporary Italian painters, the elegant Pannini, who also put Watteauesque figures into his compositions (see L. Ozzola, *Pierpaolo Pannini*, Turin, 1921) was perhaps the best represented in English aristocratic collections.

37. At one time S. Ireland owned the sketch, now in Windsor, in which the figures and their attitudes are identical with those in the Dublin sketch but the scene is set in a garden; he asserts that his picture was painted after Hogarth had become Serjeant-Painter in 1757, as a kind of memorial picture and that the figures included George II, his Queen and some of his children; Frederick, Prince of Wales, the Duke of Cumberland, the Princess of Hesse. Queen Caroline and Prince Frederick were both dead in 1757 and the personages appear to be represented at the ages they would have been at least twenty years earlier. But matters are not quite so simple. From a contemporary report of Vertue, Hogarth was commissioned to paint the Royal Family and made a sketch of them before his quarrel with Kent in 1734. If we assume this to have been one of the two sketches, the actual ages and number of the royal children, prior to 1734, appears to fit quite well. If, on the other hand, it is merely a memorial picture, then it is impossible to guess with any certainty who the figures represent and all explanations based on this assumption must be arbitrary. In fact all explanations are confused and arbitrary. E. Duncan ('The National Gallery of Ireland', *Burlington Magazine*, x, 1906) implies that at least one person, as yet unborn at the time of the Queen's death, is depicted beside her, that the two youngest children portrayed are the Prince of Wales's, although in 1757 he had six and they are here shown at the age they would have been in about the mid-1730s: finally that the Duke of Cumberland has been depicted at the age he would have been more than twenty years earlier (and similar in appearance to Hogarth's portrait of him of 1732) and only two or three years older than his as yet unborn nephew, the future George III, whose senior he was in reality by seventeen years. The Dublin Gallery catalogue lists the

same persons as Duncan: like the New York sale catalogue, in which the Windsor picture is listed, it surmises that the sketch was painted shortly before the King's quarrel with Hogarth over *The March to Finchley*, allegedly in 1746 (probably a confused echo of the 1734 quarrel with Kent which, in fact, prevented Hogarth from executing the picture of the Royal Family). Only the New York sale catalogue attempts a complete but equally arbitrary enumeration: George II, Queen Caroline, Frederick Prince of Wales, two of his sisters—the Princess Royal and the Princess of Hesse—his wife Augusta and their children, namely the future George III, Augusta Charlotte and Elizabeth. In my view only the children of George II are shown with their parents and not the Princess of Wales (who married the prince in 1736) or her children. In fact, although S. Ireland does not offer an exhaustive list, he excludes the Princess of Wales and her children and consequently does not infer that anyone is represented with the Queen who was not yet born at the time of her death. George II's two youngest children are identical with those represented in Hogarth's *Indian Emperor* of 1731; they are approximately of the same age and display many points of similarity. Finally, and this to my mind is decisive, the rigid style, the comparative lack of depth, and the small size of the picture all point to its being an early work. The arrangement is akin to that of a portrait group of approximately the same years, *The Broken Fan* (Lord Northbrook) which probably represents Hogarth's wife, his sister and his mother-in-law; it also clearly shows relations with *The Earl of Strafford and his Family* (Carstairs Collection, New York) painted in 1732 by Gavin Hamilton, Hogarth's early imitator in portrait groups.

38. The mixture of styles in Kent's paintings, although weak and crude in execution, is characteristic of English painting on a high social level in the 1720s. His frescoes, when treating architectural and ornamental motifs or when copying antique statues, are classicising, somewhat in imitation of Giulio Romano, yet they are often combined with pronouncedly baroque elements. The way in which, on the staircase at Kensington Palace, Kent gives his baroque-illusionistic figures a realistic, contemporary appearance has in principle a certain kinship with Hogarth's style, though on a grander social plane. Such treatment was rather unusual at the time by continental standards, and foreshadows Alessandro Longhi's frescoes in the Palazzo Granacci in Venice by half a century.

39. Frederick, Prince of Wales, whose circle Hogarth was continually courting, never thought of sitting to Hogarth, although he had his likeness painted by every foreign artist who turned up in England and also by several fashionable English painters. It is not known what portrait commissions Hogarth received from the King after becoming Serjeant-Painter in 1757, since he refers to them but does not name them in his autobiographical notes.

40. Around 1740, he also portrayed the Duke of Devonshire (1741, Lord Chesham), the Countess of Pembroke, the children of Lord Grey (1740, St. Louis) and Captain Hamilton, the Earl of Abercorn's son (Frick Collection, New York).

41. As to the Dutch streak in English portraiture, it

should be remembered that Kneller, who produced the greatest number of aristocratic courtly portraits in the van Dyck manner in England, before becoming a pupil of Maratta, had studied in Amsterdam under Rembrandt's own pupil, Bol, at a time when Rembrandt was still alive.

42. See Nichols, *Genuine Works*.

43. J. Nichols, *Biographical Anecdotes*.

44. One of the versions was not ordered by the 'vicious nobleman' but by a Mr. Thomson.

45. As to the painting of Sir Francis Dashwood posing as St. Francis worshipping a nude figure of Venus, I think it most unlikely that Hogarth, in his late, most moralising phase, would have painted him in a blasphemous manner, although he was on good terms with him socially at that time. I had no access to the original, but the engraving after it makes the attribution to Hogarth seem improbable. In the 1740s and '50s, it was no longer Hogarth but Knapton who represented the eccentricities of the aristocracy in the numerous 'official' portraits of members of the Society of Dilettanti. Knapton's half-length portrait of 1742 of Dashwood as a member of this society (now in the St. James's Club), which also shows him as St. Francis worshipping Venus, is undoubtedly related (as Lionel Cust has already noticed in his *History of the Society of Dilettanti*, London, 1914) to the full-length figure of the engraving in question. Portraits by Knapton of other members have similar vapid expressions and still-life motifs.

46. The taste of the aristocracy for baroque painting corresponds to their taste for French courtly literature of the Louis XIV period, for the lengthy, gallant-historical novels of Mlle. de Scudéry and La Calprenède, even for the still earlier pastoral poetry of d'Urfé. In English literature Dryden was the parallel for this type of poetry and it is not by chance that Hogarth's works done for the aristocracy are so often connected in some way or other with the name of Dryden.

47. Moreover pictures were considered a safe investment by the new middle-class collector. In his description of an art collector, Defoe thus refers to the profit incentive: 'He always had the finest Collection of Paintings of any Merchant in Leghorn: he is a great lover of art and has a nice Judgment, which are the two only things that can make buying so many pictures rational, for his Pieces are so well chosen that he may sell them when he pleases far above Thousand Pounds more than they cost.'

48. The wedding actually took place at St. Benet's but the church represented by Hogarth is St. Martin-in-the-Fields, which had been completed a few years earlier and which Hogarth apparently preferred.

49. The picture measures about 40 in. × 50 in.

50. Hogarth's small, oval portraits of his two sisters (c. 1740, Columbus Museum, Ohio) are also extremely simple (Pl. 69b).

51. A portrait by Hogarth (1741, Royal Society) akin to this in character and painted about the same time does indeed represent a bourgeois intellectual—his friend, Martin Folkes, friend of Newton, Voltaire and Montesquieu, President of the Royal Society and Vice-president of the Foundling Hospital. He is shown in the act of speaking, with a candid expression and an indicative gesture of the hand.

52. The portraits by Jonathan Richardson (1665–1745; Pl. 64a), are the closest precursors in English art to the picture of Mr. Arnold: apart from aristocrats Richardson painted a surprisingly large number of intellectuals with whom he was on friendly terms, including Addison, Steele and eighteen members of the Royal Society (see G. W. Snelgrove, *The Work and Theories of Jonathan Richardson*, unpublished thesis at the Courtauld Institute, London University, 1936). It is still a far cry from Richardson's portraits to *Mr. George Arnold*, since they lack a truly middle-class character, merely representing a middle-class streak within aristocratic portrait painting; yet they are undoubtedly simpler and more sober than Kneller's. Though mainly a painter of simple, documentary portraits, he sometimes gave them a classicist turn, even imitating antique models. Of his innumerable portraits of his friend Pope, one may instance in particular his rendering of him as an ancient poet, in severe profile, with a laurel wreath on his head (National Portrait Gallery). Even a painter of fashionable society like Richardson's pupil, Hudson, was influenced by his master in his portraits of intellectuals.

53. W. Whitley, *Artists and their Friends in England, 1700–99* (London, 1928). Ramsay also greatly appreciated La Tour.

54. Hogarth was soon followed by others in rendering plain, individualised bourgeois likenesses. Portraits of *Dr. Messenger Monsey* and *Mrs. Edith Hope* by Hayman, though weaker in quality, belong to this category. Those by Benjamin Wilson are better: e.g. *The Rev. H. Wood*. Pond's realistic self-portrait, an etching of 1739 (Pl. 64b), has an almost 19th-century look. Last but not least are the busts of intellectuals by Hogarth's great friend Roubilliac. Portrait painting in the American colonies in Hogarth's day acquired an even more consistently bourgeois character, though on an artistically lower level. The sitters were usually merchants and their wives and sometimes clergymen. Even the Scottish Smibert (1688–1751) at one time Thornhill's assistant on the frescoes in St. Paul's, concentrated in America not so much on decorative effects as on grasping, with unmitigated realism, the character of his sober sitters. Still sharper in characterisation and at the same time stiffer in pose are the portraits by the American-born Feke (1705–c. 1752). In the next generation, Copley (1737–1815), before coming to England, used his greater technical knowledge to change Feke's flatness into something more plastic and metallic, while paying even closer attention in his austere likenesses to the expression of his sitters.

55. When a portrait attributed to Rembrandt came up for sale at Christie's in 1948, I identified it as this portrait of Pine.

56. An engraving of it had already passed as a Rembrandt portrait, said to represent 'Le Bourgmestre Syx, ami de Rembrant'.

57. Rembrandt's influence is also noticeable in Hudson's portrait of a professional man, the Lord Advocate Charles Erskine, 1749 (engraving by McArdell). Among well-known contemporary French portraitists, perhaps only Aved painted a man's portrait (Richer de Rodes) in an oriental costume and in Rembrandt's manner; he had studied in Amsterdam, had many middle-class sitters, and owned a vast quantity of Rembrandt etchings which, after his death, came to England and ended up in the hands of the painter, engraver and art dealer, Pond. Doubtless at that time a connection could also easily develop between a liking for Rembrandt and a scientific middle-class mentality. A case in point is Benjamin Wilson, who was the most pronounced English imitator of Rembrandt in the 'fifties; he also wrote several books on the science of electricity and was the expert who fixed the lightning conductors on St. Paul's Cathedral. Wilson portrayed Benjamin Franklin, the inventor of the conductor, with a book on Electric Explosions in his hand and a great flash of lightning in the background. Hogarth so greatly appreciated Wilson's qualities that in about 1756, the probable date of his portrait of Pine, he is reported as being anxious to procure him as a kind of partner for portrait painting. See Whitley, *op. cit.*

58. But not to every artist; when the sitter was Gibbs, the Italianate architect *par excellence*, the pupil of Carlo Fontana, the designer of St. Martin's-in-the-Fields and the Radcliffe Camera, Hogarth produced a grand, elegant portrait (1747) and engaged Baron to engrave it.

59. Hogarth not only mentions Rigaud in *The Analysis of Beauty* but singles out Drevet as a great engraver.

60. Hogarth also modulated Thornhill's sumptuous portrait schemes although he obviously learned from them: compare Thornhill's portrait of Richard Scott, a Warden of the Painter's Company (E. Croft-Murray Collection) which features the usual grand arcades, with Hogarth's portrayal of Daniel Lock, architect of the Foundling Hospital (Spencer-Churchill Collection) in a similar pose and also holding a paper but of course with the arcades omitted.

61. Hudson's pompous portrait of George II (1744, National Portrait Gallery), though the painter of course knew Hogarth's *Coram*, keeps much closer to the van Dyck likeness of Charles I. Hudson's series of judges' portraits are also of a more sumptuous baroque. But even Ramsay's portrait of Dr. Mead of 1747, also painted for the Foundling Hospital, although close to the Coram portrait, is more aristocratic and grandiose, at least in its architectural background. Ramsay was also a writer and a man with lively cultural interests and it was not by chance that he painted such men as Hume, Rousseau and Benjamin Franklin.

62. Of portraits in the Foundling Hospital, besides Ramsay's of Dr. Mead, Hudson's one of J. Milner, a vice-president of the institution, also seems to be modelled on *Captain Coram*.

63. Cf. my articles on David and Géricault ('Reflections on Classicism and Romanticism', *Burlington Magazine*, LXVI, 1935 and LXXVII–LXXVIII, 1940–1), and my book *Florentine Painting and its Social Background* (London, 1948).

64. When describing an imaginary picture gallery in *The Spectator* (1711), Addison names Raphael, Titian, Correggio, Annibale Carracci, Reni and Rubens.

65. From the end of the 17th century, a number of well-known Dutch and Flemish genre painters even came to England either temporarily or to settle here for life: e.g. Th. Wyck (from *c.* 1660 onwards), Samuel Hoogstraten

(1662–68), Jan Griffier (from *c.* 1667 till 1695 and from *c.* 1705 till his death, 1718), Jan Siberechts (from *c.* 1672 till his death, *c.* 1703), Egbert van Heemskerk (after 1663 till his death, 1704); William van de Velde, the younger (from 1672 till his death, 1704): and, in Hogarth's time, Tillemans (from 1708 till his death, 1734), Peter d'Angelis (1712–28), van Aken (from *c.* 1719 till his death, 1749), F. de Paula Ferg, an Austrian imitator of Dutch landscape and genre painting (from *c.* 1720 till his death, 1740). So long as the middle class refrained from buying pictures, the patrons of even the Dutch and Flemish painters were mostly aristocrats.

66. In 1732, the East India Company commissioned Lambert and Scott to paint its principal ports and settlements (Lambert, the ports and landscapes, Scott, the ships). Between 1746 and 1748 a number of artists, including the young Gainsborough, painted pictures of the various London hospitals for the Foundling Hospital.

67. Richardson's life was similar to that of the industrious apprentice in Hogarth's *Industry and Idleness*. He was a tradesman, a printer on a biggish scale, married his employer's daughter, acquired riches and finally became Master of the Stationers' Company. He wrote *Pamela*, as he himself records, in breaks between his business activities. He also found time to compose an *Apprentice's Guide* similar to the one which, in Hogarth's *Loom* scene, is opened by the good boy but which the bad boy is throwing away; and, in it, to complete the circle of ideas, Richardson praises Lillo's *Merchant of London*. See A. D. McKillop, 'Samuel Richardson's Advice to an Apprentice'. (*Journal of English and Germanic Philology*, 1942, XLII).

68. See, on Highmore's portrait style, F. Antal, *Mr. Oldham and His Guests*, *Burlington Magazine*, XCI, 1949. Bartholomew Dandridge (1691–*c.* 1754), another contemporary and Highmore's rival, mainly painted members of the upper middle class, though he also portrayed the Prince of Wales and, in a conversation piece with other aristocrats, Lord Burlington. His style derived from the Kneller tradition and later he came under the influence of Hogarth and Mercier. His *Price Family* (Metropolitan Museum, New York; Pl. 30d)—until recently attributed to Hogarth but rightly assigned to Dandridge by Collins Baker ('The Price Family by Bartholomew Dandridge', *Burlington Magazine*, LXXII, 1938)—represents an upper-middle-class family on the fringe of the aristocracy and is even more French-modish than Hogarth's own conversation pieces. This dual trend in style, typical of middle-class portraiture amongst Hogarth's contemporaries, is also evident in Hayman's elegant 'French' portraits of members of the middle class.

69. The specifically upper-middle-class atmosphere of Delft in Vermeer's time shows a certain interesting parallel, *mutatis mutandis*, with the early 15th-century Florence of Masaccio's realistic classicism (see on the latter F. Antal, *Florentine Painting and its Social Background*). The upper middle class of Delft was more exclusive and cultured than that of other Dutch towns. It was ruled by a small coterie of the *grande-bourgeoisie* grown rich through industry (textiles and breweries) and still investing in overseas enterprises (Dutch East India Company). Though by the

mid-17th century this class was no longer as active economically as it had been (see a summary of the specialised literature in M. Eisler, *Alt-Delft*, Vienna, 1923), its pride and self-assurance were at their peak—exactly as in 15th-century Florence. It is not surprising that the humanistically cultured upper middle class of Delft should have been the *arbiter elegantiarum* of Holland, as its counterpart in Florence was of Italy. Classicist architecture and painting based on rationalistic perspective were common to the art of both towns.

70. Certain portraits said to represent Richardson are incorrectly attributed to Hogarth.

71. On the mutual relationship of Richardson and Fielding, which has a strong bearing on the understanding of Hogarth's art, see L. Stephen, *English Literature and Society in the 18th Century* (London, 1903), A Digeon, *The Novels of Fielding* (Eng. Trans. London, 1925), E. Ewald, *Abbild und Wunschbild der Gesellschaft bei Richardson und Fielding* (Elberfeld, 1935) and A. D. McKillop, *Samuel Richardson* (Chapel Hill, 1936).

72. Even in Highmore's portrait of Richardson, the entire background is filled by the picture of an elegant, aristocratic-looking couple, Mr. and Mrs. Budworth, friends of Richardson, seated in a deer park in front of a castle.

73. Sometimes, when representing moral persons juxtaposed with immoral ones, Hogarth could not resist giving them a comic twist, suggestive of hypocrisy: the steward in the *Breakfast* scene of *Marriage à la Mode* feigns indignation at the indifference of the viscount and his wife to unpaid bills. In *An Election Entertainment*, amidst universal corruption, the tailor rejects bribery despite his poverty. It was not by chance that both these personages are shown as Wesleyans or Quakers.

74. Even the faithful girl, the only 'good' character in *A Rake's Progress*, Richardsonian in spite of her lost virtue, is reported to have been introduced by Hogarth on the suggestion of a friend. Although the artist endowed her with manifold qualities and brought her to life, she was incapable of saving the Rake.

75. Engraved in S. Ireland, *op. cit.*, Vol. II.

76. With all his reverence for Raphael, Hogarth condemned the 'straight and stiff manner' of this father of all classicism when referring to Raphael's early and middle period before he, as Hogarth put it, came under the influence of Michelangelo and antique sculpture.

77. When occasion offered, Highmore also attempted to make use of Hogarth's classicist potentialities: his *Marriage of Pamela* (Tate Gallery) is purely a simplification of the *Marriage of the Rake*. Yet the sketchy character of Highmore's *Pamela* pictures, their lack of solidity and the superficiality of the faces, are partly due to their having been painted only as models for engravings.

78. The germs of this point of view are to be found in Shaftesbury, but he still preferred a style representing Deities to what he called 'common history painting'. Jonathan Richardson, who foretold what English history painting was to become, had already compared the English with the Greeks and Romans. Perhaps the first occasion in 18th-century English art when patriotism was linked with

an antique-imitating classicism was Kent's architectural projects in the 'thirties under the auspices of Lord Burlington for a Royal Palace, a National Memorial Temple and the Houses of Parliament.

79. It was also Wilkes who later (1777) pleaded for the establishment of a National Gallery and the purchase by the State of Robert Walpole's pictures, and who expressed his regret at the Raphael cartoons being transferred from Hampton Court to Buckingham Palace and so lost to view. In art, as in politics, Wilkes was associated with every progressive idea.

80. He also bought Dr. Mead's two Watteaus, which shows that a taste for Watteau accorded well with a taste for Hogarth.

81. At the time of the publication of *A Harlot's Progress* Vertue reported that it 'captivated the minds of most people, persons of all ranks and conditions from the greatest quality to the meanest'. The author of the pamphlet *The Effects of Industry and Idleness Illustrated* (1745) wrote: 'Walking some Weeks ago from Temple-Bar to 'Change in a pensive Humour, I found myself interrupted at every Print-Shop by a Croud of People of all Ranks gazing at Mr Hogarth's Prints of *Industry and Idleness*.'

82. Hogarth's engravings were so popular that, apart from Rembrandt, he was the only artist whose portrait served as sign-boards for a London print-seller (for John Smith in Cheapside: *At Hogarth's Head*, 1752) and, even more unusual, a bookseller (Ryall and Withy, in Fleet Street: *At Hogarth's Head and Dial*, 1755).

83. See R. B. Beckett: 'Famous Hogarths in America' (*Art in America*, XXXVI, 1948).

84. As a parallel in literature, the deliberately crude style of the first book of Fielding's *Jonathan Wild*, is inspired by a desire to be generally understood.

85. Late medieval characteristics are preserved in popular art and also taken over into mannerism, whence they return again into popular art.

86. In England even the broadsides were called emblems. See M. Praz, *Studies in 17th-century Imagery* (London, 1939).

87. See E. N. Thompson, *Literary Bypaths of the Renaissance* (New Haven, 1924).

88. English engravings of an entirely popular type had originally no consistent realism of detail. Yet, before Hogarth's time, some English popular engravings of a rather documentary character did exist, comparable with a kind of crude genre painting. Close to the broadsides, they are nevertheless on a higher artistic level, based on a truer observation of everyday life. Characteristic specimens of this type are the sets of *The Cries of London*, illustrating the various street traders. Published first as woodcuts under James I, a great number of these sets appeared during the 17th century. The most important with single figures date from the second half of the 17th century, one from 1655, one from 1670–86, the third, by Tempest after Laroon the elder, from 1688 (Pl. 15b). Originally deriving from large Italian towns, the theme, once introduced, spread throughout the country and the artistic standard rose visibly from set to set, the figures becoming less rigid and primitive, and more lively. The last set in particular, after Laroon, is characterised by a style which can already be called moderate baroque. It was so popular that it ran into different editions and was still being republished with variations (e.g. by Boitard, one of Hogarth's pirates) during Hogarth's working years. Though it is seldom possible to recognise the literal origin of figures from the Laroon set in Hogarth's engravings, yet in some of them such as *The Enraged Musician* (Pl. 75a), and *The Execution of the Idle Apprentice at Tyburn* (Pl. 107b), both teeming with street traders, the continuation of the tradition is clearly apparent.

89. According to F. G. Stephens (*op. cit.*) this process set in from about 1725 onwards as a result of Hogarth's engravings of 1724 (e.g. *Masquerades and Operas*) (Pl. 5a).

90. *W. Hogarth invenit, J. Sympson Junior sculpsit.*

91. Hogarth's drawing of a scene from *The Beggar's Opera* (Windsor) for this benefit ticket still exists. It is not easy to judge Sympson's particular style since the British Museum Print Room possesses only one engraving by him, namely a mezzotint after Hogarth's picture, *A Woman swearing a Child to a grave Citizen*; however, all the prints in the group in question are etchings and consequently far freer in style. Even technically it is conceivable that the etchings are by the same hand as the engraving. S. Ireland, who first published most of the rare etchings in this group, also contended that they were done after drawings by Hogarth and explicitly states in some cases that the engraver was Sympson. However, there is a slight possibility that at least some of the etchings date from as late as the end of the 18th century and are forgeries masquerading as Hogarths and designed for such connoisseurs as S. Ireland. A print-seller of the time, W. Richardson, considered that these etchings were forgeries by a certain Powell (quoted in J. N. Nichols, *Anecdotes of William Hogarth*, London, 1833). A strong argument in favour of this view is that the notably sketchy manner of the etchings was exceptional in the first half of the 18th century and quite common in the second half; furthermore, motifs appear in them which repeat later motifs of Hogarth. But these arguments are not unanswerable.

92. Only seldom were good painted copies made after Hogarth's engravings, such as those by his friend Hayman.

93. Real hero worship existed for notorious rogues: broadsheets and ballads were published about them and also their (frequently apocryphal) memoirs. In *The Execution of the Idle Apprentice* from *Industry and Idleness*, the hawker selling the traditional 'dying speech' of the criminal is given the prominent position. Even Defoe, working for the publisher, Applebee, specialised in 'dying speeches' and wrote biographies of famous criminals, such as Jack Sheppard (1724) and Jonathan Wild (1725). Gay immortalised Wild as Peachum in *The Beggar's Opera* and also made a hero of the highwayman, Macheath.

94. On the day of Sarah Malcolm's execution, *The Daily Advertiser* brought out the following: 'On Monday last, the ingenious Mr Hogarth made her a Visit, and took down with his Pencil, a very exact likeness of her, that the Features of so remarkable a woman may not be unknown to those who could not see her while alive.'

95. Jack Sheppard's escape from prison caused such a sensation that, after his recapture, everyone wanted to see

or hear about him. Through Defoe, writing in *Applebee's Journal*, we know that members of the aristocracy went out of curiosity to Newgate and that even the king wished to see two prints of Sheppard in chains (one of which may have been Thornhill's).

96. Horace Walpole considered Hogarth such an expeditious reporter of topical events that when Theodore, King of Corsica, was sitting in the Debtors' Prison in London, he wrote to Horace Mann (1750): 'I have desired Hogarth to go and steal his picture for me.'

97. At the same time they were so popular that, with Hogarth's permission, they were used to illustrate verses.

98. Despite this, no buyer could be found for the original pictures of the cycle.

99. E. Wind, in 'Borrowed Attitudes in Reynolds and Hogarth' (*Journal of the Warburg Institute*, II, 1938–9), suggests that the motif of Hercules on the Crossroad influenced this group by Hogarth; even so its direct origin from this popular engraving of the same theme is certain.

100. Fielding did sometimes write for the lower orders, but not novels. In 1752, when a magistrate, he published and distributed among the poor a pamphlet with the title, *Examples of the Interposition of Providence in the Detection and Punishment of Murder*; it is mainly an extract from a popular 17th-century chapbook full of admonitions and quite different from his *Enquiry*, published a year previously and also from *Amelia*, likewise from 1751, destined for his customary reading public.

101. Walpole also acquired the sketched as well as the finished set of drawings for *Industry and Idleness* and a number of paintings: *Sarah Malcolm*, a sketch of *The Bambridge Committee*, a version of *The Beggar's Opera* and the picture of Monamy with Walker. His brother, Sir Edward Walpole, whose portrait Hogarth painted, owned the painting of *The Sleeping Congregation*. Lord Charlemont, who also had himself painted by Hogarth, bought *The Gate of Calais*, drawings of the *Four Stages of Cruelty* and ordered *The Lady's Last Stake*. Garrick, another of Hogarth's sitters, owned *Falstaff examining his Recruits*, the *Election* cycle, *Satan, Sin and Death* (an illustration to *Paradise Lost*) and apparently also *Preparations for the Wedding Banquet* from *The Happy Marriage*. William Huggins, the poet and translator of Ariosto, owned versions of *The Bambridge Committee* and *The Beggar's Opera*. Miss Edwards, eccentric but by no means stupid, chose Hogarth as her particular artist: she possessed *Southwark Fair* and commissioned *Taste in High Life* and various portraits of herself, her family and her child.

CHAPTER FOUR

1. The average middle-class attitude towards the theatre lay somewhere between Defoe and Steele. Defoe was still opposed to it; Steele, as both critic and playwright, loved it and aimed at its moral reform; with Addison he was also in favour of the middle path, in this case a compromise between the extremes of libertine Restoration comedy and Collier's invective against the stage. It was Steele's and Cibber's sentimental comedy which prepared the way for Lillo's domestic drama.

2. See A. Nicoll, *A History of Early 18th-Century Drama, 1700-50* (Cambridge, 1925).

3. From people like Lord Chesterfield and Horace Walpole, but not from some of the aristocracy. Yet, as Voltaire stresses in his *Lettres Anglaises*, actors were accepted far more generally here than in France.

4. The oldest of these was perhaps that of the actor Lacey by Wright in three different roles (Hampton Court), painted as early as 1662, and specially commissioned by Charles II who, an imitator of the French court, owned a theatrical company. Kneller painted the actor Anthony Leigh in Dryden's *Spanish Friar* (1689, National Portrait Gallery). Giuseppe Grisoni painted Cibber in the role of Lord Foppington from Vanbrugh's *Relapse* (Garrick Club). Grisoni was in England from 1715 to 1728 and collaborated with Hogarth on the illustrations to de la Mottraye's *Travels*.

5. C. K. Adams of the National Portrait Gallery dates the costume in this portrait about 1735-40.

6. The comic, stumpy Roman general in a wig, in the first plate of *The Analysis of Beauty*, is held to be Quin in the role of Brutus.

7. Many portraits attributed to Hogarth are alleged to represent Peg Woffington. Lately it has been held that the Glenconner likeness does not represent her; indeed when comparison is confined to her generalised portraits by Jean Baptiste van Loo, Eccard, Pickering, van Bleeck, etc., only a vague resemblance can be admitted. Yet the identity seems probable enough if it is compared with two more realistic paintings portraying her at a more advanced age: Haytley's painting of her as Mrs. Ford, 1751 (mezzotint by Faber) and the one by Pond (*c.* 1758—National Portrait Gallery), in which she is represented lying paralysed in bed. Moreover, the Glenconner portrait reveals a personality which is completely different from the usual type of society lady as seen in contemporary portraits.

8. Hogarth's portrait of another famous actress, Mrs. Pritchard, has not survived.

9. See A. Heppner, 'The Popular Theatre of the Rederiskeers in the Work of Jan Steen and his Contemporaries' (*Journal of the Warburg and Courtauld Institutes*, III, 1940).

10. See A. Ballantyne, *Voltaire's Visit to England* (London, 1893).

11. On the intricacies of the various versions and their pedigrees, see R. B. Beckett, *Hogarth's Early Painting, II, 1728: The Beggar's Opera* (*Burlington Magazine*, XC, 1948).

12. In the earlier version most of the onlookers and actors in the background are rather caricatured.

13. Many portraits attributed to Hogarth are said to represent Gay, but all these identifications seem to have originated in the 19th century.

14. Hogarth also did a portrait group of Rich with his family. The portrait in the Garrick club, however, which is said to represent them, is not by Hogarth but probably by Highmore.

15. Yet certain loose threads remain between the *Commedia dell' Arte* and *The Beggar's Opera*. See E. M. Gagey, *Ballad Opera* (New York, 1937).

16. The early penchant in England for pictures of the theatre is also borne out by Hayman's representations of plays. Soon after the time of Hogarth's *Beggar's Opera*, he was engaged in decorating Vauxhall Gardens with paintings, including a number of scenes from plays.

17. This picture, which some have dated slightly earlier, was until recently in England. Watteau's *Ile de Cythère*, inspired by a play performed at the Comédie Française, in which the main actors are lined up in a row, was engraved by Mercier in London in the 'twenties.

18. In the earlier version, the group of the five main actors is more detached from the rest and the whole composition is less flowing and spatial. On the other hand, the same group is more vehemently and traditionally baroque, particularly with regard to Polly's kneeling pose, while her father stands more awkwardly, in a slightly crouching position.

19. Hogarth could not have known this work at the time of *The Beggar's Opera*, since it was not engraved until 1731.

20. The drawing is close to the Benefit Ticket for Walker, who played the role of Macheath, engraved by Sympson after Hogarth.

21. Theophilus Cibber's most famous role at this time was Pistol (in both *Henry IV*, Part II and *The Merry Wives of Windsor*)—a part popularised in several engravings, one of which was used by Hogarth as a show-cloth in *Southwark Fair* (1733).

22. His engraving must have been a great success, for five different states of it exist. It must have been bought by the same public which flocked to the play, and in the same good-humoured mood in which Hogarth did it.

23. For instance Thomas Herring, preacher of the Society of Lincoln's Inn, later Archbishop of Canterbury, whom Hogarth was one day to paint, harangued his congregation against the play. Defoe was also quite incensed by its immorality and prophesied that some dreadful disaster would befall London as a consequence (*Second Thoughts are Best*, 1728).

24. Or, as Boswell, who made something of a study of the influence of *The Beggar's Opera* on morals, was later to put it 'The Contrast with the ordinary and more painful modes of acquiring the property are artfully displayed'. Typical of these much stricter views in the second half of the century was Sir John Fielding's request in 1773 to Colman and Garrick not to stage *The Beggar's Opera* since its effect was to increase criminality; and when the play was revived in 1777 Macheath was not pardoned but sent to the hulks for three years.

25. Nichols alleged that this feature of Hogarth's composition harked back to an engraving after Charles Antoine Coypel in which cats are performing an opera (*Les Chats ou La Tragédie d'Iphigénie sur les Gouttières*, Amsterdam, 1728). See also, on this latter work, A. Blum, 'L'Estampe satirique et la Caricature en France au XVIIIᵐᵉ siècle, (*Gazette des Beaux Arts*, 1910).

26. Dacier, in *Les Graveurs de Watteau*, has already remarked on the similarity between this composition and some of Hogarth's musical scenes.

27. Even the composition is generally regarded as not by Hogarth.

28. Because of its weak execution the engraving was held by the print-seller, W. Richardson, at the end of the 18th century, to be a forgery. A pen drawing of the figure of the Mock Doctor (published as Hogarth's by S. Ireland, *op. cit.*, Vol. 1) is certainly not by Hogarth but a copy after the engraving.

29. Hogarth liked to use the figure of Punch, the English derivation from Punchinello; it occurs, for example, on the sign-board in the second scene of the Election series, *Canvassing for Votes*.

30. An anonymous engraving, which I think might be by Vandergucht, caricatures the landing of the singer Senesino in England and probably dates from *c.* 1725. Apart from this, there were no other satirical engravings of the stage except Hogarth's until 1728.

31. A satirical print, similar to this show-cloth but with the singers alone, is more probably by Vanderbank than by Hogarth. When using this engraving in *Masquerades and Operas*, Hogarth changed the order of the singers and added the aristocrats and the curtain. A pen drawing (Windsor) for the distorted, elongated figure of a singer, possibly Senesino, which appears in both works, seems to be just as close to the young Hogarth as to his teacher, Vanderbank. Hogarth's early work and a great deal of the English art of his time is so closely connected with mannerism and so particularly adapted for elongated, curved figures that this impressive drawing almost creates the effect of a 16th-century work. On various opinions as to the identity of the opera and the singers, the attribution of the engravings and the drawing, see A. P. Oppé, *The Drawings of William Hogarth* (London, 1948) and H. R. Beard, 'An etched Caricature of a Handelian Opera' (*Burlington Magazine*, XCII, 1950).

32. Though he had no objection to caricaturing English singers when occasion arose, as in an engraving of those performing Huggins' oratorio *Judith*.

33. In England some of the fashionable foreign baroque artists such as Marco Ricci, Servandoni, Amigoni and Brunetti, painted stage decorations for the Italian operas performed here: Ricci, in 1710, for Mancini's *L. Idaspe Fedele*; Amigoni, in 1734, for an opera by Porpora performed at the New London Opera House with Farinelli. Thornhill did drawings (Victoria and Albert Museum) for the scenery of the first Italian opera performed in England, Stanzini's *Arsinoe*.

34. The borderline between the group of Sympson prints and those either executed by other engravers after Hogarth or quite erroneously linked with him is in a state of flux and will require definition when a systematic catalogue of Hogarth's engravings is undertaken.

35. Hogarth himself owned a terra-cotta bust of Newton, given him first by his friend Roubilliac. The marble bust depicted in *The Indian Emperor* was ordered from Roubilliac by Conduitt who was connected with Newton by marriage and succeeded him as Master of the Mint. The Conduitt household was an essentially Whig milieu;

Newton himself, as Member of Parliament for Cambridge University, had resisted James II and, like Addison, was a *protégé* of the Whig leader, Lord Halifax.

36. In the 'thirties, Fielding had already deprecated the customary mutilation of Shakespeare on the stage; the staging of Shakespeare at that time tended to draw on his comic and grotesque aspects. *Falstaff examining his Recruits*, Hogarth's picture of 1728, reflects this attitude. When Hayman later illustrated the same theme in the Shakespeare edition of 1744, that is, at the time of Hogarth's *Richard III*, he gave the scene a more polished, more outspokenly rococo character than had Hogarth in his early rendering.

37. This was certainly the general line of division although Rich did sometimes produce Shakespeare whereas pantomimes and even more popular shows were also performed under Garrick's management.

38. Something similar though on a more modest scale occurs in another, probably earlier, picture by Hogarth of a scene from *The Tempest* (Nostell Priory Collection), showing the second scene of Act I with Miranda and Prospero in the centre, the shipwrecked Ferdinand about to kneel on one side and Caliban on the other.

39. It was Garrick who finally drove the spectators off the stage in order to give it greater dignity, and thus put an end to a custom which still figured prominently in Hogarth's *Beggar's Opera*.

40. In France there was a similar though less radical move to endow representations of the stage with greater respectability and even to turn them into historical paintings. Towards the end of the 'thirties Lancret became a chronicler of performances of the Comédie Française; when he represents the performance of a tragedy (*Le Comte d'Essex* by Corneille; Hermitage, Leningrad) the scenery is less discernible and the picture tends more to assume the character of a history painting than when he depicts a comedy. Charles Vanloo's *Medea and Jason* (1758, Potsdam), with the famous actors Mlle. Clairon and Lecain, departs so far from the actual stage setting that it could almost be viewed as a mere historical picture.

41. At precisely this time, Roubilliac who came to England in 1726, was working on his first large baroque tomb in London—the Duke of Argyll's in Westminster Abbey (erected 1749). Roubilliac's first master was the German Permoser, one of the most impetuous baroque sculptors on the continent. If his style was perhaps somewhat restrained under the influence of his other master, the Frenchman Nicolas Coustou, it later—and precisely after the Argyll monument—became all the more Berninesque. Hogarth and Roubilliac were friends, and also had some fashionable, aristocratic clients in common. Hogarth was the only painter of whom Roubilliac did a bust (Pl. 46.)

42. Hogarth did a modish subscription ticket to this engraving which showed a mask, a palette and a laurel wreath.

43. When adapting *Romeo and Juliet*, Garrick cut out the comic scenes to gain what he considered to be dramatic unity. But Hogarth, more genuinely Shakespearean in this, deliberately intermingled tragic and comic motifs in his cycles.

44. Fielding describes, in *Tom Jones*, the reaction of Partridge, the 'common man', to Garrick's portrayal of Hamlet in the Ghost scene: he found nothing extraordinary in it and considered that Garrick behaved just as he himself would have done had he seen a ghost.

45. Literature on Shakespeare in the 18th century at first confined itself to considering how far the plays conformed to the rules and whether their author was really learned. Later the question of the purity of the text became of topical interest. Only in the third quarter of the century, in Garrick's time, did critics become interested in Shakespeare's characters. See N. Smith, *Eighteenth Century Essays on Shakespeare* (Glasgow, 1903).

46. It was Garrick who introduced footlights in place of chandeliers, so as to focus light on the actor's face and make the scene more like a picture. Although, like the clearing of spectators off the stage, this was only introduced after 1745, both developments are in line with Hogarth's painting.

47. Quoted in Ch. Gaehde, *David Garrick als Shakespeare-Darsteller* (Berlin, 1904).

48. The spirit of these Shakespeare performances, even allowing for their mutilated and expurgated texts, was still astonishingly naturalistic. The great impression made by Shakespeare, despite equally expurgated translations, ten or twenty years later on the continent and mostly in middle-class intellectual circles, was due precisely to their seemingly unbridled realism.

49. Coypel's famous tapestries depicting various operatic performances (1733–41) follow the stage events very freely. Lancret's illustrations of comedies by Molière and Destouches (1739), which have mostly survived only as engravings, are more accurate but assume rather the character of society pictures. See W. Kelch, *Das Theater im Spiegel der Bildenden Kunst* (Berlin, 1938) and H. Tintelnot, *Barock-theater und Barocke Kunst* (Berlin, 1939).

50. In *The Analysis of Beauty*, Hogarth mentions the tapestries woven after this cycle. Moreover an engraving by Gribelin of *The Tent of Darius* was published in 1703 in an English translation of Félibien's Commentary on this picture, so the motif was well-known in this country. It was also used in Rowe's 1714 edition of Shakespeare for du Guernier's illustration of *Coriolanus*.

51. The first appeal that actors should wear costumes of the period in which the play was set was made by Wilkes.

52. On Garrick's costumes in plays of Shakespeare, see G. C. D. Odell, *Shakespeare from Betterton to Irving* (London, 1921).

53. J. Mann, 'Sir John Smythe's Armour in Portraiture' (*The Connoisseur*, xc, 1932).

54. Shortly before this, the fashionable Liotard painted both Garrick and his wife in Paris.

55. Not so much on account of this as in spite of it, Hogarth and Garrick quarrelled over the likeness and the angry artist spoiled Garrick's face and did not deliver the picture.

56. The ultimate origin of the motif is perhaps to be found in Rembrandt's *Ship-Builder and His Wife* (Windsor), in which the wife is bringing a letter to her husband. The motif of Garrick's head pensively resting on his hand with

raised forefinger might have come to Hogarth from Reynolds' portrait of Horace Walpole, painted the year before (Marchioness of Lansdowne).

57. Nichols, *op. cit.* It so happens that J. B. Vanloo also painted a portrait of Garrick (W. Somerset Maugham) but it is in every way more superficial than Hogarth's.

58. Garrick probably enjoyed this parody as much as Hogarth, since Cibber had been the constant target of Fielding's jokes.

59. *The Green Room* (Lord Glenconner), which is often ascribed to Hogarth, is certainly by Highmore. See also C. H. Collins Baker (*Burlington Magazine*, XLV, 1924).

60. Representations of rehearsals and of actors dressing for a performance existed before Hogarth, but probably never before had actors been shown dressing and rehearsing against the background of their miserable everyday life. A rehearsal of the Haarlem Rhetoricians, the Dutch Guild of Poets and Actors, had been painted in a documentary manner by Job Berckheyde (Haarlem); slightly nearer in spirit to Hogarth are Steen's numerous scenes from the life of these popular rhetoricians; but their actual themes, often accurate reports of the rhetoricians reciting as they intermingle with the public, are quite different from Hogarth's. E. van Heemskerk, in many ways the connecting link between Steen and Hogarth, also produced paintings of this kind (see A. Heppner, 'The popular Theatre of the Rederijkers in the Work of Jan Steen and his Contemporaries', *Journal of the Warburg and Courtauld Institutes*, III, 1939–40). A boisterous drawing by Gillot, glamorous and fantastic (State Art Gallery, Berlin), which is perhaps closest in theme to Hogarth's composition, portrays actors of the Italian comedy dressing for a performance. Peter d' Angelis, often confused with Gillot, also did a picture of strolling comedians in a village street; he was still working in England at the time of the young Hogarth, who was certainly interested in him.

61. The representation of fairs by the Watteau school, e.g. Pater, also derives from Callot but their transposition in a gallant, pastoral sense is quite different from Hogarth's

documentary interpretation and, if anything, closer to Callot's *Fair of Gondreville* than to his *Fair of Impruneta*.

62. A copy after Hogarth's *Enraged Musician* also hung at Vauxhall. The other pictures for Vauxhall—painted by Hayman (two of them in the Victoria and Albert Museum) —chiefly represented fashionable pastimes in a rather rough, drab imitation of French rococo engravings.

63. Nichols pretended that Hogarth had 'stolen' the idea of *Masquerades and Operas* from an anonymous engraving of the same year, also directed against Heidegger and bearing the inscription 'Hei! Degeror, o! I am undone'. The truth, however, is the other way round, as pointed out by Stephens in his catalogue of the satirical engravings in the British Museum.

64. Slightly reminiscent of this is a pen drawing of 1724 (Windsor), wooden but not without charm, by Egbert van Heemskerk the younger, also for a masquerade ticket and a picture by him (formerly in the Collection of Sir Osbert Sitwell). Hogarth certainly knew such works by Heemskerk; but the similarity between them and his own may be just a consequence of the identity of the motif.

65. Inigo Jones often kept close in detail to individual motifs of Callot yet generally transformed his popular motifs into courtly theatre. Hogarth, on the contrary, changed Callot's courtly theatre effects into popular ones.

66. In harlequin motifs of the early 18th century, the impact of Callot had on the whole to give way to that of Watteau, even in rather popular Dutch or English engravings.

67. The original painting of *A Masquerade at Somerset House*, extant only in an engraving done in the early 19th century, if by Hogarth at all, could have been done in the early Vauxhall days, the time of his first genre paintings such as *A Baptism* (Sir Felix Cassel). This work reflects little of the satirical tendency and popular style of the *Large* and *Small Masquerade Tickets*.

68. Even at Vauxhall moralising pictures were shown. For instance, *The Good Family* and its companion-piece, *The Bad Family*, and two scenes from *Pamela*.

CHAPTER FIVE

1. On his own shop-card of 1720 he signed himself, *W. Hogarth Engraver.*

2. Cheron was a rather undistinguished painter of baroque decorations and religious compositions, a weaker version of Thornhill; Vanderbank was a fashionable portraitist in the Kneller tradition. Highmore, Kent and Pond were fellow-pupils of Hogarth at this Academy. Apparently Hogarth did not frequent Thornhill's private school, which was an unsuccessful rival to it, but he must have come into personal contact with his future father-in-law at an early date.

3. Writing retrospectively in his autobiographical notes, he may, however, have exaggerated his antipathy.

4. See A. P. Oppé, *The Drawings of William Hogarth* (London, 1948). Oppé goes perhaps too far in suggesting that Hogarth scarcely ever did drawings on the spot. Nichols, who still knew many of Hogarth's acquaintances, does not give quite this impression.

5. A precedent for this procedure is found in Caravaggio. Degas, who relied almost exclusively on his memory, is the most obvious modern parallel. Rather unexpectedly, Watteau's method was the exact opposite. Most of his drawings were studies after nature, from which he selected figures when painting his pictures.

6. His first figure composition, a small engraving of a scene from *The Rape of the Lock* for the lid of a snuff-box, done perhaps as early as 1717, shows rather primitive, conventionalised poses.

7. The trade-cards attributed to Hogarth are assembled in A. Heal, *London Tradesmen Cards of the XVIII Century* (London, 1925).

8. The authenticity of this work has been questioned without any justification.

9. The same is true of Hogarth's ticket for Tiverton School and his headpiece for the Foundling Hospital's power of attorney to collect subscriptions.

10. Hogarth owned John Smith's mezzotints, published in 1709 after the cartoons of *The Loves of the Gods*, which belonged to the Duke of Marlborough. These cartoons were attributed to Titian but were, in fact, by Padovanino, based on an earlier cycle with the same theme by Vaga. However, the scene of *Mercury and Herse* from which Hogarth took his figure only occurs in the original series by Vaga, which Hogarth must therefore have known as well. Later, in the Countess's *Toilette* (*Marriage à la Mode*) Hogarth was to use various scenes of the loves of the gods as pictures on the wall (*Jupiter and Io* by Correggio, *Jupiter and Ganymede* after Michelangelo) and even as decorations for dishes (*Jupiter and Leda* by Giulio Romano) to accentuate the motif of seduction.

11. *Sign-Boards of Old London Shops* (London, 1947).

12. Daniel Marot (1663–1752) worked in Holland and also in England as an architect for William III. On the transitional position between baroque and rococo of Marot's ornamentation see F. Kimball, *The Creation of the Rococo* (Philadelphia, 1943).

13. Both sides were published in S. Ireland (Vol. II). The authenticity of this work has unjustifiably been questioned. Apart from stylistic considerations, there is the additional proof that the picture in the Grant Collection is painted on mahogany, quite rare in the early 18th century, and so were both sides of the sign originally in S. Ireland's collection.

14. Just as Hogarth did a caricature on the South Sea Bubble, the two most quick-witted French artists, Gillot and Watteau, did some on the Law Scandal (Gillot two engravings, Watteau an allegorical drawing, now in the Ashmolean Museum, Oxford). The outstanding caricature produced in Holland on the Law scandal was by the French immigrant, Picart.

15. The scandal following the dismissal of the Jacobite clergyman, Dr. Sacheverell, in 1710 occasioned the first wave of indigenous caricatures in England. See T. H. Wright, *A History of Caricature and Grotesque for Literature and Art* (London, 1865).

16. From this Hogarth also borrowed the figure of the flying angel in *The Beggar's Opera Burlesqued*.

17. At the time of the Law crisis many older engravings were republished, including Breughel's *Battle between Carnival and Lent*, now under the topical title of *Battle between the Good Living Bubble-Lords and approaching Poverty*.

18. See J. Ashton, *A History of English Lotteries* (London, 1893).

19. Cibber's relief on Wren's Monument erected in 1675 to commemorate the Great Fire of London and introduced by Hogarth in his *South Sea Scheme* contains allegories of a similar character. The figure of Liberty swinging a broad-brimmed hat and placed next to Charles II refers to the fact that non-members of the guilds were now allowed to participate in the rebuilding of London. See H. Faber, *Caius Gabriel Cibber* (Oxford, 1926).

20. It was Lord Halifax, Addison's patron, who founded the Bank of England and later, in 1695, reformed the English currency and restored national credit.

21. In the first volume of his *Graphic Illustrations*,

Samuel Ireland wrote: 'Hogarth's partiality for the works of this great genius (Callot) has been generally admitted: a strong resemblance of manner both in their style and execution is everywhere so discernible as to confirm the idea.'

22. One gets a better understanding of the motives behind Callot's *Misères de la Guerre* if a clear distinction is made between the early, small cycle and the later, large one. Both were certainly dictated by documentary interest in daily events during the continuous wars (which had not yet found artistic representation on a high, non-popular level). But Callot's first idea, i.e. the small cycle, which was not published until after his death and which shows *only* the ill-treatment of peasantry by soldiers, was probably also prompted by some sympathy for the former's sufferings. In the large cycle he adopted a more official attitude and the miseries of the peasants are relegated to the background. Deep compassion for the sufferings of the poor in war-time only appeared in really popular engravings such as those of the Bolognese G. M. Mitelli (1634–1718), a pupil of Albani. In French painting, the young Watteau's military pictures from about 1710 show, perhaps for the first time, the soldier's life far behind the battle zone in an unusually drab prosaic light and are to some degree influenced by Callot. *Le Pillement d'un Village* and *La Revanche des Paysans* which follow motifs of Callot's cycle, were published in London in 1748 as prints after Watteau by Baron. P. Marcel holds the view, with which I do not agree, that the originals, no longer extant, were painted by Watteau in England; R. Huyghe and H. Adhémar attribute them rather to a Watteau pupil. At any rate the engravings in a Callot-Watteau vein were accessible to Hogarth.

23. *La Fiera*, an elaborate comedy by Michelangelo's nephew, first performed at the Florentine court theatre in 1618.

24. Yet both Callot's and Hogarth's compositions were so widely circulated that they appeared in popular art on pottery, china, faience, etc.

25. Callot's influence (*Misères de la Guerre*) is especially evident in Hogarth's illustrations to S. Beaver's *Roman Military Punishments* (1725) and in a drawing for Beaver's projected book on a history of Modern Military Punishments (c. 1725). Picart's influence is evident in Hogarth's frontispiece to N. Amhurst's *Terrae Filius* (1726).

26. This also served as a source for Voltaire's *Histoire de Charles XII* (1731).

27. This composition was not engraved by Hogarth himself.

28. This rather crude, popular, much accentuated mannerism is even truer of the other collaborators in de la Mottraye's illustrations than of Hogarth himself. At that time elongated proportions and small heads were still a characteristic of genuinely elegant art; for example, in fashionable English portraits and in Watteau's own early etchings, *Figures de Modes*.

29. The volume of the *Cérémonies* dealing with Mohammedan customs was of a posthumous nature, for Picart died in 1733. The first engraving, taken over from Hogarth and to which I refer in the text, bears the inscription *Picart delin.*

1731; the second, *Picart direxit*. Not all works signed 'direxit' go back to Picart. This apart, he himself quite frequently plagiarised without indicating the source. In addition to these two engravings, one or two other minor plagiarisms occur in the *Cérémonies* from de la Mottraye's illustrations. The illustrations of de la Mottraye's book (by Hogarth and others), those in Picart's consecutive volumes and various independent works by Hogarth interacted on each other over a period of several years.

30. In the 1660s the Dutch upper class, which was also inclined to come to terms with Louis XIV, became partial to French taste. It also became fashionable among the adversaries of France and was even favoured by the Orange dynasty.

31. Illustrations in a previous edition of 1709 served as models for three of Hogarth's seven scenes for *The Golden Ass*. Baldwin Brown, *William Hogarth* (London, 1905) is the only author who has seriously touched on some of these cases of 'borrowings'.

32. The comic journal of Hogarth and his friends, *Five Days Tour in Kent* (1732), was put into Hudibrastic verse by Hogarth's friend, the Rev. W. Gostling, Canon of Canterbury Cathedral.

33. Under Queen Anne Tory pamphleteers and imitators of *Hudibras* dwelt intensely upon the political implications of Butler's poem (see E. A. Richards, *Hudibras in the Burlesque Tradition*, New York, 1937). Ned Ward wrote his *Hudibras Redivivus* (1708) and *The British Hudibras* (1710) from this viewpoint. Hogarth's admiration for *Hudibras* was of course no longer inspired by this spirit but was more in line with Fielding's play, *Eurydice Hiss'd* (1735), which commiserated with Butler for his poverty and neglect by the Court. Swift shared Hogarth's liking for Butler's rationalism. Addison and Steele were continually quoting *Hudibras* in *The Spectator*. Voltaire, who rated Swift above Rabelais, translated into French and published in a compressed form the first four hundred verses of *Hudibras*; he wrote on it in his *Lettres philosophiques*—'un poème qui force le lecteur le plus sérieux à rire.... Un composé de la Satire Ménippée et de Don Quichotte....' In 1757 a French translation of the whole of *Hudibras* was published together with Hogarth's first set of illustrations.

34. See also the finished but very lively pen, ink and wash drawing in Windsor.

35. Annibale Carracci's composition was a frequent model for early 18th-century French mythological paintings, whose themes became increasingly erotic, particularly after the death of Louis XIV: e.g. Delafosse's *Triumph of Bacchus*, Louvre.

36. The motif of the faun's bending attitude from the same painting was used a little later (1731) for a small satyr in Hogarth's first idea for the subscription ticket for *A Harlot's Progress*, *Boys Peeping at Nature*, whereas the representation of Nature as the many-breasted Ephesian Diana was used by Hogarth in the Arms for the Foundling Hospital.

37. J. Nichols (*op. cit.*) mentions this Callot figure as Hogarth's model.

38. Although one cannot claim any real outward resemb-

lance between Hogarth's Hudibras and Ralph and Ch. A. Coypel's Don Quixote and Sancho Panza, one is occasionally aware of reflections of these latter figures and their expressions in Hogarth's types.

39. However it seems unlikely that it was intended as a frontispiece to the first volume of the book itself. Its republication in 1757 with the title *The Political Clyster* directed against four contemporary Parliamentarians apparently had nothing to do with Hogarth (see Nichols, *Genuine Works*, Vol. II, 1810, p. 200).

40. Noted by J. Nichols, *Biographical Anecdotes of William Hogarth* (London, 1785).

41. The picture is usually considered to be a discarded sketch for *A Rake's Progress* or for *A Harlot's Progress*. For stylistic reasons, however, it must be earlier than either of the cycles.

42. Engraving, after the no longer extant oil sketch, in S. Ireland, *op. cit.*, Vol. II.

43. This does not imply, as S. Ireland thought it did, that during these years Hogarth set up as a painter of signboards. The sign of St. Luke and the ox was not confined to sign-painters but was used by all artists.

44. The picture, at least in its present state, does not seem of very high quality and possibly is only a copy.

45. Some doubt exists as to the identities mentioned and even as to the authenticity of the drawing representing Dennis (known only through an engraving in S. Ireland); yet, in a general way, they seem acceptable. See L. Binyon, *Catalogue of Drawings by British Artists in the British Museum* (London, 1900, II), A. C. Sewter's 'Some Early Works of Hogarth' (*Burlington Magazine*, 1942) and A. P. Oppé, *op. cit.*

46. Pope, who gambled heavily in the South Sea Company, was probably represented by Hogarth as early as in his *South Sea Scheme* (1721).

47. A portrait in the Zürich Museum attributed to Hogarth is said to represent Figg but, judging from a photograph of Broughton's likeness, it seems to me that the person portrayed is, rather, Broughton.

48. Social intercourse between painters, theatrical people and boxers was not uncommon. John Ellis, a pupil of Thornhill, imitator of Hogarth and manager of Drury Lane Theatre, was also a well-known *habitué* of Broughton's school of boxing.

49. Although the date, which came to light during a recent cleaning, terminates a long inscription on a plaque, it seems to me undoubtedly to represent the date of the picture itself.

50. In 1736, when Hogarth set about engraving *The Sleeping Congregation*, he reduced the congregation to a few large figures, his concentration of the composition having by then become much stronger.

51. Oil sketch for the central motif of the picture in the British Museum.

52. The continuous interaction between the young Hogarth and the *Cérémonies* can also be seen in the use of the same Hogarth composition by one of the Dutch engravers, Schley, in the later volume of *Cérémonies* published in 1736.

53. Crespi, although a Bolognese, played a great part,

mainly through Piazzetta and Pietro Longhi, in the formation of Venetian painting, which in turn was closely linked with that of England.

54. In a late volume of 1736 of the *Cérémonies et Coutumes Religieuses*, published after Picart's death, in which the ceremonies of the Anglicans are illustrated, not only by Picart but also by some Dutch engravers, one of the engravings, *Sermon de la Fille qui se trouve enceinte*, takes this composition over almost *in toto*, with the acknowledgment 'Hogarth invenit'.

55. About the same time, or a year or two later, Hogarth painted a picture which has not survived but which is known from Vertue's description. It represents another grotesque act of justice: Sir Isaac Shard, a London magistrate, condemning a dog to death for stealing a leg of mutton from his kitchen.

56. The scheme for these scenes by de Troy originated in the frequently represented seduction scene of *Joseph and Potiphar's Wife*, which de Troy himself also depicted.

57. In 1736 Hogarth reproduced *Before* and *After* as engravings, just as he had *The Sleeping Congregation*, and these later versions also have a more clarified and monumental pattern than the originals.

58. So great was the popularity of this engraving that it was even adapted to the theatre in 1742.

59. The painting must have existed, for Hogarth represented it in his *Battle of the Pictures* (Pl. 102b). However the picture formerly in the Seabury collection, New York, now at Frederickton, introduced by R. B. Beckett (*Hogarth*, London, 1949) as the original must be only a copy after the engraving. The picture, too insipidly painted to be by

Hogarth himself, has far more unoccupied space in the foreground and at the sides than the print, so that the figures almost seem lost in it—a manner of composition entirely opposed to the relatively cramped arrangement of the early Hogarth and this particular engraving. The numerous lemons and empty bottles on the table and floor, motifs absent from the print but included in the picture to fill up empty space, are displayed in a monotonously cumulative manner quite unlike Hogarth's usual flowing pattern, whilst many 'baroque' objects in the engraving, among them the broken crockery so characteristic of the artist, are missing from the painting. The angular table on the right, instead of a baroque suggestion of a corner of a table, as in the engraving, appears too stiff for him. Finally, to use a very simple argument, the shape of the original picture, as introduced into *The Battle of the Pictures*, is quite different from that of the very long and narrow painting—a format which, in such exaggerated proportions, Hogarth never used.

60. The verses beneath *A Midnight Modern Conversation*, with their reference to Rabelais and Cervantes, are in the spirit of Fielding's farces of those same gay years.

61. On the other hand I think that the seized movements of the figures walking or lying down by Siberechts, a painter who lived in England and left numerous works here and whose movements of this kind were the most spontaneous among Flemish or Dutch artists, may genuinely have influenced Hogarth.

62. The superior and benign attitude towards peasants is particularly noticeable in Teniers, who had a relatively high social standing.

CHAPTER SIX

1. The date 1731 appears on the coffin in *The Harlot's Funeral*; they were probably begun several years earlier, at the latest in 1729, when Hogarth married.

2. The paintings must have been ready for engraving at the end of 1733, but Hogarth waited till the law of copyright had passed through Parliament before publishing the prints.

3. See F. Novati, 'La Storia della Stampa nella Produzione Popolare Italiana' (*Emporium*, XXIV, 1906), and A. Bertarelli, *L'Imagerie populaire italienne* (Paris, 1929).

4. Mitelli's other engravings are traditional in theme, directed against vice and stressing the vanity of the world and the proximity of death. See A. Bertarelli, *Le incisionii de G. M. Mitelli* (Milan, 1940).

5. Somewhat closer to Hogarth's artistic level is a cycle representing the life of a drunkard (*Vie de Geiton, fameux Ivrogne*) by a 17th-century engraver, Brébiette, a follower of Callot.

6. A woman with her knees crossed while washing her feet in a brook was also a recurrent motif of Siberechts.

7. Steen's frequent motif of a man seated with one leg raised was an imitation of a famous antique statue, the Barberini *Faun* (see F. Antal 'Concerning some Jan Steen Pictures in America', *Art in America*, 1925, XIII). Thus Hogarth's rake, following in the steps of Steen, unwittingly echoed a motif from antiquity.

8. These observations do not apply of course to Rembrandt. Compared with the complex, fluid states of mind which he depicts, where different traits of character combine and intermingle in one face, Hogarth's characters are simple, in keeping with their roles in the story, with one trait emphasised at the expense of the rest.

9. In his frequent use of perspective effects in the depiction of interiors, Hogarth was perhaps influenced, even beyond the general Dutch impact, by Hoogstraten, who lived for a time in England (1662–6).

10. The idea of the harlot's Jewish protector sitting with her at table in a Jewish-rococo, middle-class setting could have been suggested to Hogarth by numerous illustrations of Picart's, whose Jews frequently sit round a table in a bourgeois-rococo setting at one of their religious ceremonies (e.g. *Jewish Easter*).

11. While late Dutch and Flemish genre pictures appeared in large numbers in English collections, and not alone those by immigrants, they could rarely be found at the same time in France.

12. Some suggestion for Hogarth's *Morning*, the first plate of *Four Times of the Day* (1738), set in Covent Garden, may well have come from Angelis's crowded pictures of Covent Garden. These also contain numerous figures crowded together in silhouetted *repoussoirs*, particularly old market women seated on the ground.

13. See Hildegarde Reiter *William Hogarth und die Literatur seiner Zeit* (Breslau, 1930).

14. Hogarth who, like Fielding, objected to poor people spending money extravagantly, here satirised the predilection for expensive funerals.

15. An engraving of 1736 by du Bourg, *Cérémonies Funèbres Domestiques chez les Anglois*, in Picart's *Cérémonies Religieuses*, also shows a corpse in an open coffin, surrounded by grieving guests whilst maid-servants carry round refreshments.

16. Certainly no previous painting of this subject existed at that time, nor probably any engraving: lunatics, divested of religious or demoniac associations, were probably first represented in drawings by Breughel. In an English novel it was as late as 1760 that the first description of a madhouse occurs, namely in Smollett's *Launcelot Greaves*, where the motif could have been suggested just as well by Hogarth as by Lesage's *Diable boiteux*. See W. Dibelius, *Englische Romankunst* (Berlin, 1922).

17. See J. Nichols, *Biographical Anecdotes* and J. Ireland, *Hogarth Illustrated*, III.

18. As H. Reiter (*op. cit.*) says, this effect could almost be compared with Shakespeare's motif of a play within a play.

19. Apart from the actual illustrations, Fielding's comedy, *The Author's Farce* (1730) may have given Hogarth the idea for his *Distressed Poet* (Pl. 47b), being requested by the milkwoman to pay his bill (1735, Birmingham); in the opening scene of the play, a landlady demands her rent from an impoverished poet.

20. W. Dibelius (*Englische Romankunst*, Berlin, 1922) points out that Fielding, following the tradition of the old novel of adventure, does not usually describe in detail the physical appearance of his characters; in consequence, Hogarth's figures must have been very welcome substitutes. It was not by chance that, in his introduction to *Joseph Andrews*, Fielding adduced Hogarth's cycles of the 'thirties to explain his own works of the 'forties, both of which present real characters, and not caricatures.

21. Watteau's drawing was certainly well known to English artists, although it was engraved by Pond as late as 1739.

22. The picture of the *Betrothal of the Rake* (Ashmolean Museum, Oxford) (Pl. 54b) was undoubtedly left out of the cycle for thematic reasons, but apart from this, Hogarth must have found the composition too crowded. He accordingly dispersed the motifs and introduced some into the *Levée of the Rake*, others later into two scenes of *Marriage à la Mode*.

23. Arthur Murphy, the playwright and Fielding's biographer, wrote in the *Grey's Inn Journal* in 1754 (quoted in Dobson, *op. cit.*): 'His Harlot's Progress and Marriage à la Mode are, in my opinion, as well drawn as anything in Molière, and the unity of character, which is the perfection of dramatic poetry, is ... skilfully preserved.' So his contemporaries already judged Hogarth's pictures by the criteria of the stage.

24. Hogarth may have had in mind the lines from *As You Like It*:

> All the World's a stage
> And all the men and women merely players.

It also may well be that this viewpoint and his desire to be judged by theatrical standards, was a distant echo of the official Félibien-Lebrun theory on the importance for painting of the stage with its three classical unities. Antoine Coypel, Ch. Antoine's father, had also stressed already in 1721 the importance for painting of actor's gestures, thinking mainly of the grand, heroic poses in Corneille's and Racine's tragedies.

25. First performed together with Fielding's adaptation of Molière's *L'Avare* and still running in 1738–9. Plays written under the influence of Hogarth's first two cycles included *The Jew Decoyed* and H. Potter's *The Decoy* (both ballad operas); E. Philip's *The Livery Rake* and *The Country Lass* (1733): J. Ayres, *The Female Rake* (1736). As to other works of Hogarth's, *The Undertaker's Arms* (1736) almost certainly inspired the play *The Woman Doctor*, with *Harlequin female Bonesetter*, enacted the following year and directed against the same charlatans as the print. *The Enraged Musician* (1741) was adapted by Colman in 1789 as a burlesque, with the title of *Let Pictura Poesie* or *The Enraged Musician*, the closing tableau reproducing the print. Colman's and Garrick's *The Clandestine Marriage*, a play that, as one would expect by 1766 was no longer merely satirical but also sentimental, was inspired by *Marriage à la Mode*. *Industry and Idleness* inspired a play by James Love.

26. The impressive effect of *The Harlot's Funeral*, with the coffin in the middle of the room and mourners around it, may have been taken from an illustration in the 1711 edition of Fletcher's *The Tamer Tamed*.

27. While the engraving after Gillot's picture has no architectural background, the painting gives a faithful, documentary rendering of the stage setting.

28. Steen was also much interested in the theatre; he often treated his compositions as scenes on the stage and, like Hogarth, frequently used curtains in his pictures. Even his Biblical pictures reveal a stage influence.

29. Dryden did not approve of fashionable marriages among the aristocracy which led to infidelity, and therefore he good-naturedly and indulgently chaffed at them. Hogarth, on the other hand, severely condemned such marriages as corrupt and inevitable sources of tragedy.

30. The tradition may well be correct that the original of the bridegroom's father in the *Marriage Contract*, pointing with pride to his genealogical tree, was the Earl of Scarsdale, Lord Lieutenant of Derbyshire, Envoy to Vienna (died 1736), of whom a portrait exists by Dahl and who was exceedingly vain as regards his title and the symbols appertaining to it. (See Nisser, *Michael Dahl*.) According to another tradition Hogarth's model was the Earl of Portsmouth, who set great store by his ancestry which was traceable back to Saxon times.

31. In Paris a taste for Watteau's engravings began to show itself in the sales catalogues from about 1737–9. In 1744 the Count of Rothenburg wrote from Paris to Frederick the Great, for whom he had tried to buy Watteaus in Paris: 'Tous les ouvrages que Watteau a faits vont en Angleterre, où on en fait un cas infini.' London sales catalogues during these years confirm this vogue.

32. It was the Italian painter, Brunetti, who first published

designs for rococo ornaments in England, in 1731. A combination of rococo, chinoiserie and even Gothic is characteristic of the Chippendale furniture of these years, beginning in 1740. In fact Chippendale furniture was so essentially French in character that it was also called 'French taste' (and only 'modern taste' by the anti-Gallics). See F. Kimball and E. Donnell, 'The Creators of the Chippendale Style' (*Metropolitan Museum Studies*, I, 1929). The Shakespeare chair which Hogarth himself designed for Garrick as president of the Shakespeare Club (engraving in S. Ireland *op. cit.*, Vol. II) is a stylistic mixture from Kent (Venetian baroque) and Chippendale (with perhaps, on account of its destination, even a slight Gothic streak). All English interior decoration of these decades—including applied arts, *objets d'art* and even silver—shows the marks of Oppenord and Meissonier. English porcelain (Chelsea) was entirely under the influence of continental rococo. Gibbs' interiors were decorated by Venetian craftsmen skilled in rococo stucco-work.

33. Thornhill's frescoes in St. Paul's and Highmore's *Pamela* pictures had already been engraved almost entirely by Frenchmen.

34. Vertue mentions that in 1744 Hogarth brought a young engraver from Paris to work for him. Ravenet came to London in 1745; it is conceivable that Hogarth, when in Paris, had induced him to come over to engrave scenes of *Marriage à la Mode*.

35. Vertue mentions that Hogarth had to pay large sums to the French engravers of *Marriage à la Mode*.

36. Vertue, in another context, uses the word 'assurance' in connection with Hogarth; it is therefore probable that this was the missing word, though it could also have been assets. As to the journey itself, there is no reason to doubt the most reliable Vertue's statement. Diderot in his *Salon* of 1755 referring to Hogarth's observation in *The Analysis of Beauty* that the French had no good colourists retorted that Hogarth, when sojourning in France, could have convinced himself of the excellence of French colourists such as Chardin. Hogarth himself, in *The Analysis of Beauty*, refers to the façade of the Louvre in a way that makes it clear that he had seen it. It is conceivable that the series of *Marriage à la Mode* we possess to-day was painted after Hogarth's return from Paris, on the basis of his new experience of French painting. H. R. Willett, a collector of the first half of the 19th century, owned a set of *Marriage à la Mode* and Redford, who saw it at a sale in 1869, considered that it was left unfinished by Hogarth and touched up by a later hand (see *Gentleman's Magazine*, 1842, XVII, and R. B. Beckett, *op. cit.*). So this may have been the cycle originally advertised by Hogarth in 1743 as almost ready, in which case one could suppose that Hogarth, dissatisfied with this first series, on his return from Paris, set about painting a completely new one. This could account for the delay which then occurred before the plates were actually engraved in 1745.

37. The remark in his notes referring to his arrest in Calais is ambiguous: 'It was thought not necessary to send me back to Paris.' J. Ireland (*Hogarth Illustrated*, III, London, 1798) thought it meant that Hogarth, when arrested, was already on his way back from Paris to England. If this were so, he would have been twice to Paris. However, as A. P. Oppé (*op. cit.*) has proved, the phrasing is the invention of J. Ireland himself.

38. Take the elegant grace of the countess herself, here or in the *Contract* scene. Hitherto Hogarth had usually preferred to represent the robust beauty of unaristocratic rather rustic wenches such as the drummeress in *Southwark Fair* (1733), the actress undressing in *Strolling Actresses* (1738) or the milkmaid in *The Enraged Musician* (1741).

39. Addison had already condemned this habit as immoral. Nor could Hogarth refrain from expressing his feelings on the immorality of French society of the rococo period. Beside the lawyer, the countess's seducer, there lies on a couch a symbolic indictment of the whole scene, Crébillon's famous licentious novel *Le Sopha*, widely read by the better-class public.

40. It seems that Coypel in his turn appreciated Hogarth (see Nichols, *Biographical Anecdotes of Hogarth*), for he took over the bride and the maid from the *Rake's Wedding*, transforming them into a more rococo-like composition of his own (*La Folie pare la Décrépitude des Ornements de la Jeunesse*, engraving by Surugue, 1743) (Pl. 53a).

41. Another work by Hogarth of about the same time, also representing a breakfast scene with music-making, close to the *Levée of the Countess*, is the unconventional portrait-group of *Lord George Graham in his Cabin* (c. 1745, Maritime Museum, Greenwich) (Pl. 75b), in which a man is singing a ballad, a negro is beating a drum and a cabin boy is bringing in the meal. Although the contemporary Venetian Bartolommeo Nazari's *Lord Boyne in his Cabin with Sir Francis Dashwood* (c. 1731–2, versions in the collections of Lord Boyne, Sir John Dashwood, etc.: see F. J. M. Watson, 'The Nazaris', *Burl. Mag.*, XCI, 1949), evidently served Hogarth as a starting-point, he has here created one of his most original pictures, certainly his most original portrait group. All Nazari's conventional poses fall away and Hogarth's painting becomes a riot of comic figures, unexpected movements and loud noises.

42. Some English genre pictures of the period frequently combine the reality of an actual scene with a charming though not super-refined rococo ease in the grouping or in details, for example Hayman's *Entrance to Ranelagh Gardens* (Lord Ilchester) or Laroon's *The Mall*.

43. The teaching in Hogarth's academy was probably of a looser, less severe character than in Gravelot's own school, but this does not imply a less stimulating atmosphere. An impression of Hogarth's school is given by a picture representing a life class (Royal Academy), painted perhaps about 1740 and wrongly attributed to Hogarth himself; it is possibly by Hayman or Benjamin Wilson.

44. Drawings by Gravelot were well-known in this country, not only from his work as a teacher but also through engravings made after them by le Truchy, Major and Grignion.

45. Mercier's late pictures depicting Concerts or Comedians à la Watteau but with a certain robustness were realistic in the English manner.

46. Mercier's and Hogarth's portraits around 1740 are also very close to each other. Compare Mercier's of a man (1740) in the National Gallery with Hogarth's from the

same time, such as *John Thornhill* (extant only as an engraving), *Benjamin Hoadly* (1740, Dublin), or that of a young man (1741) in Dulwich. Although Hogarth's handling is broader, the poses and expressions of the sitters are surprisingly alike.

47. Apart from book illustrations, Gravelot began in London by doing shop-cards, political caricatures, headings for ballad sheets and arias under Gillot's influence, thus showing a certain resemblance with the beginnings of Hogarth, although Gravelot's style is on a much less popular level. His headpieces to songs, together with prints after Gillot, Watteau and Lancret adapted to this purpose, formed part of a series entitled *The Musical Entertainer*, published in book form by George Bickham (father and son) in 1737–8.

48. See, for instance, Highmore's two drawings, *The Enraged Husband* (British Museum) and *The Husband's Return* (Pierpont Morgan Library, New York), both frequently attributed to Hogarth. These drawings can best be compared with those by Gravelot for the comic opera *Flora*, produced by Rich at Covent Garden. Engravings after these can be found in Bickham's publication mentioned in Note 47.

49. Hayman's more rococo portrait of the children of Tyers, the owner of Vauxhall, (Fitzgerald Collection, London) is related to the young Gainsborough's likenesses, with Gravelot and French art as their common denominator. In this picture there may be a direct influence from an Audran engraving after Watteau, *Retour de Chasse*, portraying a girl sitting under a tree with hunting trophies. Hayman's portrait of a gentleman standing behind a lady sitting under a tree by a cornfield (formerly Leggatt Gallery, London) is astonishingly close to Gainsborough's *Mr and Mrs Andrews*, painted soon after 1748 (Pl. 30b). Equally close to the early Gainsborough is Hayman's *Girl spinning beside Haystacks* (formerly Christie-Miller Collection), once attributed to Hogarth. To round off this pre-Gainsborough milieu, I should like to add that Laroon sometimes painted lovers sitting under a tree in a forest— compositions which in some ways recall the spirit of the early Gainsborough's portrait groups.

50. The unmistakable French rococo note in Gainsborough's portrait groups (as in those of the young Hogarth) comes out clearly when they are contrasted with the contemporary and slightly earlier rigid, flat, very 'native' portrait groups of the young Devis. Although the general arrangement of these (e.g. *The Swaine Family*, 1749, Gilbey Collection, Pl. 30a), is often almost identical with that of Gainsborough and the early Hogarth, every detail— the tracing of each line, the conception of each face—is totally different, being infinitely more backward and provincial, not to speak of the hardness of the colours, which became softer later on in the painter's life.

51. In the same year Gravelot took Major with him to France, where he became a pupil of Le Bas.

52. There are at least two charcoal drawings by Gravelot for this figure, one in the British Museum, the other in the Witt Collection, Courtauld Institute.

53. Published by S. Ireland, *op. cit.*, Vol. II.

54. Various French engravers living in England, like Dubosc and the Hogarth engraver Baron, even set up here as print-sellers, thus contributing to the knowledge of French prints.

55. Somewhat later in the same year of 1737, Ravenet took part in engraving a similar cycle of everyday figures, *Cris de Paris* by Boucher. A third cycle of the same date, the most famous of them all and perhaps the thematic initiator of the two others with 'common' scenes, was Bouchardon's *Cris de Paris* (engraved by Caylus), less rococo, more realist-classicist in style than the other two. Either through Ravenet or even before he came to England, Hogarth may have known such French cycles, the types of which would have greatly interested him: indeed, sometimes they came close to his own. This is the case with his *Enraged Musician* (1741) (Pl. 75a), in itself almost a compressed cycle of various street vendors and in which the milkmaid is particularly reminiscent of Bouchardon's monumental style. The little girl in *The Enraged Musician* might well derive from a Boucher or even a Chardin figure (e.g. Cochin the elder's engraving after Chardin's *Fille aux Cerises*). Apart from the French cycles, whose ancestors were the *Cris de Paris* of Bosse (1636) and ultimately the Italian 16th-century engravings of street vendors.

56. The build-up of *The Staymaker* corresponds fundamentally to that of the *Death of the Countess*, with its two groups. Even the manner in which the nurse holds up the child to be kissed is almost identical: in the latter it has a tragic, in the former a comic, implication.

57. Fielding, the John-Bullish author of *The Roast Beef of Old England*, was also the best connoisseur of French literature in the country.

58. See F. Antal, 'Hogarth and his Borrowings' (*Art Bulletin*, 1947). Up till then the traditional theory in the Hogarth literature of our time (e.g. *Catalogue of the Exhibition of British Art in the Royal Academy*, London, 1934) was that this picture was the same *Wanstead Assembly* ordered by Lord Castlemaine and mentioned in Hogarth's list of unfinished pictures in his studio on the 1st January, 1731, and that it probably represented a dance given for Lord Castlemaine's tenants. But there is no basis at all for these theories. J. Nichols and S. Ireland, who bought the picture together with three others of the same cycle from Hogarth's widow, noted that it was sometimes called *The Country Dance* and was originally intended, like *The Wedding Dance*, for a scene in *The Happy Marriage*. In consequence, A. Dobson also remarked (though only among the corrigenda of the last edition of his Hogarth book, 1907) that the picture was probably never painted for Lord Castlemaine. But these various references have been constantly overlooked. On stylistic grounds too it cannot be by the young Hogarth but must date from soon after 1745.

59. The sequence of the six scenes is not quite clear but the one published by Beckett (*op. cit.*) is certainly wrong. However, the problem is not easy to solve. The following tentative suggestions accord with those of E. Wind. The composition published by Beckett as *I, Courtship* is neither Scene I nor a Courtship but is intended as innocent rural amusement, probably corresponding to the *Levée* of the Countess in *Marriage à la Mode*, which shows urban pastimes. Beckett's *III, The Wedding Banquet* (i.e. the Truro

picture) would seem to correspond to the *Contract* in *Marriage à la Mode* and is probably the first scene. His *IV, Relieving the Indigent* (the Charity scene) perhaps corresponds to that of the *Quack Doctor*; *V, The Garden Party* is probably the last scene, showing the happy couple, now grown old, watching the younger generation dancing.

60. As far as I am aware this Coypel composition was not engraved in Hogarth's time, so he must have known either the cartoon for the tapestry (to-day in the Château de Compiègne) or the tapestry itself.

61. A Dutch satirical engraving of 1742 by S. Fokke, representing Maria Theresa and Frederick II dancing at a ball for European royalty is, like Hogarth's work, based on Coypel's composition (Pl. 95a). Hogarth may have made use of this Dutch print as well; the figure of the King of Prussia could have served as a model for his dancing bridegroom.

62. As a poetic parallel to the scheme of *The Wedding Dance*, Hogarth quoted the description of the angels dancing about the sacred hill from his favourite Milton's *Paradise Lost*:

> Mystical dance! . . .
> . . . Mazes intricate,
> Eccentric, intervoly'd, yet regular
> Then most, when most irregular they seem.

63. It would be a mistake to regard Magnasco as a popular artist. He worked for the most elevated patrons, such as the Grand Duke of Tuscany, the Governor of Milan and Count Collorado.

64. Magnasco's sombre but dashing pre-rococo and his blurred manner of painting strongly influenced Venetian rococo painting, however gay and lightened it became in the two Riccis, the young Tiepolo and Guardi. (This is also the opinion of G. Fiocco, *Venetian Painting of the Seicento and the Settecento*, Florence, 1928.) The small, spirited, loosely painted, somewhat sketch-like pictures of Sebastiano Ricci must have made an impression on Hogarth.

65. There is little reason to doubt that S. Ireland was right in calling the sketch which had actually belonged to him *Ill Effects of Masquerades* (*op. cit.*, Vol. II). It is only as part of this theme that the half-naked woman with a bleeding wound below her breast, the man rushing dramatically in and placing one knee on a chair or the second wounded woman in the background could make sense. Ireland could have learned of the theme from Hogarth's widow, from whom he acquired the picture.

66. In drawings for his 'first thoughts' he preferred chalk to pencil as being nearer to the brush (see Oppé, *op. cit.*).

67. The nearest continental equivalent to *Ill Effects of Masquerades*, are Magnasco's oil sketches (e.g. *Nativity*, Albertina, Vienna), which in their turn derive from van Dyck's Genoese sketches.

68. In 1732 a poem was published on G. White's engraving of Hals' laughing boy playing a fiddle, which shows that such kinds of work by this artist were well-known in England at that time.

69. One can assume that engravings after Chardin's compositions were known in England. That Mercier did engravings here in the manner of Chardin suggests that there was a demand for them.

70. Decidedly more 'French', more elegant and dressed-

up than the middle-class *Mrs. Salter* are the portraits of Mr. James, High Sheriff of Kent, and his wife (Worcester, U.S.A.; Pl. 82a), painted in 1744. The man's likeness and also his pose may reflect the impact of a La Tour portrait which Hogarth could have seen in Paris in the Salon of 1743 (Pl. 82b). There is also a slight touch of Tocqué in these two rather conventional portraits of the James couple, and possibly in the Paris Salon of 1743 Hogarth acquired his ideas of elegance precisely from Tocqué, who was relatively the most realist portraitist of the elegant Parisian world (Pl. 83a). His art, derived from the more natural among Largillière's portraits, lies in between the emptiness of Nattier and the new Dutch faithfulness of Aved.

71. Not all the drawings for the cycle are preserved. On the other hand, among the first set are two drawings not used in the cycle.

72. In his modest way the French engraver Jacques Rigaud helped English artists to make their crowds more 'orderly'; in the 1720s or early '30s, he depicted many castles of the nobility, enlivening the prints with figures.

73. An example of such a parallel is Cochin's *Le Chanteur de Cantiques* from *Diverses Charges des Rues de Paris* (1731) a cycle which it is quite certain Hogarth knew.

74. Ricci's works of a documentary kind such as *The Mall* (Howard Collection)—an Anglo-Italian precursor of Pannini—with its loose association of groups of street-vendors, must have had an effect on Hogarth and Hayman.

75. In the light of this composition of Hogarth's one realises that Lebrun's motifs of workmen had probably already crept into the first scene of *A Rake's Progress*: Tom Rakewell taking possession of the rich miser's effects.

76. In this regard Canaletto was determined by the Venetian views of Carlevaris. Later, in England, he may have been influenced by the almost porcelain-like neatness of the pictures of van der Heyden (1637–1712), the 'Dutch Canaletto', who had visited England and many of whose pictures could be seen here.

77. Hogarth is said to have sometimes painted figures for Scott's London views.

78. Two pictures in the Foundling Hospital painted in 1748 by Wale, an artist particularly interested in architecture and perspective, and representing St. Thomas's and Christ's Hospitals show an even stronger influence by the Venetian painter. They fall stylistically between Canaletto and *The Gate of Calais*.

79. In the same year as *Industry and Idleness*, 1747, Hogarth did one of his most famous records of everyday life, *The Stage Coach*, a scene in the yard of a country inn, with the most precise documentation of contemporary travelling conditions. Every person in or around the coach, which is about to set off, fulfils a necessary function both in the telling of the story and in the formal build-up.

80. See L. Brieger, 'The Baroque Equation'. (*Gazette des Beaux Arts*, XXVII, 1945.)

81. Pannini's religious pictures are derivations from Luca Giordano, Solimena, Conca, etc.

82. The *Cérémonies Religieuses* also include Quaker meetings with women preaching by du Bourg; these are of an even more documentary character than Heemskerk's.

83. Just like Hogarth, Magnasco was not only a follower

of Callot and Rosa but also something of a forerunner of Goya and Daumier.

84. Even while working on *Marriage à la Mode* Hogarth also did engravings in a very popular style; one done in 1742 represents a mock procession of beggars and cripples against the Freemasons.

85. The motif of the candle in the background, throwing a dim light on the pictures on the wall, is a typical Schalcken effect. Such effects were thought to lend a more intimate, homely atmosphere to the scene.

86. It is this grotesque streak in Hogarth's pictures which distinguishes them from Ruben's and Watteau's habit of making antique or similar statues (usually placed in parks) appear alive. Even in mere copies of antique statues Hogarth usually laid strong emphasis on the expressive as, for instance, in the bust of Hesiod he did for Cooke's translation of the poet (1728).

87. This is the tragic figure that Lamb so much admired, comparing it, to its enormous advantage, with the empty grimacing heroes in Reynolds' historical pictures.

CHAPTER SEVEN

1. E. Wind deals very lucidly with this important theme in 'Three Nonconformist Painters' (*Art News*, XLVI, 1947).

2. See E. Gombrich and E. Kris, *Caricature* (London, 1939).

3. Expression used by J. Ireland (*op. cit.*).

4. The Legion Club (1736).

5. In the picture the buttons are on the wrong side of the coat, which suggests that it is a copy after the print.

6. *British Caricatures*, London, 1942.

7. See S. Grego, *A History of Parliamentary Elections and Electioneering* (London, 1886).

8. Another caricature of Dodington appears in Hogarth's engraving, *The Five Orders of Periwigs* (1761) (Pl. 141a), as the leading figure of the Old Peerian or Aldermanic Order; and yet another in *The Times II* (Pl. 143a).

9. Satires on doctors, even in writings by Pope and Swift, were most common.

10. Hogarth probably knew works by Honthorst who stayed for a while in England.

11. Much later, in a projected supplement to *The Analysis of Beauty*, Hogarth intended to publish new orders of architecture, i.e. capitals of his own invention built up from shoes, feathers, etc. (see illustrations in J. Ireland, *Hogarth Illustrated*, III). In a similar vein he did the engraving, *The Five Orders of Periwigs*, directed against James Stuart, author of *The Antiquities of Athens*, who had made exact measurements of the classical capitals in Greece.

12. Many mannerist artists such as Erhard Schön in Nürnberg and Luca Cambiaso in Genoa reduced human bodies to cubes for purposes of teaching or as part of their own working method.

13. See K. Clark 'The Bizarie of Giovanbattista Braccelli' (*The Print Collectors' Quarterly*, XVI, 1929).

14. In Pond's publication of twenty-five caricatures after foreign masters, twelve were after Ghezzi.

15. See R. W. Lee, 'Ut Pictura Poesis'; the humanistic theory of painting' (*Art Bulletin*, XXII, 1940).

16. Descartes: 'Point de passion de l'âme qui ne produise une action corporelle' (*Passions de l'Ame*, 1649). On the close connection between Descartes' and Lebrun's views, see L. Hourticq, *De Poussin à Watteau* (Paris, 1921).

17. The full title was *Human Physiognomy explained in the Crounian lectures on muscular motion for the year 1746 read before the Royal Society by James Parsons, M.D. and F.R.S., being a supplement to the Philosophical transactions for that year*, London, 1747.

18. *The Spectator*, Vol. 86.

19. See on Parson's theories and some of his illustrations, E. Kris, 'Die Charakterköpfe des Fraz Xaver Messerschmidt' (*Jahrbuch der Kunsthistorischen Sammlungen in Wien*, V.F., VI, 1932).

20. It is probable that Hogarth was generally considered the leading authority on physiognomy in this country. The Rev. John Clubbe, a humorous writer, dedicated his book *Physiognomy* to Hogarth in 1763.

21. The so-called *Two Philosophers*, etched by Pond after Carracci and included in his publication of caricatures which Hogarth owned.

22. This Ghezzi caricature was also known to Hogarth through Pond's etching.

23. Heads of expression and caricatures are also closely connected in French art. The same Caylus, who introduced the 'Concours de la Tête d'Expression' at the Paris Academy, did not disdain to do caricatures in Ghezzi's style.

24. Smollett's references to Hogarth are collected together in Moore, *op. cit.*

25. That is why, as F. D. Klingender (*Hogarth and English Caricature*, London, 1944) has already pointed out, Smollett's art corresponds more to Rowlandson's than to Hogarth's.

26. In one of his late manuscripts, published by J. Ireland, Hogarth wrote: 'I have ever considered the knowledge of character, either high or low, to be the most sublime part of the art of painting or sculpture, and caricatura as the lowest.'

27. Somewhat earlier, in 1758, when questioned by his friend Dr. J. Townley, headmaster of Merchant Taylors' School (the well-known middle-class school in London) on his theory of character and caricature, known as his favourite problem, Hogarth forthwith did three pen drawings side by side of the same periwigged, elderly gentleman (published by S. Ireland, *op. cit.*, Vol. II), corresponding to the categories of *The Bench*. These heads, drawn on the spur of the moment, are more alive, more vibrant and less schematic than those of *The Bench*.

28. J. Meier-Graefe, *William Hogarth* (Munich, 1907).

29. Similarly to Hogarth, Ghezzi painted grand baroque altar-pieces and frescoes. He also collaborated on sketches for festive celebrations with Pannini, whose baroque characteristics offer an obvious parallel with similar features in Hogarth, and, like Hogarth, Ghezzi also did faithful portrayals from ordinary middle-class life.

30. English artists travelling to Italy still in Hogarth's lifetime also tried their hands at imitations of Ghezzi.

Thomas Patch (1720–82), who lived first in Rome (1747–55) and later in Florence (1755–82), and who wrote a book, no longer extant, on physiognomy, painted quite a number of portrait groups with caricatures of English aristocrats in Italy on the grand tour. His *Punch Party* (1760, Earl of Stamford) (Pl. 42b), depicting some twelve of these distinguished travellers round a table, is based on Hogarth's *Midnight Modern Conversation*. These caricatures are usually in profile with the customary Ghezzi-like distorted features and devoid of any Hogarthian characterisation. Even the young Reynolds, under Patch's and Ghezzi's influence, did caricature portrait groups while in Rome, though he was later to disapprove of them. As to Patch himself, both Ghezzi and Marco Ricci's musical caricatures done in England, as well as some of Laroon's conversation-pieces, e.g. *A Great Man's Levée*, should be counted among his ancestors.

31. This theme of semi-nudity may have been suggested to Hogarth by a similar motif in an engraving of a rather erotic character, *Jeu d'Enfans* by B. Lépicié after Ch. A. Coypel (1731).

32. The same figure, for the same deterrent reasons, is repeated by Hogarth as an illustration in *The Analysis of Beauty*. It appears, too, in his very spirited etching of the same year, *The Charmers of the Age* (Pl. 102a). Here both Dunoyer and Signorina Barberini are reduced to stylised poses.

33. Genuine *trompe l'œil* broadsheets already appeared in the early 18th century in England.

34. This style already manifested itself during Hogarth's lifetime in Bentley's subtle illustrations to Gray's poems, done for Horace Walpole (1753) (Pl. 115b). Here, too, mannerist elements of the elegant type contribute towards a very expressive style.

35. It was engraved after the owner's death and without Hogarth's authority.

36. Mannerist features also form a constant undercurrent in the partly baroque, partly classicist architecture of 18th-century England. They were especially strong at the time of the young Hogarth, in Vanbrugh and Hawksmoor, and linger on in the Burlington style.

CHAPTER EIGHT

1. In Paris, he may also have seen the royal pictures in the Louvre.

2. Including Correggio's *Jupiter and Semele, Ganymede and the Eagle* after Michelangelo (one version perhaps then already in the Royal collection, another in that of Sir Robert Walpole), Reni's *Judith* and Caravaggio's *Medusa* (a version in Thornhill's collection).

3. *Burl. Mag.*, August 1943.

4. On this publication see Ch. Rake, 'Pond's and Knapton's Imitations of Drawings' (*Print Collector's Quarterly*, IX, 1922).

5. In literature, an interest in antique writings and the burlesquing of great classical styles were parallel phenomena.

6. See E. Wind, ' "Borrowed Attitudes" in Reynolds and Hogarth' (*Journal of the Warburg Institute*, II, 1938–9).

7. Pointed out by E. Wind (*op. cit.*), according to whom Hogarth also took over the motif of the Betrayal.

8. When, in 1751, he published the popular cycle, *Four Stages of Cruelty*, he wrote: 'If they ... checked the progress of cruelty, I am more proud of having been the author than I should be of having painted Raffaelle's cartoons.'

9. All his complaints are factually corroborated by C. H. C. Baker and M. J. Baker, *op. cit.*

10. These three essays were published in two volumes in 1725 and were translated into French in 1728.

11. As is well known, the original division between higher-class artists concerned with noble themes and lower-class ones concerned with vulgar themes started with Aristotle's *Poetics*. On the importance of this work in 16th-century Italian literary criticism, see F. E. Spingarn, *A History of Literary Criticism in the Renaissance* (New York, 1899); on its interpretation with regard to painting, see R. W. Lee, 'Ut Pictura Poesis: The Humanistic Theory of Painting' (*Art Bulletin*, XXII, 1940).

12. The inscription shows how persistently Hogarth tried to bring home the point that these were historical paintings: 'The historical paintings of this staircase were painted and given by Mr. William Hogarth, and the ornamental paintings at his expense, A.D. 1736.'

13. In 1728 Hogarth did a design, *The Element of Earth*, for a tapestry. The upholsterer, Joshua Morris, was dissatisfied and refused to accept the composition, alleging that Hogarth was an engraver and no painter. In court, to prove the contrary, Hogarth brought a number of witnesses, including Thornhill, Vanderbank, his master at the Academy, and the history painter Highmore. He won his case. This early lawsuit reveals in embryo his later efforts and troubles concerning history painting. As regards his (lost) design of *The Element of Earth*, it is conceivable that he imitated Lebrun's similar representation from his cycle of *The Elements*, which were copied in the Soho tapestry factory.

14. See A. Gertsch, *Der steigende Ruhm Miltons* (Leipzig, 1927).

15. Yet this did not prevent him from poking fun at Richardson's *Explanatory Notes and Remarks on Paradise Lost*, 1734, in his engraving of the same year, *The Complicated Richardson*, although it is true that he later destroyed the plates and recalled the prints. Nor did he feel any contradiction between this admiration for Milton and his fondness for Butler's anti-Puritan *Hudibras*, which he illustrated at about the same time.

16. Addison, in a similar vein, described Milton's Paradise as an informal garden. A generation earlier, Dryden had characterised it as a formal garden.

17. Hayman's later illustrations to *Paradise Lost* (1760) are of a more moderate-baroque character, almost verging on classicism.

18. And cherubim among them. In *The Analysis of Beauty*, Hogarth explains: 'A painter's representation of Heaven would be nothing without swarms of these little inconsistent objects, flying about or perching on the clouds;

and yet, there is something so agreeable in their form, that the eye is reconciled and overlooks the absurdity, and we find them in the carving and painting of almost every church. St. Paul's cathedral is full of them.' Hogarth's feeling for baroque led him to approve sincerely, even if a little grudgingly, of these composite beings, originally closely linked with Italian Catholic art; and he welcomed the opportunity to adduce the decoration of a great Protestant church as including them. An even stronger predilection for Italian Catholic baroque art is shown in another passage where he compares the interior of St. Paul's with that of St. Peter's.

19. A drawing done for *Paradise Lost* by the Venetian rococo painter, Piazzetta, and representing the Creation of Adam (formerly Coll Landgrafe of Hessen, Rome) is in its general stylistic effects not very dissimilar from this illustration by Hogarth.

20. *The Wedding Dance*, with its vibrant, agitated theme, perhaps shows an even greater similarity with *Pandemonium* than the Church scene. This again provides an insight into the, at times, relative proximity of Hogarth's different styles as he shifts one or other of their components.

21. As the picture is lost and the engraving bears the inscription: Hogarth *design, and sculp.*, it is not quite certain whether there was an original picture by Hogarth or only an original drawing which was copied in a painting by someone else. However, the former assumption is much the more probable.

22. It speaks for the picture's popularity that a satirical engraving published on the occasion of the marriage of the Prince of Wales (1736) took over Hogarth's composition, substituting the prince for Henry, the princess for Anne Boleyn, Miss Vane (the prince's mistress) for Catherine and Robert Walpole for Wolsey.

23. See the list in Leslie and Taylor, *Life of Sir Joshua Reynolds* (London, 1865). Illustrations from English history by Hayman and Blakey, published in 1751–2 and engraved by the same French engravers who worked for Hogarth at that time, continue this line.

24. In 1748, Hogarth's *Pool of Bethesda* itself became a Bible illustration proper, as the engraved frontispiece of Stackhouse's *Family Bible*.

25. Dr. L. Münz drew my attention to a woodcut representing the Good Samaritan among illustrations to the Gospels produced about 1600 in the Swiss artistic circle of Amman and Maurer (J. Maurer was the woodcutter). This probably goes back to an invention of Stimmer. The general arrangement is similar to Hogarth's, the pose of the horse, in particular, being almost identical.

26. Hogarth had ample occasion for such studies through the assistance of his friend, J. Freke, surgeon of St. Bartholomew's. See L. P. Mark, *Art and Medicine* (London, 1906).

27. The figures of two Pharisees reading from a large book in the background of Hogarth's sketch for *The Pool of Bethesda* (Beckett Collection, London) are also derived from Rembrandt.

28. Conversely, it can also be regarded as a transposition of Rembrandt in the Raphael sense. Compare, as a parallel to the arrangement of the central part of Hogarth's picture,

also in its half-conventional, half-realist style, Rembrandt's pupil Eeckhout's representation of the Raphael theme, *St. Peter and St. John Healing the Lame* (1667, Neeld Collection). For in Dutch religious paintings there existed a movement—which might be called the Eeckhout-van der Werff line—which rendered Rembrandt's extremely sensitive and intimate baroque composition more conventional and smooth, partly by blending it with Italian classical art.

29. There is also a general stylistic resemblance between Hogarth's picture and one painted by Amigoni, probably shortly before, for Emmanuel College, Cambridge, representing *The Return of the Prodigal*.

30. Ricci's picture is in St. James's Palace.

31. In England Amigoni painted many mythological subjects with nude figures and even pictures with erotic themes from the Bible, some of which were disseminated through the engravings of I. Wagner.

32. A charcoal drawing of a nude (Windsor) done from the life in the St. Martin's Lane Academy, was certainly used for this figure.

33. Roughly about this time (certainly before 1745, when Vertue refers to its sale) Hogarth also painted a mythological picture representing Danae, which was bought by the Duke of Ancaster for £63. It has not survived and no engraving of it exists. Dr. Parsons praised the expression of the main figure, while Horace Walpole derided her prostitute-like character, and the motif of the old nurse biting one of the coins from the shower of gold to test its genuineness. This latter feature is typical of Hogarth's realistic way of interpreting mythology. As Dr. E. Wind assumes, a black chalk drawing in the Pierpont Morgan Library, New York, of a semi-reclining nude female figure with a town in the background is possibly a study for this picture.

34. See G. Becker, *Die Aufnahme des Don Quijote in die englische Literatur* (Berlin, 1906).

35. See F. Seznec, 'Don Quixote and his French illustrators' (*Gazette des Beaux Arts*, 1948).

36. Gillot was received into the Academy (1710) with a picture representing *The Armed Watch of Don Quixote*. On the other hand, one of his drawings depicting Sancho Panza starved by his physician (a theme which Hogarth represented later) was probably influenced by a Comédie Italienne about Sancho Panza acted in Paris at the rather popular Théâtre de la Foire (1705).

37. Later, from 1735 to 1744, it was Natoire's turn to make cartoons for another cycle of *Don Quixote* tapestries, so popular had the theme become.

38. In the 1725 edition they were done by van der Gucht, in the 1731 edition by Simms. They were both very poor.

39. The similarity of this engraving to Coypel's style was already noticed in the 18th century. Nichols (*op. cit.*) says that Hogarth's object here was to compete with Coypel. On Hogarth's engraving in the Royal Library, Windsor, is an old inscription to the effect that Hogarth had taken over one of the figures from Coypel's *Don Quixote and the Bearded Princess* (engraved by Picart). This probably refers to one of the women attendants, with whom there is a slight resemblance. It so happens that Hogarth's grotesque print, *The Mystery of Masonry brought to Light by the*

Freemasons (1742), also in Windsor, bears the remark that it was 'taken from Coypel's Don Quixote'.

40. The translator Jarvis is none other than the fashionable painter, a pupil of Kneller and Maratta. He was a friend of Pope, Addison, Swift, Dr. Arbuthnot, Warburton, etc.

41. It seems probable that two scenes, *Don Quixote attacking the Barber* and *Don Quixote releasing the Galley Slaves* (pen, ink and wash drawing in Windsor), contain suggestions from motifs in one of two of the non-Coypel illustrations in the French *Don Quixote* editions, e.g. Lebas' *Don Quixote fighting against the Sheep*.

42. Incidentally Gillot also made great use of Karel du Jardin's art. See B. Populus, *Claud Gillot* (Paris, 1930).

43. Any Dutch pastoral picture could serve as a parallel; for instance the portrait of a Dutch bridal pair as the Shepherds Damon and Phyllis (Berlin), by Jacob Gerrits Cuyp.

44. The exact dates of the drawings of both artists are unknown. According to Vertue, Vanderbank's were done in 1730; according to Horace Walpole, in 1735; whilst the style of Hogarth's compositions suggests that they were done not long before 1738. Yet it is difficult to imagine that Hogarth would have borrowed from Vanderbank; on the other hand, Vanderbank could easily have had access to Hogarth's rival drawings, since they belonged at the time to the publisher of the *Don Quixote* edition.

45. The stately frames in which English artists kept their most treasured pictures, as Hogarth did *Marriage à la Mode* and *Paul before Felix*, were called Maratta frames.

46. R. H. Nichols and F. A. Wray, *The History of the Foundling Hospital* (London, 1935), who it is to be hoped examined the minutes of the Foundling Hospital, give 1746 as the date and so apparently does Vertue (Vol. III, pp. 134–5). The engraving after the picture is as late as 1752, but its forthcoming publication had already been announced in 1750. Since, according to Vertue, the picture was presented to the hospital in 1747, it could have been painted in 1746.

47. Another picture in the Foundling Hospital, the altarpiece of the chapel, *The Adoration of the Magi*, typical of the baroque-rococo current of contemporary Roman-Neapolitan history painting, was delivered in the same year (1750) by the Italian Casali, a pupil of Conca and Trevisani, His pictures were of a far more accentuated and lively rococo than those done here by Amigoni ten years earlier.

48. This choice may have had something to do with the ideas of Bishop Hoadly. Hoadly (*St. Paul's Behaviour towards the Civil Magistrate*, 1708) identified the principles of the Revolution of 1688 with those of St. Paul and said that the Saint, through his behaviour before the magistrate, established the principles of liberty and the superiority of the law to the executive power. See F. C. Hearnshaw, *The Social and Political Ideas of some English Thinkers of the Augustan Age* (London, 1928).

49. Thornhill's sketches in the Vestry of St. Paul's (sepia wash heightened with white) for all eight compositions show an even richer, more intense baroque. In style they closely resemble Ricci, Thornhill's unsuccessful competitor for the frescoes. Since these sketches, together with the frescoes, constitute the peak of English baroque painting, the two sets greatly merit worthy publication.

50. In Winckelmann's book, *Gedanken über die Nachahmung der griechischen Werke*, soon to be published (1755), not only was Rembrandt to be singled out as a representative of coarse realism but also Watteau.

51. It is conceivable that Hogarth, having in the meantime acquired a more dignified style in his historical paintings, now tended to laugh off his own former realist-grotesque figures in *The Pool of Bethesda*, which partly imitated Rembrandt.

52. Sold at Christie's in 1938.

53. After painting this picture, he also did a portrait in the manner of Rembrandt.

54. This caricature could even have served as a shaft aimed at the religious pictures of his favourite Dutch painter, Steen. If ever there were 'undignified' Dutch historical pictures from Hogarth's point of view, they were Steen's.

55. Two years later, in 1753, Paul Sandby published a satirical engraving, *The Magic Lantern* (Pl. 125b): Hogarth's head represents a magic lantern and from his mouth projects the caricature of *Paul before Felix*. The implication of this work, in which Hogarth's caricature is further exaggerated, is that Hogarth, as the genuine painter of ugliness, cannot absolve himself from this by parodying Dutch art. According to Sandby, Hogarth's caricature of Rembrandt represents his true style. Sandby expressed the same idea in two other engravings, near in date: in his *Burlesque sur le Burlesque* (1753) Sandby added to Raphael and Rembrandt the names of Titian, Rubens, van Dyck and Lebrun as being plagiarised or imitated by Hogarth; in *Pug the Painter* (1754) Hogarth is shown to be imitating Rembrandt in a picture of *Moses Striking Water out of a Rock*. In the latter work, one of Hogarth's books appears, bearing the inscription: 'A journal of my travels from Rome to Rotterdam. I had the supreme happiness of touching Raphael scull that Divine skull.' The cause of these attacks was partly envy, partly Hogarth's resistance to the establishment of a Royal Academy.

56. Hogarth received the large sum of 300 guineas for it.

57. Luyken was *the* Bible illustrator of the 18th century. His Bible illustrations were so popular in England that they were still used at the end of the century (in the same volume as those by Stothard).

58. Observation of Dr. E. Wind. A chalk drawing of a nude man evidently done from the life in the St. Martin's Lane Academy for the large figure seen from behind (Pierpont Morgan Library, New York) is combined in Hogarth's picture with impressions from Raphael.

59. A revealing transition in Hogarth from the Claude Lorraine landscape (used constantly by his collaborator Lambert, who was praised in *The Analysis of Beauty* as a Claude follower) to that of Rosa can be seen in the rather stereotyped landscape (British Museum) he drew in red chalk in 1760 for the frontispiece to *The Perspective of Architecture* by Joshua Kirby (deduced from the principles of Brooke Taylor). From about the same late period should, I think, be dated the only landscape Hogarth ever painted with gnarled trees, rocks and water as the main

motifs (preserved only as an engraving). All these land-scapes are on the heroic plane, whereas the landscape backgrounds of the *Election* cycle, done a few years earlier, are natural, lively and varied.

60. Engraved after Hogarth's death and published in S. Ireland, *op. cit.*, Vol. I.

61. Shaftesbury and Addison still disliked Gothic architecture, considering it barbaric. But Hayman's Shakespeare illustrations of 1744, although retaining much of the rococo style, were already full of Gothic and pre-Romantic motifs, in contrast to contemporary French art: see his various illustrations for *King John* (Pl. 79b), *Henry IV*, *Henry V* and, in particular, the tournament in *Richard II* (Pl. 79a). This stage was reached in French painting only in the second half of the 'seventies with Brenet, leading the way to Delacroix. Even Fielding in *Tom Jones* gave Squire Alworthy a Gothic, not a classical, house.

62. In 1742 Tiepolo illustrated a similar theme for an Italian edition of *Paradise Lost: Death seducing Sin*. But despite the macabre theme, Tiepolo's stylistic conception of the whole is much more rococo than Hogarth's. Bentley's illustrations, whose starting points were those by Hayman to Shakespeare, show how in England, too, this gothicising tendency was at first still connected with rococo. But the sharpening of Bentley's elegant rococo, combined with Gothic-mannerist elements, led towards Expressionism and there were even motifs heralding Blake.

63. There already existed in England, probably in the collection of Sir Matthew Decker, an art-loving director of the East India Company, a picture by van der Werff. *Tancred's Servant presenting the Heart of Guiscardo in a golden Cup to Sigismunda* (Fitzwilliam Museum, Cambridge). Hogarth might have known this picture.

64. On sale at Christie's in 1939. It was engraved in the 1833 edition of J. Nichols' *Anecdotes of William Hogarth*, as after Correggio.

65. The poet Matthew Prior (1664–1721) owned a picture of Lucretia by Furini. Close to Dryden, he was also a friend of Thornhill, Dahl and Gibbs, and his art collection is well documented (see H. B. Wright and H. C. Montgomery, 'The Art Collection of a Virtuoso in 18th-century England', *Art Bulletin*, XXVII, 1945).

66. Hogarth's *Time smoking a Picture* (1761) (Pl. 140b), designed as the subscription ticket for the engraving of *Sigismunda*, was intended to explain his competition with paintings of the past and to show that these, bought by the connoisseurs, owed their value mainly to their darkness. In fact Hogarth said in his *Epistle* that when his *Sigismunda* had become black through age, people would find it a good picture. The engraving bears a quotation from Paul Whitehead, co-author of the *Epistle*.

67. Yet even here Hogarth had a realistic starting-point, namely the sorrowful appearance of his wife, grieving at the time over her mother's death.

68. Hogarth, when exhibiting *Sigismunda*, announced: 'If the piece meets the approbation of the public, it will be engraved in the manner of Drevet.' This is again the same engraver whom he mentions in *The Analysis of Beauty* and

whose portrait of Samuel Bernard after Rigaud he had followed in *Captain Coram*.

69. *Sigismunda*, although considered an outstanding example of Hogarth's sentimentalism, is less ostentatiously sentimental than Coypel's work or the Italian baroque half-figures of a similar type deriving from Reni, such as those by Dolci and generally those by Furini.

70. Whether or not Hogarth knew the teachings of Antoine Coypel, in his own development towards grand art he now followed his advice to painters regarding imitation of the gestures and mime of actors in heroic tragedies and incidentally in so doing, he leaned on a 'role portrait' by Coypel's son. Hogarth always liked to portray theatrical gestures, whether he took them seriously or travestied them, and by slight shifts of emphasis he was wont to give them varying significance. That is why, in *Strolling Actresses*, done more than twenty years before, the gestures of the actress portraying Juno is almost like an anticipated caricature of *Sigismunda*.

71. A preliminary oil sketch for the picture, known only through an engraving by Dunkarton, is more vertical in shape and in consequence nearer to the continental models of the composition.

72. Her attitude bears some resemblance to Mercier's portrait of Peg Woffington (Garrick Club) with a medallion of Garrick in her hand. When comparing *Sigismunda* with other pictures one always arrives at some stage effect.

73. Hogarth must have known an edition of Ripa's *Iconologia*, the standard model for the allegorical figures of history painting in Europe and also for Thornhill. In his frontispiece to the catalogue of the Artists' Exhibition (1761), the figure of Britannia watering the young trees of the arts is taken from a figure in the *Iconologia*—that of Grammatica (the basis of the liberal arts in the Middle Ages) watering the flowers (i.e. the younger generation). See R. Wittkower, ' "Grammatica" from Martianus Cappella to Hogarth' (*Journal of the Warburg Institute*, II, 1938–9).

74. There were nevertheless signs of it when, in the late 'forties, Lord Chesterfield had some of the rooms of his house decorated in a rococo, others in a classicist, style. The Burlingtonian architect, Isaac Ware, consented only very reluctantly to do the former. In his book, *A Complete Body of Architecture* (1756), Ware combined an attack on French curves and rococo with a dislike of religion in France and the French form of government. See on Ware, R. S. Allen, *Tides in English Taste* (Cambridge, U.S.A., 1937).

75. Yet the public, taken as a whole, felt the difference to be very great. Hogarth's historical pictures were not a real success, partly at least because the public wished him to stick to his usual themes. This was also the reason for the failure of Fielding's most mature novel, *Amelia*. If people wished to read something moral, they preferred Richardson, whose acknowledged line it was.

76. Although I would not go quite as far as R. E. Moore 'Hogarth as Illustrator' (*Art in America*, XXXVI, 1948), I agree that the quality of Hogarth's illustrations of other authors is not as high as that of the cycles illustrating his own stories.

CHAPTER NINE

1. Of novels written after *Amelia* perhaps only Goldsmith's *Vicar of Wakefield* still appears in spirit as a straggler from the earlier period, though it already contains features from the new. The exact contemporary of *The Vicar of Wakefield*, written in 1762 and published in 1766, was Horace Walpole's 'Gothic novel', *The Castle of Otranto* (1764), ancestor of all the gruesome terror stories to come at the end of the century.

2. No strict border-line can be drawn between a style and a fashion. Yet the new movement in England might almost be called a change of fashion rather than of style, as on the continent.

3. For instance, Stuart and Revett's heavy neo-Greek style, Chambers' eclectic-classicising one, and above all that of Robert Adam, based on his archaeological studies. The Adam style was more moderate than rococo, less simple than classicism, more refined than either; one might call it classicism gone wrong or, to be more exact, grown elegant. Although it was to a large extent the aristocracy who employed it, it necessarily had a bourgeois trend as well, following prevailing social conditions. The interior now became more important than the façade. Adam himself explains that he adhered to domestic architecture, not to the temples of antiquity, as the Palladians did. Many of Hogarth's friends and patrons employed the new architects during his own lifetime.

4. Referring to contemporary architecture in *The Analysis of Beauty*, Hogarth says: 'There is at present such a thirst after variety, that even paltry imitations of Chinese buildings have a kind of vogue, chiefly on account of their novelty.' In the 'fifties the mixture of styles in one piece of architecture, such as a suburban villa—classicist, Gothic, Chinese—must have been extraordinary (see Chambers' only slightly later buildings in these styles in Kew Gardens).

5. Hogarth's friend Rouquet (*op. cit.*) certainly instructed by the artist himself, put it that, through *The Analysis of Beauty*, 'the mortifying absurdity of je ne scais quoi was constantly substituted'. Reynolds, on the other hand, living on the exclusive heights of international conservative art theory, attacked Hogarth scornfully in Dr. Johnson's paper, *The Idler* (1759), for wasting his time on 'artistic experiences and artists' recipees'.

6. Hogarth's originality was so great and his observations so much on a level with the most advanced science that when, for instance, he writes of the effects of the forms of magnitude on the spectator, one hesitates as to whether he refers to his own experience or was stimulated by the famous psychologist Hartley's *Observations on Man* (1749). See Reiter, *op. cit.* In any case psychology was extremely advanced in England and one is very conscious of this in the views expressed in *The Analysis of Beauty*.

7. See R. Wittkower ('Principles of Palladio's Architecture II.' *Journal of the Warburg and Courtauld Institutes*, VIII, 1945). Hume, Burke and Hone elaborated the new empiricist point of view.

8. Although Shaftesbury believed in the artistic judgment of the people, he held the virtuoso, the gentleman of fashion, to be the public's guide. Jonathan Richardson directed himself exclusively to the connoisseur. *The Spectator* and Fielding, on the other hand, championed the appeal to a wide public. Hogarth's book had a mixed reception, being apparently better appreciated by a large, intelligent section of the public (including Sterne and Bishop Warburton) than by the connoisseurs and artists, except for the scientifically-minded painter, Benjamin Wilson, who wrote Hogarth a sincerely enthusiastic letter. Horace Walpole, though admitting in his *Anecdotes of Painting* that the book contained 'many sensible hints and observations', dismissed it in a letter as 'very silly'.

9. W. L. Phelps (*The Beginnings of the English Romantic Movement*, Boston, 1893) and L. Cazamian (*History of English Literature*, London, 1940) suggest that *The Analysis of Beauty* is the first link in a chain of English books upholding the rights of artistic originality, followed in 1756 by Warton's *Essays on Pope*, and in 1759 by Young's *Conjectures on Original Composition*. This, however, is true only in a very broad sense. Hogarth was opposed to regularity in art (such propositions were never taken very seriously in this country) but he was certainly no supporter of the theory of genius, the germs of which were already to be found in Shaftesbury and Addison. He was not a systematic thinker, and, though acquainted with former theories, he only dealt with matters of keen interest to him and from his own angle of interest. 'I know of no such thing as genius', he said to Gilbert Cooper, twisting 17th-century tradition in a bourgeois sense: 'Genius is nothing but labour and diligence' (Seward, *Biographilana*, 1799).

10. In Lomazzo this spiral, said to be based on a precept of Michaelangelo, is fundamentally still mannerist, in the spirit of the 16th century and not yet really baroque. Dufresnoy, the 17th-century French art theorist, whom Hogarth knew in Dryden's translation, also took up the idea of Michaelangelo's and Correggio's spiral.

11. That is why it was asserted with some justification in satirical engravings that, from the illustrations in *The Analysis of Beauty*, people could learn how to behave elegantly.

12. See Allen, *op. cit.*

13. Paul Sandby, in his satirical engraving *Burlesque sur le Burlesque*, shows Vanbrugh's drawings among books belonging to Hogarth, with the apparent purpose of exposing Hogarth's predilection for baroque. Hogarth replied, though not in a caricature of his own, attacking Kent's architecture. So Hogarth's old struggle for baroque against the classicism of Kent (who was no longer even alive) was still going on.

14. Pietro da Cortona's pictures were also quite often bought for aristocratic collections. On the whole Hogarth's taste in Italian art was close to the norm. Addison's favourite painters were Raphael, Titian, Correggio, Annibale Carracci and Reni; those of Horace Walpole, Raphael, Annibale Carracci and Reni.

15. Yet he was ready to cast scorn upon an 'inelegant' mannerist picture. The heavy proportions of one of the many replicas after Michaelangelo's *Venus and Child*, usually attributed to Pontormo, so greatly enraged him

that he reproduced it as a negative example. He almost certainly meant the version which, in his day, was in Kensington Palace (now in Hampton Court) and which he had already denounced in an article written in 1737 (on the occasion of an attack on the art dealers for selling 'old black masters') as a 'monstrous Venus'. This same Venus—one of the few he bought himself—was George II's favourite picture.

16. See J. Burke, 'A Classical aspect of Hogarth's theory of art' (*Journal of the Warburg and Courtauld Institutes*, VI, 1943). It is possible that for his rendering of the antique statues Hogarth used the illustration in Domenico de' Rossi's *Raccolta di Statue antiche e moderne* (Rome, 1704), all the more so as one of his drawings for the boxer Taylor's grave showing *Death triumphing over Taylor* is very close to the famous antique group of the wrestlers (Uffizi) as rendered here (see Ch. Mitchell, 'Two new Hogarth Drawings', *Burl. Mag.* 1951). The other drawing, *Taylor defeating Death*, shows the influence of Laocoön.

17. It was also the favourite antique sculpture of Lebrun, the most officially-minded president of the French Academy of Painting there ever was.

18. According to Horace Walpole this figure was intended to satirise the painter Liotard, who 'could render nothing but what he saw before his eyes'; but Liotard came to England in 1754, that is after Hogarth's *Beer Street*.

19. See G. Steevens, *Biographical Anecdotes of William Hogarth* (London, 1781).

20. Apart from this general source another half-popular engraving might have suggested the figure of the butcher, e.g. the rather obscene print by the Venetian, Nicolo Nelli, *The Queen of the Land of the Idles* (1565, allegedly a caricature against Catherine de' Medici); the queen, fed by attendants, sits in an armchair in the same pose as the butcher, has the same enormous belly and even similar buttons on her dress.

21. In spite of many allusions to Breughel's social views they have never really been clarified. As these and other engravings of his show Breughel was opposed to vested interests and wealth. This view conforms with the sectarian religious and philosophical convictions he held.

22. A similar spirit pervaded a picture (now lost) by Hogarth, part of which was engraved after his death (S. Ireland, *op. cit.*, Vol. II). This represented a hay field with happy harvesters in bourgeois dress in a landscape (painted by Lambert) dominated by the country-house of Hogarth's friend, Mr. Cook, the picture auctioneer.

23. Drawings, mainly in chalk, in the Pierpont Morgan Library, in Windsor and in the collection of the Earl of Exeter.

24. The French friar supervising religious instruments for the invasion reflects, in a general way, the influence of Dusart's skits on Catholic dignitaries in his *Collection of Caricatures* (1695), published when the Edict of Nantes was revoked.

25. The maltreatment of a dog is alleged to have been inspired by a similar motif in Callot's *Temptation of St. Anthony* (Pl. 7a) (J. Nichols, *op. cit.*).

26. For this reason surgeons, like butchers, were excluded from juries. See M. Bowen, *op. cit.*

27. It is characteristic of Hogarth's perennial interest in criminals and hanging, which he shared with the man-in-the-street, that as late as 1761 he joined the procession for the execution of the murderer Gardelle. On this occasion he corrected a drawing of Gardelle by his godson and fellow painter, J. Richards, adding (in pen) such characteristic and expressive touches to the miserable face that the work can be considered his own. However, this drawing is known only through the engraving by S. Ireland.

28. In point of fact the frescoes were carried out by Peruzzi.

29. A Dutch satirical print of 1651 shows Cromwell as a kind of Popish devil, surrounded by symbolical allusions, preaching a thanksgiving sermon at the time of the Battle of Worcester (Pl. 137b). The pulpit is adorned with scenes in relief representing, ironically, the revolutionary Anabaptist Knipperdolling of Munster as Cromwell's ancestor. The print shows the roots of Hogarth's composition in popular art.

30. The stilts are transpositions of Pitt's crutches.

31. Engraved in S. Ireland, *op. cit.*, Vol. II.

32. The expressions used in this article are so like Hogarth's that F. G. Stephens (*op. cit.*) was most likely right in assuming that he was its author.

33. A motif in Steen (e.g. *Twelfth Night Feast*; Duke of Bedford) could have suggested the group of merry-makers behind those seated at the table. The figure of the bagpiper is a combination of a Jordaens with a Dutch type.

34. E. Wind, 'The Lion filled with Lillies' (*Journal of the Warburg and Courtauld Institutes*, VI, 1943).

35. Later, for his own house in Dublin and his Casino at Marino near Dublin, Charlemont employed classicising English and Italian artists whom he had met at Rome; Chambers, the architect of the two buildings, the sculptors Wilton and Vierpyl (both of whom did copies for him after the antique) and the painter, Cipriani. Both Cipriani and Wilton later collaborated with Adam.

36. Quite soon afterwards this 'dignified' attitude—the conventional contemplative pose of the 17th and 18th centuries—was repeated in *Sigismunda*.

37. True, the young man in the outdoor scene of *Before* (more sentimental than the indoor version) had already made a similar gesture. For the transposition into the comic of this pose in *The Lady's Last Stake*, see the farmer's daughter in *The Farmer's Return* (1762).

38. There is even a certain resemblance with such a sparkling, delicate French rococo composition as *Le Danger du tête à tête* by Baudouin, Boucher's son-in-law (engraved by Simonet).

39. *Les Contes*, not *Les Fables*.

40. The very faithful red of the uniform would have been too strong for *Marriage à la Mode*. However, the handling of the lady's yellow dress, into which Hogarth infused a certain amount of green to harmonise with the green marble, shows that his new realism did not preclude its combination—on a new level of solidity—with painterly features.

41. Hogarth was proud of this picture which, together with *The Gate of Calais*, *Sigismunda* and the *Election* cycle, he showed in Spring Gardens in 1761.

42. Lord Charlemont's portrait remained unfinished, probably because of Hogarth's death.

43. I would cite, as an extreme case, the old woman in brown in the Cook Collection, although I only reluctantly count this among Hogarth's genuine works.

44. This commission—though the date is a late one—still reflects the revival of Palladio and Jones.

45. This work was probably painted before the other likenesses discussed in this chapter. In fact, C. K. Adams of the National Portrait Gallery dates the costumes about 1750–55.

CHAPTER TEN

1. In America Hogarth's engravings, almost the only works of art known up to the Revolution, were of great significance in their relation to Franklin's doctrines.

2. Both pictures are reproduced in T. S. R. Boase, 'Illustrations of Shakespeare's Plays in the Seventeenth and Eighteenth Centuries' (*Journal of the Warburg and Courtauld Institutes*, x, 1947).

3. On the influence of Hogarth's portraits on Slaughter, a somewhat older painter, see A. C. Sewter, 'Stephen Slaughter' (*The Connoisseur*, CXXI, 1948).

4. See E. Waterhouse, *Reynolds* (London, 1941).

5. One might further mention the portraits by the young Richard Wilson and at least some by Hayman, Benjamin Wilson and by Cotes.

6. It was also the great period of English 18th-century landscape painting. This had nothing to do with Hogarth's influence but everything to do with the pronounced middle-class character of the age. This is borne out not only by the young Gainsborough's varied 'Dutch' landscapes (as he calls them) but also by his *Charterhouse* (1746, Foundling Hospital), which goes far beyond the sunlit tidiness of V. J. Heyden; and even more by the background to *Mr. and Mrs. Andrews*, where the attempt to give a *plein air* rendering of an unpretentious Suffolk field is unique in European 18th-century painting. Just as astonishing in their way are the young Richard Wilson's broad, atmospheric *View of Dover* (*c*. 1747, National Museum of Wales, Cardiff) and a few small landscapes done in Italy in the early 'fifties in a striking style, at once pictorial, topographical and classicist.

7. See on this process, L. B. Namier, *England in the Age of the American Revolution* (London, 1930).

8. As Boswell records, when Dr. Johnson was asked in 1770 what had become of the gallantry and military spirit of the old English nobility, he replied: 'Why, my lord, I'll tell you what is become of it: it is gone into the City to look for fortune.'

9. In the 'sixties and even in the 'seventies, the City still behaved most cavalierly towards the King's absolutist tendencies and during the War of American Independence, when trade suffered heavily, even sympathised with the rebels. However in 1784 the City financiers, the shareholders of the East India Company, allied themselves with the court against Fox's liberal Indian policy and, by financing the elections, put Pitt the younger into power whose policy of the next decades was equally supported by the wealthy middle class.

10. As shown by E. Wind ('Humanitätsidee und heroisiertes Porträt in der englischen Kultur des 18. Jahrhunderts', *Vorträge der Bibliothek Warburg*, IX, 1930–1).

11. Within this parallel development, Wind's comment (*op. cit.*) on the contrast between Reynolds' grand, solemn style and Gainsborough's (and Ramsay's) more simple and natural one remains true, as does his linking of the former with a more heroic philosophy (Dr. Johnson, Beattie) and of the latter with a more human and sceptical one (Hume). Yet this contrast should not be exaggerated, since the period taken as a whole (despite certain strong, if sporadic, radical tendencies) was ideologically more conservative than the previous one. The sceptic Hume, whom Wind adduces as the type of the more human philosopher, wrote for only a few select readers in his own time and was politically a Tory. In fact, his influence was almost greater in contemporary France than in England.

12. The painterly, almost 'Hals-like' qualities of Gainsborough's sketches of the Bath period (made almost exclusively of members of his family) evidently derive in great part from Hogarth; yet even these are more conventional than the latter's. They are almost closer to the somewhat schematic and ostentatious sketchiness of Fragonard than to the spontaneous freshness of *The Shrimp Girl*.

13. As Gainsborough's sitters became of higher rank, even the character of his landscape backgrounds grew more 'pleasing', just as did his independent landscapes. He ceased to follow Dutch landscape painting, which he developed on the basis of a close observation of nature in an almost 19th-century manner, but even when still in Bath went back repeatedly to Claude's schemes, slightly altering the decorative trees of van Dyck portrait backgrounds in a still more 'elegant', pseudo-rococo vein (often a parellel to Fragonard's late, more schematic and superficial type of landscape). As in his early phase, a relationship to certain types of Dutch Italianising landscape painting is also discernible in Gainsborough's late phase but its nature had entirely changed: while in his early works (Pl. 149a), he altered and surpassed this type, guiding it in the direction of the artistic 'left', he now gave it an even more generalising character than the original, veering towards the 'right'. This perhaps appears unjust towards the undeniable painterly qualities inherent even in Gainsborough's late landscapes, but in contrasting them with his revolutionary early landscapes the remarks are justified.

The majority of Wilson's late landscapes, done after 1756, following his journey to Italy, are equally disappointing, judged by the very high standard of his early view of Dover. Wilson did some juicily painted topographical views of country houses and Welsh valleys, which are impressive in their unpretentiousness and reveal his potentialities, but in order to please the few patrons on whom his precarious livelihood depended, he generally repeated the same Claude Lorraine or Gaspard Poussin schemes, even if broadly painted, with documentary details often skilfully woven into the pattern.

14. During the next generation, with growing political reaction, Gainsborough's natural portraits were followed by Lawrence's more affected ones, and Mme. Vigée-Lebrun, heir to the international van Dyck tradition at the court of Louis XVI, came as a royalist refugee to work in England.

15. Wright of Derby, who lived in the Midlands amidst the vast changes and discoveries of the Industrial Revolution and portrayed the great industrialists and engineers, carried on the middle-class solidity of Hogarth's portraits far more than Zoffany did.

Characteristically, after coming to London, the American Copley also retained much of the middle-class realism of Hogarth's period. Though his portraits then fell under the influence of the English tradition in the Reynolds spirit and thus gained in painterly quality, they preserved and, insofar as the sitters were members of the middle class, even accentuated, the directness of his American period.

16. From small beginnings as an engraver, Boydell became Lord Mayor of London in 1790. He gave a fillip to English trade through his enterprise in selling English prints abroad.

17. This feature of West's history paintings remains constant although he painted many of them for George III; moreover it was chiefly the middle-class public who bought the engravings done after them.

18. Although he eschewed Hogarth's variety of facial expression, West sometimes used Raphaelesque heads of expression, accentuated in the manner by which Hogarth treated them in his engravings. Without these Hogarthian features (strengthened perhaps through Lebrun or Caylus), West's *Ascension* (Tate Gallery) would be very like a work of Mengs. West valued *The Analysis of Beauty* highly and praised it: 'It is a work, my man, of the highest value to everyone, studying the Art' (J. T. Smith, *Nollekens and his Times*).

19. Most of these pictures by Copley were ordered by the Corporation of London or by Boydell.

20. See E. Wind 'The Revolution of History Painting' (*Journal of the Warburg Institute*, II, 1938–9).

21. See T. S. R. Boase, 'Illustrations of Shakespeare's Plays in the Seventeenth and Eighteenth Centuries' (*Journal of the Warburg and Courtauld Institutes*, X, 1947).

22. It is significant of the similarity between baroque Italian and neo-baroque English pictures that, even a generation ago, one of Furini's semi-nude female half-lengths representing *Liberality* (Budapest Museum), such as served Hogarth as a model for *Sigismunda*, was generally thought to be by Romney.

23. Wind, *op. cit.*, and C. Mitchell, 'Three Phases of Reynolds' Method' (*Burl. Mag.*, LXXX, 1942). A passage from Haydon's Memoirs also throws light on the patently mannerist features of Reynolds' *Continence of Scipio*; 'Ottley said the first time he saw Sir Joshua he showed him a picture of the *Continence of Scipio*. Ottley said it put him in mind of Parmigiano. Sir Joshua seemed angry, for it was stolen from that painter.'

24. Fuseli was not an isolated phenomenon in English art but a more mannerist extreme of the baroque-romantic history painting of the W. Hamilton-Martin type.

25. It is a mad-house, not a lazar-house as is sometimes stated.

26. See, further, F. Antal: *Fuseli Studies*, London, 1956.

27. It is characteristic that Smollett, who in many ways still belonged in mentality to the first half of the century, complained (in *Humphrey Clinker*) of the dullness and degeneracy of the times and of art after Hogarth's death.

28. See H. Ronte, *Richardson and Fielding* (Leipzig, 1905) and F. T. Blanchard, *Fielding the Novelist* (New Haven, 1926).

29. The Rev. Gilpin, an educationalist and social reformer, in his *Essay on Prints* (1768), refers to Hogarth in more or less the same vein as Horace Walpole: Hogarth treats only low life, he has insufficient grace, he cannot draw figures, his composition is not good; however, his expression is excellent, is based on nature, and he can make the beholder laugh.

30. It was this more prudish generation which conceived the notion of Hogarth as a drunkard, a notion which apparently went back to the sculptor and printseller, Nathaniel Smith, and was recorded by his son, J. T. Smith, in *Nollekens and his Times* (London, 1829).

31. In that year Boydell bought from Mary Lewis, Hogarth's last surviving relative, the rights of his engraved copper plates. Besides *Sigismunda* Boydell also owned one of the portraits of Sarah Malcolm and the famous self-portrait of 1745, all of which he bought at the sale of Hogarth's widow's property.

32. There were new editions of J. Ireland's book in 1793, 1806 and 1812. In 1798 he added a third volume by publishing Hogarth's autobiographical notes, which he obtained from Mary Lewis. This material (which Hogarth himself intended for publication) is of incalculable value for understanding Hogarth's art. The volume also contains a 'Memorial for Hogarth' drawn by the painter, John Mortimer, who seems to have been interested in Hogarth in other ways as well. In 1794 and 1799, S. Ireland, an antiquarian and collector somewhat similar in type to the other Ireland, published many minor, hitherto lesser known, works by Hogarth, mostly in his own possession (*Graphic Illustrations of Hogarth*).

33. Françoise Duparc, a French follower of Chardin who between 1763 and 1766 exhibited portraits as well as genre figures in London, painted astonishingly simple, genuine, colouristically delicate half-lengths of peasant women, mill-girls and women knitting. I could imagine that her works (the few that exist to-day are all in Marseilles), influenced Henry Morland, George Morland's father, but the English painter transposed the austere French type into a coquettish, half erotic one. Françoise Duparc must have met with a certain success and clientèle in England, but owing perhaps to the change of taste so noticeable after Hogarth's death, she later returned to Paris. Loutherbourg, another French immigrant who settled here permanently did pictorial reportage, a genre which was rare at that time. His early, slightly grotesque *Summer Afternoon with a Methodist Preacher* (c. 1774, National Gallery of Canada, Ottawa) (Pl. 149b) still reflects something of Hogarth's spirit and can be compared with works of the early Zoffany. In fact, Loutherbourg was almost the only painter in England at this

time whose compositions (mainly landscapes) contain real, not just 'stage', figures. In his picture of road-makers, *The Gravel Pit* (previously Earl of Aylesford) one can, if one wishes, find a faint echo of Hogarth's *Sign of a Paver*, though the later painting no longer concentrated on the motif of hard work.

34. In theory, of course, the moral aims of caricature were upheld (e.g. F. Grose, *Rules for drawing Caricatures*, 1788); J. P. Malcolm, *An Historical Sketch of the Art of Caricaturing*, 1813).

35. See A. P. Oppé, *Thomas Rowlandson* (London, 1923).

36. F. D. Klingender (*Hogarth and English Caricature*, London, 1944) juxtaposes some of Hogarth's compositions with those by Gillray and Rowlandson derived from them.

37. In 1808–10 there already appeared the first two volumes of a new edition of Nichols' *Biographical Anecdotes*, with the title *The Genuine Works of William Hogarth*.

38. Coleridge in an article in *The Field* in 1809 already expressed similar views, though in a more superficial way.

39. 'I would ask the most enthusiastic admirer of Reynolds whether in the countenances of his *Staring* and *Grinning Despair*, which he has given us for the faces of Ugolino and dying Beaufort, there be anything comparable to the expression which Hogarth has put into the face of his broken-down Rake in the last Plate but one of *A Rake's Progress*.'

40. For instance: 'it is the fashion with those who cry up the great Historical school in this country, at the head of which Sir Joshua Reynolds is placed, to exclude Hogarth from that school as an artist of an inferior and vulgar class. Those persons seem to me to confound the painting of subjects in common or vulgar life with the being a vulgar artist.'

41. Crabb Robinson's *Diary*, 1811, 4th Nov.

42. How little Hogarth's pictorial qualities were understood is revealed by the fact that *The Shrimp Girl* was sold in 1799 for £4 10s. Appreciation of his pictures demanded an unusually refined taste such as that of Sir John Soane, who bought *A Rake's Progress* as early as in 1802 and later, in 1823, the *Election* cycle.

43. Hazlitt was also much interested in the theatre and it was he who discovered Kean, whose naturalistic acting, after the declamatory style of the intervening decades, was the true successor of Garrick's. There exists a coloured porcelain statuette of about 1815, showing Kean in the tent scene of *Richard III*, which is a faithful copy, in a popular style, of Hogarth's engraving of Garrick in the same scene.

44. In 1833 J. B. Nichols, the son of J. Nichols, published the *Anecdotes of William Hogarth* with appreciations of Hogarth by Lamb, Hazlitt and others.

45. Constable shared Hogarth's contempt for the connoisseurs who did not buy his pictures because of their realism.

46. In graphic art, the outstanding figural compositions produced in England were certainly Géricault's London lithographs (1820). Social, documentary and partly sentimental, they were probably too strong meat for the English public and did not meet with any success in contrast to the more sensationally dramatic *Raft of the Medusa*.

47. Yet certain history paintings with a contemporary theme, even foreign ones, held an interest for the English public. The exhibition of Géricault's *Raft of the Medusa* in 1819 and of David's *Coronation of Napoleon* in 1822 were great financial successes.

48. Cruikshank also illustrated J. Collier's book on the history of the Punch and Judy Show (1828). Rowlandson, too, had drawn Punch and Judy Shows.

49. See W. Dibelius, *Charles Dickens* (Leipzig, 1916) and T. A. Jackson, *Charles Dickens: The Progress of a Radical* (London, 1937).

50. Hogarth's art—suffering the fate of every art once very much alive—could be, and indeed was interpreted after its own time in a conservative, retrograde sense. It was not only after Hogarth's death that his engravings were twisted into something extremely pure and exclusively edifying; one finds the same trend later on, especially in Victorian times, a strengthening of the influence of Trusler's *Commentary*. The underlying tendency of Hogarth's engravings, the praise of work—once a question of life and death for the middle class to offset the way of life of the aristocracy—now apparently served as a sentimental-paternal appeal to the working population. *Industry and Idleness*, especially, was frequently put to this purpose. In America, too, even shortly after the Civil War, *Industry and Idleness* was thought by conservative and religious circles to serve as a stabilising influence against the ideas of Jefferson and Tom Paine.

51. That Hogarth's fame remained very much alive in Dickens' circle is borne out by the fact that G. Sala, an intimate of Dickens and close collaborator with him on *Household Words*, wrote a book on Hogarth purely inspired by his personal enthusiasm. This book, which revelled in the 18th century, was first published in serial form in Thackeray's *Cornhill Magazine*, 1860, and in book form in 1866. Thackeray, too, wrote on Hogarth in his *English Humourists of the Eighteenth Century* (London, 1853), one essay being dedicated to Hogarth, Smollett and Fielding.

52. For instance, the *Sketches*, *Pickwick Papers* and *Little Dorritt* contain descriptions of the Debtors' Prison, and the former also depicts a house of correction. In *Pickwick Papers* a corrupt election is described. The pauper's funeral in *Oliver Twist* has its precursor in the *Harlot's Funeral*. Compare also Dickens' description of a law court in *David Copperfield*, where he likens the judges to owls, with Hogarth's *Bench*.

53. Cruikshank had already illustrated two books by Dickens' predecessor in this field, J. Wight, police reporter of *The Morning Herald*: *Mornings at Bow Street* (1824) and *More Mornings at Bow Street* (1827).

54. The controversy that had raged round Hogarth, as to whether his figures were characters or caricaturas, was now revived with regard to Cruikshank's Dickens' illustrations. Horne (*op. cit.*) thought them more caricatura-like than the text warranted. Cruikshank was doubtless the most original and vital of all Dickens' illustrators. The later, more docile ones whom Dickens preferred—even Cruikshank's imitator, Phiz—were much weaker and increasingly conventional, especially in scenes of a dramatic character.

55. I have as little intention of taking part in the easy

game of 'debunking' Pre-Raphaelitism as of subscribing to the recent fashion of over-estimating it. The entire English 19th-century artistic movement in all its variety, from Turner to the Pre-Raphaelites, corresponding to the great diversity of middle-class thought then prevailing, has never been seriously analysed historically. The best historical account of Pre-Raphaelitism known to me is the short introduction by J. A. Gere to the catalogue of the exhibition in the Whitechapel Art Gallery (London, 1948).

56. In 1858, only nine years after Courbet's epoch-making picture (Dresden Gallery), Brett and Wallis both painted the theme of the stone-breaker. Brett's work, representing a little boy, though more romantic than Courbet's and having something of the charm of Wald-müller (the Austrian genre painter of the previous decades), attempted to be documentary in a Ruskinian sense. Wallis's painting, which deplores the fate of the workers and, reinforced by a quotation from Sartor Resartus ('Thou wert our conscript'), shows the stone-breaker dead, is an interesting parallel to Courbet in the spirit of Carlyle.

57. Hunt's pictures of the type of *The Awakened Con-science* were very close to those of the Royal Academician Egg, who was influenced by the Pre-Raphaelites. On the other hand, Egg was also very close to Frith; this shows that the transition between the official and the 'revolutionary' Victorian artists was often very slight.

58. Apart from that of Morris, who represents the more consistent continuation of Ruskin's mentality, the medieval-ising art of any of these artists was, in my view, mere escapism and not a genuine protest against modern times.

59. *Le Charivari*, for which Daumier worked, was the first illustrated periodical published daily. *La Caricature*, to which Daumier contributed when quite young, began in 1830 but was suppressed in 1835.

60. The National Gallery did not acquire a single work by Hogarth between 1824 (when, as part of the Angerstein collection, it acquired *Marriage à la Mode* and the *Self-Portrait*) and 1884 (when *The Shrimp Girl* and *Lavinia Fenton* were purchased). Condemnation of Hogarth of course also involved Fielding, whose true rehabilitation only began in post-Victorian times.

CHAPTER ELEVEN

1. The impact of English culture on France in that period was first analysed by H. T. Buckle (*History of Civilisation in England*, London, 1857–61), a pioneer in the application of the sociological method in history.

2. See L. Stephens, *English Thought in the 18th Century*.

3. Voltaire stayed in England from 1726 to 1729, the outcome being his *Lettres sur les Anglais* (or *Lettres Philosophiques*, 1734); Montesquieu from 1729 to 1731, resulting in his *Esprit des Lois* (1748).

4. Even the original starting-point for the French Encyclopedia was Chambers' English one (1728).

5. Prévost, Hogarth's contemporary, had translated English middle-class literature (Addison, Richardson) and launched a French version of *The Spectator*.

6. Both the Richardson and the Fielding types of novels helped to pave the way towards different trends in France, the first leading to Rousseau's *Nouvelle Héloïse*, the second to the great analytical novels of the 19th century.

7. Throughout this book I have stressed the connection in England between the baroque of the Restoration period and the rococo taste of the mid-18th century. Yet, another aspect of English art, e.g. rationalism aiming at greater simplicity, was so strong in Hogarth's lifetime that it led to a kind of classicism, even if it was diluted and full of baroque undertones—above all in architecture, where from about 1720 onwards classicistic elements were more pro-nounced than on the continent. See on this trend and its influence on French development, F. Kimbal ('Les Influences anglaises dans la formation du style Louis XVI', *Gazette des Beaux Arts*, LXXIII, 1931). In this context I should like to add the suggestion that Servandoni, the architect of St. Sulpice who came to London in 1749 and worked on various noble houses, may yet prove to have been quite an important link between the art of the two countries, e.g. the English influence on French classicist architecture.

The informal, sentimental English garden was also connected with these developments, being an important new medium for the doctrine of truthfulness to nature—a realistic tendency being the frequent corollary of classicism, in this case classicist architecture. The English garden (whose political, democratic implications were stressed by Shaftesbury) took France by storm and destroyed the cult of the formal garden.

8. See L. Hautecoeur, 'La Sentimentalisme dans la peinture française', *Gazette des Beaux Arts*, LI, 1909.

9. The continued popularity of Hogarth's work with the French middle class even after the Revolution is borne out by the eulogistic reference to *Four Stages of Cruelty* in his poem, *Le Malheur et le Pitié* (1803), by the Abbé Delille (1738–1813), the extremely popular didactic extoller of family life, an imitator of Thomson and Gray. *The Analysis of Beauty* was translated into French in 1805 together with Nichols' *Biographical Anecdotes*.

10. Diderot began his philosophical career in 1745 by adapting Shaftesbury's *Enquiry concerning Virtue*. As in France Shaftesbury was considered a dangerous free-thinker, Diderot omitted both their names from the book, and also toned down the English original; yet his version was burned by the Parliament of Paris.

11. The ideas of Winckelmann's friend, Mengs, leading in the same direction, were first expounded by D. Webb, an Englishman whose work (*Enquiry into the Beauty of Painting*, 1760) Diderot knew well.

12. One of Diderot's forerunners in French art theory was Charles Antoine Coypel who, in his capacity as Director of the Academy, sought to give art a 'philosophical' turn and connect it with literature; his common points with Hogarth have already been referred to.

13. See L. Cru, *Diderot as a Disciple of English Thought* (New York, 1913).

14. Diderot, like all French intellectuals, was much influenced by Garrick's realistic acting, which was felt to be new and revolutionary.

15. Its original title was *Le Paralytique servi par ses Enfants*, but the critics and public could not quite decide whether it was the father or the grandfather who was on the point of dying.

16. This was also the theme of one of the scenes for *A Rake's Progress* (Ashmolean Museum, Oxford) which Hogarth ultimately rejected.

17. The young, still 'Flemish' Watteau also represented it (c. 1710, Soane Museum, London) but in a very different atmosphere: the main theme recedes into the background —the bridal pair and the lawyer are still rather *Commedia dell' Arte* figures—and groups of dancing mock-shepherds form the chief feature of the picture.

18. Greuze and Hogarth viewed and represented not only the middle class but also the poor very differently. In France, in the tenser atmosphere of an impending revolution, Greuze was more obviously a painter of the poor and humble than Hogarth, although the latter represented them in a far more documentary manner. In England, where the social revolution had already taken place, Hogarth fitted the poor into the outlook of the wealthy middle class, which was not very sympathetic towards them. A certain difference between the French and English conception again occurs when Greuze's didactic paintings are compared with those of similar moralising sentimental subjects by the post-Hogarthian generation in England, e.g. Morland and Wheatley. Despite a certain elegance and voluptuousness, Greuze's pictures display more dramatic force and seriousness, even a more convincing realism.

19. The evolution of Chardin, the first great French middle-class painter of the 18th century, from a moderate baroque to a realistic painterly classicism, already started in the 'thirties. As for the realism of *The Village Bride*, Diderot thought it lay midway between Teniers and Boucher and considered this to be just right.

20. Hogarth's unflattering realism of detail was on the other hand too much for French art. Grosley, a French connoisseur who saw the original pictures of the *Election* cycle at Garrick's in 1765, compared them with Breughel: 'These pictures are in the taste of old Breughel. . . . It is pure nature but nature too naked and too true; a truth very different from that displayed by two of the masters of the present French school, Messieurs Chardin and Greuze.' (See Whitley, *op. cit.*)

21. It is equally their more consistent sentimentalism, apart from their veiled eroticism, which distinguishes Greuze's numerous female heads of expression from Hogarth's contemporary *Sigismunda*. Unlike *Sigismunda*, Greuze's heads all have sentimentally upturned eyes with the white emphasised and a half-open mouth—motifs which derive not only from French works of the type of Coypel's *Adrienne Lecouvreur*, from which Hogarth, too, borrowed, but also from the baroque religious-ecstatic half-figures of Reni or Dolci.

22. Diderot's enthusiastic reviews of Greuze's pictures reveal how every psychological nuance of character and expression was carefully scrutinised, approved or disapproved.

23. Towards the end of his life, Diderot, going beyond his predilection for Greuze, praised David's early but already classicist pictures (1781). The political background of Greuze's and David's paintings was determined by the generation they belonged to. Greuze was favoured by the enlightened absolutists and the future Girondists (Mme. Roland); David became a Jacobin.

24. Some general resemblance with Hogarth also appears in the elegant yet extremely realistic, chronicle-like etchings of Gabriel de St. Aubin, whose idiom was still baroque-rococo; compare, for instance, his *Salon of 1753* (Pl. 23a), with Hogarth's *Auction of Pictures* (Pl. 23b).

25. This picture has even been attributed of late to the revolutionary wave of the 1840s, but this seems to me most improbable.

26. See E. Wind ('The Source of David's Horaces', *Journal of the Warburg and Courtauld Institutes*, IV, 1940–1).

27. Not only Hogarth's portraits were more realist than contemporary French ones, but also those by Hudson, Highmore and Hayman, the young Gainsborough and the young Ramsay. Even the more fashionable English portraits of this period are more humanised and psychologically conceived than their contemporary counterparts in French art.

28. Greuze also sought acceptance by the Academy as a history painter. His attempt (*Severus and Caracalla*, 1709, Louvre) ended not unlike Hogarth's, though more deservedly, in failure. Greuze was considered by the critics to be a 'painter of the passions', just as Hogarth thought of himself as a painter of characters, a kind of transition between the genre painter and the history painter, but closer to the latter. Greuze was confirmed in the former flattering assessment by Diderot, Hogarth in the latter by Fielding.

29. The discordant, harsh colours of classicism, especially in David's history paintings done shortly before and after the Revolution, are not anti-realist, as is generally supposed, but rather a realist reaction against the decorative colours of rococo. It was only in the next generation, in Géricault's equally realistic classicism, when the anti-rococo reaction was no longer felt to be necessary, that the colour composition acquired a new balance and harmony. (See F. Antal, 'Reflections on Classicism and Romanticism, I', *Burlington Magazine*, LXVI, 1935).

30. French middle-class intellectuals, above all Diderot, advocated a revival of Poussin as a means of fostering a new history painting and a classicist style. See J. Locquin, *La Peinture d'Histoire en France de 1747 à 1785* (Paris, 1912).

31. Andromeda's expression seems to me to derive directly from Domenichino (e.g. *St. Cecily*, Louvre, or *Sybilla*, Borghese Gallery, Rome); realist features derived from Italian 17th-century painting are also apparent in *Sigismunda*.

32. Among Hogarth's contemporaries in Rome, history painting even assumed a rococo manner (Trevisani) and the classicising line was carried on more by the French Subleyras than by the Italians themselves.

33. In terms of the most advanced contemporary French

art, Hogarth's picture, in its classicising structure, solidity and the realism of its figures, far surpasses the young Vien's slightly later figural compositions of *Susannah and the Elders* (Nantes) and *Lot's Daughters* (Le Havre), which still adhere closely to Bolognese schemes and expressions.

34. W. Whitehead wrote an English adaptation of Corneille's *Horace*, called *The Roman Father*, in 1750. J. G. Noverre, a French friend of Garrick, influenced by Garrick's manner of acting, produced a dramatic pantomime of this play, *Les Horaces*, in Paris in 1777. The idea of the swords in David's picture, which originated with Whitehead (not with Corneille), came to David through Noverre. See Wind, *op. cit.*

35. Gavin Hamilton (1723–98) lived in Rome, first in the Stuart-Revett, later in the Mengs-Winckelmann, circle. Both West and Canova were under his influence.

36. See J. Locquin, 'La part de l'influence anglaise dans l'orientation neo-classique de la peinture française entre 1750 et 1780' (*Actes du Congrès d'Histoire de l'Art*, Paris, 1924).

37. See E. Wind, 'The Revolution of History Painting' (*Journal of the Warburg Institute*, II, 1938) and C. Mitchell, 'Benjamin West's Death of General Wolfe and the Popular History Piece' (*Journal of the Warburg and Courtauld Institutes*, VII, 1944). The representation of current history in contemporary dress, not even practised consistently by David, was popularised by West's *Death of General Wolfe* (1771). It is significant of the close connection between realism and classicism that when Zoffany undertook an historical subject, *The Death of Captain Cook* (Maritime Museum, Greenwich), the result was a classicist painting in the manner of West, even including imitations of antique statues. In its composition this is not far from David's *Oath in the Tennis Court*, which it precedes by over ten years and is stylistically close even to Géricault.

38. The name is formed from the initials of the Latin titles of the five scenes.

39. There is a common link with Hogarth in Troost's possibly even greater use of Picart's *Cérémonies Religieuses*, published in Amsterdam. Troost had an almost closer resemblance with Highmore than with Hogarth. Highmore's *Pamela* cycle was attributed to Troost at a sale in 1920.

40. Many further editions of it appeared in Italy; one in Milan as late as 1833.

41. Longhi was a friend of Goldoni, the first playwright in Venice to create realistic characters from Venetian everyday life in contrast to the conventional, typified ones of the *Commedia dell' Arte*. Though Goldoni was more bourgeois in outlook than Longhi, it is easy to quote parallel 'passages' from both (see E. Masi, *Carlo Goldoni e Pietro Longhi*, Florence, 1891). Goldoni was also under the influence of the new English psychological literature and adapted *Pamela* for the Italian stage; while one of his own plays was transformed by Diderot into a 'bourgeois' tragedy (*Le Fils naturel*). Finally he left Venice, which was not yet ripe for his realism, to join his friend Beaumarchais in Paris. These facts, even if they seem irrelevant, help to define the place of English middle-class art and literature in general European culture. On the influence of English middle-class

ideas in Italy see A. Graf, *L'Anglomania e l'Influsso inglese in Italia nel Secolo XVIII* (Turin, 1911).

42. Alessandro Longhi states that his father's pictures were much favoured by the aristocracy and even at various courts. However his compositions were also widely disseminated through engravings—more so, I think, than those of the decorative fresco painters.

43. In terms of Northern Italy, one could perhaps define Hogarth's paintings as a combination of Magnasco's wild grotesqueness and Amigoni's elegance (the former being in theory, the latter in practice, close to Hogarth). It seems an impossible alliance, yet there is undeniably a general stylistic similarity between Magnasco's sketches and Amigoni's grisailles of Biblical themes.

44. There is (as Waterhouse, *op. cit.*, has remarked) a similarity between some of the young Reynolds' portraits in the mid-'fifties and Longhi's. It is very instructive that by fusing the 16th-century Venetians and Rembrandt, Reynolds occasionally created something comparable to Venetian 18th-century middle-class painting.

45. Even Longhi's *Dancing Master* is fundamentally a free, though much weaker, copy of Crespi's picture of the same theme in Munich.

46. Compare Crespi's series of the Sacraments with their engraved copies by Longhi, which are less baroque, harder and more 'middle class'. When Guardi in turn copied Longhi's Sacraments, his drawings (Museo Civico, Venice) were of a more impressionistic baroque than Longhi's and so again closer to Hogarth. Guardi's impressionism, however, is not only later in date but also more playful than that of the more solid Hogarth, as in his drawings for *Industry and Idleness*.

47. His œuvre was discovered as late as 1927 by R. Longhi ('Di Gaspare Traversi', *Vita Artistica*, 1927).

48. Among its other predecessors representing the *Marriage Contract* Aert de Gelder's picture in Brighton (Pl. 85a), is perhaps the one to which the psychological conception of Traversi's painting is most closely related, historically speaking.

49. Hogarth's influence on Traversi is undoubtedly more important than his influence on Alessandro Longhi adduced by G. Fiocco (*Venetian Paintings of the Seicento and Settecento*, Florence/Paris, 1929).

50. The other contemporary Italian painters interested in physiognomy did not share in individualised, Hogarthian or super-Hogarthian expressions as Traversi did. Probably they only followed Lebrun's academic, schematic types of expression, as for instance Bonito (1707–89), a painter of Neapolitan genre pictures, far weaker but better known than Traversi, and Count Rotari (1707–62) the Neapolitan painter of internationally celebrated, sentimental female heads.

51. For a long time *The Vicar of Wakefield* was the most widely read book among the German middle class. As to philosophy, the influence of Shaftesbury's was even deeper and more general than in France. It was also in Germany that the first foreign imitation of *The Spectator* appeared as early as 1713.

52. 'Die Werke des Herrn William Hogarth in Kupferstichen, Moralisch und Satirisch Erläutert', was published

in Hamburg as early as 1769. And only two years after its publication in England, Nichols' catalogue of Hogarth's engravings was translated into German in 1783.

53. After Lichtenberg's death, his Hogarth edition with a dull commentary by others was completed as late as 1835. Re-engravings for the whole publication were done by the Göttingen engraver, E. Riepenhausen, a follower of Chodowiecki, who had also done reduced engravings after Hogarth and composed new groups made up of various Hogarthian figures. I think, however, that in the 'unpolitical' and reactionary Germany of the early 19th century, interest in Hogarth, previously sustained by progressive intellectuals, now assumed an increasingly philistine cast.

54. See his 'Visits to England' as described in his Letters and Diaries (Eng. Transl. Oxford, 1938). He himself says: 'When I was in England, I lived sometimes like a lord and at others like a workman.'

55. He was also interested in the most advanced English psychology, in Priestley and in Hartley, many of whose ideas were similar to Hogarth's.

56. He gave the most accurate known description of Garrick's acting in his numerous roles.

57. Although Goethe collaborated with Lavater on this book, he later rejected his views.

58. Even Lavater had to admit the didactic-moral effect of Hogarth's engravings. On his relation to Hogarth, see Ch. Steinbrucker, *Lavaters Physiognomische Fragmente im Verhältnis zur Bildenden Kunst* (Berlin, 1915).

59. Needless to say, Chodowiecki abhorred the French Revolution and attacked it in engravings.

60. This realism is the least evident in his illustrations for Lavater's *Physiognomische Fragmente*. Only sometimes, in those of sick people, were they based on close observation; usually they are schematising, following Lavater's hampering instructions.

61. Christian Bretzner later based a novel of the same title on it, recording his debt to Chodowiecki and Hogarth. Chodowiecki also illustrated this work, again leaning on Hogarth.

62. It reflects the 18th-century German middle-class mentality that Lichtenberg should have advised Chodowiecki to seek ideas for 'good people' in Lavater and also have asked him to avoid physiognomic studies of a depressing nature. See the correspondence in Ch. Steinbrucker, *Daniel Chodowiecki Briefwechsel zwischen ihm under seinen Zeitgenossen* (Berlin, 1919).

63. As secretary of the Berlin Academy of Painting, Chodowiecki proposed a special class for the teaching of expression.

64. Other German book illustrations, especially those for translations from the English, were frequently in the Hogarth vein. Crusius, a Leipzig engraver, literally copied one of Hogarth's scenes from *Tristram Shandy* (1774). Gessner, the famous Swiss poet and engraver, followed Hogarth's first *Hudibras* scene (1765) quite closely. Like Schellenberg, another Swiss illustrator of *Hudibras* and a follower of Chodowiecki, he selected identical episodes, so that he could steer close to Hogarth.

65. The best analysis of his style is given in E. Kris, 'Die Charakterköpfe des Franz Xaver Messerschmidt' (*Jahrbuch der Kunsthistorischen Sammlungen in Wien, N.F.VI* 1932).

66. Now Bratislava, in Czechoslovakia.

67. The most moderate of these heads, the laughing self-portrait in an astrakan cap, recalls Roubilliac's portrait busts of artists. It is not impossible that Messerschmidt was in London in 1765. See Kris, *op. cit.*

68. Lessing's *Laokoön* owed much to English thought, in particular to Shaftesbury, Jonathan Richardson, Webb and Harris.

69. Winckelmann applied to art history, and specifically to antique sculpture, Montesquieu's historical method whereby states were held to have their own lines of development, subject to definite laws. According to him—and in this he was perhaps under Shaftesbury's sway—the rise and fall of art followed the rise and fall of political freedom. That is why, for him, contemporary baroque art was connected with the absolutist form of regime.

70. Although his biographer, Carl Justi (*Winckelmann und seine Zeitgenossen*, Leipzig, 1866–72) thoroughly investigated these sources, later scholars were not interested in this aspect of his theories.

71. Mengs, like Hogarth or Fielding, also distinguished between the 'sublime' and 'natural' styles, comparing the latter to the comic muse in poetry.

72. Goethe already rejected Hogarth's 'serpent-line' outright as the contrary of 'characteristic', the feature of ancient art (*Der Sammler und die Seinigen*, 1799).

73. Hogarth's and Mengs' views were described by Goethe's friend, Merck, in an imaginary conversation between himself, Hogarth and Mengs in the Court of the Belvedere ('Über die Schönheit', 1776, in the magazine *Teutscher Merkur*). Hogarth here uses strong arguments to uphold his serpentine line; Merck, in face of the antique statues, abandons his theory of proportion as a basis of beauty; while Mengs, having just completed a drawing of the *Apollo of Belvedere*, believes in a synthesis of the various theories of beauty.

74. In spite of Winckelmann's theories, the development of German art at the end of the 18th century was very different from that of France. In Germany, as in other countries where middle-class feeling did not follow the French Revolution, the neo-antique movement, though associated with Winckelmann's theories, did not lead to middle-class art as it did in France. In these countries where, immediately after the French Revolution, fear of a similar upheaval became the overriding factor, the neo-antique ideology was used on the contrary to support a 'timeless' non-topical, unrealistic classicism.

75. Hogarth's impact in America can be seen in the gesture of Trumbull, painter of the War of Independence, who portrayed himself (1817, Boston) with a volume of Hogarth's engravings before him.

76. See on this aspect of Goya's art, F. D. Klingender's *Goya in the Democratic Tradition* (London, 1948).

77. The caption for the scene of *Los Caprichos* in which Goya represents himself drawing—'Fantasy abandoned by Reason produces Monsters: united with reason she is the mother of the arts and the source of their marvels'—was

written under the influence of a passage from Addison's *Pleasures of Imagination*.

Goya's drawing of *Divine Reason holding Scales and Driving off the Birds of Darkness* (Prado) may have been intended as an ideological counterpart to Reynolds' portrait of Dr. Beattie, in which the genius of Truth, also holding scales, is driving away the free thinkers, Voltaire, Gibbon and Hume. Goya could have known Reynolds' composition through an engraving (see J. Lopez-Rey, 'Goya and the World around Him', *Gazette des Beaux Arts*, XXVIII, 1945).

78. See Klingender, *op. cit.*: also for parallels in Goya with certain features of English popular art.

79. Callot is certainly reflected in Goya, though less than in Hogarth. *Los Desastres de la Guerra* is a highly dramatised revival on a new, emotional level of *Misères de la Guerre*.

80. Goya's early cartoons for tapestries with scenes from Spanish life already show a degree of monumental and realistic rococo possessed by no artist before him except Hogarth (and, to some extent, Guardi in his genre pictures). It is the realism, not the rococo, that I wish to stress, for again in Goya's case the formal yardstick must be taken *cum grano salis*. The similarity with Hogarth of some of these cartoons was noticed by H. Stokes (*Francisco Goya*, London, 1914).

81. Goya was said to be the first Spanish painter to represent scenes from the theatre—another example of his and Hogarth's similar interests.

82. See J. Lopez-Rey, *op. cit.*, and *Gazette des Beaux Arts*, 1945.

83. Meier-Graefe (*op. cit.*), who studied these problems, pointed out the obvious similarity of pictorial qualities in Hogarth's and Goya's portraits.

84. As another historical parallel, note the strong similarity between the refined simplicity in pattern and colouring of some of David's portraits, such as *Mlle. le Peletier de Saint-Fargeau* from 1804 and some of Goya's contemporary likenesses.

85. Severe censorship under Napoleon III compelled Daumier to curb himself. His admirer Michelet's hope of seeing his compositions adapted for the stage (as Hogarth's had been) was frustrated by Napoleon's advent to power.

86. Although he regarded the middle class from the opposite, conservative viewpoint of the aristocracy, Balzac reached conclusions similar to Daumier's and, among writers, is the most apt for comparison with him.

87. Whilst among artists, Hogarth was one of the earliest and most sincere philanthropists, Daumier poked fun at their boastful hypocrisy and their organisations.

88. For historical reasons, Daumier could not have had such important artistic precursors in French caricature as he had in Hogarth and Rowlandson (Rowlandson's influence on Daumier, e.g. that of his *Special Jury* on the famous *Ventre Legislatif*, was remarked by J. Doin, 'Thomas Rowlandson', *Gazette des Beaux Arts*, LI, 1909).

89. He did two series, *Physionomies tragico-classiques* (1841), *and Physionomies tragiques* (1851).

90. Daumier's Offenbachian jibes at ancient mythology (cycle of *l'histoire ancienne*)—although like Hogarth he was interested in antique statuary—were anticipated in Hogarth's *Strolling Actresses*.

91. In Russia, on the other hand, owing to her belated economic and social development, it was only after the 1870s that the real fight against Czarism set in and middle-class painting and with it the influence of Hogarth began. This emerged above all in the realistic genre paintings of Fedotov (1815–52), whose anti-romantic art also showed a parallel to Dickens and Gogol. Like Ostrovski in his comedies, Fedotov assiduously satirised the vacuity and soullessness of contemporary society. His picture, *The Major's Prospective Bride* (1848, Tretyakow Gallery, Moscow) (Pl. 87b), depicting a wealthy girl forced by her parents to marry a handsome, swaggering officer, is fundamentally the problem of *Marriage à la Mode* as it became topical a hundred years later in middle-class Russia. Hence this picture in its time made as deep an impression as did Hogarth's cycles in theirs.

92. R. Muther (*Geschichte der Malerei im 19. Jahrhundert*, Munich, 1893), whose views on Hogarth are at least partly mistaken, holds him responsible for the whole of 19th-century genre painting. This is far too sweeping a judgment, at once false and true. The real ancestor was of course Wilkie or, rather, the conservative philistine anecdotal twist which Wilkie gave to Hogarth's art.

93. Even in the 1870s Carl Justi was shocked beyond words by the realism of Hogarth's themes ('William Hogarth', *Zeitschrift für Bildende Kunst*, 1872). A. Woltmann, another prominent art historian of the period ('Hogarth und Chodowiecki aus vier Jahrhunderten niederländischdeutscher Kunstgeschichte*, Berlin, 1878) praised Chodowiecki as being more artistic and measured in his moralising and believed that Wilkie was more important than Hogarth.

94. See A. Cassagne, *La Théorie de l'art pour l'art* (Paris, 1906). Cassagne shows how *l'art pour l'art* theory could be maintained only in peaceful and stable conditions, breaking down under the impact of political and social events in 1848 and 1870–1. Something similar occurred on the continent in the years immediately following World War I, with the economic crisis of 1929, the Spanish Civil War, and again during and immediately after World War II.

95. 'William Hogarth' (*L'Artiste*, ser. IX, vol. VI, 1868). Gautier would certainly have been more sharply critical of Hogarth's engravings, especially those of a popular character. He compared Courbet's *Funeral at Ornans* with tobacconists' signs, and Hogarth's *Sign of a Paver* might well be considered the forerunner of Courbet's *Stone-Breakers*.

96. Very revealing of the ruling taste at that time is the description by Harper Pennington, an American pupil of Whistler, (in his *Reminiscences of Whistler*) of a visit which the two of them paid to the National Gallery. Admiring the painterly qualities of *Marriage à la Mode*, Pennington 'fairly gasped for breath', because 'up to that day I had supposed that what I was told, and had read, of Hogarth was the truth—the silly rubbish about his being *only* a caricaturist and so forth and so on'.

97. Cf. R. Muther, J. Meier-Graefe, Roger Fry. Meier-Graefe, however, not only praised *The Shrimp Girl* but also

realized the very great pictorial qualities, hitherto generally overlooked, of Hogarth's entire painted *œuvre*. Through his studies of the Impressionists and Post-Impressionists, his eye was so well trained that it was impossible for him, however much he may have advocated *l'art pour l'art*, not to feel exalted by Hogarth as a painter. He dedicated a whole book to an elaboration of this appraisal. Though the best one to date on the artist, it yet fell on barren ground, unlike his books on French art which had a wide response throughout Europe. 1907, the high water-mark of *l'art pour l'art*, was too early a date for a general understanding of Hogarth's art. Later E. Waldman (*Englische Malerei*, Breslau, 1927), another lover of French painting, was also completely carried away by Hogarth's colouristic charms.

98. It is now realised to what an extent artistic rediscoveries depend on changes in social and political conditions and on consequent changes in taste. See, on the re-discovery of popular art, Schapiro, *op. cit.*; see also S. Meltzoff, 'The re-discovery of Vermeer' (*Marsyas*, II, 1942) and the re-discovery of the Le Nains (*Art Bulletin*, 1942).

Index

Entries in *italics* refer to works of art or literature. Superior figures after a page number, thus 241[76], indicate the number of a note.

✳✳

Index

Index

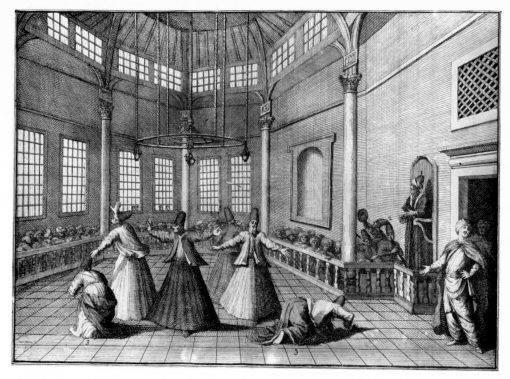

1a HOGARTH: 'Dance of the Dervishes' from de la Mottraye's *Travels*, 1723. Engraving.

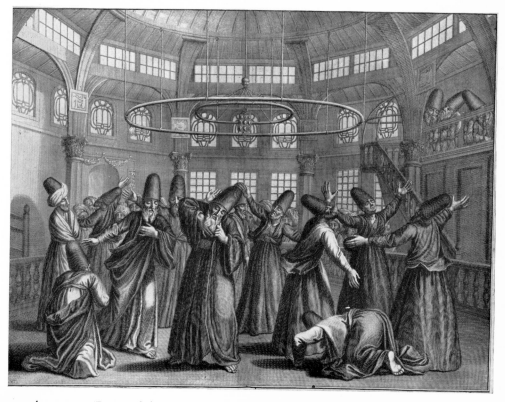

1b PICART: 'Dance of the Dervishes' from *Cérémonies et Coutumes Religieuses*, 1731. Engraving.

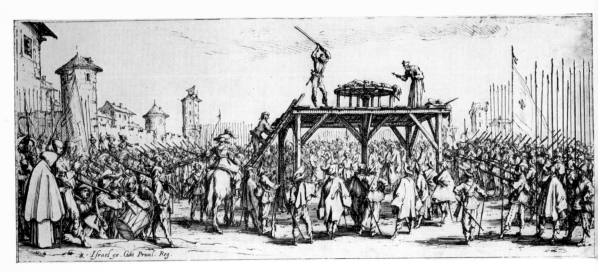

2a CALLOT: 'La Roue' from *Misères de la Guerre*, 1633. Engraving.

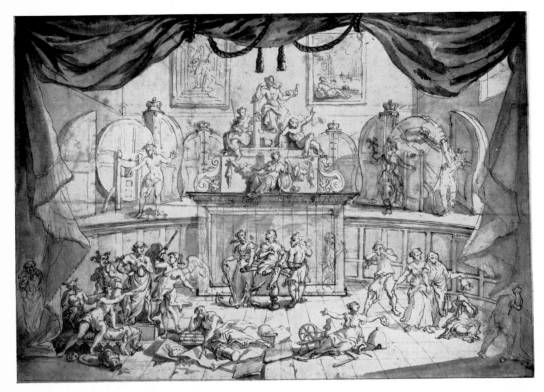

2b HOGARTH: The Lottery, 1721. Drawing.

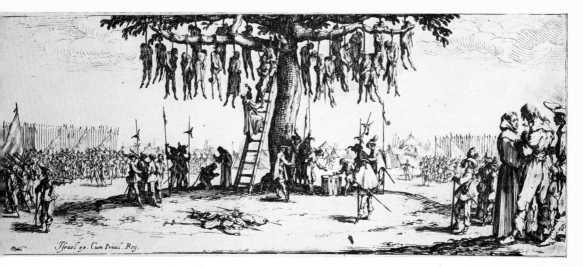

3a CALLOT: 'La Pendaison' from *Misères de la Guerre*, 1633. Engraving.

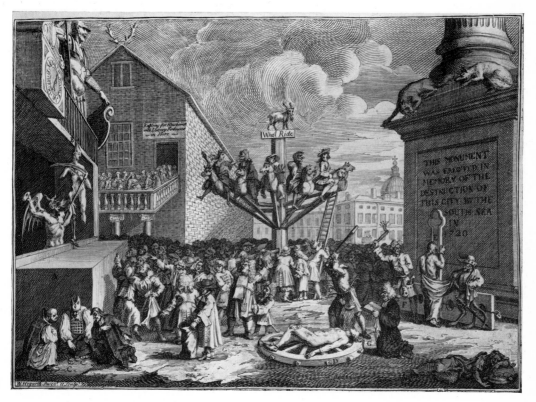

3b HOGARTH: An Emblematical Print on the South Sea Scheme, 1721. Engraving.

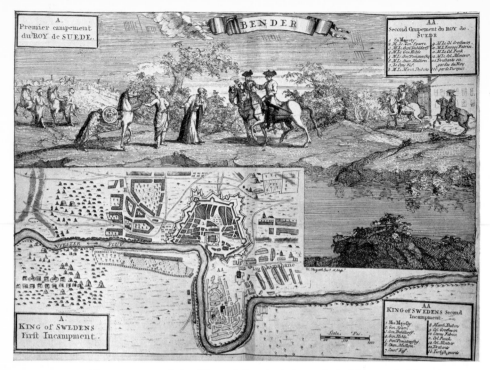

4a HOGARTH: 'Encampment of the King of Sweden', from de la Mottraye's *Travels*, 1723.
Engraving.

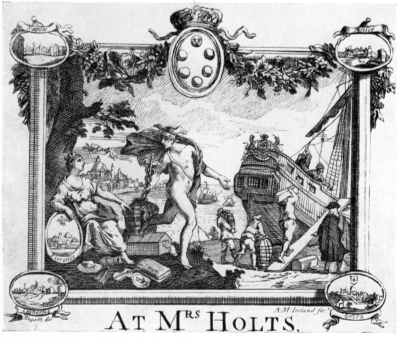

4b HOGARTH: Mrs. Holt's Trade-card. Engraving.

4c VAGA, engraved by Caraglio: 'Mercury and
Herse' from *The Loves of the Gods*. Detail, 1709.

5a HOGARTH: Masquerades and Operas, 1724. Engraving.

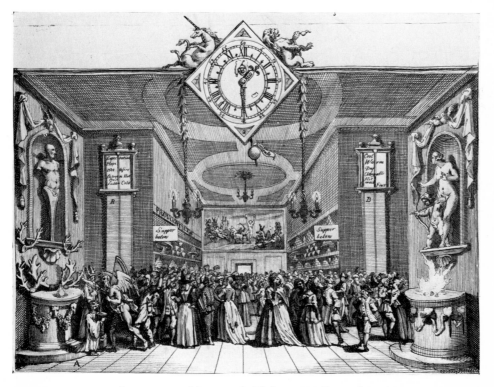

5b HOGARTH: Masquerade Ticket, 1727. Engraving.

Vol. 1 p. 185. W. Hogarth Inv. et Sculp

6a HOGARTH: Illustration to Apuleius'
Golden Ass (The New Metamorphosis),
1724. Engraving.

W. Hogarth Inv. et Sculp

6b HOGARTH: Illustration to Milton's
Paradise Lost: Pandemonium,
c. 1724. Engraving.

7a CALLOT: Temptation of St. Anthony, 1616. Engraving.

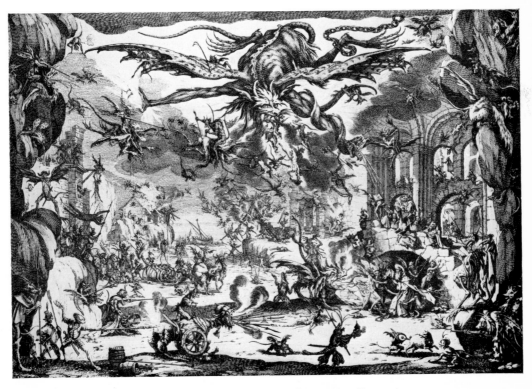

7b CALLOT: Temptation of St. Anthony, 1635. Engraving.

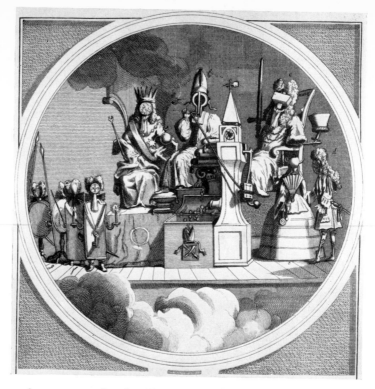

8a HOGARTH: Royalty, Episcopacy and Law, 1724. Engraving.

8b HOGARTH: A shop-bill, *c.* 1725. Engraving.

9a HOGARTH: Illustration to La Calprènede's
Cassandra, 1725. Engraving.

9b DU GUERNIER: Illustration to
Cymbeline, 1714. Engraving.

10a HOGARTH: The Political Clyster, 1726. Engraving.

10b HOGARTH: Frontispiece to *Hudibras*, 1726. Drawing.

11a HOGARTH: Hudibras—Encountering the Skimmington, 1726. Drawing.

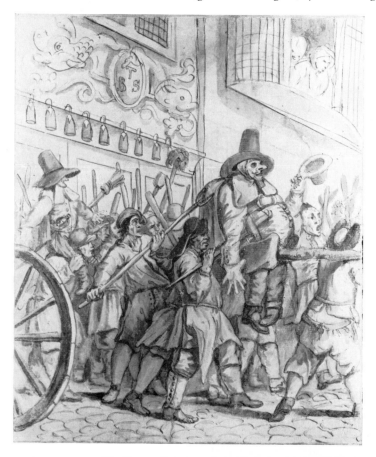

11b HOGARTH: Hudibras—Burning of the Rump, 1726. Drawing.

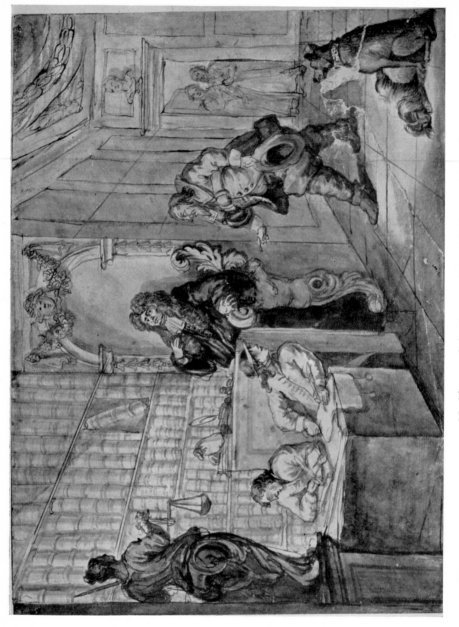

HOGARTH: Hudibras and the Lawyer. Second Series, 1726. Drawing.

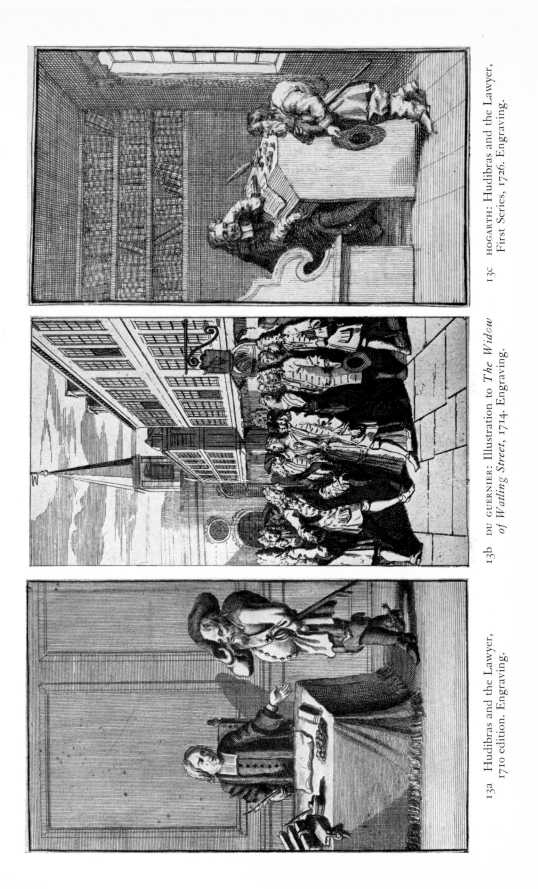

13a Hudibras and the Lawyer, 1710 edition. Engraving.

13b DU GUERNIER: Illustration to *The Widow of Watling Street*, 1714. Engraving.

13c HOGARTH: Hudibras and the Lawyer, First Series, 1726. Engraving.

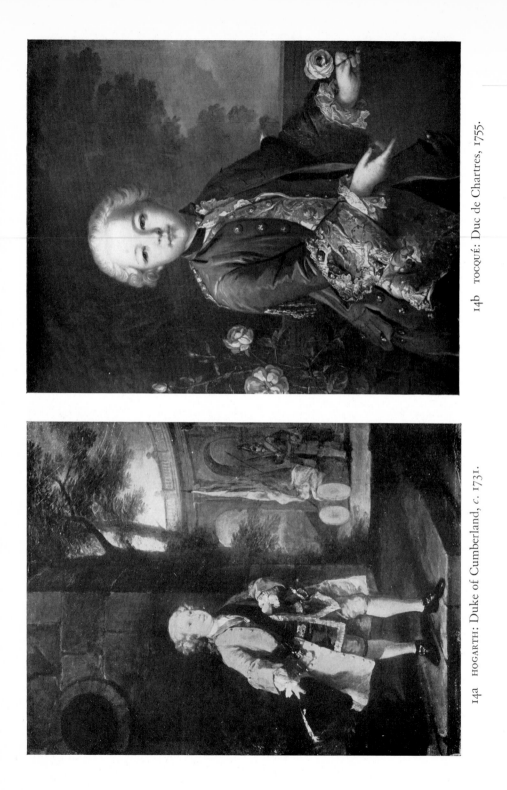

14b TOCQUÉ: Duc de Chartres, 1755.

14a HOGARTH: Duke of Cumberland, c. 1731.

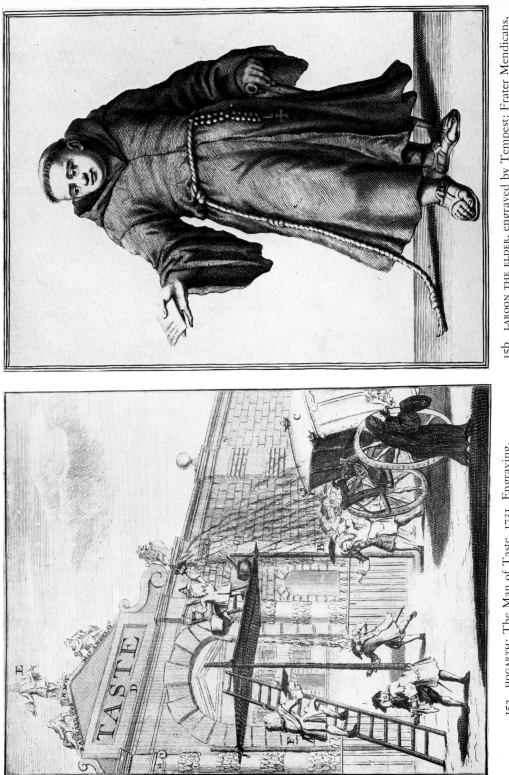

15a HOGARTH: The Man of Taste, 1731. Engraving.

15b LAROON THE ELDER, engraved by Tempest: Frater Mendicans, *c.* 1688.

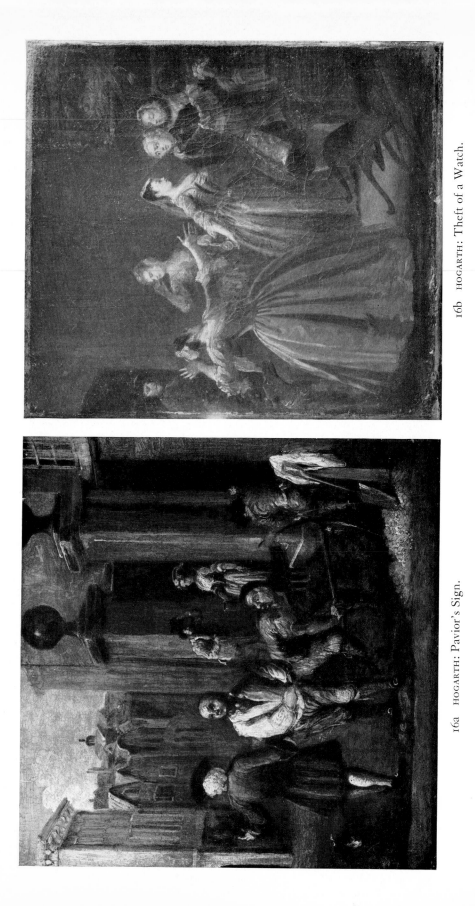

16b HOGARTH: Theft of a Watch.

16a HOGARTH: Pavior's Sign.

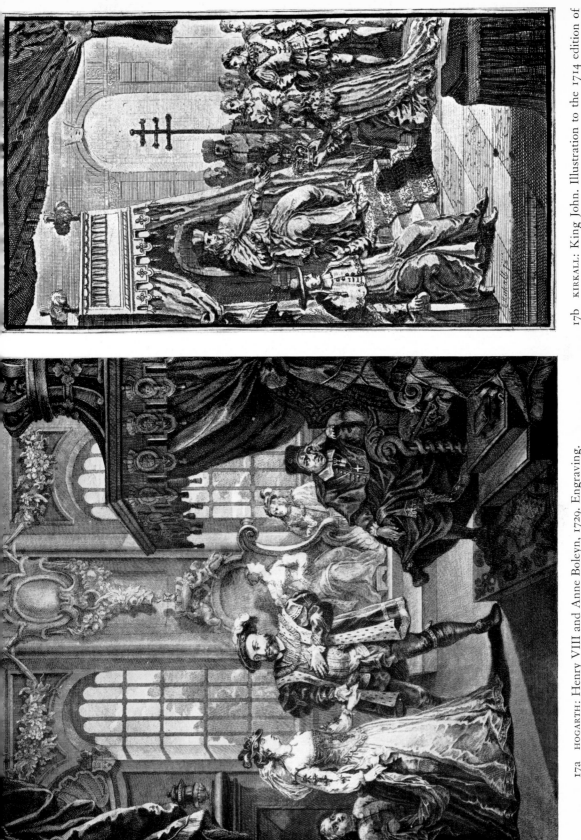

17a HOGARTH: Henry VIII and Anne Boleyn, 1729. Engraving.

17b KIRKALL: King John. Illustration to the 1714 edition of Shakespeare. Engraving.

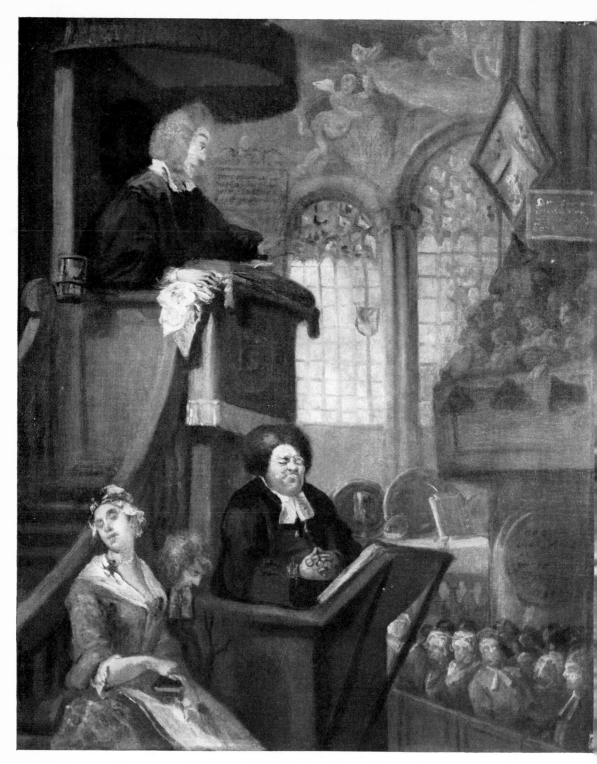

18 HOGARTH: The Sleeping Congregation, 1728.

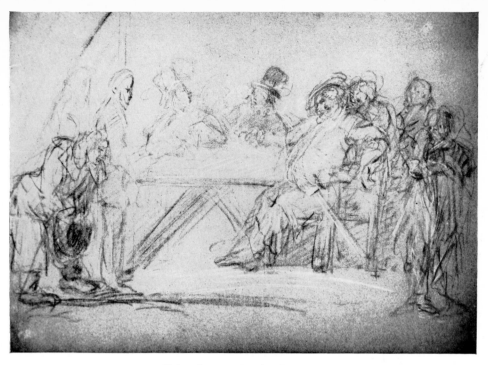

19a HOGARTH: Falstaff examining his Recruits, 1728. Drawing.

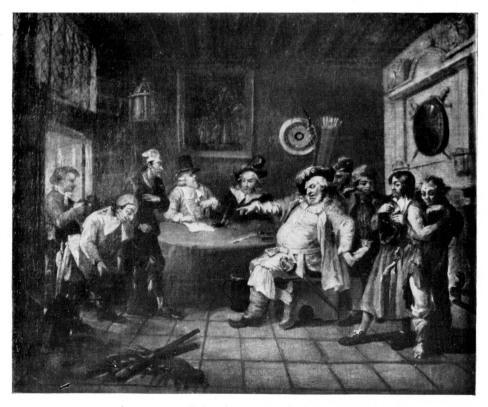

19b HOGARTH: Falstaff examining his Recruits, 1728.

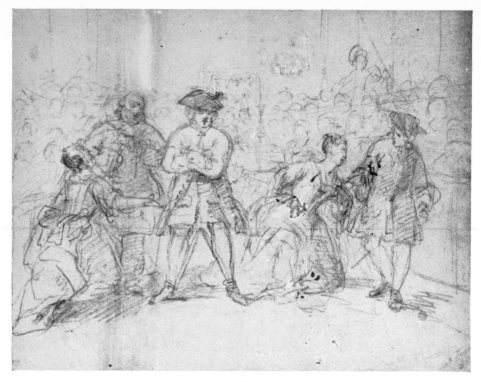

20a HOGARTH: A Scene from *The Beggar's Opera*, 1728. Drawing.

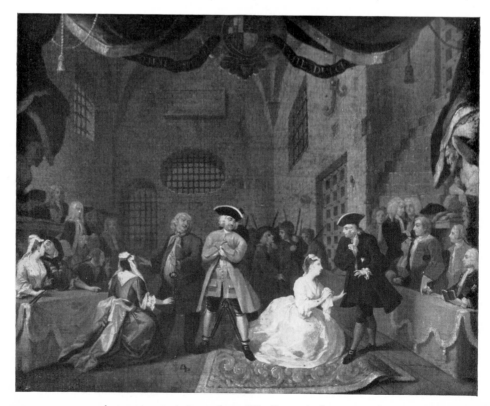

20b HOGARTH: A Scene from *The Beggar's Opera*, 1729/30.

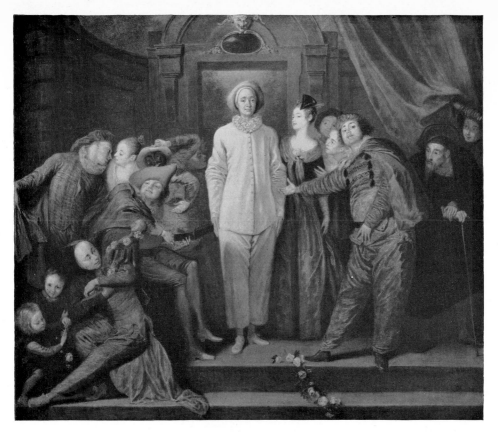

21a WATTEAU: Italian Comedians, 1720.

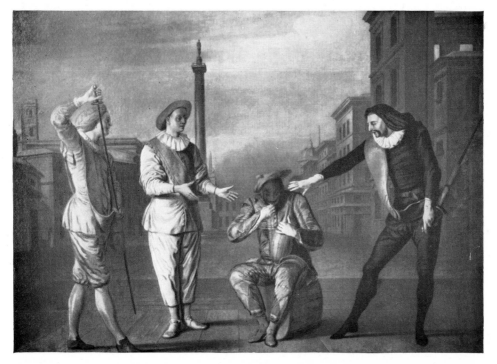

21b GILLOT: Scene from the Italian Comedy. Le Tombeau du Maître André, *c.* 1716.

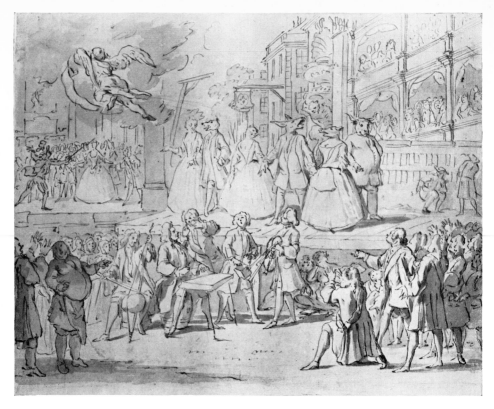

22a HOGARTH: *The Beggar's Opera Burlesqu'd, 1728.* Drawing.

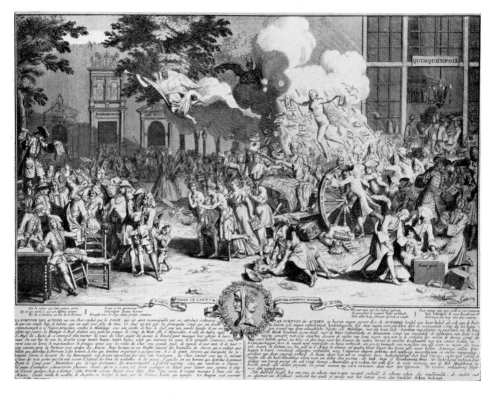

22b PICART: A Monument Dedicated to Posterity in Commemoration of ye Incredible Folly
Transacted in the Year 1720. Engraving.

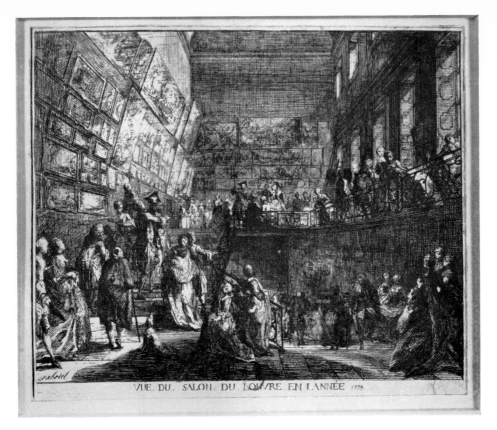

23a GABRIEL DE ST. AUBIN: Vue du Salon du Louvre en 1753. Etching.

23b HOGARTH: Auction of Pictures, c. 1729. Oil-sketch.

24a HOGARTH: Consultation of Physicians, *c*. 1729.

24b HOGARTH: Study for A Committee of the House of Commons, *c*. 1729.

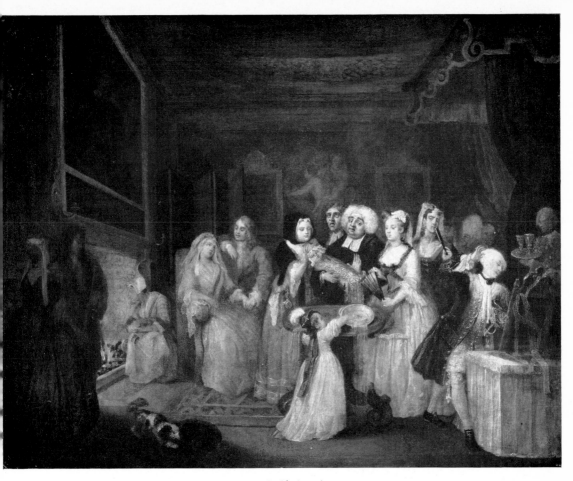

25a HOGARTH: A Christening, *c.* 1729.

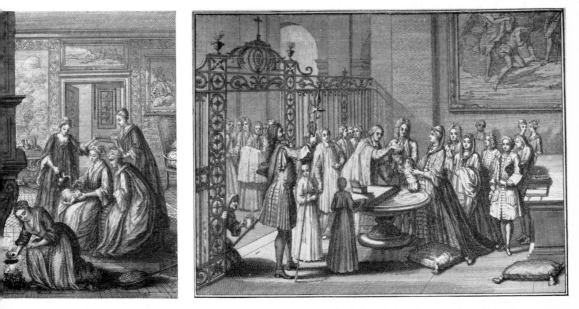

25b (left) PICART: 'Baptism by a Midwife'. Detail. 25c (right) PICART: 'Baptism by a Priest'.
From *Cérémonies et Coutumes Religieuses*, 1723. Engravings.

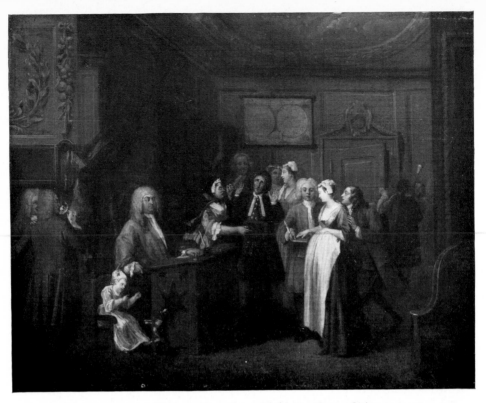

26a HOGARTH: A Woman Swearing a Child to a Grave Citizen, *c.* 1729.

26b HEEMSKERK, engraved by Kirkall: The Midnight Magistrate.

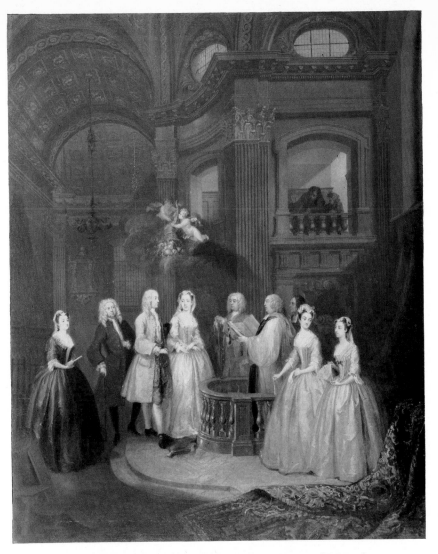

27a HOGARTH: The Wedding of Stephen Beckingham and Mary Cox, *c.* 1729.

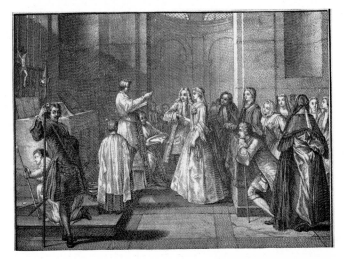

27b PICART: 'A Catholic Wedding' from *Cérémonies et Coutumes Religieuses*, 1731. Engraving.

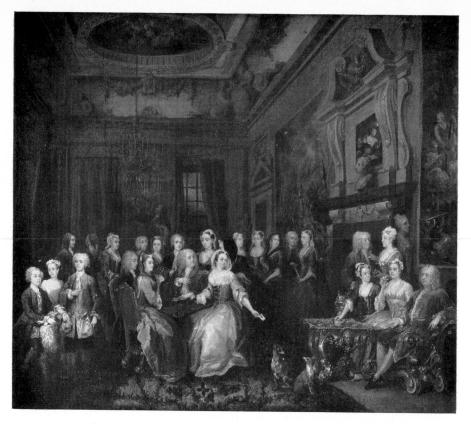

28a HOGARTH: An Assembly at Wanstead House, *c.* 1731.

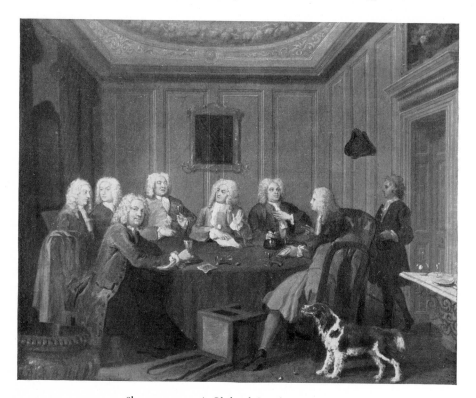

28b HOGARTH: A Club of Gentlemen, *c.* 1730.

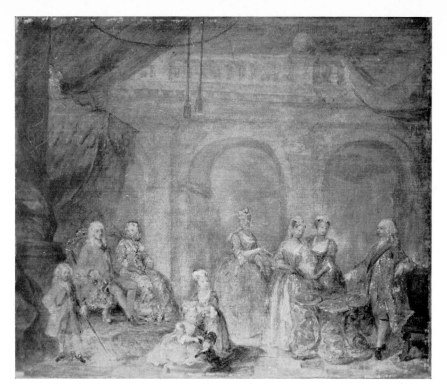

29a HOGARTH: The Royal Family, *c.* 1731/34. Oil-sketch.

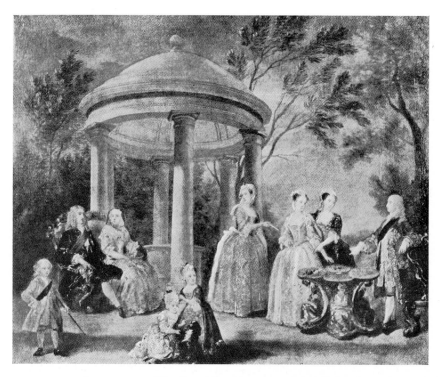

29b HOGARTH: The Royal Family, *c.* 1731/34. Oil-sketch.

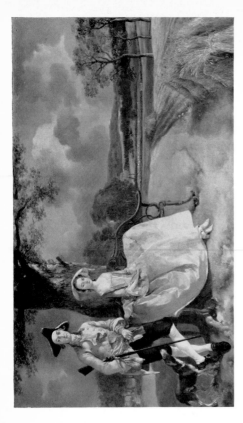

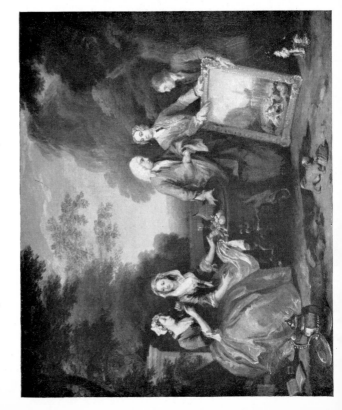

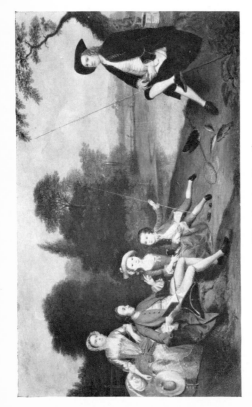

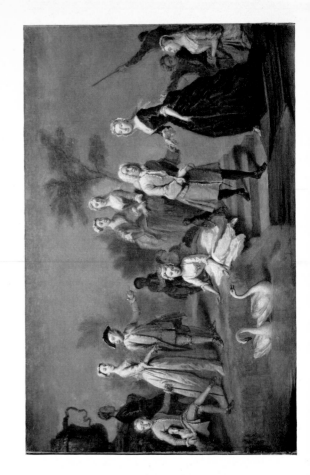

30b GAINSBOROUGH: Mr. and Mrs. Andrews, c. 1748.

30a DEVIS: The Swaine Family, 1749.

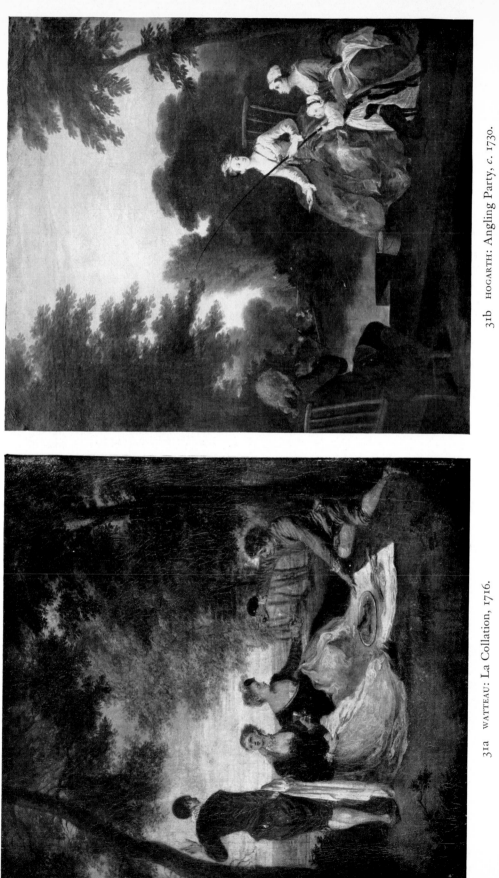

31a WATTEAU: La Collation, 1716.

31b HOGARTH: Angling Party, c. 1730.

32a METSU: Geelvinck and Family.

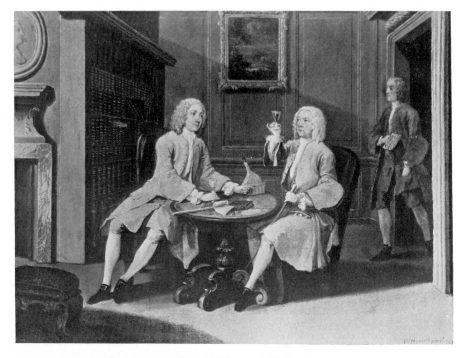

32b HOGARTH: Woodbridge and Holland, S.D., 1730.

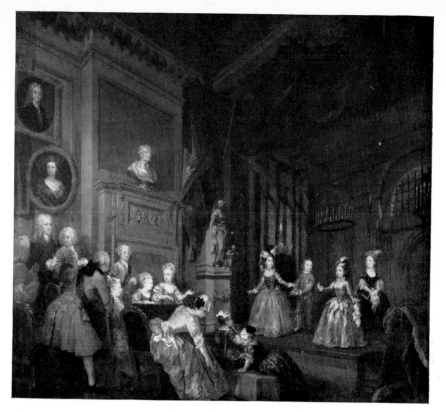

33a HOGARTH: The Indian Emperor, *c.* 1731.

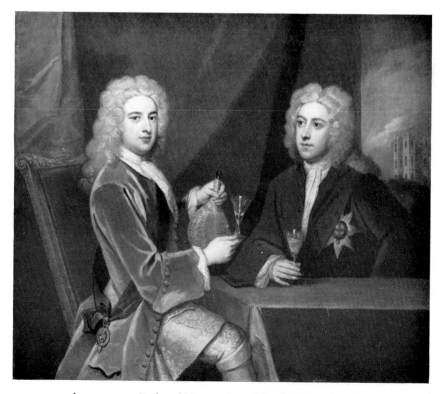

33b KNELLER: Duke of Newcastle and Earl of Lincoln, 1702/17.

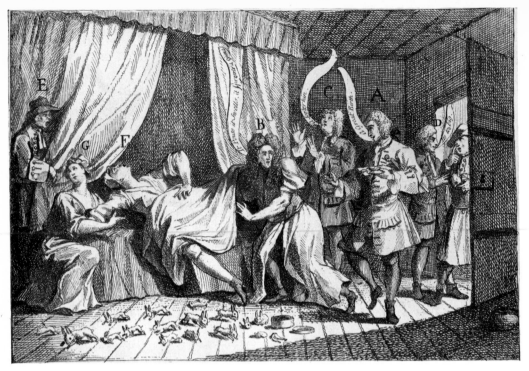

34a HOGARTH: The Wise Men of Godliman in Consultation, 1726. Engraving.

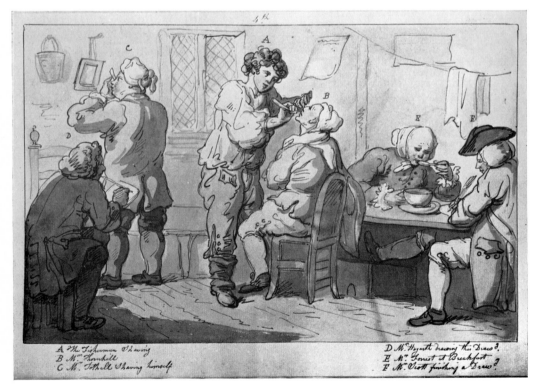

34b Hogarth's Tour: Breakfast at the Nag's Head, 1732. Drawing.

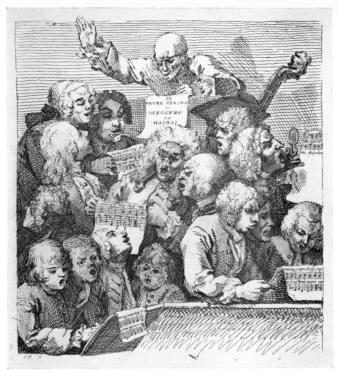

35a HOGARTH: Chorus of Singers, 1732. Engraving.

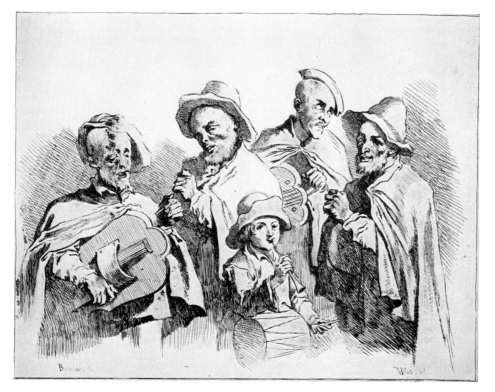

35b After WATTEAU: Réunion des Musiciens. Engraving.

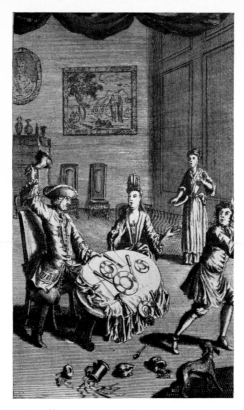

Prenez des Pilules, prenez des Pilules.

D.ʳ Misaubin.

36a Illustration to *The Taming of the Shrew* in Rowe's edition of Shakespeare, 1709. Engraving.

36b WATTEAU, engraved by Pond: Dr. Misaubin, 1739.

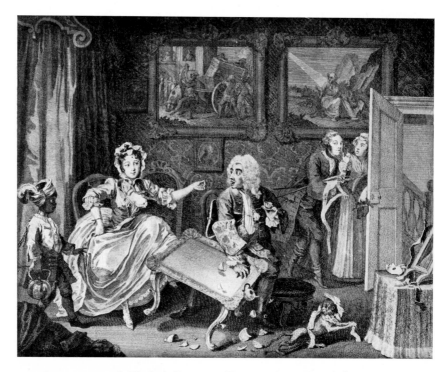

36c HOGARTH: A Harlot's Progress, II, 1732. Quarrel with her Protector. Engraving.

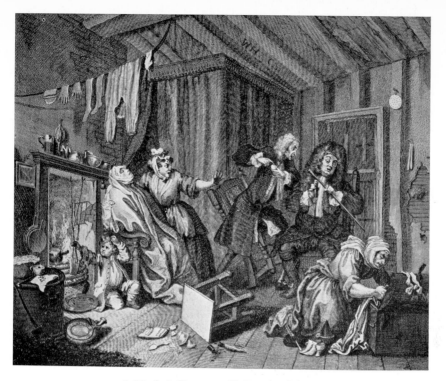

37a HOGARTH: A Harlot's Progress, V. Death of the Harlot. Engraving.

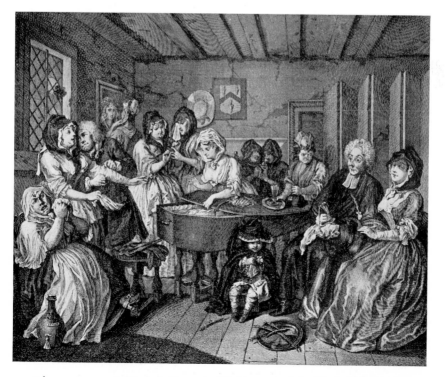

37b HOGARTH: A Harlot's Progress, VI. Funeral of the Harlot. Engraving.

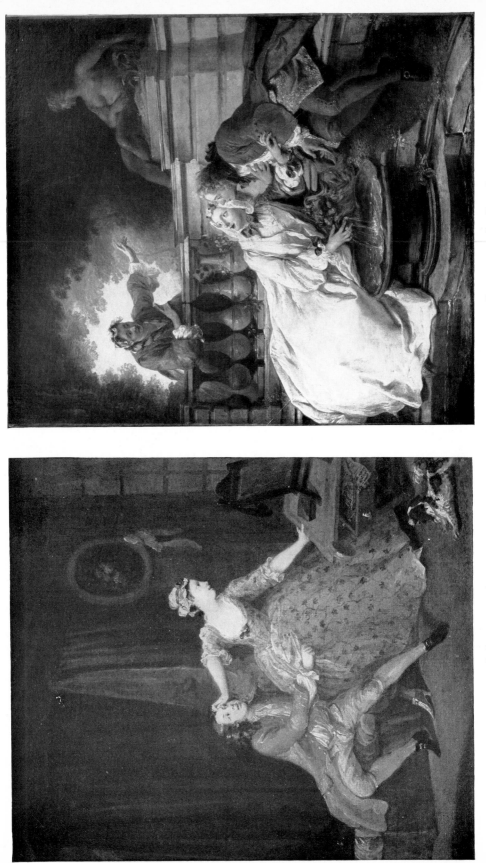

38a HOGARTH: Before c. 1730/31.

38b DE TROY: La Surprise, c. 1720.

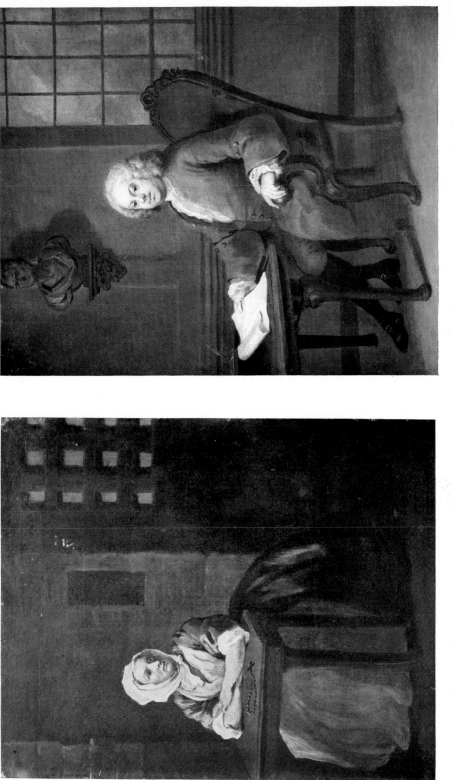

39a HOGARTH: Sarah Malcolm, 1732/3.

39b HOGARTH: Dr. Benjamin Hoadly, 1730/40.

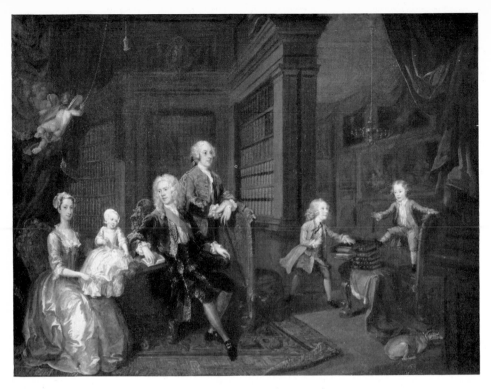

40a HOGARTH: The Cholmondeley Family, S.D., 1732.

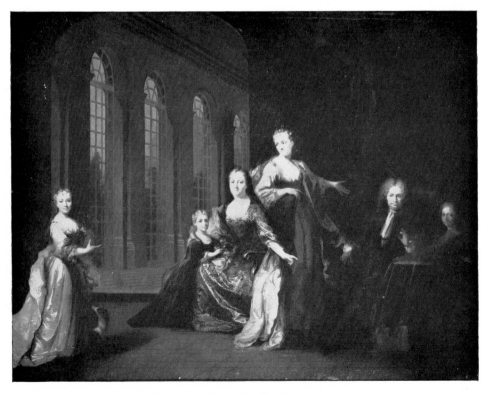

40b TOURNIÉRES: Family Group, 1721.

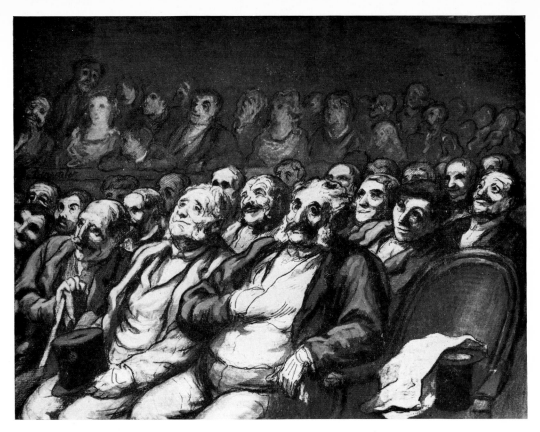

41a DAUMIER: Au Théâtre, *c.* 1858. Watercolour.

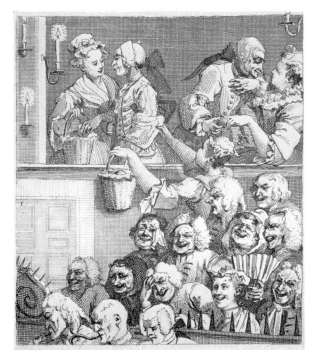

41b HOGARTH: The Laughing Audience, 1733.
Etching.

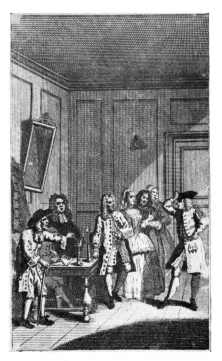

41c HOGARTH, engraved by Vander-
gucht: Illustration to Molière-Fielding's
L'Avare, c. 1733.

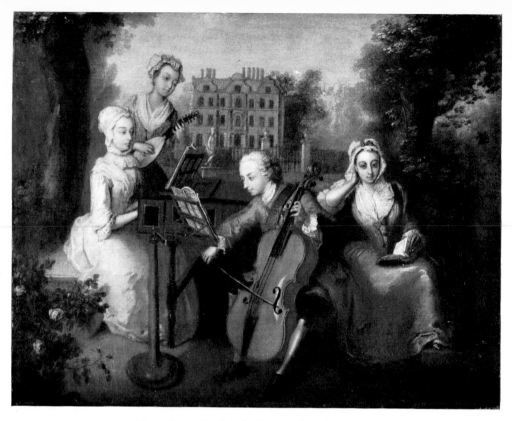

42a MERCIER: Music Party. Frederick, Prince of Wales with his Sisters, 1733.

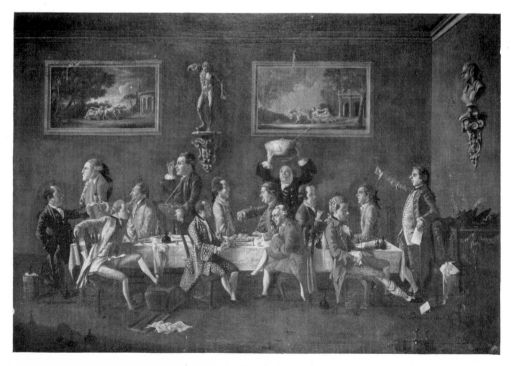

42b PATCH: Punch Party, 1760.

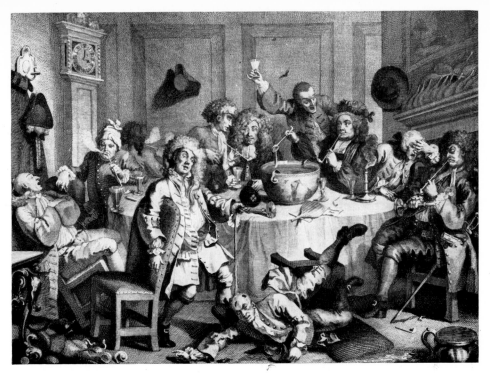

43a HOGARTH: A Midnight Modern Conversation, 1734. Engraving.

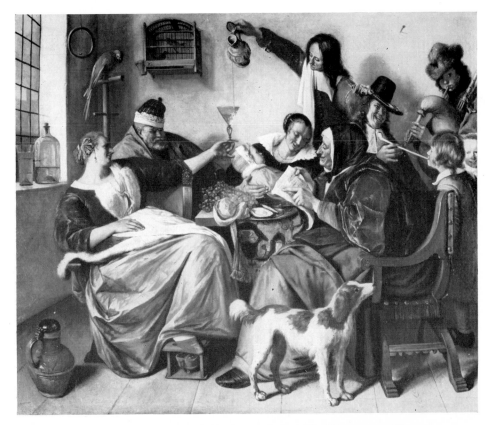

43b STEEN: As Old Folks Sing, Young Folks Pipe, S.D., 1668.

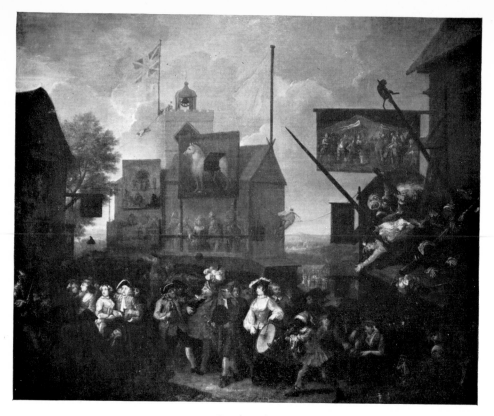

44a HOGARTH: Southwark Fair, S.D., 1733.

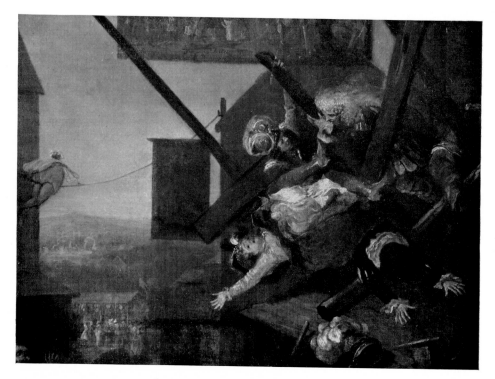

44b HOGARTH: Southwark Fair. Detail.

45a DAUMIER: Parade des Saltimbanques, *c.* 1868. Drawing.

45b C. A. COYPEL, engraved by Pailly, 1723/24: Don Quixote
Demolishing the Puppet Show.

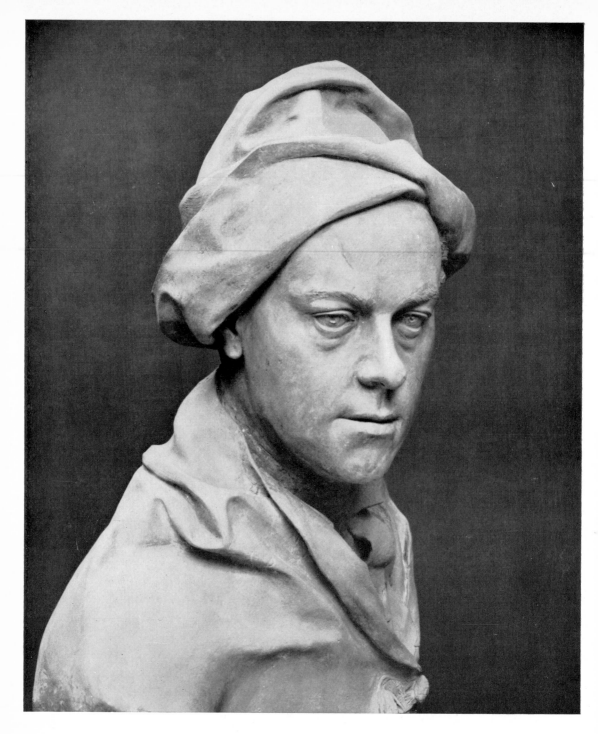

46 ROUBILIAC: Bust of Hogarth, c. 1732.

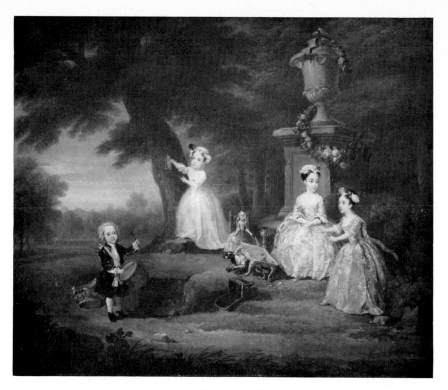

47a HOGARTH: A Children's Party, S.D., 1730.

47b HOGARTH: The Distressed Poet, c. 1735.

48b C. A. COYPEL, engraved by Beauvais, 1724:
Sancho Panza's Feast.

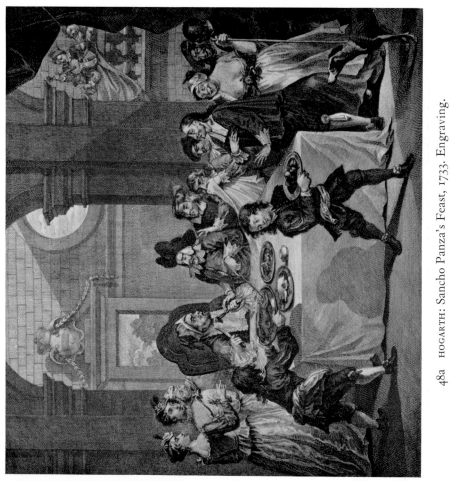

48a HOGARTH: Sancho Panza's Feast, 1733. Engraving.

49a HOGARTH: Mrs. Anne Hogarth, S.D., 1735.

49b RIGAUD: His Mother. Detail, 1695.

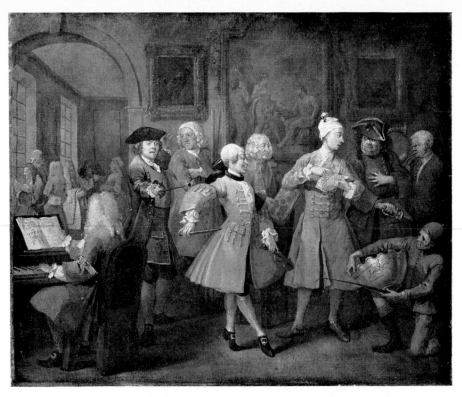

50a HOGARTH: A Rake's Progress, 1735, II. The Rake's Levée.

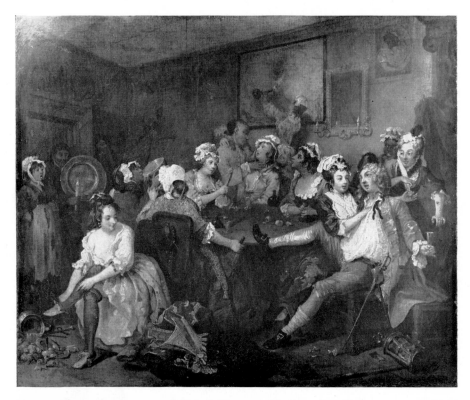

50b HOGARTH: A Rake's Progress, III. Scene in a Tavern.

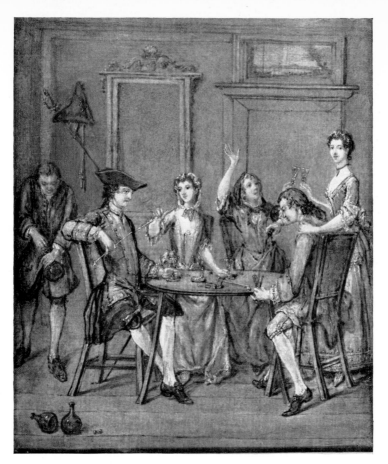

51a LAROON THE YOUNGER: Interior with Figures.

51b STEEN: The World Reversed, 1663 (?).

52a HOGARTH: A Rake's Progress, IV. Arrest for Debt.

52b GILLOT: Scène des Carrosses, *c.* 1707.

53a C. A. COYPEL, engraved by Surugue, 1743: La Folie
pare la Décrépitude des Ajustemens de la Jeunesse.

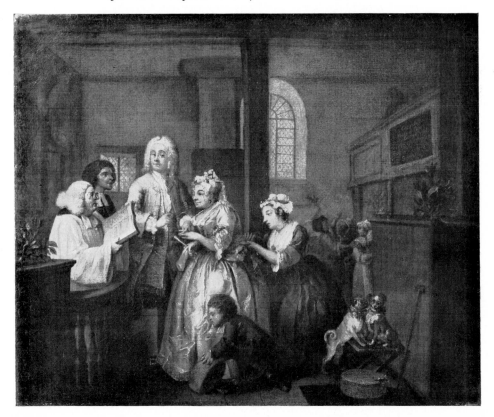

53b HOGARTH: A Rake's Progress, V. Marriage of the Rake.

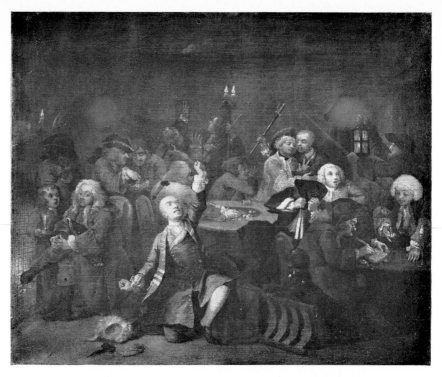

54a HOGARTH: A Rake's Progress, VI. Scene in a Gaming House.

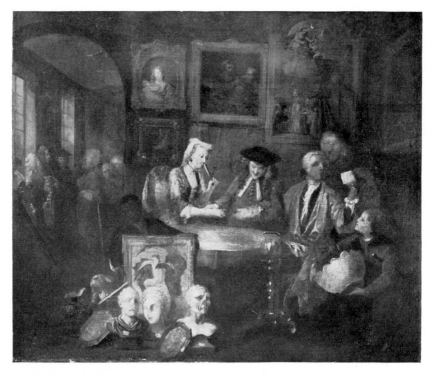

54b HOGARTH: Betrothal of the Rake. Sketch.

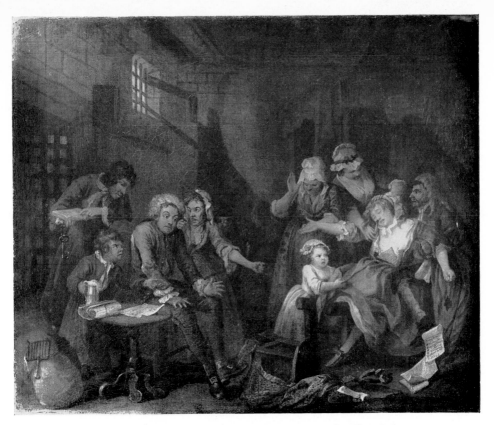

55a HOGARTH: A Rake's Progress, VII. Scene in the Fleet Prison.

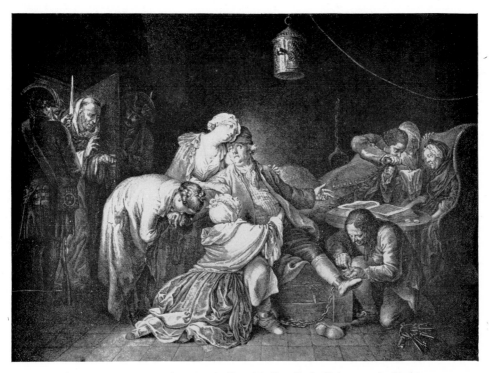

55b CHODOWIECKI: Calas' Farewell to his Family in Prison, 1767. Etching.

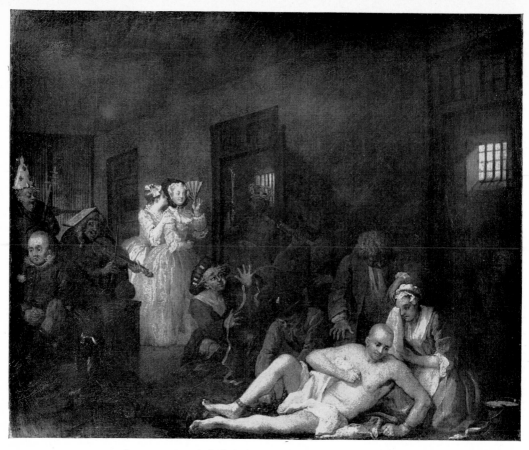

56a HOGARTH: A Rake's Progress, VIII. Scene in Bedlam.

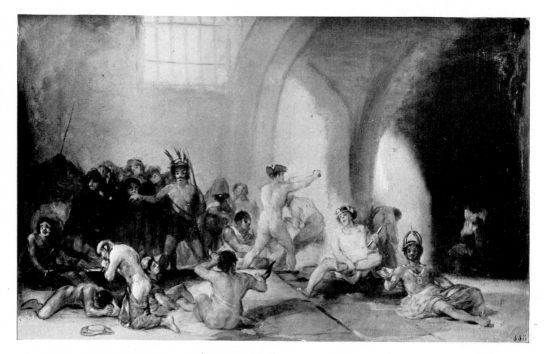

56b GOYA: Madhouse, 1794 (?).

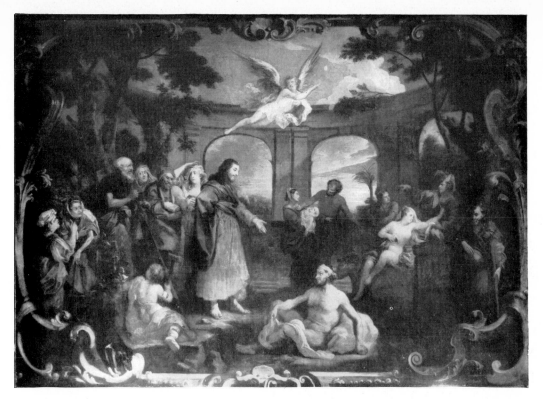

57a HOGARTH: The Pool of Bethesda, 1735.

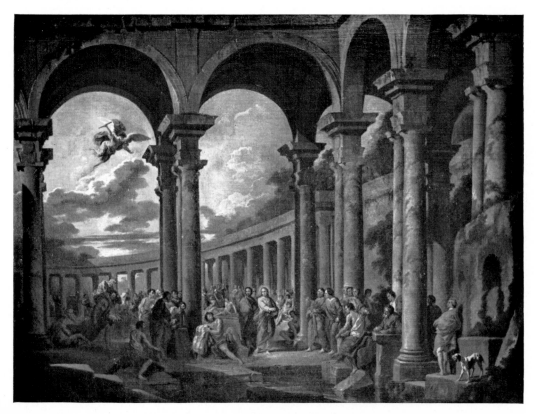

57b PANNINI: The Pool of Bethesda.

58b HOGARTH: Four Times of the Day, II. Noon.

58a HOGARTH: Four Times of the Day, I. Morning, *c.* 1736.

59a HOGARTH: Four Times of the Day, III. Evening.

59b HOGARTH: Four Times of the Day, IV. Night.

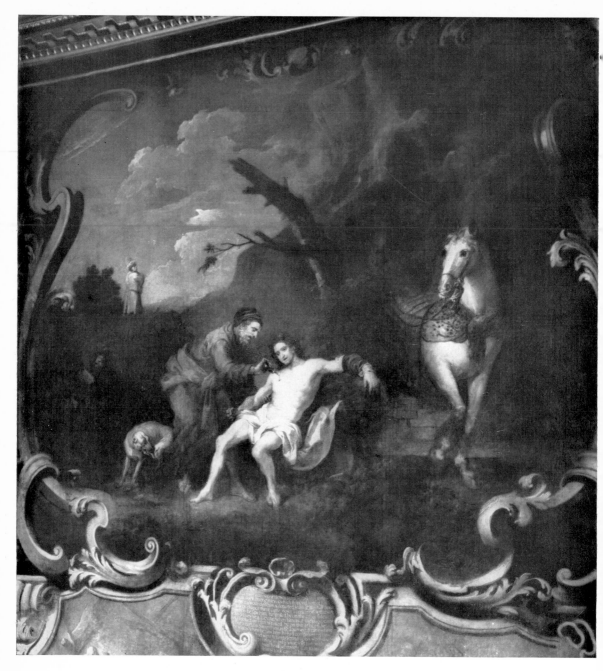

60 HOGARTH: The Good Samaritan, 1736.

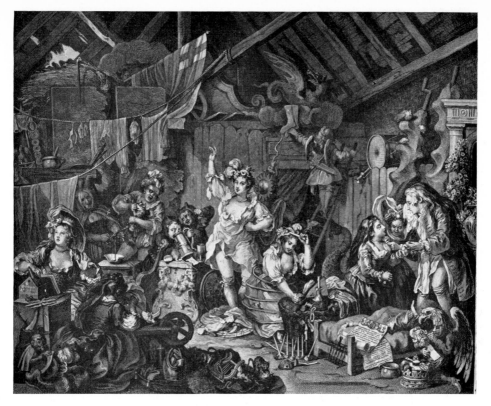

61a HOGARTH: Strolling Actresses Dressing in a Barn, 1738. Engraving.

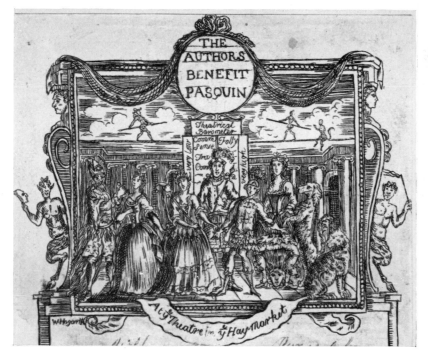

61b After HOGARTH: Author's benefit ticket for Fielding's *Pasquin*, 1736.
Engraving.

62b CHARDIN: Bénédicité, 1740.

62a HOGARTH: The Strode Family, c. 1738.

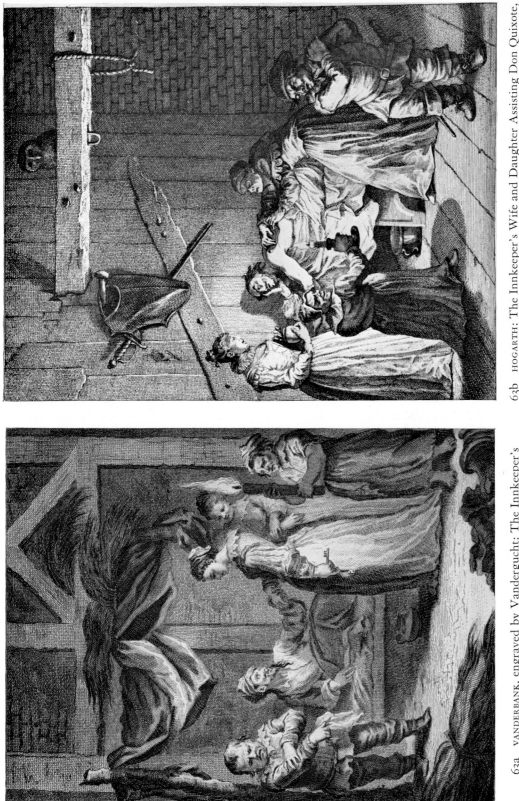

63b HOGARTH: The Innkeeper's Wife and Daughter Assisting Don Quixote, 1742. Engraving.

63a VANDERBANK, engraved by Vandergucht: The Innkeeper's Wife and Daughter Assisting Don Quixote, 1738.

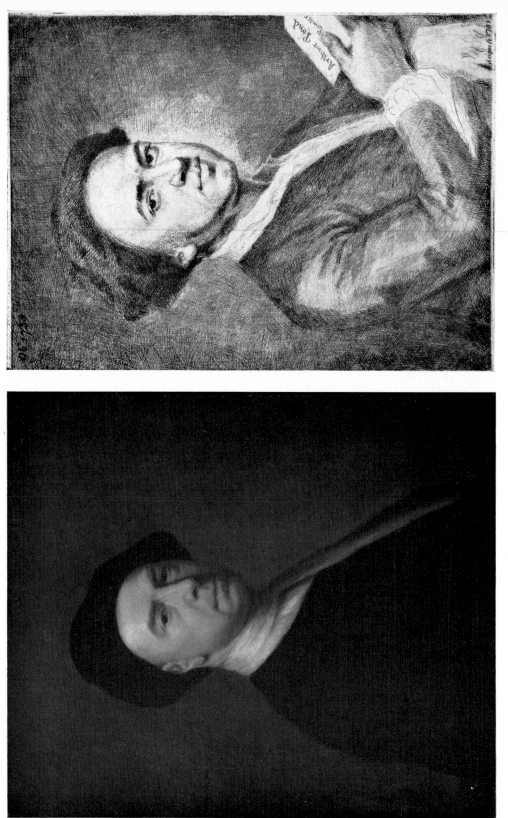

64b POND: Self-portrait, 1739. Etching.

64a JONATHAN RICHARDSON: Self-portrait, *c.* 1738.

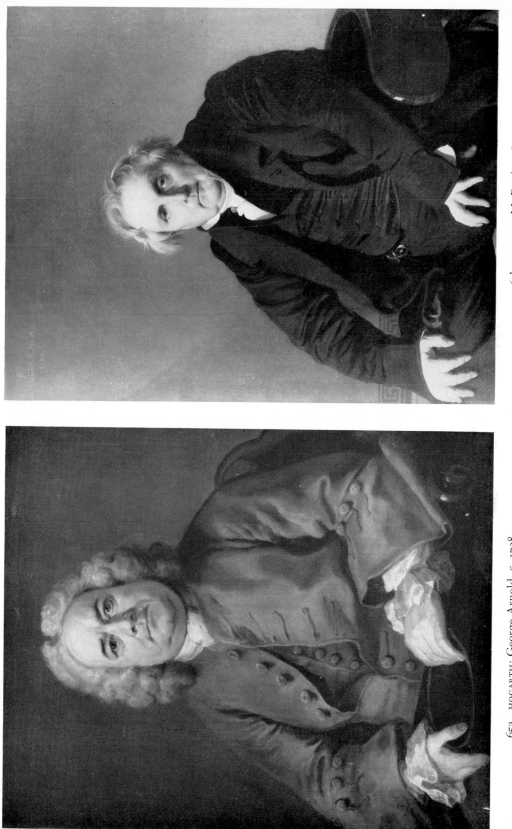

65b INGRES: M. Bertin, 1832.

65a HOGARTH: George Arnold, c. 1738.

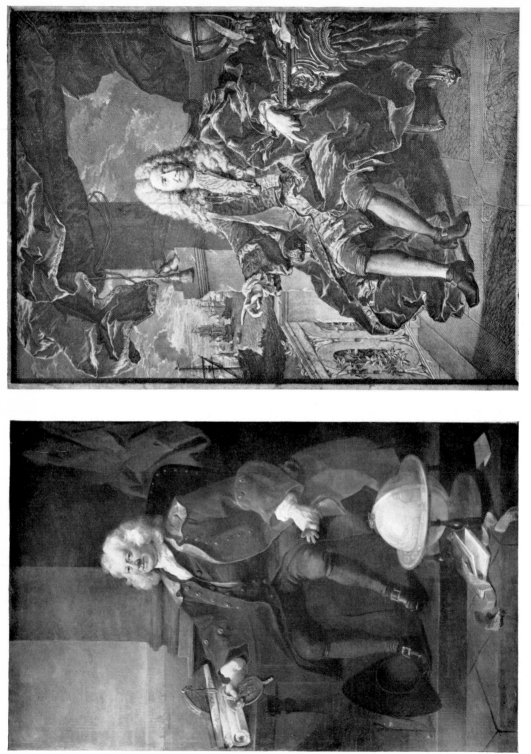

66a HOGARTH: Captain Coram, S.D., 1740.

66b RIGAUD, engraved by Drevet in 1729: Samuel Bernard.

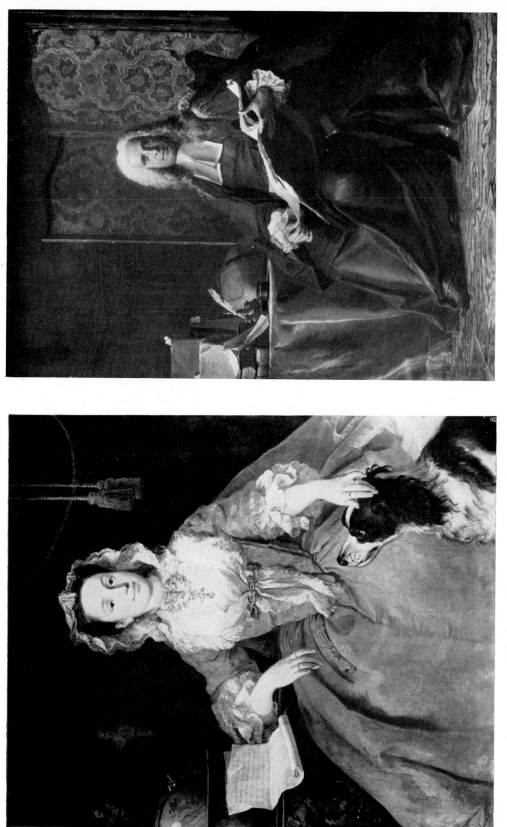

67a HOGARTH: Miss Mary Edwards, c. 1740.

67b LA TOUR: Bernard des Rieux, 1741.

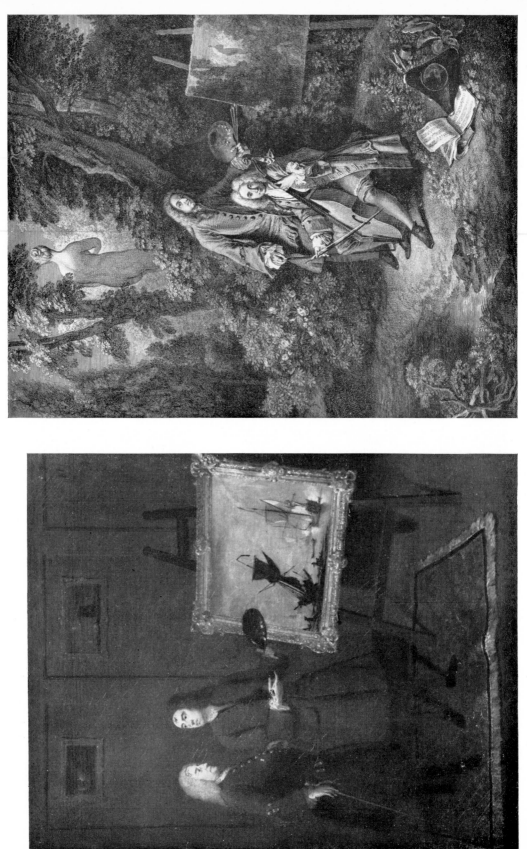

68a HOGARTH: Monamy and Walker, 1740 or earlier.

68b WATTEAU, engraved by Tardieu in 1727: Watteau and Julienne.

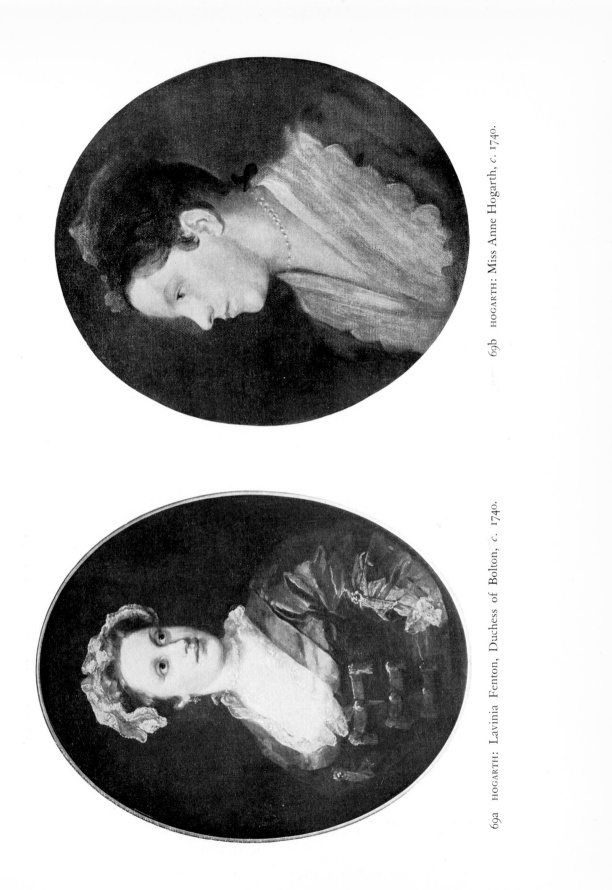

69b HOGARTH: Miss Anne Hogarth, c. 1740.

69a HOGARTH: Lavinia Fenton, Duchess of Bolton, c. 1740.

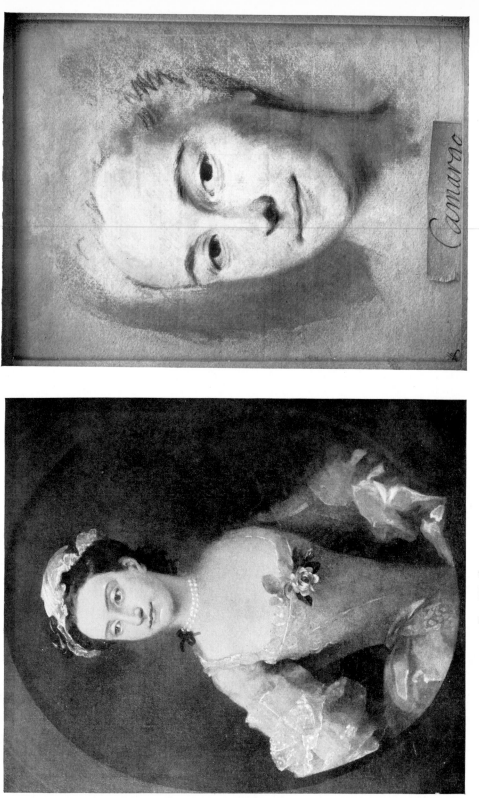

70b LA TOUR: Mlle Camargo, *c.* 1740/50. Pastel.

Camargo

70a HOGARTH: Peg Woffington, *c.* 1740.

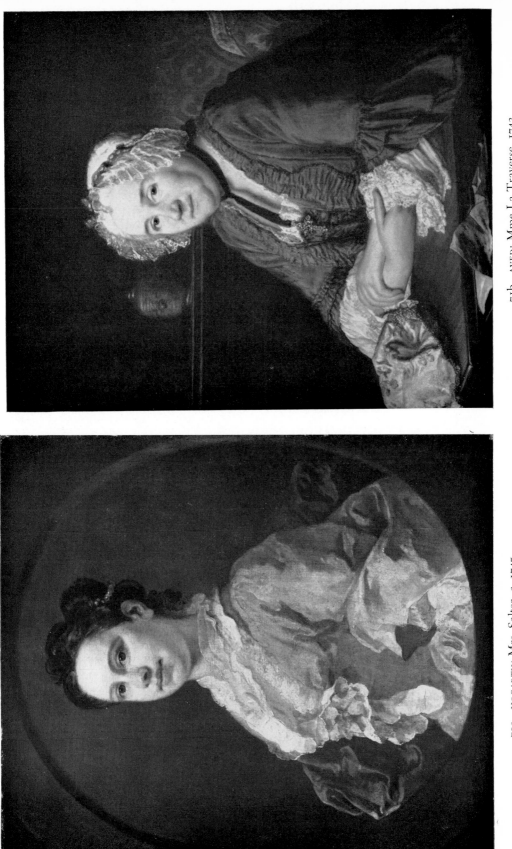

71b AVED: Mme La Traverse, 1743.

71a HOGARTH: Mrs. Salter, c. 1745.

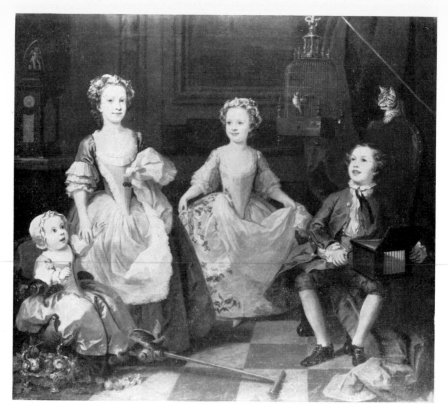

72a HOGARTH: The Graham Children, S.D., 1742.

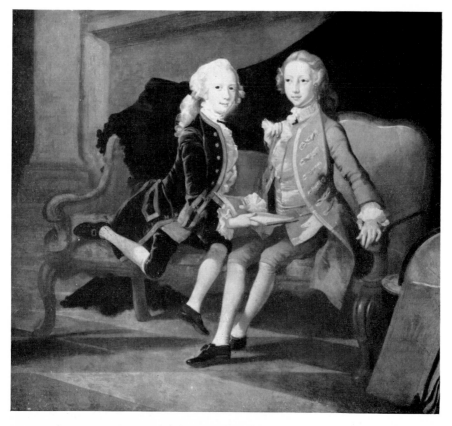

72b RICHARD WILSON: The Prince of Wales and Duke of York, *c.* 1749.

73a HOGARTH: Ill Effects of Masquerades, *c.* 1740/5. Sketch.

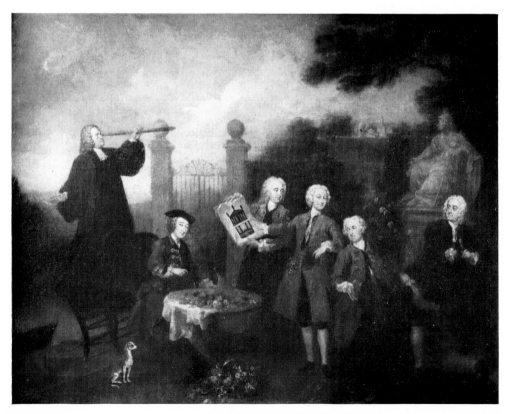

73b HOGARTH: Lord Hervey and his Friends, 1738.

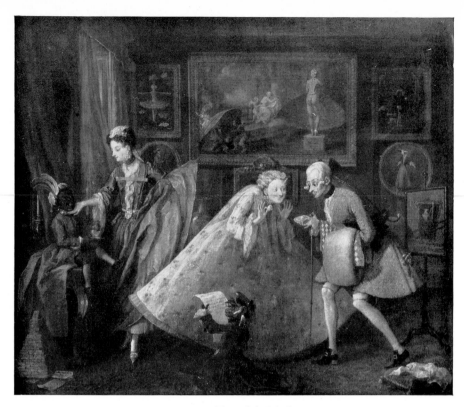

74a HOGARTH: Taste à la Mode, 1742.

74b HOGARTH: Taste à la Mode, 1742. Detail.

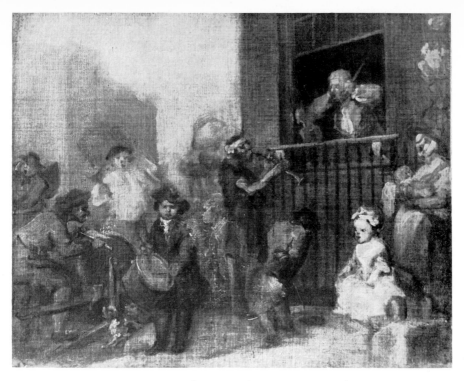

75a HOGARTH: The Enraged Musician, *c.* 1740/41.

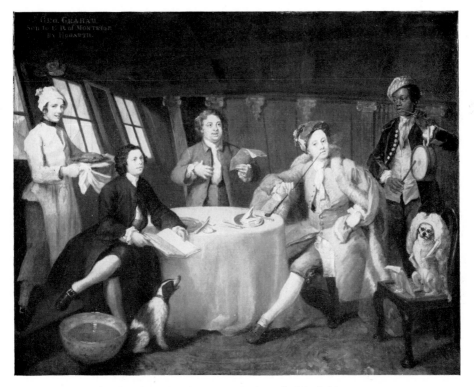

75b HOGARTH: Lord George Graham in his Cabin, *c.* 1745.

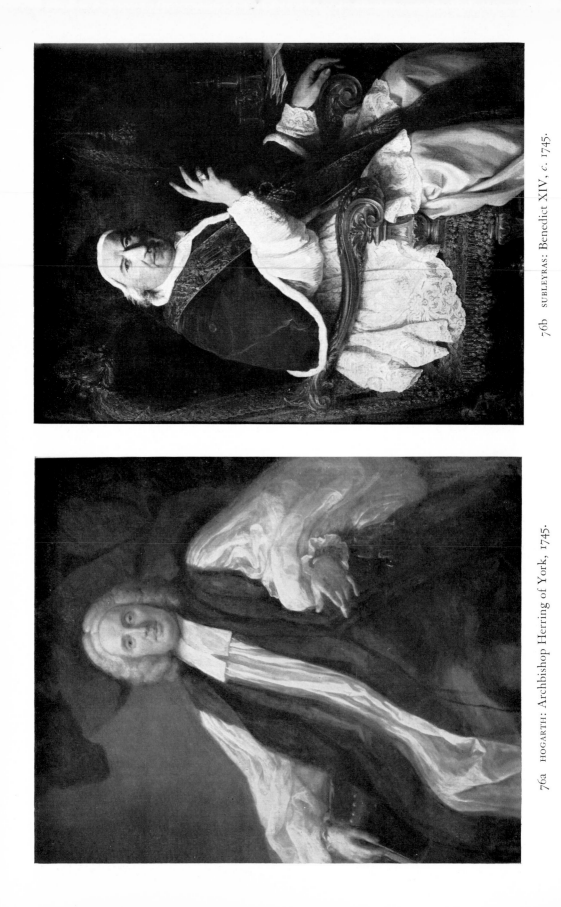

76b SUBLEYRAS: Benedict XIV, c. 1745.

76a HOGARTH: Archbishop Herring of York, 1745.

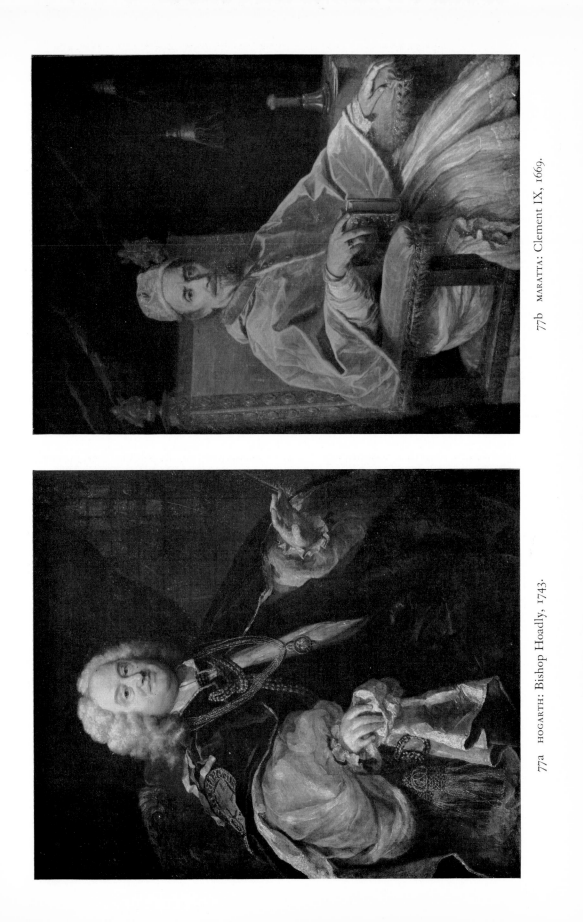

77a HOGARTH: Bishop Hoadly, 1743.

77b MARATTA: Clement IX, 1669.

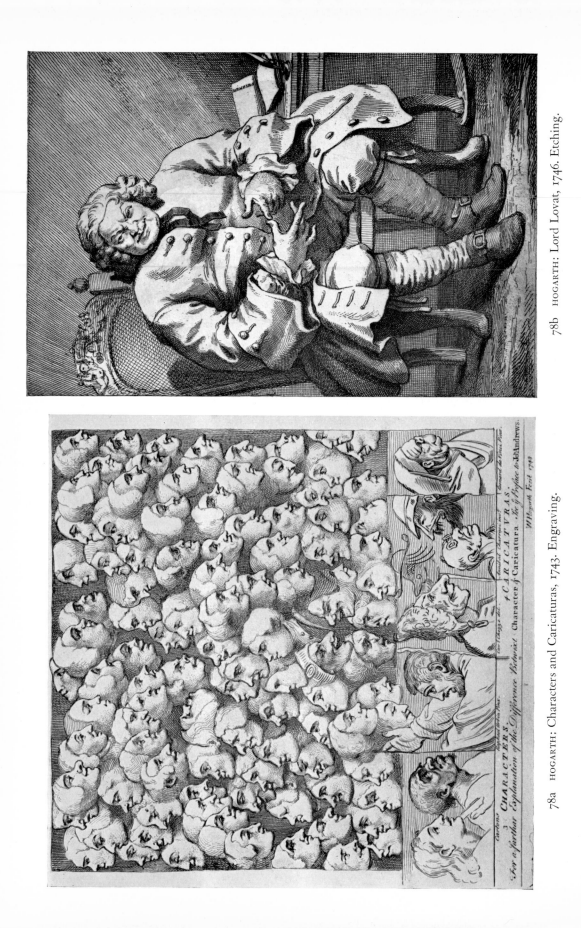

78b HOGARTH: Lord Lovat, 1746. Etching.

78a HOGARTH: Characters and Caricaturas, 1743. Engraving.

79b HAYMAN-GRAVELOT: Illustration to *King John*,
from Oxford Shakespeare edition of 1744. Engraving.

79a HAYMAN-GRAVELOT: Illustration to *Richard II*,
from Oxford Shakespeare edition of 1744. Engraving.

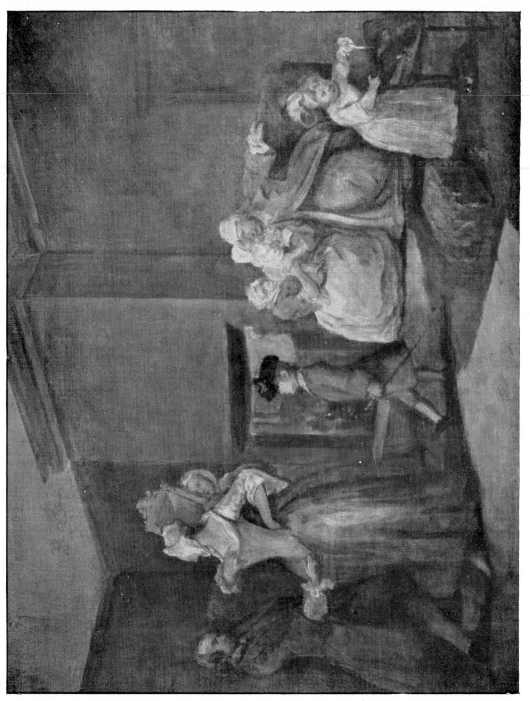

80　HOGARTH: The Staymaker, c. 1744.

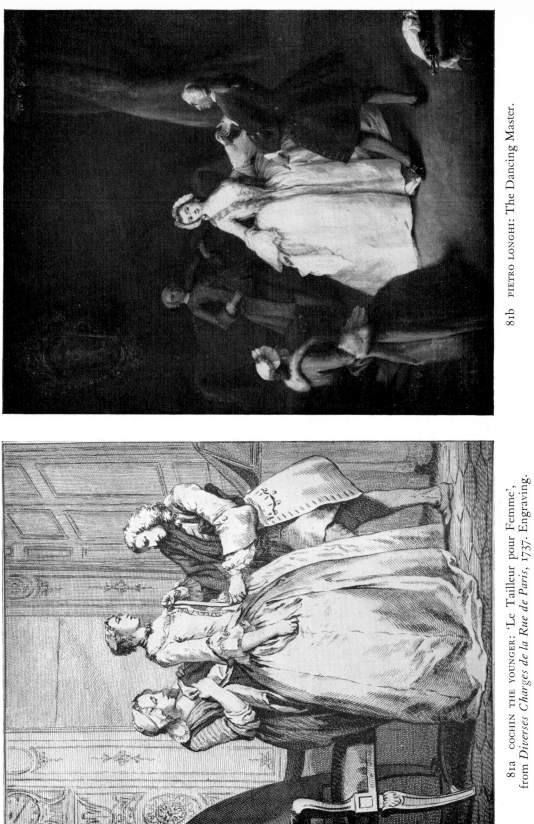

81a COCHIN THE YOUNGER: 'Le Tailleur pour Femme',
from *Diverses Charges de la Rue de Paris*, 1737. Engraving.

81b PIETRO LONGHI: The Dancing Master.

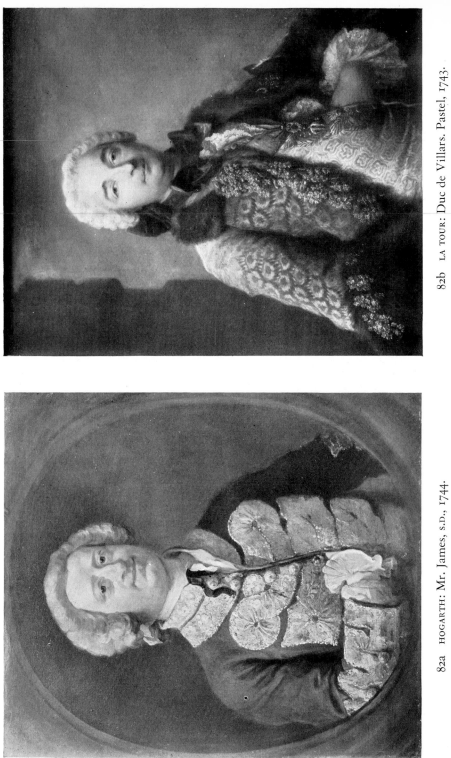

82b LA TOUR: Duc de Villars. Pastel, 1743.

82a HOGARTH: Mr. James, s.d., 1744.

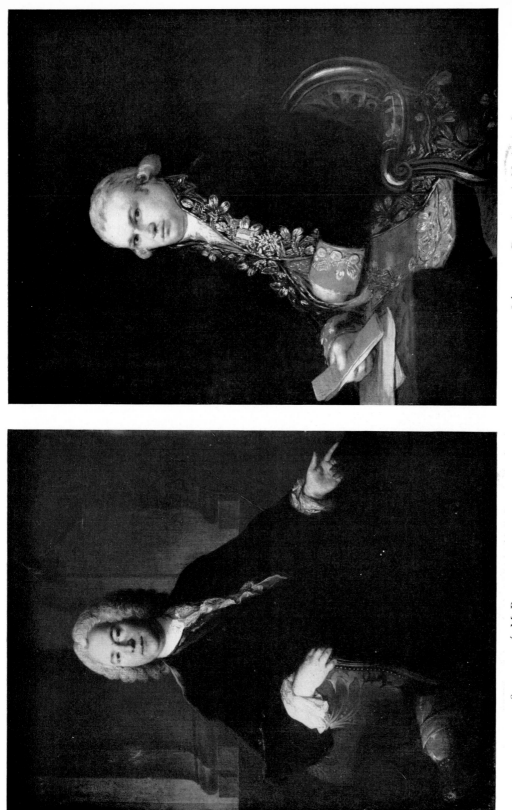

83a TOCQUÉ: M. Pouan, 1743.

83b GOYA: Don Antonio Noriega, 1802.

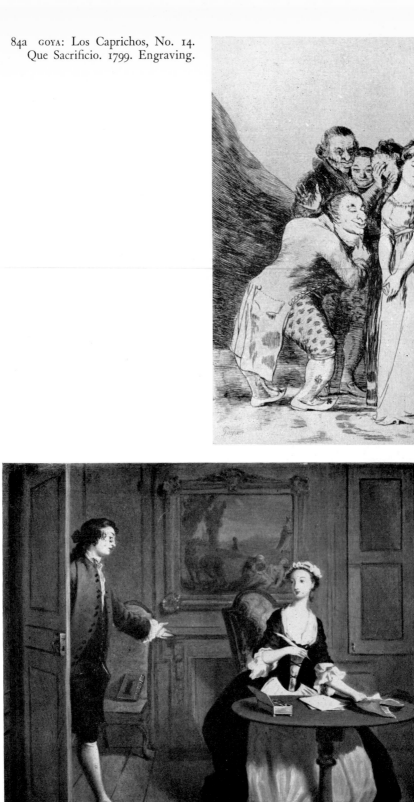

84a GOYA: Los Caprichos, No. 14.
Que Sacrificio. 1799. Engraving.

84b HIGHMORE: Mr. B. coming upon Pamela Writing a Letter, c. 1744.

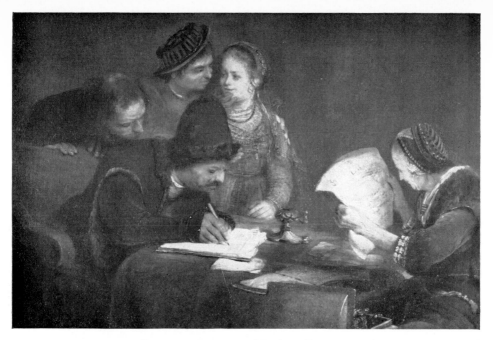

85a AERT DE GELDER: Marriage Contract.

85b CHARDIN: La Gouvernante, 1738.

86a TRAVERSI: Marriage Contract, *c. 1750.*

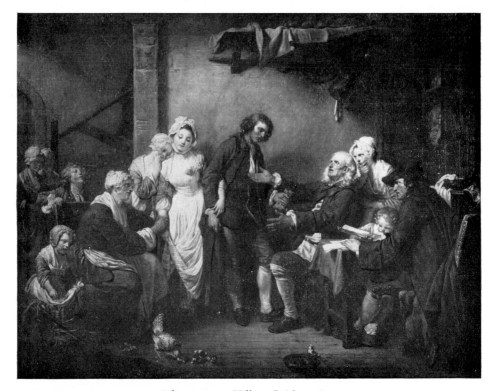

86b GREUZE: Village Bride, 1761.

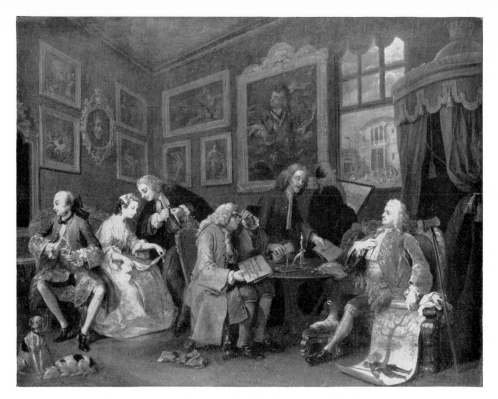

87a HOGARTH: Marriage à la Mode, 1745. I. The Contract.

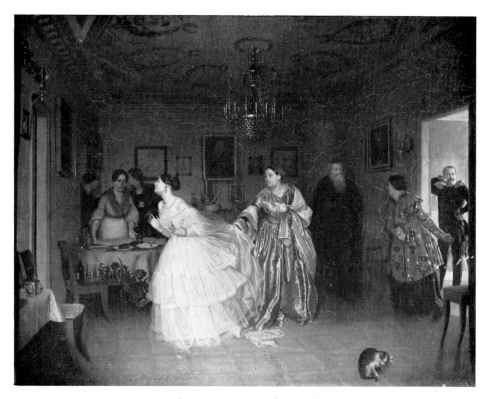

87b FEDOTOV: Betrothal, 1848.

88a GRAVELOT, engraved by J. Major:
Seated Cavalier, 1745.

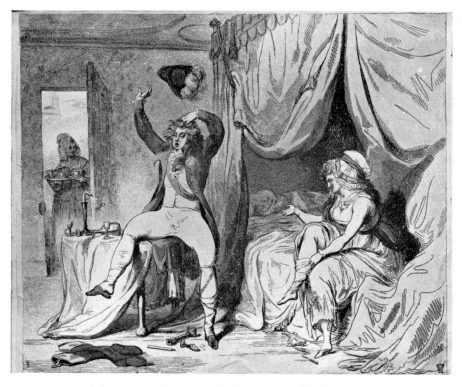

88b GILLRAY: Morning after Marriage, 1788. Engraving.

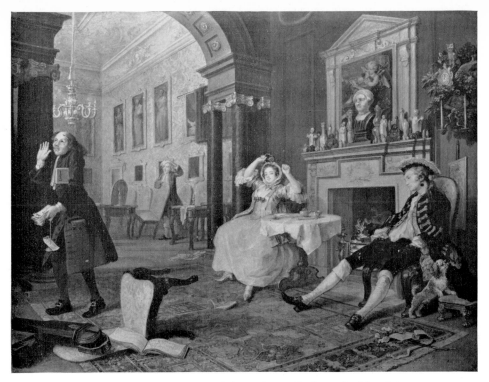

89a HOGARTH: Marriage à la Mode, II. Early in the Morning.

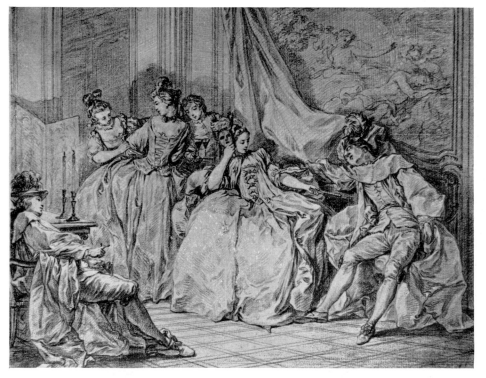

89b COCHIN THE YOUNGER: La Soirée, Drawing; engraved in 1739.

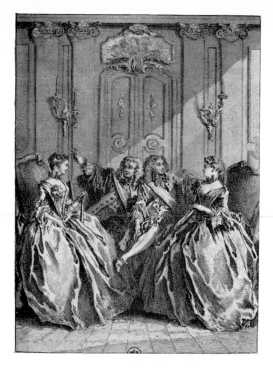

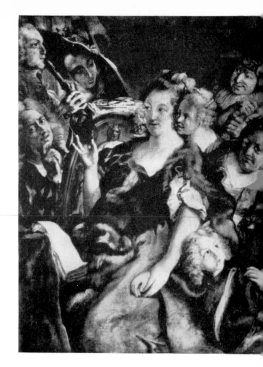

90a BOUCHER, engraved by Cars: Illustration to
Molière's *Les Précieuses Ridicules*, 1734.

90b MERCIER: Lady Preparing for a Masquerade

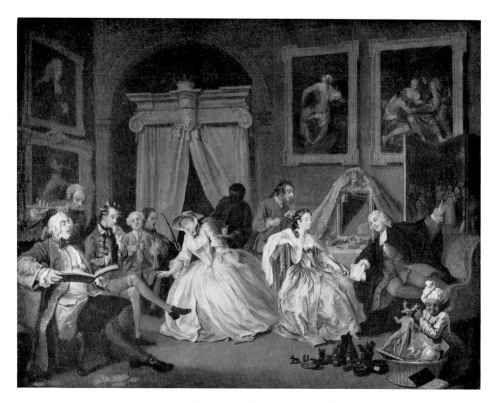

90c HOGARTH: Marriage à la Mode, IV. The Toilette.

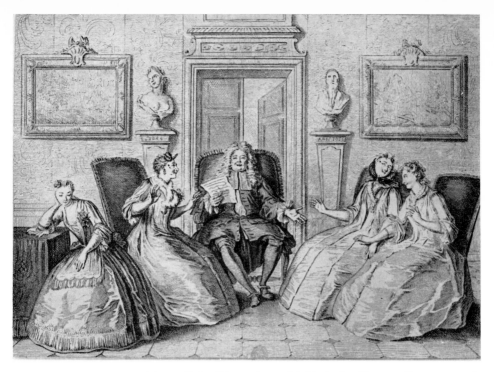

91a C. A. COYPEL, engraved by Joullain: Illustration to Molière's *Les Femmes Savantes*, 1726.

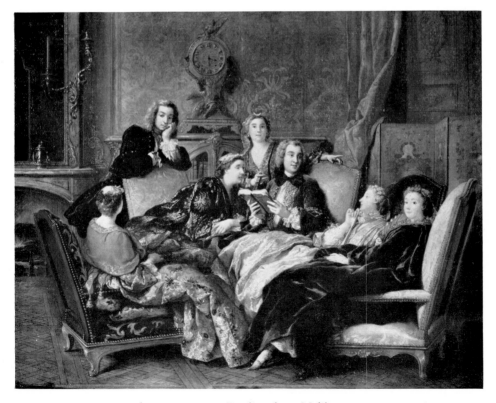

91b J. F. DE TROY: Reading from Molière, 1740.

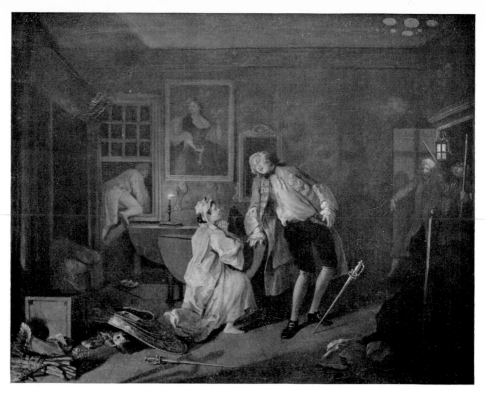

92a HOGARTH: Marriage à la Mode, V. Death of the Earl.

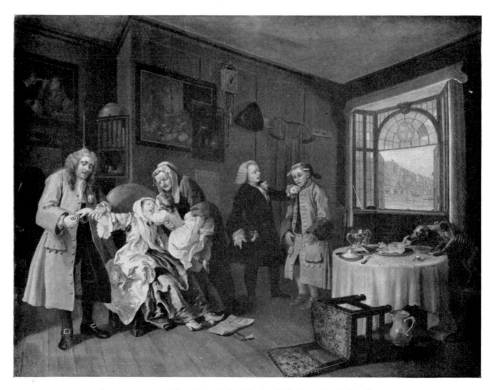

92b HOGARTH: Marriage à la Mode, VI. Death of the Countess.

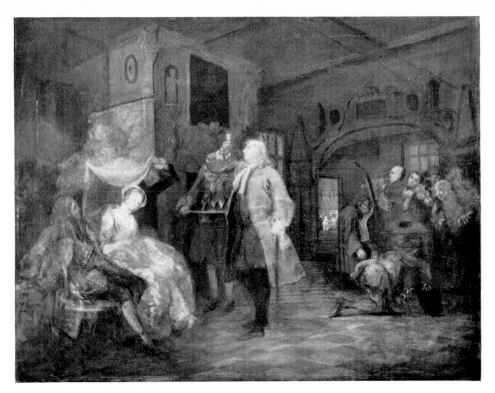

93a HOGARTH: Wedding Banquet, after 1745.

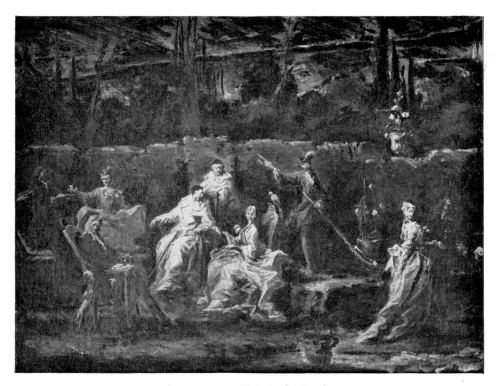

93b MAGNASCO: Visit in the Garden.

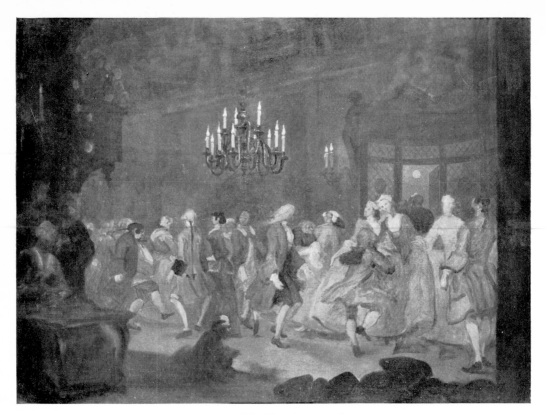

94a HOGARTH: Wedding Dance, after 1745.

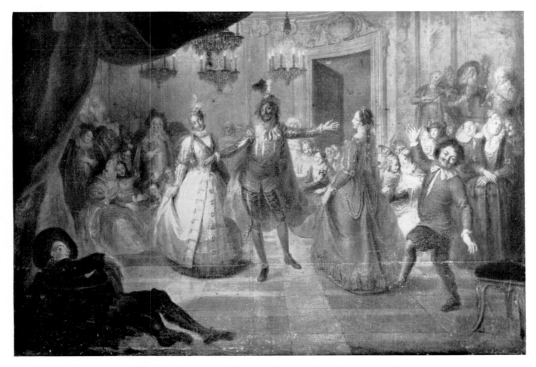

94b C. A. COYPEL: Don Quixote and Sancho Panza Dancing, 1732. Cartoon for tapestry.

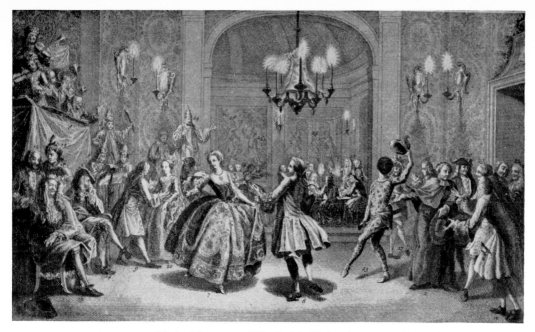

95a s. fokke: Maria Theresa and Frederick II dancing, 1742. Engraving.

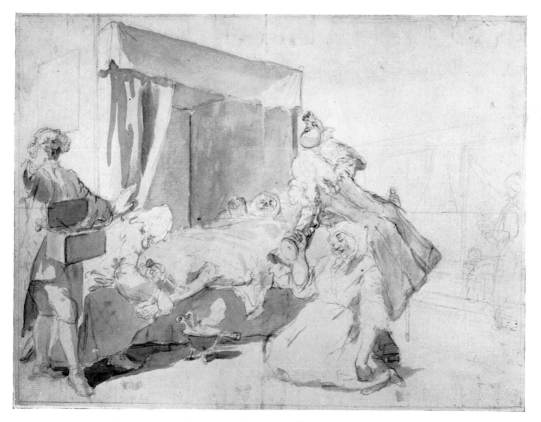

95b hogarth: Operation Scene in a Hospital, c. 1745. Drawing.

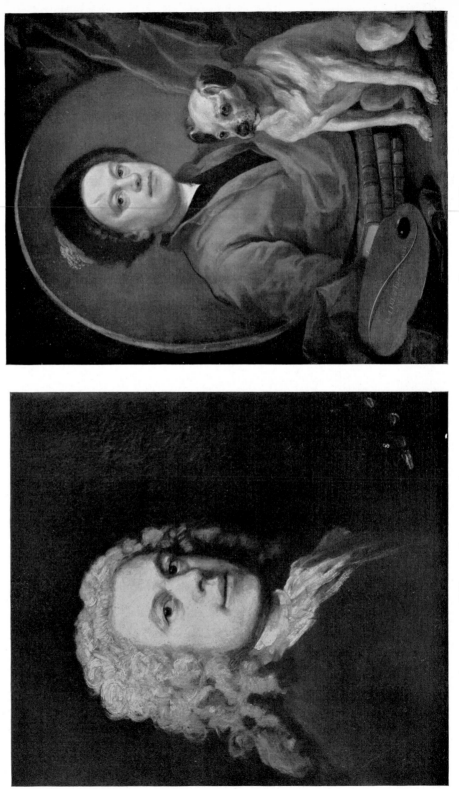

96b HOGARTH: Self-portrait, S.D., 1745.

96a HOGARTH: Self-portrait, c. 1728.

97a HOGARTH: Self-portrait, before 1758.

97b SOLDI: William Hogarth.

98a WILLIAM HAMILTON, engraved by
Bartolozzi, 1780/4: Richard III.

98b CRUICKSHANK: Tom Thumb, 1830. Woodcut.
Detail.

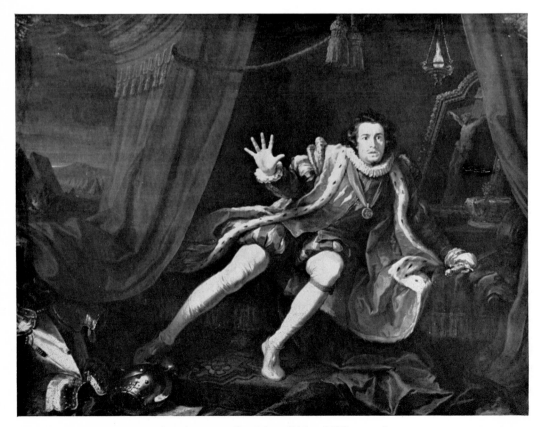

98c HOGARTH: Garrick as Richard III, *c.* 1746.

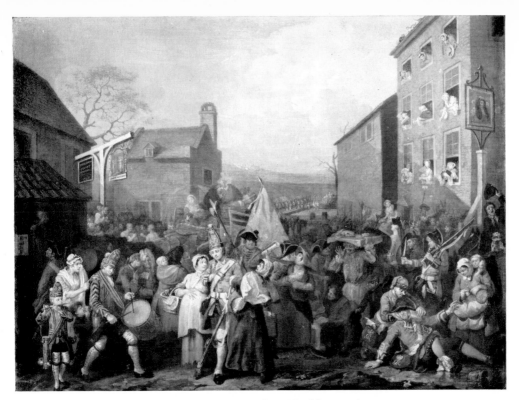

99a HOGARTH: March to Finchley, 1746.

99b WATTEAU, engraved by Ravenet, 1738: Départ de Garnison.

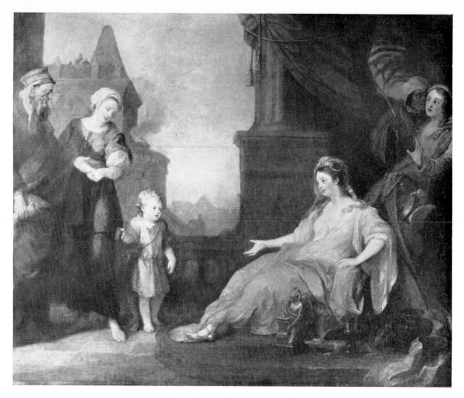

100a HOGARTH: Moses brought to Pharaoh's Daughter, 1746.

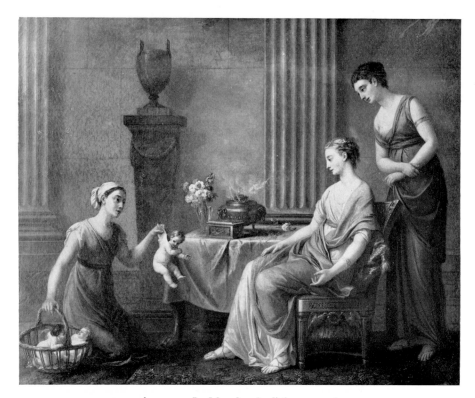

100b VIEN: *La Marchande d'Amour*, 1763.

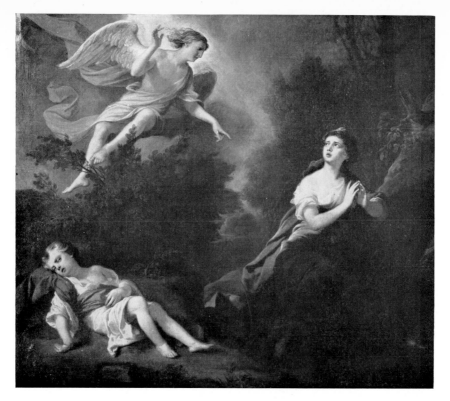

101a HIGHMORE: Hagar and Ishmael, 1746.

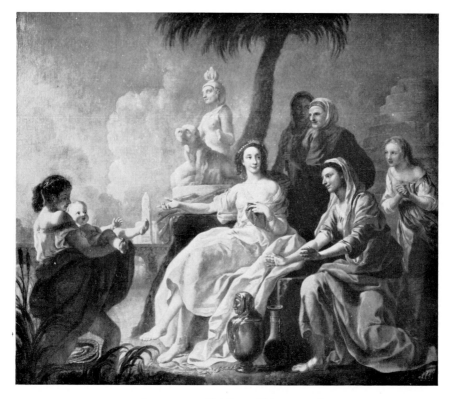

101b HAYMAN: Finding of Moses, 1746.

102a HOGARTH: Charmers of the Age, 1742. Etching.

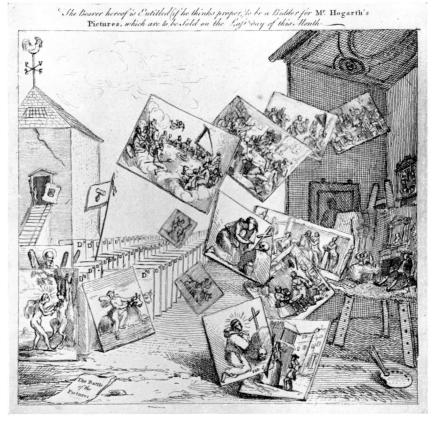

102b HOGARTH: Battle of the Pictures, 1745. Engraving.

103a HOGARTH: Industry and Idleness, 1747. Sketch for plate I. The Fellow 'Prentices at their Looms.

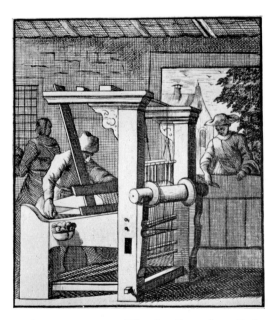

103b CASPAR LUYKEN: Weaving Scene from Cycle of Human Occupations, 1694. Engraving.

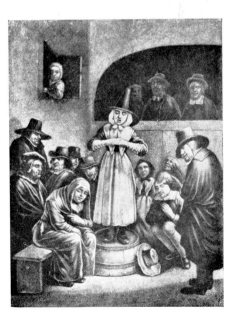

103c HEEMSKERK: Quaker Meeting. Engraving.

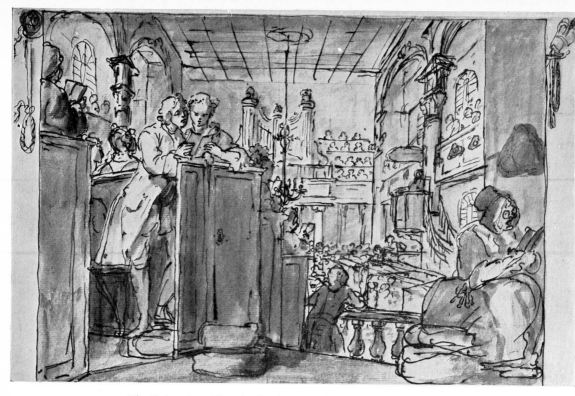

104a HOGARTH: The Industrious 'Prentice Performing the Duty of a Christian. Sketch for plate II.

104b CALLOT: Liberazione di Tirreno (First Interlude) 1616. Engraving.

104c ROSA: Gambling Soldiers, *c.* 1660 (?).

105a HOGARTH: The Idle 'Prentice at Play in the Churchyard. Sketch for plate III.

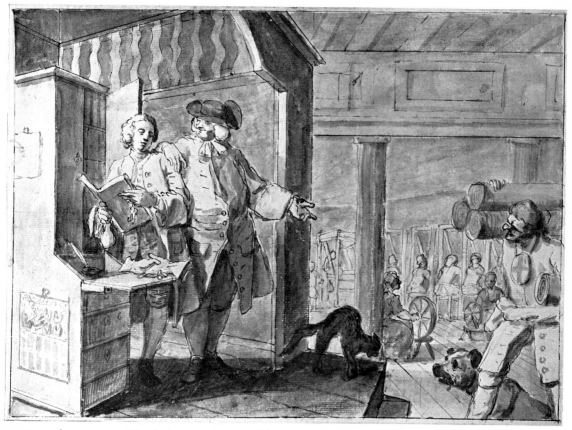

105b HOGARTH: The Industrious 'Prentice Entrusted by his Master. Final drawing for plate IV.

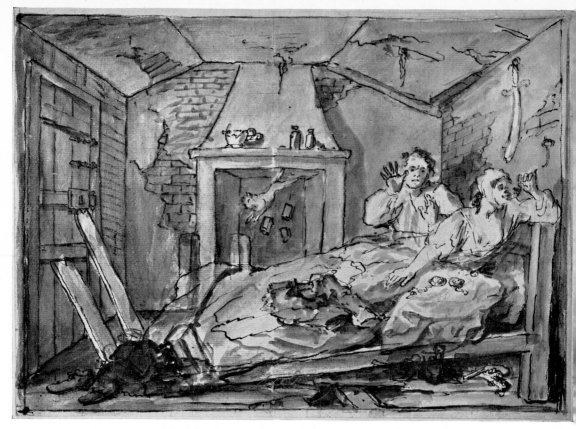

106a HOGARTH: The Idle 'Prentice Returned from Sea. Final drawing for plate VII.

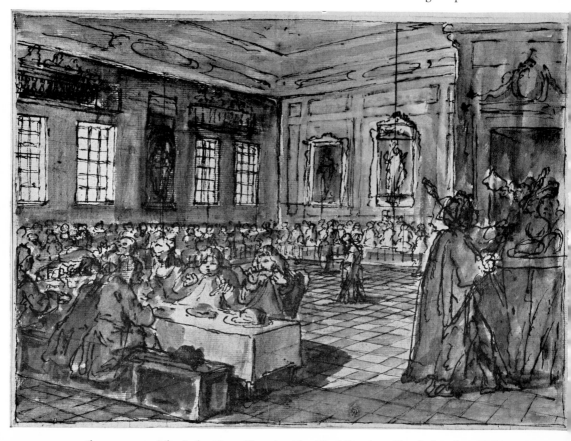

106b HOGARTH: The Industrious 'Prentice Sheriff of London. Sketch for plate VIII.

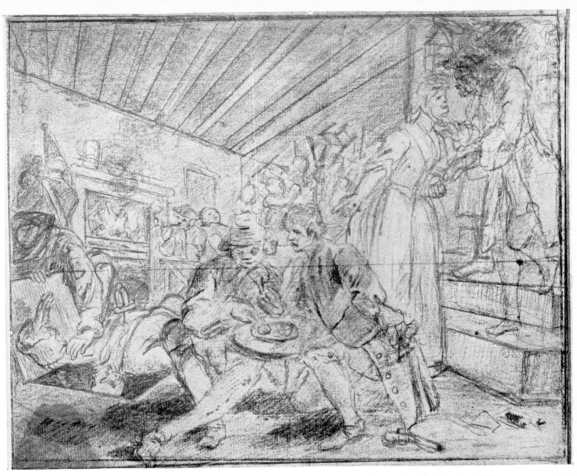

107a HOGARTH: The Idle 'Prentice Betrayed by His Whore. Sketch for plate IX.

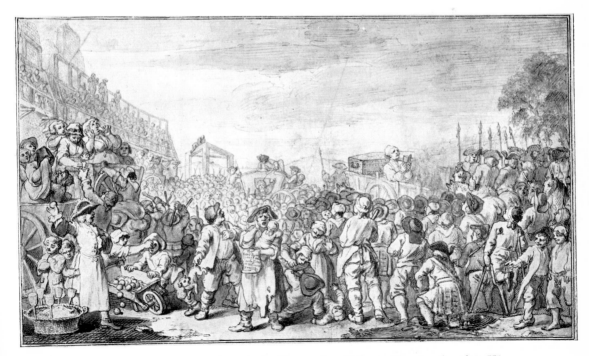

107b HOGARTH: The Idle 'Prentice Executed at Tyburn. Drawing for plate XI.

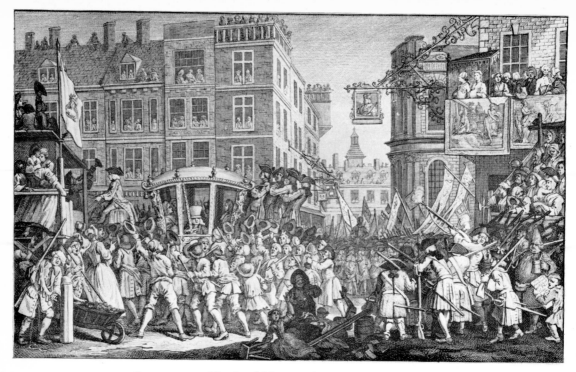

108a HOGARTH: The Lord Mayor's Show. Plate XII. Engraving.

108b PANNINI: Meeting between Pope Benedict XIV and King Charles III of Naples, 1744.

109a HOGARTH: The industrious 'Prentice Married and Furnishing His House. Drawing, not engraved.

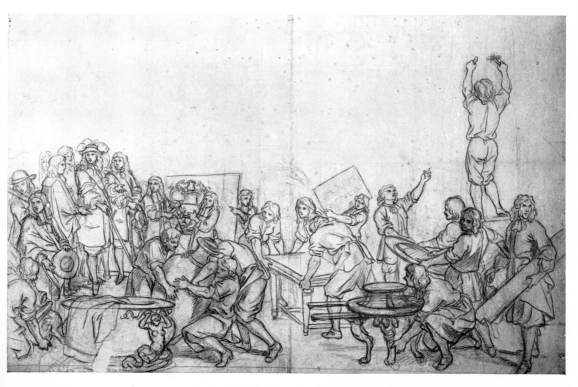

109b LEBRUN: Louis XIV Visiting the Gobelins, 1667/73. Drawing.

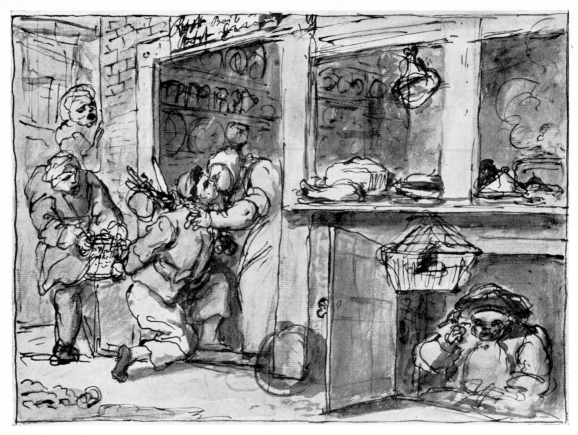

110a HOGARTH: The Idle 'Prentice stealing from His Mother. Drawing, not engraved.

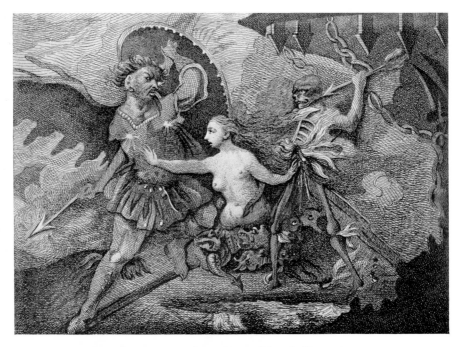

110b HOGARTH: Satan, Sin and Death. Engraving.

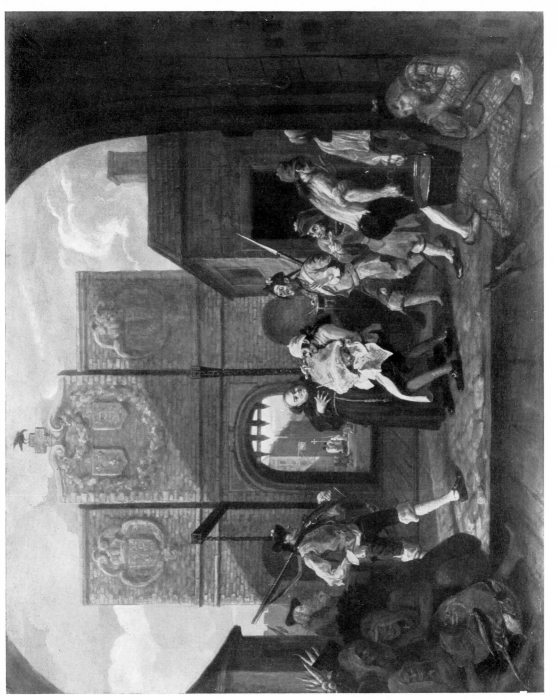

III HOGARTH: Calais Gate, 1749.

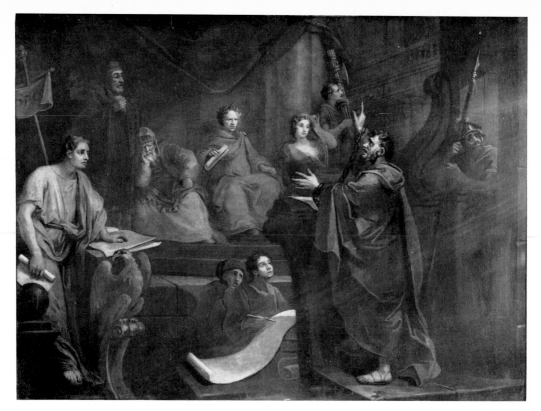

112a HOGARTH: Paul before Felix, 1748.

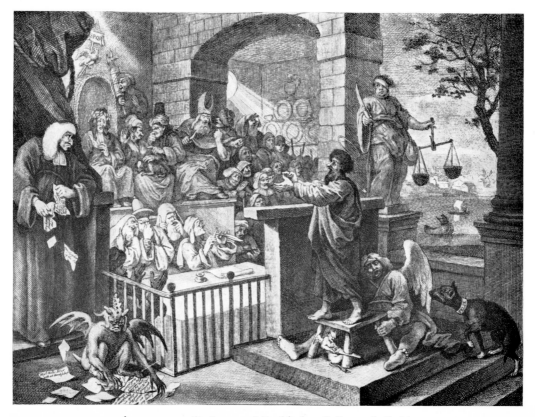

112b HOGARTH: Caricature of Paul before Felix, 1748. Etching.

113a HOGARTH: Columbus breaking the Egg, 1752. Etching.

113b HEEMSKERK: Prisoner in Court.

114 Frontispiece to *The Jacobite's Journal*, 1747. Drawing.

115a HOGARTH: 'Hymen and Cupid'—Ticket for the *Masque of Alfred*, 1748.

115b BENTLEY: Illustration to Gray's *Ode on the Death of a Favourite Cat*, 1753.

116 HOGARTH: 'The Country Dance' from *The Analysis of Beauty*, 1753. Engraving.

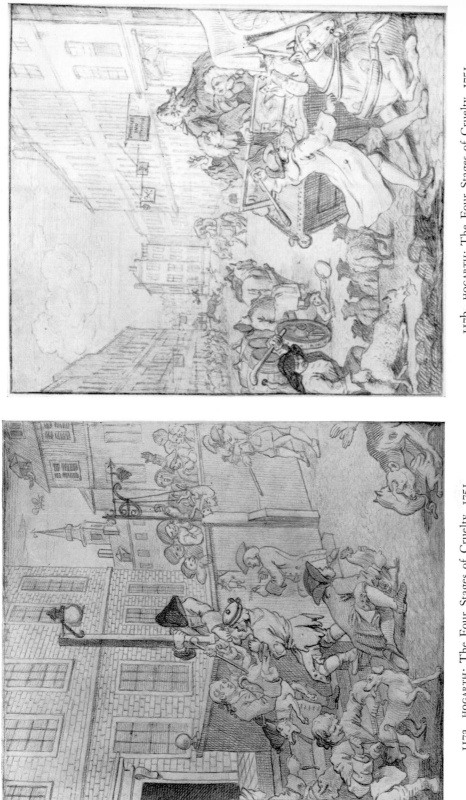

117b HOGARTH: The Four Stages of Cruelty, 1751.
Drawing for plate II.

117a HOGARTH: The Four Stages of Cruelty, 1751.
Drawing for plate I.

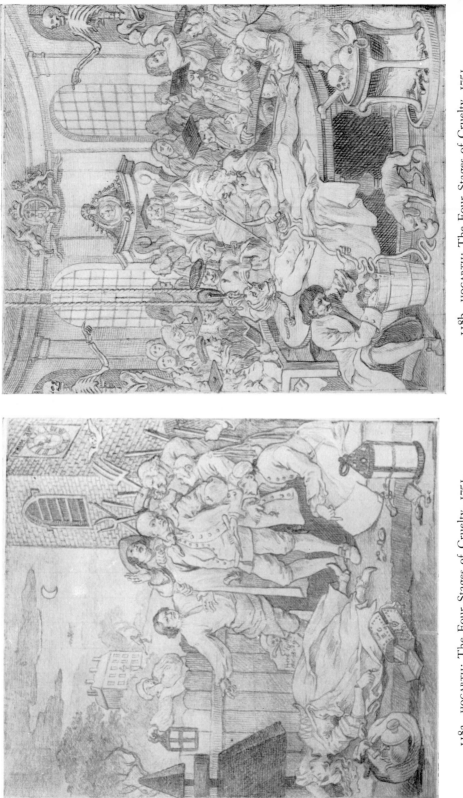

118b HOGARTH: The Four Stages of Cruelty, 1751.
Drawing for plate IV.

118a HOGARTH: The Four Stages of Cruelty, 1751.
Drawing for plate III.

119b HEEMSKERK, engraved by Toms, c. 1730: Quack Physicians' Hall.

119a HOGARTH, engraved by Ravenet, 1759: Illustration to *Tristram Shandy*.

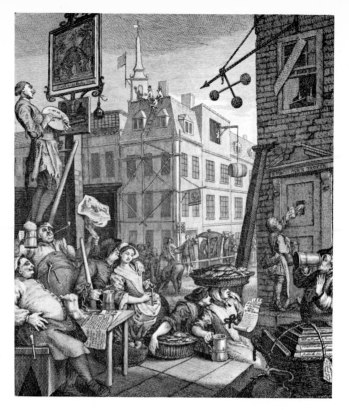

120a HOGARTH: Beer Street, 1751. Engraving.

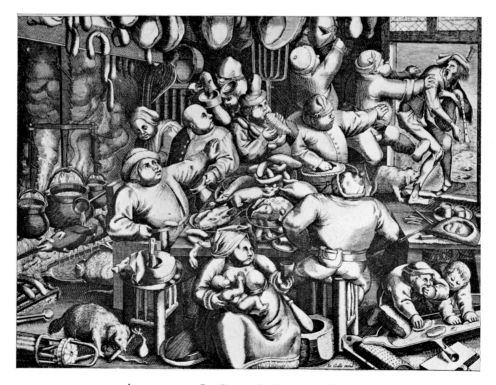

120b BREUGHEL: La Grasse Cuisine, 1563. Engraving.

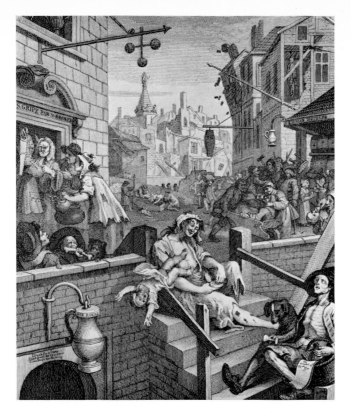

121a HOGARTH: Gin Lane, 1751. Engraving.

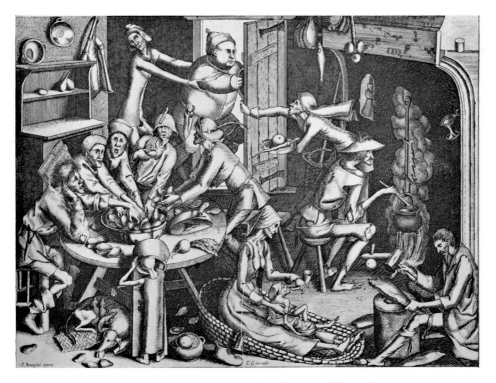

121b BREUGHEL: La Maigre Cuisine, 1563. Engraving.

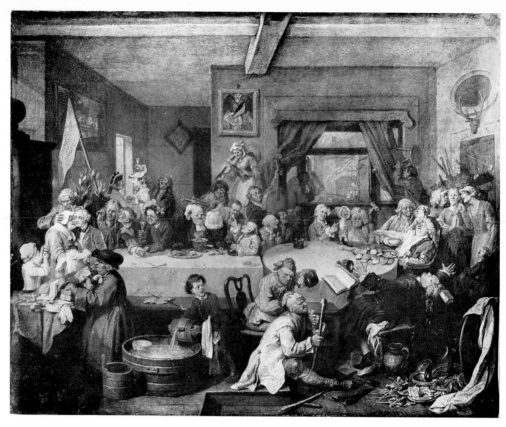

122a HOGARTH: Election Entertainment, 1754.

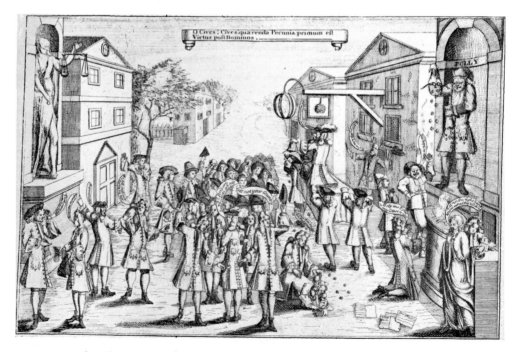

122b Election Won by Bribery: Humours of an Election, 1727. Engraving.

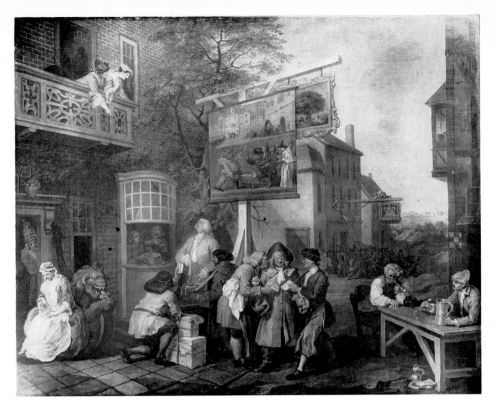

123a HOGARTH: Canvassing for Votes, 1754.

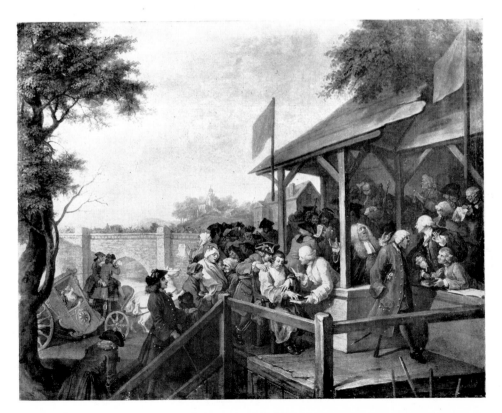

123b HOGARTH: Polling, 1754.

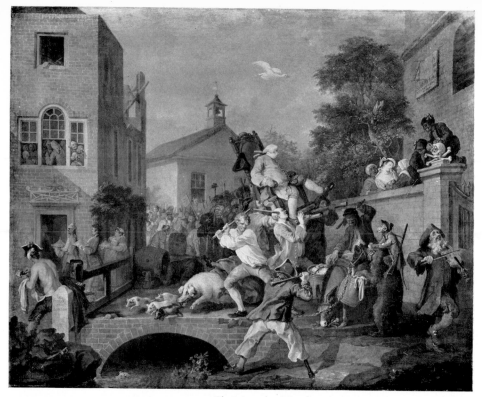

124a HOGARTH: Chairing the Member, 1754.

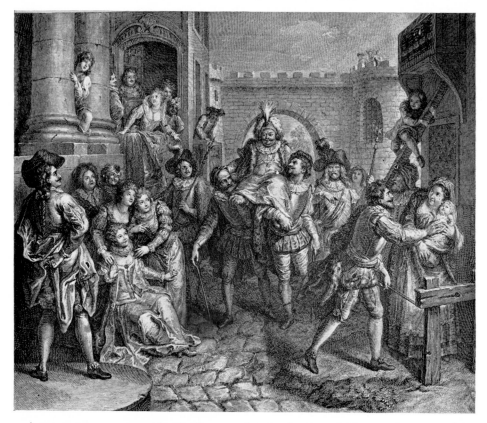

124b C. A. COYPEL, engraved by Tardieu, 1723/34: Sancho Panza's Entry as Governor of the
Isle of Barataria.

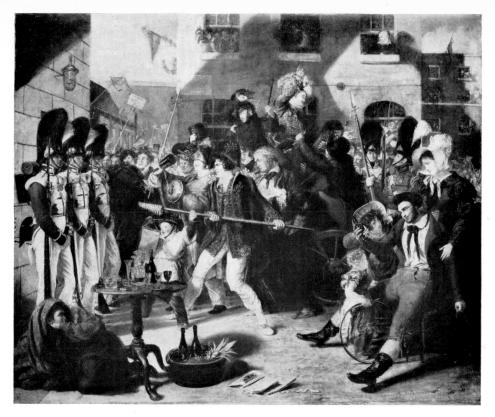

125a HAYDON: Chairing the Member, 1828.

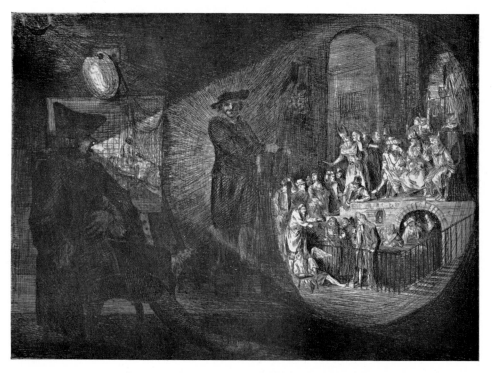

125b PAUL SANDBY: Magic Lantern, 1753. Engraving.

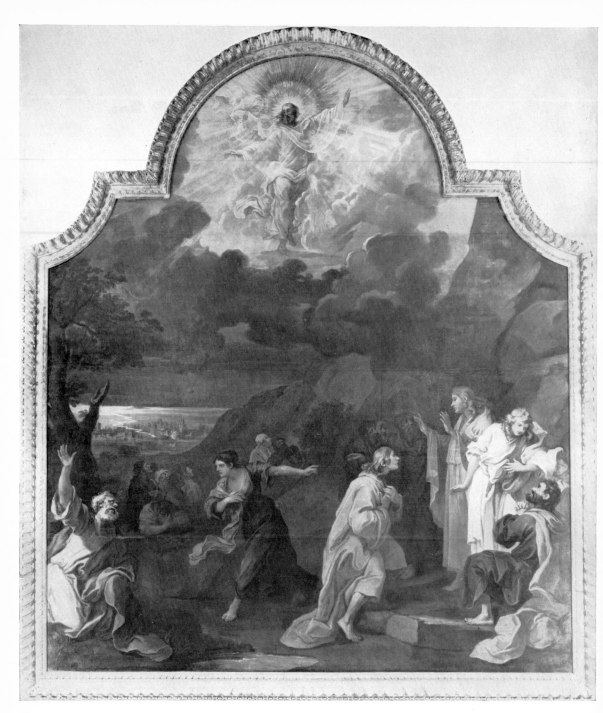

126 HOGARTH: St. Mary Redcliffe altarpiece: The Ascension, 1756.

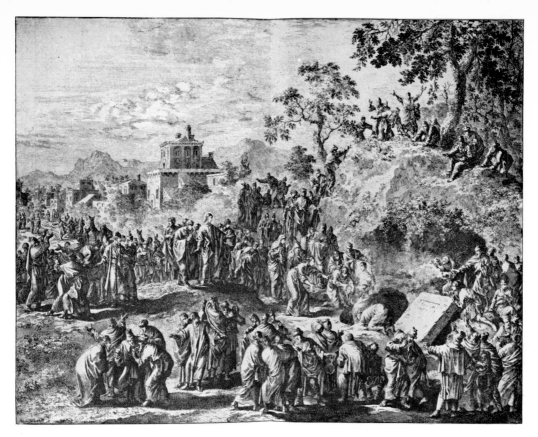

127a LUYKEN: 'Resurrection of Lazarus' from *Afbeldingen der Merkwaardigste Geschiedenissen van het oude en nieuwe Testament*, 1729.

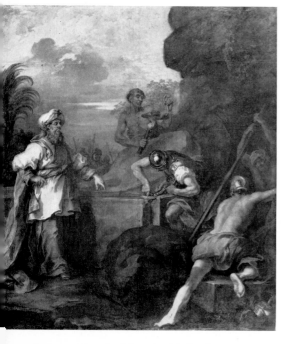

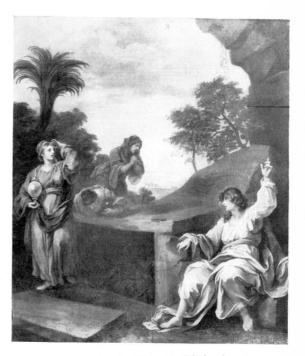

127b HOGARTH: St. Mary Redcliffe altarpiece: The Sealing of the Sepulchre.

127c HOGARTH: St. Mary Redcliffe altarpiece: The Three Marys at the Tomb.

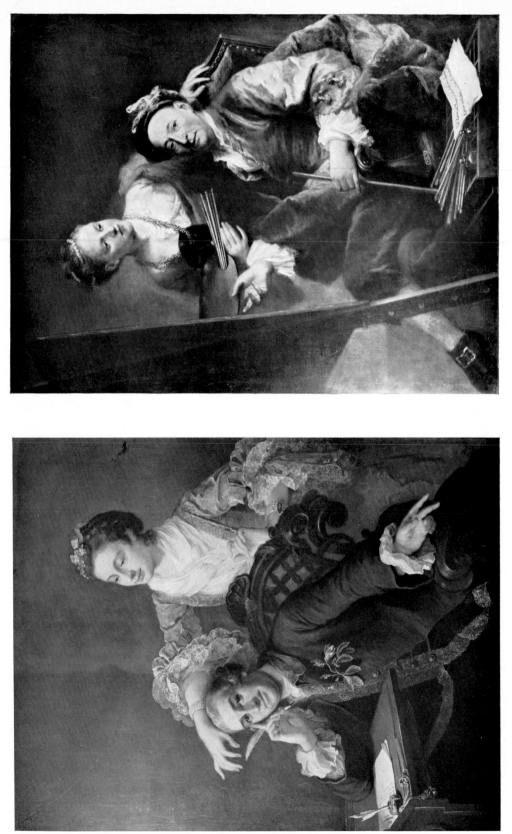

128b DESMARÉES: The Artist with His Daughter, 1760.

128a HOGARTH: Garrick and His Wife, 1757.

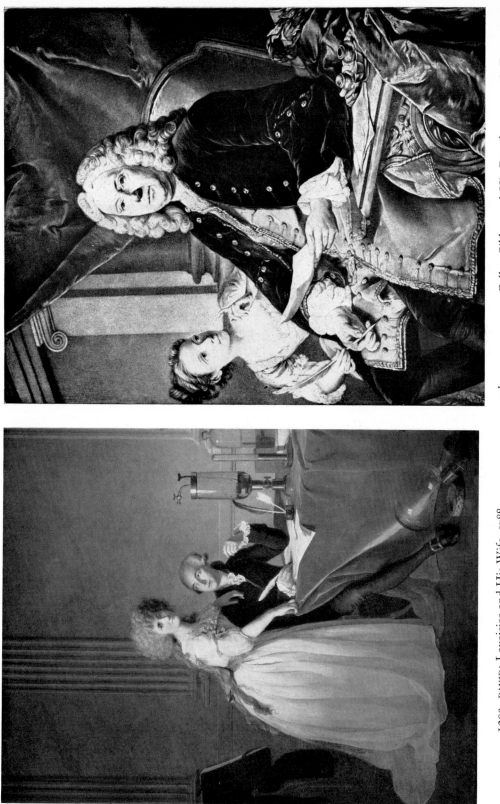

129a DAVID: Lavoisier and His Wife, 1788.

129b J. B. VAN LOO: Colley Cibber and His Daughter, *c.* 1738. Engraving.

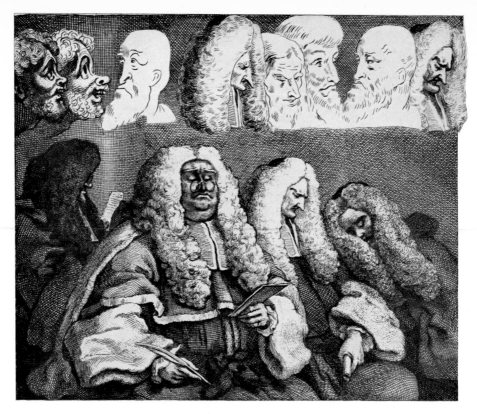

130a HOGARTH: The Bench, 1758. Engraving.

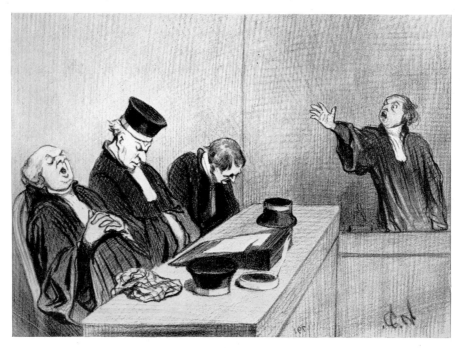

130b DAUMIER: Les Gens de Justice, 1845. Engraving.

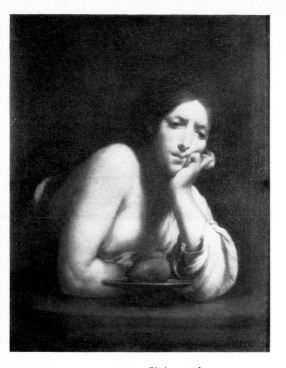

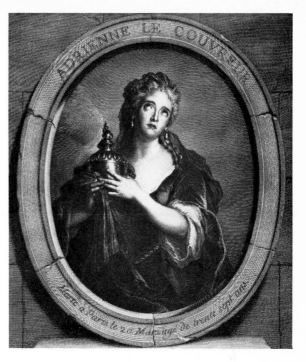

131a FURINI: Sigismunda.

131b C. A. COYPEL, engraved by Drevet, 1730.
Adrienne Lecouvreur as Cornelia.

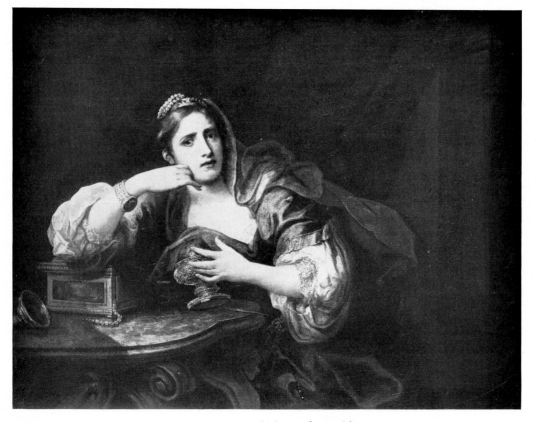

131c HOGARTH: Sigismunda, 1758/9.

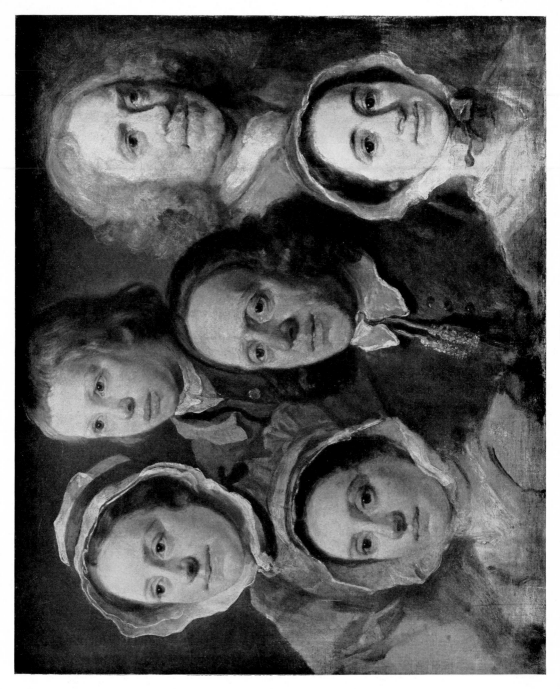

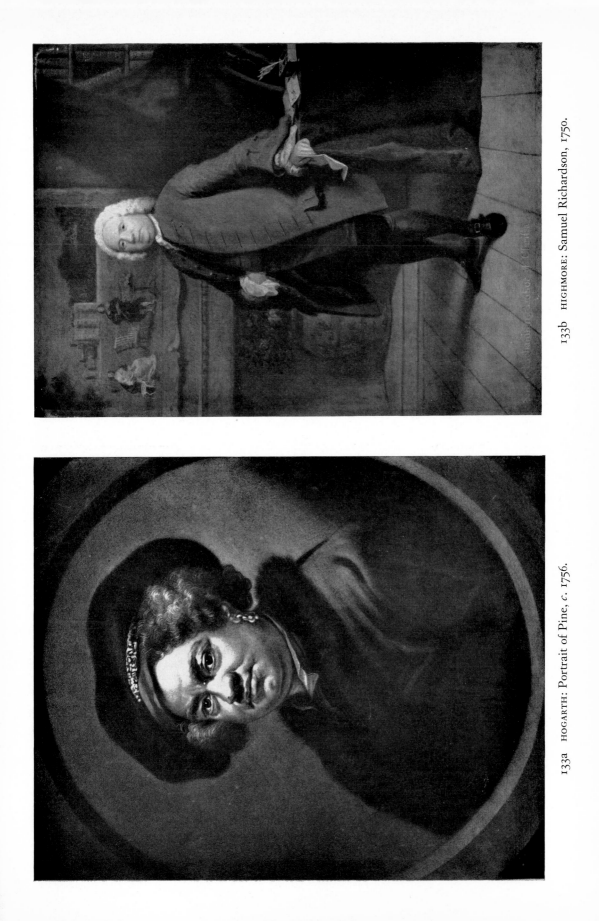

133a HOGARTH: Portrait of Pine, c. 1756.

133b HIGHMORE: Samuel Richardson, 1750.

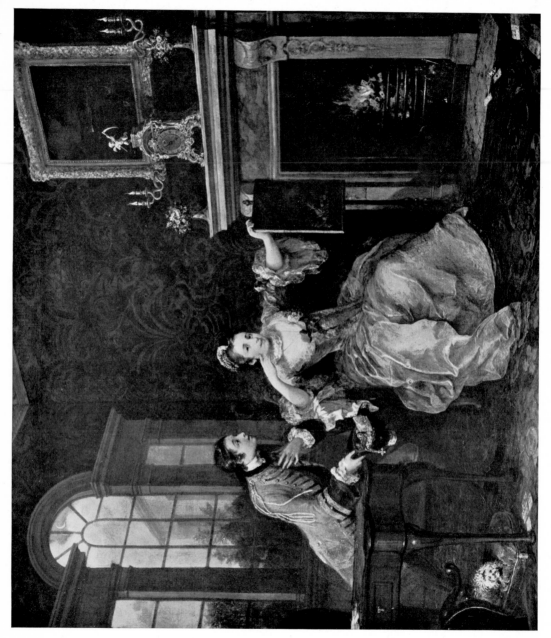

134 HOGARTH: The Lady's Last Stake, 1758/9.

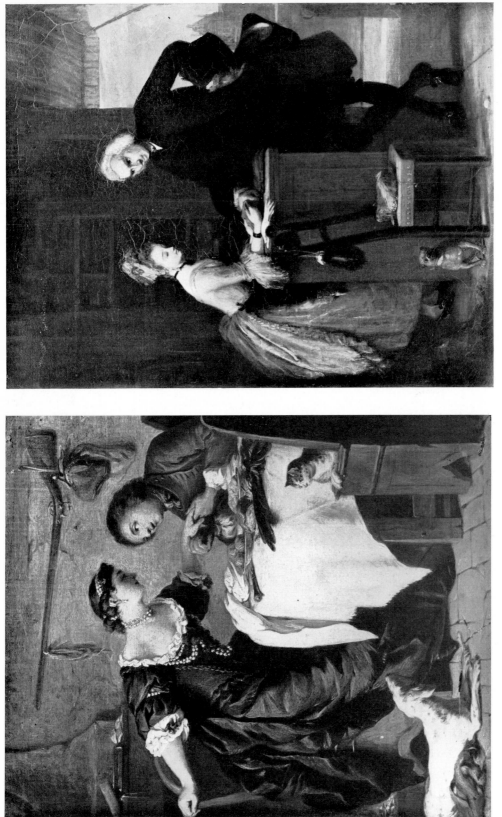

135b STUART NEWTON: Yorrick and The Grisette in the
Glove Shop, c. 1830.

135a SUBLEYRAS: Le Faucon.

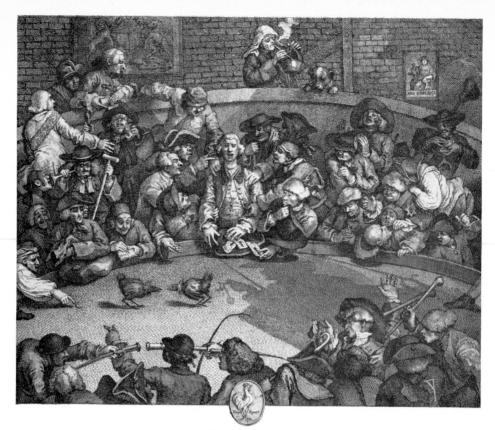

136a HOGARTH: The Cockpit, 1759. Engraving.

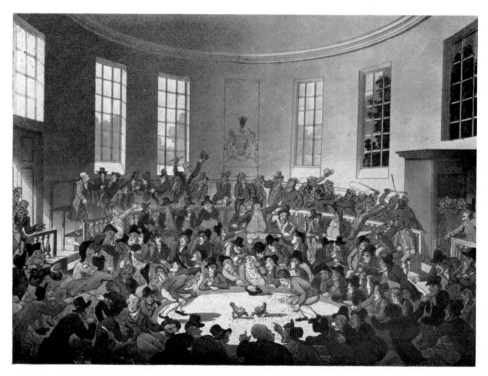

136b ROWLANDSON: Royal Cockpit, 1816. Aquatint.

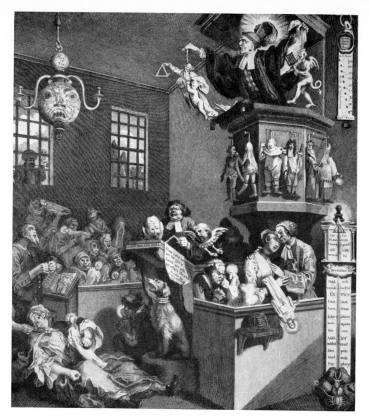

137a HOGARTH: Enthusiasm Delineated, 1762. Engraving.

137b Dutch print: Cromwell Preaching, 1651.

138a HOGARTH: The Shrimp Girl.

138b FRANS HALS: Fisher Girl.

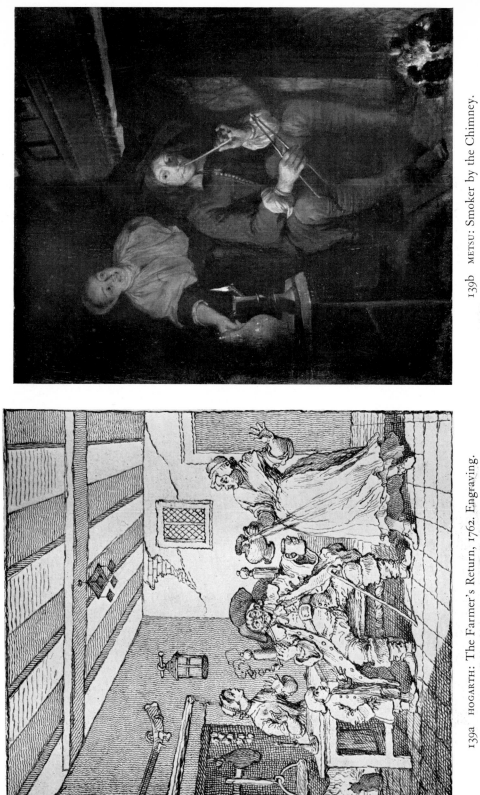

139a HOGARTH: The Farmer's Return, 1762. Engraving.

139b METSU: Smoker by the Chimney.

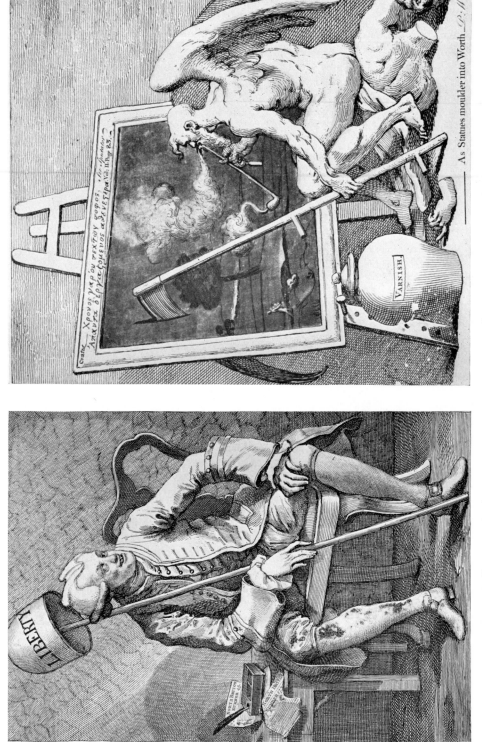

140b HOGARTH: Time Smoking a Picture, 1761. Engraving.

140a HOGARTH: Wilkes, 1763. Etching.

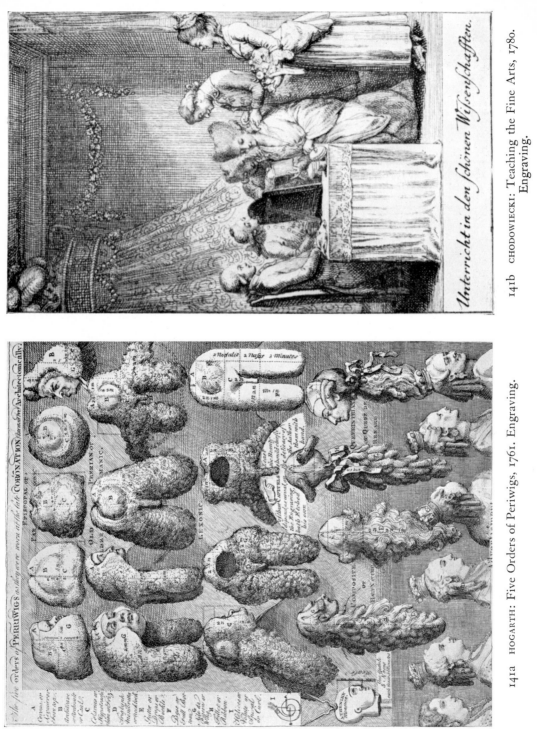

141b CHODOWIECKI: Teaching the Fine Arts, 1780.
Engraving.

141a HOGARTH: Five Orders of Periwigs, 1761. Engraving.

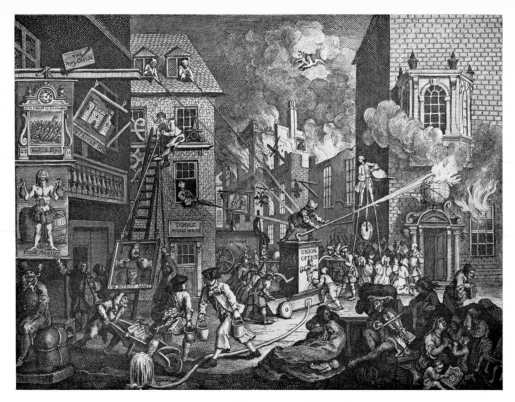

142a HOGARTH: Times I, 1762. Engraving.

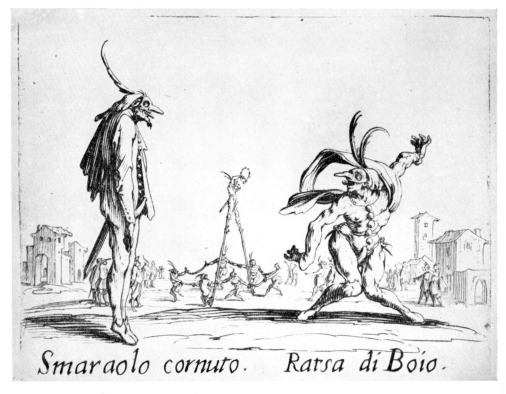

142b CALLOT: Smaraolo Cornuto. Ratsa di Boio, c. 1622. Engraving.

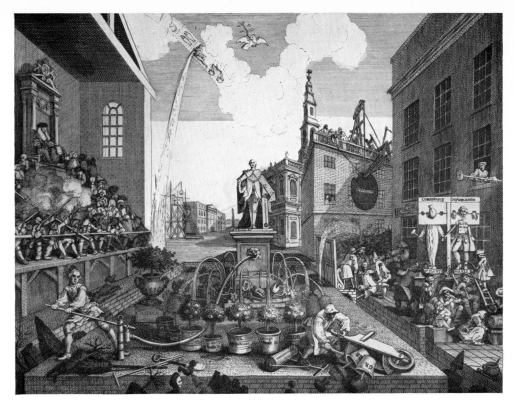

143a HOGARTH: Times II, 1762. Engraving.

143b HOGARTH: Bathos, 1764. Drawing.

144a ZOFFANY: Concert of Wandering Minstrels, 1773.

144b CHODOWIECKI: Progress of Virtue and Vice, 1778. Engraving.

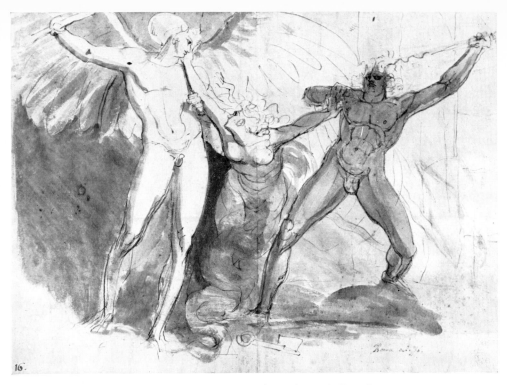

145a FUSELI: Satan, Sin and Death, 1776. Drawing.

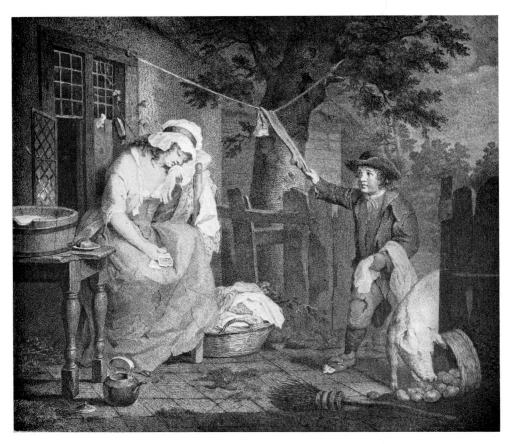

145b MORLAND, engraved by Blake, 1788: Idle Laundress.

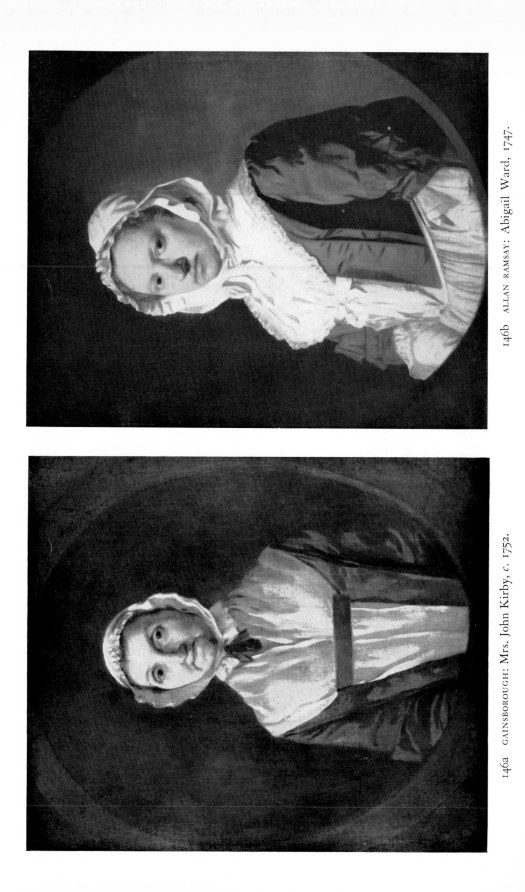

146b ALLAN RAMSAY: Abigail Ward, 1747.

146a GAINSBOROUGH: Mrs. John Kirby, c. 1752.

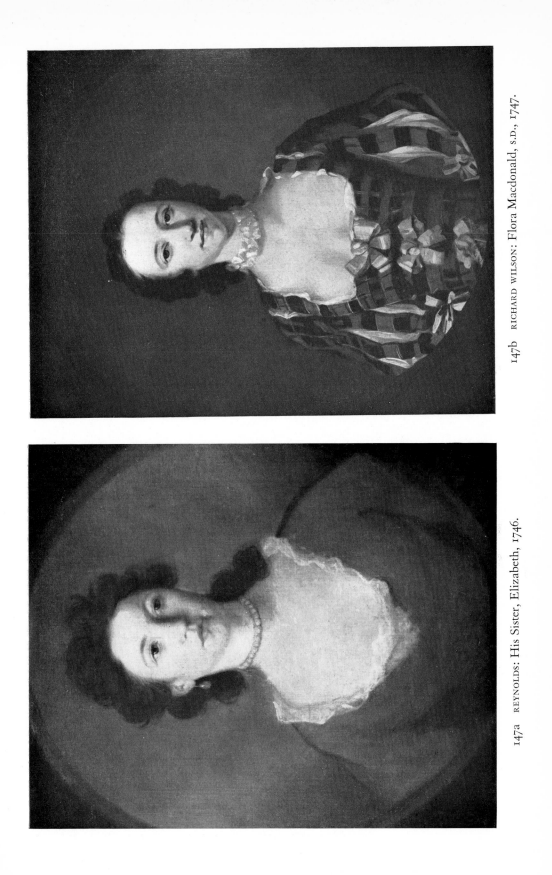

147b RICHARD WILSON: Flora Macdonald, s.d., 1747.

147a REYNOLDS: His Sister, Elizabeth, 1746.

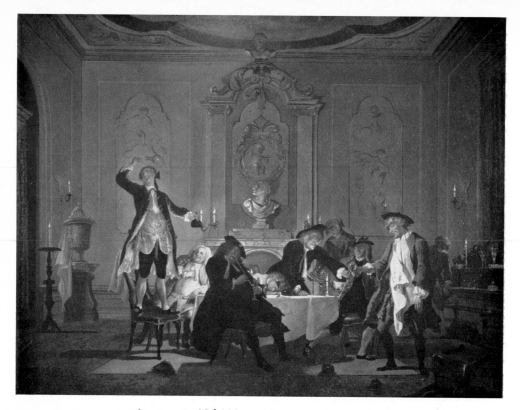

148a TROOST: Nelri No. 4. Rumor erat in casa, 1740.

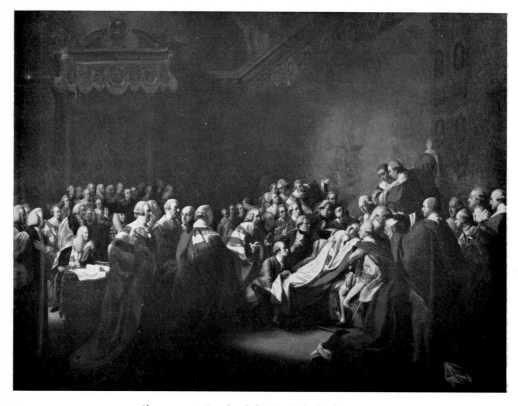

148b COPLEY: Death of the Earl of Chatham, 1778.

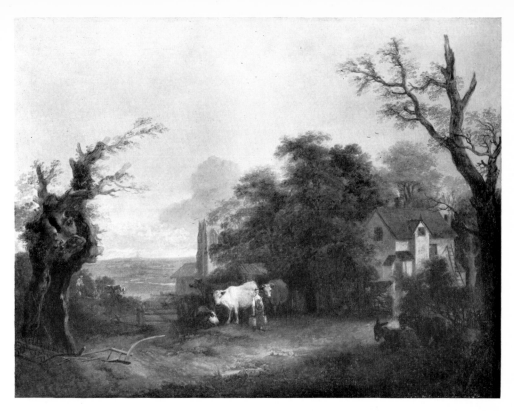

149a GAINSBOROUGH: Farm Landscape, *c.* 1750/5.

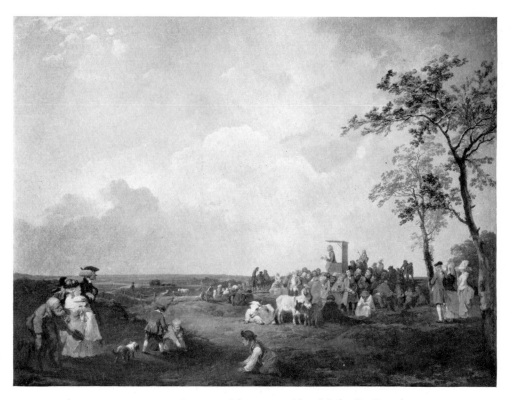

149b DE LOUTHERBOURG: Summer Afternoon with a Methodist Preacher, *c.* 1774.

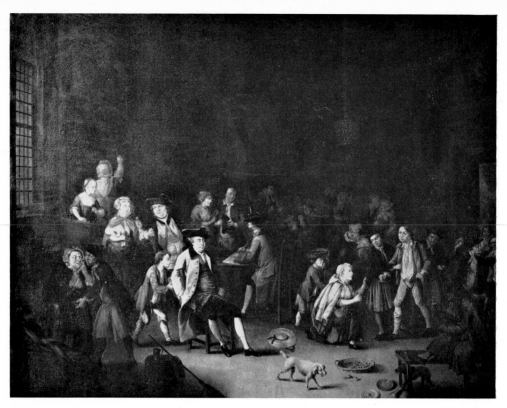

150a JOHN COLLET: The Press Gang, 1767.

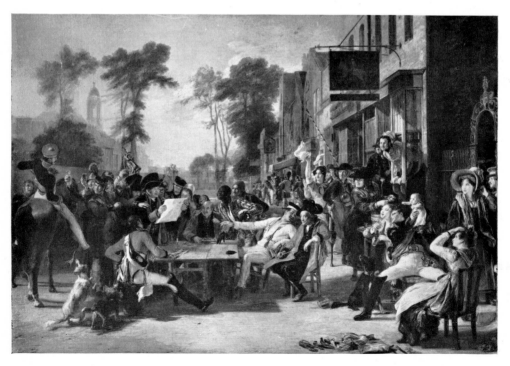

150b WILKIE: Chelsea Pensioners Reading the Waterloo Despatch, 1817.

151a CRUIKSHANK: The Drunkard's Children, 1848. Engraving.

151b GILLRAY: Dilettanti Theatricals, 1803. Engraving.

152 MILLAIS: Race Meeting, 1853. Drawing.